HARLAXTON COLLEGE

HARLAXTON COLLEGE LIBRARY WITHDRAWN

UNIVERSITY OF EVANSVILLE HARLAX LANGE HARLAX LANGE HARLAX LONG HANGE GRANTHAM, LINCS

ALL THE MIGHTY WORLD

The Photographs of Roger Fenton, 1852-1860

HARLAXTON COLLEGE LIBRARY WITHDRAWN

UNIVERSITY OF EVANSVILLE
HARLAXTON COLLEGE LIBRARY
HARLAXTON MANOR
GRANTHAM, LINCS

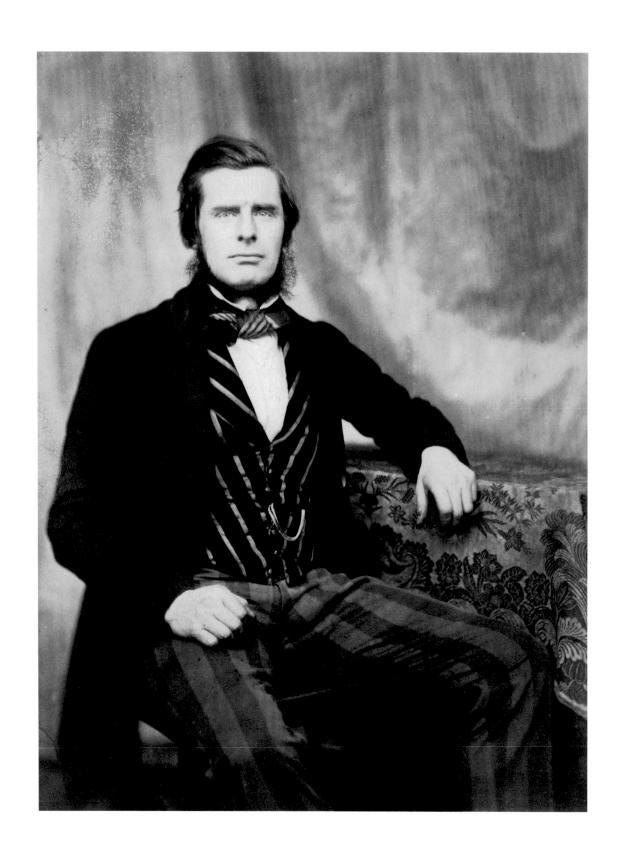

ALL THE MIGHTY WORLD

The Photographs of Roger Fenton, 1852-1860

Gordon Baldwin, Malcolm Daniel, and Sarah Greenough

With contributions by Richard Pare, Pam Roberts, and Roger Taylor

The Metropolitan Museum of Art, New York

National Gallery of Art, Washington

The J. Paul Getty Museum, Los Angeles

Yale University Press, New Haven and London

This publication accompanies the exhibition "All the Mighty World: The Photographs of Roger Fenton, 1852–1860," held at the National Gallery of Art, Washington, from October 17, 2004, to January 2, 2005; The J. Paul Getty Museum, Los Angeles, from February 1 to April 24, 2005; The Metropolitan Museum of Art, New York, from May 24 to August 21, 2005; and Tate Britain, London, from September 21, 2005, to January 2, 2006.

In New York, the exhibition is made possible by The Hite Foundation.

At the National Gallery of Art, the exhibition is made possible through the generous support of the Trellis Fund and The Ryna and Melvin Cohen Family Foundation.

The exhibition catalogue is made possible by The Andrew W. Mellon Foundation.

The exhibition is supported by an indemnity from the Federal Council on the Arts and the Humanities.

The exhibition was organized by the National Gallery of Art, Washington; The J. Paul Getty Museum, Los Angeles; and The Metropolitan Museum of Art, New York.

Copyright © 2004 The Metropolitan Museum of Art, New York

All rights reserved. No part of this publication may be reproduced or transmitted in any form or by any means, electronic or mechanical, including photocopying, recording, or any information storage or retrieval system, without permission in writing from the publishers.

Published by The Metropolitan Museum of Art, New York

John P. O'Neill, Editor in Chief Ruth Lurie Kozodoy, Editor, with Margaret Donovan Bruce Campbell, Designer Peter Antony and Douglas J. Malicki, Production Minjee Cho, Desktop Publishing Jayne Kuchna, Bibliographic Editor New photography by Mark Morosse, the Photograph Studio, The Metropolitan Museum of Art Map by Anandaroop Roy

Typeset in Bell and Centaur
Printed on 135 gsm Gardapat
Quadra- and duotone separations by Martin Senn
Printed and bound by EBS Editoriale Bortolazzi-Stei s.r.l., Verona

Jacket/cover illustration: Roger Fenton, Westminster from Waterloo Bridge (detail), ca. 1858; plate 60 Frontispiece: Roger Fenton, Self-Portrait, ca. 1854

LIBRARY OF CONGRESS CATALOGING-IN-PUBLICATION DATA

Baldwin, Gordon, 1939-

All the mighty world: the photographs of Roger Fenton, 1852-1860 / Gordon Baldwin, Malcolm Daniel, and Sarah Greenough; with contributions by Richard Pare, Pam Roberts, and Roger Taylor.

p. cm.

Catalog of the exhibition held Oct. 17, 2004—Jan. 2, 2005 at the National Gallery of Art, Washington, D.C.; Feb. 1, 2005—April 24, 2005 at the J. Paul Getty Museum, Los Angeles; May 24, 2005—Aug. 21, 2005 at the Metropolitan Museum of Art, New York; Sept. 21, 2005—Jan. 2, 2006 at Tate Britain.

Includes bibliographical references and index.

1. Photography, Artistic—Exhibitions. 2. Fenton, Roger, 1819–1869—Exhibitions. I. Daniel, Malcolm R. II. Greenough, Sarah, 1951– III. Fenton, Roger, 1819–1869. IV. Metropolitan Museum of Art (New York, N.Y.) V. National Gallery of Art (U.S.) VI. J. Paul Getty Museum. VII. Title.

TR647.F46 2004

779'.092—dc22

2004015294

Contents

Directors' Foreword · vii

Acknowledgments · viii

Lenders to the Exhibition · xi

A Note on Early Photographic Techniques · xii

Map of the British Isles, with major sites photographed by Fenton · xiv

"A New Starting Point": Roger Fenton's Life · 2

Sarah Greenough

"On Nature's Invitation Do I Come": Roger Fenton's Landscapes · 32 Malcolm Daniel

In Pursuit of Architecture · 54 Gordon Baldwin

"Mr. Fenton Explained Everything": Queen Victoria and Roger Fenton · 74 Roger Taylor

"Trying His Hand upon Some Oriental Figure Subjects" · 82 Gordon Baldwin

Roger Fenton and the Still-Life Tradition · 90

Pam Roberts

PLATES · 99

"A Most Enthusiastic Cultivator of His Art": Fenton's Critics and the Trajectory of His Career · 199 Roger Taylor

"The Exertions of Mr. Fenton": Roger Fenton and the Founding of the Photographic Society · 211

Pam Roberts

Roger Fenton: The Artist's Eye · 221
Richard Pare

A Chronology of the Life and Photographic Career of Roger Fenton · 231 Roger Taylor and Gordon Baldwin

List of Plates · 240

Notes to the Essays and Chronology · 245

Bibliography · 267

Index · 283

Photograph Credits · 290

Directors' Foreword

It is fitting that the first collaboration in the field of photography between The Metropolitan Museum of Art, the National Gallery of Art, and The J. Paul Getty Museum should concern a photographer so thoroughly intertwined with the broader art of his time as Roger Fenton. Trained as a painter in London and Paris, linked in aesthetic spirit to Turner and Constable, inspired by the Orientalist fantasies of Ingres and Delacroix, the land-scapes of David Cox, and the still lifes of George Lance, Fenton is at home in the company of artists known and admired by our museums' visitors. He was, moreover, one of photography's supreme artists—not only of the nineteenth century or in Britain, but in the entire history of the medium. His perfect technique and unerring choice of vantage point and lighting conditions allowed him to render the smallest details while at the same time conveying a sense of monumentality, and thus to imbue his pictures with both delicacy and sublime power.

This catalogue takes its title, All the Mighty World, from William Wordsworth's "Lines Written a Few Miles above Tintern Abbey," an ode to nature in which the author declares himself "A lover of the meadows and the woods, / And mountains; and of all that we behold / From this green earth; of all the mighty world / Of eye and ear, both what they half-create, / And what perceive." The poet's words find an echo in the reverence for nature so evident in Fenton's landscapes, and, even more aptly, they suggest the photographer's grand ambition and broad reach. In the course of a single decade, Fenton mastered every photographic genre. He produced majestic architectural views of England's ruined abbeys and her stately homes, Romantic depictions of the countryside, moving reportage of the Crimean War (the first extensive series of war photographs), intimate portraits of Queen Victoria and her family, enchanting Orientalist tableaux, and astonishingly lush still lifes. Fenton helped shape the early progress of the medium in other ways as well. He served as the official photographer of the British Museum, being the first to hold such a position in any museum; he fought for the extension of copyright

protection to photographs; and he was the principal force behind the establishment of what would eventually become the Royal Photographic Society.

Our deepest thanks go to the many individual and institutional lenders who have generously shared their prized photographs, allowing us to represent the artist at his very highest level of achievement. We are also grateful to the exhibition's curators, Sarah Greenough, Gordon Baldwin, and Malcolm Daniel, for the dedicated work that went into the organization of the exhibition and for the benefit of their scholarship and connoisseurship. Three guest authors, Roger Taylor, Pam Roberts, and Richard Pare, made important and eloquent contributions. We also thank the staffs of our three institutions and of Tate Britain for their efforts on behalf of the exhibition and catalogue. The Metropolitan Museum is very much indebted to The Hite Foundation for its generosity toward this exhibition. The Museum also thanks The Andrew W. Mellon Foundation, whose publications endowment provided support for this catalogue. The National Gallery of Art would like to express appreciation to the Trellis Fund and The Ryna and Melvin Cohen Family Foundation for their support of the exhibition, and to the Federal Council on the Arts and the Humanities for providing an indemnity for the exhibition.

Both in his own work and through his advocacy for the medium, Fenton sought to establish photography as the equal of other, long-established fine arts. A century and a half later, we derive profound pleasure from his success.

Philippe de Montebello

Director, The Metropolitan Museum of Art

Earl A. Powell III

Director, National Gallery of Art

Deborah Gribbon

Director, The J. Paul Getty Museum; Vice President, J. Paul Getty Trust

Acknowledgments

In the past decade, as interest in the history of photography has escalated exponentially, a number of nineteenth-century photographers have been the object of in-depth scholarly studies. Monographic exhibitions and publications appeared that were devoted to Édouard Baldus, Mathew Brady, Julia Margaret Cameron, Gustave Le Gray, Nadar, William Henry Fox Talbot, and Carleton Watkins, among others. Notably absent from this growing pantheon has been Roger Fenton, although an exhibition of his work showed at the Royal Academy in London in 1988 and traveled in a much-reduced scale to the Yale Center for British Art. Especially in the United States, Fenton's accomplishments have emphatically warranted further attention.

As is often the case, the idea for this catalogue and exhibition occurred simultaneously to several different people. Sarah Greenough of the National Gallery and Gordon Baldwin of The J. Paul Getty Museum had already been having conversations on the subject when The Metropolitan Museum of Art acquired The Rubel Collection, with its superb Fenton photographs. Maria Morris Hambourg of the Metropolitan Museum suggested that her colleague Malcolm Daniel join the discussion under way and that the Metropolitan Museum, the National Gallery, and the Getty embark on their first collaboration in the field of photography by organizing this important exhibition. The three curators quickly asked the noted Fenton scholars Roger Taylor, Pam Roberts, and Richard Pare to lend their expertise and to write essays for the catalogue. We have benefited enormously from the different perspectives and insights these colleagues have brought to the subject.

From the very beginning of this undertaking, energetic support has come from the leadership of our three institutions, and we are grateful to Earl A. Powell III, Director of the National Gallery of Art, Philippe de Montebello, Director of The Metropolitan Museum of Art, and Deborah Gribbon and John Walsh, the present and former Directors of The J. Paul

Getty Museum, for their guidance and unwavering commitment to the project. Also deeply appreciated are the efforts at the National Gallery of Alan Shestack, Deputy Director, and D. Dodge Thompson, Chief of Exhibitions; at the Metropolitan Museum of Mahrukh Tarapor, Associate Director for Exhibitions; and at the Getty of Quincy Houghton, Head of Exhibitions and Public Programming. One of our principal objectives has been to introduce Fenton's photography to both an American and an international audience. We wish to thank Stephen Deuchar, Director of Tate Britain, for enthusiastically joining with us to bring this exhibition to London and reacquaint the British public with Fenton's art.

An exhibition and catalogue of this magnitude and complexity could not have been organized without the devoted work of many individuals. Special thanks are due to April Watson, Sara Cooling Trucksess, and Sarah Kennel in the Department of Photographs at the National Gallery; meticulous and unfailingly gracious, they have assisted with all aspects of the planning, organization, and execution of the exhibition.

We are joined by our fellow authors in expressing heartfelt gratitude to all those whose efforts made possible the realization of this catalogue, under the able leadership of John O'Neill, Editor in Chief and General Manager of Publications at the Metropolitan Museum. Ruth Kozodoy, Senior Editor, edited the essays gracefully, challenged the authors to clarify their ideas, and helped mold the book's contents into a cohesive whole. Valuable editorial work was also performed by Margaret Donovan and by Jayne Kuchna, the Bibliographic Editor. Bruce Campbell is responsible for the catalogue's elegant design, Mark Morosse of the Photograph Studio for much of the copy photography, and Martin Senn for the quadra- and duotone separations. Peter Antony, Chief Production Manager, oversaw the complex printing of the book after shepherding it, assisted by Douglas J. Malicki, through the many stages of production. Special thanks go also to Minjee Cho, Cathy Dorsey, Mary Gladue, and Anandaroop Roy.

This exhibition and publication are built on foundations laid by earlier scholars, many of whom are cited in this book's footnotes and bibliography. Special recognition should be given to Helmut and Alison Gernsheim, John Hannavy, and Valerie Lloyd for their pioneering work on Fenton. A friend, colleague, and former Curator of the Royal Photographic Society, the late Valerie Lloyd inspired all of us with her passionate dedication to Fenton's legacy. Her extensive research into his life, generously made available to Gordon Baldwin by her family, proved invaluable for the assembling of the chronology and the discovery of previously unpublished Fenton images.

In the course of our work on this project, many people have responded to our requests with a generosity that is both inspiring and humbling. We are particularly grateful to the directors and trustees of the lending institutions and to the private collectors who have magnanimously allowed their works to be included in the exhibition. In addition we especially wish to thank their curators, conservators, and registrars, whose assistance has been enormously helpful and who include Gary Thorn, Christopher Date, and Helen Sharp at The British Museum; Nicholas Olsberg, Louise Désy, Jo Anne Audet, Margaret Morris, and Marie-Chantal Anctil at the Centre Canadien d'Architecture/Canadian Centre for Architecture, Montréal; Pierre Apraxine and Maria Umali at the Gilman Paper Company Collection; Terence Suthers, Robin Diaper, Jane Stewart-Sant, and Karen Lynch at the Harewood House Trust; Mary Daniels and Irina Gorstein in Special Collections at the Frances Loeb Library, Harvard Design School; Bodo Von Dewitz at the Museum Ludwig; Paul Goodman, Jane Fletcher, Russell Roberts, and Brian Liddy at the National Museum of Photography, Film & Television, Bradford; Roy Flukinger, Barbara Brown, Debra Armstrong-Morgan, Linda Briscoe, and David Coleman at the Gernsheim Collection, Harry Ransom Center, the University of Texas at Austin; Frances Dimond, Theresa-Mary Morton, and Annaleigh Kennard at the Royal Collection, Windsor; Janet Graffius and David Knight,

Stonyhurst College; Mark Haworth-Booth, Martin Barnes, David Wright, and Janet Skidmore at the Victoria and Albert Museum; and Violet Hamilton at the Wilson Centre for Photography.

At the National Gallery, special thanks are due to Carol Kelley in the Director's Office; Joe Krakora, Executive Officer, External and International Affairs; Jennifer Rich and Ann Robertson in the Department of Exhibitions; Jonathan Davis, Sarah Dennis, Karen Hellman, Marcie Hocking, and Stephen Pinson, interns in the Department of Photographs; Constance McCabe, Hugh Phibbs, Jenny Ritchie, and Jamie Stout in the Department of Conservation; Susan Arensberg and Margaret Doyle in the Department of Exhibition Programs; Elizabeth Croog and Isabelle Raval in the office of the Secretary-General Counsel; Mark Leithauser, Gordon Anson, Jame Anderson, Deborah Kirkpatrick, Nathan Peek, John Olson, Barbara Keyes, and Jeff Wilson in the Department of Design and Installation; Sally Freitag, Michelle Fondas, and Melissa Stegeman in the Office of the Registrar; Cathie Scoville in the Development Office; Chris Myers in the Office of Corporate Relations; Genevra Higginson in the Office of Special Events; Judy Metro, Sara Sanders-Buell, and Ira Bartfield in the Publishing Office; and Deborah Ziska and Mary Jane McKinven in the Press and Public Information Office.

At the Getty, thanks are due to William Griswold, Chief Curator; Weston Naef, Judith Keller, Julian Cox, Anne Lyden, Michael Hargraves, Brett Abbott, Paul Martineau, Marisa Weintraub, Valerie Graham, Edie Wu, and Ann Magee in the Department of Photographs; Marc Harnley, Ernie Mack, Lynn Kaneshiro, and Martin Salazar in the Department of Paper Conservation; Chris Hudson, Mark Greenberg, and Catherine Comeau in the Publications Department; Merritt Price, Tim McNeill, and Patrick Frederickson in the Department of Exhibition Design; Jack Ross and Christopher Foster in the Department of Photo Services; Sally Hibbard and Betsy Severance in the Registrar's Department; Pamela Johnson and

Tracy Gilbert in the Communications Department; Cathy Carpenter, Viviane Meerbergen, and Jaime Villaneda, in the Education Department; Christina Olsen and Uttara Natarajan in the Interactive Programs Department; Amber Keller in the Exhibitions Department; Ivy Okamura in the Events Department; and Bruce Metro, Mike Mitchell, Tracy Witt, and the entire team in the Preparation Department.

The Metropolitan Museum is profoundly grateful to Sybil and Lawrence Hite for their devotion to nineteenth-century British photography and to The Hite Foundation for its enlightened sponsorship of this exhibition. Also greatly appreciated is the support for the publication of this catalogue provided by The Andrew W. Mellon Foundation. At the Metropolitan, special thanks are owed to Rachel Becker for invaluable assistance with the catalogue and exhibition and to Maria Hambourg, Laura Harris, Lisa Hostetler, Nora Kennedy, and Nancy Reinhold, all in the Department of Photographs; Linda Sylling, Manager for Special Exhibitions; Martha Deese, Senior Assistant for Exhibitions; Nina Maruca, Registrar; Elly Muller, Senior Press Officer; Christine Scornavacca of the Development Office; Mike Norris and Elizabeth Hammer of the Education Department; Barbara Bridgers and Susan Bresnan of the Photograph Studio; Curators Elizabeth Barker and Laurence Kanter; and Michael Langley and Sophia Geronimus of the Design Department. The handsome presentation of the exhibited photographs is the work of Predrag Dimitrijevic of the Department of Photographs and Jed Bark of Bark Frameworks.

We also wish to give special recognition to our colleagues at Tate Britain, Sarah Munday, Judith Nesbitt, Christine Riding, and Sheena Wagstaff, for the effort they have put into presenting this exhibition in London.

Numerous other individuals gave freely of their time and eagerly of their expertise. We wish to thank Robert Flynn Johnson, Achenbach Foundation for Graphic Arts, the Fine Arts Museums of San Francisco; David Travis, Art Institute of Chicago; Peter Bunnell and Toby Jurovics, The Art Museum, Princeton University; Sylvie Aubenas, Bibliothèque Nationale de France, Paris; Pete James, Birmingham Central Library; Sally Pierce, Boston Athenaeum; Keith Sweetmore, British Records Association, London; Aidan Flood, Camden Local Studies Library, London; Jim Ganz,

Sterling and Francine Clark Art Institute, Williamstown, Massachusetts; Dr. Lindy Grant and Jeffrey Fisher, Conway Library, Courtauld Institute of Art, London, and Philip Ward-Jacson, Courtauld Institute of Art; Lynn McNabb, Guildhall Library, London; Anne Tucker and Del Zogg, Houston Museum of Fine Arts; Jennifer McDonald, Hulton Getty Archive, London; Mike Chrimes, Institution of Civil Engineers, London; Hans P. Kraus and Jennifer Parkinson of Hans P. Kraus, Jr., Inc., New York; Verna Curtis and Michelle Delaney, The Library of Congress, Washington, D.C.; Robin Darwall-Smith, Magdalen College Archive, Oxford; the Henry Moore Institute, Leeds; the staff of the Archives du Musée du Louvre, Paris; Clifford Ackley and Anne Havinga, Museum of Fine Arts, Boston; Cathy Ross and Michael J. Seaborne, Museum of London; Rachel Cognale, Museum of Modern Art, New York; David Hodge, National Maritime Museum, London; Ian Leith, National Monuments Record, Swindon; Oliver Fairclough, National Museums & Galleries of Wales; Ed Bartholomew, National Railway Museum, York; Melanie Aspey and Richard Schofield, The Rothschild Archive, London; Michael Hall, Curator to Edmund de Rothschild; Maggie Magnuson, Royal Engineers Library, Chatham, Kent; David Haberstich, National Museum of American History, Smithsonian Institution, Washington, D.C.; Paula Fleming, National Museum of Natural History, Smithsonian Institution, Washington, D.C.; Katia Busch, Société Française de Photographie, Paris; Juliet Hacking, Sotheby's, London; Peter Lord, University of Wales Centre for Advanced Welsh & Celtic Studies, Aberystwyth; Jay Kempen, Washington University Archives, Saint Louis; and Roger and Jennifer Davies; Harry and Elizabeth Ellis; Scott and Donise Ferrel; Philippe Garner; Anthony S. Hamber; Robert Hershkowitz; Charles Isaacs; Ken Jacobson; Glyn Jones; Barbara Kehoe; Randall Keynes; Briony Llewellyn; Sarah Nicholson; Peter Peecock; Maria Antonella Pellizzari; Denise Raine; Michael Rich; William Rubel; Andrew Smith; Joel Smith; Pam Solomon; Howard Stein and Lee Marks; Lindsey Stewart; Chris Taylor; Quentin Tyler; and Paul Walter.

Gordon Baldwin	Malcolm Daniel	Sarah Greenough
The J. Paul Getty	The Metropolitan	National Gallery of Art
Museum	Museum of Art	

Lenders to the Exhibition

CANADA

Montréal, Collection Centre Canadien d'Architecture/Canadian Centre for Architecture 5, 10, 25, 47, 49, 50, 54, 55, 57, 60

GERMANY

Cologne, Museum Ludwig, Collection Robert Lebeck 85

UNITED KINGDOM

Bradford, National Museum of Photography, Film & Television (RPS Collection) 6, 7, 8, 27, 28, 29, 30, 38, 39, 41, 46, 59, 65, 66, 67, 70, 75, 76, 79, 80, 86, 87, 88, 89

Clitheroe, the Governors of Stonyhurst College 73

Leeds, the Earl and Countess of Harewood, and the Trustees of Harewood House Trust 68

London, Trustees of The British Museum 40

London, Victoria and Albert Museum 44, 77

Windsor, The Royal Collection 81, 82, 83, 84

UNITED STATES

Austin, Gernsheim Collection, Harry Ransom Center, The University of Texas at Austin 19

Cambridge, Massachusetts, H. H. Richardson Collection, Frances Loeb Library, Harvard Design School 35, 36, 51, 52, 69

Los Angeles, The J. Paul Getty Museum 3, 16, 21, 24, 31, 32, 33, 37, 42, 45, 48, 53, 62, 64, 72

New York, Gilman Paper Company Collection 1, 2, 4, 11, 12, 13, 15, 20, 26, 56, 58

New York, The Metropolitan Museum of Art 22, 23, 34, 61, 78

Washington, National Gallery of Art 9

PRIVATE COLLECTIONS

Richard and Ronay Menschel 71

Private collection, London frontispiece

Wilson Centre for Photography 14, 17, 18, 43, 63, 74

A Note on Early Photographic Techniques

In 1839, barely a dozen years before Roger Fenton took up the camera, two wholly different photographic processes were announced to the public: the daguerreotype in France and photogenic drawing in England.

The **daguerreotype** process was perfected and promoted by the painter, printmaker, and stage designer Louis-Jacques-Mandé Daguerre. In this process a highly polished silver-plated sheet of copper was sensitized with iodine fumes, exposed in a camera to record the desired object, developed over heated mercury vapors, and fixed with salt water or hypo (sodium thiosulfate). Each daguerreotype was a unique and dazzlingly detailed image. Although wildly popular in France and America, daguerreotypy was little practiced in England, where a patent restricted its use, and there is no indication that Fenton ever tried his hand at the process.

Instead, Fenton practiced various photographic techniques that all stemmed from the inventions of William Henry Fox Talbot. Prompted by Daguerre's announcement of his invention in January 1839, Talbot had scrambled to perfect and publish a completely different process, **photogenic drawing**, with which he had been experimenting for five years. His process involved immersing a sheet of fine writing paper in salt water and then, when dry, coating it with a solution of silver nitrate, thus forming light-sensitive silver chloride in the paper. Placed inside a camera, the paper darkened gradually wherever it was struck by light, eventually becoming a tonally reversed picture—what later came to be called a negative. Talbot's early exposures were lengthy, sometimes lasting hours, and the results were generally pale images in shades of yellow or purple.

In September 1840 Talbot discovered that even an exposure of mere seconds left a latent image that could be brought out—"developed," we would now say—by immersion in an "exciting liquid" (gallic acid). Paper negatives produced in this way were not absolutely transparent; their fibrous texture had a tendency to blur details and exaggerate the contrast between lights and darks, creating effects that some found more artistic than the cold

precision of the daguerreotype. But the principal advantage of Talbot's paper negative process, which he patented as the calotype or Talbotype, was the fact that multiple positive prints could be made from a single negative.

Although protected by patent restrictions in both England and France, Talbot's calotype process was nevertheless taken up in the late 1840s by French artists, who came up with variations that in the judgment of the French courts fell outside the bounds of Talbot's patent claims. It was one such variation, Gustave Le Gray's waxed-paper-negative process, that Fenton saw practiced in Paris in 1851 and subsequently used for his earliest photographs. In Le Gray's process, the paper support was infused with wax prior to sensitization to create a more homogeneous texture, give added transparency to the negative, and cause the photosensitive chemicals to sit on the surface of the paper rather than being absorbed by the paper fibers. This technique not only yielded a crisper image but also allowed the photographer to prepare his negatives days or weeks in advance of their use, making it particularly practical for travel photography. Fenton utilized Le Gray's process when traveling through Russia in 1852.

By the time Fenton took up photography, there was an alternative to the paper negative process, and after returning from Russia late in 1852 he used the new method exclusively. Producing a sharper image but more complex to carry out, this **glass negative** process, also called **wet plate**, **wet collodion**, or **wet collodion on glass**, had been published in 1851 by Frederick Scott Archer. The new method combined the precision of the daguerreotype with the reproducibility of the calotype, and it required an exposure time of seconds rather than minutes. In this procedure the photographer coated a sheet of glass with a layer of collodion (cellulose nitrate, also called guncotton, dissolved in ether) and sensitized it in a solution of silver salts. Since the plate had to be prepared, the picture taken, and the negative developed all before the collodion dried, it was necessary to take a portable darkroom when photographing outside the studio. Despite the difficulties of this

process, its results were considered so superior that by the end of the 1850s it had almost completely replaced both the calotype and the daguerreotype methods, even for campaigns such as Fenton's in the Crimea, where the use of an on-site darkroom might seem especially onerous.

While the process of taking a photograph was undergoing changes, methods for printing the image from the negative were also evolving. Prints made from paper negatives in the 1840s and early 1850s were most often salted paper prints, or salt prints. Although many individual recipes existed—each photographer learning over time that a dash of this or a few drops of that changed the sensitivity, color, or permanence of his prints—the basic process was the one outlined by Talbot. A sheet of paper sensitized with salt and silver nitrate was placed behind a negative and pressed tightly in a glass frame; the frame was set in the sun for as long as twenty minutes to "print out"; finally, the print was "fixed" in a bath of hypo (sodium thiosulfate). Salted paper prints are usually warm in color and have a velvety, matte surface because the silver particles that make up the image are nestled in and around the paper fibers. Fenton's Russian and Crimean pictures, most of his British Museum prints, and a few of his other works were produced by this method.

In the course of the 1850s, salted paper prints gradually gave way to albumen silver prints, or albumen prints—the medium Fenton used for the majority of his architectural, landscape, tableau-vivant, and still-life compositions. This type of print was made by coating a sheet of paper with a binder of egg white, then sensitizing it with silver salts and printing it in the sun in the same manner as the salt print. Albumen silver prints perfectly render the fine detail and continuous tones of glass negatives. These prints have a shinier surface than salted paper prints, and the highlights have often yellowed with age.

Whether made from a paper or a glass negative and whether a salt or an albumen print, every one of Fenton's photographs was **contact printed**: the positive print was made by direct contact with the negative and was

not enlarged. Thus, Fenton's unusually large prints, about 14 x 17 inches, were printed from glass negatives of the same size; and all of the photographic manipulations, such as evenly coating and sensitizing the plate, became far more difficult as the size of the image increased. Of course, all of the attendant equipment, from the camera itself to the negative holders, trays, printing frames, and the like, took on a similarly cumbersome scale to accommodate such a large ambition.

Because both salted paper prints and albumen silver prints were recognized at the time as being subject to fading, in the 1850s many photographers worked to develop a way to print photographic images using printer's ink rather than light-sensitive chemicals. The **photogalvanograph** was one of many such **photogravure** processes. Developed by Paul Pretsch and patented in 1854, this technique combined photography and electroplating to produce an etched metal plate that could be printed, like a traditional engraving, on an intaglio press. In 1856 Fenton joined Pretsch in a failed commercial venture to exploit this process for photographic publishing. Although more permanent than traditional photographic prints, photogalvanographs lacked the finesse and tonal subtlety of chemically produced prints and often required intervention by hand.

Part of the motivation for developing a practical photogravure process had been to integrate the printing of photographic images into the pre-existing procedures of the commercial printing industry. Instead, in the late 1850s and early 1860s a whole new photographic printing industry developed, capable of mass-producing pictures for widespread distribution as individual works, tourist souvenirs, or book illustrations. Thus during the scant decade of Fenton's career, 1852 to 1860, photography underwent enormous technical changes and ultimately a shift of emphasis from handcrafted technique to industrialized production.

Malcolm Daniel

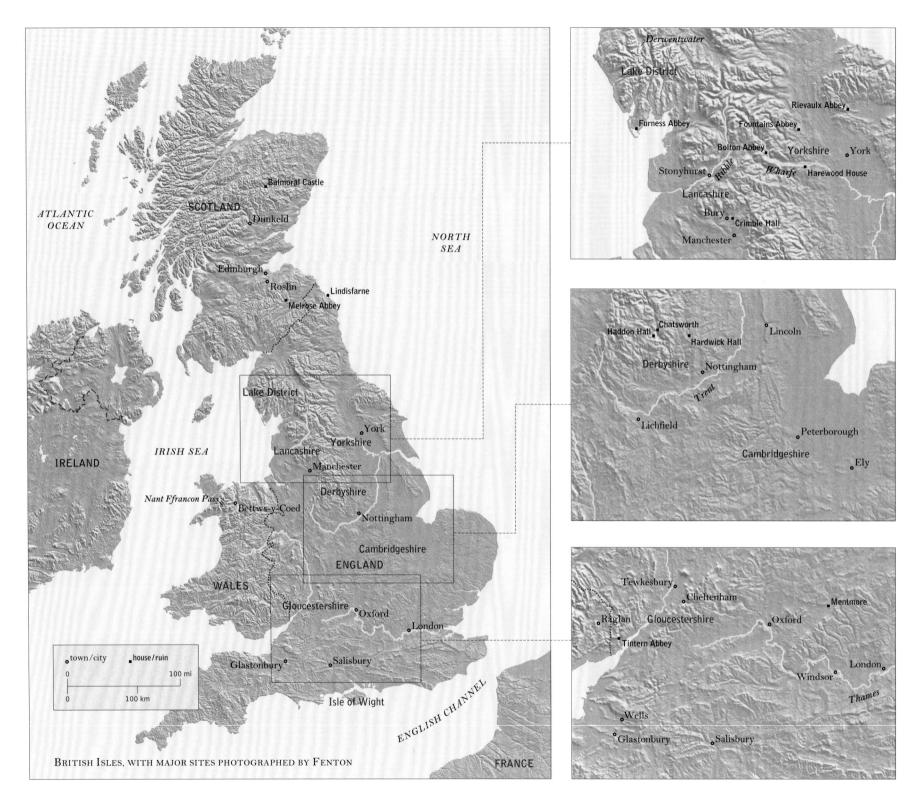

ALL THE MIGHTY WORLD

The Photographs of Roger Fenton, 1852-1860

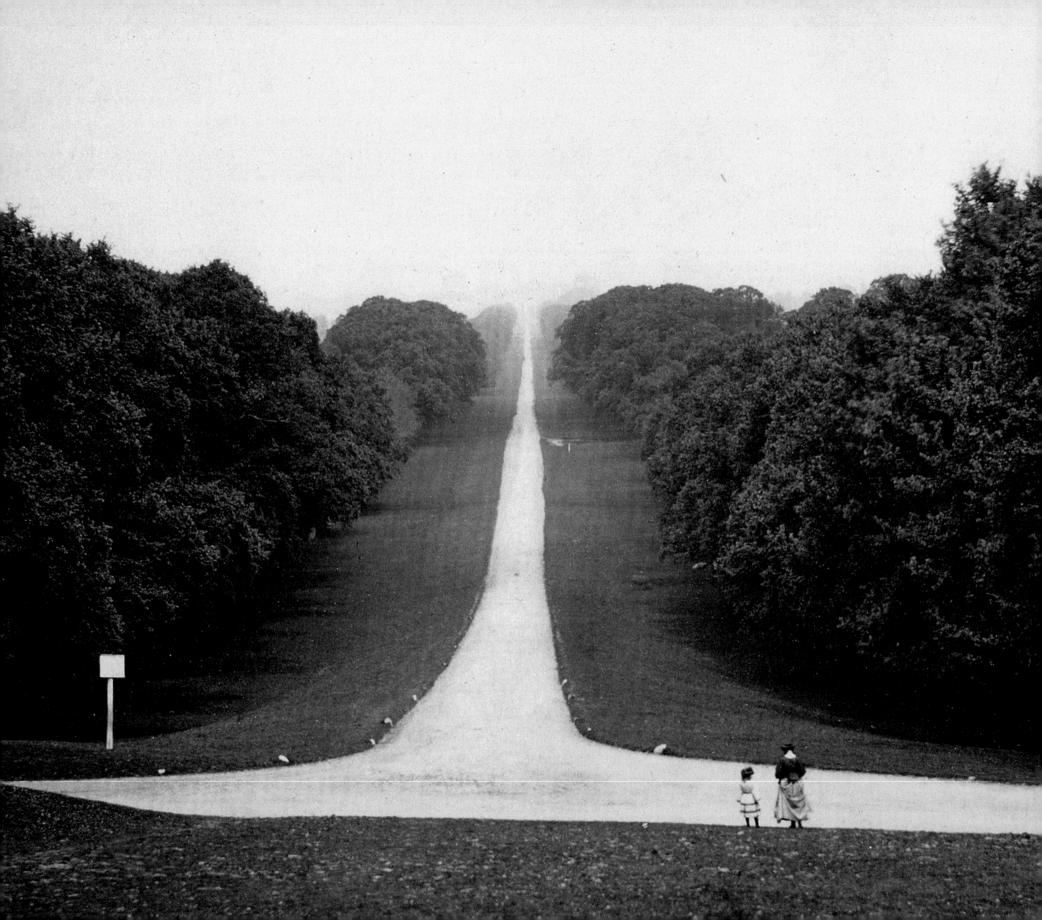

"A New Starting Point": Roger Fenton's Life

SARAH GREENOUGH

London on May 2, 1851, with a private viewing of the more than thirteen hundred works on display. The academy was especially proud of its new installation, in which paintings were hung in the more elegant and commodious of the rooms and architectural designs relegated to the decidedly unwelcoming "hall of torture." Although the exhibition was hailed as "the best that has adorned these walls for many years," it was apparently not good enough for the fortunes of one young and struggling English painter, Roger Fenton. In the previous two years Fenton's submissions had been entirely overlooked; this time his entry, There's music in his very steps as he comes up the stairs, was at least mentioned in one review. But the critic, while acknowledging the head and petticoat of the figure to be "admirably painted," thought that the meticulous execution of the draperies and accessories overwhelmed the piece; criticized the "affected title"; and dismissed the work.

Fenton's career up to this point had been checkered. Although in 1839 he had begun to prepare for a career in the law, he seems to have put this work aside to pursue painting in Paris and London. By 1851, however, Fenton was thirty-two years old, married, the father of two young girls, and plagued by professional indecision. Perhaps in acknowledgment of his less-than-stellar abilities as a painter, he had earlier in the year resumed his law studies, and a week after the opening of the Royal Academy exhibition he was called to the bar, that is, admitted to the legal profession. Yet by the summer of 1852,

only twelve months later, Fenton had not only discovered a new profession—photography—and established himself as a leading figure in its growing community but had also awakened a passionate, ambitious commitment unknown in his earlier life.

The year 1851 was a pivotal one not only for Fenton but also for England as a whole. May 1, 1851, the day before the opening of the Royal Academy show, was proclaimed by Queen Victoria "one of the greatest and most glorious days of our lives."7 On that day she and Prince Albert opened the celebrated and influential Great Exhibition of the Works of Industry of All Nations in the newly constructed Crystal Palace in Hyde Park. Although the previous few decades had brought violent upheavals on the Continent, England experienced only peaceful democratic changes, and at midcentury it was the most advanced nation on earth, with a military reach that extended around the world. Prince Albert, who had helped to shape the exhibition, hoped it would foster world peace by promoting friendly exchange between countries, but in reality it became a showplace for England's new technological prowess—its impressive new machines and its other wondrous inventions—as well as an implicit advertisement for the strength of its political system. Within the enormous structure, the newest, most powerful locomotives and blast furnaces, the fastest printing presses and carding machines, the strongest telescopes and microscopes, as well as the sensational American sewing machine and electric telegraph greeted the more than six million visitors who viewed the exhibition before its close in October of that year. The exhibition was "a new starting point," Prince Albert proclaimed, "from which all nations will be able to direct their further exertions."8

But while this new starting point celebrated the triumph of both England and the machine age, it also highlighted the profound dilemma facing contemporary artists. The Industrial Revolution had transferred money from the aristocracy and gentry to the new industrialists of the north, in Manchester, Liverpool, Leeds, and elsewhere, who eagerly bought works of art. However, their tastes differed from those of earlier collectors: they sought not old master paintings but contemporary British art, not historical, allegorical, or mythological depictions but portraits, landscapes, rural studies, and especially scenes of everyday life. In unprecedented numbers this newly rich upper middle class amassed large collections of paintings, often buying directly from the artists themselves.⁹ Moreover, with an increasing number of international fairs modeled after the Great Exhibition, a growing attendance at annual art exhibitions, and a rising middle class with disposable income, popular artists often reaped even greater financial rewards by also allowing their paintings to be reproduced as engravings.¹⁰ However, this infusion of money into the art world brought with it significant self-scrutiny. If England in the 1850s was the age of the machine, if it was a materialistic culture enamored with science, technology, practical inventions, and verifiable facts, what, then, was the role of art? Aspiring to be more than merely decorative, how could it express the great ideas of its age? How could it compete, for example, with the Crystal Palace, Joseph Paxton's glass-and-iron monument to the industrial age, with its bold articulation and brazen "raw modernity"?¹¹

The year 1851 was a new starting point for photography in England as well. The Great Exhibition, which was among other things the first large public display of photographs in England, highlighted the extraordinary appeal of the young medium, especially its seductive ability to record information about the world and simultaneously capture the spirit of the time. Equally apparent, though, was the poor quality of English photography. Although England won more awards in photography at the exhibition than any other country, this was probably an indication of the judges' partiality more than the true merit of the work. In their report issued the following year, the jurors themselves noted that France was "unrivalled" in the calotype (the negative/positive process invented by the Englishman William Henry Fox Talbot), while in the daguerreotype (the process invented by the Frenchman Louis-Jacques-Mandé Daguerre), "America stands prominently

forward." But English photography, the judges lamented, was noteworthy only for "distinct character." The exhibition raised an obvious if difficult question: if an Englishman invented the calotype process and if other Englishmen were able to invent, design, and manufacture some of the most sophisticated machines and instruments ever created, why was the work of English photographers so lamentable? If English photographers were to keep pace with others around the world, the jurors concluded, they would have to do far more to explore the potential applications of the medium to art, science, and industry and demonstrate the ways in which photography benefited mankind.

Spurred by such sentiments as well as by the widely held conviction that the English patent system urgently needed reform, many prominent individuals pressured Talbot to relinquish the restrictive patents he had placed on his process, which required photographers to buy rights from him before making calotypes and thus severely inhibited exploration of the art. In 1852, Talbot agreed.¹³ In addition, another new starting point for photography had surfaced at the Great Exhibition. There, among all the other inventions, Frederick Scott Archer presented publicly for the first time his newly discovered collodion process for making negatives. This technique, which combined the fine detail of Daguerre's daguerreotype with the reproducibility of Talbot's calotype, became the dominant method for making negatives in the 1850s. With these two developments, photography, after years of languishing in England, blossomed. New practitioners, both amateur and professional, flooded the field with their imagery, inventions, and aspirations for the medium. They opened photographic studios in unprecedented numbers and sold their works at seemingly ever cheaper prices; they founded photographic societies, first in London and then around the country; they organized annual exhibitions and traveling exchanges of their photographs; they published their work, improvements, and inventions in newly established journals dedicated to photography as well as in more general newspapers and publications; and they distributed their photographs, often through print or book dealers, both as individual prints and in albums and portfolios. Thus, in a way that it never had before, photography seeped into almost every aspect of middle-class English life.

But for many, this transformation sparked doubts as well as opportunities. Photography satisfied the growing materialism of the age and its seemingly insatiable appetite for the "facts, facts, facts" that Charles Dickens's character Thomas Gradgrind craved in Hard Times (1854), but to many minds it did so all too quickly, with little grounding in rigorous analysis or aesthetic scrutiny. 14 In the 1840s photography in England had been fairly rigidly divided between commercial practitioners, who usually made daguerreotype portraits, and gentleman amateurs, who usually made calotypes. 15 The former photographed purely for profit, the latter for private delectation. But by the 1850s, as most photographers adopted the collodion process, these divisions began to blur. Even more significantly, though, a new breed of photographer came to regard older practitioners of both types as obsolete and ill equipped to imagine a transformed role for photography. These emerging photographers sought both to professionalize the medium, enhancing its stature and providing it with institutional supporting structures, and to demonstrate that photography was a tool of social, political, even national significance. The struggle between the various factions—commercial practitioners, gentleman amateurs, and new professionals—was at the core of the photographic discourse in England in the 1850s.

Roger Fenton was not only a central figure in this dialogue but also frequently the catalyst for changes. One of the first and most forceful champions of the need for a learned society to support the efforts of photographers in England and abroad, he led in the formation of the Photographic Society and the establishment of its annual photography exhibitions. He was also one of the photographers who demonstrated to Queen Victoria and Prince Albert the power and potential of the new medium. The contemporary of such innovative and dynamic figures as the Frenchmen Gustave Le Gray (1820-1884) and Nadar (1820-1910) and the American Mathew Brady (1823–1896), Fenton was part of the second generation of photographers, who sought to propel the practice to a new level of maturity. Neither gentleman amateur nor commercial hack, he was determined to become the new kind of photographer: a professional educated in his craft, dedicated to its art and science, and committed to demonstrating how the medium could respond to the advances of the modern age. The range, accomplishment, and innovative vision of his photographs reveal his aspirations and establish him as one of the most important of all English photographers. Yet for all this, his career lasted only a little more than eleven years. Its brevity was perhaps as much a result of the changes Fenton himself fostered as of his own restless ambition. 1819 - 1851

The drive from Rochdale to Burnley is one of the grandest and most interesting things I ever did in my life . . . the cottages so old and various in form and position on the hills—the rocks so wild and dark—and the furnaces so vast and multitudinous, and foaming forth their black smoke like thunderclouds, mixed with the hill mist.

—John Ruskin, 1859 16

Roger Fenton was born in 1819 into a world of intense contrasts. His birth-place, Crimble Hall, near Bury, was several miles north of Manchester in Lancashire, one of England's most beautiful areas. Its open countryside and expansive views, its hills, lowlands, and moors had captured the public imagination for many generations. But at the time of Fenton's birth, Lancashire and neighboring counties were being rocked by profound changes as the Industrial Revolution transformed cities like Manchester and nearby Liverpool, Leeds, Newcastle-upon-Tyne, and Sheffield into thriving hubs of manufacturing and commerce. A vast network of roads, railroads, and canals was built to transport both the raw materials consumed by numerous newly constructed steel and cotton mills and the products they generated. Thousands of poor, usually unskilled laborers, often from other parts of England or Ireland, flowed into the area, and all too soon, disease, overcrowding, poverty, and crime, accompanied by political unrest, plagued the cities.

Fenton was both removed from these changes and a part of them. His immediate world had been built, quite literally, by his paternal grandfather, Joseph Fenton. One of the storied generation of Manchester industrialists, merchants, and bankers, Joseph Fenton established a bank, Fenton, Eccles, Cunliffe & Roby, in the town of Rochdale, ten miles north of Manchester, in 1819—the year of his grandson's birth. ¹⁷ It prospered through most of the nineteenth century and endowed Joseph Fenton with more than enough capital to pursue other, even more lucrative business ventures. In 1826, taking advantage of the region's many canals and plentiful sources of power, he built a mill in Hooley Bridge, near the neighboring village of Heywood, for the spinning and weaving of cotton and fustian. While most nineteenth-century mills were places of desperate poverty and degradation—poor wages, long hours, dangerous working conditions, and unregulated child labor—such generalizations are perhaps more applicable to mills in large urban centers than to those in villages such as Hooley Bridge, Cheesden Valley, and Hurst

Green, where Fenton also established mills (fig. 2). Because his enterprises were somewhat removed from the seemingly endless supply of workers in Manchester, it behooved the shrewd but decent Joseph Fenton to take care of his labor force. In addition, unlike the mostly Anglican Manchester industrialists, he lived in the same community as his employees and attended the same Congregational church where many of them worshiped; its teachings, coupled with his liberal politics, also instilled in him a sense of civic responsibility, which he clearly manifested. The mill at Hooley Bridge was fireproof and lit by gaslight, a great novelty at the time. Fenton also built three hundred workers' houses, long before other industrialists erected similar villages for their employees, and hired a schoolteacher to instruct the children. Despite intense competition—by 1840 there were more than nine hundred mills in Lancashire, with more than a hundred in Bury alone—the superior quality of

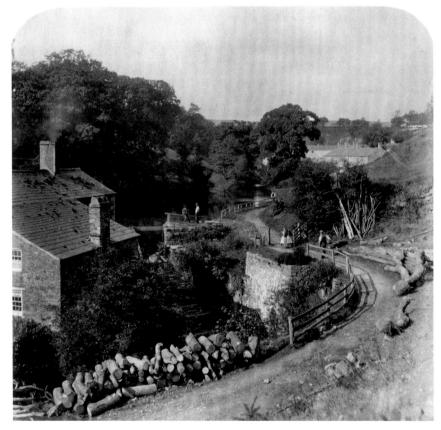

Fig. 2. Roger Fenton, *Mill at Hurst Green*, 1858. Albumen silver print, 35.2 x 43.6 cm ($13\frac{7}{8}$ x $17\frac{3}{16}$ in.). The RPS Collection at the National Museum of Photography, Film & Television, Bradford, 2003-5000/3145

the work produced by Fenton's mills, their excellent commercial reputation and large stock of manufactured goods, and his "almost unlimited capital resources" allowed Joseph Fenton, as a local journalist noted, to become "an immensely rich" man. ¹⁸ He owned many other properties, including Crimble Hall (fig. 3), which he gave to his older son, John; Bamford Hall, which he gave to his second son, James; and manors in Aighton, Bailey, Chaigley, Dutton, and Ribchester, as well as extensive landholdings and farms. ¹⁹ When he died in 1840 his estate was thought to be worth more than one million pounds.

Fenton was the fourth child and third son of John and Elizabeth Aipedaile Fenton. His mother, who was from Newcastle-upon-Tyne, died at thirtyseven, when Roger was only ten years old, but his father, who was described as a "sterling and upright character [with] a sly, humorous disposition" and a gifted conversationalist, quickly remarried and fathered ten more children. Joseph Fenton had provided both his sons with a fixed income as well as substantial monetary gifts, but this does not seem to have predisposed John to lead a life of leisure. Active in his town, he was elected at age thirty-six—on the passing of the 1832 Reform Bill that abolished boroughs with only a handful of votes and extended suffrage to all men of property—as a Whig (Liberal) member of Parliament for the newly designated borough of Rochdale. Although the challenges to a newly enfranchised MP must have been significant, he held this position almost continuously until his retirement in 1841.20 During many of the years that John was in Parliament, Roger and his younger brother William were also in London, where Roger studied Latin, Greek, English, mathematics, literature, and logic at University College from 1836 to 1840. As was common at the time for second or third sons, Roger prepared for a career in the law, and in 1839 he was admitted as a member of the Honourable Society of the Inner Temple at the Inns of Court, one of the legal societies that controlled admission to the bar. In 1841 he began to study law, also at University College.

If character is at least in part the product of background, family, and education, then this is the raw material Fenton was endowed with at the age of twenty-two. As the grandson of an astute businessman and the son of a dedicated Liberal and committed public servant—both of them men who relished challenges, who saw opportunities and took advantage of them—and as the child of the wild, dark hills and mills of Lancashire, he was, although eminently prepared to pursue a conventional life, perhaps ultimately ill

suited to one. Grandfather and father had given the young Roger the financial freedom to do anything while instilling in him the belief that he need not conform to prevailing expectations: he could forge a new path for himself, creating, as they had, something out of nothing. Neither aristocracy nor landed gentry, the Fentons belonged to a new breed of nineteenth-century gentleman who eagerly adopted the advances of modern life, especially its technological inventions and scientific discoveries, but who also passionately embraced England's past: its traditions, history, and political structure. It is precisely this sense of living on the cusp between old and new, between an order that was thoroughly known and a nascent one that was fluid, uncertain, yet profoundly stimulating, that is the defining characteristic of Fenton's life and is at the core of his best photographs.

Unfortunately, just at this time when so many choices presented themselves to the young man, Fenton's history becomes murky. Sometime in the early 1840s he put aside his legal studies to pursue painting. If he went to Paris as early as mid-1842—he received a passport in June of that year—he could have, as his friend the French photography critic Ernest Lacan asserted, studied with the history painter Paul Delaroche. In his large and intensely competitive studio Delaroche trained several painters who later became celebrated French photographers, including Charles Nègre, Henri Le Secq, and Le Gray, all of whom Fenton later greatly admired. Fenton could have studied with Delaroche for only a year, however, since the French painter, renowned for both his oratorical skills and his harsh criticism, abruptly closed his atelier in the summer or fall of 1843, after a new student died as a result of *blague*, or hazing.

By August 1843 Fenton was in Yorkshire, where he married Grace Elizabeth Maynard (fig. 4). Little is known about her. Early photographs depicting a woman, presumably Grace, and children indicate that she supported his work and accompanied him on at least some of his photographic expeditions. His letters to her from the Crimea, warm and occasionally jesting in tone, suggest that their marriage was happy and affectionate. He called her "honey" and their children "bairns" and concluded one letter by telling her to "be sure of the best love of your loving husband." We can deduce that Grace was a strong, competent individual, for she endured Fenton's long absences in Russia and the Crimea, no easy task for a wife and mother of several young children, and survived the undoubtedly wrenching deaths of three

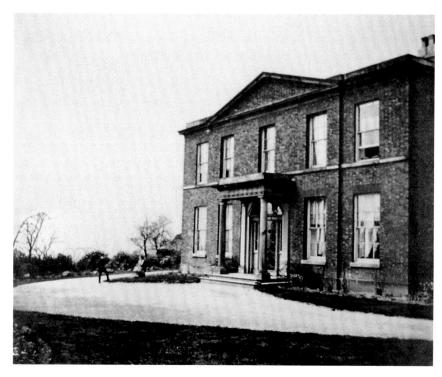

Fig. 3. Roger Fenton, *Crimble Hall*, ca. 1856. Albumen silver print, 23.8 x 29.4 cm (9\% x 11^{11} /16 in.). Private collection

of their children.²⁴ Fenton's devotion to her is evident in the name he chose for their last home, in Potter's Bar, north of London: Mount Grace.

By May 1844 Fenton was certainly in Paris, where he registered to copy at the Louvre as a pupil of Michel-Martin Drolling. A student of Jacques-Louis David, Drolling (1786–1851) was a Neoclassical artist renowned for his portraits and history paintings, especially the rather theatrical *Anger of Achilles*, which won him the Prix de Rome in 1810. Throughout his long career at the Académie Royale de Peinture et de Sculpture, Drolling espoused the Neoclassical belief that art should instill moral and civic values and present subjects that demonstrate heroism, patriotism, loyalty, and courage. Despite his outmoded style he ran one of the more popular ateliers in Paris, and several of his students, including Jules Breton and Alfred de Curzon, went on to establish successful academic careers.

Pedagogically, in Drolling's studio Fenton was exposed to the highly systematized and rigorous course of study of France's state-sponsored

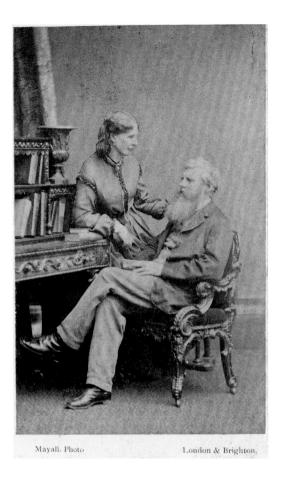

Fig. 4. John Mayall (English, 1810–1901), Roger Fenton and His Wife, ca. 1866. Albumen silver print, carte de visite, 9.4 x 5.9 cm (3 ½ 6 x 2 ½ 6 in.). Private collection

Académie. This regimen required students to copy engravings, plaster casts, and old master works in the studio and at the Louvre; only much later did they advance to working from a live model and finally to painting. Although as a non-French citizen Fenton was ineligible for the highly coveted Prix de Rome, he was immersed in a world where students focused all their efforts to attain this prestigious award, and he surely witnessed the fierce competition it generated among them as well as the blatant favoritism of the award juries. The must also have seen that the Prix de Rome and the ultimate goal of this training, acceptance into the Académie, conferred a level of official approbation rarely obtained in other professions, even though these were more often achieved by dogged commitment than by innovative genius.

In many ways, however, Drolling was an unusual studio master, because beyond the mastery of technique he valued individuality and understood the importance of the rapid sketch. "Do sketches, train yourself in composition," he told Fenton's fellow student Paul Baudry, "whatever ideas you've got, put them on to paper in a single day at one stroke, and even though it's on a small scale, you can put into it anything you like in the way of harmony, elegance, costumes, poetry and so forth." This was useful advice for the beginner in either painting or photography. Fenton's only mediocre progress within this environment, however, may be surmised from the fact that he does not appear on any matriculation records at the École des Beaux-Arts, evidence that he never passed the qualifying *concours des places*. 29

When Fenton returned to England, probably in 1847, he sought out another teacher, Charles Lucy (1814-1873), who was in many ways similar to Drolling. A former student of Delaroche's and at the École, Lucy, like Drolling, specialized in portraits and history paintings, although most of his subjects were drawn from English history. When Fenton first began to study with him, Lucy had recently completed his most celebrated work, The Embarkation of the Pilgrim Fathers in the Mayflower (fig. 5), which was awarded a prize, bestowed by Prince Albert, in the prestigious Westminster Hall competition in 1847.30 Although an established figure in the London art community, Lucy was only five years older than Fenton, and the two, more friends and colleagues than master and pupil, often socialized (fig. 6).³¹ In December 1847 Fenton moved with his wife and two daughters into a newly built house at 2 Albert Terrace, near Primrose Hill on the northern edge of London, close to Lucy's home in Tudor Lodge, a popular residence for artists. Lucy quickly introduced Fenton to artistic issues under discussion in England at the time and also to some leading artists, including, in early 1848, Ford Madox Brown (1821–1893). Inspired by their training in France and the many schools for artisans they had observed scattered throughout Paris, these three joined with other artists to found the North London School of Drawing and Modelling, which opened in May 1850 under the patronage of Prince Albert (fig. 7). 32 The school's purpose was to raise the quality of industrial design by teaching drawing and modeling to workmen, thus enabling them to "execute the designs supplied to them with artistic feeling and intelligence."33 To augment their teaching program, the school's directors also organized exhibitions of paintings and drawings and such crafts as pottery, bookbinding, and carving.

Fenton's friendship with Brown, which lasted at least through 1851, was an important one. ³⁴ Brown was never an official member of the Pre-Raphaelite

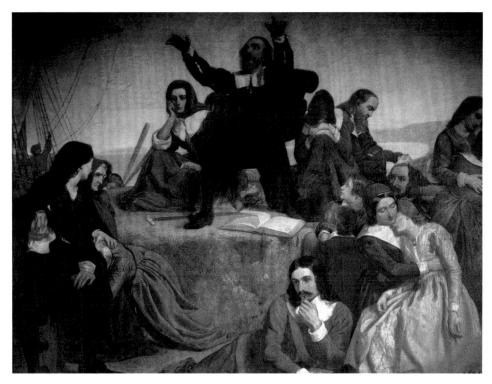

Fig. 5. Charles Lucy (English, 1814–1873), The Embarkation of the Pilgrim Fathers in the Mayflower, 1847. Oil on canvas, 304.6 x 430.8 cm (9 ft. $10\frac{7}{9}$ in. x 14 ft.). Pilgrim Hall Museum, Plymouth, Massachusetts

Brotherhood founded in September 1848 by William Holman Hunt, John Everett Millais, and Dante Gabriel Rossetti, but he was close to those artists and espoused many of their beliefs. Like them he maintained a devotion to visual facts and attempted to present not an idealization but the "absolute, uncompromising truth," as the Pre-Raphaelite champion John Ruskin stated in 1853, "down to the most minute detail, from nature, and from nature only." Fired by the empiricism of the age, Brown, like the Pre-Raphaelites, prized the particular, drawing with increasing zeal upon subjects from everyday life. And like the Pre-Raphaelites he was convinced that art could provide moral and spiritual guidance, which led him to fill his ever more complicated narrative paintings with obvious symbolism and moral messages.

Although none of Fenton's paintings appear to have survived, the Pre-Raphaelite influence on them is obvious both in his titles and from a few extant descriptions. His 1849 entry to the annual summer exhibition at the

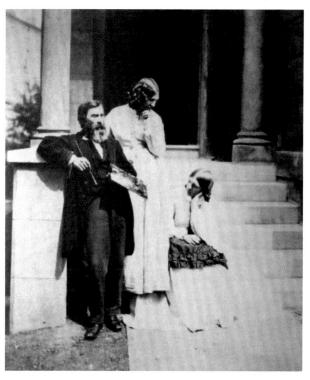

Fig. 6. Roger Fenton, Charles Lucy, Grace and Annie Fenton, London, ca. 1859. Albumen silver print, 26.7 x 24.2 cm ($10\frac{1}{2}$ x $9\frac{9}{6}$ in.). Private collection

Royal Academy, entitled *You must wake and call me early*..., was inspired by "The May Queen" by Alfred, Lord Tennyson, indicating that, like the Pre-Raphaelites, Fenton deeply admired this man who was soon to be named poet laureate. Fenton's 1850 submission to the academy, *The letter to Mamma: What shall we write?*, clearly depicted a subject drawn from daily life and perhaps also carried a moral lesson, albeit a minor one. From the review of his 1851 entry, *There's music in his very steps as he comes up the stairs*, we know that he rendered his subjects with meticulous attention to detail. But this is the last we know of Fenton's career as a painter; although he continued to sketch and to paint watercolors, rarely—or never—did he exhibit his paintings again. Yet these ten years were hardly wasted. If youth is a period of exploration and experimentation, of intense friendships and pivotal experiences, then this was a highly productive time for Fenton; the lessons he learned, the beliefs he established, and the aspirations he began to formulate for his art would fuel him for the next twelve years.

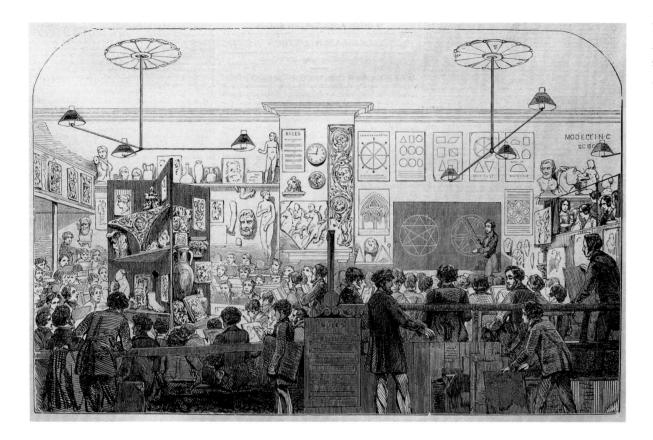

Fig. 7. The North London School of Drawing and Modelling, Camden Town. Wood engraving, 14.9 x 23.8 cm (5% x 9% in.). From Illustrated London News, January 17, 1852, p. 45

1851 - 1854

As an art, it is yet in its infancy . . . the uses to which it may be applied will yet be multiplied tenfold.

—Roger Fenton, 1852³⁷

On December 22, 1852, the opening day for the first public exhibition in Britain devoted exclusively to photographs, Roger Fenton read a paper to the assembled members of the Society of Arts in London, "On the Present Position and Future Prospects of the Art of Photography." In a clear, brisk, and eminently self-confident manner, fully in keeping with the man seen in his early photographic self-portrait (frontispiece), he reviewed the many recent technical developments—including the collodion process, albumen prints, and waxed paper negatives—and explained the advantages and disadvantages of each. Much of his paper, though, was a discussion of the relationship of photography to the other arts. While many painters, he noted, had originally viewed the camera as only a mechanical device, "a kind of

power-loom," most were now "enthusiastic admirers"; still, they did not make sufficient practical use of photography in their studios. His Pre-Raphaelite beliefs much in evidence, he insisted that "everything that is ideal, and that constitutes expression in the human form, is translated to us materially" and therefore could someday be photographed. Surveying the development of photography in Europe and the United States, he summarized the "striking" differences between French and English photographs: "The French pictures are of cities, fortresses, churches, palaces—the living triumphs or the decaying monuments of man's genius and pride," while the English ones are "representations of the peaceful village; the unassuming church, among its tombstones and trees; the guarded oak, standing alone in the forest; intricate mazes of tangled wood, reflected in some dark pool," as well as "shocks of corn . . . the wild upland pass . . . or the still lake." Despite these achievements clearly embodied in the exhibited photographs, however, Fenton declared that neither the artistic possibilities of the medium

nor its scientific, industrial, and commercial uses had been sufficiently explored, nor had the chemistry of the process been extensively analyzed. The medium would never advance beyond this youthful stage, he concluded, until a professional, learned society was established, comparable to those that existed for painters, architects, or engineers, where artists, researchers, scientists, and practitioners could freely exchange information.

A clarion call to his generation of photographers, Fenton's speech was also an audacious display of expertise made all the more remarkable by the fact that he had been practicing photography for a little over a year at most. From his dual vantage point—as a painter steeped in the academic tradition and as a member of a movement promoting the educational function of art—Fenton clearly understood that the practice of photography must change if it was to keep pace with the rapidly changing culture. It must shed its status as quaint curiosity or commercial service and transform itself into a thoroughly modern profession that both expressed and responded to the concerns of English society. From 1851 through 1855 Fenton worked vigorously to effect these changes and to establish himself as a new kind of photographer, a professional artist whose photographs would capture subjects of both picturesque interest and historical importance and whose work would serve photography, the arts, the monarchy, ultimately the nation itself.

When Fenton began to photograph is unclear, but he was most likely inspired to do so after seeing photographs displayed at the Great Exhibition in 1851. ⁴⁰ In one of those remarkable intersections of time, place, and personality, the challenges to photography revealed at the exhibition obviously intrigued the then somewhat adrift Fenton. Discouraged with his career as a painter and ambivalent at best about the prospect of returning to the law, he may well have seen photography as a burgeoning field, full of promise and opportunities. In October of that year he traveled to Paris and sought out Le Gray, one of the leading French photographers of the period, and his student and colleague Auguste Mestral. They had just returned from a three-month tour of southern France, where as part of what is now called the Mission Héliographique they had photographed buildings of historic importance for the Commission des Monuments Historiques. ⁴¹ One of the first and certainly most ambitious government-sponsored programs for photography, the Mission Héliographique sought to provide a visual census of

France's rich architectural heritage, especially its ancient and medieval monuments. In May 1851, after extensive deliberation, the mission commissioned five photographers to travel throughout the country and photograph specifically designated buildings: Édouard Baldus, Hippolyte Bayard, Le Secq, Le Gray, and Mestral. Le Gray and Mestral also used the trip to perfect Le Gray's newly invented waxed-paper-negative process. Earlier that year Le Gray had discovered that sealing the negative paper with wax before sensitizing allowed the sheet to absorb the liquid chemicals more uniformly, without the spots, blemishes, and inconsistencies that had characterized Talbot's calotype process. The resulting waxed paper negatives were, moreover, exceptionally translucent, with a rich, subtle tonal range. And this is what Fenton saw when he arrived at Le Gray's studio in October 1851: not finished prints, seamless and complete, but "several hundred negatives," otherworldly in their reversal of tones yet cogent in their articulation of scenes and facts, and immensely potent. 42 Entranced, Fenton immediately adopted Le Gray's process and, after consultation with other French photographers, began to make it his own. 43

Fenton was one of the dozens who flocked to Le Gray's studio to learn more about photography. He may have seen Le Gray's announcement, at the beginning of his 1850 publication *Traité pratique de photographie sur papier et sur verre*, urging "those persons who might be impeded by some difficulty" to visit him at his studio at 7, chemin de Ronde, barrière de Clichy; or he may simply have heard of the highly regarded school. He Resembling in many ways a painter's atelier, Le Gray's was an "advanced school," as L. Maufras recounted a few years later, "one of the most frequented in Paris. . . . The most aristocratic hands from the capital and from abroad came, without compunction, to dirty themselves there with silver nitrate. . . . Scientists and artists came there in droves as well," all too happy to pay the four hundred francs that Le Gray charged most pupils. He may have seen Le Gray's announcement, at the beginning of the same papier et sur verre, urging "those papier et sur verre

At Le Gray's studio Fenton found not just a school but a model on which he could base his own career. Le Gray was a professional photographer who had devised numerous ways to support himself and his family: in addition to collecting fees from his students he made portraits at his studio, photographed works of art (paintings, sculpture, and architecture), and received official commissions, like that from the Mission Héliographique or one to photograph the distribution of the regimental standards on the Champs-de-Mars

in 1852. Moreover, he benefited from his close association with Prince-President Louis-Napoléon, who became Emperor Napoléon III in December 1852. Perhaps of greatest importance to Fenton was that Le Gray was a professional—indeed, commercial—photographer who had not in any way lowered his standards or degraded his art. Nothing like the common commercial daguerreotypists Fenton may have encountered in the 1840s, Le Gray, trained as a painter, was passionately committed to the art of photography. Le Gray's "deepest wish," he wrote, was "that photography, instead of falling within the domain of industry, of commerce, will be included among the arts. That is its sole, true place, and it is in that direction that I shall always endeavor to guide it." ⁴⁶

While in Paris that fall, Fenton also visited the Société Héliographique established only nine months earlier, in January 1851. Temporarily located in five rooms on the top floor of the house of its generous president, Baron Benito de Montfort, the Société Héliographique provided its members with a studio, a laboratory, and a small gallery where "choice specimens of the art" were displayed; photographic chemicals were manufactured and sold in a shop on the ground floor. The offices of *La Lumière*, the weekly journal that published the proceedings of the society, were also located there. Fenton approvingly noted that the Société Héliographique's members included "many of the most distinguished of the French artists, who, as a body, have been much more quick than our own in appreciating the great advantages which this science presents to the careful and conscientious interpreter of nature." Both Eugène Delacroix and Désiré Albert Barre were members of the society, along with writers—Jules Champfleury, for example—and many other prominent Parisians.

Fenton learned one more critical lesson on his 1851 trip to Paris: he saw that many French photographers had their work printed by others. Perhaps recalling his grandfather's businesses, he quickly came to believe that with photography, as with "every other pursuit, the most complete results are obtained by the division of labour." The great challenge of obtaining a satisfactory negative, he noted, made most photographers far more eager to record "some new object than to proceed immediately to the multiplication of the positive copies." Thus from early on in his career he separated the two processes and placed his emphasis on the creation of the negative rather than the making of the print. "Why," he asked in 1852, "should not the reproduc-

tion of these positive photographs be as distinct an occupation from the making of the negative type, as is the engraving of a steel plate, from the taking of impressions of it upon paper?"⁴⁹

Fired by all that he had seen and learned in Paris, Fenton returned to London in the fall of 1851 intent on enacting an ambitious program. From early 1852 through early 1855 he worked simultaneously on many different projects: he made photographs for ever more prestigious clients, publishing his work and circulating it to colleagues in Europe; he wrote articles on photography; he helped found a photographic society; and he organized exhibitions of his own and others' photographs. All of these activities were intended to foster understanding and appreciation of the medium in general and Fenton's work in particular. Capitalizing on the enthusiasm for photography generated by the Great Exhibition and the vacuum left in its wake, he perceived that the field needed an accomplished, articulate leader with a clear vision of the future and the medium's potential; and he worked with intense dedication to become that person.

Recognizing that a professional organization was critical to his success, Fenton published his "Proposal for the Formation of a Photographical Society" in the *Chemist* in March 1852, soon after his return from France. 50 Modeled closely on the Société Héliographique, the organization envisioned by the liberal Fenton would not discriminate by class or profession but would be composed of "men of all ranks," photographers both amateur and professional, as well as artists, chemists, opticians, and all others committed to the "advantageous study" of the art. It would have a laboratory, a library, and a place to hold regular meetings and exhibitions of photographs, and it would publish not only a journal of its proceedings but also annual albums of members' work. While nearly two hundred people contacted him expressing interest, Fenton and his collaborators, including the photographer Robert Hunt, the artist and amateur photographer Sir William Newton, and the inventor Charles Wheatstone, knew that there were numerous hurdles to surmount.⁵¹ First, in order to achieve the necessary stature and attract prominent members, a photographic organization needed the support of another learned society. Fortunately, the active and influential Society of Arts, which included many of London's leading artists, scientists, and cultural figures, was eager to give that support and in June 1852 formed a provisional committee, including Fenton, Hunt, and Wheatstone, to establish the

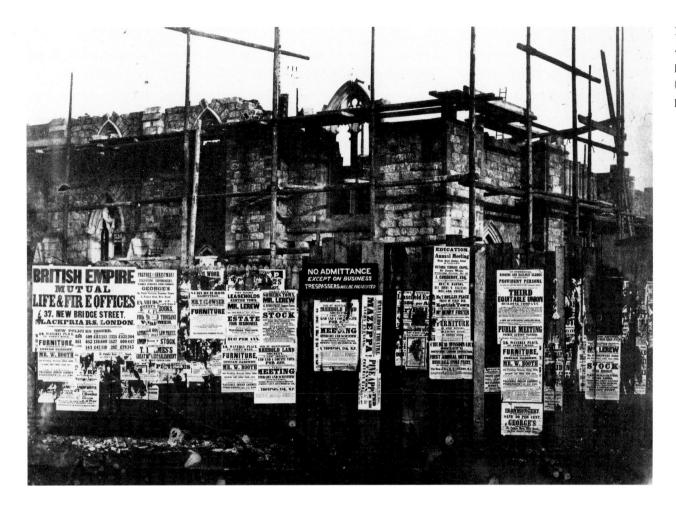

Fig. 8. Roger Fenton, Billboards and Scaffolding, Saint Mark's Church, Albert Road, 1852. Salted paper print from paper negative, 14.4 x 20.5 cm ($5^{11}/_{16}$ x $8^{1/}_{16}$ in.). From the Paul Jeuffrain album, p. 22. Société Française de Photographie, Paris

new society. But an even greater challenge, as everyone knew, was posed by Talbot's rigorous pursuit of any infringements on his patent on the calotype. Hunt's communications with Talbot in the spring of 1852 became acrimonious. However, Sir Charles Eastlake—president of the Royal Academy, director of the National Gallery, and a member of the Society of Arts—stepped in and brokered an agreement. In July, at Talbot's request, Eastlake and the noted astronomer Lord Rosse (William Parsons), "the acknowledged heads of the artistic and scientific world," petitioned Talbot to relax his patent so that the art he had "invented [might] flourish as much as possible." At the first meeting of the Photographic Society several months later, on January 20, 1853, Eastlake was elected president (after Talbot declined the honor) and Fenton, in recognition of his critical work on behalf of the organization, honorary secretary. (For further discussion of Fenton's

involvement with the Photographic Society, see "The Exertions of Mr. Fenton" by Pam Roberts in this volume.)

Concurrently, Fenton was perfecting his own photography. While in Paris in October 1851 he had made collodion negatives and experimented with Le Gray's waxed paper process, but his first dated photographs are from February 18, 1852. 54 These salt prints from waxed paper negatives include views near his home in London (figs. 8, 20)—Regent's Park, Albert Road, Saint Mark's Church—and five rather stiff, hesitant portraits, perhaps including ones of his wife or a sister-in-law and a daughter, posed against simple drop cloths, as well as a self-portrait. In photographing the Zoological Gardens near his home in London later that summer, he used a stereoscopic camera that took two successive photographs from viewpoints several inches apart, which, when looked at in Wheatstone's reflecting stereoscope viewer, gave

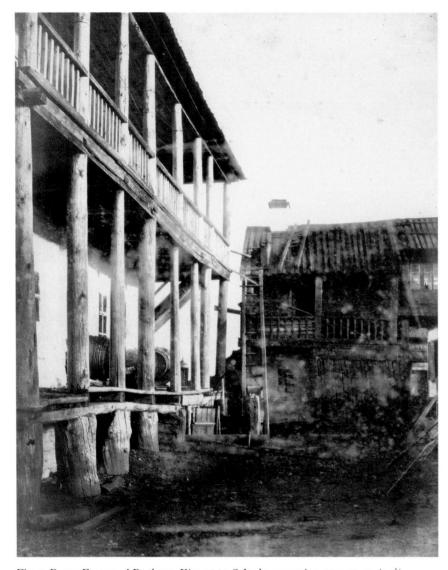

Fig. 9. Roger Fenton, A Posthouse, Kiev, 1852. Salted paper print, 36 x 28 cm ($14\frac{1}{8}$ x 11 in.). Collection Centre Canadien d'Architecture / Canadian Centre for Architecture, Montréal, PH1985.0693

the illusion of three-dimensional depth. Significantly, Fenton almost immediately circulated and published his photographs. He sent examples of his first dated works to a colleague in France, Paul Jeuffrain, and the following year sent photographs to Lacan in Paris, who exhibited them in his home. ⁵⁵ In October and November of 1852, when he had been photographing for only a year, Fenton published six works in *The Photographic Album*, a two-part portfolio

issued by the London publisher David Bogue. Made in Gloucester and Cheltenham, they were of picturesque sites in the region and included *Tewkesbury Abbey, The Plough Inn at Prestbury,* and *The Village Stocks.* The press roundly criticized his efforts. Fenton had "much yet to learn," the *Illustrated London News* opined, while the *Athenaeum* said the "indistinctness of the objects in the foreground" in one print gave them the appearance of "being mildewed" and the *Art-Journal* lamented that Fenton had "aimed only at making the best of bad subjects" rather than selecting ones of "large—of national interest." ⁵⁶

These criticisms fell on deaf ears, however, for Fenton had already embarked on a bold photographic expedition. On September 24, 1852, he reached Kiev, arriving there a week after his friend Charles Blacker Vignoles (1793-1875), an engineer, to photograph the suspension bridge Vignoles was building over the Dnieper River for Czar Nicholas I. From the time work began on the bridge in 1848, the artist John Cooke Bourne had been employed to make sketches for the often-absent engineer and his demanding patron. Bourne also learned how to make daguerreotypes and calotypes—no doubt encouraged by Vignoles, an amateur photographer who understood the valuable role photography could play in the project.⁵⁷ Yet as the bridge neared completion, Vignoles clearly felt the need for more extensive photographic documentation of it. While the challenges Fenton encountered in making the photographs did not rival those Vignoles faced in constructing the bridge itself, they were formidable, especially for such a novice. With no prior experience in orchestrating such a complex undertaking or in making waxed paper negatives under adverse conditions, Fenton had to transport quantities of photographic equipment and chemicals and at least two cameras, including a large one used to make stereo views, over the hundreds of miles that separated Russia from England, and he had to cope with the dim light and often bitter cold of a Russian autumn.⁵⁸ That he was able to make any photographs at all is a testament to his perseverance and drive, coupled with what must have been fastidious planning; that he did so successfully is an indication of the remarkable progress he had made in only a few months, especially the lessons he had learned from using a stereo camera.⁵⁹

The photographs Fenton made in Kiev, and later in Moscow and elsewhere, demonstrate a new level of competence and maturity. As their titles—among them, *Moscow*, *Domes of Churches in the Kremlin*; *Walls of the Kremlin*, *Moscow*; and *A Posthouse*, *Kiev* (pls. 2, 4, fig. 9)—make clear, he was now

treating subjects of more than enough "national interest" and picturesque vitality to satisfy the Art-Journal. Far more comfortable with his cameras and more confident of his technique, Fenton now began to consider such issues as how camera vision differs from human vision and how to construct compositions of the many-colored world using only the monochromatic palette of a photographer. Displaying a newly sophisticated understanding of space, no doubt the result of his recent work with stereo photographs, he now employed dramatically receding diagonal lines to translate the illusion of three-dimensional depth onto a two-dimensional surface. Now understanding that his waxed paper negatives were not equally sensitive to all colors and that the monochromatic, matte surface of a salt print could further blur contours, he began to construct his images so that near and far objects echo each other in shape and pattern. And, now appreciating the power of empty space, he alternated voids with densely packed forms, thus energizing his compositions and giving them a sense of life. Only a few months after making the "mildewed" studies of Gloucester and Cheltenham, Fenton had come to recognize that a camera and photographic materials would not allow him to depict the world in the same way a painter does. Instead of struggling to make photography into something it was not, from this point forward he eagerly embraced it for all that it could become.

On his return to London that fall, Fenton showed some of his Russian work in the December exhibition of photographs at the Society of Arts. Comprising some four hundred photographs, the exhibition had been proposed by the book publisher and amateur photographer Joseph Cundall (1818-1875) and organized by Cundall, Fenton, and Philip Henry Delamotte (1820–1889), a photographer and illustrator. Although initially scheduled to be open for only a little more than two weeks, the show unexpectedly tapped into the public's fascination with both photography and exhibitions and because of its popularity was extended through the end of January 1853, while growing to include over eight hundred works. 60 This lesson in public taste was not lost on either the Society of Arts or the organizing photographers themselves.⁶¹ In the months immediately thereafter, the Society of Arts circulated a smaller version of the exhibition, which included several of Fenton's photographs, to many similar societies around England. More daring was Cundall and Delamotte's opening of the Photographic Institution on New Bond Street, London, where they presented exhibitions of photographs that were for sale, with catalogues listing a price for each work. Fenton himself showed a number of photographs, including more than twenty views made in Russia, at the institution's opening exhibition in April 1853—the first commercial display of photographs in England. (For further discussion of Fenton's exhibitions and their critical reception, see "A Most Enthusiastic Cultivator of His Art" by Roger Taylor in this volume.)

Cundall, Delamotte, and Fenton quickly discovered, however, that selling photographs was a tricky business. Since the early 1840s commercial portrait photographers had fulfilled the public's desire for cheap likenesses, but the sale of other kinds of photographs had been slow to catch on in Britain. By the early 1850s, however, members of the Victorian middle class, with far more disposable income than previous generations, were eager to own both reproductions of works of art and original prints. They purchased prints of all types, from cheap, crude woodcuts to more expensive engravings, etchings, and color lithographs (a newly invented, very popular medium). Hoping to tap into this burgeoning market, Delamotte and Fenton sought an audience for their work distinct from the clientele of the hack commercial portraitist. In an advertisement that appeared in the catalogue of the Photographic Institution's first exhibition, Delamotte described in detail the customers these new professional photographers envisioned for their work. They were people who wished to have portraits with "the appearance of beautiful mezzotint engravings"; artists who wanted a record of their paintings or statues or who needed depictions of live models or costume studies; engineers and architects who required records of buildings; nobility and gentry who desired depictions of country houses and of castles, ruins, or picturesque spots; and clergy who sought images of their churches or refectories. 63 To appeal to this discerning audience, the new professionals tried to make their photographs look like fine prints, mounting them on large sheets of thick paper with printed credits and plate marks. And like painters before them they adopted a hierarchy of subjects based on their perceived importance. For the Photographic Institution's 1853 exhibition, for example, Fenton priced almost all his photographs of cathedrals, churches, and monasteries significantly higher than his picturesque views of village streets or old barns.⁶⁴ Tellingly, he did not exhibit any portraits, nor did many other photographers.

While Delamotte and Fenton had defined the new audience they sought, reaching it proved more difficult. Exhibitions attracted some attention but never enough to generate substantial print sales. Arrangements made with established print dealers like Paul & Dominic Colnaghi or Thomas Agnew & Sons were more lucrative, but even these brought sporadic earnings at best. Fenton and others began to make photographs of picturesque or famous subjects on speculation, but the financial reward was meager in comparison to the expenditure. Moreover, the question of physical permanence plagued the practice. Even photographers themselves recognized that until they could vouch with greater certainty for the stability of their prints, there was little chance of selling their works at other than rock-bottom prices.

Government patronage, though, was absent and steady clients were rare. Thus, when the British Museum solicited proposals from both Fenton and Delamotte in the summer of 1853 to establish a photographic studio and record objects in the collection, it must have seemed as though an ideal patron had appeared. 65 Eager (as Fenton wrote), "to be connected with so useful an application of the photographic art" that would demonstrate how photography could help the museum catalogue, classify, and disseminate information about its burgeoning collection and prove photography's usefulness to the other arts, both men submitted bids. 66 Reflecting his grandfather's business acumen and the thoroughness and diligence of a man who had traveled to Russia to make photographs, Fenton's detailed proposal listed all the equipment, including various cameras, lenses, and darkroom materials, that would be necessary to photograph objects of varying size and texture. He even gave extensive instructions for the construction of a photographic studio on the roof of the museum, specifying the size of the building and describing blinds that could be employed to control the light.⁶⁷ Delamotte's brief letter, perhaps because of his own poor business skills, paled in comparison.⁶⁸ In October, after receiving a recommendation from Wheatstone, who described Fenton as "a good artist . . . very skillful . . . persevering and pain-staking, and at the same time expeditious," the trustees asked Fenton to perform some trials and spend up to 180 pounds on equipment, making him the first photographer to the British Museum and conferring institutional approbation on his new career.⁶⁹

Fenton's work for the British Museum began in earnest in February 1854. While it may not have provided aesthetic rewards, it was technically and logistically challenging and once again put his organizational skills, as well

as willingness to adapt, to good use. For several months, dozens of rare Assyrian tablets—heavy, awkward, and fragile—were brought to the rooftop studio to be photographed, along with other recent acquisitions. With few precedents to follow, Fenton had to devise the best way to illuminate the objects, a difficult matter in the days before artificial light. It often entailed taking them out of the studio to the adjacent roof, where, to diminish the harsh contrasts caused by direct sunlight, he devised ingenious solutions, placing his camera in a box with curtains at the front that acted like a large lens hood, for example, and in later years even dusting sculptures with powder. To avoid distortions he used five different cameras. The complex undertaking was too much for one person; in his first year Fenton's business grew to include several assistants, employed at his own expense, who most likely helped him arrange and light the objects and prepared and developed his wet collodion negatives. The number of salt prints they made was astounding-more than two thousand in 1854 alone, and by May 1856 over eight thousand. 72 Although Fenton netted more than 350 pounds from this endeavor in the first year, he must have needed all his managerial skills to complete the work in a timely and profitable manner. The trustees, fully satisfied with his work, late in 1854 directed that an additional one thousand pounds be allocated for continued photography of the museum's holdings.⁷⁴

Another, ultimately far more important official recognition came to Fenton in 1854. On January 3 of that year his colleagues at the Photographic Society selected Eastlake and Fenton, the members most able to explain "the *artistic* and the *practical* sides of the art," to be the principal escorts for Queen Victoria and Prince Albert as they viewed the society's first exhibition. During their lengthy tour, the royal couple, who had agreed to become patrons of the society the previous summer, expressed far more interest in the more than eight hundred works on exhibit "than is ordinarily displayed on the occasion of a royal visit." They noted with "extreme satisfaction . . . the wonderful advance" photography had made in the last year and paid particular attention to Fenton's work, purchasing several of his photographs—including all of the more than twenty-five Russian views he exhibited. The control of the force of the provious summer, explained everything & there were many beautiful photographs done by him.

Fenton's subsequent relationship with the royal family had a profound impact on his career. Both Queen Victoria and Prince Albert took a great

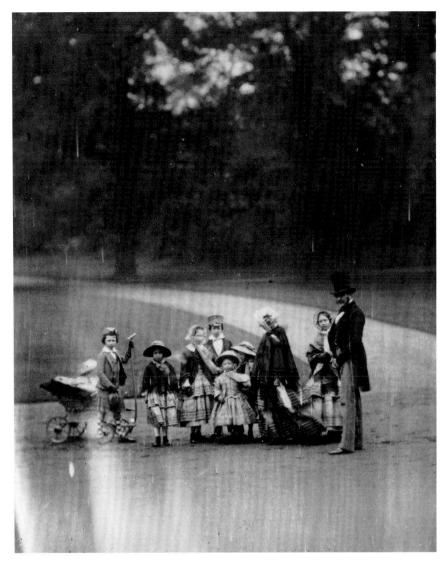

Fig. 10. Roger Fenton, *The Queen, the Prince, and Eight Royal Children in Buckingham Palace Garden, May 22, 1854.* Albumen silver print, 11.9 x 10 cm ($4^{11}/_{16}$ x $3^{15}/_{16}$ in.). The Royal Collection © 2004, Her Majesty Queen Elizabeth II, RPC.03/0002/91

interest in advances in science and technology, and photography genuinely intrigued them. With his keen intellectual curiosity, Prince Albert wanted to understand all aspects of the medium: its science, practical applications, and artistic potential. In the early 1850s the royal couple's staff included Dr. Ernst Becker, librarian to Prince Albert and assistant tutor to the princes, who was an amateur photographer and member of the Photographic Society

and taught the young men photography. Also at that time Albert initiated an ambitious and innovative program to have the queen's entire art collection recorded photographically, and together Victoria and Albert began to build what would become a large and important collection of photographs.⁷⁹ Both personally and professionally, Fenton clearly impressed them more than any other photographer they had previously encountered, perhaps because he was an educated artist and from the upper levels of society. He was granted exceptional access to the royal family and invited to photograph them on many occasions. On January 23 and 25, February 1 and 10, April 10, five times in May, and several other times during 1854, Fenton appeared at Buckingham Palace or Windsor Castle to take pictures. Because his portraits were never intended to be seen by the public at large but were solely for the queen's own enjoyment, he was allowed to witness and record the daily life of the family, often in very private moments away from the trappings of the court and the constraints of its highly regimented life (see "Mr. Fenton Explained Everything" by Roger Taylor in this volume). Accustomed to wealth and privilege, Fenton was not intimidated by either his subjects or their surroundings and took full advantage of the exceptional opportunities given him, for example photographing the royal children in the costumes they had worn for a private family play, or the entire family—the queen, the prince, and their eight children—on the grounds of Buckingham Palace (fig. 10). Unaccompanied by attendants and without official accourrements, they all wear simple day dress and look like just another upper-class family out for a Sunday stroll. Fenton's intensely personal records of an otherwise excessively public family obviously had special meaning for both their maker and their subjects, who provided him with even greater opportunities and an even more privileged vantage point in the months to come.

1855

And who loves war for war's own sake/Is fool, or crazed, or worse; . . .

— Alfred, Lord Tennyson, 1882⁸⁰

On Saturday, March 11, 1854, Queen Victoria, Prince Albert, and other members of the royal family boarded their yacht, *The Fairy*, and sailed through the First Division of the Baltic Fleet to salute the departure of the

Fig. 11. Roger Fenton, "The Fairy" Steaming through the Fleet, March 11, 1854. Albumen silver print, 14.6 x 20.5 cm (5^{3} /4 x 8^{1} /6 in.). The Royal Collection © 2004, Her Majesty Queen Elizabeth II, RPC.03/0002/15

military forces for the impending war with Russia. As *The Fairy* glided out of Portsmouth harbor and passed each ship in turn—all with flags flying, yards manned, sailors on every inch of deck and still more hanging from the rigging—loud cheers rang out both from spectators lining the shores and from the men onboard because "Her Majesty [was] literally leading them out to sea." When *The Fairy* reached the head of the fleet, guns on all the ships blazed in a deafening roar; then one by one the ships sailed past the queen to begin their long journey. Finally, as *The Fairy* headed off to Osborne, the royal residence on the Isle of Wight, a few sailors shimmied to the very tops of two of the masts of the *Duke of Wellington*, the flagship of Vice Admiral Sir Charles Napier and the last ship in the line, and waved so enthusiastically that they caught the queen's attention. Waving her handkerchief, she returned the cheer, as did the prince. Even as

the spectacle drew to a close, she was unable to tear her eyes away from the ships that towered so "majestically above the blue waters," she later recorded in her diary. "One gazed & gazed," the queen wrote, "till the noble ships could scarcely be discerned on the horizon."⁸²

Roger Fenton also witnessed this grand display. Like his patron he was entranced by the spectacle and touched by its poignancy, and he too recorded the day, in an evocative photograph of a woman and children (possibly his own family) peering intently out to sea (fig. 11). For queen and commoner alike, rapt awe at the spectacle just witnessed was no doubt tinged with anxiety over the fate of the vessels, the sailors, and the nation. This day, portentous for both the queen and her photographer, would significantly affect the future course of their lives. In the days and weeks to come, England's alliance with France and Turkey against Russia would inexorably draw it deeper into a

war that, while supposedly about "truth, integrity, honour,"83 came to exemplify anything but those noble ideals. Eager to assert its power on the European stage, Russia had moved into Moldavia and Wallachia, principalities on the Danube then under Turkish control, and was threatening to make further incursions into the weakening Ottoman Empire. Allying themselves with the Ottoman sultan, England and France decided to teach the czar a lesson by capturing Russia's Black Sea naval base at Sebastopol, in the Crimea. Thus began a long, deadly siege, the centerpiece of one of the most disorganized and costly conflicts in all of English history. After forty years of relative peace, England was ill equipped to fight. Few commanders were younger than sixty and even fewer had actual field experience; a generation of officers had purchased their commissions; and neither they nor their troops had had much military training. Perhaps even more surprising, and ultimately devastating, was the woeful inadequacy of the infrastructure put in place to feed, clothe, and equip the troops once they arrived at the site of the war. The suffering of the common soldiers was horrific. The appalling casualties of battle were compounded, especially during the winter of 1854-55, by bitter cold, scant clothing and housing, nonexistent sanitary conveniences, and grossly inadequate nursing and hospital facilities. Troops had to scavenge fuel and provisions and cook their own meals. With so many people crowded into unsanitary living conditions, disease, especially cholera, became rampant. The soldiers were "overworked, badly fed with no fuel to cook with, only one blanket, many [with] no shoes," the head of the army medical unit in Constantinople, Dr. John Hall, abjectly recorded in his diary, and "dying by hundreds." The agony of their families at home was made all the more excruciating by daily reports dispatched to the *Times* by William Howard Russell, who branded the conduct of both the English and the French leaders "recklessness verging on insanity." 85

Like others, the queen and prince were genuinely appalled by these reports, but they were constitutional monarchs and it was not their role to question, much less criticize, the military's and the prime minister's handling of the war. They could, though, show concern for their troops in other ways. Queen Victoria regularly visited the hospitals filled with wounded soldiers sent back from the war and, despite feeling that her inadequate words "all stuck in my throat," endeavored to comfort the men. See She donated funds to provide artificial limbs for amputees and established the Victoria Cross for

acts of heroism and bravery, presenting it for the first time not to an officer but to an Irish mate on the *Hecla*, Charles Lucas. She also forged a close friendship with Florence Nightingale, who arrived in the Crimea in November 1854 and whose letters to the queen kept her abreast of the often dreadful conditions she and her nursing staff encountered. Victoria used her influence to have the commander in chief, Lord Raglan, appoint Nightingale sole supervisor of the nursing staff for the war. ⁸⁷ When one of the queen's private letters expressing great worry about the soldiers' welfare and morale was published—an astonishing breach of protocol at the time—she did not criticize the disclosure but let her words stand as condemnation of the appalling debacle. ⁸⁸

Victoria and Albert also supported Fenton's photographic expedition to the Crimea in 1855. Since the inception of the war there had been speculation in the photographic press on whether the military authorities would appoint an official photographer, not just to record events but to describe the ports, fortresses, and disposition of fleets and even to copy maps and other important documents.⁸⁹ At the beginning of the conflict, in March 1854, a suggestion to the Photographic Society that it propose names of photographers to the military authorities elicited "a shower of letters," all addressed to Fenton as secretary of the organization, from hopeful volunteers who were no doubt motivated by both patriotism and the expectation that fame would accompany this appointment. 90 In April Captain Scott took an amateur photographer, Gilbert Elliott, on board his ship, the Hecla, to determine whether "instantaneous" photographs of sufficient clarity could be taken of the shoreline and fortifications from a moving ship; in May Fenton, not to be outdone, made photographs in Portsmouth of the fleet at anchor and under sail.91 Soon, too, the Times began to print Russell's dispatches, and the Illustrated London News began to carry wood engravings copied from photographs made by James Robertson in Constantinople. 92 War as theater, as "spectator sport," had begun.93

We do not know who initiated Fenton's trip to the Crimea. Many scholars have suggested that the prince himself proposed it.⁹⁴ His deep interest in photography and understanding of its potential make this possible, but they do not tell us what his objective might have been. Was he motivated by sheer scholarly interest (possibly)? By a desire to produce propaganda (unlikely for a discreet, foreign-born prince) and if so, to benefit pro- or anti-war factions? Others, noting that Prime Minister Aberdeen's position was weakening in

late 1854 and early 1855 as the debacle of the war grew ever worse and public morale plummeted, have theorized that he asked the Manchester printseller Thomas Agnew to send someone to the region to supply photographs that could refute the assertions of the liberal press. ⁹⁵ This seems speculative at best, though, for the intense criticism of Aberdeen's administration did not begin in earnest until December 1854 and January 1855, when the Crimean winter caused extreme suffering; and we know that Fenton, in his usual organized manner, had begun preparing for the arduous journey a number of months before his February 1855 departure. 96 In the fall of 1854 he purchased a wine merchant's van and outfitted it as a traveling darkroom. He even traveled to Rievaulx Abbey and elsewhere to test it out, and subsequently made modifications.97 We know for certain that Fenton was furnished with letters of introduction from Prince Albert; that Agnew financed the expedition; and that Fenton's passage on the *Hecla* was provided by the Duke of Newcastle, secretary of state for war, and Sir Samuel Morton Peto, a Manchester railway entrepreneur.98 We can surmise, because both Agnew and Peto were from Manchester, that they knew Fenton, either personally or professionally. And since Agnew was not only a print seller but a publisher, perhaps eager to exploit the commercial potential of the public's interest in the conflict, we can also conjecture that he was the instigator of the mission. But what we indisputably have are the photographs themselves, as well as letters Fenton wrote to his family and to Agnew on his journey in 1855, all of which are rich with explicit and implicit information.

The tone of the letters is noteworthy. Although they were edited when published in 1954 and their more personal ruminations deleted, Fenton's sense of humor and his intrepid spirit are readily apparent. ⁹⁹ Yet he also assumed the voice of an almost jaunty world traveler witnessing a spectacle that alternately amazed and amused him, that complicated but never confounded his efforts, and that, while it provoked periods of sadness, never aroused deep moral indignation. He described, for example, "the constant succession of startling novelties" he encountered within a few days of his arrival at Balaklava on March 8, 1855: the densely packed harbor crowded with more than 150 ships, and the dazzling mix of people and animals. "The emptying of Noah's Ark could not have been half so queer a sight," he wrote to his wife, for there was "an incessant stream of officers and men in all kinds of costumes, on foot and mounted on every variety of charger; Zouaves were

loitering about with baggy breeches, Turks with baggier." ¹⁰⁰ He detailed his somewhat comical labors to get his van and thirty-six crates of materials and supplies off the Hecla and his persistent and ingenious efforts to outfit himself properly with adequate horses, saddle, and bridle. Even though he wrote of seeing dead bodies, he casually remarked that "life seems to be squandered here like everything else." Especially during the first few months, the war remained somewhat distant, "a picture of dreamy repose, which was only heightened by the contrast of a dashing Zouave clad in a garb of many colors." Fenton's experience in the Crimea was far more positive than most in part because he did not arrive until the spring, when the devastating winter was over and some improvements had been made, but mostly because the letters of introduction he carried from Prince Albert guaranteed him exceptional access and privilege. While the journalist Russell was barely tolerated, everywhere Fenton turned he received "the assurance of assistance in every possible way" from the highest-ranking officers in the region, including Lord Raglan. The war Fenton experienced was one where officers had dinner parties with elaborate multicourse meals, wine, champagne, cognac, and cigars, and entertained visiting ladies; where he sat at a dinner "on Lord Raglan's right," near Lady George Paget, the "belle of the Crimea"; and where he quickly became a celebrity. 102 His hut was "the rendezvous of all the Colonels and Captains in the army," Fenton remarked to Agnew, "everybody drops in every day."103

Aided by two assistants, Marcus Sparling (a photographer, member of the Photographic Society, and former corporal in the Fourth Light Dragoons) and a handyman identified only as William, Fenton began to photograph within a few days of landing at Balaklava. Using a variety of cameras—he had brought five, including one specifically for portraits—he worked diligently for three months, making more than 350 negatives. Yet what he did not photograph is almost as revealing as what he did. In one of his early letters home he recounted that when in his van preparing or developing his wet collodion negatives he was repeatedly interrupted by soldiers, who, reading the words "Photographic Van" painted on its side, asked to have their pictures taken "to send home." But Fenton had no intention of becoming a hack portraitist of "all comers" who should happen to ask, even though he "might make a regular gold digging," as he told Agnew. Nor did he have any interest in recording recent improvements that made life more bearable and

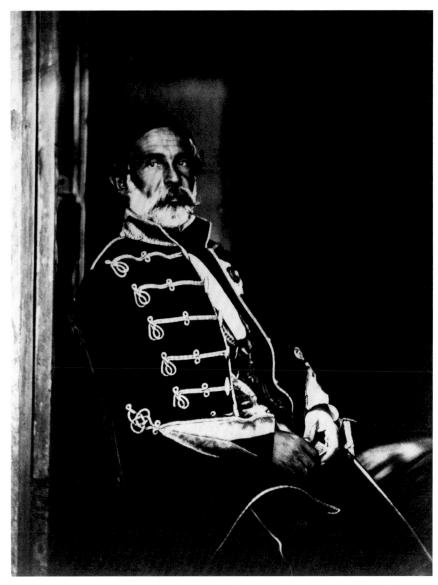

Fig. 12. Roger Fenton, *Omar Pasha*, 1855. Salted paper print, 17.9 x 13.4 cm ($7\frac{1}{16}$ x $5\frac{1}{4}$ in.). Gilman Paper Company Collection, New York, PH78.449

viable in Balaklava in the spring of 1855, such as the newly built roads that he described in his letters. And, while battle scenes were beyond the technical capabilities of photography at the time, he also never violated Victorian taste by photographing the battle's aftermath, the dead bodies, or the chaos and clutter of the trenches, although he had plenty of opportunities to do

so. 105 He did not even record the extensive fortifications constructed by the allies, as the photographers James Robertson and Felice Beato did after his departure. For the purpose of his trip was not to produce propaganda, not to provide images that could be used as evidence either in support of or against the war itself; it was to create a commercially viable portfolio of photographs. The portfolio's high price—more than sixty pounds—makes clear that it was aimed at the upper levels of British society. This audience, many of whom had lost family and friends in the conflict, did not want to see photographs of death, suffering, chaos, and ineptitude, or images that would challenge their closely held belief in the necessity and correctness of the conflict. They wanted pictures to support the myth that their loved ones had died not ignominiously or in vain but with dignity, and in a noble cause.

To this end, Fenton tried to photograph the leading figures of all the allied armies. He depicted the commander of each: Lord Raglan—about whom "the soldiers have nothing but good words to say," he told Agnew; his French counterpart, Field Marshal Jean-Jacques Pélissier; and General Omar Pasha (fig. 12). 106 British officers he portrayed included General Sir James Scarlett, who had earlier commanded the heavy cavalry in the Battle of Balaklava; Lord George Paget, colonel of the Fourth Light Dragoons, who was in command of his regiment when it charged with the Light Brigade at Balaklava in October 1854; and General Sir John Lysaght Pennefather, who had led the Fourth Division at Inkerman in November, valiantly battling thirty-five thousand Russians with a force one-tenth the size. (Fenton was so intent on securing likenesses of all the key participants that he even made some after his return to England and incorporated them into his portfolio, Photographic Pictures of the Seat of War in the Crimea, with no explanation that they were later additions.) 107 He photographed notable officers such as Captain Adolphus Brown, Fifth Dragoon Guards, whose squadrons were hit hard by cholera, and Cornet John Wilkin of the Eleventh Hussars, who survived the charge of the Light Brigade (fig. 74). He also made "essays of camp life," which show officers, often attended by aides and surrounded by their regiments, relaxing near their tents (pl. 16). And he made studies of the picturesque and exotic individuals who populated this "Noah's Ark": the Highlanders in their colorful garb, the Grenadier Guards with a Nubian servant, a French cantinière, Russian children, the Zouaves, Croats (pl. 17), and Turkish soldiers.

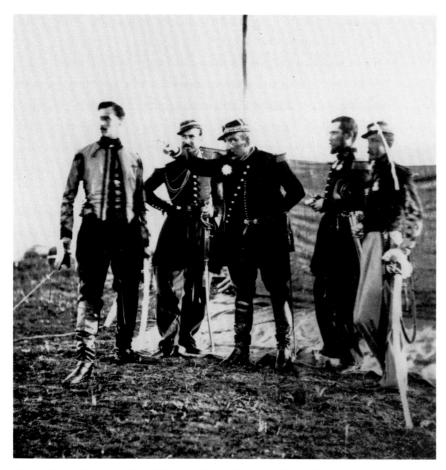

Fig. 13. Roger Fenton, General Bosquet Giving Orders to His Staff, 1855. Salted paper print, 19.8 x 16.8 cm ($7^{13}/_{16}$ x $6^{5}/_{8}$ in.). Gernsheim Collection, Harry Ransom Center, The University of Texas at Austin, 964.0351.0123

While the vast majority of the more than 350 photographs Fenton made in the Crimea are portraits, he also recorded the densely packed harbor of Balaklava and the plateau of Sebastopol (pls. 14, 15, 20). There, no doubt responding to current fashion, he made several panoramas, including a five-part one showing the plain of Balaklava, where English cavalry brigades had won important victories, a three-part study of the site of the Battle of Inkerman in November 1854, and an eleven-part panorama of the view from Cathcart's Hill, where many officers had positioned themselves to safely survey the Battle of Balaklava fought on the plains below (fig. 73).

Fenton's subjects were, in short, the very people and places the English public had been reading about for so many months. Fought far from English soil, the Crimean War was the first "armchair war," experienced by the general public not through firsthand knowledge or as an imminent threat but through newspaper and journal articles, and almost (as Fenton described it) as a spectacle. 108 The rapid growth of the popular illustrated press and the increased availability of prints circulated by dealers such as Agnew and Colnaghi also made it the first war in which visual as well as printed information could be—and was—avidly devoured by the public. Fenton himself recognized a need to feed the appetite of his audience and from time to time sent Agnew works he considered "worth engraving and will serve to keep up the attention of the public until my return." And if the public hungered to be kept constantly informed about the war, if they viewed it as theater, they also craved heroes to star in this drama of victories and defeats. 110 Russell's dispatches, rich with details, often captured public attention by focusing on the individuals who waged the war, both the inept and the laudatory, the officer and the common soldier. Fenton, too, sought out the individual, but he was not greatly concerned with the anonymous foot soldier, "the crowds of all ranks who flock round" spoiling his pictures, and wanted instead the "great guns," as he wrote to Agnew, "the persons and subjects likely to be historically interesting."111

Working in the tradition of history painting that he had learned from Drolling and Lucy, Fenton strove to depict the heroes of this significant moment in human history in order to "perpetuate" them and enlighten future generations.¹¹² Because specific, literal truth mattered less than edification, Fenton did not try to capture the instantaneous life he saw around him (which by the dictates of history painting was too unresolved and unfocused to be instructive) but instead carefully posed his subjects to express timeless and noble qualities such as fraternity, leadership, or dedication to country. And, just as Drolling and Lucy dressed their models in Grecian robes or seventeenth-century Puritan garb in order to illustrate more convincingly the anger of Achilles or the grief of the Pilgrims, so too Fenton had no compunction about asking his subjects to don their heavy winter fur coats even though he was photographing them in the warm spring weather, or to put on dress uniforms usually reserved for special occasions. 113 He even dressed up himself, as a Zouave (fig. 52). His compositions and especially his group scenes, with their pyramidal groupings and shallow, stagelike picture box, draw on the lessons of his masters, as does his use of dramatic gesture

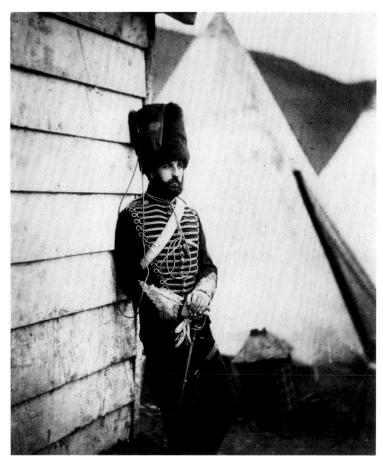

Fig. 14. Roger Fenton, *Captain Dames*, 1855. Salted paper print, 17.7 x 15 cm ($6^{15}/_{16}$ x $5^{15}/_{16}$ in.). Gernsheim Collection, Harry Ransom Center, The University of Texas at Austin, 964.0351.0235

(compare figs. 5 and 13). Indeed, Fenton described the subject of his portrait General Bosquet Giving Orders to His Staff (fig. 13) as "very good to take, resembling much the portrait of Napoleon when he began to grow stout." ¹¹⁴

Fenton's Crimean expedition was one of the most difficult, complicated, and ambitious projects any photographer had undertaken. At times it was also dangerous; the Russians occasionally fired on his van and once even hit it. Working out of doors, without a studio, he was forced to improvise every photograph in a foreign and frequently hostile terrain. Yet, in part because he was relying on earlier artistic models and in part because so many portraits were "wanted" for the project, as he wrote, he often resorted to rote formulas, posing any number of groups in front of the same tents or sitting

on the same bales of hay.¹¹⁵ Toward the end of his time in the Crimea, however, a new sense of war-weariness crept into Fenton's letters and portraits. As he worked his way down through the ranks, finally photographing junior officers and some noncommissioned soldiers—those who actually bore the brunt of the fighting—their exhausted and shattered state became ever more apparent (pl. 18). Precisely because the subjects did not try to hide their desperation and the photographer did not seek to transform them into something they were not, these are among Fenton's most compelling Crimean portraits.

Fenton learned many valuable lessons during his three months spent in the Crimea. The bright southern light was unlike anything he had encountered before, but he came to realize that by posing his subjects against lightcolored tents or huts, which contrasted sharply with the dark ground, he could energize his compositions with bold geometric forms (fig. 14). More significantly, when he ventured out of Balaklava up onto the plateau of Sebastopol, he found a vast, barren, undistinguished landscape that conformed not at all to the picturesque and sublime traditions he knew from English art. Initially Fenton lamented that with virtually no people or objects in the landscape he "could make no foreground," and with a vista so vast there was little he could focus on for his background. 116 Yet he learned how to deal with this emptiness and how to construct a composition out of nothing but vacant sky, the lines of a hill, the rise of a barren land. These allover and edge-to-edge compositions, without drama or focus, were far removed from the traditional landscapes he had studied with Drolling, Lucy, or Brown, and far more innovative. And when Fenton made Valley of the Shadow of Death, he rose to the daunting challenge of addressing the shattering loss of life incurred by British forces (pl. 21). The subject of this photograph is not the site where the doomed charge of the Light Brigade had transpired the previous October but a separate ravine the soldiers called by that name because the Russians shelled it so frequently.¹¹⁷ Yet its title, so similar to the lines "Half a league, half a league/Half a league onward/... Into the valley of Death/Rode the six hundred" from Tennyson's celebrated 1854 poem "The Charge of the Light Brigade," immediately linked the photograph to that battle of profound national significance. 118 Fenton depicted the scene not as a painter might have done, describing the chaos, death, and destruction of the shelling, the dramatic glory of the action; but as a photographer

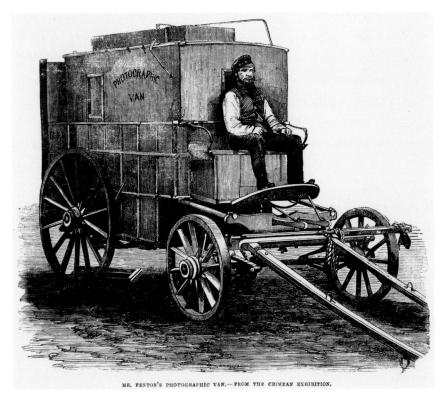

Fig. 15. Mr. Fenton's Photographic Van—From the Crimean Exhibition. Wood engraving, 14 x 15.9 cm (5½ x 6¼ in.). From Illustrated London News, November 10, 1855, p. 557

had to do, showing the quiet emptiness of its aftermath. Appealing as much to the imagination as to the eye, this image has perhaps more resonance than any other of the Crimean War.

On June 7 Fenton witnessed the capture of a Russian fortification, the Mamelon. On June 18, the anniversary of the British triumph at Waterloo, he participated in the disastrous attack on the Malakhov and Redan fortifications where, in one day, the British lost more than fifteen hundred troops and the French more than thirty-five hundred. He described the events as a "hideous dream," the attack as "disgraceful," with "no management, no orders," and himself as acting like "a madman . . . covered with blood and brains spurting from a poor fellow" shot close to him. In the days that followed Fenton grew increasingly depressed. ¹²⁰ He contracted cholera and sailed from Balaklava on June 22, 1855, arriving in England on July 11, one week after the birth of his fifth daughter.

If Fenton had been a celebrity in the Crimea, he was an even greater one on his return to England (fig. 15). By early August the queen had seen some of his Crimean photographs and described them as "extremely well done," and in September he and Agnew showed the set of photographs to Emperor Napoléon III at the palace of Saint-Cloud, outside Paris. 121 The emperor looked at them for quite a long time; whenever he saw one that particularly interested him he showed it to the empress, who was in the adjacent room.¹²² In September the exhibition "Photographic Pictures Taken in the Crimea," consisting of more than 280 works by Fenton, opened at the Gallery of the Water-Colour Society in London, the first of three venues in London and more than seven elsewhere in Britain. It was an astounding success. The exhibition was hailed as "one of the most interesting series of photographs that has ever been executed" (Art-Journal), its photographs judged "more interesting at the present moment than the finest works of imagination" (Athenaeum). 123 "A more impressive exhibition or more deeply interesting application, in an historical point of view, of the photographic art, it is scarcely possible to imagine" was the assessment of the Literary Gazette. 124 Also that September, Agnew announced the publication of *Photographic Pictures* of the Seat of War in the Crimea, a series of three portfolios: Scenery,—Views of the Camps, &c.; Incidents of Camp Life,—Groups of Figures, &c.; and Historical Portraits. 125 Despite the high praise, the almost weekly appearance of Fenton's work in the *Illustrated London News* in the fall of 1855, and Agnew's creative efforts to market the portfolios (including the claim that only a limited number of prints could be made from a negative), sales were poor. In December 1856, the negatives and remaining prints were sold at auction. 126

1856 - 1859

Photography has become a household word and a household want; is used alike by art and science, by love, business, and justice; is found in the most sumptuous saloon, and in the dingiest attic.

—Lady Elizabeth Eastlake, 1857¹²⁷

Between 1851 and 1855 Roger Fenton had displayed an acute understanding of precisely how to establish himself not just as a leading figure in English photography but as its foremost practitioner. The next three years, 1856 to 1859, would be the most productive in his career. His experiences in the

Crimea ripened his art, which became more ambitious and sure. He traveled widely, recording landscape and architecture throughout England, Scotland, and Wales and eloquently demonstrating that photography could infuse these scenes with intense personal and moral meaning while also creating symbols of national identity and collective memory. (See "In Pursuit of Architecture" by Gordon Baldwin and "On Nature's Invitation Do I Come" by Malcolm Daniel in this volume.) No doubt as a result of his Crimean work, Fenton's use of figures within these compositions became ever more confident. Eschewing literary and narrative devices, he began to place people in more subtle, meaningful ways, often presenting a figure as a surrogate for the viewer, back to the camera, in quiet contemplation of a historic ruin or sublime vista. Digging ever deeper into the ways cameras and lenses describe the world, he created boldly innovative photographs. Rigorous and taut like the man himself, they demonstrate a geometric structure and a visual sophistication unknown in his earlier work. When in London, where he had recently improved the studio at his home on Albert Terrace, he made portraits and tried new subjects, including Orientalist studies and still lifes. He exhibited widely in Britain and Europe, participating in 1856 alone in nine exhibitions, where he won several medals. His art continued to be frequently and extravagantly praised in the press. It was "landscape photography pushed to the highest degree of perfection," according to the Bulletin de la Société Française de Photographie (1856). 128 "No one can touch Fenton in landscape: he seems to be to photography what Turner was to painting," asserted the Journal of the Photographic Society in 1858. 129

Yet Fenton's drive to perfect his own art was equaled by his ambition to establish a truly professional practice, and this proved a far more difficult course to navigate. During these years the field was changing rapidly. Cartede-visite portraits, introduced early in the decade, became extremely popular in the mid- to late 1850s, as did stereoscopic photographs; these fads drew many frankly commercial operators into the field. While most of them were photographers of little consequence, some, such as George Washington Wilson, used their prolific production of stereo views to spawn thriving businesses that allowed them to undertake extensive picture-making expeditions around the world. Additionally, as photography became more popular among the Victorian middle and upper classes, a number of trained artists—such as Francis Bedford, William Lake Price, Oscar G. Rejlander, and Henry

Peach Robinson—began to make and sell photographs and in some cases establish significant photographic businesses. While some of these new professionals, among them Bedford, came from middle- or upper-middle-class families, others, including Wilson, were from more common backgrounds. For a people as bound by the idea of class as the Victorians, who admired innovative gentleman amateurs but viewed those in "trade" as somehow tainted, these developments further complicated an already fraught situation. No longer the sole or even the most celebrated new professional photographer, Fenton now found the path that he had blazed crowded with others, many of whom he did not recognize. While the competition spurred him to ever greater artistic accomplishments, he was increasingly flummoxed by the difficulty of making photography both a viable business undertaking and a respectable one for an artist such as himself. Although he embarked on one business venture after another during these years, none was lasting, few were commercial successes, and several brought him into conflict with his colleagues.

That conflict was epitomized by Fenton's relations with the Photographic Society in 1856. In early February, when he stepped down as honorary secretary of the society (the position was being combined with that of editor of the journal), his colleagues enthusiastically praised his accomplishments on the society's behalf and applauded his recent exhibition of Crimean photographs. 130 Yet only three months later, in May 1856, Fenton resigned from the Council of the society after a heated debate about his participation in a new enterprise called the Photographic Association. 131 Seeking to exploit photography's commercial applications to "every Branch of Art, Literature, Science and Mechanics," the Photographic Association hoped to raise ten thousand pounds from investors, who would be paid dividends, and hire a staff to run a business "profitably" selling members' photographs "on an extensive scale." 132 Flush with the popular success of his Crimean photographs (and perhaps not yet fully cognizant of their limited financial return), Fenton clearly thought that the Photographic Association would provide a viable way to market his photographs. However, the Council of the Photographic Society strongly opposed its members' having "any connexion with photography as a commercial speculation." ¹³³

Although the Photographic Association appears to have been abandoned, and Fenton returned to the Photographic Society's Council the following year, the episode laid open the contentious issue of photographers selling

Fig. 16. Roger Fenton, Raglan Castle Porch. Photo-galvanograph, 24×27 cm ($9\frac{7}{6} \times 10\frac{6}{7}$ in.). From Photographic Art Treasures; or Nature and Art Illustrated by Art and Nature (London, 1856). Museum of Fine Arts, Boston, Anonymous Lender

their works. The controversy had first erupted at the Photographic Society earlier in the decade, when a motion was proposed, then rescinded, to disqualify "all persons practising photography professionally with a view to profit" from becoming members of the Council. Many members of the society regarded Fenton, because of his class and wealth, not as a professional photographer but as an amateur who sold his photographs. Yet, as one author noted at the time, the line between the professional "selling his pictures for profit, and the amateur who sold pictures" was difficult to define, to say the least. For the next several years, both this issue and the question of whether exhibitions should include work that had been for sale in "shop-windows" were increasingly and often contentiously debated, with few satisfactory answers emerging. 136

In late 1855 and early 1856, when supervising the expensive and timeconsuming printing of his Crimean negatives, Fenton began to seek a more economical means of circulating his photographs to a wide audience. Ever since the invention of photography, many people had been concerned about the lack of permanence of photographic materials and had tried to find a way to print photographs as ink reproductions that could be incorporated with texts. 137 Fenton had been following the experiments of Abel Niépce de Saint-Victor, who was working on transferring photographs to printing plates, but found the method "uncertain both in its theory and its results." 138 He was impressed, however, by the "ingenuity" of Paul Pretsch's so-called "photo-galvanographic" process, a photomechanical means of reproducing photographs, drawings, or paintings in ink printed on a press. 139 By the end of the year Fenton had become a partner with Pretsch in the Patent Photo-Galvanographic Company in North London, as well as its chief photographer. Heralding a "new era in art," Pretsch and Fenton released the first part of Photographic Art Treasures; or Nature and Art Illustrated by Art and Nature, with reproductions of four photographs by Fenton, in late October 1856 (fig. 16). 140 Four more parts, with reproductions of photographs by Lake Price, Robert Howlett, Lebbeus Colls, and Fenton, were issued in the coming months.

But Pretsch and Fenton's proclamation of a new era was premature. Photogalvanographic plates were not durable and wore down after several inkings, which no doubt explains why the prints were sold as "choice proofs," "proofs," and "prints." ¹⁴¹ More significantly, after the image was transferred onto the plate it had to be heavily retouched by hand to strengthen details lost in the process, thus destroying the veracity of the photograph. Neither drawing nor photograph, this odd hybrid was difficult for the public to interpret was it artistic fancy or photographic truth? Retouching by hand also made the process time-consuming and expensive. By May 1857 the company had sustained a "severe loss" of four thousand pounds. 142 Compounding the partners' problems, Talbot threatened to sue them for infringement on his 1852 patent for photographic engraving, and they were also embroiled in a lawsuit with a former employee who had set up a competing company. 143 Over the summer of 1857 Fenton tried to extricate himself from the embattled company, at one point even offering his share in it to Talbot. "They would only require about £1,200 after the liabilities are discharged!" Talbot's amazed solicitor informed him. "A more unbusiness like proposal was never made."144

Another professional disappointment came the same year. Fenton had won high praise for works he exhibited at photographic societies in London, Manchester, and Edinburgh, but at the first exhibition in England that presented photographs together with all the other arts he was largely ignored. 145 This show, the celebrated Manchester Art Treasures Exhibition, organized with the full support of Prince Albert, was widely seen as evidence that the public had accepted the artistic merit of photography. Prince Albert and Oueen Victoria lent several photographs from their own collection to the show and purchased others from it, including some by Bedford, but none by Fenton. 146 The unquestioned star of the photography display was Rejlander, whose elaborate composite photograph The Two Ways of Life so intrigued the prince that he summoned its maker to Buckingham Palace and subsequently bought three copies. 147 Although Fenton continued to photograph the royal family on occasion throughout the decade, making some of his most sympathetic portraits of them, he no longer enjoyed their special favor. Further wounding his pride, when the queen needed a photographer to make a series of photographs of Prince Albert's home in Coburg, Germany, for his birthday in 1857, she commissioned not Fenton but Bedford. 148

On his return from the Crimea, Fenton had resumed his work for the British Museum, and in June 1856 the museum, with Colnaghi acting as the publisher,

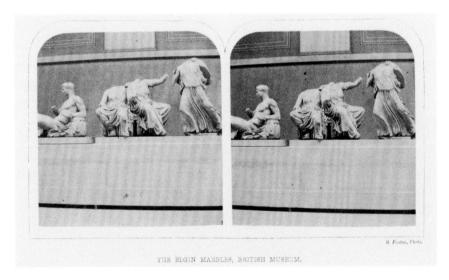

Fig. 17. Roger Fenton, *The Elgin Marbles, British Museum, III*, 1857. Albumen silver prints, stereograph, each 7 x 6.7 cm ($2\frac{3}{4}$ x $2\frac{5}{8}$ in.). From *Stereoscopic Magazine*, no. 18 (December 1859)

released Photographic Facsimiles of the Remains of the Epistles of Clement of Rome, with salt prints of the original leaves, in an edition of fifty. 149 The publication was undertaken at the request of the divinity professors of Oxford and Cambridge and, like his earlier work for the British Museum, was intended primarily for scholars. However, after 1856 Fenton embarked on an ambitious project to exploit the commercial value of his museum photographs and market them more widely.¹⁵⁰ In the summer of 1857, after recording several Roman statues, he asked permission, which he eventually received, to photograph the Elgin Marbles (fig. 17). Fenton wrote to the museum's trustees that the work would be "of unparalleled interest and of the highest value to Art Education," but he also knew that photographs of these celebrated and already controversial friezes from the Parthenon, brought to England early in the century, would have great commercial potential. 151 He offered to make the negatives without charge provided that at least one hundred copies of each image were ordered by the museum and the negatives became his property. 152 Pushing his marketing scheme still further, in 1858 Fenton secured permission from the trustees to advertise in the front hall of the museum that his photographs were for sale there; they could also be bought from Colnaghi's in London or certain print dealers in Paris. 153

At this point the trustees seem to have recognized that there was a lucrative market for photographs of objects from their collection. In the summer of 1859 they transferred all the negatives Fenton had made for the British Museum to the South Kensington Museum (now the Victoria and Albert Museum), where prints were henceforth to be made. His pride wounded and his pocketbook significantly impacted, Fenton objected vehemently, arguing that the prints needed to be made under his supervision and that he had not been paid for many of the negatives taken in 1858 and 1859. ¹⁵⁴ After a meeting with the trustees, which Fenton admitted was "doubtless as unpleasant to the trustees, which Fenton admitted was eventually conceded and some compensation paid, but the museum kept the negatives. ¹⁵⁵ With this, Fenton's association with the British Museum ended.

In the late 1850s, as his business grew ever more complex, Fenton struggled to make it more economically viable. Throughout most of his career he had employed technicians to make salted paper prints for his large projects, such as the work for the British Museum and most likely the Crimean photographs. Salt prints were prized for their rich texture, subtle tonal

range, and broad massing of lights and darks; however, salted paper was not commercially manufactured and had to be prepared in the photographer's darkroom. The prints were not only time-consuming to make but difficult to control, requiring Fenton's careful supervision. On the other hand, albumen paper, first introduced in the early 1850s, could be purchased from an increasing number of retailers. Albumen prints were also easier to control, more consistent, and thus more economical than salt prints. Albumen prints also presented a sharper image than salt prints, and in the mid-1850s, as sharpness itself became a desired quality in photographs, they were increasingly prized. Fenton, who was traveling ever more frequently to make photographs and had little time to supervise the production of his prints, bowed to both changing taste and economics and switched to albumen prints. Soon he, too, came to appreciate the bold value contrasts and crisply delineated geometric forms that could be achieved with this process.

Fenton's production of stereoscopic photographs in the late 1850s represents yet another attempt to chart a middle course in the increasingly commercial world of photography. By the second half of the 1850s, stereo views printed on cards and looked at through a handheld viewer were a craze few photographers could avoid: in 1856 the London Stereoscopic Company sold half a million stereo viewers and listed more than ten thousand different stereo photographs for sale in its catalogue; two years later it offered more than one hundred thousand. 156 Unlike so many others, though, Fenton turned to stereos for their educational value as well as their financial potential. In the spring and summer of 1859 he contributed several examples to the Stereoscopic Magazine, a monthly publication issued by the London publisher Lovell Reeve that included actual stereo photographs mounted on its pages; soon Fenton was a regular contributor. In 1860 Reeve released two more publications with Fenton's stereos, The Conway in the Stereoscope and Stonyhurst College & Its Environs. Reeve's specific intent was to elevate stereos from a mindless pastime to an educational tool and to counter the "vulgar" and "unmeaning" views then so ubiquitous. 157 He printed "intelligent descriptions" to accompany his edifying studies of antiquities, architecture, landscape, and works of art. 158

As Fenton worked once again with stereos he became intrigued with their aesthetics. While earlier he had explored compositional strategies that increased the illusion of depth, now his attention was caught by the way a stereo viewer, cupping the eyes to exclude everything beyond the photograph, provided an intense and intimate experience. He began to play with the sense that was created of actually being in the three-dimensional space depicted. Throughout his career Fenton had used figures in his compositions with increasing sophistication, often positioning them in the middle ground to direct the viewer's attention. Now he began to employ them in both stereos and other photographs in a far more dramatic way, placing people so that they walked into or out of the composition (pl. 54). These glimpses of human life add an uncanny frisson to his photographs, further intensifying the viewer's almost palpable sense of not merely witnessing the scenes but actually participating in them.

As Fenton's business endeavors grew more complex and diverse in the late 1850s, so too did his art. At the end of the decade he explored a number of new subjects. In each case he seems to have been initially inspired by work of his contemporaries. Rejlander's ambitious and celebrated Two Ways of Life and William Grundy's critically less successful photographs of figures in Near Eastern costumes prompted Fenton's 1858 Orientalist studies, and George Lance's still-life paintings inspired his own examinations of the genre in 1860. (See "Trying His Hand upon Some Oriental Figure Subjects" by Gordon Baldwin and "Roger Fenton and the Still-Life Tradition" by Pam Roberts in this volume.) Fenton hardly needed others to suggest subjects to him, but he was both intensely competitive and fully confident of his own abilities. He believed, as he remarked at a meeting of the Photographic Society in 1858, that works like Rejlander's stood at the beginning of a new era in which the "artistic application of photography" would be fully explored, and he wanted to be at the forefront of those investigations. ¹⁵⁹ In addition, he wanted his work to refute the mediocre results of his contemporaries, for he ardently believed that photographers could explore all the subjects treated by the other arts if they took the "same pains, in the conception of the subject and in the selection of suitable models." ¹⁶⁰

Toward the end of the decade, as Fenton moved from one project to another and one subject to the next, his life and work took on an almost frenetic quality. For an artist who thrived on challenges and who eagerly consumed all that was innovative, this must have been an exhilarating time. For a forty-year-old father of several young children, it must also have been an exhausting and stressful one.

1860-1869

These are not slow times. Photography is the type of the age, it won't wait.

—Anonymous, 1861¹⁶¹

Early in the summer of 1860, at the height of his photographic career, Fenton created two of his most audaciously modern photographs: *The Queen's Target* and *The Long Walk* (pls. 85, 82). Made within weeks or perhaps even days of each other, both were part of series of photographs, one documenting the inaugural meeting of the National Rifle Association at Wimbledon on July 7, the other portraying Windsor Castle and its grounds. Both photographs grew out of his fascination with exploring new compositional strategies and had roots in his earlier work, including the still lifes and stereo views. Both were most likely spontaneous inventions that resulted from their maker's restless probing deep into his chosen subject. Both were of subjects there for any other photographer to record, but no other portrayed them as Fenton had, and none would for decades to come. Both were unprecedented in their radical reconfiguration of pictorial space and daringly simplified compositions. And both are among Fenton's last works.

An overwhelming sadness pervades Fenton's personal and professional life in the early 1860s. Only a few days after he made *The Queen's Target* he was called to testify before the House of Commons Select Committee on the South Kensington Museum, which was investigating the decision to appropriate his negatives, make prints, and sell them. Speaking on Fenton's behalf, John Scott, a partner in the Colnaghi firm, maintained that the government was interfering with private enterprise and that Fenton had "given up all the higher branches of photography, as he finds he cannot compete with the Government Department." In his testimony Fenton repeatedly and categorically asserted that the government's actions adversely affected the price of all photographs and were "injurious to the profession." Perhaps trying lightness to relieve the tension of an acutely embarrassing situation, he suggested that while the government might "start establishments for selling boots and hats and everything in the same way, . . . at present it savours a little of communism." 164

If Fenton found it hard to keep up with the changing practice of photography in the late 1850s, by the early 1860s he was entirely stymied. Armchair travelers not only bought hundreds of thousands of stereoscopic

photographs of every imaginable subject but also voraciously consumed carte-de-visite portraits, especially of celebrities; John Mayall, for example, sold sixty thousand copies of his album of carte-de-visite portraits of the royal family. 165 As a result of this proliferation, prices for all photographs plummeted, and Fenton, like many others, simply could not remain competitive. In 1860 he was selling his photographs for twelve shillings apiece, while the carte-de-visite operator sold his for a few pence. But price was not the only issue. The glut of crude photographic images profoundly changed the public's perception of photography and did away with the respect the photographer had once commanded. "Our streets and thoroughfares are thronged with pictorial display, exhibiting every abortion of art, in the shape of hard, harsh, crude, unsightly representations, void of all natural grace or artificial elegance, destitute of all . . . artistic attributes," one photographer lamented in the late 1850s. Many carte-de-visite operators called themselves "fine art photographers," he pointed out, but "that this is not 'art' requires no argument; and that such 'artists' . . . are not worthy of taking rank amidst educated professional artists, can be understood without further explanation." ¹⁶⁶ But while many photographers keenly perceived the differences between the educated professional artist and the hack commercial practitioner, the public did not. In 1862 the organizing committee for the International Exhibition in London announced its plans to place photography, not with the other fine arts as had been done in the Manchester Art Treasures Exhibition only five years earlier, but in the section reserved for machinery, tools, and instruments. 167 For Fenton and many of his colleagues, this was conclusive proof of photography's diminished status. The French photographer Nadar recollected many years later, "You had to either succumb—that is to say, follow the trend—or resign." ¹⁶⁸ Profoundly discouraged, a number of photographers with whom Fenton had worked so closely did resign, abandoning the field they loved: Delamotte, Lake Price, and Newton, for example, stopped photographing in the early 1860s, while Le Gray, Fenton's hero, moved to Egypt.

Battered by the market and the public's growing disdain for photography, Fenton did not fare much better in the photographic press. Although some reviewers continued to praise his work, growing numbers of others were looking for novelty and had tired of his offerings. Fenton's subjects were "uninteresting"; 169 his Orientalist studies were inadequate because he had not

Fig. 18. John Eastham "of Manchester" (English, fl. 1850–60s), *Roger Fenton*, ca. 1865. Albumen silver print, carte de visite, 9 x 5.6 cm (3%₁₆ x 2%₁₆ in.). Private collection

employed "real national types as models" and had even used string to hold up the hands of a female figure; 170 one of his remarkable still-life photographs was called a mere copy of a painting and "not attractive as a picture, from the absence of colour, which constitutes the sole beauty of such paintings." In 1860 the *Photographic Journal*—the publication of the Photographic Society and an organ Fenton had helped create—ranked his photographs fourth in "claims to excellence," behind works by Lyndon Smith, James Mudd, and Maxwell Lyte, all relative newcomers to the field. 172 Even the quality of his prints was criticized. 173

More distressing still for Fenton was the diminished authority of the Photographic Society in the early 1860s. Its exhibitions were routinely criti-

cized for their lack of novelty—"no one curious or amazing work," "no striking advances." At the same time they were excoriated for commercialization, especially "the very objectionable" practice of "putting in their catalogue the prices at which the photographs are to be sold." The society itself had "failed in every way" in its mission to promote the art and science of photography.¹⁷⁵ It was seen as ineffective and outmoded, and as not having fulfilled the need many photographers felt "to investigate scientifically and fairly the merits of the various novelties in photography." ¹⁷⁶ Fenton was acutely aware of these criticisms. The government would never have appropriated his British Museum negatives, he told the House committee investigating that situation, if the Photographic Society "were a more powerful body."177 Indeed, Fenton's leadership as vice president of the organization was also under attack. One member accused Fenton of running "the most dreary meetings" and likened his management to a "heavy, lumbering" ceremonial coach "fit only to go at a slow pace." But, he continued, "These are not slow times. Photography is the type of the age, it won't wait."¹⁷⁸

Just at the moment when the practice and profession of photography were racing past Fenton to a place where he categorically did not want to go, his own family imploded. His only son, Anthony Maynard, just a little over fifteen months old, died on April 24, 1860, the third of his six children to die. Even in the nineteenth century this was a high number of children to lose, especially for a family of comfortable means. Grief-stricken, Fenton may have suffered additionally because he had spent long periods away from his family in the previous decade, photographing in Russia, the Crimea, and the British Isles. He was acutely aware of the price that the families of artists, especially photographers, paid for their loved ones' almost fanatic devotion to the medium. A sobering example had been that of Frederick Scott Archer. After his death in 1857 left his family destitute, his widow wrote to his friends in the Photographic Society that "his health failing, he could not help regretting the time he had spent in mere experiments, instead of making exertions to provide for the wants of his family." ¹⁷⁹ Fenton had been one of the organizers of a fund to provide an annuity to the widow and her children; in May 1860, only a few days after his son's death, he made a further contribution to it of fifty prints. 180

As his career ground slowly to a halt, Fenton showed in only one exhibition in 1860, whereas in 1859 he had exhibited in six. In December 1860, having served his term, he retired as senior vice president of the Photographic Society.

In 1861 he participated in two exhibitions but by August had stopped attending meetings of the Photographic Society Council. In December of that year, the family mill at Hooley Bridge, which had helped support his comfortable lifestyle, closed—a victim both of the American Civil War, which prevented cotton from reaching England, and of a family feud. Providing "the best illustration of Dickens' 'Bleak House,'" as one journalist wrote many years later, it never reopened, "swallowed up by that insatiable monster the law." ¹⁸¹ The death of Prince Albert on December 14, 1861, marked the end not only of the "new starting point" the prince had envisioned for English society, technology, and art but also of the new starting point Fenton had envisioned for photography.

In October 1862 Fenton announced his retirement from the profession of photography. To remove "all that might be a temptation to revert to past occupations," he sold all of his equipment and negatives. Although the negatives were described as badly blistered, Francis Frith bought many of them and for the next several years made prints from them that were competent but cold and mechanical. Fenton returned to the law and in 1863 was named counsel for the Northern Circuit, where he served as barrister for the courts in Manchester, Salford, and York counties. After an illness of only six days he died at his home, Mount Grace, in Potter's Bar, north of London, on August 9, 1869, at the age of fifty.

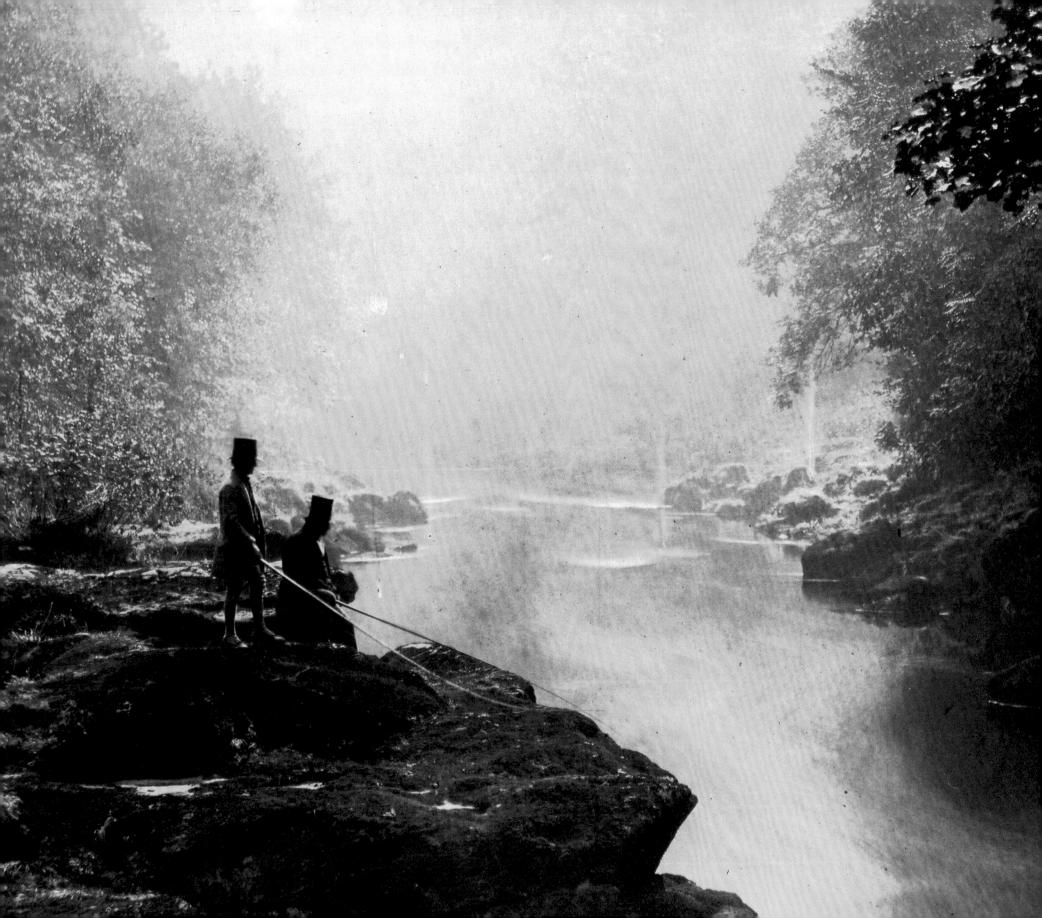

"On Nature's Invitation Do I Come": Roger Fenton's Landscapes

MALCOLM DANIEL

It is all one garden.—William Howitt, 1840 1

hat the English have a unique relationship with their land is evident to anyone who has walked the countryside. Footpaths worn into the terrain since ancient times were plotted on maps and detailed in walking guides long ago. Traversing public and private lands alike, they are guaranteed as public-access pathways by law and custom. "Every inch of English ground," wrote William Howitt in 1840, "is sanctified by noble deeds, and intellectual renown." In America the great landscape photographers of the nineteenth century recorded a virgin landscape of immense proportion, a new Eden in Yosemite and a new Wilderness in the vast deserts of the Southwest. By contrast, every field, forest, lake, and moor in England had been managed, if not entirely transformed, by generation upon generation for farming, hunting and fishing, urban and industrial expansion, and even aesthetic delight. Still today, roads follow the course of those built by the Romans; fields are enclosed by seemingly endless stone walls built centuries ago or by hedgerows just as old; tracts of land continue to be assembled into vast estates and, often, parceled out once more; woods and streams are maintained as they have been since time immemorial by those who inherited or purchased the right to hunt or fish in them. In art and poetry, the very notions of the sublime and the picturesque are practically English inventions,³ born, it would seem, from an innate understanding of the landscape as a player upon the emotions, a mirror of the soul, a stimulus to the intellect, and a delight to the eye.

Opposite: Fig. 19. Roger Fenton, Wharfe and Pool, Below the Strid (detail), 1854; see pl. 13

It is not surprising that Roger Fenton, who excelled in every other genre of photography, turned his talent and his lens toward the landscape with equal success. Earlier in the nineteenth century, as the best French painters were tackling literary and historical themes, the greatest British artists took the observable world as their subject—the shape of the hills, the course of a stream, the rhythms of rural life, the changing effects of weather, the mutability of light and atmosphere. Any British photographer seeking, as Fenton so explicitly did, to raise his craft to the level of art would have understood the position that landscape held in the hierarchy of artistic genres. No greater compliment could be paid than that bestowed on Fenton by the *Journal of the Photographic Society* in 1858: "He seems to be to photography what Turner was to painting—our greatest landscape photographer." 5

It was partly the very lack of purpose aside from expression and visual delight, that set landscape so squarely in the artistic realm. This applies even to Fenton's first extended series of photographs, made in Russia in 1852. A few of his views along the banks of the Dnieper (pl. 7), for instance, in which distant architecture plays the most minor of roles, appear to be purely artistic essays. These contrast with the informative but relatively uninteresting views of the bridge construction that were the raison d'être for his trip to Russia⁶ and also with the photographs of onion-domed churches, Kremlin walls, and town views of Kiev, which would have found a natural audience and marketability among armchair travelers (pls. 2–6).

Fenton, who seemed intent on exploring every aspect of the new medium's potential, pursued landscape throughout his career, without limiting himself to a single place or type of picture. His work in this genre was principally carried out in half a dozen major campaigns: in 1852 in and around Gloucestershire and South Wales, including Tewkesbury, Cheltenham, Tintern, and the Usk River valley; in 1854 in Yorkshire, including the countryside near the ruined abbeys of Rievaulx, Fountains, and Bolton, particularly along the Wharfe River; in 1856 in northern England and Scotland during a trip to Balmoral, including views on the Dee, Feugh, and Clunie; in 1857 in North Wales, including the valleys of the Conway, Llugwy, Lledr, and Machno; in 1859 along the Ribble and Hodder rivers, near Stonyhurst in Lancashire; and in 1860 in the Lake District. Landscapes also constitute a small portion of campaigns the main purpose of which lay elsewhere: river scenes in Russia in the autumn of 1852; battlefield, camp, and harbor views in the Crimea in 1855; and contextual views of stately homes and castles such as Harewood, Wollaton, and Windsor.

The Great Exhibition of the Works of Industry of All Nations—the 1851 world's fair held in the Crystal Palace, London—provided the impetus for Fenton to take up the camera, as it did for numerous other British photographers. Its exhibition of French photographs, in particular, showed what paper photography was capable of when unencumbered by patent restrictions and practiced by talented and ambitious artists. In October of that year, Fenton traveled to Paris and visited the meeting rooms, gallery, and darkrooms of the Société Héliographique; tried his hand at collodion-on-glass negatives with the society's president, Baron Benito de Montfort; met with Gustave Le Gray and examined the several hundred photographs he and Auguste Mestral had just produced in the Loire Valley, Dordogne, and Auvergne; and learned the waxed-paper-negative process, a French variation on William Henry Fox Talbot's calotype. Thus, as he set out to make his first photographs in early 1852, Fenton's technical formation (as, in part, his aesthetic formation as a painter) was French. His earliest pictures look to French examples at least as much as to English, few of which he would have had the opportunity to see. But he was quick to apply his newly learned skills to English subjects.

As with so many gentleman amateur photographers, Fenton began with what was closest at hand. His earliest extant firmly dated photographs, preserved in an album assembled by the French photographer Paul Jeuffrain and now in the collection of the Société Française de Photographie, Paris, include two views of Regent's Park, just steps from his Albert Terrace home,

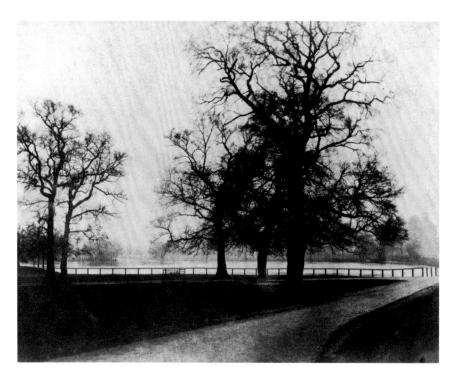

Fig. 20. Roger Fenton, *Regent's Park*, February 18, 1852. Salted paper print from paper negative, 16 x 20 cm ($6\frac{5}{16}$ x $7\frac{7}{8}$ in.). From the Paul Jeuffrain album, p. 25. Société Française de Photographie, Paris

taken on Wednesday, February 18, 1852. As first trials they are extraordinary, using to fine advantage the tendency of paper negatives and salted paper prints to exaggerate contrasts of light and dark and to dissolve details in a fibrous web of photographic tone. Although modest in scale (roughly 6½ x 8½ inches, closer to the size of Talbot's prints than Le Gray's), both are sophisticated in composition and admirable in technique. One is a view down a dark, tree-lined expanse of water, with a white suspension bridge reaching straight across the picture from edge to edge. In the other (fig. 20), a light patch of water stretches across the picture, much as the footbridge does in the first, and the bare branches of trees, silhouetted against the sky, spread out even beyond the picture's top edge.

Soon Fenton was searching farther afield for worthy subjects. Perhaps looking at French models to chart a parallel English course for his own work, he found a perfect counterpart to the Forest of Fontainebleau, south of Paris, where as early as 1849 his friend Le Gray had made some of his most

compelling landscapes. The Burnham Beeches, an ancient stand of pollarded trees celebrated by artists and poets, lay northwest of Windsor, within easy reach of London. Although Fenton exhibited as many as a half-dozen different pictures entitled *Burnham Beeches* between 1853 and 1855, none can now be identified with certainty.¹⁰

Fenton's photographs of 1852–53 rarely exceeded 7 x 9 inches, and many if not most—may have been made for viewing in a Wheatstone reflecting stereoscope. Designed by Charles Wheatstone in 1833 (i.e., even before photography), this device employed two nearly identical views made from slightly different positions in order to simulate binocular vision. A few of Fenton's photographs in the Regent's Park zoo and many of his Russian scenes were certainly intended to be viewed stereoscopically.¹¹ When they are, these early pictures shed their modest scale and take on a kind of virtual reality as the device blocks out all references to space and scale except those in the picture itself. The same powerful illusion of depth and three-dimensionality was later achieved with the smaller, classic stereoscopic cards, each of their paired images barely three inches square, meant for viewing in the handheld stereoscope first designed by Sir David Brewster. Thus, it is not surprising that Fenton would return to stereoscopy in the late 1850s, when it had reached the level of a fad, with contributions to the Stereoscopic Magazine and independently issued series on North Wales and Stonyhurst. Yet, despite the appeal of the viewing experience and the satisfaction that photographers must have felt at combining two remarkable new optical systems (photography and stereoscopy), the act of viewing photographs in a stereoscope effectively moved them from the realm of art into that of the optical toy or parlor entertainment. If Fenton intended to advocate a place for photographs alongside watercolors, prints, and paintings, his works would have to hold their own on the salon walls, and that is what he set out to do.

YORKSHIRE, 1854

It is just the sort of valley where one could live and die in peace with all men; thanking God from the beginning to the end of the chapter, that he made so beautiful a world for his dear creatures. The poet, the artist, the searcher-general after the picturesque could not hope for richer enjoyment than that which these woods and landscapes afford.

—The Scenery of the Wharf, 1855¹²

With his series of photographs made in Yorkshire in 1854, Fenton rose to a new level of ambition. Perhaps the relatively mundane (but lucrative) task of photographing objects at the British Museum, which he began in February of that year, gave Fenton the means, experience, and confidence to try working in the field with glass negatives and to employ a significantly larger camera than he had previously used when traveling. His work at the British Museum may also have instilled in him a new sense of professionalism that compelled him to leave behind the intimate scale, calotype negatives, and quaint subjects (in his words, "the peaceful village; the unassuming church")¹³ favored by amateur photographers and move to the ambitious technique and artistically complex style that would characterize the remainder of his career.

Fenton's trip to the ruined abbeys and churches of Yorkshire was as much about landscape as about architecture. Remains such as those of the vast complexes at Rievaulx, Fountains, and Bolton were quintessential elements of picturesque Romantic landscapes, suggesting the inexorable passage of time and the power of nature to reclaim the most noble creations of humanity. Diderot expressed the idea eloquently: "The ideas ruins evoke in me are grand. Everything comes to nothing, everything perishes, everything passes, only the world remains, only time endures. . . . I walk between two eternities." 14

Fenton was surely first drawn to Bolton Abbey by the ruins of the twelfth-century Augustinian priory nestled in a bend of the river, "one of the most delicious and paradisiacal scenes which the heart of England holds," according to a writer of the period, with "the gables and pinnacles of the Priory, appearing amongst a wilderness of trees in the open bosom of the valley."15 But finding the surrounding scenery to be an essential element in his experience of the ruins, as well as a compelling subject in itself, he naturally integrated architectural and landscape compositions in a single series sharing a common spirit (fig. 21). Although we, as modern viewers, may make a division between landscape and architecture, for Fenton they formed a seamless continuum. One need only read the titles of his photographs to follow Fenton's footsteps and thought process down the wooded path along the river's edge: Bolton Abbey; Bolton Abbey, Bridge on the Wharfe; Entrance to the Woods, Bolton Abbey; Valley of the Wharfe; Bend of the River; Opening in the Woods; Wharfe and Pool, Below the Strid; The Strid. The Bolton countryside, "surpassed by that of few places for softness and beauty in the valley or grandeur and extent on the fells," 16 was famed for its history and visual delight.

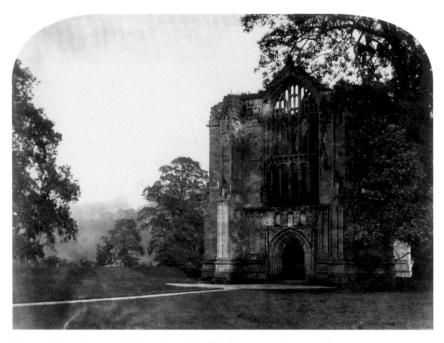

Fig. 21. Roger Fenton, *Bolton Abbey, West Window*, 1854. Albumen silver print, 25 x 33 cm (9^{13} /₁₆ x 13 in.). The RPS Collection at the National Museum of Photography, Film & Television, Bradford, 2003–5000/3054

The woods were owned by the Duke of Devonshire and were frequented, with his permission, by many a nature-loving tourist. As untouched as the woods and streams might appear in Fenton's photographs, the path he strode had been carefully opened up by a local clergyman and orchestrated to give picturesque vistas of Bolton Abbey downstream and Barden Tower upstream.

Visitors were drawn to Bolton by its natural beauty but also by its associations with William Wordsworth's historical ballad "The White Doe of Rylstone" (1807), the bloody tale of a Catholic rebel and his sons, all killed in a revolt against Queen Elizabeth, and of the comfort that the rebel's one surviving daughter found in the return of a white doe that she had bred in earlier, happier days. Such literary and historical associations had a powerful effect on the Victorian imagination and understanding of landscape, much as an otherwise unassuming field in Virginia, Maryland, or Pennsylvania may move a modern American viewer to tears if identified as the site of the Battle of Fredericksburg, Antietam, or Gettysburg. That the history of a place had been filtered through the work of the nation's greatest Romantic poet (or

painter or photographer) only intensified its impact on a contemporary Victorian visitor or viewer.

Some two miles upstream from the priory ruins, where the river hurries through a deep, narrow passage with such force that it "boils and foams," ¹⁷ Fenton made one of his finest landscapes, *Wharfe and Pool, Below the Strid* (pl. 13). *Black's Picturesque Guide to Yorkshire* provides a vivid description that explains the curious title of Fenton's photograph:

The Strid... receives its name from the ledges of rock by which the torrent is hemmed in, being here so near to each other that it is easy to stride across... Either side of the Wharfe... is overhung by solemn woods, from which huge perpendicular masses of grey rock jut out at intervals... Here a tributary stream rushes from a waterfall, and bursts through a woody glen to mingle its waters with the Wharfe; there the Wharfe itself is nearly lost in a deep cleft in the rock, ... the Strid, into which the impetuous waters of the stream are hurled with a deep and solemn roar, like "the voice of the angry Spirit of the Waters," heard far above and beneath, amidst the silence of the surrounding woods. 18

That the word "picturesque" appears in the title of Black's guide is no accident, for the book clearly capitalized on the vogue for picturesque travel—literally, the seeking out of scenes that would make good subjects for painting—that had first been articulated in the late eighteenth century by William Gilpin in writings such as *On Picturesque Beauty* and *On Picturesque Travel* (both 1792). Fenton's Wharfedale landscapes—from the rough outlines of the ruined abbey walls amid the trees to the jagged rocks, silhouetted overhanging branches, and strong contrasts of tone seen in *Wharfe and Pool*, *Below the Strid*—fit squarely within the precepts that, Gilpin explains, elevate a scene from the merely beautiful to the picturesque.

Taken "without permission, from Nature," ¹⁹ as an advertisement, tongue in cheek, described Fenton's series of views made in this area, *Wharfe and Pool, Below the Strid* is a stunningly innovative composition. Perched on one of the rocks that form the Strid, Fenton looked downstream to the frothing waters and swirling foam in the pool below. Fishermen in gaiters, or "spatterdashes," frock coats, and top hats—gentlemen enjoying recreation, no doubt—cast their lines from either side of the pool, some almost lost in the

shadows. Daring to point his camera into the light (a move that contradicted the rules of common practice) Fenton brought the rushing water, mist, sky, and sunlight together, creating an effect of atmosphere that naturally calls to mind the paintings J. M. W. Turner made a half-century earlier. No educated Englishman in the 1850s, no photographer, and certainly no one trained as a painter could have been unaware of Turner's radical approach to the depiction of light and atmosphere and the extent to which the artist had raised the stature of landscape among the genres of painting. While it seems unlikely that Fenton would have consciously set out to imitate Turner's effects, it is easy to imagine that he had naturally internalized them as part of the aesthetic sensibility that guided his picture making.

This particular spot would have also called to Fenton's mind and to that of his public another poem by Wordsworth, "The Force of Prayer; or, The Founding of Bolton Priory. A Tradition" (1807), which tells a story familiar to all who visited the Strid. Romilly, the only son of a young widow, runs with his dog to the Strid, where he had jumped across the pent-up river a hundred times before:

He sprang in glee,—for what cared he
That the river was strong, and the rocks were steep?—
But the greyhound in the leash hung back,
And checked him in his leap.

The Boy is in the arms of Wharf, And strangled by a merciless force; For never more was young Romilly seen Till he rose a lifeless corse.

The Wharfe—here, nature herself—takes with one hand that which is most precious to Romilly's mother but with the other becomes a portion of her reverence and divine comfort:

Long, long in darkness did she sit,
And her first words were, "Let there be
In Bolton, on the field of Wharf,
A stately Priory!"

The stately Priory was reared; And Wharf, as he moved along, To matins joined a mournful voice, Nor failed at evensong.

With their unavoidable connection to Wordworth's poem, the Wharfe and Strid, like the ruins of Bolton Abbey, become a reminder of the transience of human life in the face of nature's eternity and sublimity.

While the greatest impact of the 1854 campaign was to launch Fenton's long exploration of the expressive and emotional potential of landscape, the trip also provided an opportunity to test his new darkroom on wheels, a specially outfitted van designed to be a light-tight space for preparing negatives in the field. In fact, the test run probably gave little foretaste of the extreme conditions he would face in the theater of war the next summer.

Fenton made powerfully expressive landscapes in the Crimea, works that are fully as poignant as his portraits of weary officers and shell-shocked soldiers. The utter, heartbreaking desolation of *Sebastopol from Cathcart's Hill* (pl. 20) or *Valley of the Shadow of Death* (pl. 21) and the immense suffering and death these vistas represent place them among Fenton's most evocative and affecting photographs. Nonetheless, they fall outside the mainstream of his landscape work. Whereas the Yorkshire views were artistic studies enriched by historical connections, the Crimean landscapes were the opposite: essentially historical works enhanced by Fenton's artistry. His primary mission in the Crimea, however beautiful or moving the results, was far different from his steady goal of placing photography alongside the established fine arts.

SCOTLAND, 1856

It is worth a journey from any part of Great Britain to the Metropolis, to see so superb a collection of artistic photographs, and to learn how much photography can really accomplish.

—Photographic Notes, 1856²⁰

Only in the early autumn of 1856, having played out the commercial possibilities of his Crimean series, did Fenton turn once more to the fertile landscapes

Fig. 22. Roger Fenton, Loch Nagar from Craig Gowan, 1856. Salted paper print, 23.5 x 27.9 cm (9½ x 11 in.). Royal Collection © 2004, Her Majesty Queen Elizabeth II, RCIN 2160039

of Britain, traveling through Yorkshire again and on to the Scottish Highlands, presumably on a commission to photograph the royal family at their newly completed castle at Balmoral. Along the way north and near Balmoral, on the Dee, the Feugh, and the Clunie, Fenton resumed the exploration of light and atmosphere that had been so much a part of his Wharfedale landscapes of 1854. His *Windings of the Dee* and *Reach of the Dee*, both taken on the river that runs alongside Balmoral Castle, were lauded as "great triumphs" and praised for "their wide stretch of sight and thought" by the *Journal of the Photographic Society*. "For miles away you see the river," continued the review, "wandering at its own sweet will,' passing and everpresent; its silver current washes and topples below crops and meadows." A particularly beautiful salted paper print not exhibited or commented on by the press but included in an album related to Balmoral Castle, *Loch Nagar from Craig Gowan* (fig. 22),

shows the mountains that overlook the Dee and the royal residence. It is a study in atmospheric perspective; detail is suppressed, with the hills shown nearly in silhouette and the taller, more distant peaks shrouded by clouds and mist.

The natural rendering of skies presented a difficult technical problem for Fenton, as it did for all photographers of the period. Since photographic chemistry was not equally sensitive to all colors of the spectrum, a negative properly exposed for the landscape left the sky far overexposed. Most photographers found it best simply to paint out the sky on their negatives, preferring to replace the slightly mottled, seemingly dirty atmosphere with one that was perfectly blank and might consequently read on the print as bright and sunlit. While Fenton too ultimately left blank the majority of his skies, whether in architectural or landscape compositions, he was beginning to

explore the problems and potential of rendering skies naturally at just this moment, in works such as *Loch Nagar*. As early as March 1854 he reported to the Photographic Society that he had "succeeded in obtaining instantaneous pictures, with clouds, moving water, &c., with a single lens," referring to his photographs of the fleet departing for the Baltic Sea a few days earlier.²² But it was in 1856 that he began to tackle skies as an aesthetic rather than a merely technical issue.

At the 1856 Exposition Universelle de Photographie in Brussels, where the English landscapes were described as having "a character quite peculiar to themselves," Fenton was praised especially for his photographs of Rievaulx Abbey, Hampton Court Palace, and "several proofs, in which the clouds are taken at the same time with the landscape."23 Reviewing the exhibition of the Norwich Photographic Society, the critic for the Norfolk News wrote, "Pictures in which the clouds and landscape are taken simultaneously are the best upon the whole, but even here the landscape is apt to be heavy in consequence of under exposure." He continued, however, that "Mr. Roger Fenton's 'Hampton Court' is, perhaps, the finest picture of this kind which has yet been done, and may be as fine as the art, in its present state, is capable of producing."24 And at the exhibition of the Photographic Society of Scotland, in Edinburgh that December, Fenton exhibited several works that, to judge by their titles—Clouds after Rain and Evening—made atmospheric effects their principal subject. 25 Thomas Sutton, editor of *Photographic Notes*, commented, "In this superb series of views, principally from the romantic scenery of Scotland and Yorkshire, will be found many in which Mr. Fenton has surpassed the best of his former works. There are marvellous natural skies and distances, effects of rain and haze, foliage and water, rugged rocks, mountain passes, glens, waterfalls and ruins deliciously rendered. . . . Further than this, the art of Photography cannot possibly be carried."²⁶

Fenton's experimentation coincided precisely with that of his friend Le Gray, who had just produced the first of a series of seascapes that would create an enormous stir on both sides of the Channel. In 1857, in works such as *The Great Wave*, Le Gray would famously solve the exposure problem by printing his seascapes from two negatives—one exposed properly for the shore and sea, the second for the sky—but his first published essay, made with a single negative, succeeded by taking advantage of the reflective qualities of water and by suggesting the effects of twilight or moonlight rather

than bright daylight.²⁷ This work, *Brig on the Water* (fig. 23), became one of the most famous and widely distributed photographs of the nineteenth century and enjoyed enormous success in England. Although *Sea and Sky*, as it was often called, was not exhibited publicly until the Norwich Photographic Society exhibition opened on November 17, 1856, an advertisement in the *Times* just ten days later made the incredible claim of "800 copies subscribed for in two months,"²⁸ suggesting that the work had been widely seen since at least late September. Given the previous contact between Le Gray and Fenton, it is quite possible that Fenton knew of, or even saw, Le Gray's marines before leaving for Scotland and may have been spurred by them to further his earlier efforts.

Two cloud studies that are among Fenton's most moving landscapes likely date to this moment and may, in fact, be the *Clouds after Rain* or *Evening* shown at the Edinburgh exhibition.²⁹ While Le Gray's seascapes were grand theater, Fenton took a different course in two of his compositions, each known only in a unique print from the "gray albums" (pls. 22, 23).³⁰ Unlike

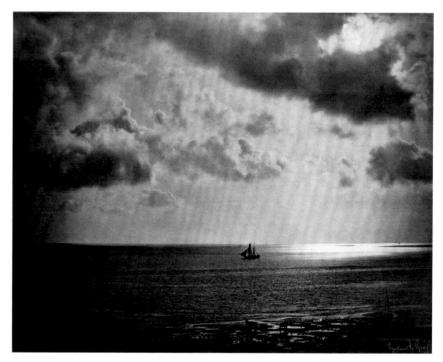

Fig. 23. Gustave Le Gray (French, 1820–1884), *Brig on the Water*, 1856. Albumen silver print, 32.1 x 40.5 cm ($12\frac{5}{8}$ x $15\frac{15}{16}$ in.). The Metropolitan Museum of Art, New York, Gift of A. Hyatt Mayor, 1976 (1976.645.1)

Fig. 24. Roger Fenton, *September Clouds*, probably 1856. Albumen silver print, 20.6 x 28.7 cm ($8\frac{1}{16}$ in.). The RPS Collection at the National Museum of Photography, Film & Television, Bradford, 2003–5000/3144/1

Le Gray's Great Wave and other dramatic seascapes, with their theatrical sleights of hand, Fenton's cloudscapes appear to be private meditations upon nature, intensely felt, printed once, and kept in his personal albums. If indeed these were the images shown in Edinburgh, they received little attention and seem to have had no commercial life, in marked contrast to Le Gray's. Perhaps they were viewed as technical failures rather than poetic successes. Regardless, they are now counted among his most romantic creations. Fenton used a single negative, exposed for the sky, letting the land go dark; he pushed the surface of man's world—silhouetted trees, barely visible grazing sheep, distant hills and horizon—to the bottom edge of his composition and filled the page with a dreamlike sea of sky with waves of clouds stretching to infinite distance. As with other prints from the "gray albums," neither of the proofs is formally mounted, retouched, or signed, but Fenton's care is evident nonetheless: one of the prints is trimmed at the top in a gentle curve, suggesting the roundness of the earth or the dome of the heavens. If it is impossible to pinpoint precisely when and where the "gray album" cloudscapes were made, it is of little consequence, for these are not mere topographic records but rather expressions of man's spiritual connection to nature. Minimal and awesome, they seem to hover between the imagined and

Fig. 25. John Constable (English, 1776–1837), Cloud Study, July 4, 1822. Oil on paper mounted on canvas, $32.1 \times 49.5 \text{ cm} (12\frac{5}{8} \times 19\frac{1}{4} \text{ in.})$. Private collection

the observed, recalling Wordsworth's love "of all the mighty world / Of eye and ear, both what they half-create, / And what perceive." ³¹

A closely related if somewhat smaller picture, *September Clouds* (fig. 24), was not presented until the 1860 exhibition of the Photographic Society in London, where it drew extensive comment. The moment of taking it was well chosen, wrote the reviewer for the *Photographic News*, and the print is a very interesting one, and would form an excellent guide to a painter. Nothing could surpass the delicacy with which the lights and shadows are given, which is especially evident in the mass of cumulus which fills the centre of the picture, the white, fleecy appearance of the edges illuminated by the sun contrasting admirably with the dark, sombre appearance of the denser portion of the cloud."

In suggesting that *September Clouds* might serve as a model to painters, the critic of the *Photographic News* undoubtedly had in mind the many water-colors and oil sketches produced by Turner, Alexander Cozens, and a host of other late-eighteenth- and early-nineteenth-century landscape artists who found in the British sky not only a visual circus of changing forms, light, and shadow but also a vehicle for the expression of emotions. John Constable, for instance, famously wrote that skies were the "chief organ of sentiment" in

landscape painting,³⁴ and it is perhaps this notion—rarer in photography than in painting—that Fenton pursued in his cloud studies. Although unlikely to have been known by Fenton in the 1850s, Constable's oil sketches of the English sky above Hampstead Heath, painted *en plein air* in 1821–22 (fig. 25), are perhaps the closest parallel to the photographer's *September Clouds*. Such subjects were still very much in vogue among painters in Fenton's time, however; for example, a group of cloud studies was made in 1857 by David Cox, whose works Fenton would undoubtedly encounter during his trip to Wales, if he had not previously seen them in the annual exhibitions of the New Society of Painters in Water-Colours in London.³⁵

NORTH WALES, 1857

Wherein lies the main attraction of North Wales to the modern holiday tourist?

Unquestionably in its scenery.

—James Bridge Davidson, 1860³⁶

By 1857 Fenton could not have helped but notice that his preeminent stature in landscape photography was being challenged by others, most effectively by Francis Bedford (1816-1894). Bedford was already usurping Fenton's place as the photographer most frequently called upon by the royal family³⁷ and was increasingly paired with Fenton in exhibition reviews. Even as Fenton's Highland views—"grand and vast expanses of aerial perspective"—were being simultaneously damned and praised at the 1857 exhibition of the Photographic Society, Bedford's Welsh scenes were being celebrated as "approaching as nearly as possible to absolute perfection" and as outshining any of his former productions.³⁸ A photograph of Bettws-y-Coed, likely the image Bedford made in June 1856 and submitted to the Photographic Album for the Year 1857 (fig. 26), was signaled as one that "should be in the hands of every amateur as a specimen of the height to which it is possible for a truly artistic eye and perfect manipulation to bring this marvellous offspring of applied chemistry." Possibly feeling that the gauntlet had been thrown down before him—or perhaps, more benignly, inspired or enticed by Bedford's views or by the "beautiful specimens of scenes in North Wales, contributed by Messrs. Bent and Fitt," the "exquisite specimens of Welsh scenery" by Messrs. J. and R. Mudd, 40 or the "interesting and very pretty Welsh series, by G. Wardley,"41 all submitted to the

exhibition of the Manchester Photographic Society—Fenton set out for the same territory later that year, in the autumn of 1857.

There he found the subjects of some of his finest landscape photographs in the rocky streams, wooded hollows, and mountainous expanses that were fast becoming artistic haunts. "The characteristics of the sublime and beautiful in natural scenery must necessarily be dependent upon the geographical peculiarities of countries," wrote Thomas Roscoe in the 1853 edition of his famous guidebook, *Wanderings and Excursions in North Wales*, "but it rarely happens that in any one nation is combined such striking examples of both these pictorial elements as are to be found in Wales." Like so many other painters and photographers, Fenton made his home base the small village of Bettws-y-Coed (Chapel in the Wood). Still a center for hiking, angling, and sightseeing today, Bettws is nestled along the riverbank, where a noble fifteenth-century stone bridge, the Pont-y-Pair (Bridge of the Cauldron), crosses the Llugwy, "an impetuous little torrent." Its location was ideal.

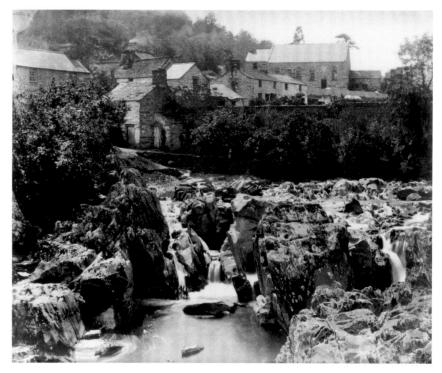

Fig. 26. Francis Bedford (English, 1816–1894), Pont-y-Pair at Bettws-y-Coed, 1856. Albumen silver print, 19.2 x 23.8 cm (7% x 9% in.). From The Photographic Album for the Year 1857 (London, 1857). The Metropolitan Museum of Art, New York, The Elisha Whittelsey Collection, The Elisha Whittelsey Fund, 1963 (63.606.1.5)

Within easy reach upstream were the Miner's Bridge and Swallow Falls, and ten minutes' walk downstream brought one to the point where the Llugwy's waters join the Conway. The confluences of the rugged Lledr and Machno rivers with the Conway were also close at hand, within an easy hike or carriage ride. Each of these rivers possessed myriad scenic spots—cataracts, trout pools, stone or wood bridges, and steep, lushly foliated cliffs.

The heart of North Wales—the valleys of the Conway, Lledr, and Llugwy—had been sparsely populated and relatively little visited by English travelers until the late eighteenth century, when a new road to Holyhead brought carriages journeying between London and Ireland. Still greater traffic came with the rebuilding of the Bettws-y-Coed section of the road and the opening of a bridge across the Conway in 1816.⁴⁴ But it was the rapturous descriptions and lavish illustrations of Roscoe's Wanderings, first published in 1836 and reissued with an expanded section on Bettws-y-Coed in 1844, that spurred the rush of British painters and watercolorists to the village. Roscoe's illustrator for the Bettws section, and perhaps his knowledgeable informant for the text, was David Cox, who first traveled through the area in 1805 and who summered there annually beginning in 1844, drawing around him a circle of aspiring and established landscapists. 45 Fenton himself owned a Welsh scene by Cox's son, David Jr., On the Lledr, as well as works by J. P. Jackson and Dr. MacKewan entitled Moel Siabod, from the Valley of the Lledr (1855) and The Last Leap of the Lledr respectively. 46 Welsh scenes by painters of the Bettws school dotted the annual salons of the Royal Academy and the New Society of Painters in Water-Colours. 47 As a former painter himself, and as one who sought to raise photography to the stature of painting, Fenton must surely have taken as active an interest in the work of these artists as in that of fellow photographers. By Fenton's time, this "yearly resort of the angler and the artist" was more popular than ever, and the painters' work, as much as nature's, accounted for the attraction: "The beauty of this situation, great as it is, would never have reached its present celebrity but for the productions of the artists who have made this place a rendezvous and camping-ground for years past."48

In Bettws-y-Coed, Fenton directly took up the challenge posed by Bedford's much-praised view of the cataract from the Pont-y-Pair (fig. 26). Adopting precisely the position described in Roscoe's guidebook—standing on a rock outcropping with his back against one pier of the old bridge—

Fenton gave form to Roscoe's words more accurately and vividly than even Cox's illustration on the page facing them: "I passed over Tthe Pont-y-Pair] to the opposite bank," wrote Roscoe, "and . . . took my station upon one of the rocky projections looking up the river. It was some time since any rain had fallen, and the stream was comparatively shallow, exposing the rude masses of granite that stood midway in the channel, and laying bare to their foundations the broad deep chasms which the rushing waters had formed in their headlong descent." Despite similarities, Fenton's picture (pl. 34) differs sharply in effect from Bedford's. Bedford had set up his camera on the bridge itself, framing his picture so as to balance almost evenly the natural and the man-made: the boulder-strewn river and falls below, the stone construction of buildings and retaining walls above. By positioning himself below the level of the upstream river, Fenton immersed himself more deeply in the natural elements, intensifying the experience of the falls (which, as when Roscoe visited, were far from being at full force). The dynamic structure of Fenton's composition—zigzagging bands of water, rock, vegetation, and sky—is noteworthy, too. The village buildings are hinted at but are given far less play than the dramatic natural setting. Finally, the strong tonal range and large scale of Fenton's print—roughly 14 x 17 inches, compared with Bedford's modest 7\% x 9\% inches—give the picture an overwhelming presence, rivaling the size and impact of local artists' watercolors. Few photographers of his day worked on such a scale.

On his travels through North Wales, Fenton carried not only his large-format camera but also a small stereoscopic camera, and at many sites he photographed with both. The stereographs lack the beauty, scale, and immediate impact—what today we would call "wall power"—of the large prints, but when viewed in a stereoscope, they convey a forceful sense of what it was like to stand on the spot, as eye and mind merge the stereograph's two images into a single illusion of three-dimensional space. Beginning in May 1859 Fenton contributed to a new publication, the *Stereoscopic Magazine*, which was issued in parts, with written commentary accompanying each image.⁵⁰ This method of distributing his images must have appealed to him, for twenty of his Welsh stereographs were soon thereafter issued in a book by the same publisher, Lovell Reeve, with commentary by James Bridge Davidson.⁵¹ "The stereographs which form the illustrations of this volume," wrote Davidson in the introductory remarks to *The Conway in the Stereoscope*, "were taken by

Mr. R. Fenton at the same time, and frequently from the same point of view, as those larger pictures which attracted so much attention in the Photographic Society's Exhibition. . . . I determined . . . to follow in Mr. Fenton's footsteps and examine for myself the spots he had selected for the subjects of his art." Clearly, the venture relied upon Fenton's collaboration, and it is likely that the book's commentary reflects Fenton's own thoughts about the places visited (or at least those that were commonly held at the time) and thus provides as valuable a narrative as one might hope for, short of the artist's own words. Most of the descriptions accompanying the stereographs apply equally to their large-format cousins.

The old bridges of the area, where the time-honored tracks of man and nature cross, were among Fenton's most frequent subjects: not only the Pont-y-Pair but also the Pont-y-Lledr and Pont-y-Pant (pl. 36), both crossing the Lledr; the double bridge on the Machno (pl. 38); the bridge atop the Ogwen, or Benglog, Falls; and the Pont-y-Garth, near Capel Curig (pl. 32). It may seem curious at first that Fenton chose not to photograph Thomas Telford's Waterloo Bridge (1816), "an elegant structure of cast-iron, with an arch upwards of one hundred feet in the span, clasping the Conway from bank to bank,"53 or Telford's equally innovative chain suspension bridge at Conway Castle (1822-26); both were engineering landmarks and trophies of the Industrial Revolution's early days. By contrast, the humble Pont-y-Pant and Pont-y-Garth, "rude wooden bridges, resting on piers of loose stones," may seem hardly worth celebrating. But Davidson describes Telford's bridges as "great engineering works, not especially connected with Wales itself,"55 while these unassuming, picturesque structures were regarded as physical embodiments of the Welsh character. Like the inhabitants of North Wales, who were viewed by mid-nineteenth-century writers as emblematic of a disappearing, simpler, preindustrial country life free of the ills of modern urban existence, ⁵⁶ structures such as Pont-y-Pant evoked a lost time and pastoral life that Londoners could only long for. "Whilst . . . the old national spirit of the Welsh people is being gradually, and of late years increasingly absorbed, under the influence of neighbouring countries," reads the commentary accompanying Fenton's view of Pont-y-Pant in the Stereoscopic Magazine, "the bold and picturesque scenery amidst which this valley holds a conspicuous place, must always remain unchanged. There the unusual forms and sounds of nature still retain their hold upon the imagination."57

Made of local stone and timber, Pont-y-Pant (Bridge of the Hollow) is ancient, solid, and functional. It lies along the route of the Sarn-Helen, the Roman road running north-south through the area, and the spot probably traces its origins as a crossing point over the Lledr to that time. 58 "The first sight of this extraordinary structure, standing in an unexpected position, arrests the eye in a way that cannot be forgotten," wrote Davidson. 59 Five miles from Bettws alongside the route to Dolwyddelan, the bridge was easily reached even with Fenton's cumbersome equipment. In Pont-y-Pant, on the Lledr, from Below (pl. 36), Fenton's new van, replacing the earlier mobile darkroom left behind in the Crimea, is visible at the edge of a road that Roscoe described as having a "primeval character . . . carried forward amidst natural features the most wild and savage."60 And indeed the rigors of travel in such terrain—and of carrying out the manipulations required for largeformat wet plate photography under such conditions—ought not to be forgotten. It is not surprising, then, to find that once arrived and set up at such a spot, Fenton found several possible pictures. In addition to the photographs of the bridge itself from both upstream and downstream, each giving a good sense of the rude construction spanning the rocky torrent, he made several views from the bridge, looking down the gorge into the wide, fertile Lledr Valley (pl. 35). 1 In each, figures are present to give a sense of scale 2 and to tie the historic sites and structures to present-day experience.

Such scenes would also have provoked in Fenton's viewers a deeper, geological sense of time. Davidson repeatedly commented on the strata visible in Fenton's photographs of the rocky landscapes of Wales, and at Pont-y-Pant, despite the relatively low water at the time, he found that "the empty channel spoke of the presence, at former periods, of its active and irresistible forces." To survey the landscape (or, by extension, Fenton's photographs) and imagine the volcanic eruptions that had formed the granite; the earthquakes, glaciers, and torrents that had scattered boulders like children's blocks; and the eons that had since passed—all this was a relatively new and heady experience. Only in the late eighteenth and early nineteenth centuries did modern geological theories based on observation of the natural world gradually replace a religious cosmology that had imagined the world to be a mere few thousand years old. The rise of geology as a science did not negate the spiritual element of the landscape, however. By invoking the visible evidence of geological formation, Davidson surely hoped also to evoke thoughts of the sublime—of the

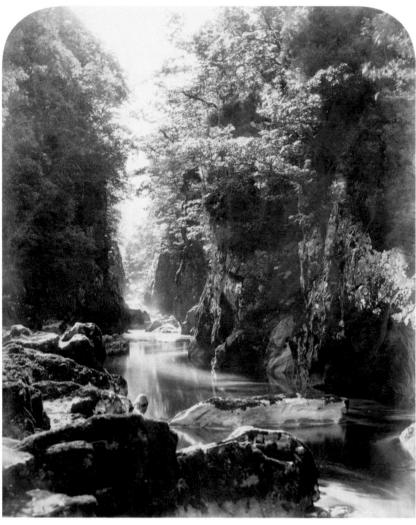

Fig. 27. Roger Fenton, Gorge of the Foss Nevin, on the Conway, 1857. Albumen silver print, 40.9 x 33.7 cm ($16\frac{1}{16}$ x $13\frac{1}{4}$ in.). The RPS Collection at the National Museum of Photography, Film & Television, Bradford, 2003–5000/3203

immeasurable scale and incomparable power of nature. Likewise, one cannot know whether Fenton took any interest in, or tried to illustrate some aspect of, the geological discussions of the period, or whether—more likely—he responded to the dramatic natural environment in a more directly aesthetic way, like the youthful Wordsworth, for whom the rocks, rivers, and woods of South Wales were "An appetite: a feeling and a love, / That had no need of a remoter charm, / By thought supplied, or any interest / Unborrowed from the eye." 65

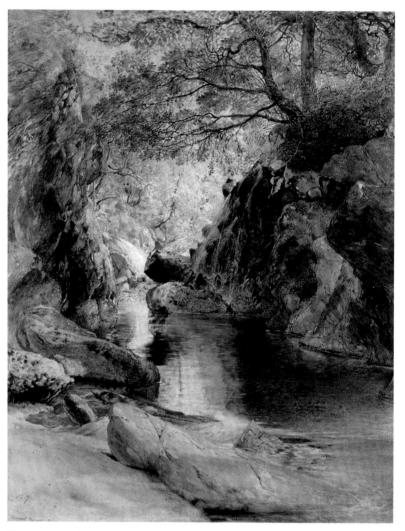

Fig. 28. Samuel Palmer (English, 1805–1881), A Cascade in Shadow, Drawn on the Spot, near the Junction of the Machno and Conway, North Wales, 1835 or 1836. Watercolor over graphite and brown ink, 46.4 x 37.5 cm (18¼ x 14¾ in.). Collection of Malcolm Wiener

At Foss Nevin, for instance, a spot popularly known then and now as the Fairy Glen, Davidson again wrote of nature's power.⁶⁶ But Fenton's photograph, *Gorge of the Foss Nevin, on the Conway* (fig. 27), is an irresistibly romantic composition depicting a spot frequented by artists before and after Fenton (fig. 28).⁶⁷ Unlike the roadside Pont-y-Pant, this narrow gorge is accessed with difficulty, and transporting his bulky photographic equipment must have presented Fenton with a far greater challenge than that faced by

watercolorists and sketchers. But the rewards were obvious. Here, as in many of his Welsh pictures, he explored the seductive potential of light and air, the "plus Turnerian atmospheres" praised in the Athenaeum. Davidson, perhaps prompted by the photographer himself, pointed out that "an hour has been chosen when the sun was shining directly down the chasm, illuminating its recesses and perpetuating their outlines imperishably in the camera" and took special note of the "dreamy effect of these warm, soft, intermingled and half absorbed lights, occupying every degree in a scale of which the dark hollows form the base, and the flashing water, grey rocks, and glancing oakleaves are the high points."

Similarly, "tender gradations of sky" and "delicate *nuances* of shade"⁷⁰ were praised in Fenton's more sweeping views of Moel Siabod rising in the distance above Dolwyddelan and the Lledr Valley (pl. 37) and in his dramatic vistas of the Nant Ffrancon Valley from the Ogwen Falls (pl. 31, fig. 29). Nant Ffrancon, in particular, presented a different type of landscape from the narrow, wooded gorges of the area around Bettws; here the deep green valley and rugged, barren crags—"beauty sleeping in the lap of horror"⁷¹—showed the majestic scale of nature. Roscoe found the Nant Ffrancon glen "savage and romantic" and sketched for the artist a scene that combined in one place all three principal concepts of landscape aesthetics. "The view presented itself full of picturesque grandeur and beauty . . . the narrow patch of green meadow overhung by lofty mountains; the bright river meandering towards the sea" (the beautiful and picturesque); "the waters of the lakes rushing down the steeps, with the distant prospect, and the gloomy horrors of the mountains far around me"⁷² (the sublime).

Again, Fenton made several images from essentially the same spot: at least three views looking down the valley (one vertical, two horizontal), two of the mountains above Llyn Ogwen, and one of the Ogwen Falls, though no stereoscopic images of this locale are known. The spot is a particularly pivotal one, where a large lake, towering mountains, precipitous falls, an ancient road, and an expansive valley pinwheel in every direction. Fenton may even have felt some frustration at trying to encompass all the elements within his frame. **The View from Ogwen Falls into Nant Ffrancon* (pl. 31) effectively conveys the rushing water at the viewer's feet, the sheer cliffs and plunging drop to the valley floor, and the soaring peaks in the distance; the horizontal variants (fig. 29) naturally emphasize the winding course of the Ogwen River, the

diminishing scale and aerial perspective of the receding hills, and the gradual descent of the roadway toward the valley floor.⁷⁴

What is nowhere seen in these photographs, and with one exception nowhere in the entirety of his Welsh series, is the reality of contemporary life. Interwoven with the picturesque and sublime scenes that Fenton experienced and captured was another Wales. At the far end of the Ogwen Valley, for example, two hundred tons of slate were extracted daily from the Cae Braich y Cafn quarries and sent by rail to Port Penrhyn, just north near Bangor. Roscoe, delighted by the employment that the slate trade brought to a relatively impoverished region, reported happily that "the startling blasts which occur every four or five minutes . . . carrying their sound like the voice of thunder into the deepest mountain recesses,—altogether make up a picture that seems raised by enchantment, especially when contrasted with the grim solitude around." Fenton's sole view of modern Wales shows the small pier at Trefriw (pl. 39), the southernmost navigable point on the Conway, where slate, hone-stones, and mineral

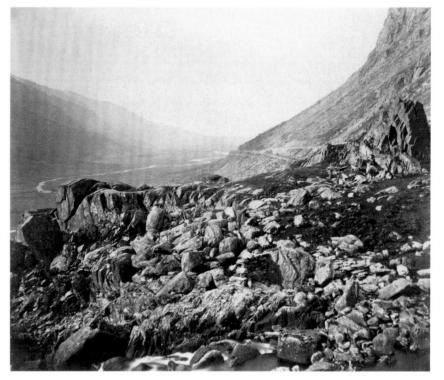

Fig. 29. Roger Fenton, *Rocks at the Head of Glyn Ffrancon*, 1857. Albumen silver print, $36 \times 43.3 \text{ cm} (14\frac{3}{16} \times 17\frac{1}{16} \text{ in.})$. The J. Paul Getty Museum, Los Angeles, 85.XM.169.19

ores were shipped out and coal and limestone brought to the region.⁷⁸ Rarely does Fenton so carefully craft a pastoral scene—here with winding river, gravel bank, rail fence, and receding mountains—and then let modern industry take up a foreground position.

If Fenton sought with his trip to Wales to reassert his reputation as the premier landscapist, he could not have hoped for more positive reviews. At the 1858 exhibition of the Photographic Society, he displayed twenty-two photographs from the Welsh series, 79 and they were universally praised: "No one can touch Fenton in landscape," wrote the Journal of the Photographic Society, "... There is such an artistic feeling about the whole of these pictures . . . that they cannot fail to strike the beholder as being something more than mere photographs." The Athenaeum praised "Mr. Fenton's Welsh scenes, with tender, loving distances, with miles of fading and brightening light. . . . The aerial perspective in some of these scenes is delicious, because true."81 The Literary Gazette found that the medium's most marked and decisive progress was being achieved in landscape photography and judged that "here the palm must be unquestionably assigned to Mr. Roger Fenton."82 And Photographic News declared flatly, "Nobody will be inclined to dispute Mr. Fenton's unrivalled claim to be the best English landscape photographer. He has succeeded in giving such breadth to his landscape pictures, that one is at first almost inclined to look upon them as copies of pictures." The views of Wales, the writer hoped, were but "the foreshadowings of still greater efforts" on Fenton's part.83

VALLEYS OF THE RIBBLE AND THE HODDER, 1859

Of the hundreds . . . who have been to Paris, and Switzerland, and the Rhine, how few have gone up their own river a few miles, to a spot, which, were it a hundred and fifty miles away, and a "cheap trip" were advertised thither now and then, would attract thousands!

—William Dobson, 1877⁸⁴

The majority of Fenton's efforts in 1858 were directed toward architectural subjects and his series of Orientalist tableaux; his submissions to the exhibition of the Photographic Society in 1859 included only a meager selection of landscapes made along the Wye and the Dove and at the Cheddar Gorge. Again the comparison with Bedford tilted away from Fenton, with the

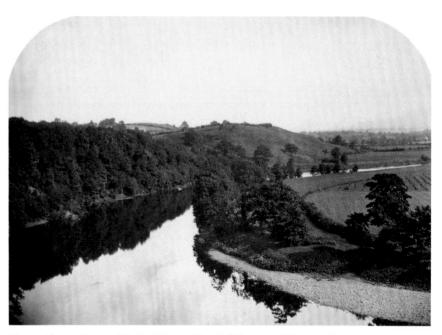

Fig. 30. Roger Fenton, *The Raid Deep, River Ribble*, 1859. Albumen silver print, $28.5 \times 40 \text{ cm} \left(11\frac{3}{16} \times 15\frac{3}{4} \text{ in.}\right)$. The RPS Collection at the National Museum of Photography, Film & Television, Bradford, 2003-5000/2973

Photographic News obviously disappointed by the follow-up to the spectacular Welsh views. "Fenton we have always regarded as the leading English land-scape and architectural photographer," the reviewer declared. "Now, however, Bedford seems likely to take the lead. In the productions of the former we see scarcely any progress, on the contrary, rather retrogression, while in the latter gentleman's pictures . . . there is great and decided improvement." Fenton's landscapes in particular were, the critic regretfully found, "far below the average merit of his pieces." **55**

Perhaps feeling the sting of criticism or the spur of competition, he again turned his lens to the landscape in 1859, this time to a softer, more civilized, and more familiar terrain—that corner of his native Lancashire where the rivers Hodder and Calder join the river Ribble. Fenton photographed the buildings and surrounding landscape of Stonyhurst College on at least two visits, in June or July and again in late December, when the yews were covered with frost and students ice-skated on the ornamental lakes flanking the entrance drive. This Jesuit school was established in 1593 in Saint-Omer, France, as a place where well-to-do English families could send their sons

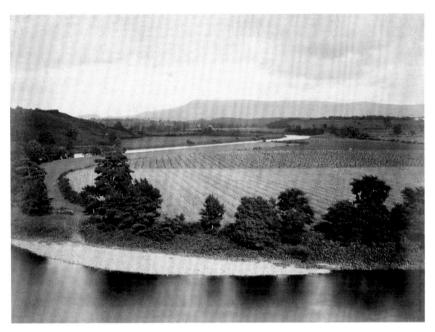

Fig. 31. Roger Fenton, *Valley of the Ribble and Pendle Hill*, 1859. Albumen silver print. Courtesy of Stonyhurst College, Clitheroe, Lancashire

for the Roman Catholic education forbidden them at home. Two hundred years later, in 1794, it moved to Stonyhurst, "a noble building, delightfully situated amid enchanting scenery," which had descended to Thomas Weld, himself a graduate of the school. By the middle of the nineteenth century, the Jesuits had acquired not only Stonyhurst but the surrounding properties as well, and the college had "a princely mansion, a noble, well-wooded park, a fine farm in their own hands and several let to tenants, and their estate borders the Hodder and the Ribble, along some of their best fisheries, for many a mile." ⁸⁷

His many photographs of Stonyhurst College—fifteen of the buildings, inside and out, and seven of the gardens and famed observatory—constitute a more extensive grouping than Fenton undertook for any other ruined abbey, great cathedral, or stately home, save Windsor Castle. The number of images, repeat visits, and opportunities for unusual access (including to the refectory [pl. 73] and the as-yet-unconsecrated Sodality Chapel) suggests that Fenton may have been carrying out a commission, though no record of such survives. But Fenton had a more direct attachment to the

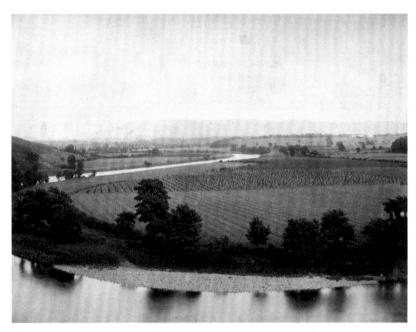

Fig. 32. Roger Fenton, *Down the Ribble*, 1859. Albumen silver print, 22.5 x 28.5 cm (8% x 11% in.). Collection of Daniel Newburg, London

area, and particularly to the landscapes and river views that seem to have occupied him most during his summer visit. His first cousin James owned Dutton Hall—"a stately erection" just a few miles from Stonyhurst "commanding an extensive and varied prospect" —as well as substantial land holdings adjacent to the college along the Ribble and Hodder rivers. Roger himself was among the family members who jointly owned Lambing Clough Farm, just next to the family's bobbin mill at Hurst Green (fig. 2). ⁹¹ Virtually every one of the twenty-seven landscapes Fenton made in the area were taken from or looked to property owned by Stonyhurst College, the Fenton family, or both.

Standing on his own land at Lambing Clough Farm, Fenton photographed the valley of the Ribble at least six times, three views showing the "Raid Deep," or "Reed Deep" (fig. 30), and three showing the valley of the Ribble, the fields of Dinkley Hall, and the slablike mass of Pendle Hill in the far distance. ⁹² When paired, images of the Raid Deep and the valley of the Ribble form a sweeping panorama. The three versions depicting the valley of the Ribble and Pendle Hill are particularly fascinating, as each

Fig. 33. Roger Fenton, *The Keeper's Rest, Ribbleside*, 1859. Albumen silver print, $35.2 \times 42.7 \text{ cm}$ ($13\frac{7}{8} \times 16^{13}$ % in.). Victoria and Albert Museum, London, PH.355-1935

frames essentially the same scene but stresses a different visual effect. In one (fig. 31), the scene is composed and exposed so as to emphasize the patch of farmland embraced by the bend in the Ribble. The fields are light, with the foreground trees silhouetted against them, Pendle Hill rises visibly in the background, and a hint of clouds can be seen in the sky. A second image (fig. 32) suggests an atmospheric perspective as the Ribble winds its way into the distant landscape. The third version (pl. 78) is the most daring. Fenton has shifted the camera to the right, so that the bend in the river is no longer evident, and has organized his page as a series of horizontal bands: glassy water in the foreground, the gravel riverbank,

the row of trees, fertile fields dotted with neat sheaves of wheat, distant farms and rolling hills, and, faintly, Pendle Hill. Most compelling, and in contrast to the other two variants, is the way Fenton has created a landscape in which the trees are more clearly defined in reflection than in reality; his shadow detail is remarkable, and the leaves of trees and furrows of fields are all visible on close inspection, but it is only as reflections that the trees have a graphic clarity. That this play of reflection is central to the composition is hinted at by Fenton's unusual decision, on all three known prints of this image, to mirror the rounded corners of the top edge—common in his work—by trimming the bottom corners in a similar manner.⁹³

Nearly every one of Fenton's many landscapes includes some passage of water: a river, waterfall, pond, or lake. Rivers in particular were essential to mid-nineteenth-century British life. They quenched the thirst and put food on the table, powered the mills and carried off effluent, provided recreation and sport, cleansed the body, soothed the soul with their murmurings, and excited the poetic and artistic imagination. In one view along the Hodder, a young boy—no doubt a Stonyhurst student—stands on the wooded bank with his back to the camera and looks downstream to an Edenic scene of rippling water, abundant foliage, and gently lit atmosphere. The spiritual connection with the landscape that Fenton's contemporaries felt is unhesitatingly expressed in the title of this photograph: *Paradise, View down the Hodder, Stonyhurst* (pl. 74).

Figures appear often in Fenton's river scenes, not merely to convey a sense of scale but also to offer, as in so many Romantic paintings, a surrogate for the viewer, a place to stand within the picture and be subsumed in its environment. Such is the case with the young boy in Paradise. In many other images, Fenton's figures are fishermen. Angling was the perfect sport for one inclined to seek communion with nature, and the angler the perfect vehicle for an artist desiring to invite a certain type of contemplation. Ever since Izaak Walton, author of The Compleat Angler (1653), had "laid aside business, and gone afishing" some two centuries earlier, the "gentle art" had become intertwined with art and poetry, and with the love of nature. Whether or not Fenton fancied himself an angler (and why not?), it is easy to imagine him finding an alter ego in the fisherman along the Wharfe, Lledr, Dee, or Hodder, studying the current, measuring the light, preparing to cast his line, as it were, at precisely the right moment. One need only substitute the photographer in place of the fisherman: "The pleasure of angling consists not so much in the number of fish we catch, as in the pleasure of an art, the gratification of our hopes, and the reward of our skill and ingenuity: were it possible for an angler to be sure of every cast of his fly, so that for six hours together his hook should never come home without a fish to it, angling would be no more a recreation than the sawing of stone, or the pumping of water."94

The photographs of the Lancashire landscape present no exception to this emphasis on water and fishing. The rivers adjacent to Stonyhurst were extraordinarily abundant with salmon and trout ("morts" and "sprods," in local parlance), racing toward the sea in springtime and returning a month

or two later "when the beans are in flower, the country folk say." Although Fenton's photographs give few hints of their economic importance, the rivers were more than spots for recreational fishing and communing with nature; fishing rights along the Ribble and Hodder were valuable assets. Stonyhurst's fisheries extended for miles, including many of the spots photographed by Fenton—the Raid Deep, the Sale Wheel, the Old Hodder Bridge. Old "Harry Keeper" (Harry Holden, the keeper of Stonyhurst) remembered netting fifty salmon one afternoon in the Raid Deep; Harry may be the man in a white hat who appears with some gentleman anglers across the river in *The Keeper's Rest, Ribbleside* (fig. 33). And it is no doubt somewhere along these banks that the salmon, trout, and rabbits of *Spoils of Wood and Stream* (pl. 75) were laid out in a rustic still life.

Given a place of honor at the east end of the annual exhibition of the Photographic Society in London in January 1860, Fenton's Stonyhurst landscapes garnered mixed, and sometimes contradictory, reviews. *The Keeper's Rest* appears to have been universally admired, the *British Journal of Photography* calling it "altogether a refreshing picture" and both the *Photographic News* and *Photographic Notes* admiring Fenton's skillful inclusion of a group of figures in a landscape. The *Athenaeum* praised his taste in selecting subjects, choosing picturesque spots, and conveying a sense of light, atmosphere, and perspective. Other pictures were described as "excellent specimens," "charming," and "no less worthy of praise," and the *Builder* declared that "Mr. Roger Fenton in landscape retains his position."

By contrast, Fenton's printing of two images, *Mill at Hurst Green* (fig. 2) and *Cottages at Hurst Green*, was generally found wanting. The *British Journal of Photography* praised the subjects but regretted that they were "not given with Mr. Fenton's usual ability." ¹⁰¹ *Photographic News* called the first "so well chosen . . . [and] so beautifully rendered, that it would seem hypercritical to mention its trifling defects" but deemed the second "deficient in sharpness." ¹⁰² The *Athenaeum* found no fault with their details but bemoaned "a uniformity of shade about them that completely mars their general effect." This, the critic felt, was not the fault of Fenton's negatives, which he divined were "as fine as any that can be produced," but rather of the printing and toning: "In this he frequently fails to bring forth a proof at all commensurate with the plate." ¹⁰³ And the *Photographic News* made the inevitable comparison with Bedford: "Fenton's pictures have the advantage as regards size, but

those by Bedford represent such beautiful scenes, and have a tone so peculiarly rich, that it is with renewed pleasure one returns to look at them." ¹⁰⁴

That the quality of Fenton's printing should be considered deficient by his contemporaries is revealing, because a viewer bemoans the same fact one hundred and fifty years later. Many of his most brilliant and beautifully composed pictures exist today only in unsatisfying examples. Fenton's albumen silver prints are often so discolored as to render the picture flat and unattractive. Whether this discoloration was visible to Fenton's critics, or whether we are seeing flaws that have become evident only with age, is difficult to know. It is striking, however, to compare Fenton's own prints with those produced from the same negatives in the 1860s by Francis Frith, who bought the bulk of Fenton's negatives at the 1862 sale of his photographic equipment and stock. Although often printed from damaged plates and with a different (or indifferent) interpretation of the image, Frith's albumen prints have a tonal range and color regretfully lacking in many of the photographer's own prints. Of all Fenton's albumen prints, the body of work that is, on the whole, most appealingly printed and best preserved is the still-life series photographed and printed in 1860; perhaps he altered his technique or replaced the assistants who helped him print his work—in response to the criticism of his submissions to the Photographic Society show earlier that year. Oddly, his landscapes from 1860 are not markedly different in print quality from most of his earlier work.

THE LAKE DISTRICT, 1860

For the lover of nature and healthful recreation, no tour could be devised of a more pleasing or agreeable character than that which these lakes afford.

—Black's Shilling Guide to the English Lakes, 1853¹⁰⁵

Having photographed a personally familiar but little touristed terrain in 1859, Fenton traveled the following year to the corner of England best known for the beauty of its landscape—the Lake District in northwest England. His final landscape campaign surveyed an area long admired not only for the lakes and rivers themselves but also for the mountainous topography, which includes England's highest peaks. The area became a particular favorite for searchers after the sublime during the Napoleonic era, when

travel to the continent was curtailed, and by Fenton's time it was a common tourist destination—nature almost at one's doorstep, easily accessible by train. According to Black's, "no tract of country in Britain combines in richer affluence those varied features of sublimity and beauty which have conferred upon this spot so high a reputation"—an appreciation, it will be admitted, that sounds rather like Roscoe's comments about North Wales. 106 The Lake District was particularly celebrated by British painters and poets, most notably by its native son Wordsworth, and the experience of the landscape was enhanced for visitors communing with the artistic spirit of those who had come before. Black's included extensive quotations from literary and poetic descriptions of the area, which, the editor felt certain, would "not only contribute to elevate the feelings and improve the heart, while the reader is contemplating the scenes which are there portraved, but will also form a spell by which, in coming years, he may recall the pleasures of the past, and revisit in imagination the scenery over which we are now about to conduct him."107 This idea—that the poem might serve as a guide to the experience and as an aide-mémoire to recall its pleasure in later years—was precisely parallel to the impulse that stimulated the tourist market for photographs at the same moment.

Wordsworth himself had published *A Description of the Scenery of the Lakes in the North of England* in 1822, and his identification with the Lake District was common currency by midcentury. Like other visitors, Fenton apparently enjoyed the literary resonance of the landscape. At the 1861 exhibition of the Photographic Society he appended to his *Bridge in Patterdale* a passage from the poet's *Excursion* (1814)—"Thus having reach'd a bridge that overarch'd / The hasty rivulet, where it lay becalm'd / In a deep pool, by happy chance we saw / a double image" ¹⁰⁸—and attached lines from "The White Doe of Rylstone" to a view of the ruined choir of nearby Furness Abbey.

Fenton's photographs of the Lake District include the region's principal tourist features—the 1,900-ton Bowder Stone near Borrowdale, the view from Newby Bridge (pl. 79), the waterfall called Ara (or Aira, or Airey) Force, and, of course, the lakes themselves, including Windermere, Ullswater, and Derwentwater. Numerous signs of recreation are visible: the Bowder Stone had a ladder that sightseers could climb for a panorama of the valley, and several photographs of the lakes include the rental rowboats maintained by

Fig. 34. Roger Fenton, *Derwentwater*, 1860. Albumen silver print, 22.4 x 28.7 cm (8¹³/₁₆ x 11⁵/₁₆ in.). National Gallery of Art, Washington, D.C., Anonymous Gift, 1997.97.2

hotel keepers "for those who prefer a quieter mode of transit" than the steamers that plied the larger bodies of water. ¹⁰⁹ Among the photographs from this campaign, *Derwentwater*, *Looking to Borrowdale* (pl. 80) stands out as the most serene and least touristic. Of all the lakes, Derwentwater was said to have special appeal for those familiar with the rugged mountain scenery of the Highlands, ¹¹⁰ and, as in his Scottish landscapes, Fenton's rendition includes a remarkable sense of atmospheric perspective and natural sky. The charm and poetic power of this picture stem from Fenton's having pared the subject down to its three most basic elements—water, land, and sky—and having blurred the boundaries between them. The sur-

face of the lake reflects the cloud-laden heavens; earth and water merge seamlessly at the marshy shore; and the air itself appears more palpable than rock as it blocks from view the distant mountains. This is the quintessence of landscape.

As with other particularly evocative locations, Fenton made more than one picture at this spot. Two close variants, *Derwentwater* (fig. 34) and *Hills at the Foot of Derwentwater*,¹¹¹ put less emphasis on receding space and more on the flat picture plane—bands of sky, hillside, and water stretching across the page—and present each element in its more characteristic form: limpid atmosphere, dark, solid earth, glassy water.

Reviews of Fenton's submissions to the Photographic Society's exhibition of 1861 suggest that critics thought his work had reached a point of stasis; it was "very beautiful [but] in no respect superior to photographs exhibited by that gentleman four or five years since." Once again the warmest praise was for Bedford. Even an admiring comment about some of Fenton's photographs concluded that "perhaps Mr. Francis Bedford never produced more perfect works"—the qualifier "perhaps" no doubt sticking in Fenton's craw. Scant evidence exists today to suggest why Bedford was so highly esteemed and so favorably compared with Fenton throughout the late 1850s and early 1860s.

Fenton's landscape work constituted a relatively brief but pivotal exploration that grew out of a gentleman amateur tradition and gave way to a more commercial topographic production. The amateur strain from which he emerged began with Talbot and his circle in the 1840s and continued in the 1850s with many of Fenton's contemporaries, including Benjamin Brecknell Turner, Thomas Keith, John Dillwyn Llewelyn, and Henry White. To be sure, each photographer had his merits—Turner excelled at conveying the rough textures and age-old traditions of rural life, for instance, and White rendered sparkling light and delicate detail as well as anyone. But for most of them photography was a relatively private affair, a weekend avocation shared with friends, family, and fellow Photographic Society members, with little aspiration for public recognition or expectation of it. Except for Turner, these gentleman amateurs commonly worked on a modest scale and produced compositions in which charm was favored over rigor or grandeur.

Despite Fenton's supreme mastery of the medium and his central role in positioning photography as a professional, artistic pursuit in the 1850s, he left behind no direct successor, no fervent disciple, no circle of students. His influence was both broader and less specific than that. As the medium's leading artist and most persuasive advocate, Fenton was an exemplar of photographic accomplishment—what other aspiring photographers reached for but failed to grasp. Particularly in the area of landscape, no one else in the 1850s worked on the scale, and with the ambition, of Fenton, and no one of note would do so again for decades. The only other British photographers who utilized the large

negatives routinely favored by Fenton were those working abroad—Charles Clifford in Spain, Robert Macpherson in Italy, Francis Frith in Egypt, Linnaeus Tripe and John Murray in India. In the oeuvre of each, landscape was a minor note, an exception among series dominated by architectural subjects and destined for topographic surveys and tourist albums.¹¹³

At home in Great Britain, landscape remained a popular subject throughout the 1860s, with photographic views of this or that region enjoying a lively tourist market at railway bookstores and local print shops. Bedford, Frith, George Washington Wilson, and others devoted vast expanses of glass plate to picturesque scenes. But in nearly every case, one feels that the photographs were meant to serve an illustrative rather than an artistic purpose—they were mementos of a trip to the Brighton seashore, the Yorkshire dales, or the Lake District, not unlike the picture postcards that would eventually take their place at the turn of the century. The economics of marketing to a middle class, rather than to gentlemen of means with literary, scientific, and artistic education, encouraged photographers to produce a larger quantity of smaller, less expensive, less refined photographs. Nearly all of Bedford's, Frith's, and Wilson's prints in the 1860s were of relatively small size or in the stereo format. Aesthetic factors such as careful composition, optimal lighting conditions, and exquisite printing were less important than the recognizable rendering of a familiar sight. The pressures of the market did not allow photographers of the 1860s to spend the time that Fenton must surely have devoted to scouting out the best viewpoint and awaiting the perfect light for his finest works of the previous decade. Even a run-of-the-mill depiction of a famed locale was far more likely to sell than a handsomely made landscape or nature study of an unidentified place. It is not surprising that when the London print seller Thomas Gladwell advertised Fenton's photographs for sale in 1858, few artistic studies per se appeared on his list, which was largely composed of views of stately homes, cathedrals, abbeys, and "Public Buildings and Parks of London" (fig. 67). Even those who sought photographs by the famous Fenton preferred a great artist's depiction of a known, historical subject to a more purely artistic composition. Such choices seem natural if one thinks of the parallels with portraiture of the period: customers at the most lavish portrait salons were

more interested in purchasing little cartes de visite or cabinet cards of the royal family, leading actors and actresses, politicians, poets, and military men than images of unknown or inconsequential persons, no matter how beautiful the subject, grand the scale, or perfect the rendering.

If not a direct result of these changing practices and economics of photography, Fenton's retirement was certainly a reflection of them, and perhaps his absence from the scene hastened the pace of change. For a decade, Fenton

had held the medium of photography in delicate balance, raising it from the domain of the sketcher and dilettante to that of the professional artist, while at the same time keeping at bay by the example of his work the push to a more commercial, industrialized product geared to mass consumption. ¹¹⁴ In Fenton's quest to find and hold that balance, landscape—which has so little raison d'être beyond the aesthetic—provided the perfect vehicle for demonstrating what could be accomplished in the new art.

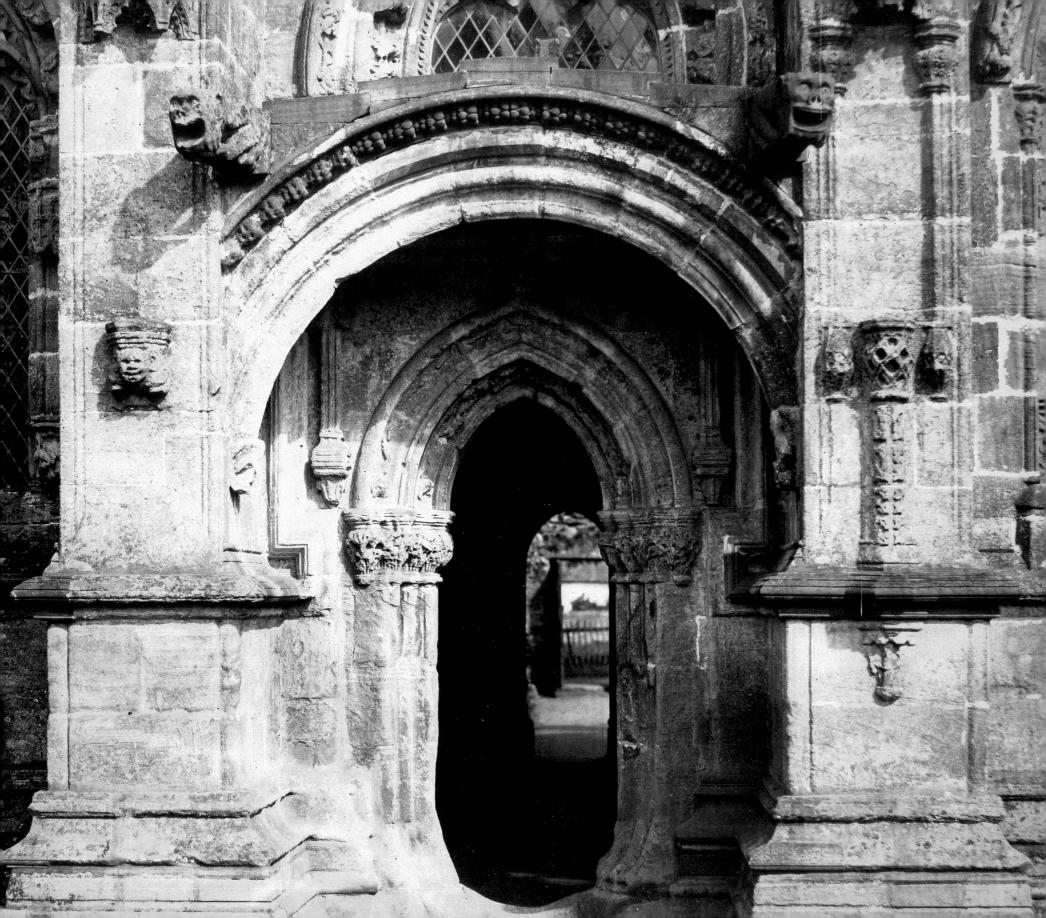

In Pursuit of Architecture

GORDON BALDWIN

For the late Valerie Lloyd, who imparted her enthusiasm for the work of Fenton, and for the late Kelly Edey, whose architectural library remains an inspiration.

The best-known and most widely exhibited photographer of the 1850s, Roger Fenton had begun to attract the attention of the press even before the Crimean work of 1855 that made his reputation. ¹ In the years that followed, the variety of his subject matter, coupled with the consistently high quality of his work, guaranteed the continuation of that interest. Fenton went on photographic expeditions in Britain in the late summer and early autumn of every year from 1852 to 1860, except for 1855, when he was in the Crimea, and each time he made both landscapes and studies of architecture—of time-wracked abbeys, weathered cathedrals, or country houses. (While reviewers of the later 1850s often thought of Fenton's ruined abbey views as landscapes² and distinguished them from his other architectural studies, here they will all be treated as part of the same innovative enterprise.)³ The following winters, at exhibitions in London, he showed his trophies. From 1854 until 1861 he placed work in every annual exhibition of the Photographic Society in London as well as at other venues in London and elsewhere. Records indicate that his landscapes were sometimes mixed with his purely architectural studies, but it is unclear how much control he had over the placement of his pictures. He made at least 450 images of buildings, more than of any other class of subject except the pictures made between early 1854 and 1860 to record objects in the collections of the British Museum.⁵ When he was free to choose his subject, most often he photographed architecture.

Opposite: Fig. 35. Roger Fenton, Roslin Chapel, South Porch (detail), 1856; see pl. 26

While an intrepid voyager, Fenton blazed no trails in selecting architectural sites. Nearly invariably he went to celebrated places, the exceptions being locations to which he had ties of kinship.⁶ During the first half of the nineteenth century there were numerous publications devoted to prints of ruined abbeys, cathedrals, and other noteworthy British edifices. These engravings or lithographs were usually accompanied by texts ranging in content from the historical to the descriptive and in tone from the reverent to the chatty. As James Ackerman has pointed out, the illustrations for these books "established conventions of architectural representation that were adopted, no doubt unconsciously, by photographers: the positions from which to shoot the facades and apsidal ends of churches, the interiors, the choice of details."7 Indeed, the formal geometric configurations of buildings like cathedrals in and of themselves dictate certain logical viewpoints to both the graphic artist and the photographer. Views aimed straight at a principal front or a side of these buildings are as inevitable as they are informative and particularly reveal the structure's formal planar geometry. Views made at an angle offer a more volumetric description. In his mature practice Fenton's usual method was to employ both types, varying their proportions in response to the particularities of the site, and occasionally incorporating a narrative element. His interest was always pictorial, not didactic.

FIRST FORAYS, 1852

Fenton's first depictions of buildings are salt prints from paper negatives that he made at Cheltenham, Tewkesbury, Gloucester, and Tintern in 1852,

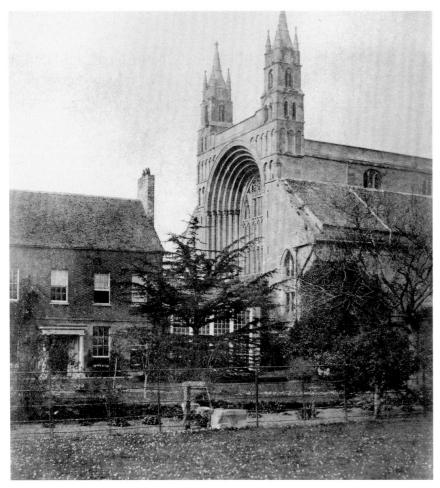

Fig. 36. Roger Fenton, *Tewkesbury Abbey*, 1852. Salted paper print from waxed paper negative, 21.3 x 18.1 cm (8 % x 7 % in.). From *The Photographic Album*, part 1 (London, 1852). Photographic History Collection, Smithsonian American Art Museum, Washington, D.C., 319,886

at the beginning of his photographic career. They were presumably accomplished during a single trip from his home in London, as the four locations lie relatively close to one another in southern England and nearby Wales. The subjects included a spa and its surrounds, parish churches, a ruined abbey (fig. 36), and a cathedral; he made several views of most of these buildings. A few were published at the end of the year⁸ but were not much liked by the *Illustrated London News*, although acknowledged therein as the product of an artist's eye.⁹ Another trip in 1852 took him to Crimble, near Bury, in Lancashire, where he visited his father and stepmother and

their children and made a photograph of the house in which he was born. ¹⁰ In short, when Fenton left for Russia in September of 1852 he had some experience in photographing architecture but had not yet arrived at a specific approach.

His nominal commission in Russia was to document the construction of a four-span suspension bridge across the Dnieper at Kiev that an acquaintance, the sometimes difficult engineer Charles Vignoles, had undertaken for Czar Nicholas I. Oddly, almost no photographs of Vignoles's bridge by Fenton seem to have survived;¹¹ however, in Russia he seized the opportunity to create his first substantial body of work on architecture or, for that matter, any class of subject, and the pictures still exist, often in multiple examples. 12 Made using Gustave Le Gray's process for waxed paper negatives, which, advantageously for a traveler, could be prepared in advance, these are quite possibly the earliest surviving photographic images of Russia. 13 They were taken in Kiev, Moscow, and Saint Petersburg; most are distant views of the walls of the Kremlin in Moscow, with churches and palaces ranged behind the fortifications (pl. 4). Fenton's overall view from what he called "the old bridge" across the Moskva River encompasses the slender water tower, beyond it the then-new great palace of the Kremlin, the early-sixteenthcentury octagonal bell tower of Ivan the Great, and the Cathedral of the Archangel (pl. 3). Towers and walls recede into the distance in a fleeing perspective enhanced by the sweep of barges angling away from the bridge and down the river. 14

Fenton partially circumnavigated the great walls enclosing the Kremlin complex and made several views of it from across the river, but if he also took views from its landward sides, they have not survived. There are gaps in his series of negative numbers, so perhaps some negatives proved impossible to print on his return to England.

A more dynamic image, taken from the riverside rampart, looks along foreground merlon crenellations past a series of towers that jostle to be seen, then zigzags to the distant water tower at the end of the rampart, with the river below and an immense construction project in the far distance (pl. 5). Because of the spectral imbalances in his photographic materials, the green slope at the right appears far darker than it was in actuality, a deeply shadowed void that dramatically counterbalances the whites of the towers and the profusion of riverine detail. While the Kremlin, a famous, large, and

sprawling subject, was hard to encompass, Fenton realized that he had entered nearly virgin photographic territory and intended to produce several summary overviews of it. His compositional abilities raised these images above conventionally descriptive touristic views.

A quietly spectacular image of the domes of the Cathedral of the Assumption was taken, as John Hannavy discovered and recounted, from a ledge halfway up the tower of Ivan the Great (pl. 2)¹⁵—a perch that took considerable effort for Fenton to reach with his bulky camera and supplies. The burnished foreground domes, which almost seem imbued with personalities, are echoed by their huddled fellows in the middle ground; the city of Moscow lies beyond. Light on a variety of surfaces—gilded metal, rough roof tile, white plaster, stone—is gently conveyed in the soft tones that a paper negative yields. One wonders what kind of permissions Fenton obtained to gain access to these ramparts and the tower staircase, since these parts of the Kremlin were effectively private property belonging to the imperial family.

A construction site, in this case that of the Church of the Redeemer, was an unusual subject choice for the period. The unfinished cathedral seems to have been adopted for purely pictorial reasons, unless perhaps Fenton's companion Vignoles wished to document the mammoth scale of this project (pl. 6). Undertaken to commemorate the epochal events of 1812, including Napoleon's burning of Moscow and the subsequent decimation of the French army, the church took from 1839 until 1883 to complete. The serried stacks of tree trunks that fill the foreground were raw material for future scaffolding; they provide a nearly abstract foil for the workers' barracks in the middle ground and the sheathing on the rising behemoth beyond. The dense overall patterning of the image, made up of repeated small-scale components that include the range of dormer windows, is relieved by the emptiness of the sky. Having lugged his equipment to this spot, Fenton also turned around and used the same battalions of wood as foreground for a long-range view of the Kremlin.

Russia provided Fenton with a variety of opportunities to develop his skill in photographing architecture, which, except for a few portraits of Russian individuals, constituted nearly his sole subject matter there. Because the Russian pictures were usually made at some distance from their subjects and have the softness that a paper negative produces, they offer general impres-

sions of the appearances of buildings and their contexts. These were not studies of architecture per se, as would later be the case with Fenton's pictures of types of buildings more familiar to him. His vision would become more expansive, his images more powerful, with time (and a change of medium and scale); but the Russian photographs were the foundation for what followed.

IN SEARCH OF THE PICTURESQUE, 1854

Having been trained as a painter in the 1840s, Fenton could hardly escape the preoccupation with the picturesque—amounting almost to a cult—that was an essential component of British art in the first half of the nineteenth century. It is true that his own eclectic, if not particularly distinguished, collection of engravings, watercolors, and paintings was made up largely of history paintings and genre scenes, with a sprinkling of portraits, still lifes, and watercolors made in Wales. 16 On the evidence of their titles, the three paintings of his own that he placed in exhibitions in 1849, 1850, and 1851 were also genre scenes.¹⁷ But if it cannot be said that an idea of the picturesque was fundamental to Fenton's artistic vision before he took up photography, it became so soon afterward. Describing his experiences in the Crimea in a speech given to the Photographic Society, 18 he mentioned a preliminary trial expedition with his photographic van in 1854 in which he set out for the ruins of Rievaulx Abbey "in search of the picturesque." He used the word without irony and expected that his audience would fully understand what was by the 1850s a thoroughly established artistic canon. 19

When Fenton chose to go to Rievaulx in northern Yorkshire in the early autumn of 1854 to photograph the remnants of the great twelfth-century Cistercian abbey, he was displaying no great ingenuity, since the site, although isolated, was well known and much appreciated. As early as the 1750s a local landowner, Thomas Duncombe, built terraces into his land-scaped grounds to afford distant views of the remains of the buildings. John Sell Cotman painted watercolors on the site in 1803, as did Joseph Mallord William Turner in 1812. Fenton may have seen these paintings and would certainly have had a general knowledge of these artists' works. William Westall (1781–1850) made and published a drawing of the distant ruin seen from Duncombe's terrace in 1820, ²⁰ and William Richardson (1822–1877)

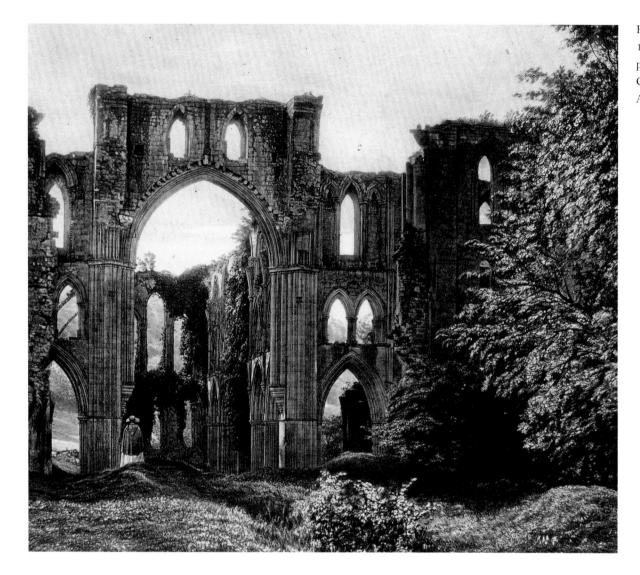

Fig. 37. Roger Fenton, *Rievaulx Abbey, the Transepts*, 1857. Photogalvanograph of original 1854 salted paper print, 18.6 x 22.4 cm (7 1/16 x 8 1 1/16 in.). Collection Centre Canadien d'Architecture / Canadian Centre for Architecture, Montréal, PH1980:0018

produced a series of precise, delicately colored Romantic views of Rievaulx. These and his other paintings of decrepit ecclesiastical buildings in the region were published as lithographs starting in 1843. The photographer Benjamin Brecknell Turner exhibited a single talbotype of Rievaulx at the annual exhibition of the Photographic Society in London in January of 1854; it was presumably made the previous year and was surely seen by Fenton. In the same show Fenton himself exhibited a number of architectural studies, including a single salted paper print of Gloucester Cathedral, two albumen prints each of Raglan Castle and Tintern Abbey, and five of Gawthorpe Hall, all made in 1853; and a small host of salt prints of ramparts, cathedrals, and

palaces in Russia from his 1852 trip. 22 (Fenton's photographic output in 1853 was smaller than usual, perhaps because he was too busy launching the Photographic Society, mastering the wet-collodion-on-glass process, and seeking employment with the British Museum.)

Nor was Fenton the last photographer to work at Rievaulx. His greatest contemporary rival in the field of architectural photography, Francis Bedford (1816–1894), was there during the same summer. Philip Henry Delamotte (1820–1889) and Joseph Cundall (1818–1875) published their albumen prints of Rievaulx in *A Photographic Tour among the Abbeys of Yorkshire* in 1856. The peripatetic Francis Frith, the architectural specialist

William Russell Sedgfield, and both the now-obscure Reverend Dr. Henry Holden (active late 1850s) and the even more obscure J. Beldon (active early 1860s) all exhibited their photographs of Rievaulx in London. In other words, the site, although remote, was famous. What Fenton accomplished there, however, was uniquely his own.

The evocative remains of Rievaulx are cupped in a serene, verdant, steeply wooded valley less than ten miles from Harlsey Hall, the house in which Fenton's wife, Grace Elizabeth Maynard, had grown up. If he had not already fixed on these lovely ruins as a destination after seeing earlier works of art made there, perhaps she suggested them as a subject. In either case, his extensive photographic expedition to Yorkshire in the summer of 1854 was undoubtedly combined with visits to her extensive family, many of whom were scattered through the county. (In 1856 he would again visit East Harlsey, this time on his way to Scotland.)

At Rievaulx Fenton used photography both to picture an extraordinary place (unspoiled to this day) and to construct a narrative, or rather, two contrasting narratives. In his transverse view across the presbytery, an extension of the nave—the nave itself had completely disappeared by the time of his visit—Fenton placed a single female figure, in all probability his wife, kneeling at the deeply shadowed site of what was once the high altar (pl. 11). In doing so he was invoking English religious history and the original use of these precincts (although not by women). If ruins represent the surrender of art to nature, here the overzealous agents of the picturesque were Henry VIII's commissioners, who had carried out the destruction of this and other monastic communities. The overt Romanticism of this image of a woman in prayer is reinforced by its predominantly dark tones, with her cloaked form nearly lost in the gloom. To achieve this composition the photographer was required to hoist his camera up onto adjacent fallen masonry.

On the other hand, in Fenton's long view back down the presbytery to the single remaining arch where transepts and nave once crossed, a solitary woman sits reading in the late afternoon sunlight, enacting a contemporary, secular use of the premises for leisure, rather than devotion (pl. 12). Within the vertical composition her diminutive figure emphasizes the tremendous size of the soaring crossing arch that spans and frames the distant land-scape—which itself continues the recession into space and then closes it. To obtain a high vantage point Fenton placed his camera in a window frame

above and behind the high altar. Therefore the perspectival lines formed by the column bases, capitals, and springings of the arches converge well above the grassy floor. For draftsmen and watercolorists of the period, a classic single-point perspective of this kind down the long axis of a church was possible even in ill-lit interiors, and indeed, predictable. But because of the limitations of his photographic materials and the dimness within medieval buildings, Fenton was generally able to produce this kind of axial view only in roofless ruins,²⁴ as he did at Rievaulx and also at Fountains and Furness abbeys.

While it is close to certain that the same person appears in both views, the first of these two photographs represents the past, the second the present. Fenton's diversity of mood from one photograph to another speaks to his complex intentions at Rievaulx and hints at his own church attendance and underlying belief. These two principal scenarios are also enacted in two other photographs of the seven that he made at Rievaulx. In the first, which seems in equal parts picturesque and religious, the woman, again wearing a cloak but with the addition of a wide-brimmed hat, stands in the middle distance, her back to the camera (fig. 37). She is nearly lost among the humps of luxuriant greenery that cover the fallen stones of the nave and is dwarfed by the foliage-tufted walls of the ruined transepts and the crossing arch, now seen from the opposite direction. The camera is placed low, seeming to follow in the woman's footsteps. Her stance, as if contemplating the ruin before her, and her garb, which resembles a pilgrim's, make the photograph into a melancholy invocation of a vanished past.

In another image the same woman sits reading in the foreground outside the church, in the shelter of a small pointed arch, while a girl, presumably Fenton's eight-year-old daughter, Annie Grace, poses as if climbing a rustic fence (pl.10). This is a representation of a relaxed and pleasant outing. Like another photograph of the same two people, in which nothing of the abbey is visible, ²⁶ it suggests to the viewer how the site is to be enjoyed in the present. Watercolorists were free to interpolate figures of any sort into their compositions and occasionally they depicted persons in medieval dress, but Fenton seems to have been the only photographer who used actual people to evoke the past. Neither when playing roles from the past nor as themselves in the present can these figures be considered to embody orthodox picturesque taste, which preferred the gypsy or beggar to the priest or tourist. ²⁷ The pictures that Fenton made at Rievaulx not long after he had begun

seriously to photograph monastic architecture reflect a certain spontaneity, a personal response to the buildings not always found in his later work.²⁸ Perhaps the presence of his wife and daughter provided inspiration.

From 1854 on Fenton employed collodion-coated glass negatives. For this process chemical manipulations had to be carried out both immediately before and immediately after the exposure of the negative in the camera, and thus a portable darkroom was a necessity. To house and transport his darkroom and numerous requisite photographic chemicals and supplies, Fenton purchased a carriage in 1854 from a Canterbury wine merchant and had it elaborately refitted to his purposes.²⁹ Following its baptismal expedition to Rievaulx the carriage was shipped to the Crimea in 1855, where, after hard usage, Fenton sold it. He had another built when he returned to England. In all probability he most often used the railroads to transport his vehicle to the station nearest the site he wished to visit, rather than having his assistant, Marcus Sparling, drive it all the way from London to distant counties along what were still rather rudimentary roads.³⁰ Fenton and his companions, whether his wife and family or Sparling or other assistants, then also traveled by train to these rendezvous, although several changes may have been required; there was not yet a united rail system, only many small lines.

INTO SCOTLAND, 1856

At the beginning of his photographic expedition to Scotland in 1856, off the windy coast of Northumberland, Fenton visited the stark ruin of Lindisfarne Priory, on a tidal island that had been revered as a holy site since the seventh century. Who accompanied him is not known, but in one photograph the informal dress and nonchalant pose of the shirtsleeved figure with his back to the camera suggest that he is the invaluable Sparling (pl. 24). Out of the disorderly components of the ruined eleventh-century Norman priory Fenton wrested a roughly symmetrical composition centered on the one remaining diagonal crossing arch, which had spanned the space where nave and transepts once met. To do so he placed his camera at a forty-five-degree angle to the axis of the nave so that its direction was perpendicular to the span, a view that would have been wholly impossible inside the building when it was intact. In fact, the blocky ends of the gaunt arch connecting the west side of one transept with the east side of the other lie in two different

planes, but the flattening effect of the lens makes them appear to be at equal distances from the picture plane. Fenton managed to torque the Romanesque masonry into place on the surface of the paper and use the great arch, now sometimes called the rainbow arch, to frame the tidal flats and coastline in the distance. While on the Holy Island he also made separate views of the adjacent salt flats. His work in this isolated place, which even today can be reached only at low tide, was an auspicious prologue to the series of photographs he made at the ruins of Kelso, Jedburgh, and Melrose abbeys in the Scottish Borders as he gradually moved north that autumn, switching from landscape to architectural study as the opportunity presented itself.

He made five studies of the ravaged but still substantial remains of the abbey at Melrose, moving his camera around the tilting tombstones in the churchyard cemetery. In a vertical study of the south transept, an enormous window filled with an elegant filigree of flamboyant Gothic tracery soars above the tiny figure of a woman in white, posing on the threshold of the porch (pl. 25).33 Closer to Edinburgh, Fenton stopped at Roslin to photograph a disused fifteenth-century chapel that after a turbulent history had been reroofed, repaved, and reglazed in the eighteenth century. While the ostensible subjects of his study of the south porch are the foliate-patterned window frames (filled with comparatively modern glass) and the porch with its heavy arch and empty niches flanking the door, the photograph is primarily an exercise in depicting depth (pl. 26, fig. 35). The view, taken from outside the building, looks through the doorframe into the chapel and across its width, then out a door on the north side that opens onto the churchyard, through a doorway in the boundary wall, and past a crude fence of pointed sticks, coming to rest on a postage-stamp-sized landscape of distant fields. By opening three doors each more distant from the camera, Fenton obtained a series of frames of diminishing dimensions and turned the chapel into a telescopic tunnel of stone leading the eye through successive shifts between light and dark. His ability to recognize that an ordinary architectural study could be transformed into a sophisticated composition of varying planes is an aspect of the highly sensitive perception that distinguishes Fenton's photographs from the work of his contemporaries.³⁴

After stopping in Edinburgh, the Scottish expedition moved north and terminated in September in the Highlands, where Fenton photographed, at Queen Victoria's request, her newly completed castle of Balmoral and made portraits of most of the royal princes, in kilts, lounging on the lawn (pl. 30). It is possible that this commission was the raison d'être for Fenton's trip to Scotland and that his visit was timed to coincide with that of the queen to her new home.

A QUARTET OF CATHEDRALS, 1857

The next year, 1857, Fenton traveled to the sleepy town of Ely in Cambridge-shire to photograph the famous cathedral that towers above the surrounding low-lying countryside. He seems to have first approached the building from the gentle slope that leads to its western front, as pilgrims do. He moved his camera progressively closer to the facade in three stages as he crossed the greensward. The west front of a cathedral, designed to make a strong initial impression on the visitor, is the logical starting point for a set of representations in any medium, even if, as at Ely, the west front is quite lopsided, its northern section having been pulled down well before Fenton's arrival. The twelve known pictures he made at this site are his first sustained study of a cathedral, and their number indicates that as a subject Ely particularly appealed to him (as well as that he was blessed with consistently good weather).

From the west he circled the building, stopping to make a general view of it from the southeast and a study of a deeply carved Romanesque doorway before arriving at its battered and appealingly gawky east end (pl. 49). He angled his view of this spiky thirteenth-century presbytery to show a row of flying buttresses whose repetitions emphasize its length. The angle also makes possible a sharply upward view of the pinnacled octagonal lantern that rises above the central crossing and, beyond it in the distance, a vertical sliver of the crenellated tower of the west front. The resultant collection of bumpy spines gives the upper section of the photograph an energetic silhouette, and the building bulges off the paper like a billowing sail. Had Fenton moved his camera even slightly to the right, the view of the flank of the presbytery would have been obstructed by a lady chapel that projects parallel to it. The effect of the length of the cathedral receding into the distance is enhanced by the overexposure, which makes the west tower seem shrouded in mist. The evenly lit east front has a somewhat patchwork appearance because of the variable weathering of the stone, the asymmetrical windows of differing dates and styles, and the lack of a turret atop one buttress. 35 This

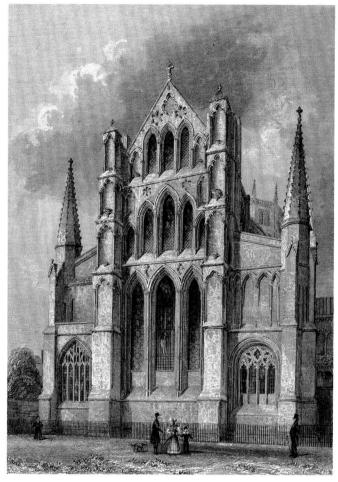

Fig. 38. Benjamin Winkles, after a drawing by Robert Garland, *Ely Cathedral, East End*, 1836. Engraving, 14.8 x 10.7 cm (5¹³/₁₆ x 4³/₁₆ in.). From *Winkles's Architectural and Picturesque Illustrations of the Cathedral Churches of England and Wales* (London, 1836–42), vol. 2, pl. 70. Research Library, The Getty Research Institute, Los Angeles, NA5461.W5

photograph is perhaps something of an ugly duckling, but it has distinct power that far more clearly conveys the timeworn character of the building than contemporary engravings of the same subject, which tend to erase the effects of time. For instance, Benjamin Winkles's engraving of twenty years earlier made from precisely the same vantage point sanitizes the facade at the same time that it overemphasizes its vertical thrust (fig. 38).³⁶

Outside the immediate cathedral surrounds, in a park to the south, Fenton made a lengthwise view of the whole of the building in which the dark foliage of trees alternates with the light stone of the towers, seemingly coeval elements in their environment (pl. 50).³⁷ Placing a structure in its context is so consistent a concern in Fenton's architectural work that in some late pictures the depiction of the space surrounding buildings is nearly as important as that of the buildings themselves. Fenton's last large-format photograph of Ely shows a lane leading to the cathedral, with a street sweeper glancing up at the camera as if caught in midstroke.³⁸

It may have been in order to have a substantial number of images to place in the first exhibition of the Architectural Photographic Association in January of 1858 that Fenton concentrated on photographing cathedrals in 1857. He probably traveled steadily north, moving from Ely first to Peterborough, then on to Lincoln, and finally, after changing trains, to York. He made few views of the cathedral at Peterborough: five, according to an advertisement in the *Sarum Almanack Advertiser*, ³⁹ which also mentioned ten taken at Lincoln. The known Peterborough images are studies of the early-thirteenth-century west front, the south transept, and the east end. ⁴⁰

What was perhaps Fenton's first study of the noble cathedral of Lincoln was made almost a mile from the building, near the spot where he would have alighted from the train. He positioned his camera to frame a view across a broad section of the river Witham and up past warehouses and other commercial premises to the hilltop cathedral, which is outlined against the sky.⁴¹ After transporting himself and his equipment up the hill, he would logically have next made a view encompassing the huge west front of the cathedral, but this was not possible; the buildings that surround the cathedral precinct and specifically the Exchequergate, which leads into the cathedral close were too near the west front to permit him to frame the whole of it on his glass plate. Instead he entered the precinct and isolated a very small section of the facade to make a symmetrical study of the formidable central doors and their immediate surrounds, with stonework filling the frame from edge to edge (pl. 51). The severity of the emphatic rhythms created by the eleventh-century semicircular repeating arches is softened by a row of statues of Christian kings later inserted into the Norman facade. Flanking the central section, mitered bishops in niches stand guard. Uncommonly for a photograph by Fenton, the image seems as flat as an architect's elevation drawing or a stage set (for a tragedy?), except for the diagonals at the bottom created by the edges of the stone flagging. At the right a man in black leans casually against the building, inconspicuous against the dark stone, but his shadow races across the pavement to end in a silhouette of his arm and top hat on the door. The inclusion of this figure, the same size as the statues above him, both makes clear the scale of the architecture and brings the photograph into the (nineteenth-century) present.

To achieve a more general view of the west facade above the line of statues, Fenton made use of the obstacle that had prevented his making a view of the whole; he stood on the roof of the Exchequergate. Even this vantage point clipped off parts of the church's towers and its sides. He resorted to putting the camera on top of a section of the old city wall, which allowed him to shoot across and over the wall of the bishop's garden in the foreground and make a photograph of the thirteenth-century Galilee porch attached to a corner of the cathedral's south transept (pl. 52). The porch, a more recent structure than the south flank of the nave adjacent to the left, is distinguished in this image, however, not by its more sharply chiseled stone but by the brilliance of the light falling on its southern side and the intensity of the shadows on its west. Because the negative was printed to emphasize

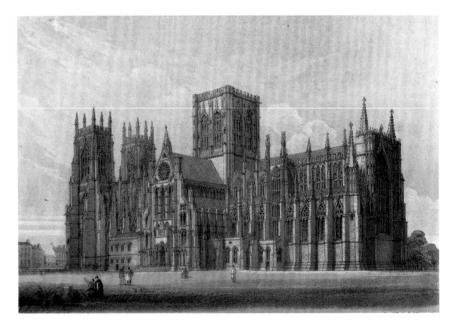

Fig. 39. Francis Bedford, after his own drawing, York Minster, South East View, ca. 1850. Lithograph, 11.5 x 17 cm (4½ x 6 ½ in.). From George Ayliffe Poole and J. W. Hugall, An Historical and Descriptive Guide to York Cathedral and Its Antiquities (York, 1850), second frontispiece. Research Library, The Getty Research Institute, Los Angeles, 90B13661

contrasts of light and shade, the porch stands out sharply in three dimensions against the relatively flatter body and tower of the cathedral. Fenton effectively vivified the inert stonework, making it appear that the porch has an existence nearly independent of the rest of the structure. Extraordinary pictures of this kind could be produced because of several factors always present in the creation of his mature architectural work. He had the ability to choose and frame a precise point of view and the patience to wait for the light to fall so that it best illuminated his subject. And, working before the invention of either light meters or automatic camera shutters, he used his experience and judgment to time an exposure correctly, then carefully printed the resultant negative to extract its maximum expressive power.

Only eight of the ten photographs of Lincoln Cathedral advertised in the Sarum Almanack Advertiser are now known. The four others that we have are an angled view of the south side of the choir with its attached chantry chapels, a straight-on shot of the same subject, a view of the east end of the cathedral, and one of the upper sections of the west facade. 44 On leaving Lincoln, Fenton moved north to York, where he made his last images of ecclesiastical edifices for 1857. It was not his first photographic excursion to that city. During the 1854 expedition to photograph ruined abbeys in Yorkshire he had also made a view of the cathedral York Minster seen from a street called the Lendall, and in 1856 he had published the image as a photogalvanograph. 45 Perhaps for that reason he did not make a distant view of the cathedral in 1857; nor did he photograph the whole of the west front, possibly because of spatial constraints within its boundary railings and traffic without. There is one photograph showing about half the western facade with two gentlemen poised to ascend the steps to the central doors, and another made closer to those doors but with only one figure.⁴⁶

Fenton's most expansive view at York is of the minster from the southeast (pl. 47). Because the photograph was made close to noon, the east sides of the south transept and of the towers are in shadow, but most of the surfaces are sunlit and free of shadows, making them appear flat. Thus the photograph resembles an architect's classical two-point perspective drawing or a nineteenth-century print based on such a drawing. Facilitation of the lithograph of the minster from the same angle made by Francis Bedford in about 1850 (fig. 39). In this medium Bedford was able to alter some of the homelier details of the building, particularly the windows

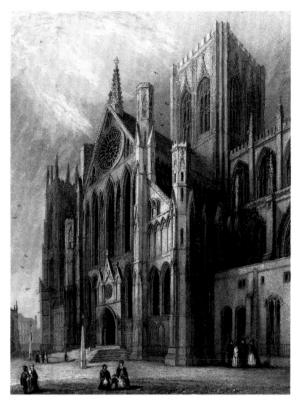

Fig. 40. Benjamin Winkles, after a drawing by Hablot Browne, *Tork Cathedral, South Transept,* 1835. Engraving, 14.7 x 10.9 cm (5¹³/₁₆ x 4⁵/₁₆ in.). From *Winkles's Architectural and Picturesque Illustrations of the Cathedral Churches of England and Wales* (London, 1836–42), vol. 1, pl. 21. Research Library, The Getty Research Institute, Los Angeles, NA5461.W5

of the sacristy adjacent to the transept, to give the cathedral a more uniform overall appearance; he also elongated and enlarged the roofline pinnacles. While Fenton could not alter the particularities of the architecture, he was able to create a counterpoint between the subtle gray tones of the cathedral and the rich black shadows of the crenellated foreground buildings, the details of which were effectively erased. His placement of the great block of the central tower at the right and running all the way up to fill the sheet more closely resembles the composition of a drawing of the south transept by Hablot Browne, reproduced as an engraving by Benjamin Winkles in 1835 (fig. 40), although Browne's drawing was made at a sharper angle to the building, visually compressing its length and emphasizing its verticality.⁴⁹

Both the engraved drawing and the lithograph are animated with figures, while, uncharacteristically, there are no people visible in Fenton's photograph. The existence of several images of this particular aspect of York Minster, in various media and spread over a long period of time, demonstrates not just the durability of certain viewpoints with breadth of view and accessibility to recommend them but their near-inevitability as stances for artists. ⁵⁰ Draftsman, engraver, and photographer all sought, and in their different ways conveyed, the amplitude and grandeur of the cathedral.

In the two other large-scale photographs that Fenton executed on this trip to York, he framed the image so as to separate out a section of the building. One was a view of the whole length of the south side of the choir, the other a view of the chapter house with a fraction of the apsidal end of the church.⁵¹ He exhibited his photographs of York at the Architectural Photographic Association in London in January 1858, along with his studies from Ely, Peterborough, and Lincoln. Nearly simultaneously he placed only one view of each of these four cathedrals in the Photographic Society of London exhibition, to which his major contribution was twenty-two photographs from his other great body of work of 1857, the landscapes he had made in North Wales.⁵²

CATHEDRALS, COUNTRY HOUSES, AND LONDON VIEWS, 1858

If Fenton's architectural preoccupation in 1857 was wholly with cathedrals, in 1858 his subjects were more varied.⁵³ To be sure, he again photographed cathedrals, this time farther west in England at Salisbury, Wells, and Lichfield. The reasons for his choices of cathedrals remain unclear. Why, for example, did he not go to Winchester? Its cathedral is famous and ancient, and the town lies nearer to London than Salisbury, to which it is close, although on a different rail line.⁵⁴ (Fenton's competitors Bedford and Sedgfield also omitted to photograph Winchester.) Near Wells Fenton also worked at the monastic ruins at Glastonbury, returning to a subject type he had not touched for two years and would not revisit for another two. His architectural repertoire expanded to include country houses such as Hardwick and Haddon, where he made several images, and Chatsworth, where he took two. He also continued a series called "Public Buildings and Parks of London." ⁵⁵ In 1858 he became

increasingly interested in photographing the interiors of buildings, a considerable technical challenge given the limitations of his photographic materials and, as Richard Pare has pointed out, the necessity of moving chemicals and paraphernalia close to the spot where the exposure was to be made. ⁵⁶

When Fenton traveled to Glastonbury—a place hallowed since the earliest days of Christianity in Britain and also connected to Celtic legends and stories of King Arthur and his court and of the Holy Grail—he found few standing remains of the great abbey that had once been there. The principal exception was the walls of a small chapel variously associated with Saint Joseph of Arimathea and the Virgin Mary. The interior of this roofless chapel was crowded with ivy rather than parishioners, the exterior encrusted with lichen. Fenton made three photographs of the chapel and three others of the arches of the choir and the remaining two great piers that had supported a tower over the crossing of the abbey church.⁵⁷ His view of the arches where the end of the north aisle met the crossing is as filled with vegetation as with stone (pl. 48). Stray bits of worked stone dot the lawn that covers what was once the floor of the abbey, including one that perfectly anchors the lower right corner of the picture. At the left edge and through the right arch, encroaching trees threaten to invade the ruins. The plinth of grass forms an edge-to-edge horizontal at right angles to the vertical band of stone rising to the top on the right. This formal geometry imbues the photograph with a gravity and tranquillity that seem wholly appropriate for holy ground.

Fenton's working method at cathedrals remained consistent in 1857 and 1858 and for Salisbury, Wells, and Lichfield may be roughly summarized (these descriptions are tallies of the images produced, not a calendar of his operations at each site). While his usual practice was to situate the structure in its landscape by making a view of it from a distance, at Lichfield he did not do so, probably because the topography afforded him no opportunity. But in every case he captured the visitor's initial and perhaps strongest impressions of the church's exterior by creating views of its west front that move progressively closer, usually in three stages with the angle of view varying slightly each time. To these studies he added others of different parts of the buildings, concentrating on the chapter house and the cloister at Salisbury, on doorways at Lichfield, and on exterior sculptural details at Wells.

In the garden at Salisbury that then was the bishop's and now belongs to the cathedral school, a spot that Turner and John Constable had often painted, Fenton dodged the substantial elm trees to obtain three views of the thirteenth-century chapter house, always seen in relation to the fourteenth-century tower. The most successful has the tower placed in the center of the page, rising above a dark block of foliage that masks the separation between the chapter house and the cathedral proper (pl. 55). In a visual collage of spatially disparate elements, one side of the octagonal chapter house directly lines up with the triangular gable of the church's south transept, the roof of which is in turn pasted to the shaft of the tall central tower. The triangular peak of the transept is balanced on the right by the slightly smaller triangle atop a second, southern transept that is mostly concealed by trees. Architecture and trees are united by the broad band of dark grass marked only by the white streak of a path traversing its upper edge. As he had with the park at Ely (pl. 50), Fenton used masses of foliage to balance masses of stone, but in this more densely packed composition he added a powerful if imperfect bilateral symmetry.

Fenton took as many photographs of Salisbury as of any other cathedral. Besides the three in the garden he made a particularly striking image of the south front seen from a distance, in which the tip of the spire, the tallest in England, grazes the top edge of the photograph—a compositional device employed by both Turner and Constable.⁵⁹ There are three studies of the west front, two in the cloister, one at the east end, another of the lady chapel, and three inside the building—one each of the south aisle, the south transept, and across the south aisle and nave to the north aisle. ⁶⁰ While his overlong exposure along the axis of the window-lined, relatively light-filled south aisle produced a somewhat bland view down its length, the far more intense view made diagonally across the long axis of the cathedral, from the south aisle looking through the nave to the north aisle (pl. 56), is perhaps Fenton's darkest photograph (he probably also made negatives that proved too dark to print). The sparse light is widely distributed and of varying intensities. One clerestory window at the top and a tiny segment of its neighbor are visible above the areas of banded light falling on the arcade of the nave. The vertical ribbing of slender composite columns that divide nave from aisles can barely be made out to left and right of the thick composite pier that bisects the image. Bright light illuminates one of the recumbent effigies, half-light another. A muted glow washes across the nave floor to the feet of two more stone catafalques, beyond which rise four softly lit lancet

windows in the north aisle. Fenton has again used a rough bilateral symmetry to structure his image. His interest in interior light, at a time when few other photographers attempted to record it, would continue to manifest itself elsewhere: at Wells Cathedral, Westminster Abbey, and Saint George's Chapel in Windsor Castle, and in country houses such as Haddon Hall and Mentmore, and at the college at Stonyhurst.

Steady concentration over several days must have been required to finish the quantity of work Fenton accomplished at Salisbury. He produced an only slightly smaller number of photographs at Wells Cathedral, taken from a similar range of viewpoints. Two of the north side, one quite close in, show medieval statues in niches that despite being nearly at ground level had survived the depredations of Cromwell's iconoclasts—unlike most in England, which had been defaced, beheaded, or pulverized (fig. 41). It was at exactly the time of Fenton's work that the Victorians began to fill these empty

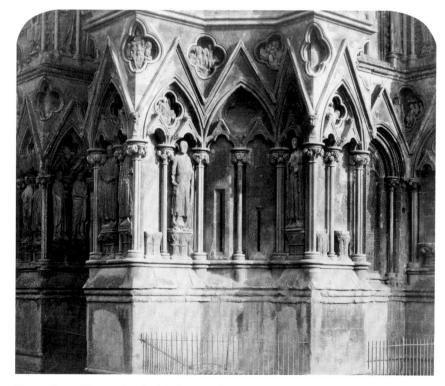

Fig. 41. Roger Fenton, *Detail of Sculpture, Wells Cathedral*, 1858. Albumen silver print, 36.2 x 43.5 cm (14½ x 17½ in.). Collection Centre Canadien d'Architecture / Canadian Centre for Architecture, Montréal, PH1978:0081

perches with new stone ranks of prophets, disciples, bishops, and English and Old Testament kings. This enthusiastic replenishing greatly animated and altered the fronts of cathedrals like Wells and Lichfield, which in Fenton's photographs are both plainer and more planar than they appear now.

At Wells, Fenton again tackled the difficult problem of working with recalcitrant photographic materials in dim interiors. His perennial interest in depicting the light inside buildings may well have originated with his work at the British Museum, which began in 1854 and continued until late in the decade. Many of the museum's galleries, however, had considerably more available light than medieval buildings. In his image of the skylit *Discobolus* at the head of a gallery of Assyrian and Egyptian sculpture, Fenton was able to play the white form of the athlete against the dark frame created by its immediate surroundings (pl. 46). One wonders whether he simply took advantage of existing dramatic lighting or had the statue moved into place expressly for the photograph.

Inside Wells Cathedral Fenton completed three images: one of the lady chapel, another of the windows in the south aisle, and a third that runs the length of the nave to a pronounced and unusual architectural feature, the great "scissor arches" installed in the fourteenth century to steady the columns at the crossing of nave and transepts. The indistinct edges of the shadow indicate that the exposure was exceedingly long. These photographs of Wells had commercial viability. A view of a gateway near the cathedral taken by an unknown photographer incidentally includes a large board leaning against railings that advertises "first class photograph views" of Wells Cathedral, Glastonbury Abbey, and Cheddar Cliffs, made by "R. Fenton, Esq." (fig. 42). 64

At Lichfield, the last cathedral he photographed in 1858, Fenton varied his program. He omitted the view from a distance and devised no interior studies. As often, he made three views of the west front, but all from about the same distance. The remaining images are of three of the cathedral's doorways. There is a single image of a side door on the west front, but more interesting are his photographs of the highly decorated central door of the west front and the door of the south transept. Apparently he used cameras of two different sizes to make a larger and a smaller picture of each doorway. The differences were not only of size but also of proportion and thus breadth of view. The larger format was more rectangular; from the negatives, untrimmed

Fig. 42. Unknown photographer, Sign near Wells Cathedral Advertising Fenton Photographs (detail), ca. 1859. Albumen silver print, 16.3 x 22 cm (6% x 8% in.). The J. Paul Getty Museum, Los Angeles, 84.XO.735.1.147

prints of about 15 x 17 inches could be made. The smaller, close to square, produced untrimmed prints of about 12 x 12 inches. 65 The larger plate necessitated a longer focal length, which implied a smaller aperture and presumably a longer exposure.

In the larger format Fenton produced a perfectly symmetrical photograph, *Lichfield Cathedral, Central Doorway, West Porch*, in which two figures can be seen just inside the partially opened left-hand door of the west front's Early English central entrance (pl. 53).⁶⁶ One appears to be a parishioner, the other a priest. While a single figure would have sufficed to indicate the great

height of the doors (which seem even taller because the floor level inside the cathedral is lower than the outside pavement), the inclusion of two people establishes a modest narrative content. Fenton is demonstrating that the cathedral is a functioning church. The doorway itself was regarded as "one of the most beautiful designs in the country." ⁶⁷ The men are dwarfed on right and left by graceless cement statues of the late 1820s so tall that their heads graze their overhead canopies. (Replacements for older, severely eroded sculptures, they would in turn be replaced by shorter and svelter stone statues in the 1870s.) ⁶⁸ The black interior of the church and the deep shadow under the portal's complex, sharply silhouetted arch both play against the lighter gray of the surrounding stone. In the even more deeply shadowed photograph made with a smaller camera, the left-hand door remains open but there are no figures.

The idea that Fenton wanted to show the cathedral in active use is reinforced by the larger of his two doorway studies of the south transept (pl. 54). Seen only from behind, the man who seems to enter the church is slightly mysterious, despite the fact that he was, of course, posed. His figure and the shadow that hops up the somewhat overexposed steps in the right foreground animate what is an extraordinarily rich print. The dog-tooth ornamentation of the central arch, chiseled from hard stone that weathered more slowly than the soft red sandstone of the subsidiary arches, still appears crisp.⁶⁹

What impelled Fenton to concentrate on exterior doorways at Lichfield, something he did nowhere else, is not known. He might have read in John Britton's book on Lichfield that the south transept doorway was "a fine and peculiar specimen of this style of architecture." By the middle of the 1850s, most English cathedrals had so often and so thoroughly been examined in both prose and picture that few of their external features remained unremarked. The novelty of Fenton's depictions was that they were photographic. They represented the distinguished beginning of a new phase in an ongoing tradition. After spending considerable effort on the photographing of cathedrals in the summers of 1857 and 1858, Fenton gave them up as a subject (with the exception of six views of Southwell Minster completed in 1860).

Great country houses are a subject quite different from medieval cathedrals, but Fenton's approach to both, like his picturesque treatment of monastic ruins, was characterized by a desire to establish the siting of the structure within the landscape. At Chatsworth House in 1858, at Harewood

House in 1859, and at Wollaton and Mentmore at unknown dates, Fenton showed the house from a distance; there are no known prints to establish whether he did so at Haddon or Hardwick. When he arrived in Derbyshire at the celebrated Elizabethan mansion Hardwick Hall, indelibly tagged "more glass than wall," the weather was good, as we know from the open windows and the just-visible laundry spread out to dry on the hedge between the simple wooden fence and a rough stone wall (pl. 69). This view of the house was devised as a diagonal perspective with two vanishing points, allowing the volumes of the building to be easily seen. The fantastic stone cresting along the tower roofs incorporates the initials ES below a coronet—a proud proclamation of ownership by the builder of the house, Elizabeth, Countess of Shrewsbury, who had outlived four husbands of ascending social status. The myriad panes of glass attested to her wealth, since glass was very expensive in 1597 when the house was completed, and houses were taxed partly according to the number of their windows.⁷¹

There are no known interior views from Hardwick, but there are two of the ballroom in nearby Haddon Hall, which was barely inhabited when Fenton visited it, perhaps with his wife. In the garden he made studies of this stately, rambling medieval manor house from six angles, including two from the same vantage point; in the larger of these he posed sideways to the camera wearing a kepi he had brought back from the Crimea. Fenton seems to have had little access to Chatsworth, which is close to Haddon, as only two views of it are known, one of the house from a considerable distance and one looking over a wall at its Italian garden.

Fenton's photographs of Wollaton Hall (in Nottinghamshire) were never exhibited and the date of their making is uncertain, but it was not during his 1858 summer trip, since the trees that partially screen this spectacular example of Elizabethan architecture are bare of leaves (pl. 71). The use of trees to veil a building, a device that unifies the landscape with the architecture, can be considered a descendant of picturesque image making, although the result differs from the picturesque in intention and effect. A highly embellished, formally symmetrical house surrounded by a groomed park is not the same as a ruined castle engulfed by twisted conifers. In this depiction of Wollaton, a wooden fence slides to the right across the foreground and then zigzags sharply back to the left while catching a marvelously subtle silvery light on its rails and pulling the eye deep into the composition. The gleaming facade

of the house moves the eye back to the right, where it comes to rest in the center of the composition. The stonework appears in what John Szarkowski termed Fenton's "low, opalescent sunlight." ⁷⁴ In comparable fashion, Fenton in about 1859 framed a seemingly mist-enshrouded Mentmore through a dense screen of trees, and in 1860 he vignetted with leaves a similarly hazy tower of Windsor Castle in the upper corner of a photograph. ⁷⁵

In addition to his photographs of monastic ruins, cathedrals, and country houses, another major type of architectural image that Fenton made is found in the series advertised as "Public Buildings and Parks of London," which he began in 1857 but probably did not finish until 1858 or even 1859. These were the only substantial group he created in the city, although not his first London photographs. Very early in his career, in 1852, Fenton had exhibited three London views: of Highgate Cemetery, of Hammersmith Bridge, and of Saint Mark's Church, Albert Road, which was under construction near his house in Albert Terrace (fig. 8), and which he later attended. In early 1856 he showed two pictures of Holford House in Park Lane and in addition an image of Saint James's Park in thick fog dated February 1857 and two undated shots of the Zoological Gardens in Regent's Park (also near his home).

Numbers inscribed on the mounts of prints in the series depicting public buildings and parks range from one to fifty-two, and at least one had a variant, so clearly this suite of large-scale pictures was extensive. Unfortunately, only twenty-three images from the sequence can now be securely identified, although there are six unnumbered prints, one with an additional variant, that from their subject material nearly certainly also belong.⁷⁸ Unless there were gaps in Fenton's numeration, there are at least twenty images of London that are now lost, and, sadly, many of the extant prints are not in good condition. Given their commercial potential, it is surprising that Fenton showed only a single image from the series, one of his three views of Trafalgar Square. A sole contemporary advertisement for their sale has been found (fig. 67). Were these products of Fenton's most accomplished period so attractive that those he sold were hung on walls until they faded wholly away? The public structures he chose included the Houses of Parliament, Westminster Abbey, Saint Paul's Cathedral, Somerset House, the Horse Guards, the British Museum, Waterloo Bridge, and Buckingham Palace. He photographed in Kensington Gardens and Hyde Park, where he studied the heroic nude Achilles by Richard Westmacott that is a monument to Wellington and the marble screen by the architect Decimus Burton. Subjects of these kinds did not carry with them the clear and compelling precedents from other graphic media that had informed his views of monastic ruins and cathedrals.

More than half the surface of the photograph that Fenton labeled L. (for London) No. 1 is taken up with the soot-stained fifteenth-century gatehouse of Lambeth Palace on the south side of the Thames, the city residence of the archbishop of Canterbury (pl. 58).⁷⁹ A policeman stands on the pavement with his back to the closed doors of the gateway, watching the photographer. Next to him is a one-horse van that seems to be a delivery wagon, not Fenton's traveling darkroom, unless he used a smaller van in the city than on his long expeditions into the country. If the van is in fact his darkroom, the man next to it would be an employee who doubled as darkroom assistant and driver, and Fenton would have placed the vehicle there to animate the scene. Across the river lie the new Houses of Parliament in the final stages of construction. Visually, palace and parliament roughly balance each other, but the photograph should probably be understood as a juxtaposition of the very old with the very new rather than as an abstract statement about the relation of church and state. Unsurprisingly, Fenton made more images of the New Palace of Westminster (the official name of the Parliament buildings), ranging from details to distant views, than of anything else in London. It was the seat of government at a time when Britain dominated the world and was also an imposing construction project and source of national pride. The vast Neo-Gothic Houses of Parliament, designed by Sir Charles Barry assisted by A. W. N. Pugin, had been under construction for nearly twenty years and would not be entirely finished for another ten.⁸⁰

From a spot very close to his vantage point for the Lambeth Palace gate-house but on the riverbank itself, Fenton made a more comprehensive view of the Houses of Parliament (pl. 59). By calculating the angle of his view so that the length of Westminster Abbey appears as a continuation of the parliamentary buildings, Fenton was able to use the cathedral's west towers to extend the parade of pointed silhouettes and have the church's bulk act as a counterweight to the left of the colossal Victoria Tower. The center of the picture falls exactly at the corner where the facade of the building shifts from sun into shadow. The dark vertical of the tower, topped by scaffolding, is doubled by its reflection in the river, so that it reaches from the foreground

to the sky at right angles to the long horizontal run of the linked church and palace. The exposure must have been short, since the outline of the steam vessel crossing the river is distinct and clouds are visible. The muddy tidal flat on which the tripod sat would soon disappear with the construction in the middle 1860s of the Albert Embankment on the south side of the river.

To make his most distant and atmospheric view of Parliament, Fenton stood on Waterloo Bridge facing upstream (pl. 60). He used the long arc of the chains of the Hungerford suspension bridge (built by Isambard Kingdom Brunel in 1845), which bore pedestrians, not vehicles, to frame his view of Westminster. By rounding the upper corners of the print he eliminated areas of inadequate plate coverage while echoing, in reverse, the curving chains. The dark form of the bridge stands out against the progressively lighter gray tones of buildings receding along the shoreline to the west. These delicately modulated tones are complemented by the striated clouds overhead. This is one of numerous works that demonstrate Fenton's ability to carry the eye into the depths of an image—his mastery of aerial perspective. The composition also makes evident how completely the towers of Parliament and Westminster Abbey dominated this part of London in the mid-nineteenth century and how central the river remained to the life of the city, acting as both an artery and a barrier.

In addition to surveying Parliament from Lambeth and from Waterloo Bridge, Fenton took at least two views along Victoria Street as he approached the west facade of Westminster Abbey, flanked by the parliamentary clock tower on the left and Victoria Tower on the right (fig. 78). There were also at least three studies of the exterior of the new House of Lords: one shows its flank and that of the adjacent, ancient Westminster Hall, and two others concentrate on the Peers' Entrance, both with and without a hansom cab drawn up at the door. There were three if not four views of the main front of Buckingham Palace, inside which Fenton had frequently portrayed the royal family. So

Involved since 1854 in a project to document parts of the British Museum's collections and some of its galleries, Fenton also made two studies of the building's front exterior (pl. 40). To establish a fleeing perspective, he placed his camera so that the sharply raking lines of the entablature of Sir Robert Smirke's Neoclassical facade begin in the upper left corner of the photograph and, with all the other perspectival lines, continue to a vanishing point at the right beyond the frame of the image. The heavy Ionic colonnades encasing the blocky volumes of the museum's two wings and central pavilion pivot

around the stubby, black iron lamppost with which his camera was aligned. The scale of these elements and of the forecourt itself wholly dwarfs the woman and two children who bring life to what would otherwise be an empty, even ominous scene. The only persons who stayed still long enough to register clearly on the negative, they are altogether likely to be Mrs. Fenton and two of her young daughters. Fenton's other view of the museum's exterior, taken straight on and thus more static, is a study of its central pedimented portico. 84 As previously noted, when studying buildings Fenton had always been concerned with establishing them in their context, whether woods, street, lawn, or waterside, but as he continued to make images of city structures he became increasingly interested in depicting urban space for its own sake. For example, when photographing the buildings along each side of Trafalgar Square he took pains to include the square itself, even though that meant diminishing the scale and visibility of the surrounding museum, church, hotel, and office buildings. This interest in space as shaped by architecture would continue to develop in his later work, particularly that done at Harewood in 1859 and at Windsor Castle in 1860.

HAREWOOD, MENTMORE, STONYHURST, AND OXFORD, 1859

Fenton had far greater access to the magnificent eighteenth-century Harewood House in West Yorkshire than had been the case at Haddon, Hardwick, and Chatsworth. When he went to Harewood in 1859 his brother-in-law Charles Septimus Maynard was the estate manager. This connection, and a commission from the Lascelles family to document at least some aspects of their house, made it possible for Fenton not only to survey it from a distance and photograph its terraces but also to make group portraits of its inhabitants on the terraces. His most distant view of Harewood, taken from the south, is more landscape than architectural study (pl. 66). Within an oval format, an irregular dark wreath of foliage opens just enough to show one wing of a building on a slope above a lake that returns barely discernible reflections of house, hillside, and trees. This can be thought of as a view of a Neoclassical house in the picturesque style.

To encompass the whole of the house rather than just a wing, Fenton moved out of the trees and to the right for a view across a meadow and the

Fig. 43. Paul Sandby (English, 1731–1809), $Harewood\ House$, ca. 1785. Watercolor, 61.5 x 87 cm (24 $\frac{1}{4}$ x 34 $\frac{1}{4}$ in.). Reproduced by the kind permission of the Earl and Countess of Harewood and the Harewood House Trust Ltd., HHTP:2001.2.47

lake and up the slope to the house. The photograph was made near the spot from which Turner depicted the same subject for its owners in 1798, but it more closely resembles a watercolor of the same view by Paul Sandby (figs. 43, 44). The picnicking figures in Sandby's meadow are replaced in the photograph by a stout figure on horseback, Fenton's father-in-law, John Charles Maynard, who evidently accompanied Fenton in order to visit his son. ⁸⁶ Whether or not Fenton had seen the works by Sandby and Turner or engravings after them, in this photograph and a variant made nearby he chose to adopt what seems to be the established vantage point from which to show Harewood's graceful integration into the surrounding landscape. ⁸⁷

Then moving to the house itself, he made five studies of the great terrace on its south front that overlooks the lake. The documentation of this recently completed construction, designed by Sir Charles Barry for Louisa, Lady Harewood, wife of the 3rd Earl of Harewood, must have been Fenton's principal commission. From the central door of the south front, which Barry had extensively remodeled, a few steps descend to a landing where stairs branching left and right lead to an upper terrace, and from there two more flights go down to a broad lower terrace. It has a large central fountain and

Fig. 44. Roger Fenton, $Harewood\ House$, 1859. Albumen silver print, 28.5 x 43.5 cm (11% x 17% in.). Reproduced by the kind permission of the Earl and Countess of Harewood and the Harewood House Trust Ltd., HHTPH:2001.1.5

symmetrical box-bordered flower beds filled with anabesques of greenery and pointed topiary. At the edge farthest from the house is a balustrade that bows out in two places to hold benches.

Fenton placed his camera on the upper landing to make two views over this lower terrace and lawn, past a group of shoreline trees, and across the lake to the park from which he had taken his distant views of the house (pl. 68). The highly ordered parterre in the foreground gives way by stages to the comparatively wild woodland in the distance. These views of the lower terrace taken from above differ only in the groupings of various members of the Lascelles family ranged along the balustrade, standing, sitting, or lounging on a bench. ⁸⁹ (How much Fenton directed their poses can only be speculated, but we know that he posed groups in the Crimea, and he may have done so here.) They present a relaxed and charming picture of an aristocratic family at leisure in an expansive setting, in "the perfect middle of a splendid summer afternoon." ⁹⁰ Their forms are echoed by those of the sculpted figures on the fountain, just as its still surface is mirrored by that of the distant lake. Fenton made the people and fountain into visual centers of interest to punctuate his depiction of the terrace rather than relying on the

geometry of the garden alone to structure his composition. It is a wholly satisfying synthesis of natural and shaped landscape.

Fenton's view along the length of the upper terrace is at such an acute angle to the facade of the house that the structure's lateral proportions are indecipherable (pl. 67). The architectural elements include end pavilions with Palladian windows and short connecting wings containing trios of arched windows, flanking a central block where giant Corinthian pilasters alternate with windows in two stories. The central entablature is topped by a balustrade with finial-topped urns that march down toward the horizon. This lavish array of stonework is played against the nearly empty quadrant of sky and the plain expanse of white gravel that floors the terrace. The converging edges of the gravel walk reach a dead end in a dark mass of trees. The face of a man who leans against the terrace balustrade looking out into the distance is averted, but a nearby stone sphinx stares blindly at the camera. One might imagine the man a stand-in for the architect, although his stance seems more ruminative than proprietary. Individually and collectively, the photographs from Harewood represent some of Fenton's finest works in architecture.⁹¹

We know more about how Fenton came to be at Harewood than about the origins of his work at any other country house (unless Windsor Castle can be counted as a country house). It is tantalizing to conjecture that his work at Chatsworth, Wollaton, or Mentmore was also commissioned and that groups of photographs of these places, perhaps in albums, have yet to be discovered. This is particularly the case with Mentmore, the great Rothschild house in Buckinghamshire constructed to Sir Joseph Paxton's designs in the middle 1850s, because the fact that Fenton had access to its interior implies some specific connection to the Rothschild family. Two photographs inside the billiard room are known, one in which Fenton poses alone, leaning over the large billiard table with cue stick in hand, and another made at a slightly different time in which a group of people are posed around the table (pl. 72). The first image was perhaps a test study for the second. 92 In the second, six people, all of unknown identity, act out a scene of indoor domestic amusement. (Are the women who wear hats planning to go outside or are they guests? Is the man at the right an instructor advising the young woman at the table on the pocket to which she should direct her next shot or just a helpful friend or relation? Why is she the only one holding a cue stick?) Although it is rare to find any photographic depiction of people at leisure in an interior or of a domestic interior during this period, it is the dramatic light, with shadows slashing across the floor and onto the tabletops, that makes the photograph astonishing. The plethora of detail contained is also remarkable; for instance, while the woman standing in the doorway at the end of the room appears to be wearing a white cap, it is in fact the top of a marble bust on a mantelpiece in the next room and the reflection of the bust in a mirror behind it. Fenton was able to capture the particularities of all of these objects because, unlike most Victorian interiors, the room was abundantly lit. Originally designed as a conservatory, it had been converted into a billiard room shortly after the completion of the house, without any alteration to the ample window at the far end of the room and those along one side. The photograph seems likely to have been a commission, but whatever the answer to the question why Fenton was given such liberty in an aristocratic household, the result is a work of considerable sophistication and great visual brilliance.

Fenton made another significant interior study during one of his two visits (in summer 1859 or at Christmas in 1859) to Stonyhurst College, a Jesuit institution in his native Lancashire that was housed principally in a sixteenth-century manor house. In the refectory, another room that had large windows running along one side, he photographed students seated at a midday meal, with servants and a priest standing among the tables (pl. 73). This photograph lacks the overall luminescence of the one from Mentmore, however, probably because the impossibility of making dozens of boys sit still for long limited the time of the exposure. His preliminary studies without the students had longer exposures and are more evenly lit. Fenton did not show pictures from Stonyhurst until January of 1860, at which time he exhibited thirteen selected from his two visits, ⁹⁴ a few less than three weeks old, together with a few Lancashire landscapes made on land belonging to the Fenton family that was adjacent to the school.

At the same 1860 Photographic Society exhibition Fenton also showed a series of views of Oxford from the late summer of 1859. He seems to have summarily surveyed many of its colleges, making at least one image each at Wadham, New, University, Merton, Christ Church, and Brasenose. With the exception of a view through a gateway and a streetside study, they are all, predictably, of quadrangles, the most accessible areas of the colleges. For unknown reasons he was granted liberal access at Magdalen and made nine

photographs there in two different size formats, showing quads, gardens, gates, and most memorably the great tower. There are also five views of Oxford's not-quite-finished museum of natural history.⁹⁵

AN ABBEY AND A CASTLE, 1860

If Fenton chose his destinations with upcoming exhibitions in mind, it would have been in anticipation of the Architectural Photographic Association's fourth exhibition in 1861 that he journeyed the previous summer to Furness, on the west coast of England in Cumbria, where the impressive remains of a once-powerful Cistercian abbey stood. Since travel to Furness had been quite difficult until the arrival of the railroad in 1846, ⁹⁶ few prototypes existed in the graphic arts. Fenton completed at least twenty-two different views of the majestic ruins in much the same vein as those he had made at Rievaulx and Fountains, including two backlit studies of two different young girls (possibly two of his daughters) in an archway at the top of a flight of steps. ⁹⁷ He showed seventeen of these photographs from Furness at the Architectural Photographic Association in January of 1861 and three others at the nearly simultaneous exhibition of the Photographic Society in London.

When Fenton went to Windsor Castle in the summer of 1860 he apparently did so on his own, not in response to a royal commission. 98 He was highly productive there, creating at least thirty-one images of the residence at varying distances, often from the surrounding parks, a project that must have required several days. Taken from a wide assortment of directions, the views are mostly of the early-nineteenth-century exterior of the upper castle. The most distant and comprehensive view of the castle complex is that made from the town park (pl. 81). As with his view of Ely Cathedral from the park (pl. 50), Fenton played the dark density of middle-ground foliage against lighter stonework in the distance. Here, however, he used a wide foreground expanse of lawn to emphasize the scale of the castle stretched out along the horizon. (Had he moved closer he could still have encompassed the entire building, but the tree would have loomed larger, interrupting the castle's skyline and making it appear smaller.) Of the tiny figures sprinkled across the middle distance, only the two dark-clothed men in the center, backs to the camera, are likely to have been asked to pose. A minor turret of the

overly regularized facade (by Sir Jeffry Wyatville) falls at the center of the picture; the greater bulk of the building, on the left, is roughly balanced by the masses of the round tower and tree to the right. In an elegant, subtly modulated composition, Fenton summarized this quintessential British monument.

Within the lower precinct at Windsor, Fenton made four views. Two look uphill along the side of Saint George's Chapel toward the ancient round tower that dominates the castle complex; one shows the chapel alone; and another looks back downhill from the foot of the tower (pl. 83). At first glance this last image seems empty of people except for a ghost figure at the right, but a closer examination discovers a whole troop of soldiers lined up as if for inspection in the distance near the perimeter wall. Beyond the wall are the rooftops of the town, and even farther away lies a hazy line of low hills. It is no wonder that contemporary reviewers commended Fenton's mastery of aerial perspective. 99 The foreground clarity gradually dissolves, diminishing in delicate shades of gray into the farthest distance. Well exemplified in this image is the way Fenton's considerable experience photographing landscape informed and influenced his treatment of buildings and their relation to their settings. Although stonework frames the picture at right, left, and bottom, the principal subject is as much the shaping of external space by architecture as the architecture itself.

Both views looking back uphill to the round tower are so animated with figures deployed on the slope that the architecture and the contours of the space became somewhat subordinated to them (pl. 84). This effect is enhanced by the anomalies of the photographic materials, which make the spectators in their dark clothing appear more substantial than the buildings around them. Four Grenadier guards, two other soldiers, and eighteen men, women, and children are scattered up the roadway, along a path that veers to the left, and at the entrance to Saint George's Chapel; all of them face the camera. The Fenton's ability to elicit the cooperation of two dozen people (only one of whom visibly moved) depended to some extent on the fact that by 1860 exposure times in broad daylight were short, and to a considerable extent on his possession of persuasive powers even outside the courtrooms in which he appeared when intermittently practicing law. Still, why he asked them all to turn toward the camera is a puzzle. A great deal of detail is conveyed in the image; it even is possible to see, although very dimly, swaths in

the grass that appear to show the direction in which it had been mowed. While the recession of planes is less than perfectly balanced, the photograph is nonetheless one of Fenton's best.

Although his thirty-one Windsor pictures would seem to have represented considerable potential for sales, Fenton entered none of them in the Architectural Photographic Association show in January of 1861 and displayed only two in the concurrent exhibition of the Photographic Society. He had been instrumental in founding that organization and for seven years had made steady contributions to its shows, but this was the last in which he placed his work. In the International Exhibition of 1862 he showed examples of his landscapes, a work for the British Museum, an Orientalist image, and some architectural studies, including one Windsor picture. It was the last time he ever exhibited. 102

Fenton's architectural work took considerable sustained effort to accomplish, not least the planning and carrying out of extensive travel at a time when such was far from smooth. Discernment in choosing desirable buildings to photograph, judgment in assessing specific sites immediately on arrival, and ingenuity in fixing on appropriate vantage points and camera placements were all necessary for achievement of his compositional intentions. Agility was occasionally required for hoisting his cumbersome equipment into place, and from 1853 forward, after he had adopted the wet-collodion-on-glass

process, speed was a necessity. Above all Fenton needed patience, much patience, when waiting for the sun to arrive—if it arrived at all, given the exigencies of the British climate—at the place where it best illuminated his subject. Once safely home with his fragile glass negatives he employed his considerable technical skill to produce prints of great finesse, with rich tonal values and subtle gradations of gray.

Fenton's great steadiness of purpose, as resolute as that of his Lancashire forebears, produced a formidable body of architectural work diverse in subject, effect, and mood: from bold to contemplative, from pastoral to urban. Collectively these pictures celebrate the accomplishments of generations of British architects and builders. His gaunt arches and tumbled stones of ruined abbeys, his scarred and weathered cathedrals bear witness to enduring faith, passing history, and devouring time. Fenton depicted English prosperity and pride, as embodied in country houses, and patriotism, as reflected in the urban monuments of London, capital of the mid-nineteenth-century world. The figures that animate these images filled with stone, sky, and vegetation insinuate a modest narrative that softens the pictures and makes them more approachable. Fenton's photographs of architecture form the most important component of his extraordinary photographic career. A man of acute visual intelligence and perseverance, he truthfully and with great sensitivity translated the three-dimensional solidity of architecture onto the surface of the page.

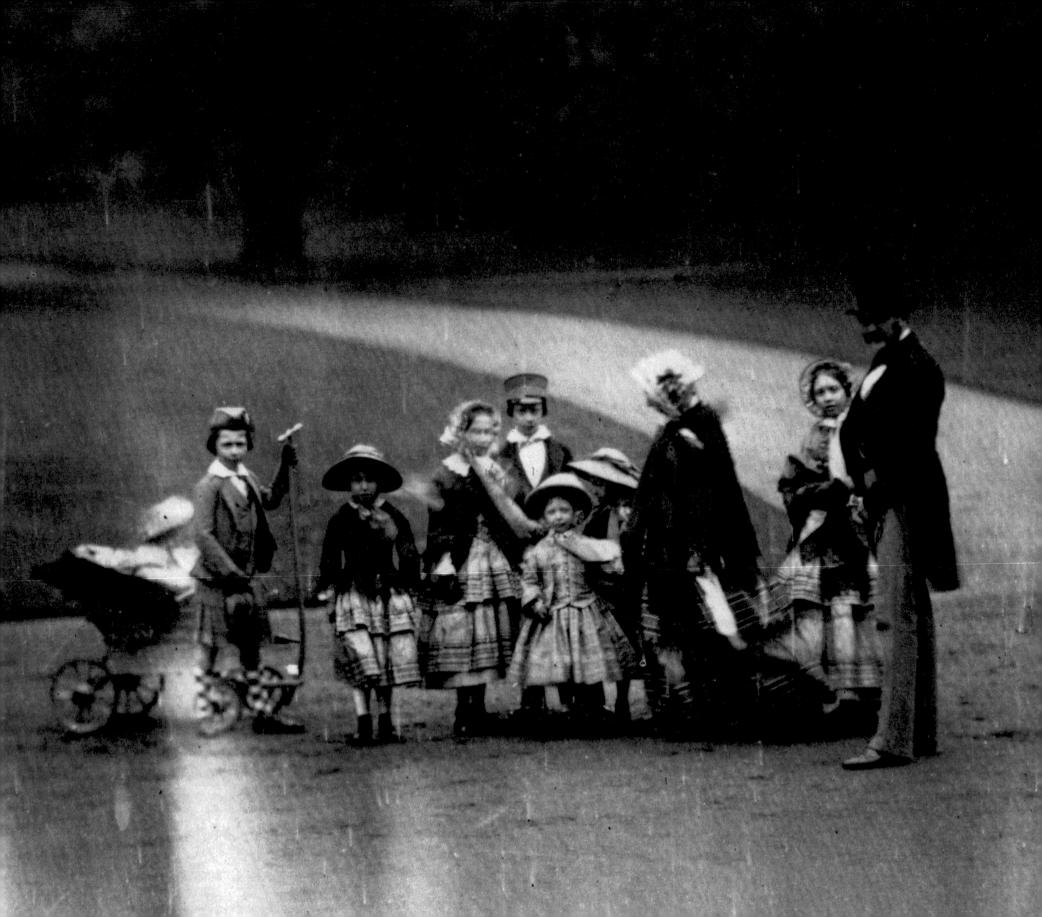

"Mr. Fenton Explained Everything": Queen Victoria and Roger Fenton

ROGER TAYLOR

The first few days of 1854 opened memorably, with heavy snowstorms and some of the coldest weather in living memory. In London the entire city gradually fell silent as deepening snow brought traffic to a halt. The adventurous braved the weather and went skating in Regent's Park, but during the nights it became so cold that two constables from the metropolitan police force froze to death while on duty. Some twenty miles to the west, Queen Victoria and Prince Albert awoke on January 3 to find the windows of Windsor Castle covered with icicles following a night that brought "twenty one degrees of frost." Despite the weather and the hazardous state of the roads, they "wrapped up well in furs" and left for London, driving "at once to Suffolk Street to visit the Photographic Exhibition." They were met by a small party including Sir Charles Eastlake, president of the Photographic Society, and Roger Fenton, the honorary secretary, who, as the queen remarked, "explained everything." The two men had been nominated by the society as the most suitable members to elucidate "the artistic and the practical sides of the art." During the course of the visit, which lasted more than an hour, Fenton drew upon examples of his own work and that of others to illustrate the latest advances.3

In June 1853 Queen Victoria and Prince Albert had agreed to become patrons of the newly formed Photographic Society, and their support proved crucial in making photography socially acceptable. Their visit to the inaugural exhibition, especially under such hazardous conditions, demonstrated that they were committed to the society and that they would continue their active patronage. Most likely a key figure in the planning and organization of

Opposite: Fig. 45. Roger Fenton, The Queen, the Prince, and Eight Royal Children in Buckingham Palace Garden, May 22, 1854 (detail); see fig. 10

the visit was Dr. Ernst Becker, an accomplished amateur photographer himself, a founding member of the Photographic Society, librarian to Prince Albert, and assistant tutor to the young princes. Fenton and Becker would have known each other, perhaps well, through the Council of the Photographic Society, on which both had served from the outset. At a time when all official communications with the royal family were ruled by etiquette and protocol, Becker's role as an informal link between the court and the society should not be underestimated.

Fenton's debut performance for the royal family undoubtedly gained their confidence, for within a month he began a series of photographic portrait commissions, chiefly at Buckingham Palace and Windsor Castle. His appointment was one of the first in a wider program of photographic activity begun in 1854 by Queen Victoria and Prince Albert. From that year on, prints were regularly purchased for the Royal Collections, either directly from photographic exhibitions or through established London print dealers, who were then adding the work of British and Continental photographers to their inventory. With photography becoming acceptable as an ideal "rational recreation" for young gentlemen, Becker made the subject part of the curriculum of Edward, Prince of Wales, and Prince Alfred, ordering regular supplies of chemicals, glass, and paper for their lessons. Such was the newfound enthusiasm for photography that a portable darkroom and photographic portrait room were installed in both Buckingham Palace and Windsor Castle. A camera was even mounted on the superstructure of the royal yacht Victoria & Albert.8 This new interest received frequent coverage in the popular press.9 Given the rapid development of photography in Britain during the early 1850s, it is easy to see why Queen Victoria and Prince Albert were attracted to the medium. What it offered could be used

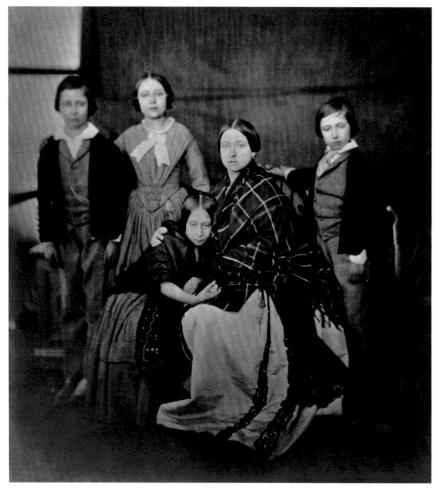

Fig. 46. Roger Fenton, *The Prince of Wales, Princess Royal, Princess Alice, the Queen, and Prince Alfred, February 8, 1854.* Carbon print copy of original albumen print, $21.9 \times 19.7 \text{ cm}$ (8% x 7^{3} /4 in.). The Royal Collection © 2004, Her Majesty Queen Elizabeth II, RCIN 2900013

for many desirable purposes: art, science, recreation, documentation, family records, and the efficient distribution of their portraits to the four corners of Europe. In return the royal family offered photography their patronage, giving it a status and authority that led to its speedy acceptance in fashionable circles. It was the perfect symbiotic relationship.

In 1854 Fenton received no less than a dozen separate photographic commissions from the royal couple, some of them complex and others involving just a single sitting. It was by far his most productive year in this regard, for although he continued to photograph for the royal family in 1855 and through

1857, his output during those years was significantly less. His first commission was prompted by a performance of Les deux petits Savoyards given by the royal children on January 16.10 The young actors were dressed in eighteenth-century costume, and although the Prince of Wales had been "painted" by his father "to look quite hideous," everyone involved was "very happy" with the outcome. 11 A week later, on January 23, this picturesque performance was restaged for the camera, as the queen noted in her diary: "Mr. Fenton photographed the children in their costumes." 12 It was undoubtedly a tricky undertaking, since the portraits had to be made in an improvised studio indoors, in such light as was available. In midwinter these circumstances invariably meant long exposure times that went against the natural inclinations of very young children unfamiliar with striking a pose and keeping still. But somehow Fenton succeeded, although Princess Helena, aged seven, had to be placed on a plinth to bring her up to the height of the camera. 13 This series of portraits is among the earliest to commemorate an event in the life of the royal children. For the remainder of their married life Queen Victoria and Prince Albert regularly engaged photographers to document such noteworthy moments and even extended the custom to include portraits of Highland servants, favorite pets, and farm animals.¹⁴

In a life crowded with historic events and significant moments, it may seem surprising to find Queen Victoria laying such emphasis on the anniversaries and birthdays that marked the passage of her own life. These were never overlooked and were invariably celebrated with some small occasion to mark the day. This fondness for family celebrations is actually quite understandable, however, for the queen's own upbringing had been lonely and occasionally difficult, and the immorality of her immediate forebears had brought little but disgrace to the monarchy. Rejecting her unhappy past, she chose to build her life on a foundation of idealized love and family values. Throughout her long reign she held fast to these ideals, becoming a principled role model for the nation and in the process reforming the way in which the monarchy was perceived by its subjects.

The anniversary of the queen's marriage to Prince Albert, that "ever blessed day," was so important to her that she always celebrated it twice, first on February 8, the day he had arrived at Buckingham Palace from Germany, and again on February 10, the day of the wedding itself. To commemorate the fourteenth anniversary of Albert's arrival Fenton was commissioned to make a

series of portraits of the royal couple and seven of their eight children, the exception being Prince Leopold, who was then just nine months old. Although the photographs were taken at Windsor Castle on January 25, 1854, the entire series of fourteen portraits is dated February 8. The most telling portrait, one that reveals how she wanted to be remembered by her family, shows the queen surrounded by her four eldest children (fig. 46). Dressed simply, without ornament or embellishment, and with a plaid shawl around her shoulders, she has shed the aura and trappings of monarchy to appear as a conventional wife and mother.

On February 10 the royal couple's fourteenth wedding anniversary was "ushered in with music and the never failing tender love of my beloved Albert." Later that morning, after the exchange of presents, they read through their marriage service together, and the queen was reminded of her promise "to love, cherish, honour, *serve & obey.*" In the late afternoon the couple went to the Rubens Room, "where the Children had kindly arranged a charming surprise," a complex series of tableaux vivants that relied upon the combined skills of Edward Henry Corbould, historical painter and court artist; Mr. Gibbs, the principal tutor; and Miss Hildyard, the children's governess. The first four tableaux were freely based on James Thomson's celebrated

poem *The Seasons*, which had remained popular with the public for well over a hundred years. For the fifth tableau, the grand finale, additional verses were specially commissioned from Martin Tupper, author of *Proverbial Philosophy*, a sugary book of homespun truths and homely beliefs. To the relief of all, the royal children recited their verses clearly and without faltering, and everything was carried off to perfection.

Some time later, Fenton photographed the children reenacting the tableaux complete with costumes, props, and telling theatrical gestures. But the scenery of the original performance was replaced by rumpled backdrops and draped sheets that make the photographs look amateurish and incomplete. This mattered little, however, since the photographs were never intended to be seen in that form: much grander things had been planned for them. For the queen's birthday on May 24, Prince Albert proposed to give his wife a "crimson velvet portfolio" containing five watercolors by Carl Haag that would reproduce scenes from the tableaux with extracts from the relevant poems elegantly inscribed beneath. Because Haag had not seen the performance, Fenton's photographs were to be used as figure studies for his watercolors. In this way the artist could re-create the sense of the original tableaux and people them with recognizable portraits rather than mere

Fig. 47. Roger Fenton, *The Princess Alice as "Spring" in the Tableaux Represented February 10, 1854*, winter or spring 1854. Salted paper print, 18.6 x 14.5 cm ($7\frac{5}{16}$ x $5\frac{11}{16}$ in.). The Royal Collection © 2004, Her Majesty Queen Elizabeth II, RCIN 2900024

Fig. 48. Carl Haag (German-born, active in Britain, 1820–1915), The Princess Alice as "Spring," winter or spring 1854. Illustration for James Thomson, The Seasons. Water-color painted over Roger Fenton's salted paper print of figure, $36 \times 45 \text{ cm} \left(14\frac{4}{16} \times 17^{11} \text{/16} \text{ in.}\right)$. The Royal Collection © 2004, Her Majesty Queen Elizabeth II, RCIN RL 31944

pastiche representations of the seasons. At least one of the figures from Fenton's photographs was carefully cut out and pasted onto Haag's imaginatively composed background, where it was painted over to look like a watercolor (figs. 47, 48). Tracing the genesis of this idea from inception to completion allows us to understand these otherwise somewhat puzzling photographs of Fenton's in a logical context: they should be regarded not as finished studies in themselves but as one stage in a grand scheme—the straightforward means to a sophisticated end.

Fenton's photographs of the royal family might easily be mistaken for portraits of any aristocratic or upper-class family, for they are images not of a sovereign but of a couple absorbed by their children. All traces of court life at Buckingham Palace and Windsor Castle have been set aside in favor of a vision of domestic bliss and familial harmony. These intensely personal images, made exclusively for the royal family, are far removed from both the routines and the brilliance of the British monarchy. Queen Victoria's household was in fact a many-splendored thing, with an elaborate hierarchy of ancient titles and designations that were not quite in keeping with the "modern world" of the mid-1850s. They included a Lord Chamberlain, an Earl Marshall, Ladies in Waiting, Pages of Honour, a Keeper of the Privy Purse, a Mistress of the Robes, and Ladies of the Bedchamber, each playing his or her part in the complex panoply of state.¹⁸ The social cement that held everything together was a powerful blend of lineage, education, etiquette, and exquisite manners. Only an extremely small number of individuals were ever admitted to the court, and even fewer were presented to Queen Victoria or Prince Albert. It helped if one belonged to the select group collectively known as the "Upper Ten Thousand," which comprised those of hereditary rank, members of Parliament, and the higher grades of legal practitioners, military and naval officers, civil servants, and clergy. 19

The first photographic insight into this aspect of life at court came on May 11, 1854, when Fenton made a series of four portraits of the royal couple at Buckingham Palace immediately after their return from a "Drawing Room" held in the throne room of Saint James's Palace. A formal, stately affair, the Drawing Room was conducted according to strict protocols and procedures that governed the way individuals were formally presented to the queen. ²⁰ In keeping with the significance of the occasion, the queen wore "a train of green and white brocaded silk, trimmed with white tulle and blonde,

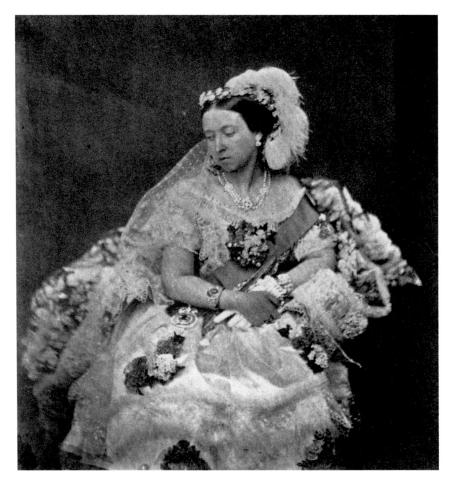

Fig. 49. Roger Fenton, *The Queen in Her Drawing Room Dress, May 11*, 1854. Carbon print copy of original salted paper print, 19.5 x 15.9 cm ($7^{11/16}$ x $6\frac{1}{4}$ in.). The Royal Collection © 2004, Her Majesty Queen Elizabeth II, RCIN 2906518

and bunches of violets and pink and white May blossoms," a motif that was carried through in her hair ornaments, which featured diamonds intertwined with blossoms. The most striking of the portraits made that afternoon shows the queen seated seemingly in a cloud of tulle and lace, her hands clasped in repose, one glove removed to reveal a bracelet mounted with a portrait of Prince Albert (fig. 49). Although she is placed foursquare to the camera, her head is turned aside and slightly downward in a fittingly demure and thoughtful pose. In the soft, flattering light of a mid-May afternoon, Fenton has created a regal portrait suggestive of the queen's dignity and authority and perfectly in keeping with the nature of a Drawing Room,

where these qualities, on public display, would have been highly valued, respected, and commented upon. Commissioning Fenton to make such a portrait was a conscious act and marks the moment when the queen decided to reveal herself before the camera as a sovereign rather than as a wife and mother. Her decision hints at her increasing awareness that photography could be harnessed to wider ambitions, and in fact this photograph would be among the first of countless images portraying her as a supremely powerful monarch, the architect of European dynasties, and Empress of India.

By midsummer of 1854, Britain's alliance with France in the war against Russia was being played out in the hostile environment of the Crimea, where the first signs of the toll taken by military incompetence and cholera were beginning to be evident.²² After forty years of peace, the army was ill prepared, ill equipped, and lacking the skills necessary to conduct a war three thousand miles from home. Nevertheless, the greatest danger to the men came not from warfare but from disease. For Queen Victoria, in whose name the war was being fought, this state of affairs was both shocking and deeply distressing. Her interest in the course of the war and the welfare of "her men" intensified with each passing month. Prince Albert believed that the conduct of the army was nothing short of scandalous. In a memorandum he noted that there was "no general staff or staff corps . . . no field commissariat, no field army department; no ambulance corps, no baggage train, no corps of drivers, no corps of artisans; no practice, or possibility of acquiring it, in the combined use of the three arms, cavalry, infantry, and artillery."23 Meanwhile, at home the nation was roused to new levels of patriotic fervor by the popular press. Every week the Illustrated London News carried fresh accounts of the war, accompanied by maps and engravings that diverted public attention from the grim realities of combat.

When Queen Victoria and Prince Albert posed for Fenton on the morning of June 30, the conduct of the war and the rapidly declining health of the army are likely to have been uppermost in their minds (fig. 50). They appear side by side on a sofa, the queen dressed simply in a flowered day dress and morning cap trimmed with ribbons, and Albert in a morning coat with a patterned waistcoat. The queen sits upright and, with her head turned away from her husband, seems isolated from him, as if preoccupied by larger events. Prince Albert adopts a gentler pose. His outstretched arm and inquiring gaze clearly reveal his concern for his wife, but despite his gesture this remains

an unsettling portrait of the royal couple. However, the queen declared it a success and commissioned Haag to hand-color the print for posterity.²⁴

This occasion, the last on which Fenton photographed either Queen Victoria or Prince Albert, effectively marked a change in his relationship with the royal family. It was not that he suddenly fell out of favor but rather that other photographers became more assertive, eroding the special nature of his relationship with the royals. The situation was not helped by Fenton's five-month absence in the Crimea, for which, after all, he had been given a letter of support from Prince Albert.²⁵ With their new and intense interest in photography, it was

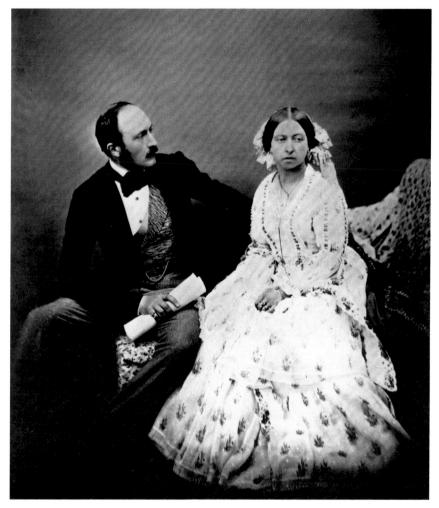

Fig. 50. Roger Fenton, *Queen Victoria and Prince Albert, June 30, 1854.* Carbon print copy of original salted paper print, 22.7 x 19.4 cm ($8^{\frac{15}{16}}$ x $7^{\frac{5}{8}}$ in.). The Royal Collection © 2004, Her Majesty Queen Elizabeth II, RCIN 2906529

inevitable that the royal family would commission other photographers in his absence.²⁶ Once under way this process proved irreversible, and Fenton never again regained the status he had enjoyed throughout 1854.

Fenton's time in the Crimea proved to be the experience that brought him to full maturity as a photographic artist, and once the body of work from that trip was published and widely circulated it confirmed his reputation as one of Britain's preeminent photographers. How ironic then that at the very moment when his reputation was at its highest, his work for the royal family had become intermittent and lacked its earlier evident purpose. ²⁷ On those few occasions when his services were requested, however, the photographs he made are more assured and complete within themselves. A very apparent difference was in size; Fenton adopted a much larger format for portraiture. The shift from a negative approximately 8 ¾ x 7 ¼ inches to one approximately four times the size, 18 x 15 inches, reveals his total command of his equipment and materials.

At Osborne House, on the Isle of Wight, where the royal family and court passed part of the summer, Fenton made a portrait of the two eldest princesses—Victoria, Princess Royal, and Princess Alice—sometime in mid-August 1855, using this large format for the first time (pl. 27). ²⁸ The sisters were photographed seated on a cast-iron garden bench and dressed in outfits rather elaborate for outdoor pursuits that reflect their status as the two eldest daughters of the queen. A portrait of two sisters with less than three years between them, it reveals the princess royal on the threshold of womanhood, confident, self-assured, and doubtless looking forward to accompanying her parents to Paris on a state visit to the French emperor in a few days. Her younger sister, despite all efforts to dress her as an adult, remains a twelveyear-old girl prone to childhood illnesses and sensitive to living in the shadow of an elder, favored sister. Poor Princess Alice looks dejected, as well she might, for she was recovering from a bout of "scarletina" that in late July had laid her low with a fever and rash.²⁹ Dressing up and going outdoors for a photograph must have been a trial, but one that she endured. With downcast eyes and tiny ankles resolutely crossed to keep absolutely still, she leans toward her elder sister for support and comfort, perhaps wishing Fenton would hurry and get it over with.

The following year, in September 1856, Fenton made a photographic excursion to Scotland, venturing as far north as Balmoral and Braemar.³⁰

Whether he undertook the journey at the request of the royal couple, for whom Balmoral Castle and all things Scottish held special appeal, or under his own initiative remains unclear. What is known is that Fenton received a royal commission during his time in Balmoral and made a series of eight negatives expressly for the queen, among which are a group of portraits that perhaps rank among his finest work.³¹ The most striking of these was another double portrait, this time of Princess Helena and Princess Louise, who, despite being dressed as twins, were ten and eight years old respectively (pl. 28). Fenton selected his setting with great care, knowing that he would be faced with the difficult task of photographing relatively young children using his largest-format camera, which because of its size made every aspect of the operation even more complex and demanding. He used as a backdrop an angled grassy bank that rose almost vertically like a wall behind the sitters—an inspired choice, since it gave the girls additional support without being obtrusive. Princess Louise is perched on a boulder that has been partially covered with a tartan shawl to mask its presence. Her feet are tucked up so that she sits comfortably at rest, her hand touching the bank to help her maintain her balance. Her elder sister stands unaided and remained motionless throughout the long exposure. At her feet an upturned stool firmly anchors the composition but inserts a puzzling innuendo, presenting itself as a metaphor open to a number of interpretations. Fenton's decision to include this provocative element says something about his self-confidence as a photographic artist. This small group of portraits made at Balmoral during the autumn of 1856 is his last known commission for the royal family (see also pls. 29, 30). In January 1857, three years almost to the day since he had first met Queen Victoria and Prince Albert, it seems that Fenton was asked to return his commissioned negatives of the royal family, which then came under the care of William Bambridge, the queen's photographic printer in Windsor. Fenton packed the negatives carefully in two specially built wooden boxes.³² One wonders what thoughts passed through the photographer's mind as he watched them being trundled away from his premises at Albert Terrace.

We have seen what Fenton made of the royal couple and their children, but what might they have thought of him and his work, and why was he given such privileged admittance at a time when access to the royal family was rigidly controlled by protocol and etiquette? Doubtless his place on the Council of the Photographic Society was a clear indication of the regard in which he was held by colleagues, and informal reports from the trustworthy Dr. Becker would have allayed any residual doubts. Although he was not among the Upper Ten Thousand, Fenton's family and connections in Lancashire were sufficiently notable and influential to ensure his acceptance. Crucially, Fenton belonged to a group of young men whom the queen and Prince Albert found irresistible: the scientists, artists, authors, musicians, engineers, surveyors, physicians, explorers, and others whose talent and mastery of a field of endeavor gave them an appeal transcending the usual social hierarchies. In one way or another they were all members of a burgeoning class of professionals whose sphere of influence lay beyond the traditional realms of church, politics, and judiciary. These

were the rising stars of Victorian Britain. When photography began to exert its influence in the years immediately following the Great Exhibition of 1851, its practitioners were convinced that they had to professionalize themselves if they were to survive in the brave new world taking shape. What better way to do this than through the formation of a Photographic Society, where the free interchange of information and the mounting of annual exhibitions would become the means of their elevation? It is in this setting that Fenton came fully into his own. And the planets lined up in his favor on that snowy January afternoon in 1854, when his explanation of photography's inner workings and visible aesthetics encountered a receptive audience willing to set aside social convention and engage him as an artist of the camera.

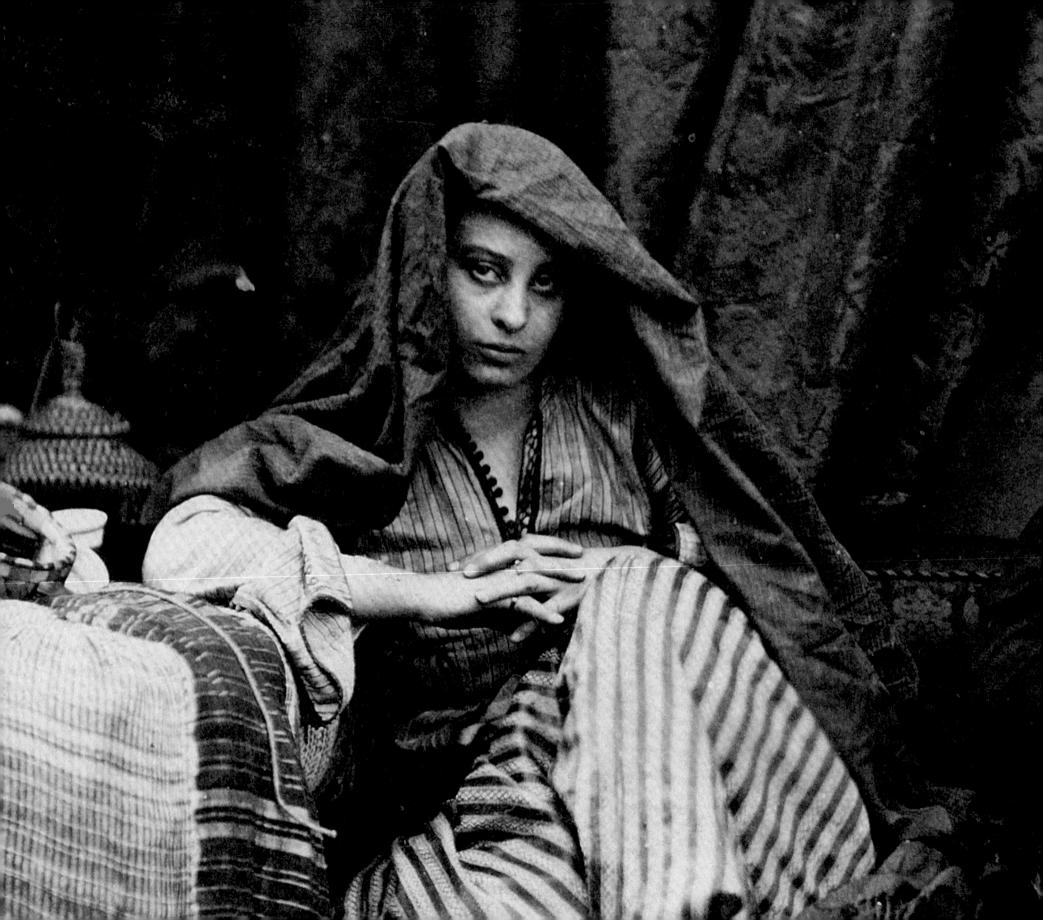

"Trying His Hand upon Some Oriental Figure Subjects"

GORDON BALDWIN

Tenton's continual quest to raise photography to the status of a fine art Ied him to appropriate the subject matter of painting: most notably and consistently landscape, but also, briefly, both still lifes and genre scenes. His interest in making photographs that had storytelling content or elements of masquerade was perfectly aligned with the Victorian passion for staging tableaux, dressing in costume, and otherwise attempting to escape the constraints of the ordinary. Flight from the mundane was one of the motives underlying the phenomenon known as Orientalism, which in the visual arts was essentially the depiction of scenes of life in a Near Eastern world far more imaginary than actual. Fenton was familiar with the work of a number of French and British artists—most notably Eugène Delacroix, David Roberts, and John Frederick Lewis—who in paintings of the 1840s and 1850s pictured a life in the Near East characterized by visual splendor, indolence, luxury, sensuality, exotic ritual, and barbarism.1 Fenton's foray into this collective fantasy of Oriental life is one more instance of his adaptation of the subject matter of painting to photography.

DRESS REHEARSALS

Well before he carried out his suite of about fifty Orientalist pictures in his London studio in mid-1858,² Fenton made pictures of himself and members of his family assuming identities other than their own. The earliest example is the appearance of his wife, Grace Elizabeth, as a stand-in for a medieval pilgrim in two photographs taken at Rievaulx in 1854 (see above, p. 59).

a narrative in his London studio. One of his daughters gazes pensively over the cradle of a sleeping infant while another buries her face in her mother's lap (fig. 53). The work's traditional title is *La Faute*; does this refer to a mistake or to a moral fault? In one possible interpretation, consistent with one meaning of *faute*, the infant is a child born out of wedlock to the apparently grief-stricken girl who hides her face. But this would make Fenton a more daring storyteller than seems to accord with his generally conventional

character, and is it likely that he would have cast one of his daughters as an

In an enigmatic photograph, Fenton posed members of his family to enact

Opposite: Fig. 51. Roger Fenton, Orientalist Group (detail), 1858; see pl. 63

Another kind of make-believe, although uncostumed, takes place in a set of four photographs of his sister-in-law Sarah Jefferson Maynard and Jack Stayplton Sutton, arranged to illustrate the happy progression of a courtship.³ When exhibited in 1855 the series was called A Romance, with individual titles like *Popping the Question*; but since the models were in fact engaged or perhaps even already married, the degree of playacting was minimal. More notable examples of masquerade are Fenton's self-portraits in the uniform of a French Zouave, which he made in 1855 while in the Crimea. In an improvised studio with a fur rug on the floor he posed in a borrowed uniform, seated on the sheepskin-lined overcoat of a captured Russian officer (fig. 52). In the several images he used various masculine props—tankard, wine bottle, rifle, pipe. Since Fenton had surmounted great obstacles to document the activities of the troops and had shared their considerable hardships, his wish to identify with them was not surprising. When he exhibited any of these self-portraits as part of his Crimean oeuvre he simply titled it Zouave, 2nd Division, leaving it up to the initiated to recognize him. It is only when the viewer knows Fenton to be the sitter that the playful nature of the poses becomes evident.

unwed mother? We lack the key to the picture's meaning. Whatever the story, clearly the intention was to make a photograph with narrative content, like genre paintings of the period.

THE CAST

Of the nearly fifty images that make up Fenton's Orientalist suite, he appears in only two (perhaps because he was usually too busy behind the camera to appear before it). In one of these, *Pasha and Bayadère* (pl. 62), he appropriately cast himself as the most powerful figure, the pasha. But any pasha has retainers or companions; uncovering the identities of the other members of the cast will help us determine what they contributed to their roles.

The discovery that a group of Fenton's Orientalist photographs once belonged to the English landscape painter Frank Dillon (1823–1909) led to the realization that Dillon frequently figures in the photographs. In Pasha and Bayadère he plays the musician to Fenton's pasha, and he appears as one of the actors in at least ten other images (pls. 63, 64). He is also seen alone in two costume studies and two other solo poses (figs. 54, 55). Four years younger than Fenton, Dillon began exhibiting at the Royal Academy at the same time Fenton did. Both showed there in 1849 and 1850, and these may have been the events that first brought them together. Most relevant for the making of Fenton's Orientalist suite is that Dillon, an inveterate traveler, spent the winter of 1854–55 sailing up the Nile and during that time made numerous watercolors at Thebes, Luxor, Karnak, Aswan, and elsewhere.8 Although he is better known for his landscapes, titles like Arabs Resting at Asouan, Figures on the Outskirts of Asouan, and A Group of Arabs at Luxor make it clear that he closely studied the appearance—including postures and body language—of people in the Islamic world.9 In 1856, 1857, and 1858 he exhibited paintings drawing on his first Egyptian expedition at the Royal Academy, where Fenton no doubt saw them. When Fenton enlisted Dillon in the making of the Orientalist suite in 1858, Dillon brought with him considerably more knowledge of the Near East and the behavior of its people than Fenton possessed.¹⁰ There is even a possibility that the project was suggested by Dillon, but whatever its genesis, the painter's experience undoubtedly informed the posing of figures for the photographs.

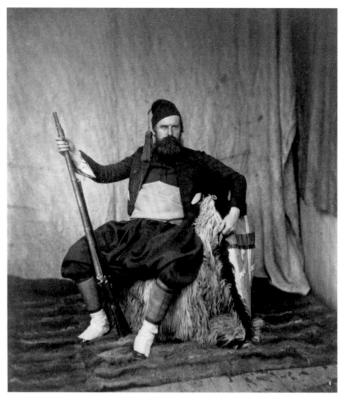

Fig. 52. Roger Fenton, Self-Portrait as Zouave, 2nd Division, 1855. Salted paper print, 19.2 x 15.9 cm (7%6 x 6% in.). Wilson Centre for Photography, 97:5626

Another person who may appear in a few of these photographs is the photographer Gabriel de Rumine (1841–1871), a Russian whose aristocratic family had settled in Lausanne. In an album that includes six of Fenton's Orientalist photographs, one of them has inscribed below it the title *Coffee Making* and written next to it in the same hand, "The Slave Gabriel de Rumine." One problem with this identification is that the figure in the photograph (visible only obliquely) seems to have a beard heavier than likely for a man of seventeen. De Rumine was certainly precocious in his activities, if not his physiognomy, since in 1858 he became a member of the Société Françaisé de Photographie and set off in October with Grand Duke Constantine, a brother of Czar Alexander II and the head of the Russian navy, on a nine-month Mediterranean cruise carried out by a squadron of five ships—photographing sites that included Nice, Naples, Pompeii, Sicily, Athens, and Jerusalem. ¹² It is tempting to speculate that de Rumine was in London in 1858 to learn

photography from Fenton, but it is perhaps more probable that he was taught by a Frenchman.

In 1962 a photograph from the collection of the Bayarian-born watercolorist Carl Haag (1820-1915) appeared on the market, and it was suggested in the auction catalogue that Haag is the heavily bearded, turbaned man who is seen with a veiled woman (fig. 56). The print was offered with another image of the woman standing alone; neither was described as the work of Fenton. 13 In the early 1980s three other photographs using the same two models appeared at auction. 14 In the same period, other prints of all five images that came from albums closely associated with Fenton and likely belonging to him or his family appeared on the market. 15 In this way the five images came to be known as Fenton works. They are, however, something of an anomaly among his Orientalist photographs. This man and woman are dressed in full regalia far more elaborate and authentically Near Eastern than the garments worn by Fenton's other sitters. The couple did not pose with the people in the larger series (although the man may appear in one of the group pictures in that series). Also, the setting cannot be clearly identified as Fenton's studio.16

There are documented connections between Haag and Fenton. In 1854 Haag had applied color to a series of salt prints by Fenton showing Queen Victoria's children dressed for a pageant celebrating her wedding anniversary. These are the first images Fenton made of tableaux. (See also figs. 47, 48.) Additionally, two watercolors by Haag were included in the sale of Fenton's collection in 1870.¹⁷ Therefore it can be presumed that the photographer and the watercolorist knew each other. Was it coincidental that soon after Fenton completed his Orientalist series Haag left England for an extended sojourn in Egypt and Palestine? Still, Haag's appearance in Fenton's photographs remains a matter of conjecture. The four other men who figure in the series can be assumed to be friends of Fenton's rather than models, but their identities—and whether they too were artists—are wholly unknown. The nexus in Fenton's studio of photographers and artists, most of whom had or would develop interests in the Islamic world, suggests that an air of collegiality as well as high jinks may have prevailed.

The woman who appears again and again in the photographs was surely a professional model because some of the poses reveal her anatomy to an extent that would have been unthinkable for a "respectable" woman. The

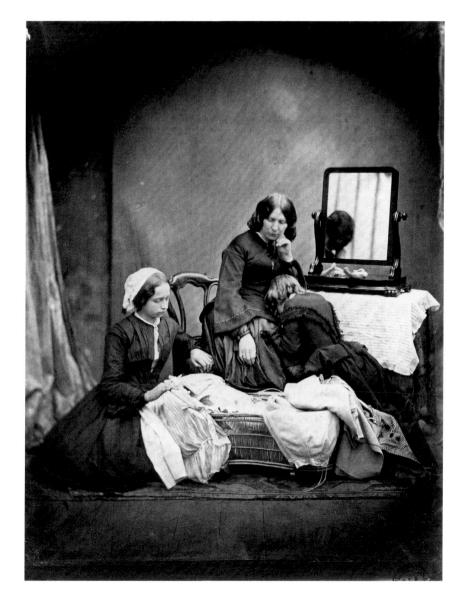

Fig. 53. Roger Fenton, *La Faute*, ca. 1855. Albumen silver print, 36 x 27 cm ($14\frac{3}{16}$ x $10\frac{5}{8}$ in.). Société Française de Photographie, Paris, 140/8

Orientalist fantasy of western Europeans of course included the idea of women as both subservient and sexually available. Around the woman's presence and these attendant attitudes the whole of the series can be said to pivot. If the photographs discussed in connection with Dillon, de Rumine, and Haag are excluded, there are only seven pictures for which she did not

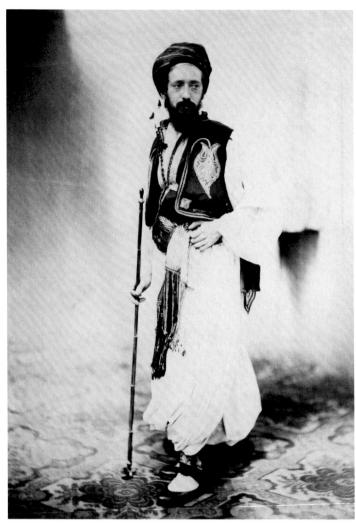

Fig. 54. Roger Fenton, Frank Dillon in Near Eastern Dress, 1858. Albumen silver print, 25.8 x 18.1 cm (10^{3} /₁₆ x 7^{1} /₈ in.). The J. Paul Getty Museum, Los Angeles, 84.XP.219.34

pose; she figures in thirteen photographs with other people and fourteen by herself. In the latter group she bears a large clay pot meant to represent a water vessel (pl. 65) or sits on a low divan, in three variant poses wearily propping her head on her wrist, meditatively cradling a goblet drum in her lap, or mimicking playing a lute.²⁰ When she is posed with men she entertains them by dancing or playing an instrument (pl. 62), keeps them company (pl. 63), serves them by carrying burdens, or cowers before them (pl. 64). In the

Fig. 55. Unknown photographer, Frank Dillon at His Easel, ca. 1865. Albumen silver print. Private collection, England

photograph that most epitomizes the sensual allure of the world of Orientalist fantasy, she reclines at full length on a low divan, her upper clothing loosened, her feet bare, and her heavy-lidded eyes gazing unfocused in what seems a dreamy trance (pl. 61).²¹ Fenton exhibited it under the title *The Reverie*. The woman was evidently both patient and pliant, although judging by her facial expressions she was occasionally bored or uncertain about what she was being asked to portray, if in fact she was given specific cues.

Fig. 56. Roger Fenton, Couple in Fancy Dress, 1858. Albumen silver print, 23.6 x 20.4 cm ($9\frac{5}{16}$ x $8\frac{1}{16}$ in.). The J. Paul Getty Museum, Los Angeles, 84.XM.922.2

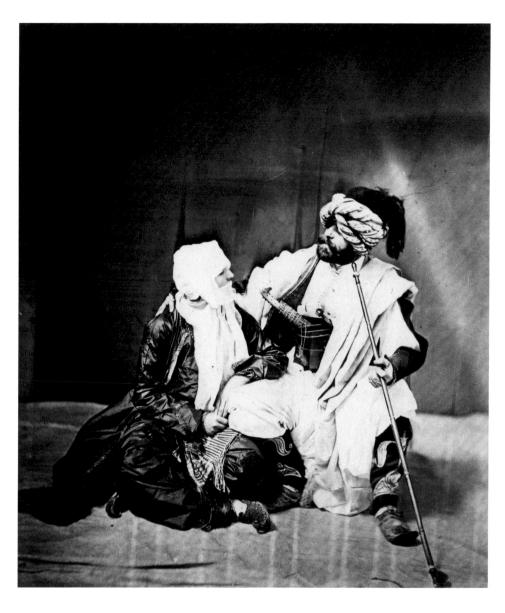

SET, COSTUMES, PROPS

All of the photographs were made in Fenton's London studio, which was at his home in Albert Terrace, most likely in a building behind the house itself. The studio skylight is visible at the top of the untrimmed print of *Pasha and Bayadère* (pl. 62), as are the wires that made it possible for the model to hold her arms motionless above her head throughout the exposure. ²² An Anatolian rug conceals nearly all of the European carpet on the studio floor. In this image a miscellany of Near Eastern objects, including a spiked fiddle, an

octagonal table with mother-of-pearl inlay, an inlaid tambourine, a goblet drum, a hammered brass coffeepot, and a water pipe have been used to dress the set. They will be rearranged for other photographs, as will the brocade cushions and draperies. Rather makeshift costumes, partly authentically Near Eastern but from various regions and partly improvised, are worn by the players. Some of the props and garments may have been souvenirs from Dillon's Egyptian journey of three years earlier. An inlaid table of exactly

the type seen here (made to this day) can be seen in a Dillon painting and in a photograph taken in the Moorish-style studio in London that he later had constructed.²⁴

THE SCRIPT

Western European fantasies loosely based on the Islamic cultures of the Near East rested on vague assumptions about the exalted status of men and the lesser place of women in that world. Essential to these daydreams was an atmosphere of freedom from inhibitions and responsibilities. Musicians played exotic melodies, servants proffered tobacco and drink; a warm climate, low divans, ample pillows, and loose-fitting garments allowed relaxed postures and intimacies unthinkable in chilly, cluttered Victorian sitting rooms. To varying degrees, Fenton's Orientalist images are based on this agglomeration of fantasies.²⁵

Dillon brought to the making of the Orientalist pictures his actual experience of an Islamic culture, but Fenton had studied painting in France and thus been exposed to French as well as British Orientalism, and he contributed to the project not only technical expertise but also greater pictorial sophistication.26 As a fledgling painter, art collector, and exhibition-goer in both countries in the 1840s and early 1850s, Fenton saw numerous paintings treating Near Eastern subjects by artists as various as Delacroix, Théodore Chassériau, Prosper Marilhat, William Holman Hunt, and John Frederick Lewis. Still, it seems logical for Dillon himself to have suggested that he pose reclining full length smoking a long pipe in one image, and kneeling as if about to pray in another. A woman balancing a water jug on her head is one of the figures animating a scene Dillon sketched on the outskirts of Luxor in February 1855, making it very likely that a similar pose was recommended to the photographer by the painter.²⁷ (To keep the jar in place during the course of the exposure, Fenton's model was rigged with the same wires that supported her arms while she played the role of a bayadère.) Whatever the origin of the pose, Fenton found it sufficiently compelling to ask the model to assume it three other times—once in the same robe and twice wearing a dark-colored garment.²⁸

Dillon and Fenton were not the only artists to immerse themselves in role-playing. There are contemporary portraits or self-portraits in Near Eastern costume of David Roberts, Charles Nègre, Lewis, Francis Frith, and the somewhat obscure British photographer William Morris Grundy (1806–1859). Immediate photographic prototypes for Fenton's pictures were the simply staged Orientalist scenes that Grundy showed at the Manchester Art Treasures Exhibition in 1857 and the Photographic Society exhibition of 1858.

Because Dillon was frequently present during Fenton's execution of the Orientalist suite, some credit for the appearance of the finished photographs should go to the painter. One wonders whether this collaboration contributed to the imagery of Dillon's paintings made on subsequent expeditions to Islamic countries.

THE REVIEWS

When Fenton exhibited seven of his Orientalist productions in London in January 1859, the critic for the *Photographic News*, who assumed that Fenton had more experience in Islamic countries than was the case, was less than enthusiastic. "For a 'first appearance' [of this kind of image], his pictures are not so bad, still they are not such as please us. With regard to the arrangement of dress and interior detail, there can be no doubt that Fenton is the one who ought to be well able to give us a correct idea of the household economy of the Orientals." He went on to complain that the models were of the wrong nationality and lacked expression and that the strings holding up the bayadère's hands were visible. The most successful picture, he thought, was the Nubian Water Carrier.²⁹ The writer for the Photographic Journal was kinder: "We are pleased to notice that he [Fenton] is turning his attention to a department of the 'art' in which he is less known than his exquisite landscapes—we mean those subjects that in art-slang are generally designated as genre subjects. Of these, No. 43, The Pasha and Bayadère—No. 50, The Reverie—No. 606, Turkish Musicians and Dancing Girl—No. 608, Nubian Water Carrier, are favourable examples, being admirable illustrations of Eastern scenes of actual life. Their execution, also, is worthy of Mr. Fenton's well-known fame."30

The five Orientalist photographs in the plate section of this catalogue display a variety of intentions and qualities. There is a sturdy feminine grace in the classic pose, akin to a caryatid's, assumed by the model carrying a water jug (pl. 65); there is evident sensuality in the image of a dreaming odalisque

surrounded by a luxuriance of patterned textiles that play against each other and her bared flesh (pl. 61). The latter photograph is one of the two masterpieces of the series (the other being *Pasha and Bayadère*, pl. 62) in which the interaction of figures is enriched not only by an array of textiles but by implied sound and feigned motion. The remaining two Orientalist photographs also display storytelling content, although their narrative structures are less precise. The image of the woman with her head bowed and her face nearly wholly concealed, seated cross-legged below a standing male figure, is vaguely sinister: her pose is abject, and a mysterious instrument dangles from his sleeve (pl. 64). The blander fifth image is related to that of the dancing woman and her audience, but here the woman interacts solely with the camera,

gazing at it with an inquisitive, if melancholy, expression.³² The man who formerly impersonated a musician now has the upgraded costume of a man of leisure and from the divan addresses a standing servitor (pl. 63, fig. 51).³³

Although we no longer look to these photographs for accurate representations of domestic life in a Near Eastern environment, distance has lent them charm. They record not only Fenton's vision of another culture but also the attitudes of his own. Seriously intended to align photography with painting, they nevertheless convey some of the high spirits that went into their creation—an otherwise elusive aspect of Fenton's character—while transcending the homely circumstances of their making to constitute a considerable artistic achievement.

Roger Fenton and the Still-Life Tradition

PAM ROBERTS

Photography will, we hope, in time entirely destroy all necessity of men wasting their time in painting still-life.

—Athenaeum, 1859¹

In 1934 the Royal Photographic Society was given a collection of photographs by unnamed descendants of Roger Fenton, the society's principal founder in 1853 and its first honorary secretary. Among these materials was a group of forty-eight still-life photographs: five depicting game, six featuring a Chinese ivory casket and other Chinese artifacts, and the remaining thirty-seven ringing rich and striking variations on conventional arrangements of fruit, flowers, intricately patterned textiles, tankards, vases, drinking cups, jewelry, small statuettes of putti, ivory carvings, and glassware. While many of these photographs appear at first glance to be duplicates, this is rarely the case. There are nuanced differences: a petal has wilted and drooped, pollen has scattered, a tightly furled flower bud has opened, a grape has wrinkled and wizened, a fern has curled, spots of mold appear, shadows elongate as the light wanes.

Remarkably, the entire series of exotic and lushly beautiful fruit and flower still lifes was very rapidly realized over the summer of 1860,³ probably in late July and early August. These glorious images, taken by a photographer at the height of his powers, were most likely the last that Fenton made. The still lifes of game had probably been taken the previous year, in December 1859, when he was photographing at Stonyhurst College in Lancashire. (The furred and feathered game would have been in season in December and legal to shoot, but the salmon and trout were out of season and illegal to catch.)⁴

Opposite: Fig. 57. Roger Fenton, Parian Vase, Grapes, and Silver Cup (detail), 1860. Albumen silver print. The RPS Collection at the National Museum of Photography, Film & Television, Bradford, Gift of Fenton descendants, 1934, 2003-5000/2889

The many factors that led Fenton to produce these still-life images were practical, personal, aesthetic, and commercial in nature—like the strands that interwove constantly throughout his life.

Fenton's new foray into still life was first made public at the seventh exhibition of the Photographic Society in 1860.⁵ He showed a still life of game (no. 135), *Spoils of Wood and Stream* (pl. 75), alongside photographs taken at Stonyhurst. It was priced at twelve shillings, at the high end of his price range. The only costlier works in his entire career were some of his Crimean pictures, sold framed for twenty-one shillings, and landscapes and architectural subjects, sold for fifteen shillings and sixpence and sixteen shillings and sixpence, respectively, in 1856, when he was at the height of his celebrity after the Crimean trip. The price of this still life perhaps reflects its size (13½ x 16½ inches), the large quantity of silver in the print, and the gold chloride toning.

This wonderfully strong image, in which the camera is very close to its subject and the eye is drawn into the central vortex created by the basket of shimmering trout on the ground, was cited in an exhibition review only as "a difficult subject, successfully treated." While pictures of game had been made in the 1850s by other British photographers, these were politely composed studies in which dead animals and birds were arranged with allied objects, usually dishes and drinking vessels. The subject had never before been photographed in the field at this low eye level, composed with such artistry, and printed so sumptuously. One can see each blade of grass, each fish scale, each tuft of wet fur.

It is another Fenton photograph in that same 1860 exhibition, however, that established the subject matter for Fenton's later experiments in still life.

Fig. 58. Roger Fenton, *Comus*, 1859. Photograph of a painting by George Lance (English, 1802–1864). Albumen silver print, 20 x 42 cm (7 ½ x 16 ½ in.). The RPS Collection at the National Museum of Photography, Film & Television, Bradford, Gift of Fenton descendants, 1934, 2003–5000/3081/1

Called *Copy of a Picture by Lance*, it was a photograph of a canvas by the English painter George Lance (1802–1864), who had been largely responsible for reviving still-life painting as an artist's specialty. Fenton's copy was, one reviewer wrote, "unusually successful" in that "the equivalent of colour in light and shade is very happily accomplished."

Which of Lance's paintings Fenton had photographed and exhibited in 1860 is not known. However, in the Royal Photographic Society Collection are two Fenton prints of a Lance painting (from the same negative), one now entitled *Comus* (fig. 58). The painting itself, whose present location is unknown, was shown by Lance under the title *The Golden Age* at the exhibition of the British Institution for Promoting the Fine Arts in the United Kingdom in 1859 and subsequently was bought by Archibald Brunton Esq. Sometime in 1859 Fenton photographed it. The wood engraving reproduction of the painting that appeared in the *Illustrated London News* in 1861 (fig. 59) may have been made from Fenton's copy photograph rather than from a metal engraving, as was more usual. Whether Fenton's picture was an *Illustrated London News* assignment or his own homage to Lance is unclear. But certainly the description of the Lance painting given by the *Illustrated London News* reviewer could in spirit equally apply to Fenton's 1860 still-life studies: "Half-buried amongst the fruit of the vine, is a rich

melon in the highest perfection of ripeness; and on the other side are apples, peaches, filberts, and strawberries on the stem, in glorious variety, every one a picked specimen of its kind, and individualised with an appreciative and loving hand."¹¹

Even if Fenton had nothing to do with the print version of *The Golden Age*, he was undoubtedly familiar with the wood engraving reproductions of paintings by both Lance and his student William Duffield (1816–1863) published in the *Illustrated London News* between 1853 and 1862, a period when his own photographs were frequently reproduced in wood engraving form in the same pages. The paper was extremely popular; in 1855 it had 123,000 subscribers, among them Fenton. He would have seen Lance's paintings exhibited at various London galleries and perhaps also at the home of the collector J. H. Mann (fl. 1827–70), a near neighbor and one of the founders of the North London School of Drawing and Modelling, with which Fenton was involved, as well as chairman of the Artists' General Benevolent Institute, patron of the Society of Engravers, and a color manufacturer with a business in Lincoln's Inn Fields. 14

During the sixty-four years of Queen Victoria's reign, the British art market underwent dramatic changes. The burgeoning urban middle classes, surrounded by the new wealth of manufacture and industry, were educated and eager to embrace not only capitalism and technology but also art. Rather than emulating the upper echelons of society, whose collecting habits had largely revolved around the Grand Tour and the works of European masters of the previous four centuries, they were open to buying work by contemporary British artists. A number of institutions and galleries had been established earlier in the century to encourage the patronage of British artists: the Society of Painters in Water-Colours was founded in 1804, the British Institution in 1805, the Society of British Artists in 1823, the National Gallery in 1824, and the New Society of Painters in Water-Colours in 1832. By 1843 the number of practicing British artists (which included Fenton) had increased threefold since the foundation of the British Institution. The institutions promoted ideas of a national artistic and professional identity. In the lively art world of the day, a new audience attended exhibitions, read reviews and scrutinized reproductions in influential publications such as the *Art-Journal* and the *Illustrated London News*, discussed artistic developments, and bought paintings.

In Britain still-life painting had never been the strong artistic discipline that it was in Holland, but with new economic opportunities and the increasing materialism of the wealthy middle classes, it blossomed. Its main practitioners were Lance, William Henry "Bird's Nest" Hunt, and Edward Ladell. A manual on flower painting by William J. Muckley published somewhat

Fig. 59. The Golden Age, after a painting by George Lance (English, 1802–1864). Wood engraving, 20.3 x 34.9 cm (8 x $13\frac{3}{4}$ in.). From Illustrated London News, February 23, 1861, p. 166

later in the century and a companion volume on fruit and still-life painting, also by Muckley, went into many editions. ¹⁶ The *Illustrated London News* conferred its imprimatur on the genre: "Still-life Painting, which in its widest sense includes dead game, fish &c., as well as fruit, flowers, vases, musical instruments, tapestry, and various ornamental articles of furniture, though not ranking with the highest departments of art, has still its legitimate uses, and holds a recognised place in the esteem of all who love and admire the beautiful in creation in a catholic spirit." ¹⁷

George Lance, although a pupil of the history painter Benjamin Robert Haydon, from the early 1820s had specialized almost exclusively in still-life painting, taking as his model works of the seventeenth- and eighteenth-century Dutch and Flemish schools. Lance's still life *The Summer Gift* was commissioned by the collector Robert Vernon and then donated to the nation in 1847 as part of a collection of contemporary British art. When the painting was exhibited the next year at the British Institution it was well received, and still life acquired a new status in Great Britain. Lance painted loving renditions of the prize horticultural produce of the great country houses such as Woburn and Blenheim, making more than four hundred paintings in his lifetime. ¹⁹

Fenton moved easily in artistic circles and collected paintings, drawings and engravings, including Lance's *Peaches and Grapes*. Among the other still-life paintings he owned were ones by J. F. Herring (Rabbits), H. Chaplin (Peaches and Plums), Philippe H. Rousseau (Dead Birds), Mrs. Margetts (Pineapple, Grapes, &c.; A Handful of Flowers; Azaleas), and Hickin (Dead Ducks). 20 He would have known the school of still-life artists in the circle of the prolific William Henry Hunt (1790–1864), who exhibited at the Royal Academy, at the Gallery of the New Society of Painters in Water-Colours on Pall Mall East, and at the Society of British Artists, Suffolk Street (the latter two, along with the Gallery of the [old] Society of Painters in Water-Colours, were frequently the venues of the Photographic Society's annual exhibitions). And Fenton would have seen both Lance's and Hunt's work at the 1857 Manchester Art Treasures Exhibition, where his own work hung as well. In Manchester Hunt showed the still life Fruit and Tankard (Whitworth Art Gallery, Manchester), which depicts a silver tankard, a glass chalice, fruit, and drapery. Hunt was certainly interested in photography. Among his effects at his death was a set of Fenton's Crimea photographs,²¹ and his drawing *The*

Photographer from the 1850s is a full-length back view of a photographer with a large camera and tripod (Tate Liverpool). Could the subject be Fenton?

A third artist who may have influenced Fenton's production of still-life photographs was Edward Ladell (1821–1886), a member of the Colchester school of still-life painters and an exhibitor at the Royal Academy beginning in 1856. Ladell's carved ivory caskets, hock glasses with reflections, translucent white currants placed at the very forefront of the image, overripe squash with an obligatory slice cut out, tumbling bunches of grapes, and wicker baskets, all arranged on a marble-topped carved wood table with draped, striped, and exotically patterned fabrics, were familiar still-life conventions (fig. 60). Put side by side, Ladell's paintings and Fenton's photographs appear strikingly similar.²²

Several factors probably played a part in Fenton's turn to still-life photography. His landscape work was curtailed in 1860, a much-remarked bad year for photography with "a long continuance of wet and foggy weather. . . . of continuous bright weather, affording both opportunities and stimulants to work, there was literally none."23 So unpromising was the weather for landscape photographers that "several photographic societies which had local habitations" closed down.²⁴ Thus it is perhaps not surprising that Fenton stayed home more than usual and sent previous work, along with his few photographs taken in bad-weather conditions, to some of the exhibitions. The doughty British photographic press was unforgiving, berating Fenton's submissions as "altogether unworthy the reputation of so celebrated an artist. . . . By far the larger number of landscapes displayed this year by this photographic veteran are heavy, dull, flat-looking affairs."25 His older works were "only valuable as showing the attainments of Mr. Fenton some time since. . . . Having been exhibited over and over again they have become weather-beaten and grimy, and present altogether a dispiriting appearance."²⁶

Meanwhile Fenton had become much involved with the Hythe School of Musketry, where in 1860 he both photographed and shot, having joined the Ninth (West Middlesex) Rifle Volunteers on April 16. This too did not go unnoticed. "We fear much that Mr. Fenton has proved an inconstant swain—that he has transferred his affections from the camera to the rifle."²⁷ There was another, soberer reason for inconstancy to his photography: the Fentons' only son, Anthony Maynard, died at the age of fifteen months on April 24 of that year, surely a devastating blow to the close-knit family.

Fig. 60. Edward Ladell (English, 1821–1886), Still Life, 1860. Oil on canvas, 34 x 29 cm ($13\frac{3}{8}$ x $11\frac{7}{16}$ in.). Courtesy of Richard Green Fine Paintings, London

From 1853 to 1859 Fenton had worked for the British Museum, where he had been able to experiment with composition, lighting, photographic chemistry, and lenses while making photographs in a somewhat peripatetic fashion of inanimate objects in the museum's collections—sculptures, paintings, engravings, ivory carvings, relics, and collections of geological, ethnographic, and anthropological specimens (pls. 41–46). He exhibited some of this work, especially in the late 1850s. His stereo photographs of landscapes, architecture, and museum interiors were published regularly in the *Stereoscopic Magazine*, which was issued from 1858 to 1865. In September and October 1859, two images by Fenton appeared that were arranged more in the manner of a still life, *Celebrated Ivory Carvings, from the Collection in the British Museum* and *Group of Corals, British Museum*. The October 1860 issue contained a stereo photograph, *Fruit with Ivory and Silver*

Tankard, identified as "First of a series taken for the Magazine by Mr. Fenton." Several more were to follow, some dated to the summer of 1860. Indeed, close examination reveals that all were made in a very short space of time over that dismal summer of 1860.

The opening pages of the March 1861 edition of the *Stereoscopic Magazine* contained this passage: "The subjects furnished by Mr. Fenton are taken by a camera with six lenses, three pairs of views being taken simultaneously on one sheet of glass, by which the printing is greatly expedited, and all contributions of negatives to the *Stereoscopic Magazine* are now made in duplicate and triplicate. The result is, that the Editor is enabled to avail himself of a more extensive and fresher choice of subjects, so that the stereographs now given, and in preparation, are of a superior and interesting character." This mention of a "camera with six lenses" is probably a reference to Petzval lenses, with which Fenton had been experimenting since early 1858. At that time he had written, "I have had the opportunity of taking a series of pictures by Professor Petzval's lens, and I may as well, before showing them, state that there are three double lenses, but only two pairs of these are used for taking landscapes, and the other pair is substituted for the back combination

arranged for taking portraits; in no case are there more than four lenses used for taking a single picture, so far as I am at present informed."³³ The ability to take multiple stereographs with one camera allowed quantities to be increased while unit costs decreased, rescuing the *Stereoscopic Magazine* from production and financial difficulties.³⁴

Fenton produced his still-life studies using not just two cameras, as the *Stereoscopic Magazine* states (see below), but three and maybe four: the six-lensed stereo camera with Petzval lenses, a large-format 20 x 16-inch-plate camera (and possibly even a larger one that took 24 x 18-inch plates), and a smaller-format 15 x 15-inch-plate camera. Almost all Fenton's still-life photographs exist in these three formats (often trimmed after printing). Over the hot summer of 1859, when "a black bulb thermometer placed in the sun, rose to 146 degrees" and "on the following day the heat was even greater; the same thermometer indicating at least 10 degrees higher in the sunshine at noon," Fenton had been experimenting with three of the new orthographic lenses made by the London optician and instrument maker Andrew Ross as well as varieties of collodion. The latter activity he undertook as a member of the Collodion Committee of the Photographic Society; twelve members

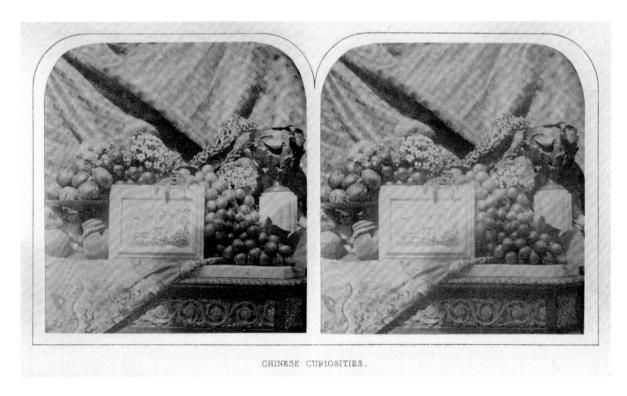

Fig. 61. Roger Fenton, *Chinese Curiosities*, 1860. Albumen silver prints, stereograph, each 7 x 7 cm $(2\sqrt[3]{4} \times 2\sqrt[3]{4})$ in.). From *Stereoscopic Magazine*, no. 34 (April 1861). George Eastman House, Rochester, New York, Gift of Alden Scott Boyer, 96:0726:0004

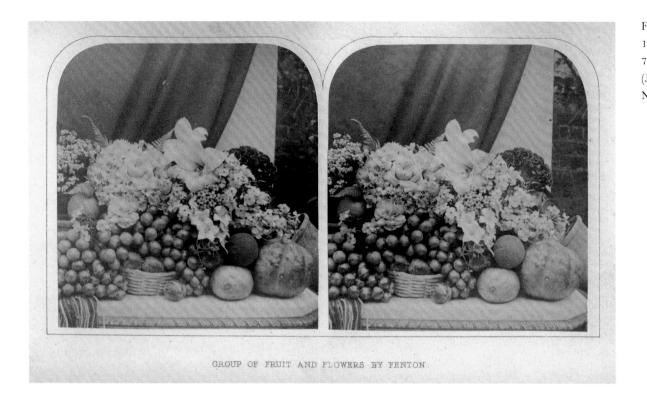

Fig. 62. Roger Fenton, *Group of Fruit and Flowers*, 1860. Albumen silver prints, stereograph, each 7 x 7 cm (2³/₄ x 2³/₄ in.). From *Stereoscopic Magazine*, no. 37 (July 1861). George Eastman House, Rochester, New York, Gift of Alden Scott Boyer, 96:0726:0013

who practiced every branch of the art, including "copying and sculpture," had been asked to spend the summer recess experimenting with collodion prepared for them by Mr. Hardwich.³⁷

The April 1861 *Stereoscopic Magazine* article contains detailed descriptions of one of Fenton's stereo photographs, *Chinese Curiosities* (fig. 61):

This is one of the compositions lately exhibited by Mr. Fenton on a large scale, in the rooms of the Photographic Society. While taking the group with his large lens, he took it also with his camera of six lenses for the stereoscope. The object in the centre is an ivory casket, laid on its side to show the carving on the top, which it will be seen is in high relief, executed with the ingenuity and neatness for which the Chinese are celebrated. Resting on the edge of the box is a small tiara of jewels, and over it to the right is a wreath of fine red coral, in natural branches. Beneath the casket is a richly embroidered mandarin's robe. The accessories of fruit and flowers consist of grapes, peaches, plums, some China Asters, and two bunches of Hoya; and the vase to the right is of antique bronze, mounted on a pedestal of alabaster.

The Chinese Ivory Casket represented in the preceding photograph is so novel a subject for the stereoscope that we are tempted to give an enlarged view of it. . . .

... The Arundel Society have prepared casts of some of the most remarkable specimens in ivory-carving contained in the different museums and private collections of Europe; and Mr. Westwood, the well-known entomologist, Hope-Professor of Natural History in the University of Oxford, possesses a collection of upwards of eight hundred casts of celebrated carvings in ivory. 40

In September 1860, Queen Victoria and Prince Albert bought two copies of "studies from life" recently made by Fenton.⁴¹ At the eighth exhibition of the Photographic Society, held at the Gallery of the Society of Painters in Water-Colours in January 1861, Fenton showed twelve still-life compositions (out of the thirty-nine prints he exhibited), including studies of fruit and flowers and of the aforementioned Chinese casket. The photographic press reacted with lavish praise, such as "His fruit studies show the highest standard to which photography can attain at present in that field."⁴² He was

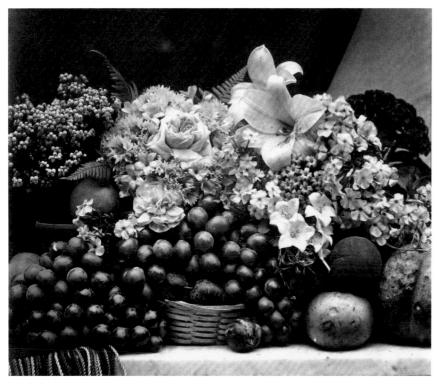

Fig. 63. Roger Fenton, *Flowers and Fruit*, 1860. Albumen silver print, 28.1 x 28.8 cm ($11\frac{1}{16}$ x $11\frac{5}{16}$ in.). The RPS Collection at the National Museum of Photography, Film & Television, Bradford, Gift of Fenton descendants, 1934, 2003–5000/3105

compared directly to Lance: "Mr. Roger Fenton has come out in an entirely new character, and may now be regarded in the photographic world in the same light as Lance amongst painters. . . . 'How delighted Lance would be with these!'" Reviewers encouraged buying: "We congratulate collectors of photographs upon the new pleasure that is in store for them in acquiring some of this novel class of productions." Prints were for sale at ten shillings and sixpence apiece. 44

One reviewer raised the issue of color for the still-life studies. "It is true that to acquire all possible beauty they do require the application of colour. We remember to have seen some specimens of flowers, on a smaller scale, that had been well tinted, exhibited at one of the meetings of the North London Photographic Association, and are convinced from what we then saw that a profitable field is open in this direction to any artist having the requisite skill, as such productions, well got up, would meet with eager

purchasers."⁴⁵ It is not clear whether the hand-colored flower studies mentioned were also by Fenton; if they were, they have not survived. Nor indeed have many Fenton still-life photographs, suggesting that these works did not sell as well as the reviewers, and perhaps Fenton, expected.

Fenton's still lifes reflect the interests and material resources of the wealthy Victorian middle classes: Chinamania, exotic products of the British Empire both edible and decorative, the new greenhouse technology, the coded language of flowers. But it is the reality of these images, the three-dimensional density of their compositions of fruit piled upon fruit, that is most startling. And because they are so abundantly real, these displays are transmuted into something lush, sensuous, and ultimately bound to decay—true *nature morte*.

Fenton often observes the classical traditions of still-life composition that can be seen in the paintings of Lance and Ladell: peaches always seem to come in twos, translucent white currants must always hang over the edge of the tabletop, baskets must always be wicker, the fruit must be arranged on a pedestaled tazza. But, employing the skills of his particular art, he infuses the still life with something quite his own.

The three cameras are set up—the six-lens stereo and the 15 x 15-inchand 20 x 16-inch-plate cameras. It is often possible to see a suggestion of camera reflections in the polished surfaces of grapes and cherries; but reflections of at least two cameras and tripods are very clearly visible, one assumes purposely, in the silver goblet used in several photographs (fig. 57). Typically, the stereo view pulls away from the arranged still life, which occupies perhaps 60 percent of the image, to show it isolated in an outdoor setting against a bare brick wall draped with cloth (fig. 62). The 15 x 15-inch format comes closer, showing the same dents in the foreground apple, the same mold on the melon, the same wizened grape near the bottom of the bunch; but now the composition is tighter, cropping out the brick wall and most of the drape so that the still life occupies 75 percent of the image (fig. 63). Finally, the 20 x 16-inch image moves right to the heart of the subject (pl. 86). The composition has been slightly rearranged, with the flowers at the right replaced by a vase for better balance, but the fruits, complete with dents and misty bloom, are intact. The image is tight and fills 90 percent of the photograph. The print's top has been arched to even more fully immerse the viewer in this most stunning of Fenton's still lifes.

The bad spring and summer of 1860 may be what allowed Fenton to achieve the impossible and photograph together fruit that in the British climate would normally reach maturity over a four-month period, from gooseberries in early June to grapes in late September. That year the early outdoor-grown fruit ripened late in the inclement weather, while the late fruit ripened early in the greenhouse. Imported exotic fruits had also become relatively common. In 1853 the *Illustrated London News* mentioned the first large twenty-four-day cargo of pineapples, imported from Eleuthera in the Bahamas. In the Crimea in 1855, Fenton had "stock" with him from Fortnum & Mason, grocers to the royal family, and later he may have bought his still-life supplies from them.

Grapes, white, black, and red currants, plums, peaches, melons, pineapples, strawberries; pinks, China asters, Hoya, lilacs, lilies and roses (flowers associated with the Virgin Mary and the Annunciation), fuchsia, chrysanthemums; cherries, gooseberries, raspberries, apples, ferns, sweet william, laurel, cucumbers, pansies, and Canterbury bells are just some of the items of produce that jostle for position in these heady photographs. Each also has a time-honored symbolic meaning. The carved ivory caskets, the richly wrought hunting cup carved with the legend of Saint Hubert and decorated with silver fox heads, the ornate silver mirror and chased silver goblet—all exquisite, intricately hand-crafted items of value—represent taste, trade, wealth, and possessions.

Fenton obviously intended this series of still lifes to express homage to the grape. Grapes are everywhere, figuring in thirty-three of his thirty-nine still lifes in the Royal Photographic Society Collection. And these grapes, still white with bloom, will ferment and make wine. To emphasize the point further, Fenton introduces wine-related objects: three different decanters, two chased silver goblets, a glass beaker, a Parian ware vase dripping with grapes and vine leaves in relief, a silver-and-ivory tankard carved with grape-picking cherubs. 48 Close observation reveals that one particular bunch of grapes in a wicker basket, recognizable from a wrinkled specimen at its bottom and the shape of the bloom on two adjoining grapes, played a part in seven different still lifes before the wrinkled grape, perhaps too wizened for beauty, was removed (and eaten?). Marks that look suspiciously like teeth indentations appear on one of the peaches.

Fenton continued to receive admiring reviews for his still lifes and—ironically, given all the glories of his photography that had gone before—a medal at the International Exhibition of 1862 "For great excellence in fruit and flower pieces, and good general photography." But the relative scarcity of these still-life images now—fewer than fifty-five worldwide—suggests that the Victorian public did not purchase them in great numbers. In February 1863 the *Stereoscopic Magazine*, announcing Fenton's retirement from photography, featured one last still life and stated gloomily, "Neither fruit nor flowers are good subjects for photography. It has long been deemed hopeless to be able to apply the art to the purposes of botanical illustration. This and one or two other pictures already given in our magazine are equal to any that have been produced; and it is not likely that any further use will be made of photography for the delineation of such subjects." 50

After the deaths of Hunt and Lance in 1864 and of Ladell in 1886, still-life painting ceased to be a genre that on its own could afford an artist in Britain a healthy living. Nor did British photographers strive to emulate Fenton's glorious example, perhaps quite rightly assuming that his still-life photographs could not be bettered. While photography, it later proved, never did "destroy all necessity of men wasting their time in painting still-life" as the *Athenaeum* predicted in January 1859, British photographers did not choose to assume the temporarily discarded mantle.⁵¹

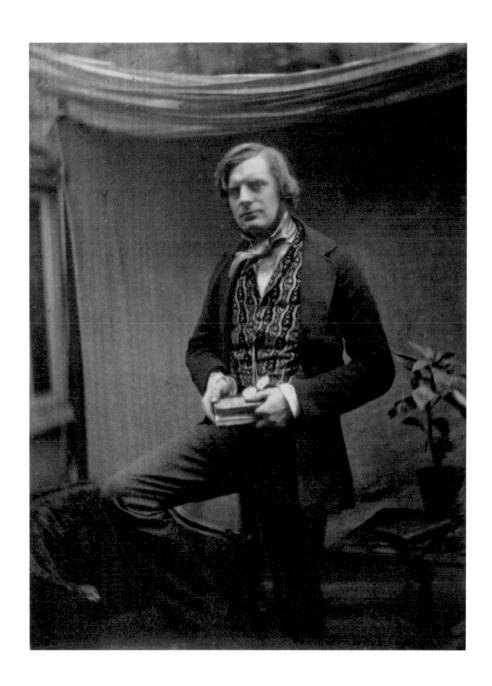

1. Self-Portrait, February 1852

RUSSIA, 1852

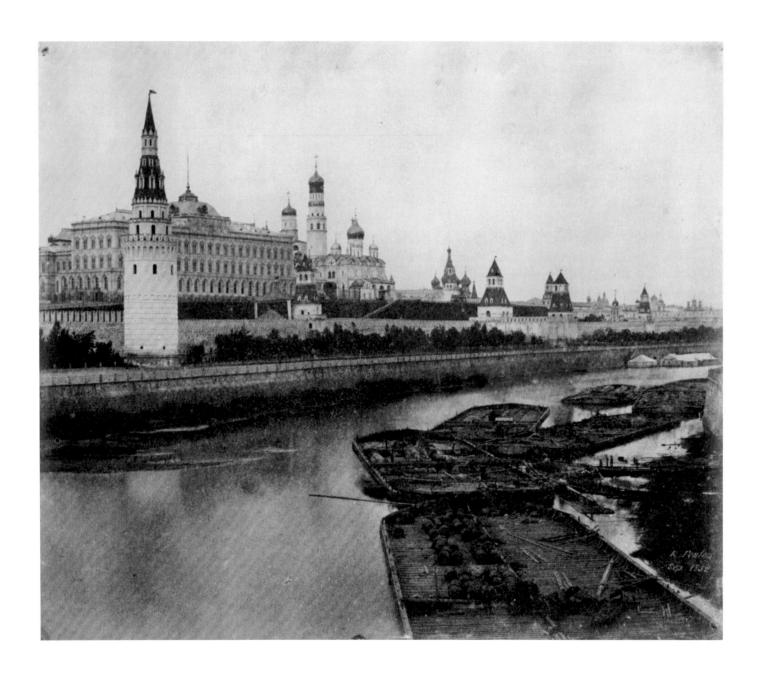

3. South Front of the Kremlin from the Old Bridge, 1852

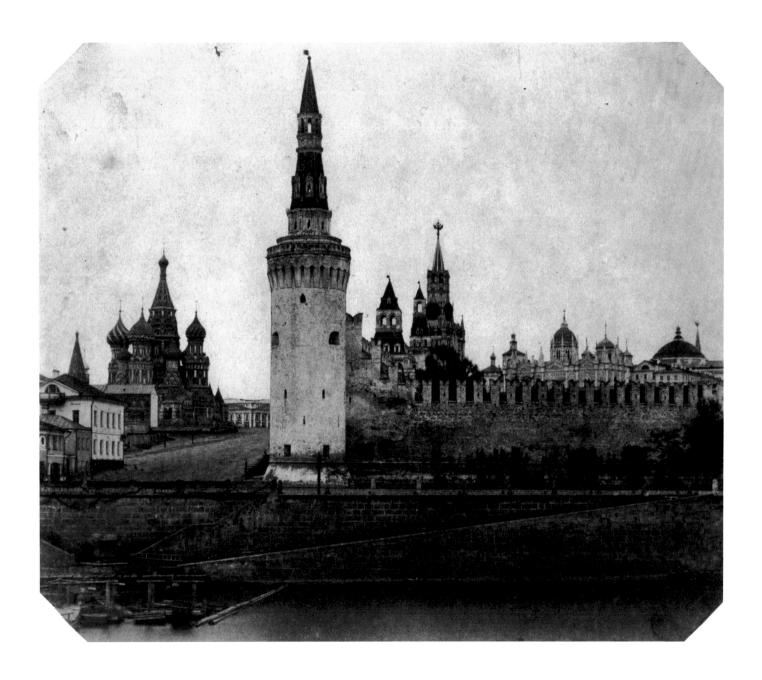

4. Walls of the Kremlin, Moscow, 1852

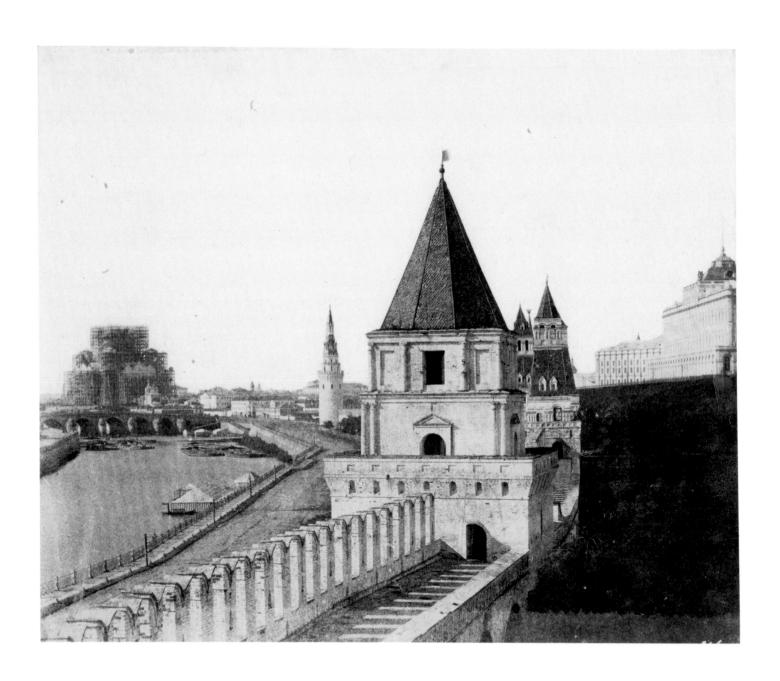

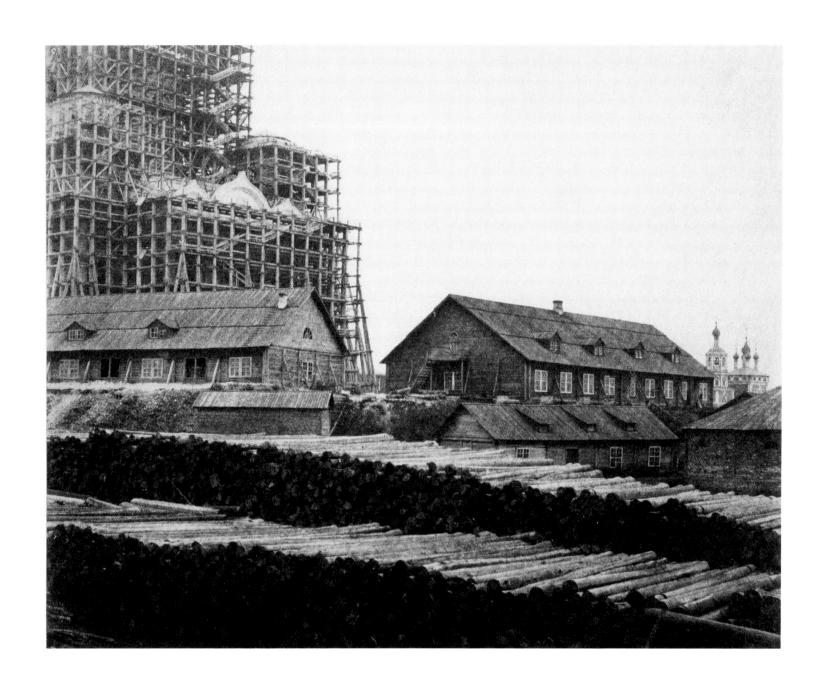

6. The Church of the Redeemer, Moscow, under Construction, 1852

7. Banks of the Dnieper; Distant View of the Forts and Low Town of Kief, 1852

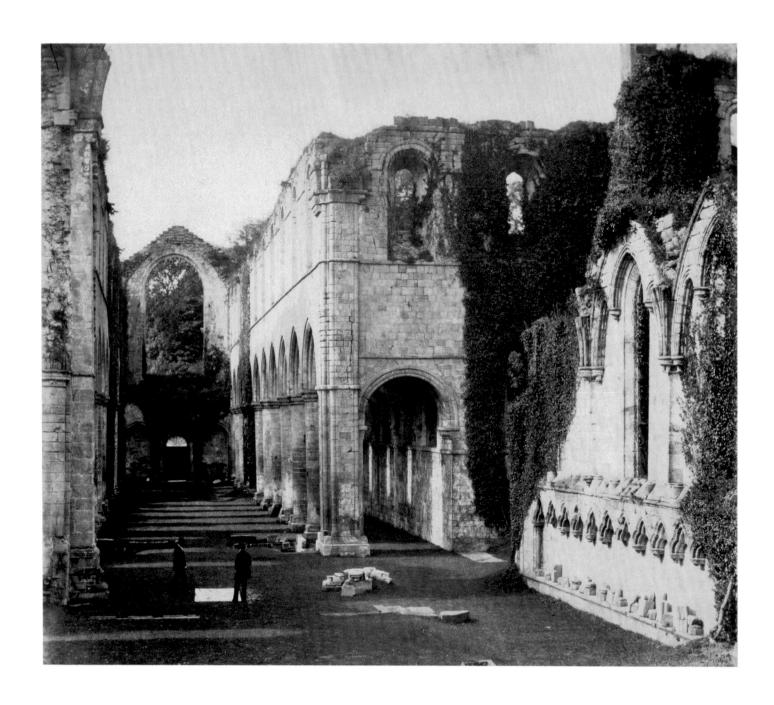

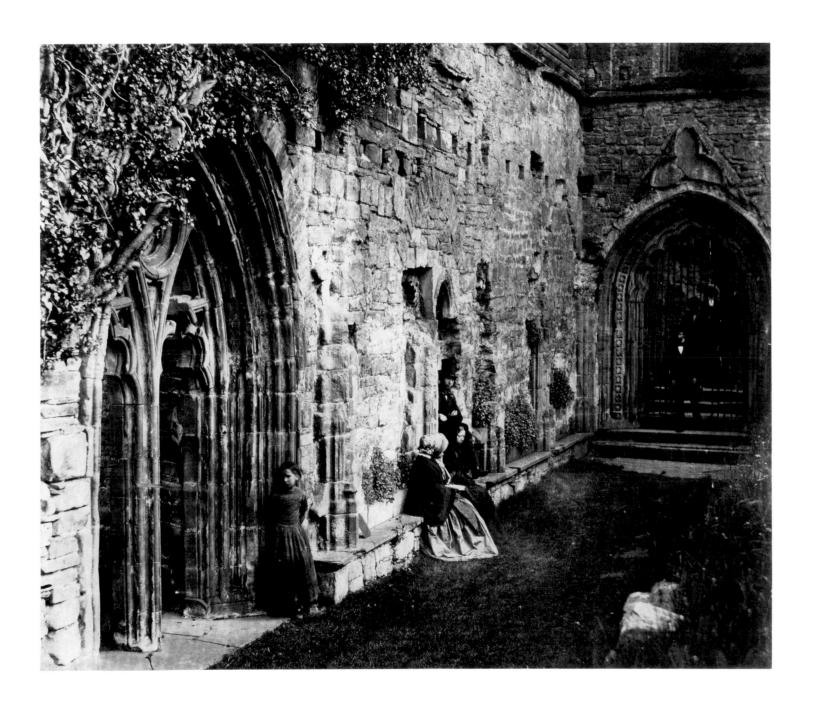

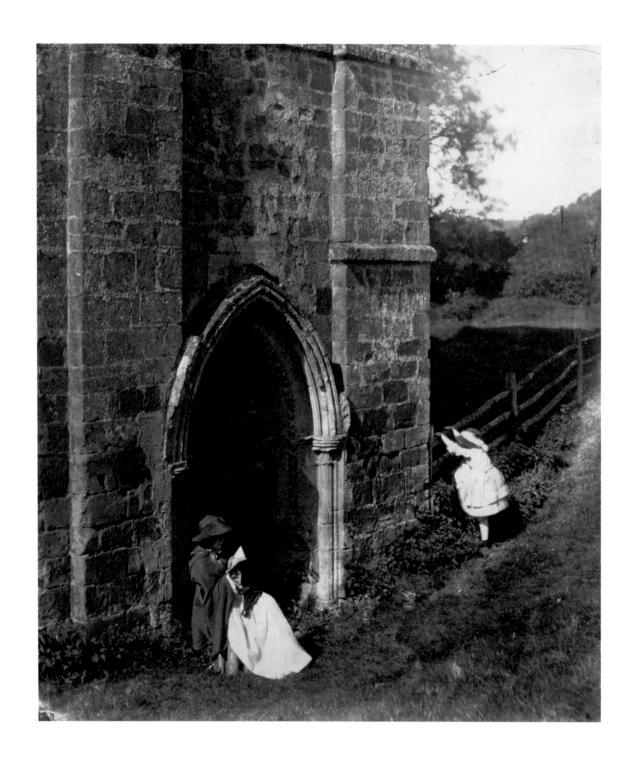

10. Rievaulx Abbey, Doorway, North Transept, 1854

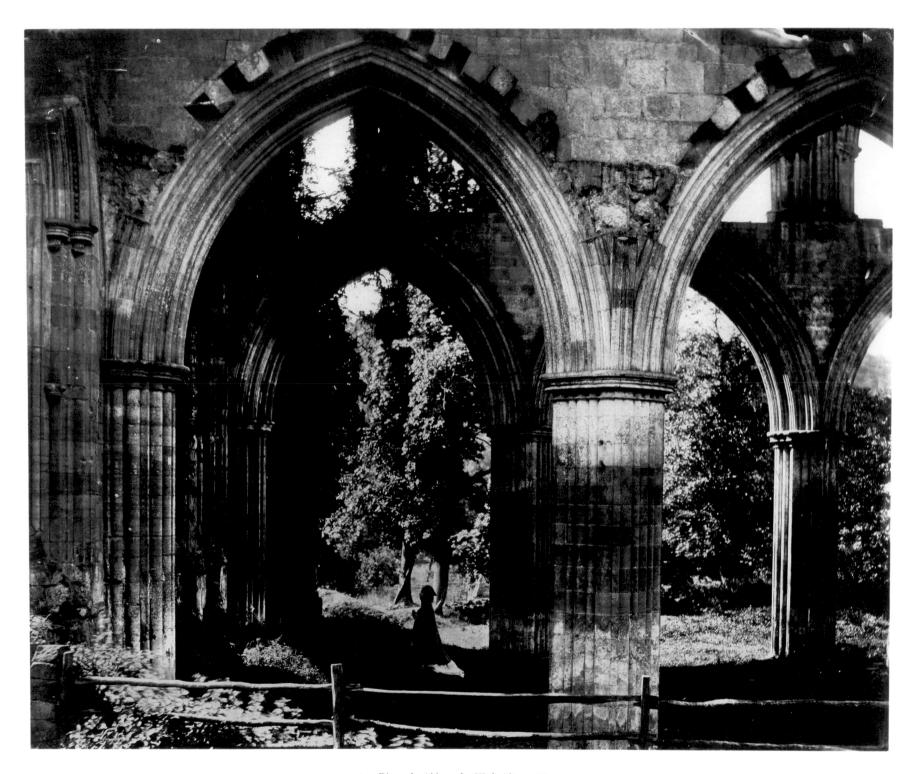

11. Rievaulx Abbey, the High Altar, 1854

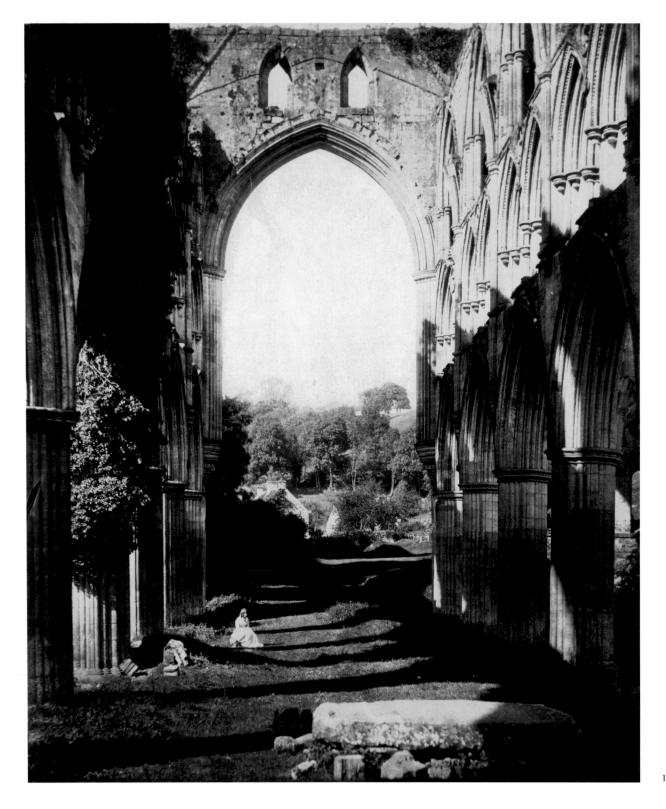

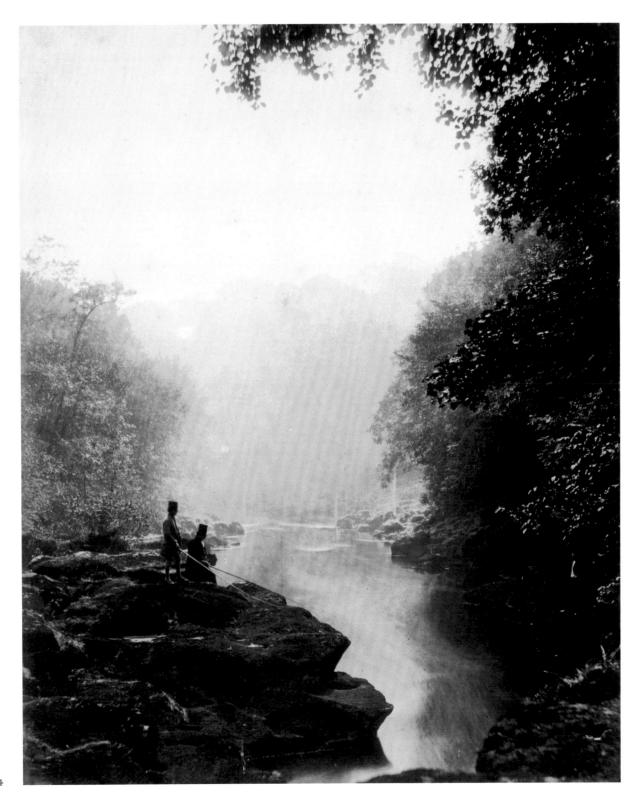

13. Wharfe and Pool, Below the Strid, 1854

THE CRIMEAN WAR, 1855

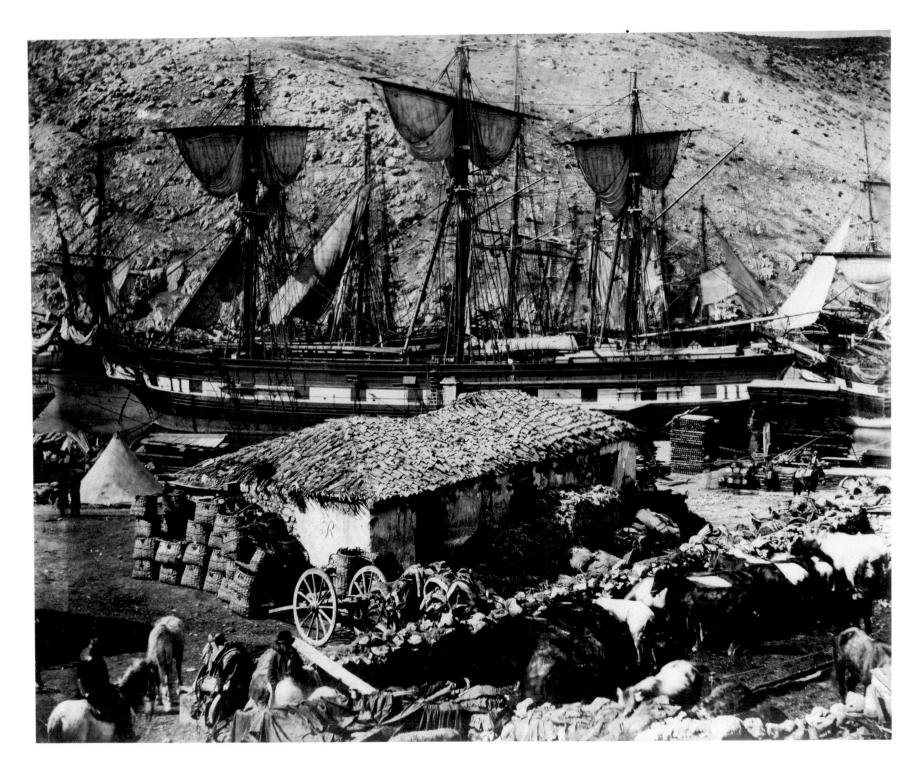

14. The Cattle Pier, Balaklava, 1855

15. Landing Place, Railway Stores, Balaklava, 1855

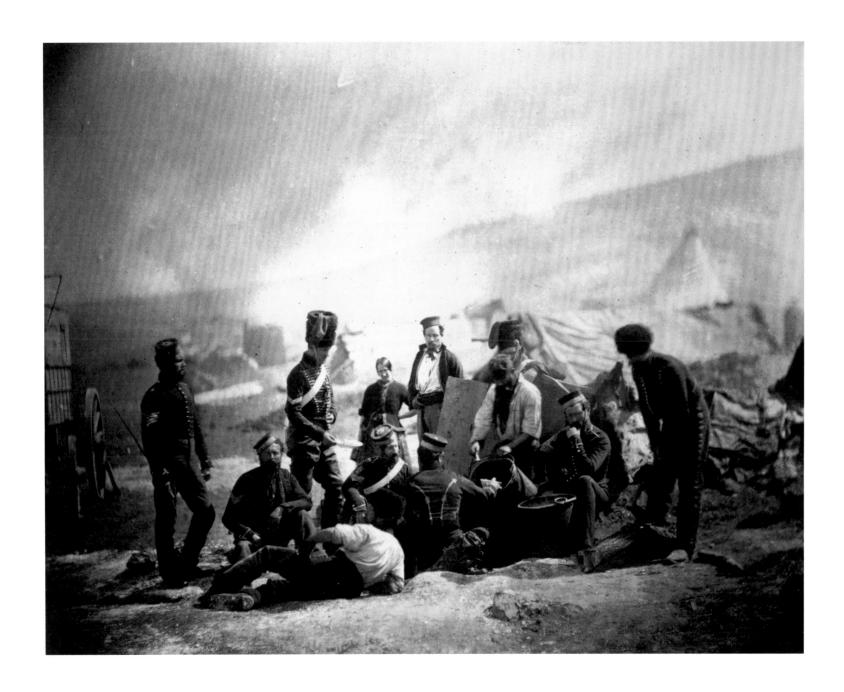

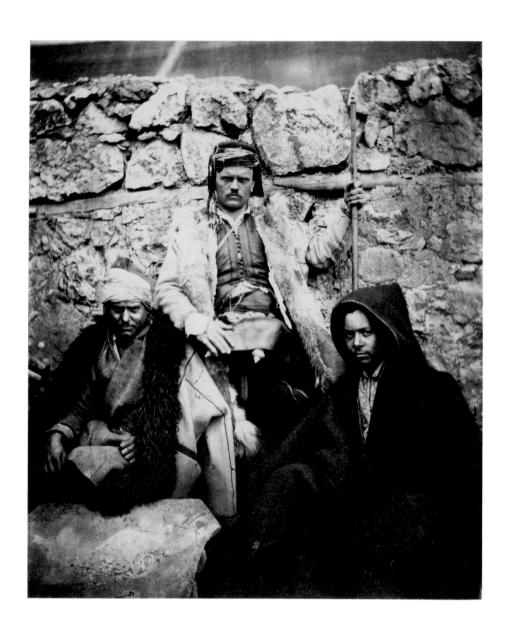

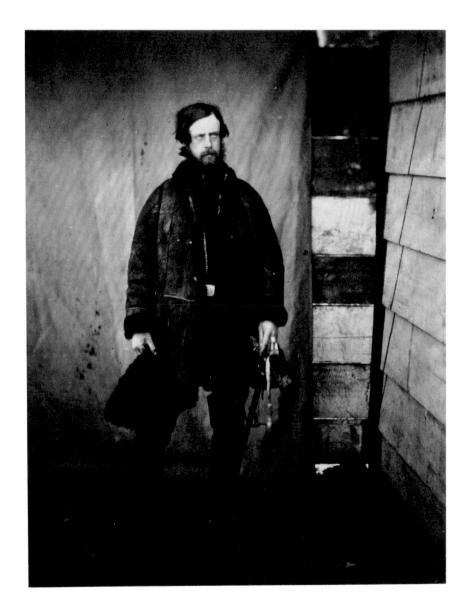

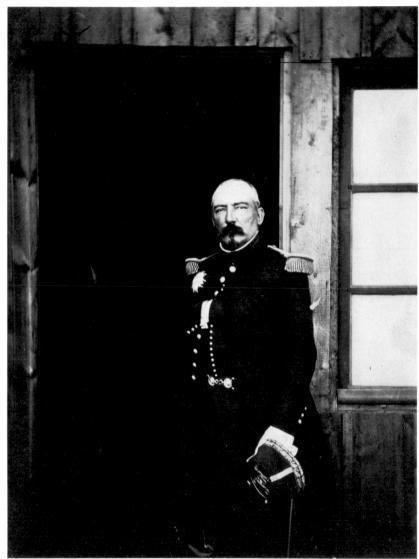

21. Valley of the Shadow of Death, 1855

EXCURSIONS TO SCOTLAND AND WALES, 1856 AND 1857

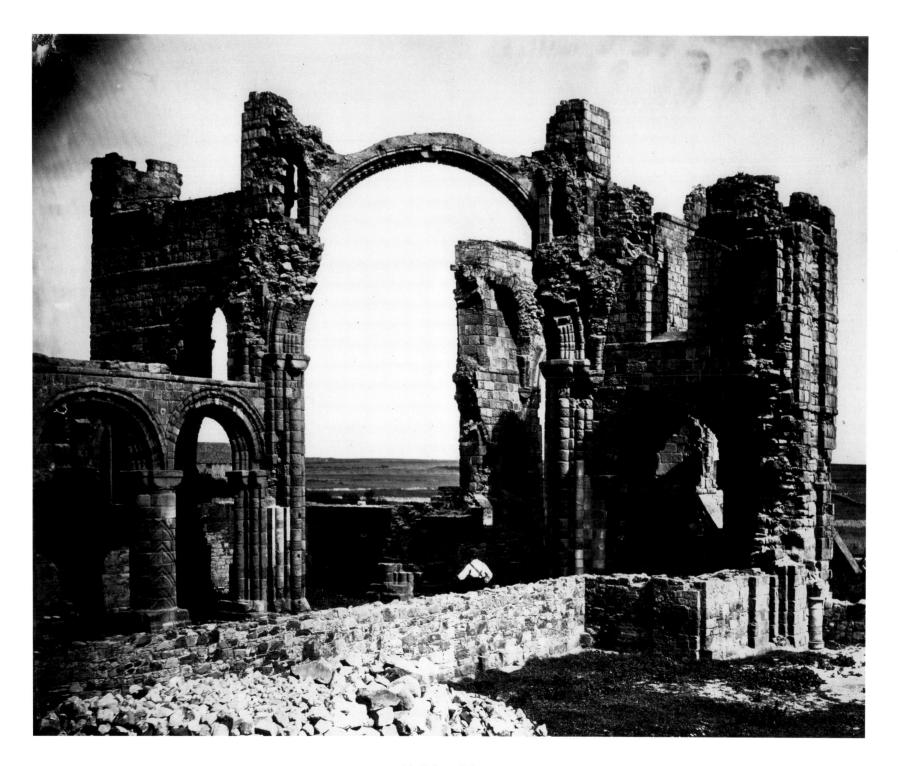

24. Lindisfarne Priory, 1856

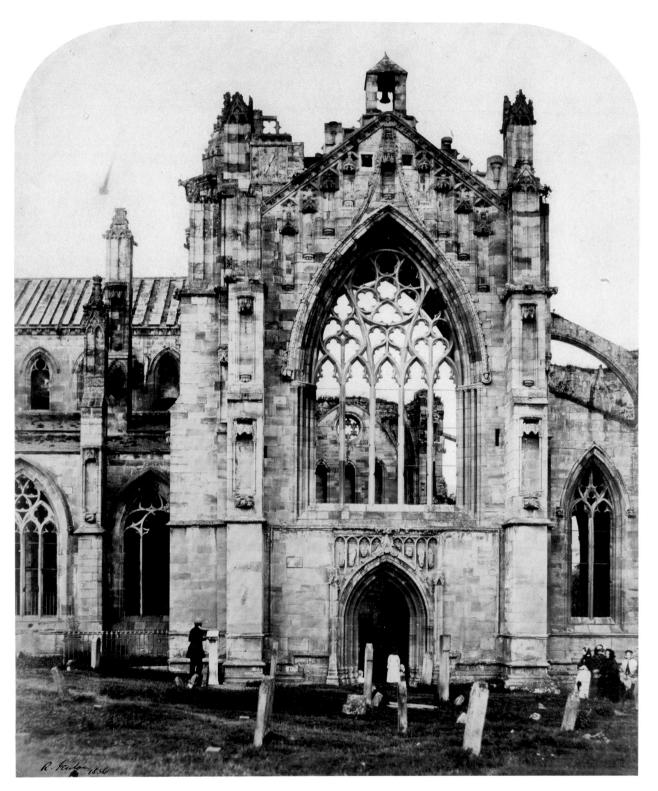

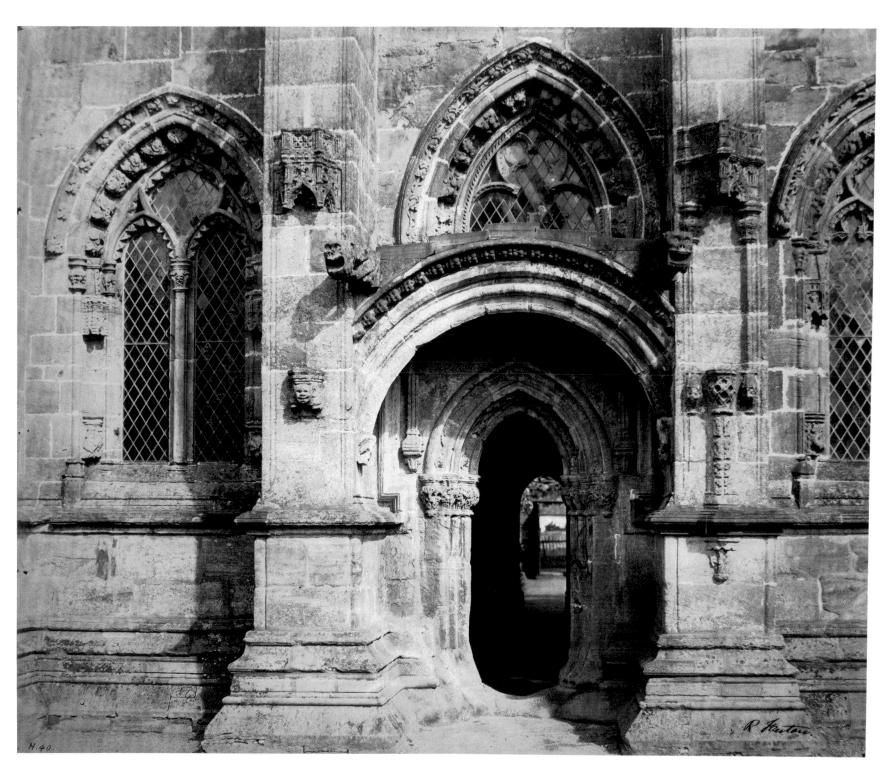

26. Roslin Chapel, South Porch, 1856

27. The Princess Royal and Princess Alice, [1855]

28. Princesses Helena and Louise, 1856

29. A Ghillie at Balmoral, 1856

30. Prince Alfred, Duke of Edinburgh, 1856

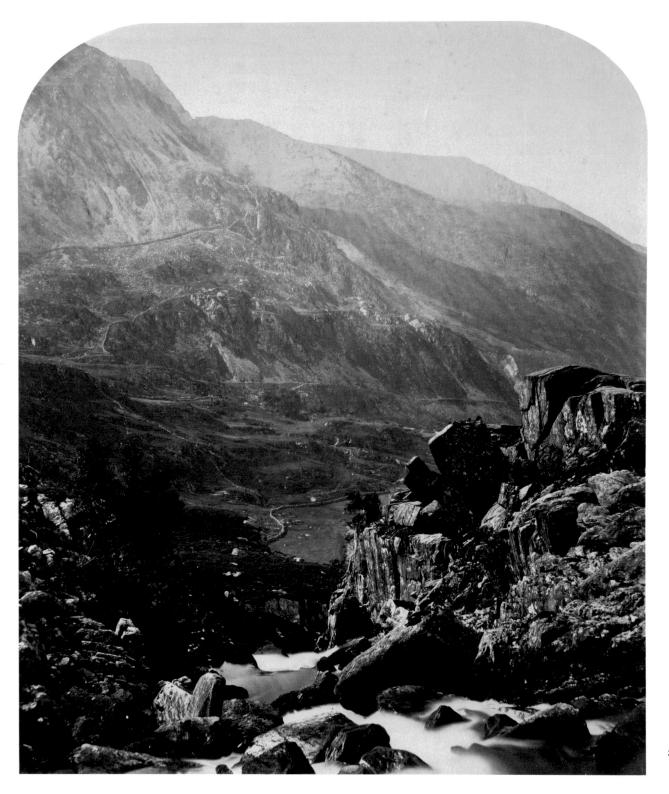

31. View from Ogwen Falls into Nant Ffrancon, 1857

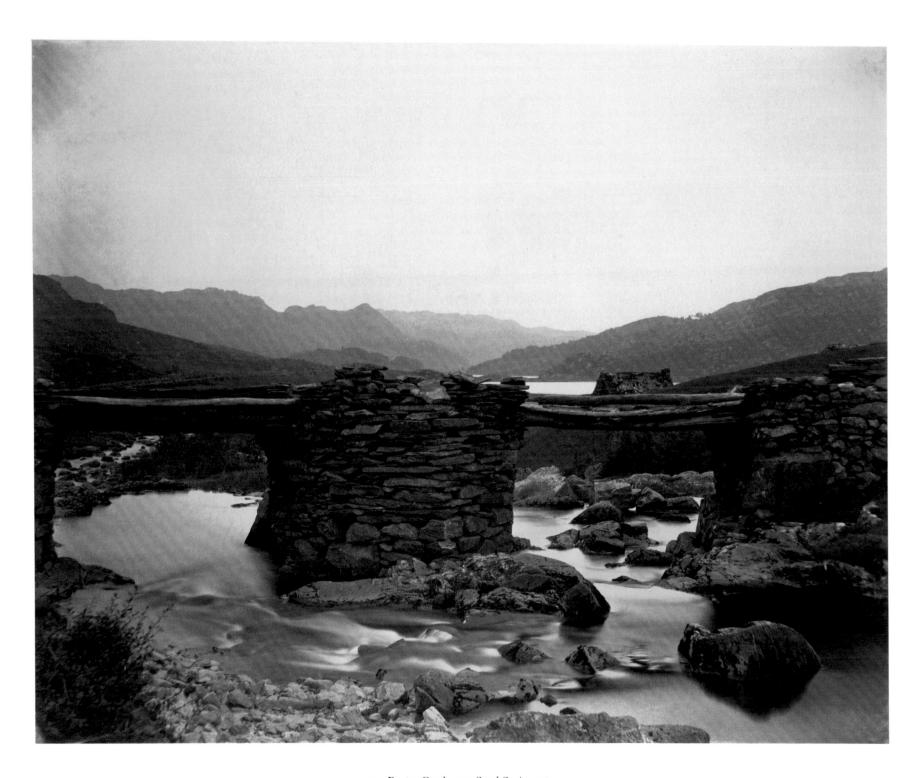

32. Pont-y-Garth, near Capel Curig, 1857

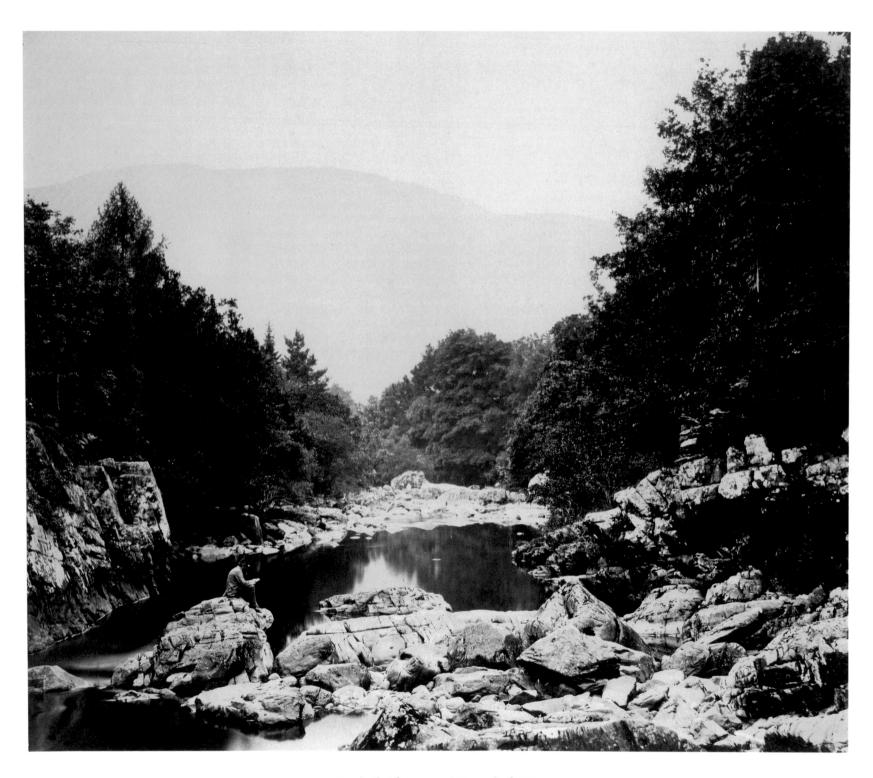

33. On the Llugwy, near Bettws-y-Coed, 1857

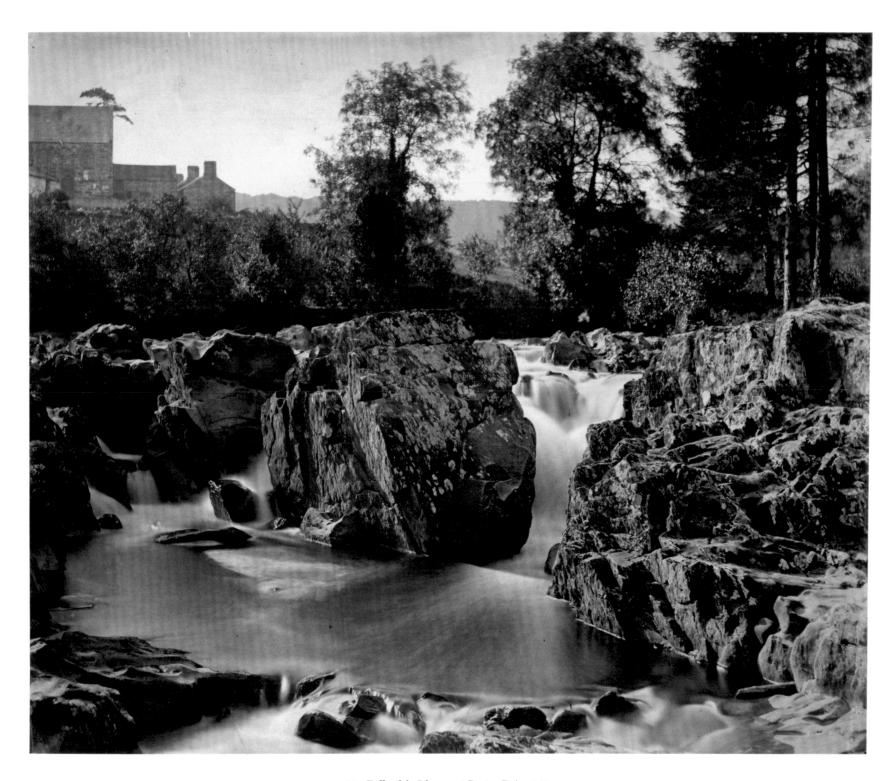

34. Falls of the Llugwy, at Pont-y-Pair, 1857

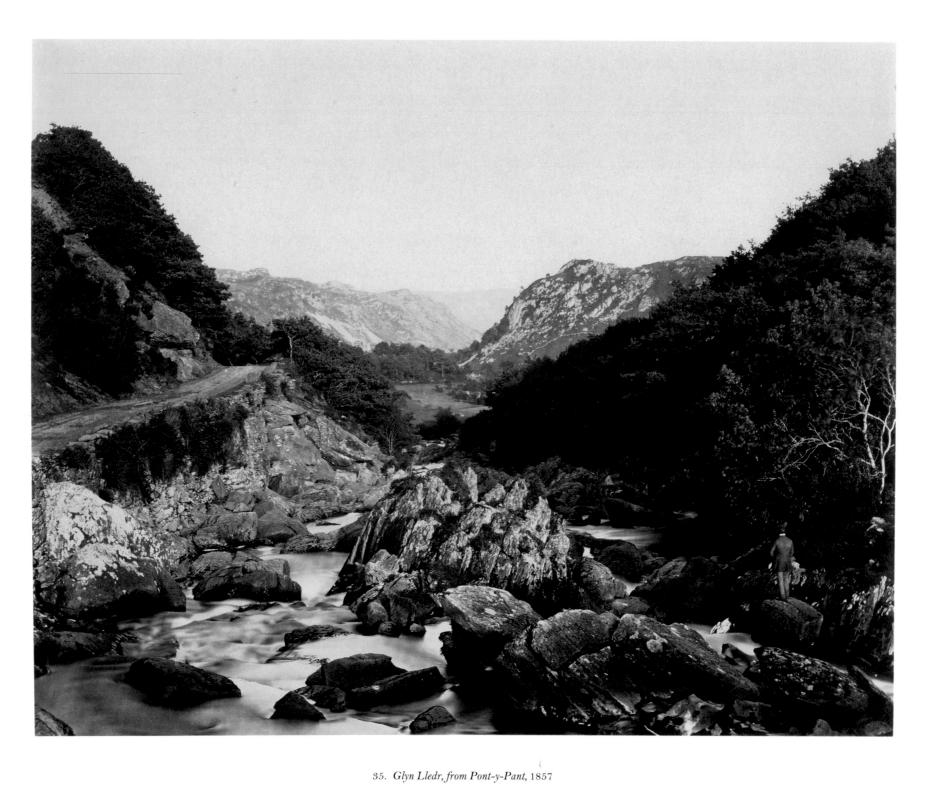

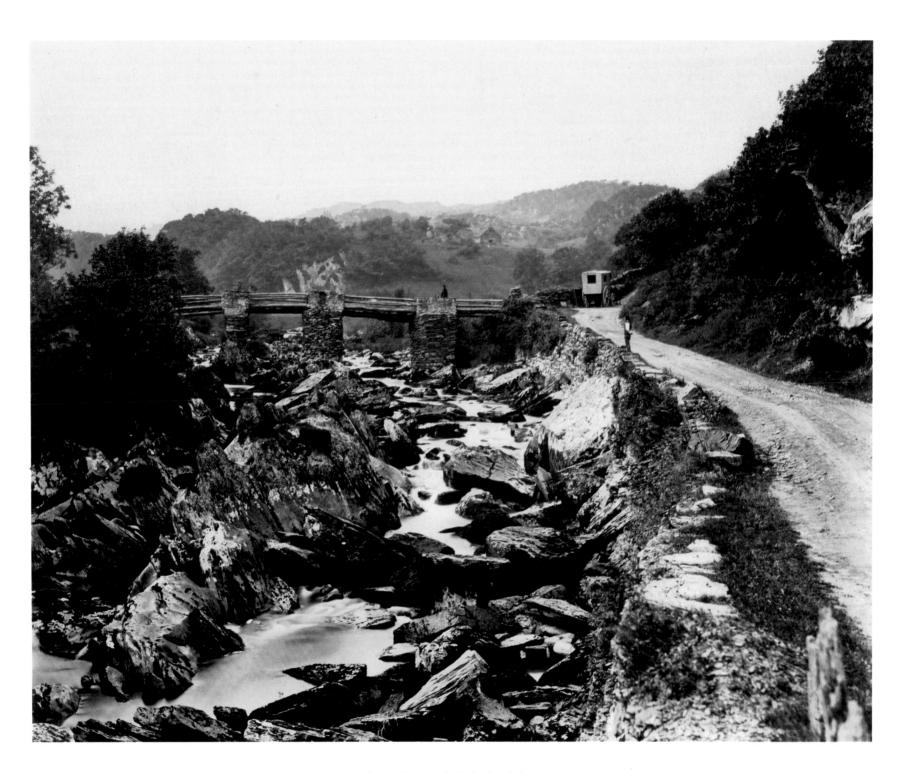

36. Pont-y-Pant, on the Lledr, from Below, 1857

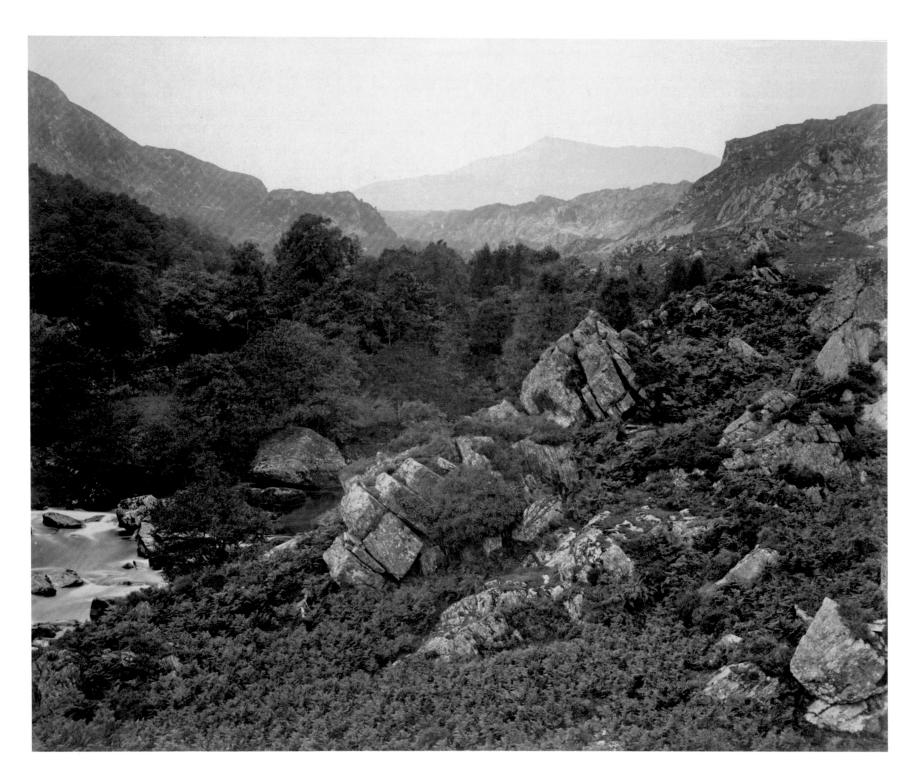

37. Moel Seabod, from the Lledr Valley, 1857

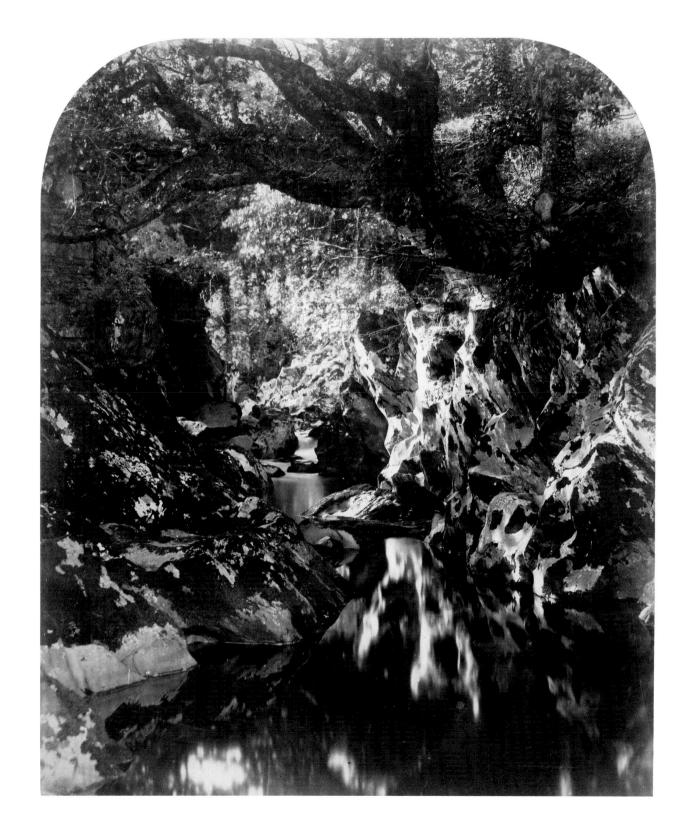

38. The Double Bridge on the Machno, 1857

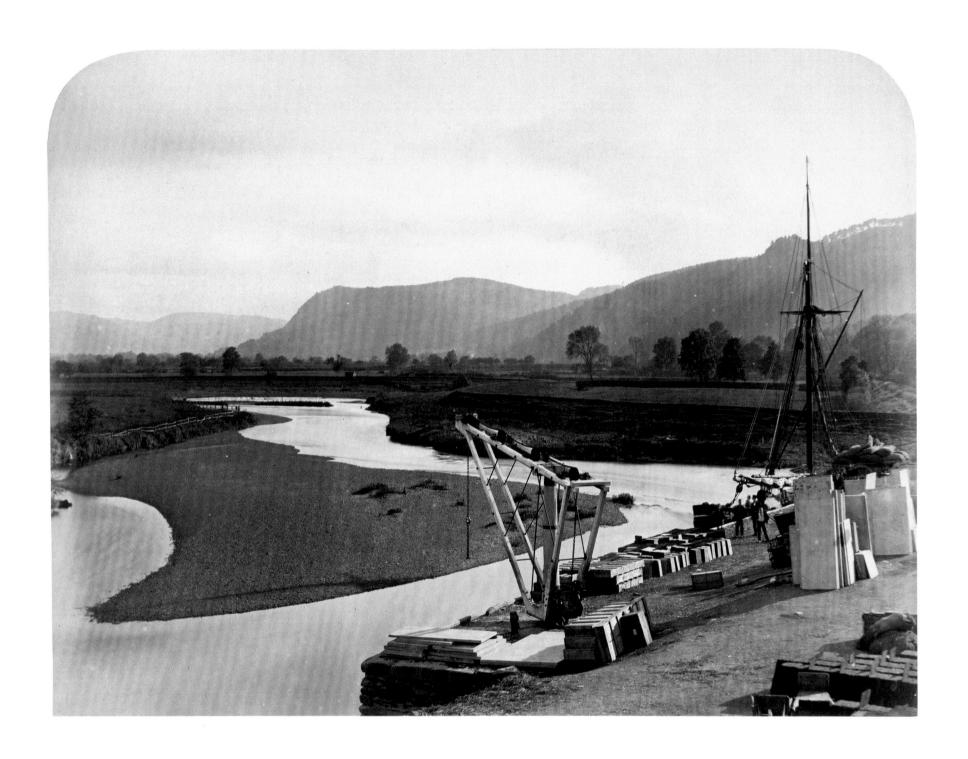

39. Slate Pier at Trefriw, 1857

THE BRITISH MUSEUM, 1854-1858

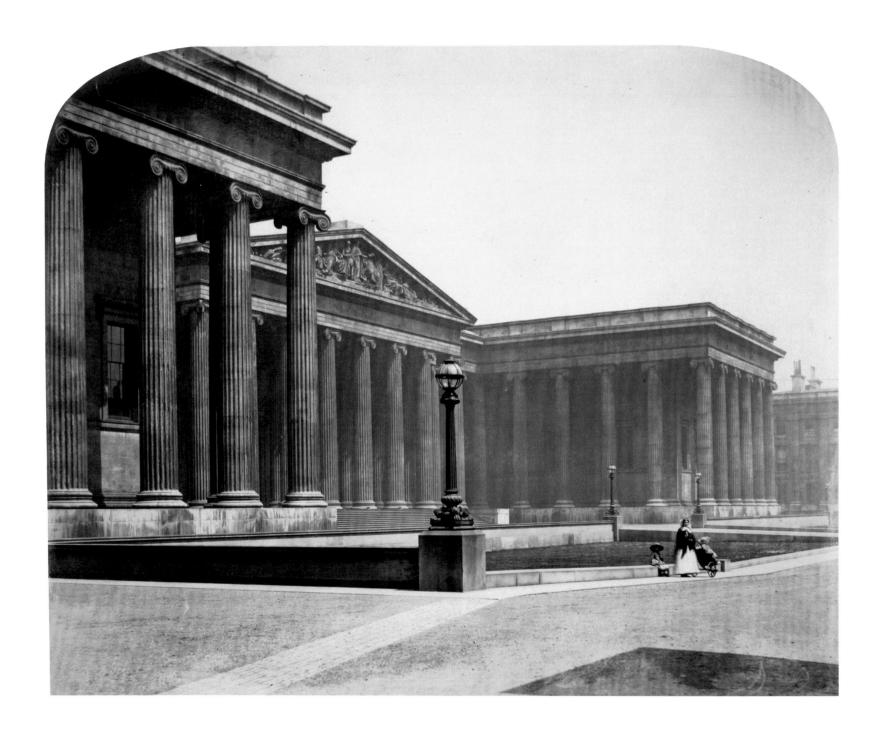

40. The British Museum, 1857

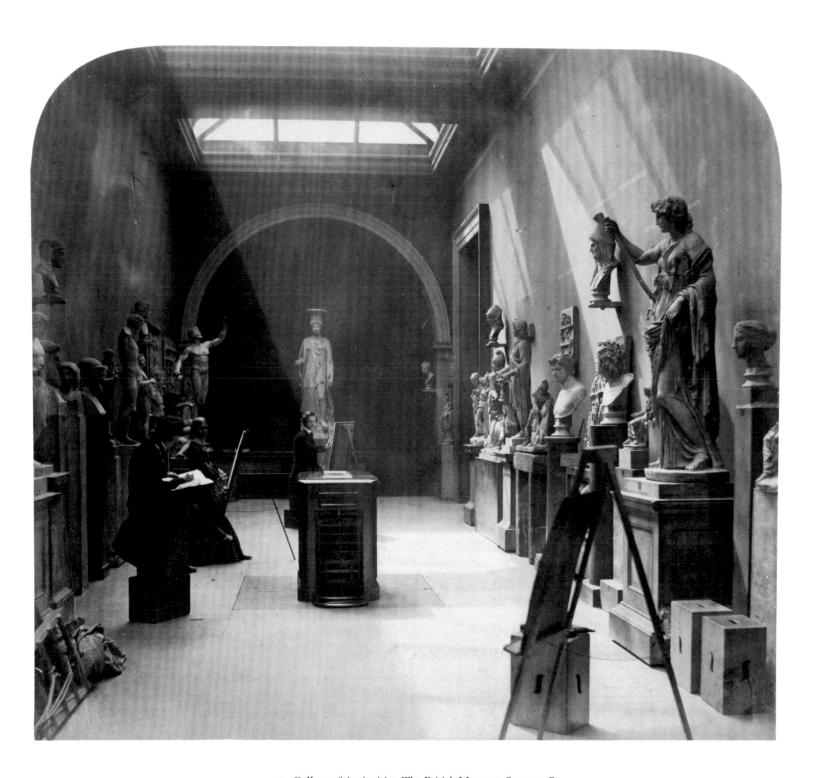

41. Gallery of Antiquities, The British Museum, [ca. 1857]

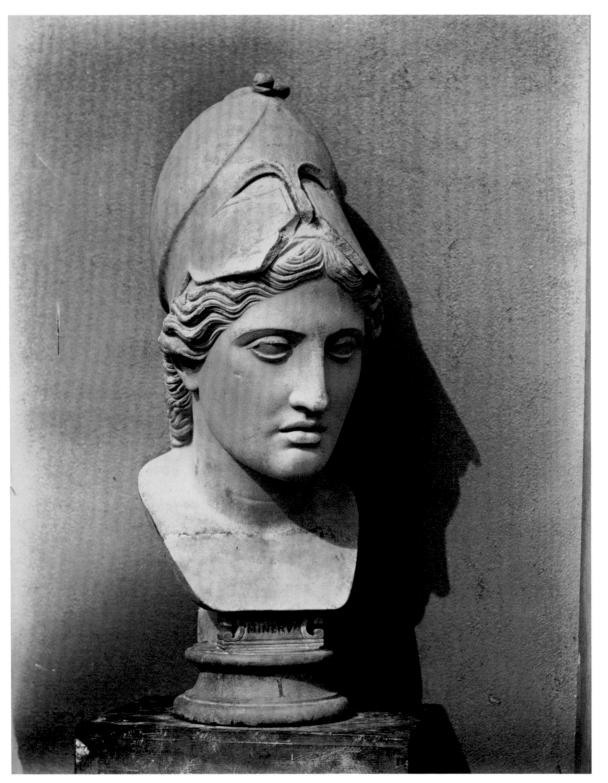

42. Head of Minerva, from the Marble in the British Museum, [1858]

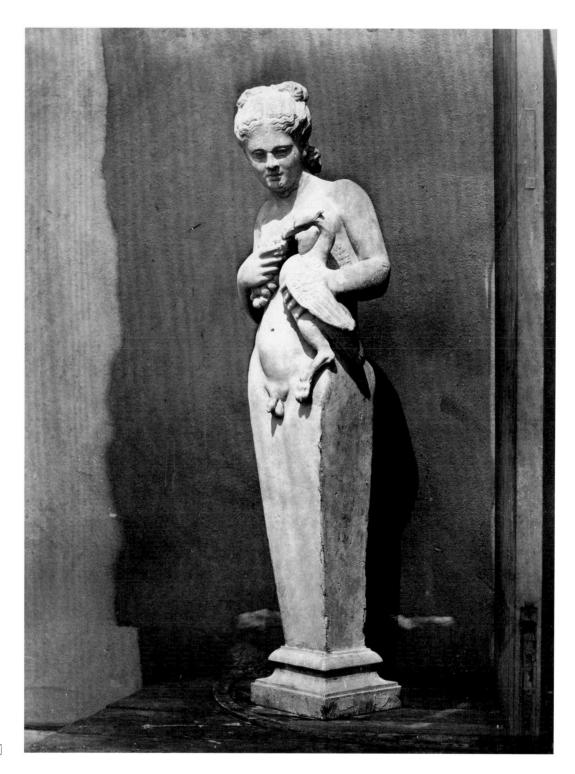

44. Skeleton of Man and of the Male Gorilla (Troglodytes Gorilla) I, [1854–58]

45. Elephantine Moa (Dinornis elephantopus), an Extinct Wingless Bird, in the Gallery of Fossils, British Museum, [1854–58]

46. Gallery with Discobolus, British Museum, [ca. 1857]

SACRED AND SECULAR ARCHITECTURE, 1857–1858

47. York Minster, from the South East, [ca. 1856]

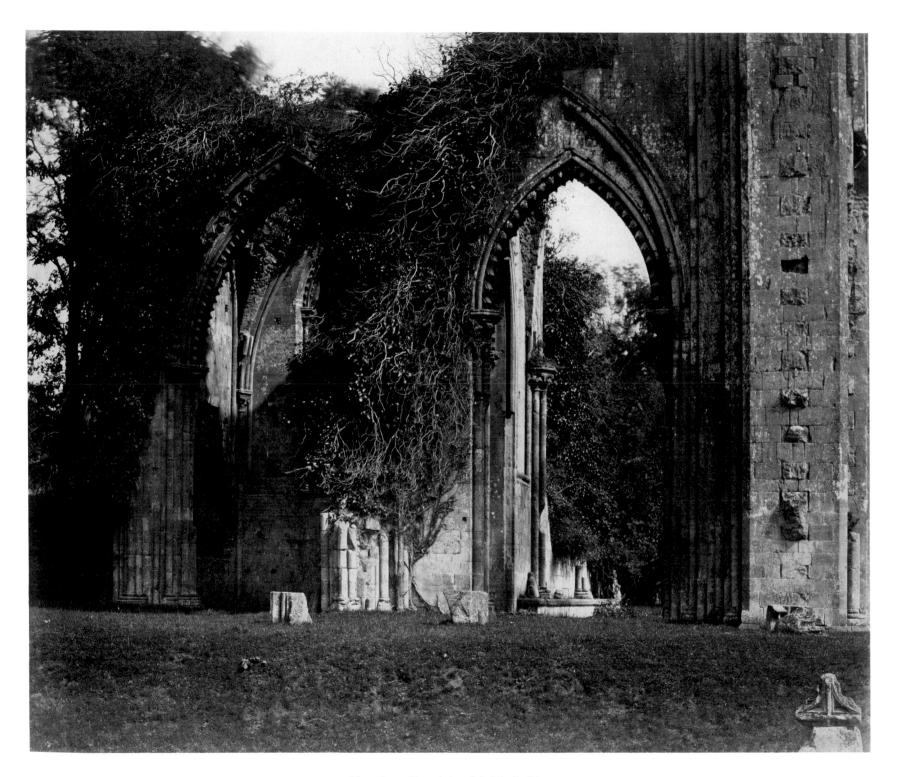

48. Glastonbury Abbey, Arches of the North Aisle, 1858

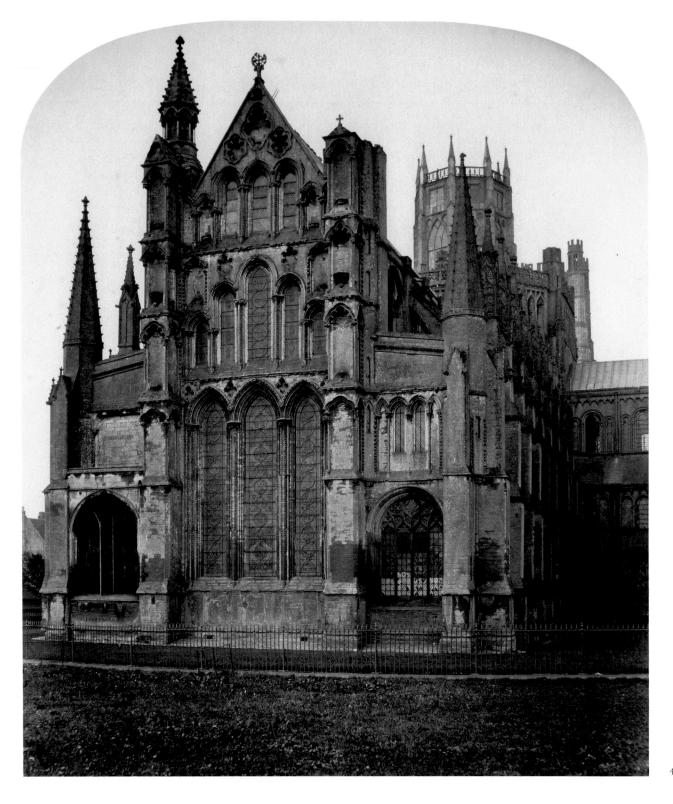

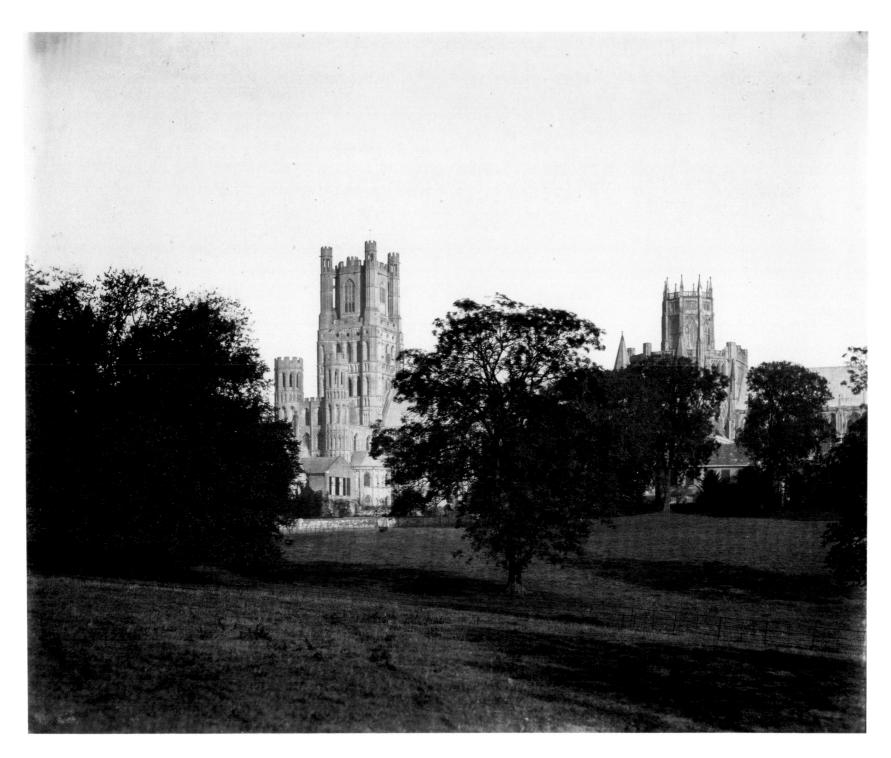

50. Ely Cathedral, from the Park, 1857

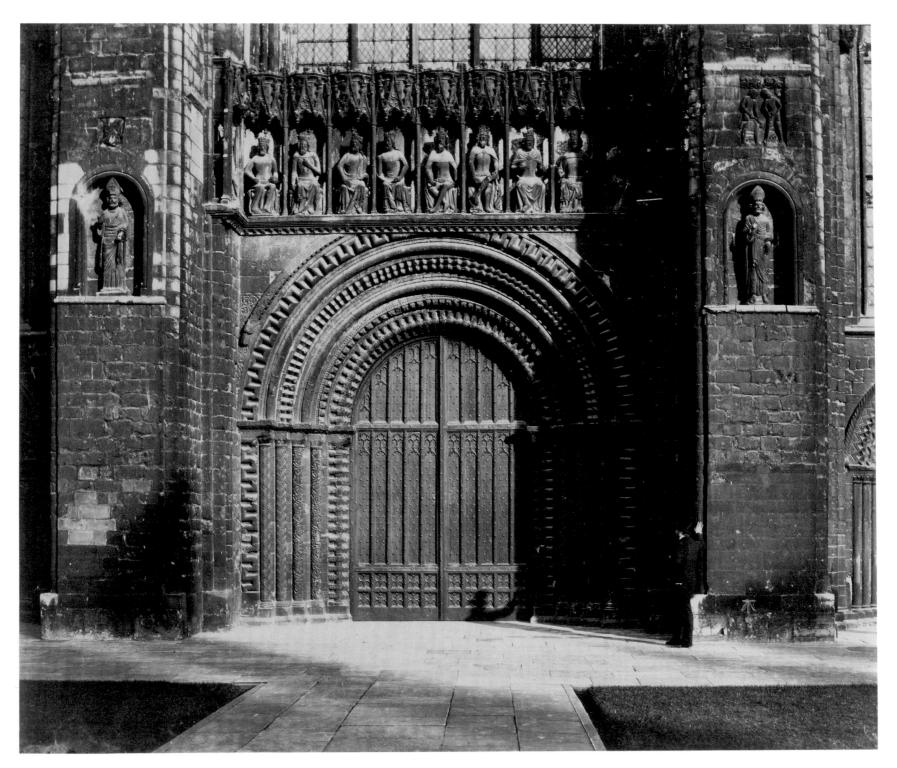

51. Lincoln Cathedral, West Porch, 1857

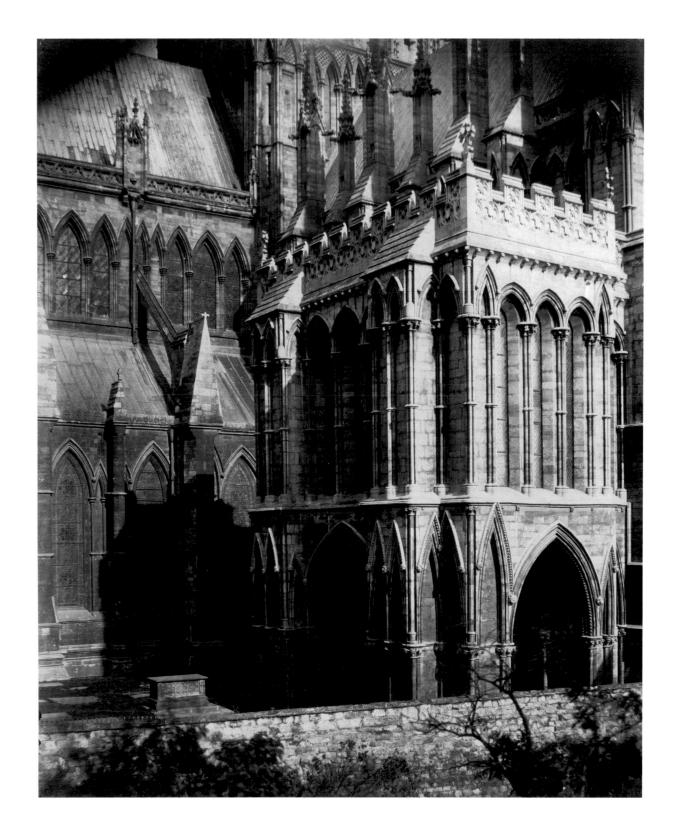

52. Lincoln Cathedral, The Galilee Porch, 1857

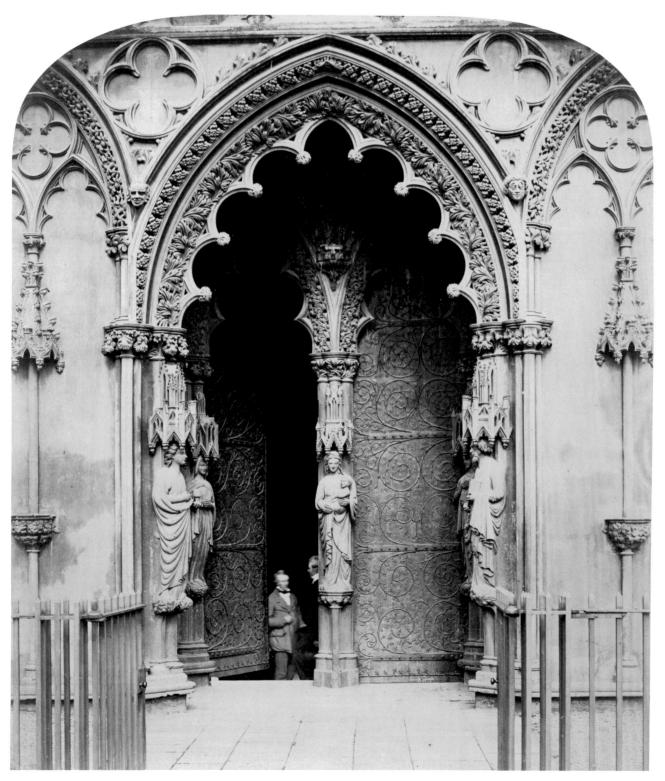

53. Lichfield Cathedral, Central Doorway, West Porch, 1858

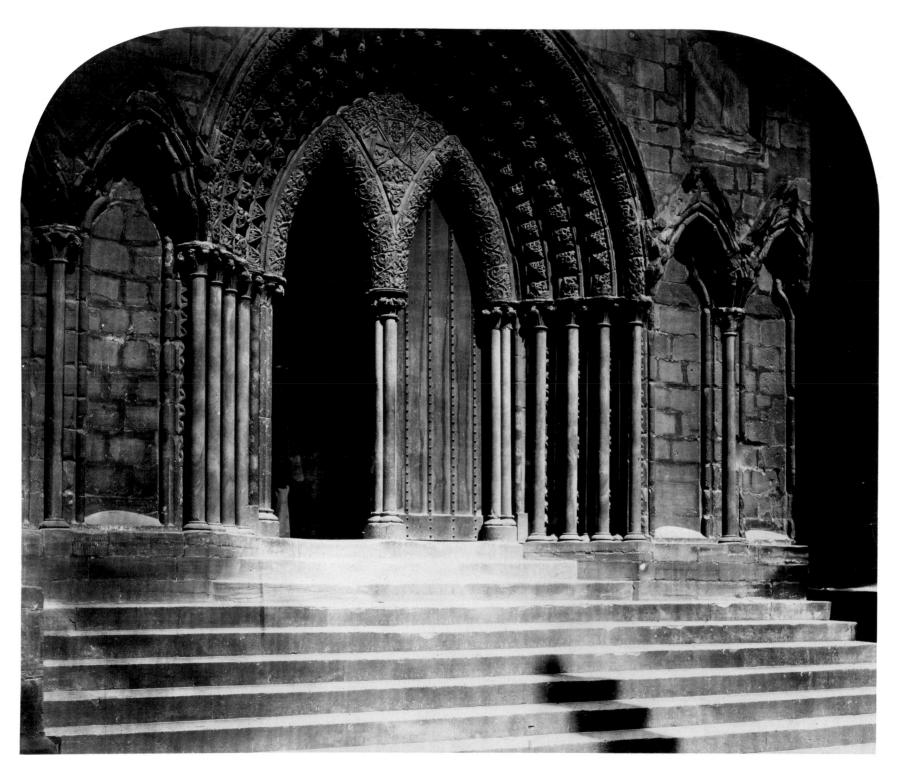

54. Lichfield Cathedral, South Transept Portal and Steps, 1858

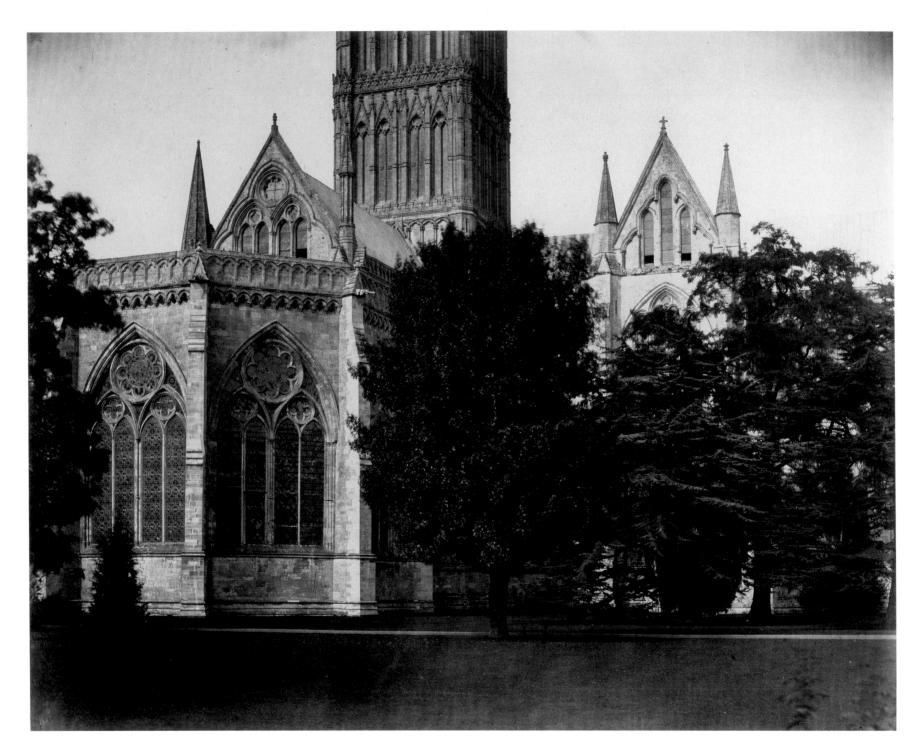

55. Salisbury Cathedral, View in the Bishop's Garden, 1858

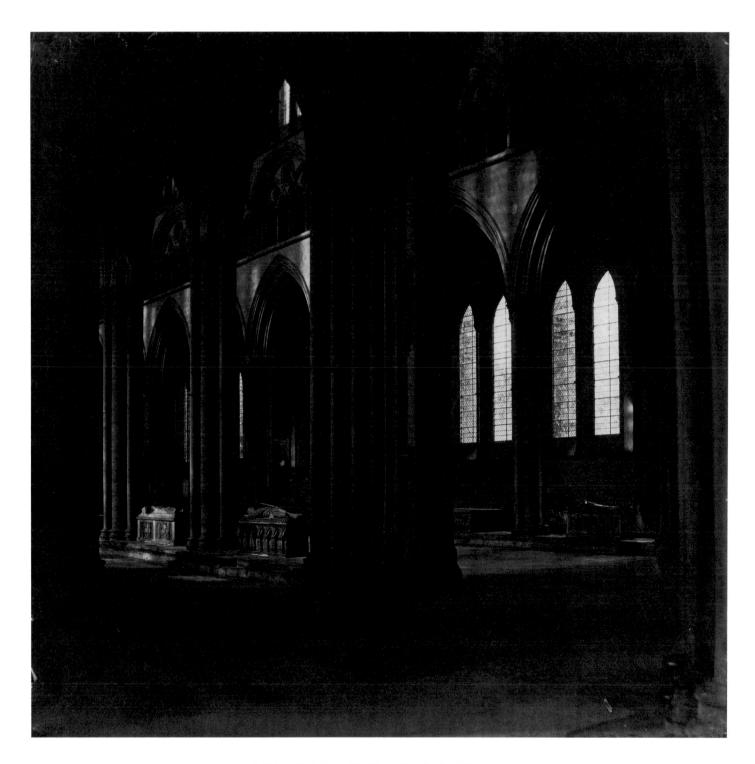

56. Salisbury Cathedral – The Nave, from the South Transept, 1858

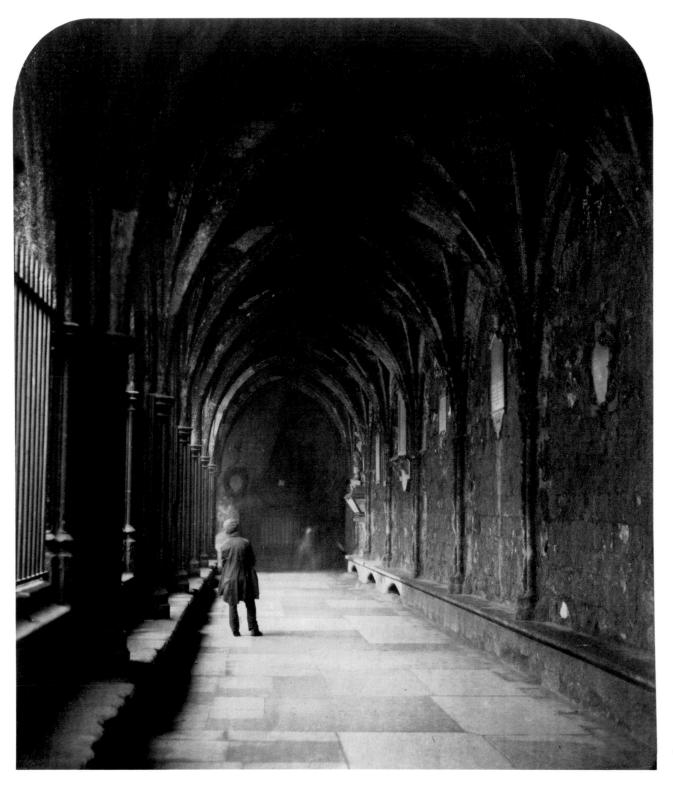

57. Westminster Abbey, Cloisters, [ca. 1858]

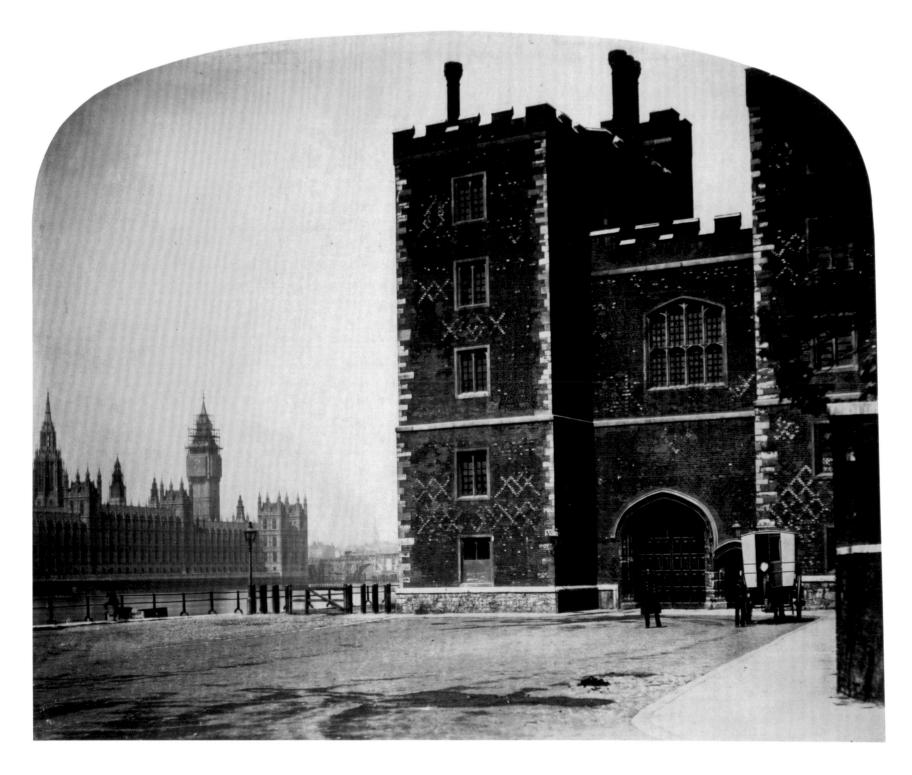

58. Lambeth Palace, [ca. 1858]

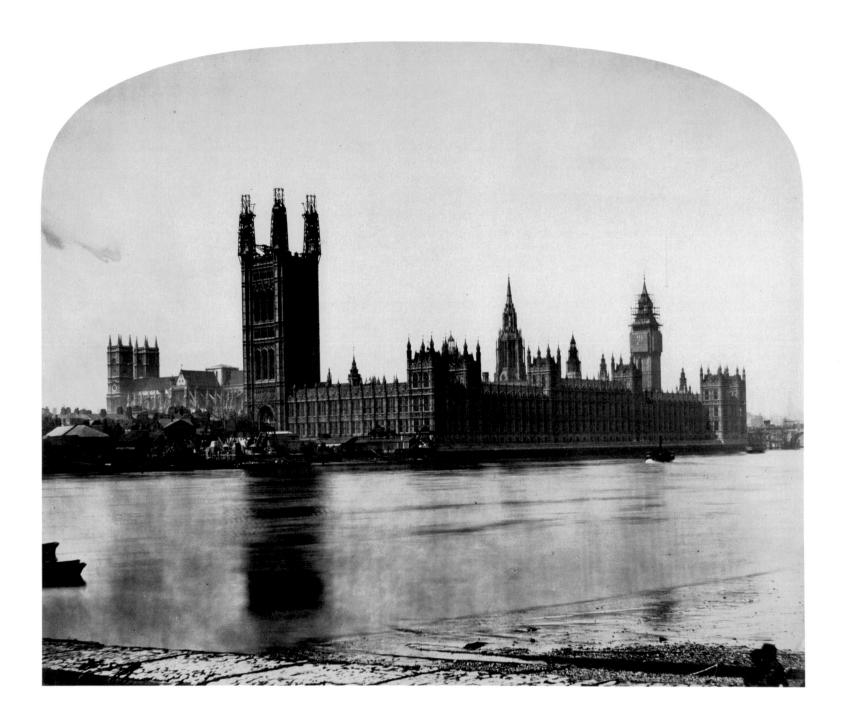

59. Houses of Parliament, [ca. 1858]

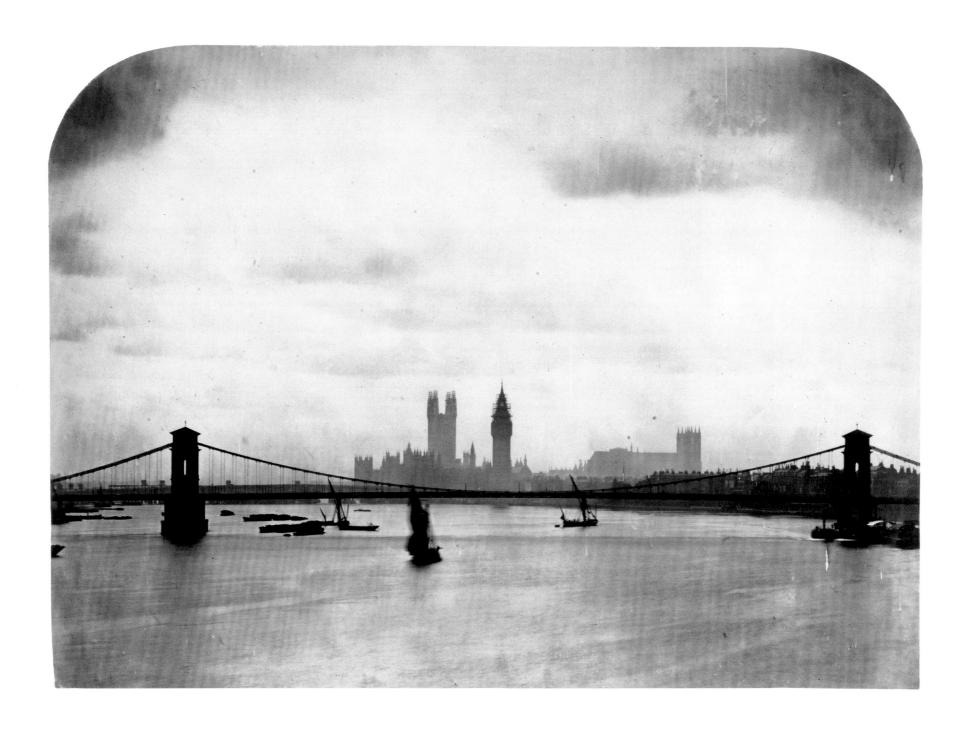

60. Westminster from Waterloo Bridge, [ca. 1858]

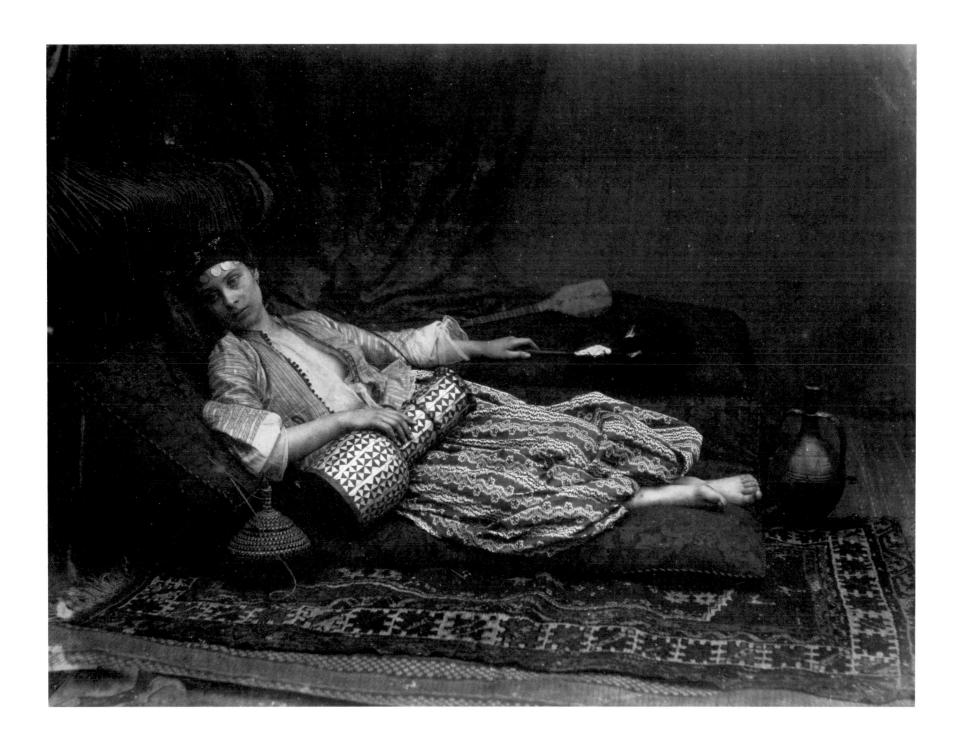

61. Reclining Odalisque, 1858

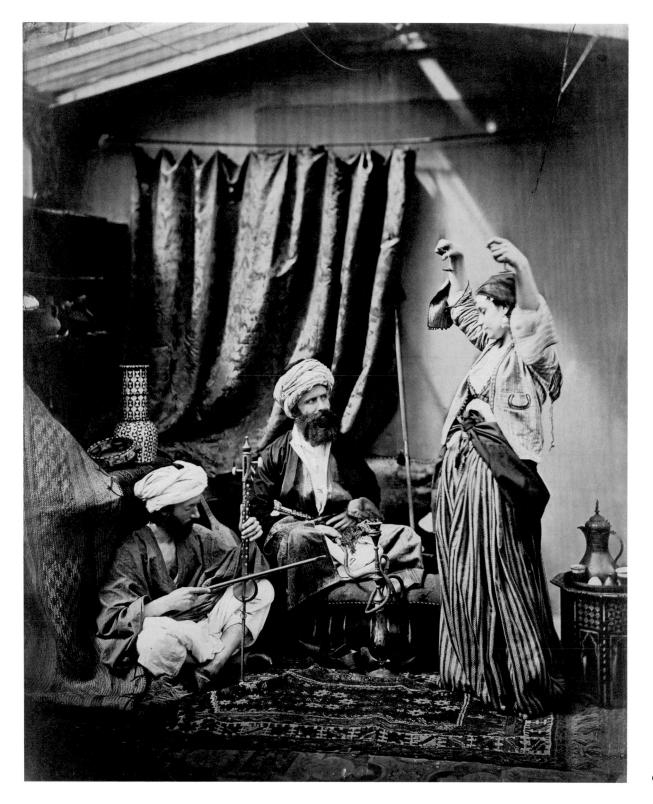

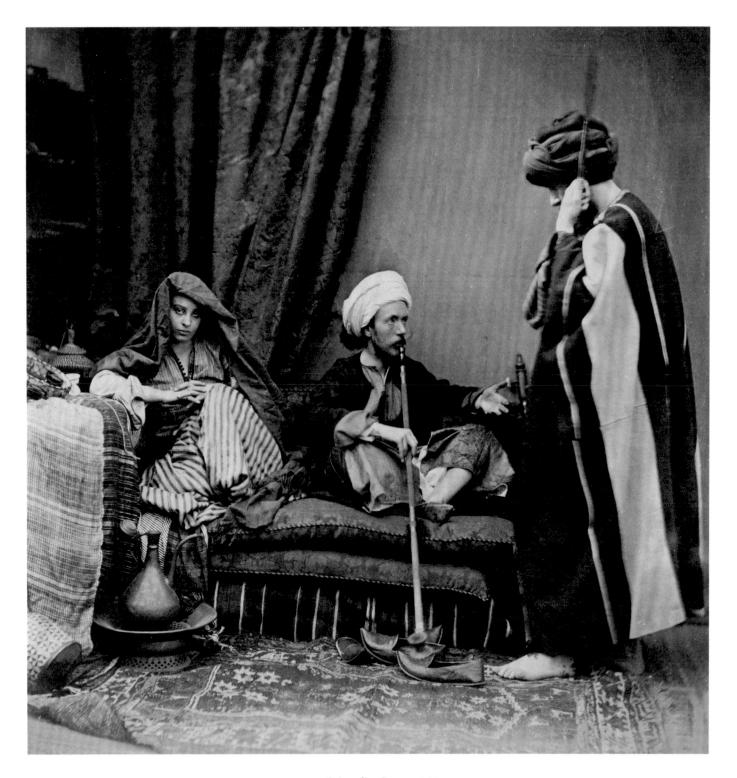

63. Orientalist Group, 1858

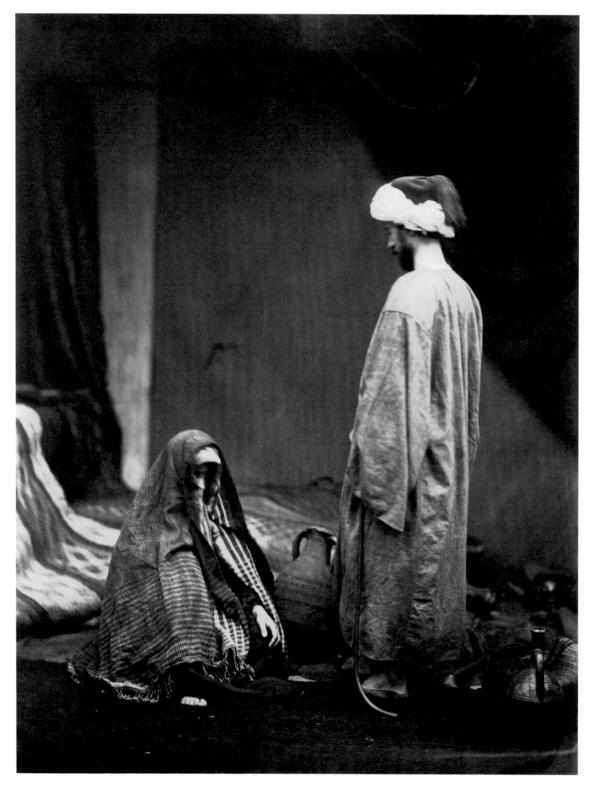

64. Orientalist Group, 1858

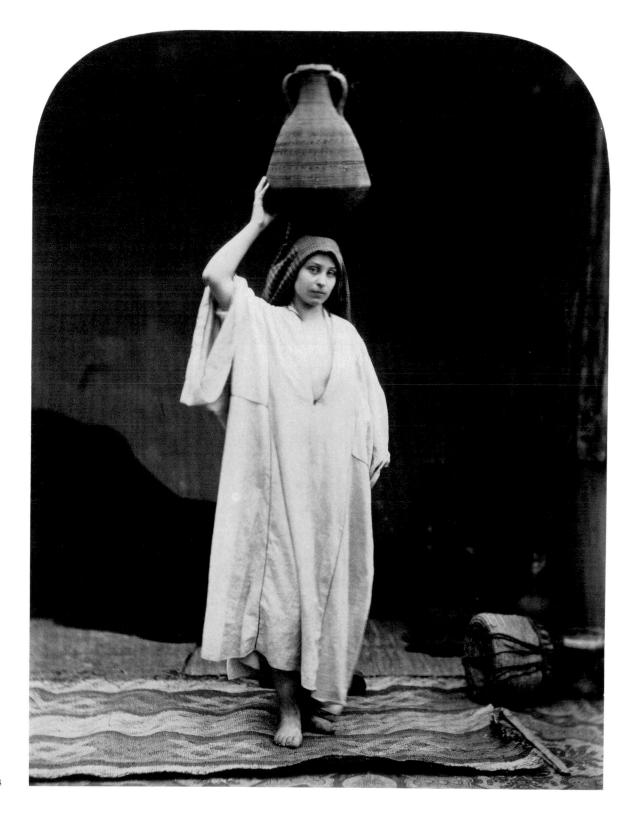

LANDSCAPES AND STATELY HOMES, 1858-1860

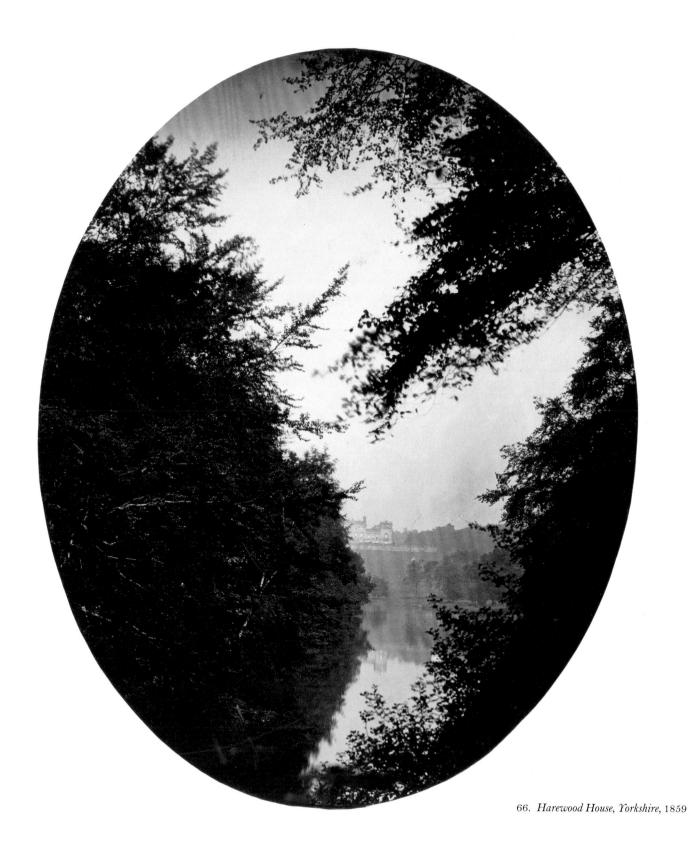

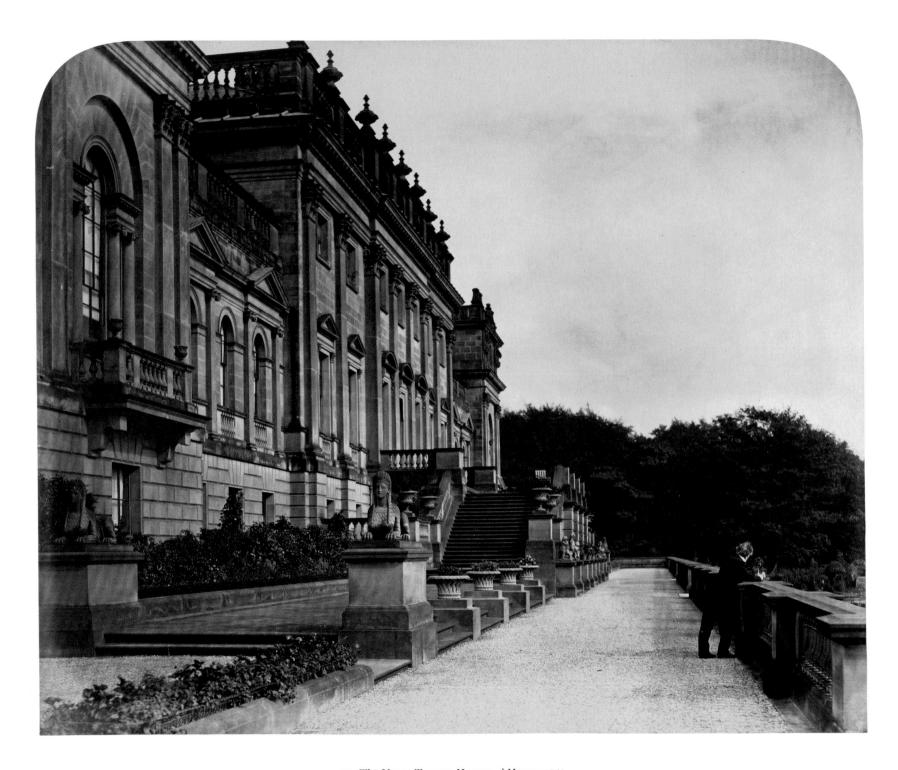

67. The Upper Terrace, Harewood House, 1859

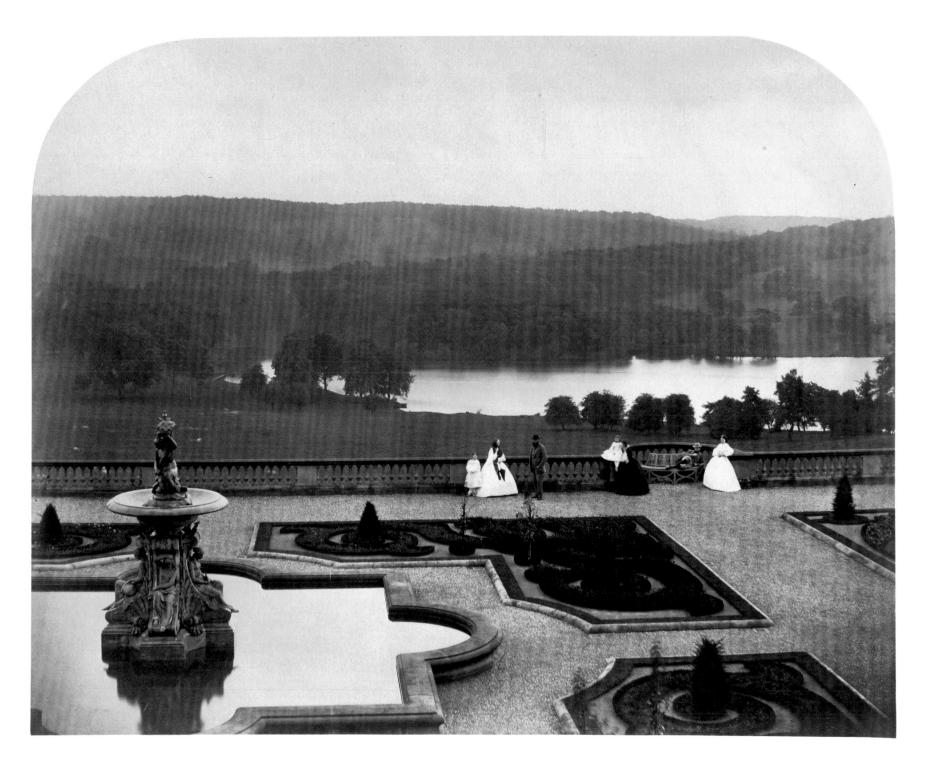

68. The Terrace, Garden and Park, Harewood, 1859

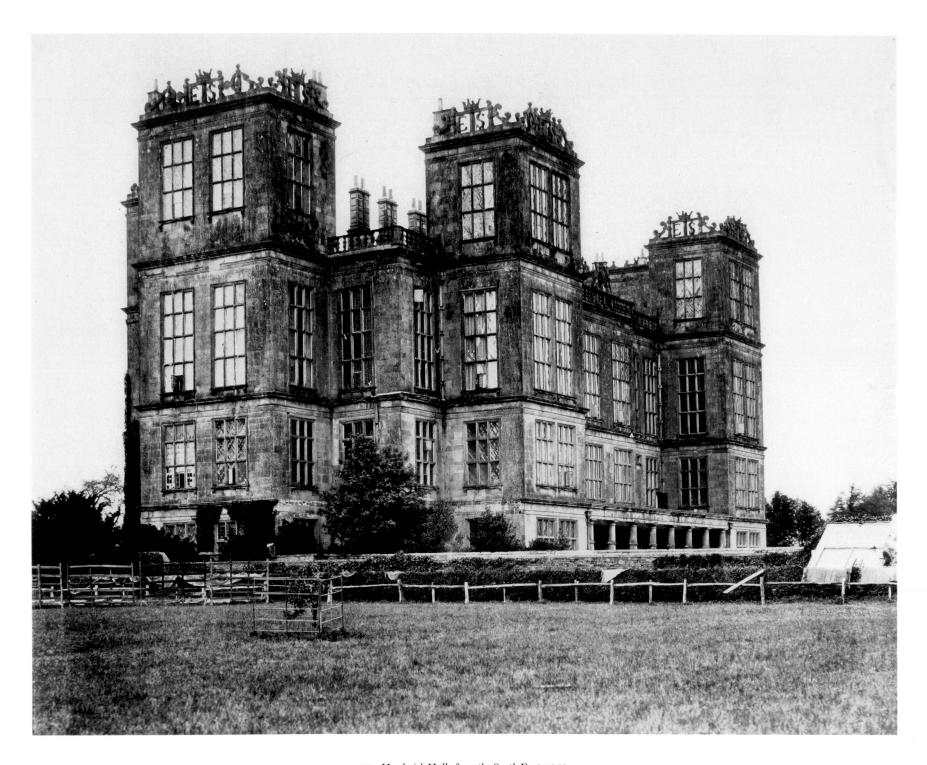

69. Hardwick Hall, from the South East, 1858

70. The Lily House, Botanic Garden, Oxford, 1859

71. Wollaton Hall, [ca. 1859]

72. The Billiard Room, Mentmore, [ca. 1858]

73. Boys in the Refectory, Stonyhurst, 1859

74. Paradise, View down the Hodder, Stonyhurst, 1859

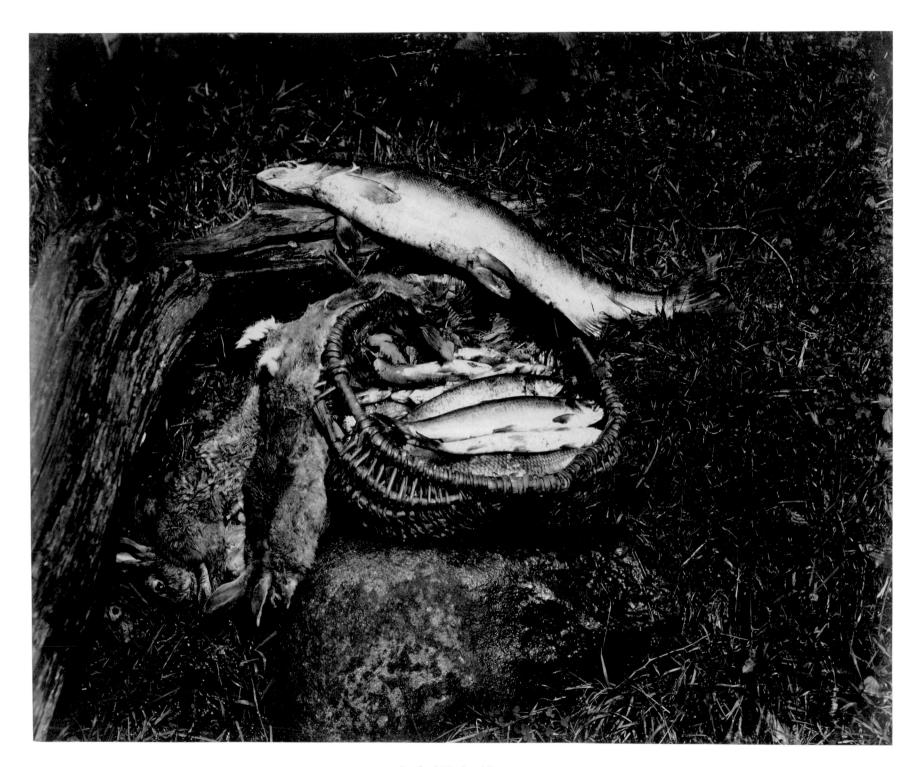

75. Spoils of Wood and Stream, 1859

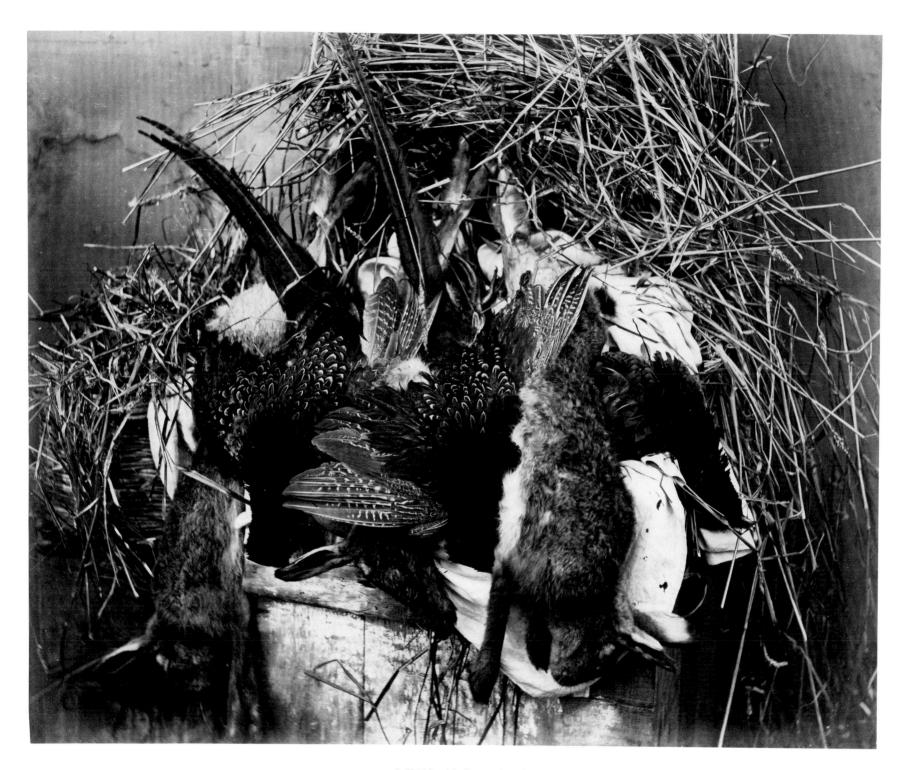

76. Still Life with Game, [1859]

77. Up the Hodder, near Stonyhurst, 1859

78. Valley of the Ribble and Pendle Hill, 1859

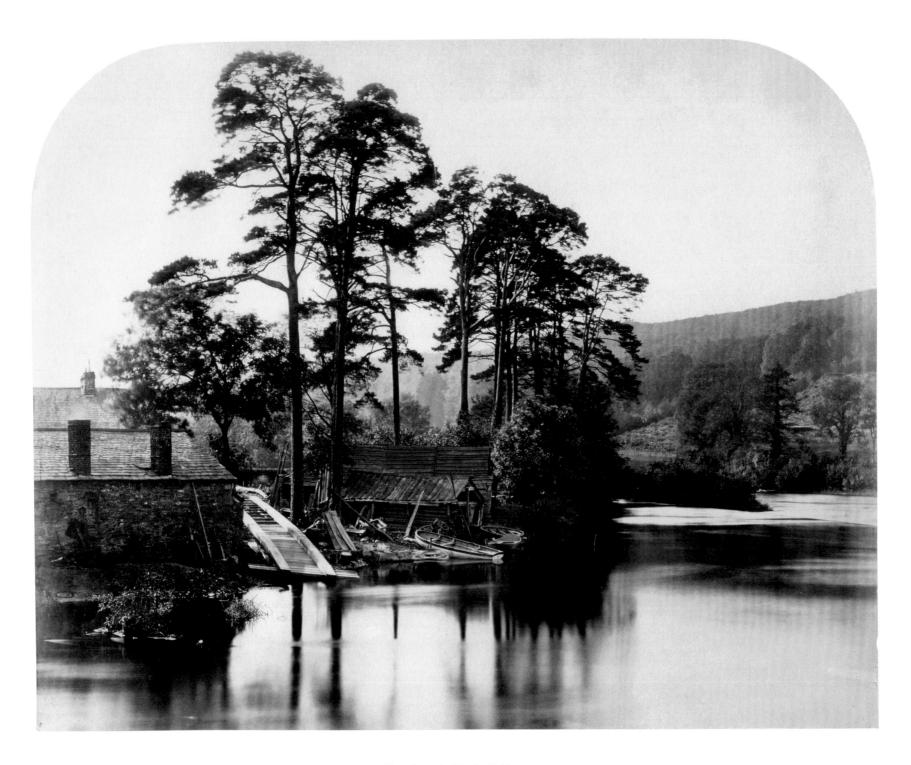

79. View from the Newby Bridge, 1860

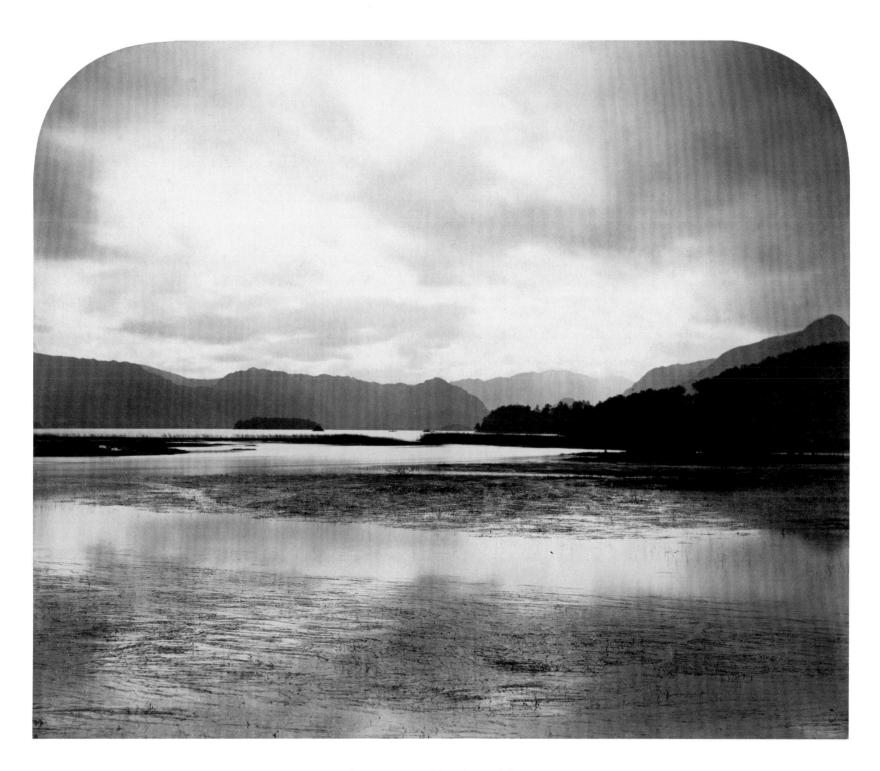

80. Derwentwater, Looking to Borrowdale, 1860

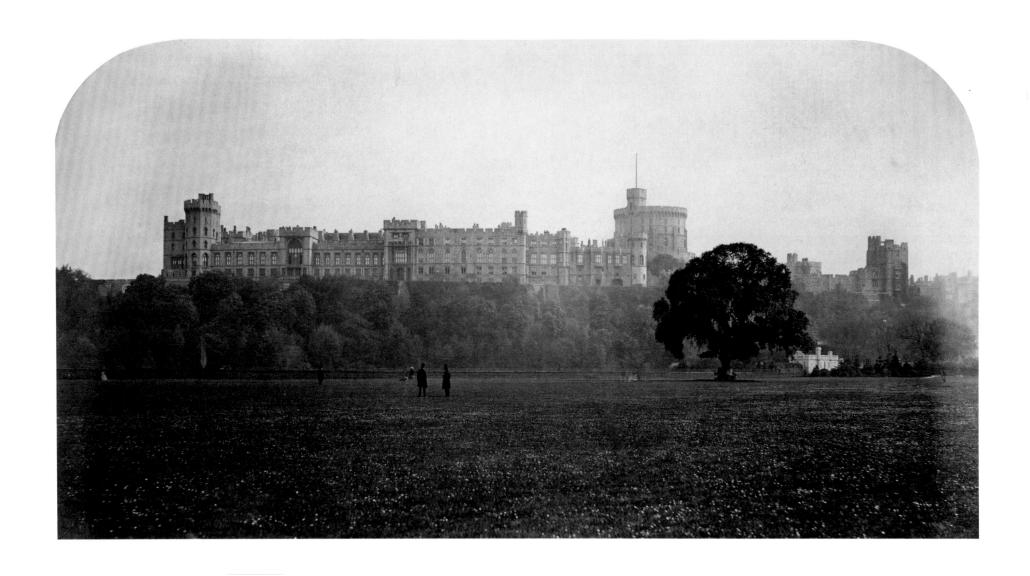

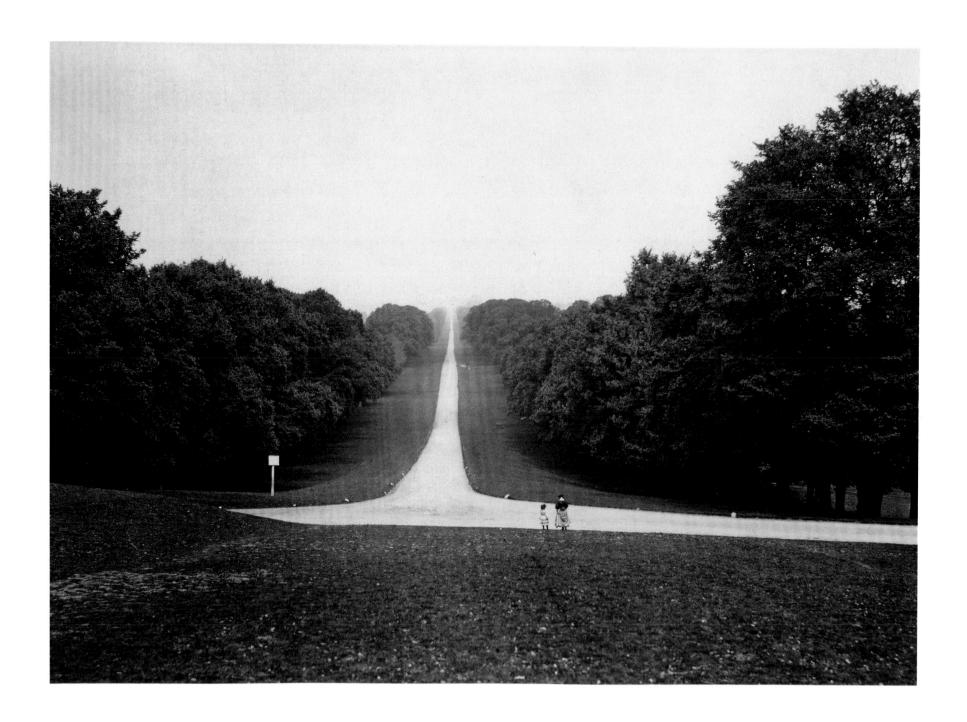

85. The Queen's Target, 1860

STILL LIFES, 1860

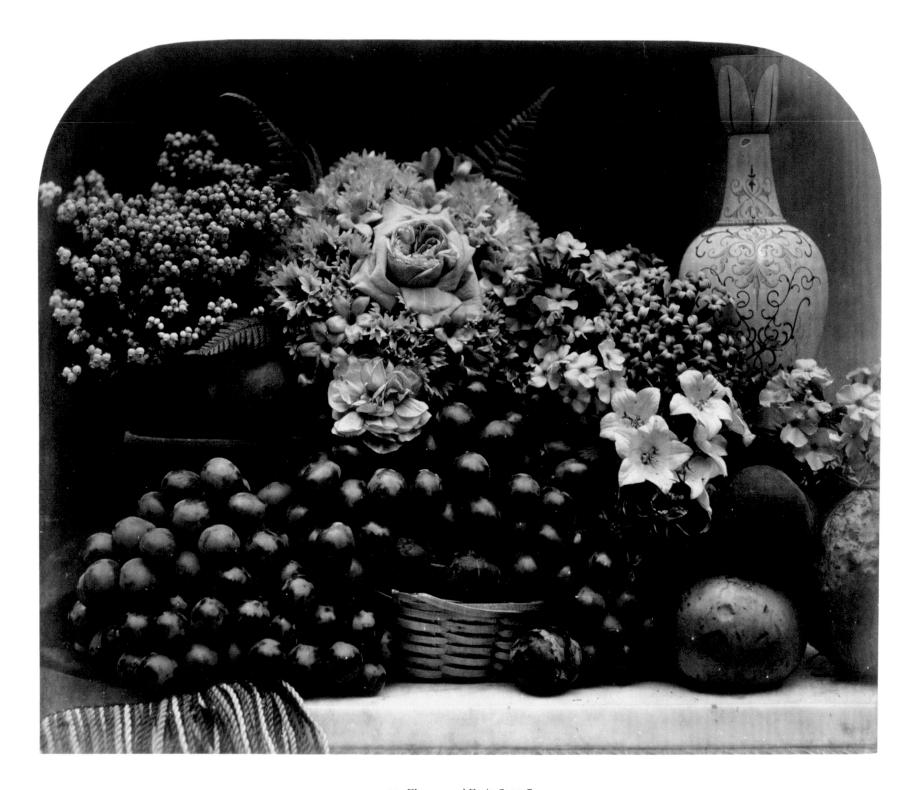

86. Flowers and Fruit, [1860]

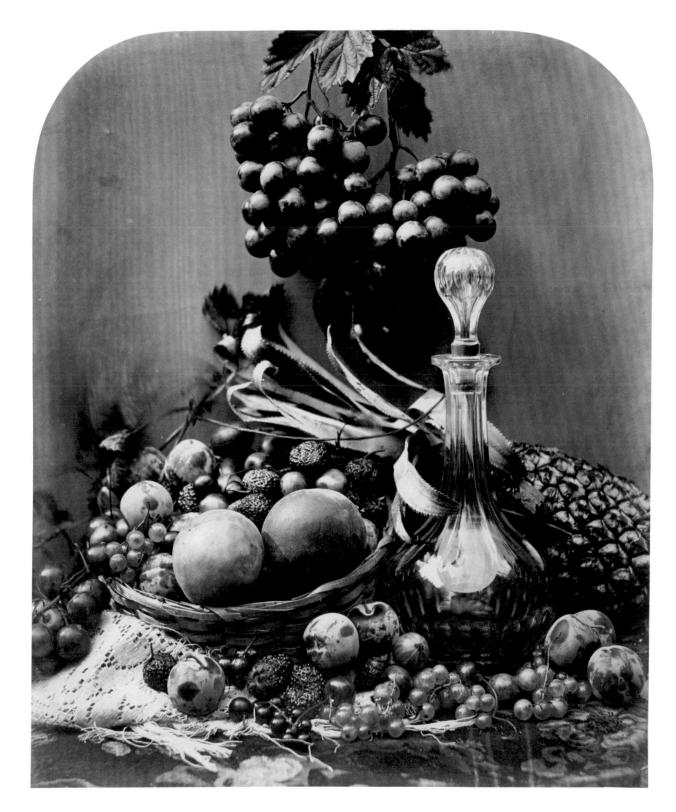

87. Decanter and Fruit, [1860]

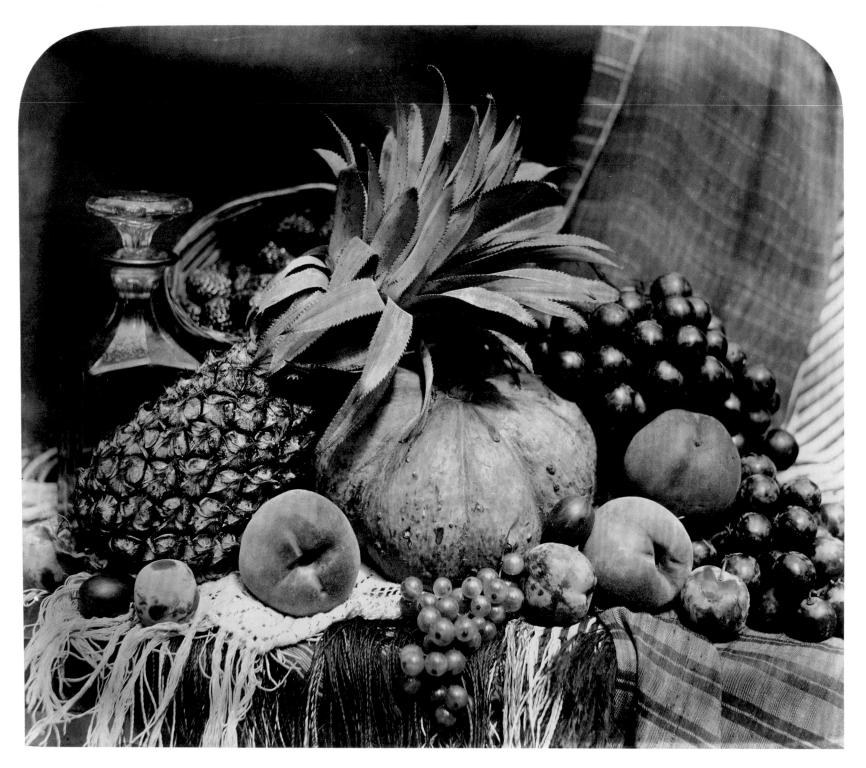

88. Decanter and Fruit, [1860]

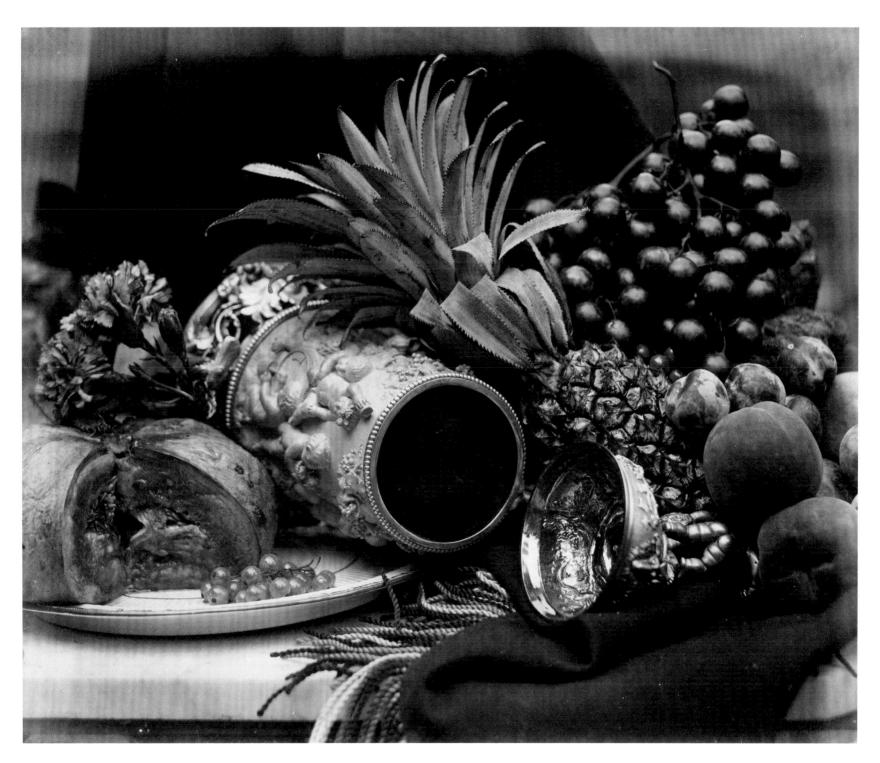

89. Tankard and Fruit, [1860]

"A Most Enthusiastic Cultivator of His Art": Fenton's Critics and the Trajectory of His Career

ROGER TAYLOR

oger Fenton's career as a photographer first came to public attention in December 1852 and closed ten years later with the announcement of his retirement in October 1862. During that single decade he exhibited more photographs in more venues than any other photographer over the same period. Every year, as regular as the seasons themselves was Fenton's submission of his latest work to exhibitions throughout Britain and Europe. By any measure his output was prodigious. He is known to have exhibited more than one thousand works, and even though this number must include some duplication of individual images seen in more than one venue, no other photographer came close to matching such productivity. The scale and geographic range of Fenton's photographic exhibition strategy—and we can be sure it was a strategy—raise important questions that will be explored here. What made it possible for him to promote his work so readily? Who constituted the audience for photographic exhibitions and what did they think of the work? To what extent were Fenton's ambitions artistic, to what extent profit-driven? And, looking at the larger subject, how did the status of photography change during this formative decade, and what role did Fenton play in shaping the taste and critical attitudes of the public?

In 1844, when Fenton was in Paris studying to be an artist, photography celebrated its fifth birthday. Perhaps it would be more accurate to speak of two birthdays: one of the daguerreotype, a direct image on a silver-coated copper plate, which had largely been taken up commercially; the other of the calotype, a paper negative used to make a positive print, which had been adopted by gentleman amateurs interested in the expressive potential of science in the service of art.² At five years old the medium was still youthful, but the differences that distinguished its two aspects were already enshrined

in practice and during the remaining years of the decade would diverge even further, by 1850 seeming to represent opposing ideologies and social strata. In these early years the daguerreotype, the more precocious medium, was widely successful in attracting public attention, but ultimately it was the negative-positive characteristics of the calotype process that won the hearts and minds of photographers with artistic aspirations. With his education and interests, and moving as he did in artistic circles, Fenton was surely aware of this evolutionary process as it unfolded around him in London and Paris.

One of the difficulties photography encountered throughout the 1840s was its near invisibility. In the wider scheme of things it was completely overshadowed by the more pressing social issues of the decade and barely entered the national consciousness. Photographs were rarely exhibited; when they did make an appearance it was usually as part of a didactic exhibition, such as one characteristically dedicated to "Arts, Manufactures, and Practical Science." Within this context photographs were thought of as novelties, scientific curiosities, or objects of conjecture, but rarely as works of art.

Traditional artists, on the other hand, enjoyed ongoing publicity and support from annual exhibitions, soirees, societies, publications, and a flourishing print trade that allowed reproductions of their works to be widely circulated. The national census of 1851 tells us that there were 5,444 artists of every caliber and distinction working in Britain. Recorded in a separate category are only 51 photographers, earning their living as daguerreotypists. The central government actively encouraged High Art, in the firm belief that it had a civilizing influence upon the general population. In addition there were a number of lottery schemes known as Art Unions dotted about the country whose sole purpose was the distribution of paintings,

sculptures, engravings, and other works of art to prizewinning subscribers. These hugely successful programs brought widespread employment to artists and engravers. Art was deeply embedded in the cultural life of the nation, with the exhibition season to some extent dictating the social calendar. By comparison, photography enjoyed few of these benefits. Paralyzed by patent restrictions and parochial attitudes, it seemed in danger of languishing as a cultural backwater.

We do not know what prompted Fenton to switch his allegiance from painting to photography, or when this happened, but to judge from his earliest known work he seems to have taken up the camera sometime during 1851, perhaps as a result of seeing the photographic displays in the Great Exhibition of the Works of Industry of All Nations, held at the Crystal Palace in London.⁶ A visitor dimly susceptible to the charms of photography would have been captivated by the show of cameras and equipment but hardpressed to find any significant presentation of images. The philosophy underlying the exhibition was that for a given subject, the means of production should be illustrated from raw material to finished product; thus, in the British exhibits photographs were grouped alongside the cameras and lenses on display in Class 10, "Philosophical Instruments and their Processes," or as examples of technique in Class 30, "Sculpture, Models and Plastic Art, Mosaics, Enamels Etc." However, "foreign countries" were given greater freedom in the selection and organization of their displays, and as a result the range and quality of their exhibits showed photography to good effect. The French photographers were especially well represented, with works by Hippolyte Bayard, Louis-Désiré Blanquart-Evrard, Comte Frédéric Flacheron, Gustave Le Gray, Henri Le Secq, and Frédéric Martens. Burdened from the outset by a system designed to showcase commerce and industrial production and further hampered by rigid classification, British photography made a poor showing in comparison.

Just as the Great Exhibition was coming to a close in October 1851 we find Fenton visiting the recently established Société Héliographique in Paris. There he saw how photography was benefiting from the mutual collaboration and free interchange of its practitioners, many of them distinguished French artists who recognized "the great advantages which this science presents to the careful and conscientious interpreter of nature." Encouraged by this experience, Fenton returned to London and joined forces with a group

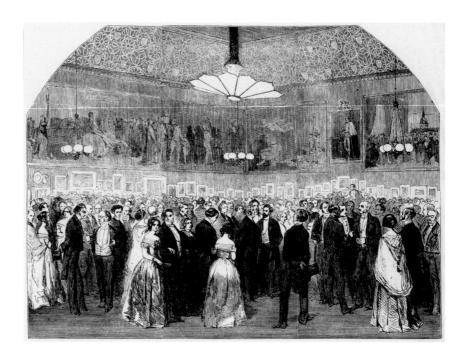

Fig. 64. Soirée of Photographers, in the Great Room of the Society of Arts. Wood engraving, 17.3 x 23.6 cm (6 13/16 x 9 5/16 in.). From Illustrated London News, January 1, 1853, p. 12

of amateur photographers to plan the establishment of a "Photographical Society" in that city. In March 1852 their campaign went public, with advertisements and editorial coverage appearing in many leading periodicals; Fenton was named as the person to whom correspondence should be addressed.⁹

It is at this point that several strands of Fenton's photographic activity begin to overlap and intertwine in mutually beneficial relationships. The first exhibition dedicated solely to photography opened to the public on December 22, 1852, at the Society of Arts, London (fig. 64). It had been suggested a month earlier by Joseph Cundall, a book publisher, entrepreneur, and amateur photographer, the idea being to draw the attention of a London audience to photography's true achievements (as distinct from those presented at the Great Exhibition). If successful the exhibition would also act as a fitting prologue to the establishment of the Photographic Society, which was planned for late January 1853. Within a matter of weeks, Cundall, Philip Henry Delamotte, and Fenton, the chief organizers, had assembled almost four hundred prints and prepared a detailed catalogue. The novelty of the exhibition made it hugely popular, even though it opened three days before

Christmas; as a result more photographs were added, a second edition of the catalogue prepared, and the closing date extended until the end of January 1853. 11 The effect of the almost eight hundred examples of British and French photography of great scope and diversity by then on display must have been overwhelming.¹² The exhibition proved a critical success, although the generally favorable reviews included one observation that some of the prints "should not have passed beyond the portfolio of the artist." The exhibition also served as the setting for the founding of the Photographic Society on January 20, 1853, when Fenton was elected to the position of honorary secretary, which he had been filling informally from the outset (see "The Exertions of Mr. Fenton" by Pam Roberts in this volume). ¹⁴ At its first regular meeting the following week, Fenton set out to the membership his ambitions for the society. His vision that photography (and the society) would be well served by the "collection and the diffusion of information," with exhibitions forming "an important part of the Society's means of action," is closely aligned with his own personal ambitions. 15 By early 1853 his name was firmly linked to photography, perhaps more so than that of any other member of the Photographic Society, leading one commentator to note wryly, "Mr. Fenton is a most enthusiastic cultivator of his art." 16

The popularity of the exhibition also prompted the Society of Arts to create a strategy for promoting photography nationally through a series of touring exhibitions. One of the powerful ideas to arise from the success of the Great Exhibition was that of "strength through unity." In a speech delivered in 1852, Prince Albert called for the continued and harmonious interchange of knowledge to bring about human advancement, and this principle was widely adopted as a rallying call by nations, industries, workmen's organizations, and educators. With mutual cooperation now high on the national agenda, the Society of Arts played its part by inviting 230 literary, philosophical, scientific, and mechanics' societies to affiliate themselves with the parent society in London and thus gain access to visiting lecturers, reduced prices on books and supplies, and other benefits. By February 1853 this important initiative had induced well over one hundred institutions to join the network.¹⁷ The great majority of these were based in small market towns with populations of between four and five thousand souls, and many enjoyed the patronage and membership of the local aristocracy. Capitalizing on the success of its 1852 exhibition, the Society of Arts created a much reduced traveling version of the show and offered it in March 1853 to these new affiliated institutions, or "institutions in union." Eighteen accepted, and a tour schedule was arranged, beginning in September, that spanned the nation from Ventnor in the Isle of Wight to Aberdeen in the north of Scotland. It was an ambitious plan and not without logistical problems; nevertheless it brought eighty-three prints by twenty-four practitioners to an audience largely innocent of the appeal of photography. In addition to photographs of the displays and objects shown at the Great Exhibition, taken by Hugh Owen and Claude-Marie Ferrier, there were pictures by Cundall, Delamotte, Le Gray, Paul Pretsch, Ross & Thomson (James Ross and John Thomson), William Henry Fox Talbot, and Fenton, who contributed ten images from his series of English and Russian studies made during 1852.

Despite frequent damage done to glass and frames by a railway system better adapted to moving coal than photographs, the society decided to send works traveling the following year as well, this time creating two sets of prints for parallel exhibitions and increasing the number of photographs to 121 and 129, respectively. Fenton more than doubled the number of prints he submitted, to twenty-four in each set. With his photographs constituting about 20 percent of the total number of works on display, he had far greater prominence than any other contributor. These three touring exhibitions not only legitimized photography's artistic potential in the eyes of the nation but also placed Fenton's work before the widest possible audience and were a key factor in establishing his early reputation.

Another strand of Fenton's career in photography dates from late 1852, when the prominent London publisher David Bogue issued the first two parts of *The Photographic Album*, each part illustrated with four photographic prints. Six of the total were by Fenton and two by Delamotte. The principal subject matter was Cheltenham, a Georgian spa town in the Cotswolds whose fortunes had been revived by the arrival of the Great Western Railway, providing connections to London. Bogue, Delamotte, and Fenton very likely thought that Cheltenham's quiet fashionability would be sufficient to ensure good sales of the publication. Sadly, their hopes were dashed by the appearance of Maxime Du Camp's *Egypt*, *Nubia*, *Palestine and Syria*, which had just become available in London through the efforts of the entrepreneurial publisher and picture dealer Ernest Gambart. It was inevitable that this work, one of the most important photographic publications of

the mid-nineteenth century, would by its sheer size, grandeur, and ambition completely eclipse the album of the two newcomers. ²⁰ Nevertheless, *The Photographic Album* demonstrates the scale of Fenton's ambitions for his photographs, albeit within the circumscribed market traditionally reserved for artists and engravers.

Early in 1853, Fenton's colleagues Cundall and Delamotte established the Photographic Institution in New Bond Street, London, one of the first businesses dedicated exclusively to promoting the medium. It soon became a lively center of photographic practice in which Cundall took charge of publications and Delamotte offered a whole range of photographic services, including calotype portraiture and architectural studies commissioned by members of the nobility, gentry, and clergy.²¹ An essential feature of their activities, and one that drew widespread critical attention, was mounting regular exhibitions of photographs by "the best English and Continental Artists," drawn together by Delamotte. 22 Their imperative, unlike that underlying earlier exhibitions, was to bring photography into the commercial print market by appealing to collectors and connoisseurs.²³ When their first show opened on April 28, 1853, there were 250 framed photographs and three portfolios on display at prices ranging from three shillings to two guineas per print. 24 Fenton was well represented, with forty-eight works offered for sale at prices ranging from three shillings each (the British studies) to twelve shillings (the Monastery at Kiev). All the other Russian studies were priced at seven shillings and sixpence each. We have little idea why one print was priced at three shillings and another at four times that amount. Fenton's prices were modest in comparison with those of other photographers represented, perhaps indicating the value he placed on his own work at the time and where he saw himself within the wider field of photographic enterprise.²⁵

These, briefly, are the context and history of Fenton's first years with photography. As it turned out, his timing was perfect; had he arrived on the photographic scene five years earlier or later, his influence would have been negligible. For this new field, the years 1852–53 proved critical to the way the medium advanced both artistically and technically. In 1851, photography had been poised for change; it needed only the impulse of the Great Exhibition to give it momentum and individuals like Fenton and his colleagues to carry it forward.

Fenton had the advantage of coming from a family in which self-improvement and private enterprise were highly valued. It also helped that he and his audience belonged to the same social stratum: a loosely defined body of individuals set apart by their education and financial independence.²⁶ By and large they were not members of the aristocracy or even the gentry but rather of a new class, that of professional gentlemen. Forward-thinking, they were comfortable with modernity and the benefits of scientific advances, especially when yoked to capitalism. Paradoxically, the same individuals revered and took comfort in traditional values and ways, viewing the past through a romantic haze of Neo-Gothic design, historical painting, and literature. They possessed both leisure time and the means to occupy it. They visited exhibitions and read the reviews. They burrowed deep into the British countryside, drawn to picturesque spots rich with literary and historical associations, and journeyed abroad following an itinerary that still carried resonances of the Grand Tour. These were the individuals who established the Photographic Society in 1853, made up its membership, and became the audience for Fenton's photographs—as he knew full well.

Knowing your public is one thing, reaching them another matter entirely. For a conventional artist or a member of the new generation of artistphotographers such as Fenton, the issue remained the same: how does an audience get to know, understand, and appreciate one's work in the most effective way? Then as now, self-promotion through the media provided the answer, and in the 1850s, newspapers and periodicals were the media that reigned supreme. In addition to daily newspapers, a staple in many households, the mid-Victorian period witnessed a most extraordinary growth in weekly, monthly, and quarterly periodicals serving the diverse tastes and inclinations of the articulate classes.²⁷ Many were aimed at special-interest groups ranging from antiquarians and architects to Zionists and zoologists. Photographers were increasingly well served; by 1860 there were four competing publications, although their circulation figures probably remained low, and their reviews and opinions barely touched the wider public.²⁸ It was the newspapers and periodicals with high circulation figures and widespread distribution throughout Britain, particularly the Athenaeum, Art-Journal, Literary Gazette, and Illustrated London News, that wielded great influence through their comprehensive coverage of literature, music, fine arts, and

photography. Detailed and scholarly (but unattributed) reviews were frequently written by leading authorities who endeavored to make difficult and complex subjects more understandable. Within the exhibition system these periodicals played an important role well beyond the announcement of forthcoming events. Their critics passed judgment, praised individual merit or dismissed it, offered opinions and influenced public taste; they had the power to shape or destroy a reputation. The *Illustrated London News* frequently published wood engraving illustrations of works of art under review—a novel approach that undoubtedly contributed to the popular success of the newspaper, which boasted a weekly circulation of 123,000.²⁹

Between February 1852, the date of his earliest known photographs, and January 1854, when the Photographic Society held its first annual exhibition, Fenton achieved a significant number of objectives that advanced his photographic career. The first was his involvement in the founding and management of the Photographic Society. This brought opportunities for new friendships and alliances, some of which, like those with Cundall and Delamotte, became relationships of mutual advantage. The Photographic Society was widely regarded as the parent society for photography, and as its honorary secretary Fenton occupied a pivotal position in the profession throughout Britain. Undoubtedly he was in correspondence with fellow photographers, knew when new photographic societies were being formed, and was involved with the leading photographic issues of the day. His close association with the Society of Arts gave him opportunities to exhibit his work both in London and throughout Britain, and of these he took full advantage, while the contributions of fellow photographers were relatively few in number. Determined not to remain an enthusiastic amateur, Fenton from the outset had commercial ambitions for his work. In the space of two years he seemingly did everything possible to position himself favorably. At the opening of the first annual exhibition of the Photographic Society in January 1854 he showed no fewer than seventy-three prints. The exhibition was widely reviewed in both the photographic and the national press, and, more importantly for his future status, Fenton, along with Sir Charles Eastlake, was chosen by his colleagues to conduct a tour of the exhibition for Queen Victoria, Prince Albert, and the royal party. This was a defining moment, elevating him to a position that distinguished him from other photographers and shaped the direction of his career (see "Mr. Fenton Explained Everything" in this volume).

For the next eight years, until his retirement in 1862, Fenton used photographic exhibitions as the principal means of promoting his work. He contributed, broadly speaking, to three very different types of exhibition: annual exhibitions of photographic societies in Britain, Belgium, and Holland; the international exhibitions held in 1855, 1857, and 1862 in Paris, Manchester, and London respectively; and his own "Exhibition of the Photographic Pictures Taken in the Crimea," which was seen in eight venues during 1855 and 1856. 30 While these exhibitions served very different audiences, both geographically and culturally, all acted to showcase Fenton's latest work and—implicitly with the photographic societies, explicitly with the Crimean photographs—to promote the sale of prints.³¹ Fenton made greatest use of the annual exhibitions of photographic societies, whose numbers were rapidly increasing; some thirty-five were established during the 1850s. 32 An annual exhibition was central to their activities, and in most cases they followed the example of the Photographic Society in London, adopting a system of open submission so that photographers were encouraged to submit work outside their immediate region. The general principle of interchange was here being applied in an artistic context.

Since the exhibition season usually fell in the winter, it provided an opportunity for photographers to show work taken in the previous spring and summer months, when the light was at its most expressive. For Fenton this cycle of photographing and exhibiting dictated the pattern of his working year: the photographs made during his tour of Yorkshire in the summer of 1854 he exhibited in January 1855, those taken of Scotland in 1856 were shown in 1857, and those taken in North Wales during the summer or fall of 1857 were exhibited in January 1858. 33 With mid-nineteenth-century London the cultural and economic focal point around which the rest of Britain revolved, he understandably chose the annual exhibitions of the Photographic Society to foreground his latest work, but his photographs were also exhibited in Birmingham, Nottingham, Macclesfield, and Manchester in central England; Norwich in the east; and Edinburgh, Glasgow, and Dundee in Scotland. While it was generally Fenton who submitted his own works, occasionally local printsellers used the annual exhibitions as showcases in which to promote their latest stock. For example, Colin Sinclair, a stationer who sold photographs from his premises at 69 George Street, Edinburgh, submitted a number of prints to exhibitions in Edinburgh and Glasgow in 1858

and 1859 respectively, among them Fenton's celebrated genre study *Pasha* and *Bayadère*, which was thus exhibited in Edinburgh before being shown in London (pl. 62).³⁴ As long as the work was new to the market it mattered little to Fenton who entered it, whether he himself, a printseller, or a local collector anxious to demonstrate his good taste. Although all this exhibiting proved an effective and cheap form of publicity, it established a cycle of work that must have been extraordinarily demanding and by its very nature almost impossible to sustain. Fashion, public whim, and changing circumstance would see to that.

One reason Fenton's name became so well known throughout Britain and Europe was that critical responses to his work appeared across the whole spectrum of the press, from daily and weekly newspapers to specialized photographic periodicals. It was not unusual for an exhibition to be more widely reviewed than we would expect even in today's media-oriented world. For example, when *Pasha and Bayadère* was shown at the 1858 annual exhibition of the Photographic Society of Scotland, it attracted reviews from nine local newspapers; the fullest coverage was in the Scottish *Daily Express*, which published three separate notices. A survey of the exhibition reviews proves invaluable for understanding the critical influences that helped shape and direct Fenton's work year by year. Some samplings follow.

They have all the appearance of being mildewed, or seen through a mist, or as if half obliterated by a sponge.

—Review of *The Photographic Album*, in *Athenaeum*, November 1852³⁶

It is quite evident that when the pictures were taken, the photographic artist consulted his convenience, and aimed only at making the best of the bad subjects which the neighbourhood of Cheltenham afforded.

—Review of *The Photographic Album*, in *Art-Journal*, December 1852 ³⁷

The productions, which are numerous, by Mr. R. Fenton . . . are of a most interesting character . . . he will excuse us from suggesting that he would do well in future to avoid subjects involving very high lights,—particularly many points of light,—and very deep shadows.

—Review of the photographic exhibition at the Society of Arts, Art-Journal, February 1853³⁸

The editor of the *Art-Journal*, Samuel Carter Hall, had worked with Fenton on the management committee of the North London School of Drawing and Modelling in 1850 and was also a fellow of the Society of Arts.³⁹ Indeed, they may even have been friends, but any familiarity made not the slightest difference and, true to form, Hall expressed his opinion bluntly and directly.⁴⁰ Rather than being oppressed by this criticism, Fenton learned from it and took care never again to issue technically inferior or poorly composed photographs.

Further examples:

In these little pictures the gradation of tone is as perfect as in any sun pictures which we have seen, and the gradual falling off of the outlines of the objects as they are respectively more and more distant from the eye, yet still retaining their distinctness, is beautifully artistic and at the same time natural. The productions of Mr. Fenton are more varied than those of any other exhibitor.

—Review of the First Annual Exhibition of the Photographic Society, Art-Journal, February 1854⁴¹

The specimen we have engraved ("Valley of the Wharfe") illustrates the chief features of the exhibition... There is a soft and mellow tone about this picture of Mr. Fenton's, and a richness of atmospheric colour, which has never been surpassed, if equalled, by the previous attempts of any photographer [fig. 65].

—Review of the Second Annual Exhibition of the Photographic Society, *Illustrated London News*, February 1855⁴²

Mr. Fenton is one of the most brilliant examples of the close union of the artist and the practical photographer.

—Review of the Exposition Universelle, Paris, Bulletin de la Société Française de Photographie, December 1855⁴³

These three slightly later reviews display a radically changed response to Fenton's work. He was now hailed for ideally combining artistic sensitivity with the technical competence necessary to produce photographs that are "perfect," "soft and mellow," and in tune with the public sensibility. Clearly his new ally was the *Illustrated London News*, in which a half-page wood engraving of *Valley of the Wharfe* was published alongside a lengthy review. Both tone and content suggest that Fenton had been "taken up" by the newspaper.

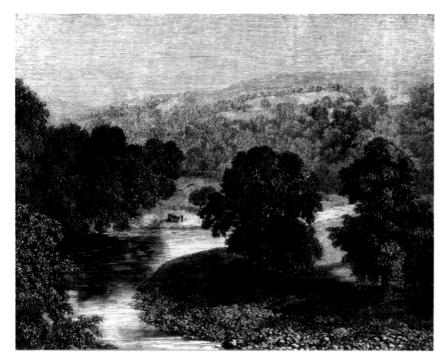

Fig. 65. Valley of the Wharfe, after a photograph by Roger Fenton. Wood engraving, 17.3 x 23.1 cm (6^{13} /₁₆ x 9/₁₆ in.). From *Illustrated London News*, February 17, 1855, p. 165

It was reported in the review that he was on his way to the Crimea, and the unnamed authors noted how much they were looking forward to seeing "the results of his labours in the East"; on his return these photographs became a prominent feature of the paper's reportage of the war.⁴⁴

The French review was prompted by Fenton's submission to the 1855 Paris Exposition Universelle, where he won a first class medal (silver) for the excellence of his photographs, and probably also reflects France's appreciation of Fenton's recent photographic activities in the Crimea. 45

It would be needless to eulogize the extraordinary breadth and detail of these "children of light," and it would be impertinent to praise the art with which momentary expressions, a smile or a glance, are fixed, to be now perpetuated in a work that may be read and obtain an almost European circulation. . . . Men will fall before the battle scythe of war, but not before this infallible sketcher has caught their lineaments and given them an anonymous immortality. . . . As photographists grow stronger in nerve and cooler of head, we

shall have not merely the bivouac and the foraging party, but the battle itself painted; and while the fate of nations is in the balance we shall hear of the chemist measuring out his acids and rubbing his glasses to a polish.

—"Photographs from the Crimea," Athenaeum, September 1855⁴⁶ We were much surprised to find a collection embracing subjects to which the artist could not have had access without influential introductions—but so it was—the artist was, we believe, recommended by H.R.H. Prince Albert to the notice of officers in high command.

— "Photographs from Sebastopol," Art-Journal, October 1855⁴⁷

Here we see reviewers struggling to find an appropriate definition of Fenton's role in the Crimea. The references to him as an "artist" and to the "battle itself painted" locate him in the company of war artists such as William Simpson, whose "Authentic Sketches" of the Crimea were also showing in London. 48 What distinguished Fenton from Simpson was the reality of his photographs; his "children of light," with their clear and unequivocal gaze, offered a new kind of witness to the conduct of war. It is not only the scope of photography that is being redefined here, but also Fenton's role as a photographer; he is transposed from the tranquillity of the British landscape to the dangers of working under "fire from the Russian batteries."49 He has become the heroic photographer with something to communicate. The prescient reviewer for the Athenaeum understood the significance of Fenton's role in the Crimea and accurately predicted the way photography would evolve several decades later into a powerful and influential tool of reportage. At a number of levels, Fenton's photographic expedition to the Crimea was of central importance for his career, perpetually linking his name to the event in the popular imagination during the Victorian period and, subsequently, identifying him as the first war photographer (pls. 14-21).

If Fenton hoped that sales of the Crimean photographs would create a regular income, his expectations were never realized. A joint publishing venture with Thomas Agnew of Manchester proved a commercial failure, and the negatives and remaining stock of prints were sold off in December 1856. As one venture was fading, Fenton launched himself upon another—perhaps reflexively, in the manner of his mercantile ancestors. During the spring of

1856 he became involved with the photographer Paul Pretsch and the Patent Photo-Galvanographic Company he had established in North London. 50 The photogalvanographic process was in essence a photomechanical halftone printing process capable of reproducing photographs in printer's ink. The ability to print photomechanically had been a central ambition for photography from its very conception and appealed to the Victorians for its combination of visual accuracy with mechanical utility. The process clearly interested Fenton, who likely saw it as the next logical step for photography, and by late 1856 he had been named a partner and photographer for the company.⁵¹ He must have been delighted when the first part of a portfolio called *Photo*graphic Art Treasures, with four studies by him, appeared on what was hailed as "a memorable day in the history of Graphic Art" (fig. 66). 52 Sadly, though, the project was encumbered from the outset, and by May 1857 the company was reported to have suffered losses of about 4,000 pounds, with the profit from sales amounting to only 120 pounds.⁵³ If Fenton had a personal stake in the company, losses of this scale must have come as a hard blow; in 1857, 4,000 pounds was a considerable sum.

At about the same time the Patent Photo-Galvanographic Company was being established, Fenton became involved in another photographic business venture, one that raises questions about his ethics as an artist and photographer. In May 1856 the Photographic Association was announced as a provisionally registered company seeking to raise ten thousand pounds of capital through the sale of shares at ten pounds each.⁵⁴ Its prospectus reveals that although the company shared many aims and objectives with the Photographic Society, it was nevertheless a commercial enterprise that expected to return a 10 percent dividend to shareholders, all of whom would become members of the Photographic Association.⁵⁵ This was a new type of photographic society, adequately capitalized and with shareholders as members, and in these respects the antithesis of the Photographic Society. With ten thousand pounds capital the association could pay the bill for premises, darkrooms, a studio, a laboratory, a library, and full-time staff to run the business—the management of which was destined to lie in the capable hands of Delamotte, Fenton, Thomas Minchin Goodeve, Thomas Frederick Hardwich, William Lake Price, Lewis Pocock, and Charles Blacker Vignoles. With the exception of Pocock, who belonged to the Art Union of London, all were members of the Photographic Society.

NEW ERA IN ART. "STAMPED IN NATURE'S MOULD." Now publishing,

DHOTOGRAPHIC ART-TREASURES. (Nature and Art Illustrated by Art and Nature.) A MIS-CELLANEOUS SELECTION of SUBJECTS engraved by the Photo-Galvano Company's Patent Process from Choice Photographic and other Originals, by the most Eminent Artists and Photographers. Parts I. and II. now ready. Choice Proofs, 10s. 6d.; Proofs, 7s. 6d.; Prints, 5s. the Part, four Plates in each.

Contents.

Part I. York Minster. By R. Fenton.

Cedars, Monmouthshire. By Roger Fenton.

Raglan Castle, the Porch. By R. Fenton.

Raglan Castle, the Watergate. By R. Fenton.

Part II. Don Quixote in his Study. By Lake Price.

Crimean Braves. By R. Howlett.

Lynmouth, Devon. By Lebbens Colls.

Hampton Court, on Thames. By R. Fenton.

Part III. will contain—No Walk To-day. After Mrs. Anderson.

Beehives, Burnham Beeches. R. Fenton.

Tired Out—Bedtime. R. Fenton.

Tired Out—Bedtime. R. Fenton.
Rivaulx Abbey. R. Fenton.
By this new and beautiful Art of Engraving, the liability to fade and the uncertainty of colour, so objectionable in Photographs, is obviated, while the detail and touch of Nature is faithfully

London: Patent Photo-Galvanographic Company, Holloway. Herr Pretsch, Inventor.—Roger Fenton, Photor. to the Company. All Communications to be addressed to the Company's General Manager.

Fig. 66. "Photographic Art Treasures," advertisement. From Athenaeum, February 14, 1857, p. 198

Little wonder the Photographic Society felt threatened. It had neither the funds nor the facilities to compete with such an attractive scheme. To members it was unthinkable that Fenton, who had worked so hard to foster the society, should now pose such a direct threat to its future welfare. Perhaps Fenton believed that the two schemes could peacefully coexist; but whatever his motives, he and his colleagues were soon brought to account at a meeting of the Photographic Society on May 1, 1856.⁵⁶ Not surprisingly, the tone of the meeting was hostile, with calls for those involved with the Photographic Association to resign from the prestigious Council of the Photographic Society. Everything rested upon a regulation stating that a photographer "trading in photography" would not be eligible for the Council.⁵⁷ It was the view of those assembled that under the terms of their association Fenton and his colleagues would be "trading" and must therefore retire. Embedded in this position was an issue far

more serious and far-reaching than the immediate problem posed by the Photographic Association.

From the beginning the notion had been generally accepted that trained artists such as Delamotte, Fenton, and Lake Price practiced on a higher level than those "trading in photography." Although they sold their works, their manner of operation and the social class to which they appealed categorized them as above trade. Increasingly, though, these distinctions were being called into question, as a growing number of photographers, especially portrait photographers, began to join the ranks of the Photographic Society. It seemed unreasonable that photographers of this type be excluded from the Council because of their "trade," when others who also sold their work were admitted on the basis of the implicit understanding that they belonged to a higher stratum of society.⁵⁸ But despite the logic of fairness, the Council ruling enshrined a fundamental aversion of many members of the Photographic Society to the very notion of trade. To them trade represented everything they were not. They were gentlemen, professional gentlemen at that, involved in photography as a vocation. It mattered little whether they actually sold photographs; their income came from elsewhere. They had the leisure time, education, and social background to set them fundamentally apart from those in trade. In mid-Victorian society, the social hierarchy was clearly defined and rigidly observed. With the benefit of hindsight, however, we can see that the decade of the 1850s introduced a period of social change that would allow far greater mobility between the classes than ever before. In part this was due to the growing importance of a whole new category of professionals, such as engineers, surveyors, and physicians, whose place in society began to be properly acknowledged. Many photographers too—especially those with fashionable portrait studios or successful topographic publishing enterprises—resented being classified as mere tradesmen and wanted more than anything to be regarded as professionals.

The double standard that allowed Fenton and others to sell photographs openly while remaining eligible for the Council was an issue that had to be resolved if the equilibrium of the Photographic Society was to be restored. But rather than amend the rules to give more open access, justice was seen to be done by having Fenton and four of his colleagues resign their positions on the Council. ⁵⁹ As it happened, the Photographic Association apparently did not progress beyond provisional registration, since it was never heard of

again; and the status of "tradesmen" photographers within the Photographic Society was never properly resolved, leaving the way open for further tension in the future.

The immediate impact on Fenton of this brief episode was minimal. Although his good name and reputation may have been bruised, he emerged relatively unscathed and was reelected to the Council the following year. Nevertheless, he must have been aware that the status quo within the Photographic Society had been challenged by photography's capacity to evolve and adapt to the pressures of an increasingly commercial world. No longer was photography the province of the upper classes; by the mid-1850s it had become a retail commodity and was on the way to being a major economic and cultural force. If there was a lesson to be learned from this incident, it was that Fenton too had to evolve and adapt to changing circumstances in order to survive artistically and professionally, and in just this sense 1856 proved to be a pivotal moment in his photographic career.

On one level Fenton continued much as before, photographing and exhibiting with his usual enthusiasm and regularity. In September 1856, as if to put London and the affair of the Photographic Association as far behind him as possible, he traveled to the very north of Scotland, to Deeside and the estates of the royal family at Balmoral (pls. 28-30). The following year it was North Wales (1857). Thereafter his trips gradually became more circumscribed; they were visits to cathedrals, stately homes (1857-58), and places perhaps familiar to him in Derbyshire, Lancashire, Yorkshire, and the Lake District (1859-60). Although Fenton's output each year was not large, he made certain that the photographs he produced were widely distributed throughout the network of available exhibitions. His most prolific season of all was in 1859, when his work was seen in eight cities and towns across Britain, from London to the far north of Scotland, and a further eleven prints were included in the annual exhibition of the Société Française de Photographie in Paris. ⁶¹ This significant range of shows gave Fenton a wider geographic exposure than any other photographer at the time; it was an achievement that he never repeated.

By any measure Fenton's photographs from this period are among his finest, and not surprisingly they elicited flattering reviews, strewn with such phrases as "Mr. Fenton's pictures may be identified anywhere," and "no one can touch Fenton in landscape: he seems to be to photography what Turner

was to painting—our greatest landscape photographer."63 It was generally acknowledged that with each new season's work "Mr. Roger Fenton keeps ahead of his contemporaries."64 What distinguished Fenton from most other photographers was not just skillful composition and superlative technique but an appreciation of light and the ability to capture its most expressive moments on collodion. Although light is of course essential to photography, very few photographers of this era appreciated its value beyond the takenfor-granted role it played in making an exposure. Many of the new generation of photographers had not trained as artists but rather had come to photography through other avenues; moreover, the commercial pressures under which they often worked meant they were unlikely to sit around waiting for the weather to clear. Fenton was either extraordinarily fortunate with the weather or extremely patient, or most likely a combination of both. Repeatedly it is the pattern of light within the overall composition that holds our attention, and critics frequently remarked upon his appreciation of light. One response in 1858, to a study of Tintern Abbey, typifies them all and reveals why Fenton's work was held in such high regard: "The play of light through the beautiful windows of the abbey ruin shows that the artist has watched, with all an artist's care, the ever-changing effects produced by the movement of the shadows, and seized upon that moment when the blending of light and shade developed that peculiar beauty which 'subdues, yet elevates, the gazer's soul." 65 That Fenton's photographs might be spiritually uplifting may surprise us today, but to a Victorian audience, weighed down with religious anxiety and burdened by social ills, the desire to seek consolation and reassurance in a photograph was quite normal. These viewers observed divine truth everywhere, in the smallest feather or the sublime grandeur of a thundercloud. Perhaps the real key to Fenton's appeal is the comfort his photographs provided, fulfilling a very real need in a troubled and apprehensive society.

Sadly, no statistics have survived to tell us what kind of client patronized photographic exhibitions or bought photographs. The social background and class of viewers can only be guessed at and cautiously extrapolated from print prices. We know from exhibition catalogues, for example, that in 1859 Fenton charged from seven shillings and sixpence to ten shillings and sixpence for his prints, making his work relatively expensive. His audience was most likely drawn from the Upper Ten Thousand, who, with the aristocracy,

were the only ones with sufficient disposable income to afford such prices. We can be reasonably certain that Fenton never directly advertised in newspapers or periodicals to sell his photographs, since that would have irrevocably classified him as a tradesman; instead he placed his work with publishers and printsellers who acted as intermediaries on his behalf. As a result there is virtually no trace of his commercial activity other than the records of exhibitions to which printsellers submitted Fenton's work as a means of promoting their business. ⁶⁶

The first indication that Fenton's attitude had changed (or adapted to circumstance) came in 1858 with an advertisement in the national press by Thomas Gladwell, a London printseller, offering the photographer's "Series of 100 exquisite Views of Dove-Dale, the Cheddar Cliffs, Haddon Hall, Hardwick Hall, Chatsworth and surrounding scenery; Lichfield, Gloucester, Wells, and Salisbury Cathedrals, Malvern Priory; Tintern, Tewkesbury, and Glastonbury Abbeys" as well as prints from Fenton's series "Public Buildings and Parks of London" (fig. 67). 67 The tone and style of the advertisement reveal that Gladwell belonged not to the well-established coterie of London fine-art dealers and printsellers but rather to a different group entirely, of importers, publishers, wholesalers, and retailers of British and foreign photographic views.⁶⁸ A keenly motivated businessman, he was one of the new photographic entrepreneurs and manufacturers who moved into the photographic market just as soon as its wider commercial potential was recognized. Though we cannot be certain, it seems likely that Gladwell was Fenton's sole London agent and acted as a wholesaler of his prints, supplying the burgeoning photographic print trade elsewhere in Britain.⁶⁹ The rising tide of tourists that had begun to spread out across Britain, traveling by rail and coach to the remotest corners, very likely created a demand for Fenton's views at every spot he had photographed. His name was so widely known and well regarded that all he needed was to place his work with an agent who would take care of orders and distribution, and that is the service Gladwell offered, promising to send "a single Specimen, or any number of Photographs, securely packed and forwarded to any part of Great Britain" for one shilling. 70 Here we see the process of commercialization at work, the very thing that had caused so much hostility at the Photographic Society just two years earlier. If Fenton's engagement with Gladwell was meant to keep him at arm's length from the more commercial aspects of PHOTOGRAPHS.—Now publishing, a Series of 100 exquisite Views of Dove-Dale, the Cheddar Cliffs, Haddon Hall, Hardwick Hall, Chatsworth and surrounding scenery; Lichfield, Gloucester, Wells, and Salisbury Cathedrals, Malvern Priory; Tintern, Tewkesbury, and Glastonbury Abbeys (general views and details). Photographed by Roger Fenton, uniform in size with his previous well-known productions. Price 10s. 6d. each. Also, seventy of the above subjects on a reduced scale, price 7s. 6d. each. A Catalogue will be sent per post on receipt of cne stamp.

Views of Chamounix, with the Glacier de Bosson, Mont Blanc, Mer de Glace, and Aiguille de Charmoz, &c., by Bisson, being a continuation of the series published last year.

The preceding are the new additions to T. H. GLADWELL'S celebrated COLLECTION of PHOTOGRAPHS, numbering upwards of 1,600 of the finest specimens produced, including 400 Views of the Cathedrals, Abbeys, Baronial Halls, Landscape and River Scenery of England, Scotland, and North Wales; the Public Buildings and Parks of London, by Roger Fenton, price 10s. 6d. each; 60 Views in Switzerland and on the Rhine; 60 of the Public Buildings and Streets of Paris, 80 of French Cathedrals (general views and details), 20 of the Hôtels de Ville and Cathedrals of Belgium, by Bisson Frères, 10s. 6d. each.

250 Views in Rome, Tuscany, and Venice, 5s. to 20s. each.

Also, Views of Tours, Arles, Nismes, La Corniche, &c.; Jerusalem, Syria, and Egypt; Algeria and the Chiffa Mountains, North Africa; Sea Views at Havre, Brest, and Cherbourg, by Le Gray; Studies of Clouds, Rocks, Trees, &c., for Artists; copies of celebrated Paintings, Sculpture, &c.; from 2s. to 50s. each.

N.B.—A single Specimen, or any number of Photographs, securely packed and forwarded to any part of Great Britain on receipt of Post-office Order for the full amount, with 1s. extra for carriage or postage.

T. H. Gladwell, Printseller, Publisher, and Importer of Foreign Photographs, 21, Gracechurch-street; and at the City Stereoscopic Depôt, 87, Gracechurch-s

Fig. 67. "Photographs," T. H. Gladwell advertisement. From *Athenaeum*, November 27, 1858, p. 694

trade, it was probably successful, but undoubtedly he was sailing very close to the margins of acceptability.

The key issue that had surfaced in the acrimonious debate over the Photographic Association—whether the Photographic Society existed to serve the interests of amateur photographers or should transform itself to accommodate the needs of professional photographers—had never been properly resolved. By 1858 there were two quite distinct factions within the society. On one side were the old-school amateur photographers happy to explore with their cameras the visual syntax of the countryside; on the other lay the professional portrait photographers, whose technically superb results

were, however, little more than merchandise. Ideologically, aesthetically, and perhaps even socially the two were poles apart, and in truth, their interests could never be reconciled. The annual exhibitions of the society became a battleground in which both sides competed for dominance, but as there was no limit to the number of photographs a member could submit, the portrait photographers were able to overwhelm the exhibitions with their prints. The exhibition of 1858 was dominated, one reviewer commented, by "professional [rather] than amateur photographers," and it was asked whether the Photographic Society had remained true to its original purpose of "cultivating and promoting 'the Art and Science of Photography."

In 1859, with the matter still unresolved, the annual exhibition prompted this critical response:

We have heard the exhibition of the Royal Academy quoted as an excuse for the exhibition of the Photographic Society. There is no parallel between them. The efforts of mind displayed in the production of a picture have nothing in common with the mechanical process of obtaining a photograph. . . . The trading character is, too, most offensively obtruded in the catalogue. . . . Our remarks are dictated by the most friendly feeling; we admire photography, and we desire to see the Photographic Society taking and maintaining its proper place amidst the societies established for the advancement of Science and Art in this country. It has allowed itself to be overridden by the commercial element; and unless, ere yet it be too late, the council resolves to return to and maintain a far more independent position, the fate of the Society is sealed. 73

Throughout this uncomfortable period of transition, Fenton continued to photograph and exhibit as if nothing had changed. His rather ambiguous status, hovering between artist, amateur, and professional photographer, was never called into question, and each new season's work won critical tributes. But it must have been abundantly clear even to him that the golden days of the Photographic Society were now drawing to a close as photography entered its next, more commercial phase of development. When photographic exhibitions became little more than shop windows for commercial photography, there were no longer any meaningful contexts in which Fenton could operate. Everything that he had achieved during the decade of the 1850s was done against the wider background of the Photographic Society

and the ideals that inspired it. Once it became clear that the society had lost its sense of purpose and succumbed to the workings of capitalism, Fenton's decision to abandon photography seemed inevitable. When he submitted a group of prints to the 1862 International Exhibition held in London, the decision, one senses, had already been made. In fourteen prints he encapsulated almost his complete repertoire, choosing examples of his work at the British Museum, views of architecture, landscapes, still lifes, and Orientalist

studies. The jury conferred on him its highest award, a Prize Medal, commending the "great excellence in fruit and flower pieces, and good general photography."⁷⁴ Three months later Fenton announced his complete retirement and sold his entire stock of negatives, cameras, and equipment in order to "deprive himself of all that might be a temptation . . . to revert to past occupations."⁷⁵ After a decade of unparalleled success, the end was swift, absolute, and irrevocable.

"The Exertions of Mr. Fenton": Roger Fenton and the Founding of the Photographic Society

PAM ROBERTS

hroughout his career, Roger Fenton was a man who got things done. He was indisputably the driving force that brought the Photographic Society into existence in January 1853 and set its principles and agendas.¹

There is no extant proof that Fenton showed any interest in photography until about the time of the Great Exhibition of the Works of Industry of All Nations held at the Crystal Palace in Hyde Park, London, from May to October 1851.² The next year Fenton threw all his undoubted energy, artistry, enthusiasm, diplomacy, and organizational and communicative skills not only into learning the complex processes of photography but also into setting up a formal learned "society that shall be as advantageous for the art as is the Geographical Society to the advancement of knowledge in its department." The objective of the new Photographic Society was "the promotion of the Art and Science of Photography, by the interchange of thought and experience among Photographers."

Fenton's involvement with the Photographic Society extended from 1852 to 1862, almost as long as his involvement with photography itself. In addition to being its principal founder, he was honorary secretary (that is, unpaid chief administrator) for three years, vice president for three years, and organizer of the annual exhibitions. He served more or less continually on the society's Council and on a variety of committees and judging panels, both within the society and as its external representative. During those same years he was building a dazzling career in photography, working for the British Museum, traveling and exhibiting widely, intermittently practicing law, and raising a family.

From 1843 to 1847, Fenton had lived principally in Paris, where he studied painting. Once back in London he moved into an area that was something of an artistic coterie. With a group of other artists, Fenton founded (1850) and served on the management committee of the very successful North London School of Drawing and Modelling, an organization set up with Prince Albert as patron. Its purpose was to improve industrial design by offering evening classes to workingmen in such subjects as drawing, modeling, carving, and cabinetmaking. From this participation Fenton derived not only organizational experience but doubtless also an appreciation of the exceptional advantages that flowed from Prince Albert's energetic patronage.

When Fenton underwent his sudden conversion to photography, inspired by the photographs he saw at the Great Exhibition, it was largely the French material—works by Hippolyte Bayard, Louis-Désiré Blanquart-Evrard, Comte Frédéric Flacheron, Gustave Le Gray, Henri Le Secq, and Frédéric Martens—that caught his eye and galvanized him into action. In January 1851 these same photographers had been instrumental in establishing the Société Héliographique, the world's first photographic society, and in October 1851, Fenton went to Paris to visit it.

Britain did have an informal organization, the Photographic Club (also known as the Calotype Club). Its existence was first reported in the pages of the *Athenaeum* in December 1847, "a dozen gentlemen amateurs associated together for the purpose of pursuing their experiments in this *art-science*," although the club may have been meeting unreported prior to this date. It was roughly modeled on the more formal Graphic Society in London, whose members, mostly painters, engravers, and architects, 6 had since 1839

occasionally viewed photographs at their monthly meetings, and which sponsored an exhibition of calotypes in 1847.⁷

Known members of the Photographic Club included Richard Ansdell, James Archer, Joseph Cundall, Peter Wickens Fry (a lawyer like Fenton), John Rogers Herbert, Robert Hunt, Edward Kater, James Payne Knight, Sir William Newton (the latter two also members of the Graphic Society), Hugh Owen, and Sir Thomas Maryon Wilson. They exchanged correspondence, experiments, advice, and prints, and those who were in town met a couple of times a month at one another's homes. Present at some of the early 1850s meetings, although not mentioned in press reports, was the sculptor and inventor of the wet collodion process, Frederick Scott Archer, who demonstrated his process to a club meeting in 1850.9 Archer "first explained the process to his friends on the 21st of September 1850, at which time he was as well acquainted with its valuable properties as he was at the time he published it in March 1851, in 'The Chemist.'" ¹⁰ The "friends" were most likely members of the Photographic Club. Archer is known to have attended at least one meeting of the club in 1851 at Fry's home, where he exhibited a collodion image on glass, whitened by mercury bichloride and mounted over black velvet, showing the entrance to Beddington Park.¹¹

While the new process seemed to open exciting possibilities for photographic expansion, and members of the Photographic Club were eager to transform their organization into a formal society along the lines of the Société Héliographique, the situation in Britain was far less favorable than that in France. William Henry Fox Talbot, the inventor of the paper negative (or calotype), had placed patent restrictions on the use of his method. He had subsequently relaxed the restrictions to charge no fees for genuine amateur or scientific use, but if a photographer sold his work he was subject to all the restrictions. Now Talbot intended to expand his patent specifications to include Archer's collodion process. These measures had a seriously inhibiting effect on the growth of photography in general and on the establishment of a more formalized photographic society (which might have some commercial activity, at least indirectly) in particular. 12 Fenton later described the situation: "It was now obvious that at this time the existence of the patent was the great obstacle, not only to the formation of the society, but to the improvement of the art itself. Few were willing to expend much time and labour upon an art, upon the study of which they were told they had no right to enter without permission."¹³ (While Talbot had registered his patents in France as well as in Britain, French photographers largely ignored the patent restrictions, with impunity.)

Discussions with Talbot aimed at persuading him to relax his patent rights for members of a hoped-for photographic society had been going on for some time. Just a few weeks before the opening of the Great Exhibition in May 1851, Robert Hunt, photography critic of the Art-Journal, wrote to Talbot about "the Photographic Club matter." Hunt—the keeper of the Museum of Practical Geology in London, a keen photographic experimenter, and, with Fry, the founder of the Photographic Club—had since 1841 been in frequent amicable correspondence with Talbot about matters photographic, and the two men seemed to respect and trust each other. Hunt wrote, on March 23, 1851: "I have submitted your letter to some of the more influential movers in the Photographic Club matter—I have not yet their reply—On Thursday there is to be a meeting if you have any proposition to make I shall be glad to be in possession of it on Thursday morning." The letter from Talbot to which Hunt alludes has not survived. It may have been one element in the ongoing discussions over a relaxation of Talbot's patent rights on the calotype, so that members of an expanded Photographic Club would not need to pay a fee. Or it may, possibly, have been a response to an unsigned and undated draft proposal that seems to have been written soon after the news of the establishment of the Société Héliographique in Paris in January 1851. Drafted by a member of the Photographic Club, possibly Fry, the paper proposes the establishment of a Photographic Society in London similar to the French society.15

Equally frustratingly, no surviving letters between Talbot and Hunt fill the gap between May and November 1851. But in a draft of a letter Talbot wrote to Hunt on November 6 and 7, 1851 (but did not send), Talbot refers to recent correspondence (no longer extant) and expresses a fair degree of annoyance with members of the Photographic Club: "With reference to your observation yesterday respecting a Photographic Club, I would mention that so long as gentlemen few in number were practising this fascinating art for their amusement I had no wish to interfere—I only regretted that so few of them either sent any courteous acknowledgement to myself or adhered to their promise of dealing with my Licensees Messeurs Henneman & Company for their photographic materials." ¹⁶

Into these entrenched discussions and seeming stalemate at the end of 1851 entered Roger Fenton, thirty-two years old, artistic, independently wealthy, well connected, with time at his disposal, and an enthusiastic convert to photography, having had lessons in Paris from Monsieur Puech and Vicomte Vigier. Even better, he was possessed of a young legal brain that might help him find a solution to the patent problem. Impressed by the way the French had organized the Société Héliographique, he published an article about it in early 1852 and determined to attempt something similar in London.¹⁷ The Société Héliographique was comfortably housed at the home of its founder, Colonel Benito de Montfort, in the classy center of Paris at 15, rue de l'Arcade, a short stroll north of the Champs-Élysées and the Madeleine. The premises held rooms for conducting meetings, lectures, experiments, and discussions; an office in which the distinguished weekly publication of its proceedings, La Lumière, was produced; even a roof garden! The initial forty members of the société, under the presidency of Baron Jean-Baptiste-Louis Gros, were a starry mix of artists, scientists, writers, photographers, optical instrument makers, and aristocrats. The likes of Eugène Delacroix, the physicist Edmond Becquerel, the writer and critic Francis Wey, and the engraver Augustin-François Lemaître rubbed shoulders with the photographers Bayard, Eugène Durieu, Le Secq, Édouard Baldus, and Le Gray. Fenton must have been deeply impressed.

A month after his article on the Société Héliographique, Fenton published his "Proposal for the Formation of a Photographical Society," which included an invitation for interested parties to contact him directly. He proposed a society "of those eminent in the study of natural philosophy, of opticians, chemists, artists, and practical photographers, professional and amateur. . . . Such meetings should be periodically held, for the purpose of hearing and discussing written or verbal communications on the subject of photography, receiving and verifying claims as to priority of invention, and for the exhibition and comparison of pictures produced by different applications of photographic principles." Another, undated version of the proposal, with two sentences crossed out in ink, shows that Fenton contemplated, but decided against, including the following passage: "The heaviest expense attendant upon the plan would be the leasing or construction of convenient premises, and this expense might be lessened by the letting off the lower part as a shop for the sale of photographic chemicals, and the upper part to some

person who would form a commercial establishment for the printing of positives" (fig. 68).¹⁹

On March 5, 1852, probably after reading Fenton's published proposal and a subsequent interchange with Talbot-who was unlikely to have been happy with Fenton's emphasis on "professional" photographers or the phrase "receiving and verifying claims as to priority of invention"—Hunt wrote to Fry, "Mr. Fox Talbot knows nothing whatever of Mr. Fenton or his society schemes and I don't fancy Sir David Brewster [the Scottish physicist, a close friend of Talbot's knows anything of it. I have not the slightest knowledge of Mr. Fenton but I somewhat doubt from the conversation I had with him if such a society as he proposes would have, and maintain, the required respectability."20 However, Talbot had agreed, Hunt also wrote, that "if a Photographic Society is formed upon a very respectable basis, he will give a licence to every member of the Society to practise the Art"—with five conditions, most of which related to the process not being used for commercial gain.21 The "respectability" that Talbot repeatedly stressed meant the amateur practice of photography as a gentlemanly pursuit, untainted by trade and commerce.

It seems that while the Photographic Club had been, through Hunt, very slowly working toward formalizing its position with Talbot, Fenton had suddenly stirred things up with his energetic and dynamic approach. (The fact that Hunt did not know Fenton indicates that Fenton was not a long-standing member of the Photographic Club and was still an unknown quantity.) As a reading of the continuing correspondence between Talbot, Hunt, and others reveals, Fenton seems to have had the effect of binding the members' various opinions into a whole. Hunt's future letters to Talbot became much shorter and sharper on legalities, perhaps with the help of Fenton the barrister.

On March 19, 1852, Hunt wrote again to Talbot, informing him that "a great many good names have been received for the Photographic Society—as yet nothing has been done—There will be a meeting when Mr. Fenton, who is now in Lancashire, returns to London." Two weeks after the letter quoted above, Hunt not only knows who Fenton is but seems to be working with him. Hunt also emphasized that prospective members of a Photographic Society were wary of joining until the question of Talbot's patent rights was finally resolved. In his reply, Talbot agreed to meet a committee of five gentlemen to discuss his patent rights. "I assure you that I have

PROPOSAL

FOR THE FORMATION OF A

PHOTOGRAPHICAL SOCIETY.

The science of Photography gradually progressing for several years, seems to have advanced at a more rapid pace during and since the Exhibition of 1851. Its lovers and students in all parts of Europe were brought into more immediate and frequent communication.

Ideas of theory and methods of practice were interchanged, the pleasure and the instruction were mutual. In order that this temporary may become the normal condition of the art and of its professors, it is proposed to unite in a common society, with a fixed place of meeting, and a regular official organisation, all those gentlemen whose tastes have led them to the cultivation of this branch of natural science.

As the object proposed is not only to form a pleasant and convenient Photographic Club, but a society that shall be as advantageous for the art as is the Geographic Society to the advancement of knowledge in its department, it follows necessarily that it shall include among its members men of all ranks of life; that while men of eminence, from their fortune, social position, or scientific reputation, are welcomed, no photographer of respectability in his particular sphere of life be rejected.

The society then will consist of those eminent in the study of natural philosophy, of opticians, chemists, artists, and practical photographers, professional and amateur. It will admit both town and country members. It is proposed:—

That, after the society has been once organised, persons who may in future wish to become members will have to be proposed and seconded, a majority of votes deciding their election.

That the entrance fee and subscription shall be as small as possible, in order that none may be excluded by the narrowness of their means.

That there shall be an entrance fee of £2 2s.—a subscription of £1. 1s.

That the society should have appropriate premises fitted up with laboratory, glass operating room, and salon, in which to hold its meetings.

That such meetings should be periodically held, for the purpose of hearing and discussing written or verbal communications on the subject of Photography, receiving and verifying claims as to priority of invention, exhibiting and comparing pictures produced by different applications of photographic principles; making known improvements in construction of cameras and lenses; and, in fine, promoting by emulation and comparison the progress of the art.

That the proceedings of the society shall be published regularly in some acknowledged organ, which shall be sent to all subscribing members.

That a library of works bearing upon the history or tending to the elucidation of the principles of the science be formed upon the premises, and at the expense of the society, to be used by the members, subject to such rules as may hereafter be agreed upon.

That the society should publish an annual album, of which each member should receive a copy, who had contributed a good negative photograph to its formation, other members having to pay (and the public being charged at the rate of)?

The heaviest cornes attendant upon this plan would be the leaving or construction of convenient premises, and this expense with the lessened by the letting off the lower part as a shop for the sale of photographic chemicals, and the upper part to some person who would form a commercial establishment for the printing of positives.

Before any progress can be made in the organisation of such a society as the foregoing, it is necessary first to ascertain the amount of support which it would be likely to obtain. If those gentlemen, therefore, who feel inclined to become members of such a society will send in their names and addresses to R. Fenton, Esq., 2, Albert Terrace, and 50, King William Street, City, together with any suggestion which may occur to them individually on the perusal of this outline of a plan, arrangements will be made as soon as a sufficient number of persons have sent in their names, to hold a meeting in some central situation, to which they will be invited to discuss the matter and to elect a committee for the organisation of a society.

Fig. 68. Roger Fenton, "Proposal for the Formation of a Photographical Society," 1852. Courtesy of Hans P. Kraus Jr., Inc., New York the best wishes for the formation of a prosperous society, but it appears to me that there is not much <u>reciprocity of feeling</u> on the part of those who would naturally take a leading part in it" (Talbot's underlining). On the back of this letter Hunt listed six men to meet Talbot: Frederic W. Berger, Peter Le Neve Foster, Fry, Newton, himself, and Roger Fenton.²³

Although the meeting occurred in late March or early April, negotiations about the waiving of Talbot's patent were still going badly, and on April 28, 1852, Hunt wrote to Talbot, "So very strong was the expression of feeling on the subject of the Society under the circumstances I believe we must abandon for the present any attempt to form a society—into which any considerations of your patent rights shall enter."24 Nevertheless, Hunt had approached the Society of Arts about the use of a large room for the new Photographic Society's inaugural meeting and a small room for future fortnightly meetings, and on April 21, Professor Charles Wheatstone, the physicist and inventor, had agreed to be one of the three vice presidents of the society, should it be formed—at Talbot's particular request.²⁵ Talbot perhaps wanted to have a sympathetic colleague and fellow scientist on the society's Council. (Wheatstone may already have known Fenton as well, since less than two months later Fenton made pairs of images to be viewed in Wheatstone's reflecting stereoscope. 26 The next year, Wheatstone recommended Fenton for the job of photographer at the British Museum.)²⁷ Members of the Organizing, or Provisional, Committee for the proposed Photographic Society were Berger, Fenton, Fry, Le Neve Foster, Thomas Minchin Goodeve, Hunt, Newton, Dr. John Percy, and Wheatstone. In a meeting held at the Society of Arts on June 19, 1852, Fenton was elected honorary secretary to the Organizing Committee.

Taking the advice given him by his uncle Lord Henry Lansdowne and by Wheatstone, Talbot engaged in correspondence with Sir Charles Lock Eastlake—artist, president of the Royal Academy, and soon to be the Photographic Society's first president—and William Parsons, 3rd Earl of Rosse—astronomer, Member of Parliament, and president of the Royal Society—whom Talbot recognized "as being the acknowledged heads of the artistic and scientific world." Eventually Talbot was presented with a joint letter from the two men, in which, using wording that he himself had proposed, they requested that he abandon his patent rights. Unless Talbot made some alteration in the exercise of his patent rights, wrote Eastlake and Lord

Rosse, British photography might "be left behind by the Nations of the Continent." The letter ends, "We beg to make this friendly communication to you in the full confidence that you will receive it in the same spirit, the improvement of Art and Science being our common object."²⁹ On July 30, 1852, Talbot agreed to relinquish his patent rights, except on photographic portraits for sale to the public. (In 1854 he would abandon all patent rights.) The Eastlake/Rosse letter and Talbot's response were subsequently published in the *Times*.³⁰

The way was now clear for the formation of the Photographic Society. An exhibition composed solely of photographs was organized after a letter to the Society of Arts suggesting such an undertaking from Joseph Cundall, a publisher as well as a photographer, was read and approved by the society's Council on November 17.³¹ Fenton's absence for three months while he was photographing in Moscow and Kiev meant that the preparations were carried out largely by Cundall and Philip Henry Delamotte. The exhibition, "Recent Specimens of Photography," opened at the Society of Arts on December 22, 1852.

At the opening,³² Fenton read a paper, "On the Present Position and Future Prospects of the Art of Photography." After paying tribute to Talbot as the "inventor of photography upon paper," he continued in honorary secretary vein:

To the commercial principle just now beginning to be applied to this art, may be safely left the development and the reward of practical skill. But these more abstract questions [concerning physical, optical, and chemical aspects of photography] will not be likely to receive the attention due to them, until photographers are united together in a society which shall give a systematic direction to their labours, and which shall keep a permanent record of the progressive steps from time to time, and of the authors of them. Such a society will be [the] reservoir to which will flow, and from which will be beneficially distributed, all the springs of knowledge at present wasting unproductively. Such a society is within one step of complete organization, and awaits only the general co-operation of the whole body of photographers to enter upon an active and useful existence.³³

This first purely photographic exhibition in Britain, consisting of almost eight hundred photographs, attracted an enthusiastic audience and was

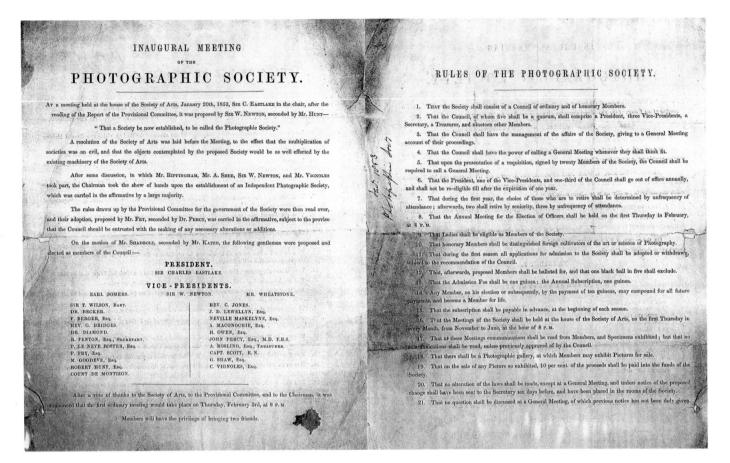

Fig. 69. Council of the Photograph Society, "Inaugural Meeting of the Photographic Society & Rules of the Photographic Society." The RPS Collection at the National Museum of Photography, Film & Television, Bradford

extended until January 29, 1853. It even drew Dante Gabriel Rossetti, who visited the exhibition on its closing day.³⁴

The inaugural meeting of the Photographic Society was held in the Great Room of the Society of Arts on Thursday, January 20, 1853, at 4:00 p.m. (the time of day suggests that participants were gentlemen with time to spare). Eastlake was elected president; Talbot—hardly surprisingly, after the patent discussions of the last two years—had declined the offer of the presidency. The question of independence or affiliation was raised by Le Neve Foster, member of the Council of the Society of Arts, who declared that "the multiplication of societies was an evil, and that the objects contemplated by the proposed Society would be as well effected by the existing machinery of the Society of Arts." Acutely aware of the momentum that photography was rapidly gaining, and encouraged by the success of the recent exhibition, the Society of Arts was keen to have the fledgling society established under its

own wing. To this end, Le Neve Foster offered "funds, rooms, officers and publications, with such other facilities as may be necessary for the full development of photographic art." But the majority of those at the meeting agreed with Newton, who "thought it essential for the Artist that there should be a separate independent Photographic Society"; 37 and the Photographic Society was born (fig. 69).

Members of the Council were elected. Earl Somers (brother-in-law of the not-yet-practicing photographer Julia Margaret Cameron), Sir William John Newton (1785–1869), and Charles Wheatstone (1802–1875) became the three vice presidents, and Alfred Rosling (1802–1882), later the father-in-law of Francis Frith, was chosen to be treasurer. Other Council members were Prince Albert's librarian, Dr. Ernst Becker (1826–1888); Frederic W. Berger; the Reverend George Bridges; Dr. Hugh Welch Diamond (1809–1886), who afterward replaced Fenton as honorary secretary and also served

as editor and vice president; Peter Wickens Fry (d. 1860); Thomas Minchin Goodeve; Robert Hunt (1807–1887); the Reverend Calvert Jones (1802–1877); Peter Le Neve Foster (1809–1879); John Dillwyn Llewelyn (1810–1882); A. Maconochie; Nevil Story-Maskelyne (1823–1911); Count Juan Carlos de Montizon (1822–1887); Hugh Owen (1804–1881); Dr. John Percy (1817–1889); Captain Scott; George Shaw (1818–1904); Charles Blacker Vignoles (1793–1875); and Sir Thomas Maryon Wilson (1800–1869). Twenty-one rules were drawn up and with slight emendations published in the *Journal of the Photographic Society* on March 3, 1853. Fenton was formally elected honorary secretary, a position he held until his resignation in February 1856.

The first ordinary meeting of the new society was held on February 3 at 8:00 p.m. There were four papers read: Newton's on photography and its relations to the arts; Percy's on the applicability of the waxed paper process to hot climates; Vignoles's on the usefulness of photography to engineers; and Fenton's "Upon the Mode in Which It Is Advisable the Society Should Conduct Its Labours." They were published in the *Journal of the Photographic Society* a month later. 39

During its first few meetings the society rapidly established specific activities that it intended to carry out. In addition to conducting ongoing experimentation and discussion, plans were made for the publication of a journal; the holding of frequent exhibitions to show the best new work by both members and nonmembers; the display of portfolios of new work to a critical elite; the provision of darkrooms; and the establishments of a library, a photographic collection, a museum, and a separate gallery for the exhibition of members' work (with the society taking a 10 percent cut on any photographs sold, as had been suggested by Talbot). Many of these aims would be rapidly realized. Professor Arthur Henfrey became honorary editor of the *Journal*.

It was Fenton who made the society work. Influenced by the model of Victorian art institutions and learned societies, he saw it as his new society's role to champion a particular idea of professional identity and individuality, encourage the association of photography with national pride, share knowledge and expertise, and create a distinctive arena for the viewing, discussion, and selling of works. To these ends the society on May 30, 1853, secured the patronage of Queen Victoria and Prince Albert. Although the Council considered asking for permission to change the group's name to the Royal

Photographic Society, no action was taken at this early date, and it would be 1894 before the society finally assumed that title.

As Fenton, perhaps still thinking of the glamorous headquarters of the Société Héliographique, had predicted, ultimately the society's heaviest expenditures were for suitable premises. Ordinary meetings and Council meetings continued to be held at the Society of Arts, and in February 1853, Vignoles briefly provided a room at 4 Trafalgar Square for clerical work. But by May 1853, the Council was leasing a room from the Botanical Society in Bedford Street, Strand, for thirty pounds a year. After July 1854, all meetings were held in a room rented from the Horticultural Society at 21 Regent Street for thirty pounds per annum plus five pounds per annum for the attendance of a servant. In the same year applications were made to the government for space in Burlington House on Piccadilly, where the tenants over the years were to be an assortment of "metropolitan societies for the promotion of natural knowledge,"40 including the well-established Royal Academy, the Royal Society, the Linnaean Society, the Geological Society, the Royal Astronomical Society, and the Royal Society of Chemistry. For the Photographic Society, which encompassed both art and science, this location shared with like-minded institutions would have been the perfect home, but, alas, nothing came of the attempt. 41 (It was not until November 1857 that the society would move to far more prestigious and expensive premises, at 1 New Coventry Street, above the Union Bank on the corner of Leicester Square. Here there were meeting and reading rooms, a laboratory, a glasshouse, and "other conveniences." However, after paying rent of three hundred pounds per annum and a further seven hundred pounds for fixtures and fittings, the society could not afford to stay at the address for long.)⁴²

The society's first annual exhibition, organized by six Council members including Fenton and thrown open to international entries, contained 980 items and was held at the Suffolk Street Gallery of the Society of British Artists in January and February 1854. Exhibitors and members were admitted free, while the public paid one shilling entrance fee, sixpence for a catalogue; the exhibition was hugely popular, and a small profit was made. Queen Victoria and Prince Albert, accompanied by Viscountess Jocelyn, Colonel Bouverie, and Lieutenant Colonel F. Seymour, were shown around the exhibition by Eastlake, Fenton, Hunt, and Wheatstone. The royal patrons bought several photographs, including six of Fenton's

Russian prints, ⁴⁴ and thus began their deep commitment, especially on Prince Albert's part, to the affairs of the new society. In the years that followed, Albert scrupulously attended every annual exhibition and often purchased prints. He also took an interest in the process of photography, experimenting with it himself and partially funding (with a donation of fifty pounds) the committee set up in 1856 to investigate the permanency of photographs.

The new society earned mixed reviews. The majority were favorable; the *Morning Chronicle*, for instance, gave the Photographic Society credit for "the rapid progress and development of photography . . . during the last two years." But the *Athenaeum* commented dryly, "Should a few real men of business be added to the Council the permanence of this useful Society might perhaps be considered as established." And a lengthy complaint was voiced by the *Builder*: "We had hoped that the formation of the Photographic Society would have led to a more systematic investigation of the chemical agencies upon which the art is based, and to a prompt and unreserved publication of the result of such investigations. . . . The council have done nothing more than call the members together seven times within the twelvemonth to talk the matter over among themselves, without, as a body, having issued or sanctioned a single communication tending to the improvement of the art, or even having made an attempt to publish a clear and minute account of the several processes already in use."

The range of opinions did not prevent the Photographic Society from concluding its first year in a very healthy position, with a membership of 370; an immense circulation figure for its *Journal*, four thousand copies per month (hinting at a huge untapped audience for photography); and a credit balance of 406 pounds 17 shillings.

The patent difficulties with Talbot continued to rumble on, however. In 1854 Talbot took out injunctions against the professional portrait photographer Martin Laroche for infringing his patents by using the collodion process in a commercial portrait business. The Council of the Photographic Society, led by the lawyers Fry (Laroche's attorney), Hunt (Talbot's former correspondent), and perhaps Fenton himself, supported Laroche. They feared that a validation of the patents' extension to the collodion process would strangle the further development of photography and discourage potential membership in their society. Talbot appealed to Story-Maskelyne,

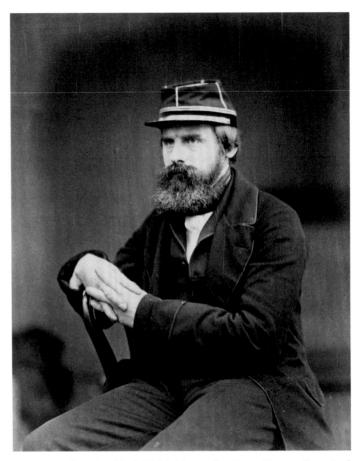

Fig. 70. Attributed to Hugh Welch Diamond or Roger Fenton, *Portrait of Roger Fenton*, 1856. Salted paper print, 19.5 x 15.2 cm (7¹/₁₆ x 6 in.). From Rules of the Photographic Society Club Album, 1856. The RPS Collection at the National Museum of Photography, Film & Television, Bradford

then a lecturer on mineralogy and chemistry at Oxford University and an experimental photographer, who was one of Talbot's few supporters on the Council of the Photographic Society. Talbot wrote to him bitterly, "The Photographic Society will hold a meeting on Wednesday next, I believe, to make their final arrangements for my destruction at the Trial. It is evident they will do their uttermost, (the same body that asked me to be their President!)" The always delicate relationship between Talbot and the Photographic Society fractured completely when, in December 1854, with the society's help (and possibly an injection of its finances), Laroche won his case. Talbot soon withdrew his remaining patent restrictions.

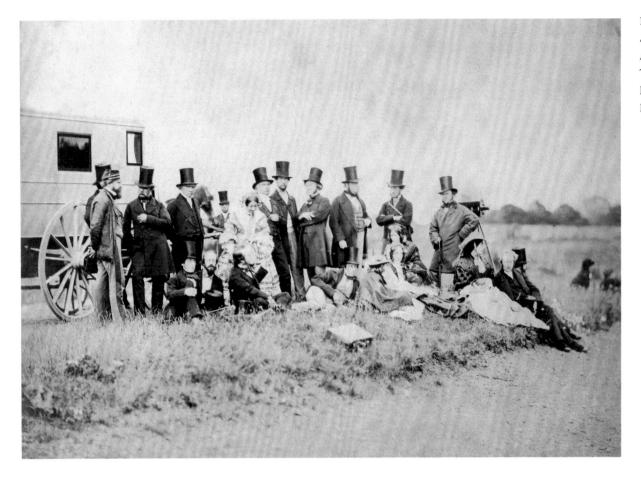

Fig. 71. Roger Fenton, *Members of the Photographic Society Club at Hampton Court, July 18, 1856.* Albumen silver print, $24.2 \times 33.3 \text{ cm}$ (9% x 13% in.). The RPS Collection at the National Museum of Photography, Film & Television, Bradford, Gift of Fenton descendants, 1934, 2003-5000/12787

In February 1856, Fenton resigned as honorary secretary, the society having accrued enough money to pay the Reverend John Richardson Major of King's College, London (one of forty-four applicants for the job), a salary of two hundred pounds per annum for carrying out the combined duties of secretary and editor of the *Journal*. In May of that year, Fenton and several others resigned from the Council because of their association with a commercial organization, the Photographic Association. ⁴⁹ He was back on the Council a few months later and became vice president of the society in December 1857.

Simultaneously the Photographic Society Club, an informal and social grouping within the Photographic Society, was established "to promote union and friendly feeling amongst the members of the Photographic Society." Made up of an elite inner core of Photographic Society members and, with its social, dining, and information-exchange functions, resembling

the Photographic Club of old, it had an annually elected president, treasurer, and combined secretary-caterer and was limited in membership to twenty-one. The club's Members dined together five times a year, "one of which dinners shall take place in some country locality favourable to photographic pursuits. The club's best-known country outing was one to Hampton Court on July 18, 1856; a group photograph taken by Fenton on that occasion, with contemporary annotations identifying members, shows them with attendant cameras, some accompanied by their wives and the occasional dog. Fenton's wife appears seated with one of their daughters, while Fenton himself poses alongside his photographic van (fig. 71).

The year 1856 was a good one for the society, which at its annual general meeting in February 1857 declared a reserve fund of 1,060 pounds and a much increased membership. The journal circulation had gone down slightly, to three thousand a month (other photographic publications had by now

appeared), but the publication still made an annual profit of three hundred pounds. At the 1858 meeting the report was of further growth in membership, journal circulation, and reserve funds, but the cost of the lavish premises in New Coventry Street was now beginning to bite. Decisions to hold two exhibitions in 1858, both of which lost money, and to publish the journal twice a month rather than once also took their toll on the society's finances.

That same year, Fenton served on the Society of Arts Committee of Enquiry, which looked into matters of photographic copyright. At the opening of the Photographic Society's sixth annual exhibition in 1859, Prince Albert suggested establishing a permanent collection of photography, and a committee composed of Fenton, Fry, Kater, and Diamond was set up to "form a collection to be preserved by the Society, illustrating the progress of the science from its earliest infancy up to its latest improvements." Regrettably, no action seems to have been taken. Over the summer recess of 1859, Fenton was one of the twelve members of the Collodion Committee who experimented with different makes of collodion, reporting on their findings in the *Photographic Journal* (as it was titled beginning in 1859) in 1860. By April 1860 the society, having slipped into debt, vacated its expensive premises in New Coventry Street and began holding meetings at King's College, with which a good number of members had connections.

In December 1860, Fenton retired as vice president; although he remained on the Council, his attendance at meetings effectively ended in August 1861. The death of Prince Albert in December 1861, which cast deep gloom, was sorely felt by the Photographic Society, of which he had been an excellent and committed patron. Fenton remained involved in the organization of the society's exhibitions and contributed to them until 1862. But after a decade of the most intense photographic activity, he was pulling back. At the International Exhibition of 1862 Fenton was awarded a Prize Medal accompanied by half-hearted praise of his "good general photography" 55—rather like the citation

for "lifetime achievement" of a non-Oscar winner. When in October he retired from photography, he sold his equipment and negatives as well. The *Photographic Journal* noted his retirement thus: "To the exertions of Mr. Fenton the Photographic Society owes its existence, and for many years it has had the benefit of his counsel and advice: it is therefore with unfeigned regret we make the announcement of his resolution, which is, however, mitigated by the hope that, although he retires from the *practical operations of the art*, he will still occasionally attend the meetings of the Society, which owes so much to him, and where his presence is always so welcome and agreeable." Fenton served as one of the jurors awarding medals for the society's ninth annual exhibition in 1863, but his only contact beyond that seems to have been in 1866, when he was awarded a President's Medal and cited as "the original Founder and Hon. Secretary of the Photographic Society, and an early and successful cultivator of our art-science." ⁵⁷⁷

Throughout his photographic career, Fenton strove to maintain a balance between the activities of a gentleman artist-amateur and those of a professional commercial photographer. Indeed, his hope was that the Photographic Society would play a major role in melding those two photographic possibilities into a seamless whole. But, although Fenton himself walked that tightrope with aplomb, during the eleven-year course of his career photography changed irrevocably. The Photographic Society changed with it, largely swinging into the commercial mainstream that photography had become, and veering ever further from the gentleman artists—Fenton above all—who had brought it into being.

After Fenton's death on August 9, 1869, obituaries were published in the three main photographic publications: the *Photographic Journal*, the *Photographic News*, and the *British Journal of Photography*. Perhaps the one that would have pleased Fenton best was in the last-named journal, which included this description: "He was a skilful artist, and possessed good taste." ⁵⁸

Roger Fenton: The Artist's Eye

RICHARD PARE

uring the eleven years that Roger Fenton worked in photography he tested the limits of the medium as it evolved day by day and from year to year. He created almost every type of photographic image, from modest and seemingly straightforward documentary works to others of great virtuosity, and it appears that he was alert to the potential in any application of the new medium. Having absorbed the significance of William Henry Fox Talbot's *Pencil of Nature*—a work that without doubt he knew well and which had, in one unprecedented sequence of images, laid out many of the medium's possibilities—Fenton seems clearly to have understood that photography had revolutionized the way we see. From the very first moment that he took up a camera his ambitions were of the highest order. He acted upon them vigorously, expanding the range and depth of photographic thinking and becoming one of the medium's most articulate and able proponents.

Fenton was born in the country within a few miles of Manchester, in the heartland of the Industrial Revolution. Traveling even a short distance meant encountering the pouring smoke of the factories, William Blake's "dark Satanic mills" roaring and vibrating day and night. Narrow streets lined with smoke-blackened workers' houses were familiar sights from the windows of the new railway carriages, and the ever-worsening, impenetrable winter fogs caused by coal burning were a commonplace. Fueled by the rapid expansion of the empire, industrialization was spurring migration to the cities and thus a parallel contraction of agriculture. In the battle over Corn Law reform, manufacturers and landed interests each sought to maintain the advantage. It was a time of struggles to achieve parliamentary reform and universal suffrage, of labor unrest, of punitive Poor Laws and Malthusian ideas about poverty. Charles Dickens was writing his most polemical assaults

on the establishment. Yet this impending social disintegration barely registers in Fenton's photographic work.² He was struggling instead to capture what he saw as a vanishing and threatened world, a vision that embodied the bucolic idea of England as a "green and pleasant land."³

The foundation of Fenton's visual aesthetic was his training with academic Neoclassical painters in Paris and London during the 1840s. The collections in the Louvre and those at the National Gallery in London, founded in 1824, were readily available. In the 1850s he must have watched with excitement as a collection of magisterial pictures was assembled by Sir Charles Eastlake, keeper and then director of the National Gallery and, as a founding member of the Photographic Society, a colleague of Fenton's. The subject of intense interest on their acquisition, these superlative works offered Fenton paradigms in composition. In the Royal Collection, he had in all likelihood seen such works as Andrea Mantegna's great painting cycle The Triumph of Caesar at Hampton Court Palace. Fenton's photographs emerge from a tradition based on Renaissance classicism. Going beyond his responses to the immediate subject, they draw on the continuum of art history. Fenton's assimilation of Western art is evident in his heroic rendering of architecture and the artistry of his evocation of Romantic melancholy in the ruined monasteries that he loved. The occasional figures who seem engaged in a suspended dialogue in his landscapes and architectural pictures are perfectly placed to create a necessary tension; they insert incident and a sense of anticipation into the larger composition. The analysis of landforms and approach to space and detail recall quattrocento landscape paintings of rivers winding between rocky outcrops, with the orderly interventions of mankind creating rhythm and articulation in the picture plane. The easy disposition of Fenton's best portrait groups, transparent and expressive, also

springs from this classical tradition. His single known study of a partly draped nude is reminiscent of works of the Northern Renaissance, with the study of drapery, which takes up about half the image area, calling to mind Jan van Eyck, Albrecht Dürer, and Rogier van der Weyden (fig. 72).

Fenton seems to have discerned early on how to put to best use the kind of observation of which photography is uniquely capable. There are few hints of hesitancy in any but the earliest surviving works. His inquiring mind placed him at the forefront of aesthetic and technical developments occurring in photography, and his seemingly innate understanding of the materials of the medium enabled him to adapt to each new process effortlessly. It is difficult now to imagine the kind of feverish excitement that must have prevailed in the early years of photography. Its science evolved rapidly and continuously. The public appetite for the new art seemed insatiable, and by the 1850s there were countless large-scale exhibitions, often including many hundreds of images.

The air was charged in these times with revolutionary scientific ideas. Robert Chambers's Vestiges of the Natural History of Creation, published in 1844, set the stage for Charles Darwin's On the Origin of Species in 1859. The same kind of desire to know had earlier in the century spurred William Smith to pursue his theories of geological stratification; they had been set down in his pioneering map of 1815⁵ and proven within recent memory. Fenton cannot fail to have taken account of such stirrings, and these ideas inform his photography of landscape, imparting a muscular sense of the land's underlying structure. The pictures in his extended series from Snowdonia (see pls. 31-39), celebrated for its rich geological inventory of rocks and landforms, offer clear examples of this new worldview, displaying as they do the effects of the past, from the era of the volcanoes and later ice ages to the marks left by man in recent times. There must have been a sense of looking at the world transformed, of seeing, with sudden insight and astonishment, into an unfathomable past of a vastness incomprehensible only a few short years before.

A man of considerable energy, Fenton traveled widely in Britain, as well as to Russia and the Crimea, in days when railway systems in eastern Europe had relatively few lines. Right at the start of his photographic career, in 1852, we find him crossing vast distances in Russia and Ukraine—the photographer as adventurer, traveling in unknown territory with all the

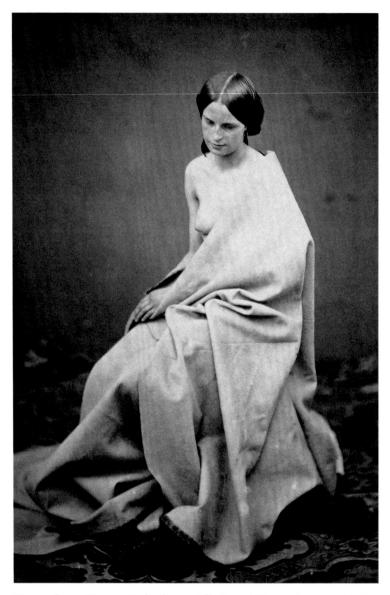

Fig. 72. Roger Fenton, Study of a Partially Draped Young Woman, ca. 1855. Salted paper print, $25 \times 17 \text{ cm}$ ($9^{13}/_{16} \times 6^{11}/_{16} \text{ in.}$). Victoria and Albert Museum, London, PH.486-1979

excitement and uncertainty of coming to terms with an alien culture. We can reasonably surmise that he sailed through the Baltic to Saint Petersburg. Possibly he then traveled on the recently opened rail connection to Moscow—the first and at that time the only long-distance rail line in Russia—thence overland to Kiev, down the Dnieper River to the Black Sea, and out through

the Mediterranean past Gibraltar.⁶ Fenton was of the generation born within memory of the upheavals of Napoleonic Europe, and in Russia the shadow of Napoleonic conquest, defeat, and ultimate victory still hung in the atmosphere. From the walls of the Kremlin and from the Old Bridge across the Moskva Fenton photographed the Church of the Redeemer, still under construction (pl. 6). It was built to commemorate the costly victory at Borodino in 1812, a battle that had not retreated from the national consciousness of the Russian people.

One of Fenton's most celebrated images, a view of the exotic domes of the Kremlin churches in Moscow (pl. 2), remains a wonderfully evocative image of the strangeness of medieval Russia, directing the imagination toward the East far more than the West. Russia was then still a deeply feudal society locked within its vast domain, and Fenton chose subjects that emphasized not only its rich history but also the bleak conditions of serfdom: the ramshackle dwellings of the poor, the stark conditions awaiting travelers illustrated by the tumbledown posthouse at Kiev (fig. 9). The tension in the Russian images derives in part from the representation of a medieval, feudal world by techniques of the utmost modernity. But even in this setting Fenton continued to experiment, making matched pairs of images to be viewed through a large-format Wheatstone stereoscope (figure 9 is one half of a stereo pair).

His next expedition through the Mediterranean took Fenton to the seat of the war in the Crimea, where he produced hundreds of negatives under extreme conditions. The Crimean photographs remain highly problematic and prone to widely differing interpretations. It is indisputable that the photographic subjects he chose were largely at a distance from the allied armies' immediate field of operation. He was present as the semiofficial representative of the queen and the government, and it would have been inappropriate for him to show death and destruction among the allies. However, the effects of the conflict were surely evident to a man of such acute sensitivity as Fenton. All ranks of the military, from high to low, had been confronting the impending catastrophe of extinction and disease. The winter of 1854–55 was one of dreadful privation for the British. The army, undersupplied and ill equipped, had further suffered the lashing of a freak windstorm that destroyed most of the tents. The forces lay at the extreme limits of unreliable supply lines and had chosen their supply harbor badly. Laid waste by sickness,

disease, and exposure, they were only now beginning to emerge from this period of unmitigated horror.

The fearful carnage and loss experienced by men engaged against over-whelming odds took place in what had once seemed idyllic countryside. It had, however, quickly become a theater of the most terrible hardships and horrors since those accompanying the defeat of Napoleon at Waterloo in 1815. In the years between the two wars the British army had ossified and was led by privileged men, many of them advanced in years, who had no experience of battle or logistics. As a result the shambles was complete.⁸

When Fenton arrived in the spring of 1855 he was immediately invited into the camp of the senior officers and given access to all. The expectation was that he would portray the British army in a state of readiness and able to effectively engage the enemy, within the uneasy alliance that had placed the English and the French, as well as the Turks, on the same side. The purpose of the photographs was largely to reassure a domestic audience that circumstances had improved and were no longer as dire as had been reported by the war correspondent William Howard Russell in the *Times*. Since this was at least in part an exercise in propaganda, we must read between the lines to gain a true insight into the pictures. 10

For their audience, the photographs had a wartime immediacy that is lost to us 150 years later. But it seems as though Fenton's eye sometimes transcended political necessity. The extended panorama of eleven plates of the plateau of Sebastopol, a landscape of bleak monotony, speaks loudly. Moving from the living to the dead, Fenton's sequence of images opens at the left with the encampment of the British above Sebastopol and proceeds across the battlefield until it concludes with the bleak graves on Cathcart's Hill at the extreme right (fig. 73). The losses had been devastating on both sides, and what Fenton wanted to portray was the prosaic, undifferentiated quality of a landscape remarkable only for the death and destruction it had encompassed. This stretch of land, which had been grubbed clear of whatever vegetation it once supported to provide fuel for the undersupplied army, had come to symbolize the extent of the human calamity. In the symbolize the extent of the human calamity.

The portraits take a similarly literalist view of the proceedings. Fenton's visual record of the officers responsible for the running of the campaign is painstakingly thorough; the principal generals are all here. The exhausted but dignified Lord Raglan, the shy septuagenarian commander of the British

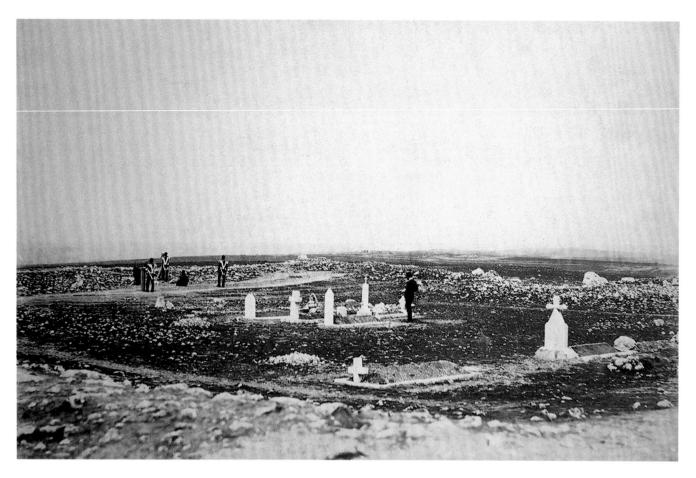

Fig. 73. Roger Fenton, View of Cemetery on Cathcart's Hill, pl. 10 from The Photographic Panorama of the Plateau of Sebastopol, April 1855. Salted paper print, 22.2 x 34.6 cm (8¾ x 13¾ in.). Courtesy of Hans P. Kraus Jr., Inc., New York

forces who could not bear to be cheered by his troops, does not look at the camera. He of Pasha, leader of the Turkish forces, appears with fez and chibouk (fig. 12). The ordinary-appearing but bellicose General Pélissier, recently appointed commander of the French forces, renowned for his poor riding skills and apparent disregard of the human cost of his maneuvers, is presented as directly and unrhetorically as possible. The journalist Russell looks untroubled by all he has seen and untroubled by being at odds with the establishment, which was continually attempting to muzzle his reports. He camera to be a seen and untroubled by being at odds with the establishment, which was continually attempting to muzzle his reports.

Many of the company were to die before the campaign was over. The non-chalance with which they gaze back at the camera, was it bravado? Was it the numbed response of men who had seen extremities of horror, a defense against incipient madness? There are also portraits of men who appear to be suffering from what they have seen, shell-shocked veterans of a war of attrition (pl. 18). Fenton made choices according to the condition of his sitters.

Some pictures were made as part of his attempt to record everyone on his list of dignitaries, a project he continued even after returning to London. ¹⁶ But it is quite clear that others were made with a degree of freedom, in impromptu, rapid sittings of busy men going about the camp with hardly enough time to pull up their horses. There are incongruities of necessity—sometimes a sitter is seen in the midst of desolation, seated on a prosaic dining chair. The slender vocabulary of pictorial devices Fenton had at his disposal is used to the utmost effect. The softening of the immediate foreground and of distant objects, a function of the rules of optics and depth of field, is utilized to focus attention on the sitter, with the hazily suggested massing of the composition creating the sense of a containing space for the image.

The harbor at Sebastopol is empty now, the Genoese fort still stands above the inlet, and it is possible to find Lord Raglan's position at the Battle of Balaklava without difficulty.¹⁷ There is still only one way that Captain

Nolan, an expert rider, would go down the hill to deliver the fatal order for the charge of the Light Brigade. Fenton's photographs are inextricably interwoven with these events even though they do not appear in direct terms, only by allusive connection with the protagonists who participated in or witnessed them. The responses of the sitters range from the bravura (fig. 74) to the introspective and reflective (fig. 14). The pictures record the panoply of full-dress uniforms, yet these are worn by men exhausted and involved in a monotonous struggle for survival accompanied by incremental, frequently fatal maneuverings against an ingenious and implacable opponent.

This uneasy counterpoint, quietly discordant, is perhaps an internalized reflection on the futility of the whole enterprise. The scant entry made in her journal by Queen Victoria (despite her known concern for the troops), "Some interesting photos taken by Mr. Fenton, in the Crimea, most portraits and views—extremely well done," seems only to reinforce the unbridgeable distance of the establishment at home from the harsh lot of the forces serving on the ground. At home heroics and rhetoric; on the battlefield a very different reality of sudden death, and for those who had survived thus far, continued suffering from sickness, exposure, and the unending barrage of the siege guns.

Of all Fenton's photographs, perhaps the most celebrated is the Valley of the Shadow of Death (pl. 21). It has been written about at length by almost every commentator, and yet it seems that there is still something more to say. It is a picture of utter silence. The stillness of the spent shot, terrible and uncountable, leads us to imagine the crump of the distant cannon. All is summed up in this, the first great photograph of the field of battle. It has achieved the same kind of iconic status as the similarly stark picture of the death of a republican soldier caught by Robert Capa eighty years later.²⁰ The eye is led first to the scattered shot²¹ and then to the side track, little more than a footpath pressed into the ground when the main roadway became an impassable morass in the dreadful winter now past; the track runs upward to join the continuation of the roadway, which recedes into the distance and finally is cut off at the crest of the ridge. This change in scale of the road, from merest side path to established passage, has the effect of collapsing perspective, creating a visual uncertainty that increases the sense of isolation and utter desolation. Fenton wrote that this was not the picture he intended to make, which, from his description, would have been a far more literal and

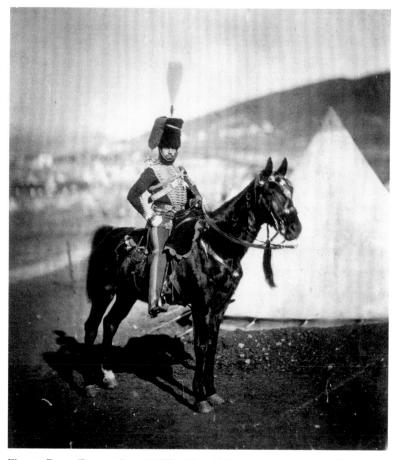

Fig. 74. Roger Fenton, Cornet Wilkin, Eleventh Hussars, Survivor of the Charge of the Light Brigade, 1855. Salted paper print, 19 x 17 cm ($7\frac{7}{6}$ x $6\frac{11}{6}$ in.). Prints and Photographs Division, Library of Congress, Washington, D.C., Purchase, Frances M. Fenton, 1944

probably recognizable view of a site that was an objective of the campaign.²² However, forced by immediate danger to retreat a little up the track, he created a very different image. He took away all of the picture's geographical content and left a palimpsest that still speaks to us of the deadly earnest of warfare and indiscriminate death.

Only one attack on Sebastopol was made during Fenton's time in the Crimea, at the very end of his sojourn. It was a major assault, and afterward there was a two-hour truce to remove the dead and wounded. But that must not have been a circumstance under which Fenton felt able to act, even though he had prepared his apparatus to move forward into the city in the

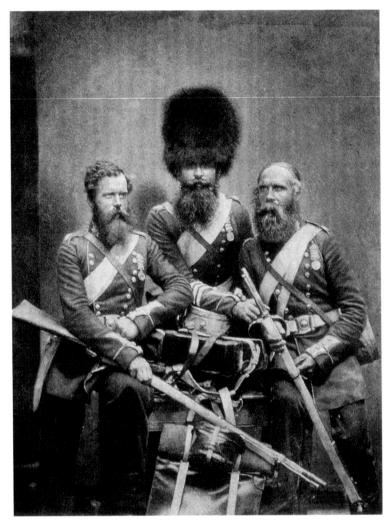

Fig. 75. Joseph Cundall (English, 1818–1895) and Robert Howlett (English, 1830–1858), Crimean Braves, 1856. Photogalvanograph, 29.2 x 23.5 cm (11½ x 9½ in.). San Francisco Museum of Modern Art, Gift of Sandra Mossbacher, 98.41

event of the anticipated victory.²³ Instead the allies were driven back with terrible losses, and Fenton found himself comforting the wounded and following the bodies of his friends to the burial ground. He seems to have been devastated by the experience. In his letters he quoted General Bosquet's remark to him shortly after the attack: "No one but a soldier can know the misery of war: I have passed six and twenty years of my life burying my most intimate friends."²⁴ He sickened with cholera and left the Crimea only

days later. Russell's reports described the destruction in the Mamelon, but there were no photographs of catastrophe until James Robertson and Felice Beato made pictures inside the Malakhov and Redan fortifications less than ten weeks later, after the Russian evacuation of Sebastopol.

Fenton's Crimean pictures were not a commercial success, no doubt because they remain stubbornly antirhetorical, do not offer a heroic rendering of the subject, and lack the romance of pictures such as Cundall and Howlett's *Crimean Braves* (fig. 75).

How blessed the English riverine landscapes must have seemed to the man who returned from the battlefields of the Crimea and the endless expanse of the steppe. The raw, scraped, bludgeoned land around Sebastopol was like the memory of a nightmare, a hallucination in the fever dreams of a cholera sufferer; while the agrarian landscape before him, with its richness of incident and boundless fertility, appeared numinous, life itself.

Fenton's British landscapes, informed by his classical training, often utilize a geometric visual structure that both anchors and energizes the picture. In his own time the strong geometry of his pictures was criticized, but in the longer view a portent of modernism can be discerned (pl. 82). He seems to take joyous pleasure in the ability of the camera to render information, pushing the photograph to the outer limits of its capacity to disclose. A rich and overwhelming sense of detail characterizes the resulting images, which are infused with a poetic understanding that is a lyrical response to a particular kind of English sensibility. In his time Fenton had no equal in the interpretation of landscape, and the expansiveness of his vistas is rarely encountered in the European tradition. He quickly understood that he could encompass a richly articulated landscape, leading the eye by his organization of the composition and creating an image evocative of the landscape's very ideal.

Fenton gives us a comprehensive description of the geographical aspect of river history, from turbulent headwaters to the lazy effulgence of the mean-dering floodplain. He seems to have spent little time in the softer country of southern England, preferring the more explicit and dramatic landforms of the glaciated country through which the more northerly rivers run.

Great landscape photographs were made by his French contemporaries Gustave Le Gray and Édouard Baldus.²⁵ Fenton's work is broader in subject and concept than that of Le Gray, who largely restricted his landscape work to the Forest of Fontainebleau, and it is more evolved than that of

Baldus, whose landscapes figure in his railway albums principally as parts of a description of the iron way or as conspicuous landmarks that leaven the record of architectural marvels along the route. With their lyric portrayal of varied landforms, from the wildnesses of northwest Wales to the cultivated and orderly river valleys of the Midlands, Fenton's images present a range of responses to landscape that had no rivals until the emergence of the great American landscape photographers of the 1860s and 1870s such as Carleton Watkins and Timothy O'Sullivan. The landscape these men photographed was itself of a heroic nature unavailable in the more tempered countryside of the British Isles.

Underlying all Fenton's landscape work is an ideal, an effort to preserve the image of a land that was diminishing and increasingly exploited. Even in North Wales, still one of the remote fastnesses of Britain, where he photographed a slate pier (pl. 39), there was already a long history of quarrying and mining. And in the countryside in general, land that had been cultivated and productive was, with the drift to the cities, falling fallow.

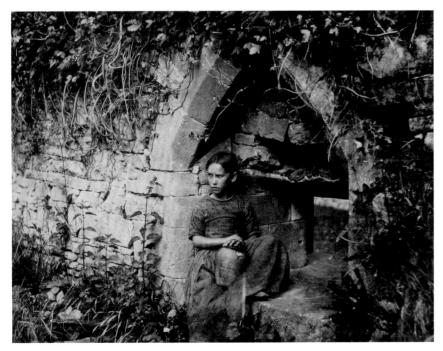

Fig. 76. Roger Fenton, *Scene in Tintern Abbey*, 1854. "Printed and Published by F. Frith, Reigate." Albumen silver print, 16.5 x 20.9 cm (6½ x 8 % in.). Collection Centre Canadien d'Architecture / Canadian Centre for Architecture, Montréal, PH1980:0689

The series of images of the great monastic foundations, Tintern, Fountains, and Rievaulx, all fallen into decay after the Reformation, express the beauty of the quietist architecture of the Cistercians as well as Fenton's attachment to the English Romantic heritage (pls. 8–12). Perhaps he knew the remark John Webster gives to Antonio in *The Duchess of Malfi:* "I do love these ancient ruins. / We never tread upon them but we set / Our foot upon some reverend history." But Fenton's Romanticism was not sentimental. He recognized the tangible relationship of structure to setting that the monks had understood so well in choosing the sites for their foundations.

Who are the people who appear in the pictures? Many are in mourning clothes, perhaps no uncommon sight in the years immediately after the Crimean campaign. Fenton lost three young children of his own, and some pictures have such intimacy that it seems likely the subjects are members of his immediate family. There is a quality of truth in Fenton's best photographs that is deeply moving. Few truer portraits of children exist than the touchingly lovely portrayal of a pensive child resting in an alcove of the refectory at Tintern (fig. 76),²⁷ while his photographs of the royal princesses, whose social position could hardly be more different, are similarly imbued with the reflective wistfulness of childhood (pls. 27, 28). Fenton seems to have recognized that the stillness required by long exposure times brought out the introspective qualities of his sitters and was something specific to portraiture in his chosen medium.

To judge from the titles of the academic paintings he produced early in his artistic career, Fenton began picture making with an approach governed by sentiment. When he turned to photography one might have expected that this member of the wealthy professional classes would take no more than a dilettantish interest in the medium. Well placed, a barrister, financially secure, he had no reason to exert himself and could easily have adopted the genteel role of an amateur. Instead the medium liberated him and gave his work the edge of discovery and rigor that has assured his place in the photographic pantheon. His search to extend the limits of photographic seeing seems to rest on curiosity about the very substance of picture making.

The fittingness of his interpretation to the materials is always apt. The early salt prints display a relish for form and massing and effectively utilize the particular qualities of the paper structure. In the later large glass plates

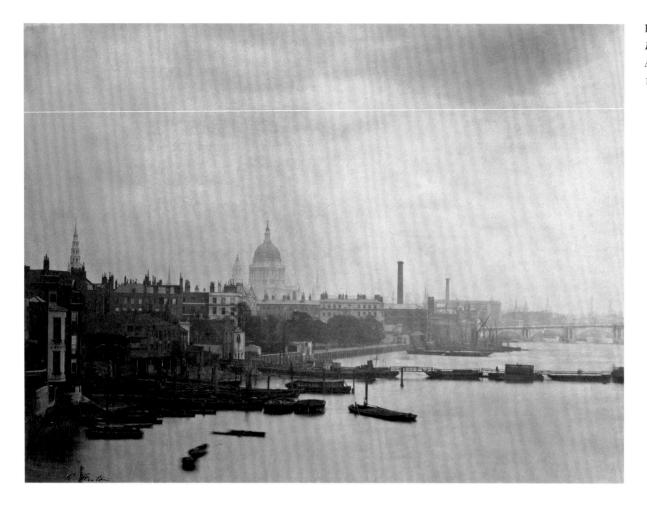

Fig. 77. Roger Fenton, *The Thames and Saint Paul's*, Looking Downstream from Waterloo Bridge, ca. 1858. Albumen silver print, $31.5 \times 42.5 \text{ cm} \left(12^{\frac{7}{16}} \times 16^{\frac{5}{4}} \text{ in.}\right)$. Tolstoy Museum, Moscow

this evolves into an overwhelming, nigh hallucinatory revelment in the rendering of detail. The obsession with detail reaches its apogee in the still lifes that represent the culmination of his career in photography, if not its zenith. One can seek a hidden iconography in these late images, but their deeper meaning remains obstinately unreachable, and instead we become fascinated by the richly rendered surfaces and the distortions in color caused by the spectral response of the photographic emulsion. The Victorian tendency to embellish is reflected in these hothouse productions, and elaboration and density of texture seem the predominant motifs. Qualities of surface fix our attention on the bloom of freshly gathered fruit and then the fragility of that bloom already brushed aside. Themes of temporality and mortality are also present in the earlier and less studiously arranged images of fish and game, which through the act of photographing suspend the inevitable decay of

their subjects, capturing the ephemeral sheen of a fish's flank and the still-supple bodies of birds and rabbits.

There is in Fenton's best works a kind of charged serenity that undoubtedly has its roots in a highly complex eye educated in the interpretation of space. He had the ability to recognize a latent order, something that had remained undiscovered, and to conduct the eye of the observer in such a way that revelation occurs.

In a photograph made at Rievaulx, the reading woman sitting before the doorway leading from the monks' burial ground is in contemplative counterpoint to the dynamic of the white-dressed child venturing out into the fields beyond (pl. 10). Mortality and nascence are encapsulated in one picture. It is clear that the figures in these highly staged images were not there by chance; the spontaneity comes from the creative tension of the idea being introduced

Fig. 78. Roger Fenton, Westminster Abbey and the Houses of Parliament, Saint Stephen's Tower, and the Victoria Tower, from Great Smith Street, ca. 1858.

Albumen silver print, 31 x 42 cm (12³/₁₆ x 16⁹/₁₆ in.).

Tolstoy Museum, Moscow

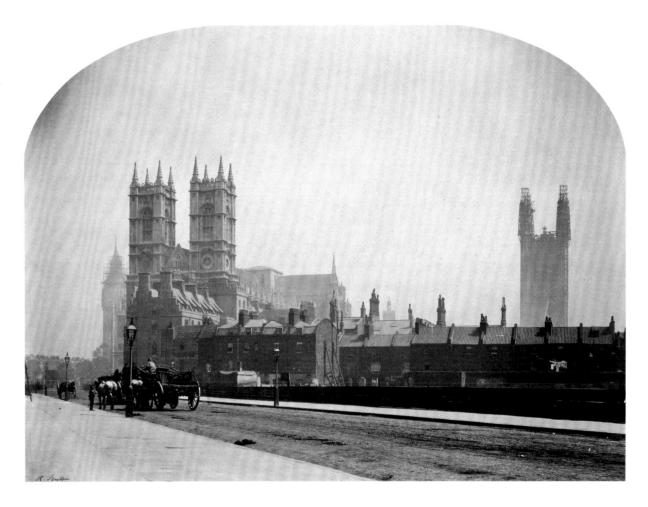

into the mind of the observer. In almost every case the inclusion of the human element in Fenton's photography is far more than a simple indication of scale. In some of the river landscapes the figures are so small as to be almost insignificant and become an experiment in the question of proportion, the balancing of attention between animate beings and the living landscape. How small can the fulcrum in a picture be? On another level they seem a reminder of the smallness of human endeavor in the continuum of time. Outbreaks of disease, child mortality, and, during these years, death and disintegration from war were never far out of mind. In this age of revolutions, the precariousness and imminent collapse of the balance of power in Europe were matters of daily conjecture. Almost as if in a deliberately constructed counterpoise are Fenton's images of perfect stability, demonstrations of order and hierarchy. The strikingly minimalist *Long Walk* at Windsor

and the view from the terrace at Harewood, so sharply delineated by the cultivated English landscape tradition and the architecture that accompanies it, are examples (pls. 82, 68). Such images stand for order and the persistence of tradition, the apparently irreducible foundations of British society, the basis of Empire.

Fenton made two pictures from Waterloo Bridge looking upstream and down, creating works of very different character. The view downstream to Saint Paul's is a dark and foreboding rendering of the "chartered Thames," with the dome of the cathedral floating unchallenged over the city (fig. 77).²⁸ To the left is another of Christopher Wren's masterpieces, the steeple of Saint Bride's, the tallest in London. Looking upstream, toward the Houses of Parliament, the whole temperament of the image is different (pl. 60). Fenton reduces the composition to three bands: the sky, the city, and the river. It is

an elemental image in which the bridge seems literally to be bearing the great monuments of London in suspension. Photographing into the light was a technical tour de force at this stage in the evolution of the medium, and a brooding atmosphere results from this use of contre-jour. Yet it also creates luminosity, giving the picture an airy quality of suspension entirely fitting to its subject. Further, the photographer takes note of significant alterations to the skyline of London, which for hundreds of years had remained virtually unchanged. The secular New Palace of Westminster (the newly completed Houses of Parliament) rises as the symbol of imperial might to dominate the sacred abbey of Westminster, where British monarchs have been crowned in succession since 1066.

From across the river at Lambeth Fenton developed further ideas on the balance of secular and ecclesiastical power. Lambeth Palace, the principal subject of this composition (pl. 58), is the seat of the Archbishop of Canterbury, here placed in dialogue with the new Parliament on the other side of the river. In a fourth image from the series (fig. 78), Fenton achieves an effective counterplay between the immediate foreground, strongly laid out in rushing and vigorous geometry, and the beautifully described towers by Nicholas Hawksmoor at the west end of Westminster Abbey. Here this venerable ecclesiastical symbol of the monarchy dominates the shadowy mass of the new Victoria Tower to the right.

Some of Fenton's images stand out even from the overall accomplishments of his career.

The Queen's Target (pl. 85) is a picture filled with artifice. A rifle had been clamped on a tripod and aimed at the target; by pulling a lanyard Queen Victoria was assured a direct hit. Thus the whole apparatus had been elaborately rigged to yield a satisfactory, if entirely artificial, result. Ultimately

this picture is a rendering of an abstract idea. Its visual audacity is the complete separation from any kind of context.

A print of the image prepared for the album presented to the queen was strategically retouched to almost completely eliminate the gestural marks left by the brush of the preparer of the target.²⁹ It is as though it was deemed necessary to correct a courtly oversight in which the appearance of the target had not been considered. The retouching robbed the image of most of the characteristics that probably pleased Fenton in his original conception, including its temporal aspects and attendant layers of meaning.

A very different picture, that of Ely Cathedral from the south (pl. 50), is suffused with the kind of English peacefulness epitomized by cathedral precincts, those enclaves left from the days of the great monasteries when the religious foundations were vast landholders. Here the cathedral towers rise up in the ethereal light of a summer morning. A tree described with great subtlety perfectly holds the center; the whole picture conveys serenity and a sense of peace. The rightness of fit between the subject and the materials and process at hand, the scale of the print, and the synchronicity of these different aspects of the art of picture making are what make this image succeed. It sums up at once the very quintessence of a particularly English place: the calm of the cloister, the resonance of long centuries of observance carried out with unvarying regularity. Fenton's ecclesiastical images are about more than the representation of architecture, for they constitute a native response to a subject richly enveloped in the history of the nation and in the recollection of turbulent times long ago. They form a beautifully rendered account of a deeply humanistic landscape and architecture that had been managed by the inhabitants of the land for centuries. Pictures like this of Fenton's remain unequaled in the subsequent history of the photograph.

A Chronology of the Life and Photographic Career of Roger Fenton

ROGER TAYLOR AND GORDON BALDWIN

1819

March 28 Roger Fenton born at Crimble Hall, near Bury, Lancashire, fourth child of John Fenton (1791–1863) and Elizabeth Aipedaile Fenton (1792–1829) of Crimble Hall, and grandson of Joseph Fenton (1756–1840), cotton merchant and banker. Already in the family are two brothers, John (born February 11, 1814) and Joseph (born September 7, 1817), and a sister, Elizabeth (born May 10, 1815).

November 9 Christened at Bamford Independent Chapel, near Bury, by Thomas Jackson.

The same year, Joseph Fenton establishes the Fenton, Eccles, Cunliffe & Roby bank (later J. & J. Fenton and Sons), in Rochdale.

1820

Joseph Fenton purchases Bamford Hall from last surviving Bamford descendant and occupies it henceforth.

June 15 Birth of third brother, William.

1822

February 6 Birth of second sister, Sarah.

1824

June 21 Birth of third sister, Ann.

1826

Joseph Fenton starts construction of Hooley Bridge Mill, a gaslit five-story brick building, alongside river Roch, near Heywood. Some three hundred workers' dwellings are later built nearby. Firm quickly establishes a good reputation as a fair employer.¹

1828

March 28 Burial of eldest brother, John, at age fourteen.

1829

July 22 Death of mother, Elizabeth, at age thirty-seven.

September 24 — Joseph Fenton signs agreement with Thomas Weld to purchase, for then-considerable sum of thirty-six thousand pounds, 3,250 acres of land at Aighton, Bailey, Chaigley, Dutton, and Ribchester, along with ancient manorial rights and lordships to a further 4,250 acres. Estate is contiguous with Stonyhurst College and includes village of Hurst Green, with water-powered bobbin mills.²

1830

Father, John, marries second wife, Hannah Owston, of Brigg, Lincolnshire; they will have ten children.

1832

December 11 John Fenton elected Whig (Liberal) Member of Parliament for new constituency of Rochdale. Except for period 1835 to 1837, remains an MP until retirement in 1841.³ Twenty years later, Roger Fenton will consider putting himself forward as candidate for Parliament.⁴

1836

Goes to London with brother William and enters University College. Studies Latin, Greek, English, mathematics, literature, and logic for next four years.

1839

May 29 Admitted to Honourable Society of the Inner Temple at Inns of Court, London, the first essential stage to becoming a barrister.⁵

1840

Graduates from University College with Bachelor of Arts degree.

June 18 Joseph Fenton dies, leaving estate worth more than five hundred thousand pounds. Each grandchild receives one thousand pounds; Roger, having passed age of majority, inherits immediately.

1841

Begins law studies at University College.

Resides at 11 Gower Place, London, giving profession in 1841 census as "Templar," a title given to law students.

University College appoints Charles Blacker Vignoles professor of civil engineering.⁷

1842

June 28 Passport number 719 issued to Mr. Roger Fenton on recommendation of Mr. Cunliffe, banker, 21 Bucklersbury, London.⁸

1843

August 29 Marries Grace Elizabeth Maynard, daughter of John Charles Maynard of Harlsey Hall, Northallerton, Yorkshire, in Harlsey Parish Church.⁹

1844

May 17 Watercolor (private collection) titled and dated "Roger Fenton, Paris, May 17, 1844." ¹¹

June 29 Registers as copyist at the Musée du Louvre, naming as his teacher Michel-Martin Drolling (1786–1851), history and portrait painter and professor at École des Beaux-Arts.¹⁰

1845

Birth of first child, daughter Josephine Frances, possibly in Paris.

1846

Birth of second daughter, Annie Grace, in Paris. 12

1847

Probably this year, begins study in London under the history painter Charles Lucy (1814–1873), a member of the Royal Academy; the two will become friends.

December Moves to newly completed house at 2 Albert Terrace, Regent's Park, London. 13

December 18 First mention of "Calotype Society," described as "a dozen gentlemen amateurs" meeting informally at the home of Peter Wickens Fry. ¹⁴ This group, consisting of Fry, Joseph Cundall, Hugh Owen, and others (but not Fenton), first regular gathering of photographers held in London, will later promote idea of a photographic society for the city. ¹⁵

1848

February 25 Mentioned in diary of Ford Madox Brown (FMB): "French Revolution proclaimed . . . went at eleven at night to see Lucy, found him in great excitement about Paris, Fenton his pupil in a sad state about it. We all three have associations with Paris." 16

 $\label{eq:June 3-December 12} \begin{array}{ll} \text{FMB records further encounters} \\ \text{with Fenton.}^{17} \end{array}$

1849

March 19 FMB: "repainted at the head of Cordelia . . .

Lucy and Fenton called in, did not like her." (Brown was painting *Cordelia at the Bedside of Lear*, now in the collection of the Tate Gallery, London.)

May Exhibits painting at Royal Academy of Arts (no. 603): You must wake and call me early . . . , illustrating scene from Alfred, Lord Tennyson's ballad "The May Queen." 18

1850

March 12 Death of eldest daughter, Josephine Frances, at age five.

March 13 FMB: "went to Fenton to paint his dead child."

March 14 FMB: "to Fenton's, finished the head—and back to work."

May Exhibits painting at Royal Academy (no. 71): The letter to Mamma: What shall we write?¹⁹

May 1 North London School of Drawing and Modelling opens under patronage of Prince Albert, offering evening classes intended to teach workmen and artisans "true knowledge of form." Fenton, Lucy, Brown, George Godwin, Samuel Carter Hall, J. Scott Russell, Thomas Seddon, and Digby Wyatt serve on Management Committee.²⁰

June 6 Birth of third daughter, Aimée Frances, at home on Albert Terrace; she will die in infancy.²¹

July 25–26 With Grace, visits at Crimble Hall until about September $4.^{22}$

November 8 Being in area "alone," dines with brotherin-law Edmund Maynard, a captain in Eighty-Eighth Regiment, at barracks in Bury.²³

1851

February 17 Having let membership lapse while in Paris, is readmitted to Inner Temple as a student, a prerequisite to being called to bar.²⁴

May Exhibits painting at Royal Academy (no. 148): There's music in his very steps as he comes up the stairs.²⁵

May 1 Great Exhibition of the Works of Industry of All Nations at Crystal Palace, Hyde Park, opened by Queen Victoria and Prince Albert. Photographs widely distributed throughout exhibition, including in foreign courts, but British photography, especially amateur work, poorly represented.²⁶

May 9 Called to bar; business address given as 50 King William Street, City of London. ²⁷

October On trip to Paris, meets Gustave Le Gray and other French photographers; visits Société Héliographique.²⁸

1852

February Publishes article describing importance of Société Héliographique to French photography and asking that similar association be established in London.²⁹

February 18 Date of earliest known photographs by Fenton, which include studies of Regent's Park, Albert Road, and Saint Mark's Church, a self-portrait, and five other portraits of unidentified persons, perhaps including his wife and a daughter.³⁰

March Chemist publishes Fenton's "Proposal for the Formation of a Photographical Society," encouraging interested parties to apply directly to its offices or to Fenton at Albert Terrace. 31 Other notices of intent are published elsewhere.

March–July Robert Hunt corresponds with William Henry Fox Talbot on behalf of those seeking to establish a photographic society, arguing that Talbot's patents would unfairly restrict practice of members of proposed society. With the further intervention of Sir Charles Eastlake and Lord Rosse, the matter is resolved on July 30, when Talbot agrees to relinquish most patent rights. 32

March 19 Letter from Hunt to Talbot notes that Fenton is currently in Lancashire.³³

April 10–13 Photographs in Gloucester and surrounding region. 34

June 15 Photographs dead game in Zoological Gardens, Regent's Park.³⁵

June 19 Meeting at Society of Arts names provisional committee to establish a photographic society.³⁶

August Fifth edition of W. H. Thornthwaite's *Guide* to *Photography* contains new chapter by Fenton that explains and modifies waxed paper process developed by Le Gray.

August 17 Departs for Russia with Vignoles and John Cooke Bourne, artist and photographer, to make pictures of construction of a suspension bridge across Dnieper River in Kiev, commissioned by Czar Nicholas I and designed by Vignoles. ³⁷ Will also make extensive series of photographs in Moscow, Kiev, and elsewhere, often in trying circumstances. ³⁸

August 25 Fenton, Vignoles, and Bourne disembark in Saint Petersburg, where "the Photographic Apparatus was not allowed to pass" through customs and was only released six days later. Fenton and Bourne go to Moscow ahead of Vignoles.³⁹

September 24 Reaches Kiev with Bourne and meets up with Vignoles, who had arrived the previous week. 40

October–December Reviews of first two parts of *The Photographic Album*, published by David Bogue, which contain a total of eight photographic prints, six by Fenton and two by Philip Henry Delamotte.⁴¹

November 10 Departs Kiev with Vignoles, arriving in London on November 20. Bourne remains in Kiev to continue photography. 42

December 8 Elected member of Society of Arts, having been proposed by Peter Le Neve Foster.

December 22 "Recent Specimens of Photography," first exhibition in Britain devoted exclusively to photographs, opens at Society of Arts, Adelphi theater, London. 43 Fenton, who contributes forty-one prints, all employing the waxed paper process, reads his paper "On the Present Position and Future Prospects of the Art of Photography." 44

1853

January 1 Illustration Soirée of Photographers, in the Great Room of the Society of Arts (fig. 64) appears in Illustrated London News.⁴⁵

January 19 Attends meeting of Society of Arts at which Antoine Claudet delivers paper on stereoscope. 46

January 20 Inaugural meeting of Photographic Society held in Great Room of Society of Arts. Eastlake elected president, supported by three vice presidents and Council of twenty-one members, including Fenton, who is elected honorary secretary.⁴⁷

January 27 At first meeting of Photographic Society Council, a committee composed of Sir William Newton, Dr. John Percy, Vignoles, and Fenton is appointed to consider future relationship with Society of Arts. ⁴⁸ (For Fenton's attendance at Council meetings, see final entries in relevant years.)

February 3 First ordinary meeting of Photographic Society held at Society of Arts: Fenton reads paper "Upon the Mode in Which It Is Advisable the Society Should Conduct Its Labours" and discusses experiences with waxed-paper-negative process in Russia. 49

February 10 Council meeting: Publication Committee, composed of Hunt, Vignoles, and Fenton, appointed to establish journal for society.⁵⁰

February 17 Council meeting: Fenton and Foster appointed to respond to Society of Arts proposal for touring exhibition of photographs by members of society.⁵¹

February 24 Council meeting: Fenton and Percy are asked to register as proprietors of the journal, to be held in trust for Photographic Society.⁵²

March 3 First number of Journal of the Photographic Society printed and laid before Council for inspection. 53 It will continue to be published under a succession of names and still exists.

March 10 Council meeting: Fenton proposes to give introductory paper on "the qualities required for a good working camera" at next general meeting of society.⁵⁴

March 17 Birth of fourth daughter, Eva Catherine, at 2 Albert Terrace. Council receives letter explaining Fenton's "unavoidable absence" from meeting. 55

April 21 Ordinary meeting: Fenton contributes to discussion on cameras submitted for examination, including one made by Fenton's future assistant Marcus Sparling, who is on hand to explain its features.⁵⁶

April 28 Shows forty-eight topographic and architectural views at inaugural exhibition of Photographic

Institution, 168 New Bond Street, London, a commercial enterprise established by Cundall and Delamotte to deal with all aspects of photography, especially retailing of photographic prints.⁵⁷

May Gives German explorer Eduard Vogel photography lessons to equip him for forthcoming expedition to Central Africa.⁵⁸

May 5 General meeting: Fenton reads Sir Charles Wheatstone's "Note on a New Portable Reflecting Stereoscope" and joins others in exhibiting stereoscopic photographs, made by him the previous year.⁵⁹

May 12 Council meeting: Sparling elected to society. 60

May 24 Fenton's "Scènes de forêt" (Forest Scenes) and "Vues de Russie" (Views of Russia) are shown at Ernest Lacan's house in Paris. 61

May 30 Queen Victoria and Prince Albert "willingly give their Patronage to the Photographic Society." 62

June 25 Sydney Smirke, architect and designer of Reading Room at British Museum, directed "to consider the construction of a temporary Photographic Chamber on the roof of the Museum." 63

July 14 Writes to Edward Hawkins, keeper of antiquities at British Museum, giving detailed advice on type of studio, darkroom, and equipment suitable for photographing museum's objects.⁶⁴

September 14 Touring exhibition of photographs organized by Society of Arts opens at Woburn Literary and Scientific Institution; ten of its eighty-three prints are by Fenton. ⁶⁵

October 4 Writes to Sir Henry Ellis, principal librarian, offering his services as photographer to the British Museum. 66

October 6 Wheatstone writes to Hawkins, recommending Fenton as museum photographer. Fenton appointed to make "some experimental trials" and authorized to spend up to 180 pounds on additional apparatus.⁶⁷

November 3 Reads paper on use of nitrate baths with collodion negative process at meeting of Photographic Society; transcript, sent to *La Lumière*, is published in translation. 68

November 19 Priest of the Greek Church, made in Kiev, appears in *Illustrated London News*, the first illustration in that publication based on photograph by Fenton. ⁶⁹

December 1 Council meeting: Fenton reports on rental of rooms at Society of British Artists, Suffolk Street, for first annual exhibition of Photographic Society. Six members of Council, including Fenton, take responsibility for organizing exhibition.⁷⁰

December 6 Writes to La Lumière inviting French photographers to participate in Photographic Society exhibition;⁷¹ as a result, their work is well represented.

In 1853, attends Photographic Society Council meetings: January 27, 31; February 3, 10, 17, 24; March 10, 24, 31; April 7, 14, 21, 28; May 5, 12, 26; June 9, 16, 30; November 17; December 1, 8, 15, 22. Absent from Council meetings: March 17, May 19, July 28, August 8, October 20, 27.

1854

January 3 First annual exhibition of Photographic Society opens with visit from Queen Victoria and Prince Albert. Eastlake and Fenton, among others, selected to conduct royal party through gallery; queen later notes that Fenton "explained everything & there were many beautiful photographs done by him." Of the 980 photographs Fenton has seventy-three prints, more than half made by waxed paper process. 73

January 14 Morning Post reports that Queen Victoria so admired Fenton's Russian views during visit to exhibition that she purchased six of those on display.⁷⁴

January 23 Photographs royal children in costumes from Nicolas-Marie Dalayrac's Les deux petits Savoyards, performed before their parents at Windsor Castle on January 16.⁷⁵

January 25 Photographs Queen Victoria and children "just outside the Green Drawing-room windows." ⁷⁶

February 1 Photographs tutor Dr. Ernst Becker with Prince Alfred and the Prince of Wales.⁷⁷

February 4 Responds belatedly to letter from Talbot about need for permanence in "positive copies," expressing hope that Talbot's experiments in photographic engraving will prove successful.⁷⁸

Russian Peasants, after a photograph by Fenton, appears in Illustrated London News.⁷⁹

February 10 Tableaux vivants of Four Seasons performed by royal children at Windsor to celebrate four-teenth wedding anniversary of parents. 80 Tableaux subsequently restaged for Fenton to photograph.

February 11 Photographic Room at British Museum completed and fitted out. Fenton makes test photographs, which are submitted to museum's trustees. 81

March Twenty-four prints included in photographic exhibition organized in support of Royal Infirmary Fund, Dundee. 82

March 11 Photographs Baltic Fleet departing Spithead for the Baltic.⁸³

March 27–28 After months of rising tension, Britain and France decide to support Turkish cause by declaring war on Russia.

April 10 For five negatives taken at Buckingham Palace, Fenton charges the royal family one guinea per negative and one shilling and sixpence for each print.⁸⁴

April 17 Second tour of photographs organized by Society of Arts begins; two sets of work are sent around Britain simultaneously, to fifteen and eighteen venues respectively. Fenton has twenty-four prints of similar subjects in each set.⁸⁵

May Makes twenty-nine more negatives at Buckingham Palace, with sittings on May 1, 5, 6, 11, and 22. 86

May 11 Photographs Queen Victoria in court dress at Buckingham Palace as well as with Prince Albert after a Drawing Room at Saint James's Palace (fig. 49).

May 22 Makes "instantaneous photographs"—i.e., those with short exposure times—of the queen, prince, and their eight children together on grounds of Buckingham Palace (fig. 10).⁸⁷

June 12 Photographs Lady Harriet Hamilton in Mary, Queen of Scots, costume, worn to Bal Costumé held at French Embassy, May 12, 1854.⁸⁸

June 20 On behalf of Photographic Society, writes Talbot asking whether Talbot's proposal to include collodion negative process in renewal of his 1841 patent would alter his existing arrangement with the society. Talbot reassures Fenton that it was never his intention "to withdraw, or to alter, the gift" he granted the society in 1852. 89

 $\it June~30$ Photographs Queen Victoria, Prince Albert, and Dr. Becker. 90

July 6 General meeting: Talbot's intention to renew patent discussed; Fenton supports Vignoles's resolution to oppose renewal because Talbot's claim, that collodion was chemically the same process as calotype, was mistaken.⁹¹

July 15 Fenton's engagement as photographer temporarily terminated by British Museum pending report to Trustees reviewing purposes and costs of photography. 92

July 20 Receives sixty-six pounds two shillings for photographic work for royal family (portraits of family and prints; prints of views on Wye and at Tintern). 93

July 27 Council meeting: Newton, Foster, Alfred Rosling, and Fenton nominated to arrange for members to submit work to Exposition Universelle, to be held in 1855 in Paris.⁹⁴

Late summer–early fall Photographs in Yorkshire at Rievaulx, Fountains, Bolton, Mount Grace, Ripon, and Helmsley, and along Wharfe River. Fenton's brother William, who has gone into the family banking business and has later become financially involved with the rapidly expanding railway network in Britain—serving as a director of several railway companies and chairman of others—perhaps facilitates Fenton's rail travel with his photographic van and paraphernalia.

October 31 Photographs Prince Nicholas of Nassau. 96

November Photographs Princess Victoria Gouramma, daughter of former Rajah of Coorg.⁹⁷

November 2 Nominated to committee arranging second annual exhibition of Photographic Society. At general meeting, voices disapproval of Maxwell Lyte's device for introducing skies or foregrounds into photographs by use of two negatives; shows recent views of Yorkshire.⁹⁸

November 11 Trustees of British Museum approve report on photography and direct that a sum of one

thousand pounds be inserted into budgets for following year, heralding Fenton's resumption of duties.⁹⁹

In 1854, attends Photographic Society Council meetings: January 2, 12, 26; February 2, 9; March 2, 16, 30; April 6, 27; May 4, 18; June 19, 29; July 6, 12, 27; October 26; November 2, 9, 30; December 7, 14, 21, 28. Absent from Council meetings: February 23.

1855

January Eleven studies, taken on paper and collodion negatives, exhibited at Photographic Institution, New Bond Street, London. 100

January 11 Shows forty-five prints at second annual exhibition of Photographic Society. 101

February 2 Submits invoice to royal household for photography undertaken during August, November, and December 1854 for Queen Victoria. In August 1855 acknowledges full payment of seventeen pounds nine shillings and sixpence. ¹⁰²

February 17 Valley of the Wharfe, after photograph by Fenton, appears in Illustrated London News (fig. 65). 103

February 20 Departs for Crimea from Blackwall Pier with Sparling and "the boy" William. Passage aboard HMS Hecla provided by Duke of Newcastle and railway entrepreneur Sir Morton Peto. On board are Fenton's photographic van, seven hundred glass plates, and thirty-six large chests of equipment and personal effects. 10-4

April 27 From Gibraltar, writes first in a series of letters home describing his experiences. ¹⁰⁵ Tells how, during a storm crossing the Bay of Biscay he "lay prostrate, groaning in spirit, unable to eat or drink."

March 6 Constantinople: Calls on British Consul, using "letter from Prince Albert" to establish his credentials. 107

March 8 Balaklava: Arrives in Crimea to begin "five months' hard labour . . . as a photographer at the seat of war." 108

March 16 Balaklava: After a week of frustration, gets horses, carriage, equipment, and supplies unloaded and begins photographing. "In order to avoid the necessity of explaining to all comers what my carriage was for,

I had made Sparling paint on it 'Photographic Van.'" ¹⁰⁹ Photographs regularly henceforth.

March 26–28 Balaklava: "The labour in itself is great, and many pictures are spoilt by the dust and heat, still more by the crowds of all ranks who flock around. I am afraid I shall not get away as soon as I expected . . . the distances are so great and the difficulty of getting people together whose portraits are wanted, that it will take me much time." 110

April 4 En route to headquarters above Balaklava: Concerned about his wife's impending confinement, advises her to employ a nurse ahead of time, "as it will not do to look for one when she is needed." ¹¹¹

April 19 Above Sebastopol: "The ground here is covered with cannon balls, and I took care to keep well behind the hill in going down, for I could hear by the whir and thud that the balls were coming up the ravine on each side . . . there was no stop to the awful commotion . . . like an express train that had broken off the line and leapt up into the air." 112

April 24 Above Sebastopol: "Anxious as I am to get back to the repose of my glass room at the Museum I will never leave my work half done here." In closing, bids "Good bye honey, keep your courage up, play the piano, [take] plenty of exercise, & go out occasionally in the evening. Thine RF." 113

April 29 "I am sadly bothered with applications to make portraits, this after all is my chief hindrance. If I refuse to take them I can get no facilities for conveying my van from one locality to another." Of course you would expect me to sleep in a bed when I get back. I shall begin by sleeping at the top of Primrose Hill hiring some one to fire off squibs all night to prevent me from feeling the silence painful. By proper precaution perhaps I may be got to sleep in the house in a fortnight's time provided it is upon the landing with all the windows open." 115

May 6 Balaklava: "I have made considerable progress during the past week with my work; have got several more of the generals & hope that another fortnight will finish what I have to do at the front & then I shall have nothing to do but sell my baggage & pack up." 116

May 13 Radikoi: "I do not like living with the French, they are very kind, but their habits are so different . . .

there is one great drawback in their camp which is not very easily described (much better understood then told). There being no women here, they are not particular as to how they exhibit themselves & there has been a story going about the camp that I had given up taking views in disgust because I could never get a picture without there being in it some object not fit to show to a British Public." 117

May 15 Exposition Universelle opens in Paris with a selection of photographs sent by Photographic Society; landscape studies by Fenton are awarded a silver medal.¹¹⁸

May 26 At headquarters: "I have sold 2 of my horses & am winding up. I have taken the portraits of 3 of our generals this morning and hope to get Lord B's & General Airey's on Monday when I shall consider that I have done." 119

June 8 "I have nothing to do but sell my things & look out for a vessel. I am hindered by Sparling who has been drinking a good deal lately, and has in consequence a bad attack of dysentery . . . I am constantly thinking of you and wishing that I were with you. Please God! It won't be long now." 120

June 18 Watching Russians repulse attack of British and French on Malakhov and Redan fortifications at Sebastopol: "In our confidence of success we had chosen this day, it is said, that on the anniversary of Waterloo a victory common to both nations might efface from the minds of one the recollection of their former defeat, but we reckoned too proudly, and now the 18th of June will be a glorious day to the Russians." ¹²¹

June 22 Departing from Balaklava: "We had nearly got outside the harbour when I began to vomit.... By nine o'clock I was bad with the cholera, and there was no doctor on board.... I got them to make me some rice water and mixed lime juice with it.... At half past ten cramp began in my legs and I had to be held upright and rubbed... William and Sparling took it in turn to watch me, and I must say they both took great care of me." 122

June 27 or 28 Sails from Constantinople on Royal Mail steamer *Orinoco*, under lease to admiralty.

July 2 Birth of fifth daughter, Rose Maynard, at 2 Albert Terrace.

July 11 Orinoco arrives at Portsmouth.

August 8 Queen Victoria, at Osborne House, notes that after dinner she looked at "some interesting photos, taken by Mr. Fenton, in the Crimea, portraits & views, extremely well done." ¹²³

Mid-August Photographs the Princess Royal and Princess Alice on grounds of Osborne House (pl. 27). 124

September "Exhibition of the Photographic Pictures Taken in the Crimea" opens at Gallery of Water Colour Society, Pall Mall, the first of three London venues. For next eight months, versions of exhibition appear in other cities and towns, notably Birmingham, Exeter, Gloucester, Leeds, Liverpool, Manchester, and Yeovil. 125

September 7 In Paris Fenton and William Agnew Jr. summoned to palace of Saint-Cloud to show Napoléon III entire collection of Crimean photographs. Emperor spends more than an hour and a half examining and discussing the works, and gives Fenton a medal and a portrait of himself.¹²⁶

September 12 Two studies by Fenton on show at photographic exhibition organized for Glasgow meeting of British Association for the Advancement of Science. 127

September 22 Photographic Pictures of the Seat of War in the Crimea, a three-part portfolio, advertised by Thomas Agnew for sale at sixty-three pounds. Panoramas and portraits of distinguished generals available as individual prints. 128

October 6-December 29 Illustrated London News publishes seven illustrations after Fenton's Crimean photographs: General Bosquet; General Simpson, Commander of Her Majesty's Forces in the Crimea; Omer Pacha [sic]; General Sir William John Codrington, the New Commander-in-Chief in the Crimea and Spahi and Zouave; Mr. Fenton's Photographic Van; and Croats. 129

December "Exhibition of the Photographic Pictures Taken in the Crimea" moves to Gallery of New Society of Painters in Water-Colours, Pall Mall. 130

In 1855, attended Council meetings: January, 3, 4, 11, 18, 31; September 27; November 29; December 6, 13, 27. Absent from Council meetings: January 24; February 7 to July 6; October 25; November 11.

1856

January Contributions to third annual exhibition of Photographic Society, London, include various subjects from British Museum work; portraits, among them "a Zouave"; and a study of children.¹³¹

January 3 Ordinary and special general meeting: Bourne describes his design for a "patent portable camera, with separate dark-chamber"; Fenton reads his "Narrative of a Photographic Trip to the Seat of War in the Crimea." ¹³²

January 21 Lectures on Crimean experiences at Public Hall, Rochdale, Lancashire. 133

February 7 Resigns as honorary secretary of Photographic Society following Council's decision to combine post with that of editor of the journal. Reverend John Richardson Major is named to new position. 134

February 27 Paul & Dominic Colnaghi & Co. chosen to act as agents for sale of Fenton's British Museum photographs. 135

April "Exhibition of the Photographic Pictures Taken in the Crimea" moves to new premises at The Gallery, Saint James's Street; 360 subjects presented in third and final edition of catalogue. Also shown are James Robertson's photographs of fall of Sebastopol. 136

April 23 Presides over meeting of Society of Arts at which Paul Pretsch delivers a paper, "On Photo-Galvanography, or, Engraving by Light and Electricity." ¹³⁷

May 1 Council meeting: disagreement arises over involvement of some Council members in promoting the Photographic Association, which has commercial ambitions directly opposed to the principles of the Photographic Society. After heated debate, Fenton, Delamotte, Vignoles, William Lake Price, and Thomas Frederick Hardwich resign from Council. 138

June 5 British Museum publishes Photographic Facsimiles of the Remains of the Epistles of Clement of Rome in edition of fifty, with twenty-two original unmounted salt prints by Fenton and introduction by Sir Frederic Madden, keeper of manuscripts. 139

July 18 Photographic Society Club, an informal social and dining organization, holds annual outing to

Hampton Court; group portrait of members includes Fenton (fig. 71).

August 14 At Exposition Universelle de Photographie, Brussels, Fenton exhibits topographic and landscape studies with clouds, for which he is awarded a medal. 140

September Forty Crimean pictures by Fenton included in Manchester Photographic Society's annual exhibition. ¹⁴¹

Travels to Scotland, photographing sites and landscapes en route to Yorkshire, Holy Isle (Lindisfarne), Jedburgh, Melrose, Braemar, Dunkeld, Edinburgh, and Roslin, and along the Feugh, Clunie, and Dee rivers.¹⁴²

At Balmoral Castle takes portraits and views commissioned by Queen Victoria; charges five guineas for each of the eight negatives, prints extra. 148

October Sparling publishes treatise, Theory and Practice of the Photographic Art: Including Its Chemistry and Optics with Minute Instruction in the Practical Manipulation of the Various Processes, Drawn from the Author's Daily Practice, which describes author as "Assistant to Mr. Fenton, in taking the Crimean Photographs." 144

October 31 First part of Photographic Art Treasures; or Nature and Art Illustrated by Art and Nature, comprising four photographs by Fenton, published by Patent Photo-Galvanographic Company, of which he is a partner and the company photographer.¹⁴⁵

November 6 General meeting: Fenton exhibits views of Yorkshire, and Le Gray, pictures of clouds and the sea. 146

November 17 Participates in exhibition of Norwich Photographic Society. 147

December 1 Shows twenty-seven prints, including Scottish and Yorkshire subjects, at second annual exhibition of Société Française de Photographie, Paris. 148

December 15 Following commercial failure of Crimean photographs, remaining stocks of prints, and negatives, are sold at general auction by Southgate and Barrett, Fleet Street, London. 149

December 17 Exhibits with other members of Photographic Society at evening reception, King's College, London. More than two thousand pictures are on display, Fenton's described as "grand north-country scenes." ¹⁵⁰

December 20 Contributes thirty-eight views to first exhibition of Photographic Society of Scotland, Edinburgh. ¹⁵¹

In 1856, attended Council meetings: January 3, 24, 31; February 4, 7, 14, 28; March 6; April 4, 17, 25; May 1, 8. Absent from Council meeting: March 26.

1857

January Shows fifty-four prints at fourth annual exhibition of Photographic Society, including landscape and architectural studies made in Scotland the previous September and examples of photo-galvanographic printing. ¹⁵²

February 5 Annual general meeting: Fenton reelected to Council.

April 21 Facing legal action, Fenton writes Talbot on behalf of Patent Photo-Galvanographic Company in attempt to settle dispute arising from firm's acknowledged infringement of Talbot's patent for photomechanical printing.¹⁵³

May 5 Manchester Art Treasures Exhibition opens. Its photographic gallery of works selected by Delamotte includes eight studies of landscape and architecture by Fenton. ¹⁵⁴

May 1 Patent Photo-Galvanographic Company reported to be facing losses of about four thousand pounds. 155

May 7 Photographic Society establishes subscription fund to provide annuity to widow and children of Frederick Scott Archer; Fenton named as one of the organizers. ¹⁵⁶

June Exhibits prints at Colnaghi's, including views of Bolton Abbey and London parks as well as photogalvanographs. 157

July 25 Photographs cricket match between Royal Artillery and Hunsdonbury Club at Hunsdonbury.

August 10 Exhibits unnamed studies at Exposition Universelle de Photographie, Brussels, for which he is awarded a medal. 158

August and/or September Photographs at Ely, Peterborough, and Lincoln. 159

 Fall Photographs in North Wales, particularly in and around Bettws-y-Coed. 160

December 3 General meeting: Fenton formally takes office of vice president of the society, following Newton's obligatory retirement. ¹⁶¹

December 12 Contributes views of Scotland to second annual exhibition of Photographic Society of Scotland, Edinburgh. 162

December 30 Joins committee on fine-art copyright established by Society of Arts and writes editor of Photographic Society's *Journal* seeking opinion of "brother photographers" about what degree of protection to require in change in law being proposed. 163

In 1857, attended Council meetings: February 5, 19; March 5, 9; April 16; May 7; June 4; July 16; November 5, 19; December 3, 17, 22. Absent from Council meetings: March 19, 26; April 4; May 21; June 11, 18; July 2; September 4; October 1.

1858

January 7 Shows twenty-five studies at first exhibition of Architectural Photographic Association, held at the Suffolk Street Galleries, Pall Mall, London. 164

January 15 Contributes forty-one prints to fifth annual exhibition of Photographic Society, which opens initially at South Kensington Museum before transferring to New Coventry Street, where it will reopen on May 15. 165

April 6 Chairs meeting of Photographic Society at which Oscar Rejlander gives his paper on photographic composition and the *Two Ways of Life*. 166

April 27 Annual Art-Union of London drawing for prizes held at Haymarket theater, London. Three hundred volumes, each containing twelve photographs, are among prizes, with Fenton contributing five prints to each volume. ¹⁶⁷

May 12 Council of Photographic Society of Ireland recommends presenting members with "one of Mr. Fenton's views of Welsh scenery." ¹⁶⁸

Summer Makes series of Orientalist studies in his London studio. 169

July 1 Lovell Reeve publishes first issue of *Stereoscopic Magazine*, a monthly periodical containing three stereoscopic views in each issue. ¹⁷⁰

Summer-early fall Photographs in two expeditions: one to Salisbury, Glastonbury, Wells, and Cheddar, the other to Lichfield, Hardwick, Haddon, and Chatsworth. 171

November 27 Thomas Gladwell, London printseller and retailer of photographic views, advertises latest series by Fenton. ¹⁷²

December 18 Shows thirteen prints at third annual exhibition of Photographic Society of Scotland, Edinburgh. Among these are four Orientalist studies: "Turk and Arab," "Pasha and Dancing Girl," "The Water Carrier," and "Reverie."

In 1858, attended Council meetings: January 5, 19, 26; February 16; March 2, 9, 16: April 6, 20; May 4, 11, 18; June 1, 8, 15, 22; July 7; August 3; October 8, 19; November 2, 16; December 7, 16. Absent from Council meetings: February 2; July 20; August 5.

1859

January 6 Prince Albert visits sixth annual exhibition of Photographic Society, at which Fenton shows forty-two of his latest works. ¹⁷⁴ These include architectural studies of stately homes and cathedrals at Hardwick, Chatsworth, Haddon, Lichfield, Salisbury, Wells, and Glastonbury, as well as seven Orientalist studies. ¹⁷⁵

January 7 Contributes landscapes to first exhibition of Nottingham Photographic Society. 176

January 8 Acquires large plot of land at Potter's Bar, then a rural hamlet north of London; adds two lots on January 10 and other parcels at later dates. A few years later this will become the site for his new house. 177

January 13 Birth of only son, Anthony Maynard, at 2 Albert Terrace.

January 17 Contributes a series of views of Welsh scenery to first annual exhibition of Macclesfield Photographic Society. 178

January 28–February 1 Reviews of Orientalist studies published. Photographic Journal praises "admirable

illustrations of Eastern scenes of actual life," *Art-Journal* does not "regard them as a success," and *Photographic News* criticizes use of string to hold up model's hands. ¹⁷⁹

March Murray & Heath advertises "Smartt's Photographic Tent," as used by Roger Fenton. ¹⁸⁰

April Shows fifty-one prints at exhibition of Glasgow Photographic Society, Buchanan Street, Glasgow. ¹⁸¹

April 15 Shows eleven prints at third exhibition of Société Française de Photographie, Palais des Champs-Élysées, Paris. 182

April 26 Annual Art-Union of London prize drawing held at Adelphi theater, London. Seven hundred volumes, each containing twelve photographs, are among prizes, with Fenton contributing eight prints to each volume. 183

May Makes first contributions to Stereoscopic Magazine: views of Ely Cathedral and the Pont-y-Pant bridge in North Wales. 184

June–July At Stonyhurst College, most likely at behest of Father William Kay, professor of chemistry. Photographs college gardens and buildings, including newly built Sodality Chapel; also photographs along Hodder and Ribble rivers and in Hurst Green, subjects related to Fenton estate purchased from Thomas Weld in 1829. 185

July After protracted and acrimonious negotiations, Fenton's employment at British Museum is terminated following Trustees' decision to transfer his negatives to South Kensington Museum. ¹⁸⁶

September Exhibits seven photographs, including "Pacha and Dancing Girl," at meeting of British Association for the Advancement of Science, Union Street, Aberdeen. 187

November 1 Council meeting: Fenton discusses results of his experiments with lenses conducted over the summer. 188

December 17 Contributes to fourth annual exhibition of Photographic Society of Scotland, George Street, Edinburgh. Works include "The reed deep on the Ribble, and Pendlehill" and "Paradise View on the Hodder" along with studies of Stonyhurst College. 189

December 23 Photographs at Stonyhurst College in wintry conditions. 190

In 1859, attended Council meetings: January 4, 18; February 1, 15; March 1, 15; April 5; May 3; July 11; November 1, 8; December 16. Absent from Council meetings: May 17; November 15; December 6.

1860

January The Conway in the Stereoscope, illustrated by Roger Fenton Esq. M.A., is published by Lovell Reeve, London; contains twenty albumen stereo prints taken in valleys of the Conway and tributaries, North Wales.¹⁹¹

January 13 Contributes thirty-seven prints to seventh annual exhibition of Photographic Society at Gallery of the Society of Painters in Water-Colours, 5A Pall Mall East, London. 192

February Has become a member of Hythe School of Musketry, where he is placed in the First Section of volunteers, participating in a fashionable pastime given status through the patronage of Queen Victoria. Takes a series of seventeen studies including *Volunteer Class* and an extended sequence showing rifle exercises. ¹⁹³

April 20 Death of Marcus Sparling. 194

April 24 Death of only son, Anthony Maynard, age fifteen months.

May Becomes captain in London University Corps, where he is known as the "Crimean celebrity, Volunteer and Photographer"; continued visits to Hythe School of Musketry prompt publication of five studies of rifle volunteers. ¹⁹⁵

May 15 Benjamin Brecknell Turner, Henry White, and Fenton each send fifty prints to Photographic Society for distribution to members contributing to Archer Memorial Fund. ¹⁹⁶

Summer Photographs in the Lake District and at Furness Abbey. 197

Executes series of fruit and flower still lifes, probably in late July and early August. 198

July 7 Takes thirteen studies at National Rifle Match, Wimbledon Common, attended by Queen Victoria, who fires first shot—a prearranged bull's-eye at four hundred yards. 199

July 17 Gives detailed evidence to House of Commons Select Committee on South Kensington Museum concerning his activities as photographer at British Museum and effect of government decision to sell photographs cheaply through Department of Science and Art.²⁰⁰

September 17 Royal family pays invoice for twenty-four pounds eight shillings for prints from Hythe, Wimbledon, Windsor Park, and two copies of "studies from life." ²⁰¹

December 4 Having served the statutory period in office, retires as senior vice president of Photographic Society and is replaced by Professor Thomas Bell, whose position he assumes on Council.²⁰²

In 1860, attended Council meetings: January 3, 17, 24, 31; March 20; April 3; June 5; October 8. Absent from Council meetings: February 7, 21; March 6; May 1; November 6; December 4.

1861

January 12 Contributes thirty-nine prints to eighth annual exhibition of Photographic Society, London, including landscapes from Lake District, views at Harewood House, and Fruit and Flower series.²⁰³

April 7 Gives occupation as "barrister" to census enumerator. The census return reveals that in addition to Fenton's wife and children, a governess, cook, and housemaid live in the house—a modest household for the period.²⁰⁴

August 7 Attends Council meeting as regular participant for the last time.

September 5 Contributes to photographic exhibition organized in conjunction with annual meeting of British Association for the Advancement of Science.²⁰⁵

December Lancashire cotton trade severely depressed following outbreak of America's Civil War and subsequent blockade of its southern ports, cutting off supply of cotton; layoffs of British mill workers increase. These factors and a family dispute cause closing of Hooley Bridge Mill.²⁰⁶

December 14 Photography loses an advocate when Prince Albert dies unexpectedly following a brief illness.

In 1861, attended Council meetings: May 3, 7; June 4; July 8; August 7. Absent from Council meetings: February 1, 5; March 5; April 2; May 22, 25.

1862

May 1 Shows fourteen prints at International Exhibition, London, drawn largely from earlier landscape, topographic, and still-life studies. This will be his last exhibition. 207

May 15 Review of Ruined Abbeys and Castles of Great Britain by William and Mary Howitt, illustrated with photographic plates by Francis Bedford, Fenton, William Russell Sedgfield, George Washington Wilson, and others.²⁰⁸

July 11 Awarded a Prize Medal for "great excellence in fruit and flower pieces, and good general photography" at International Exhibition. ²⁰⁹

October 15 Retirement from photography announced with editorial in *Photographic Journal* and preliminary notice of sale of entire apparatus and stock of almost one thousand large-format negatives.²¹⁰

November 11 Sale of equipment and negatives, Stevens Rooms, King Street, London, is well attended and realizes good prices, especially for lenses. ²¹¹ Negatives, reportedly in bad condition with "blistered and cracked varnish," do less well. ²¹²

In late 1862, still resident at Albert Terrace but probably begins construction of house at Potter's Bar, named Mount Grace, that will be principal residence for remainder of his life.²¹³

1863

Returns to law practice as barrister, with chambers at 4 Harcourt Buildings, Temple, London. Named as counsel for the Northern Circuit, which allows him to act as barrister in the Assize courts of Manchester, Salford, and York. ²¹⁴

February 3 Judges photographs at ninth annual exhibition of Photographic Society and awards four medals, including one to Bedford for landscape studies. ²¹⁵

July 25 Death of father, John Fenton, at age seventy-three. ²¹⁶

1865

Gives up chambers in the Temple.

March John Eastham of Manchester issues a series of portraits of Fenton and sends them to *British Journal* of *Photography* for review (fig. 18).²¹⁷

1866

December 11 At meeting of Photographic Society, receives medal as "the founder of the Society." His appearance is "the signal for an outburst of loud and continued cheering." ²¹⁸

1869

May 4 Six Russian views, lent by architect Wyatt Papworth, shown at Architectural Exhibition, Conduit Street, London.²¹⁹

August 9 Dies at his home, Mount Grace. Causes listed as "nervous exhaustion, weakness of heart, and congestion of lungs"; occupation cited as "gentleman." ²²⁰

In will leaves house and household effects to his wife, the balance of assets put in trust for benefit of wife and children.

August 20 British Journal of Photography prints detailed obituary, while Photographic News is brief and to the point, acknowledging Fenton as "a man of considerable culture and taste." ²²¹

1870

June 13 Fenton's collection of paintings, watercolors, and framed engravings sold at Christie's. 222

August 21 Fenton's books and portfolios of prints and engravings sold at Sotheby's. 223

1871

October 5 Fenton's house and land at Potter's Bar sold. 224

1872

April 2 Grace Fenton offers British Museum a "number of photographic negatives" of "vases, old ornaments, stuffed animals, prints &c." Offer declined a month later. ²²⁵

1878

November Family bank, trading as J. & J. Fenton and Sons, Rochdale, goes into liquidation, with liabilities variously estimated in excess of £550,000.

1886

July 14 Death of Grace Elizabeth Fenton.

1969

Fenton's grave and that of his wife destroyed when church of Saint John, High Street, Potter's Bar, is demolished. Their joint tombstone was headed with the words "God is Love." ²²⁷

List of Plates

Titles in italics are Fenton's and were either inscribed on the mount, printed on a label affixed to the mount, or published in an exhibition catalogue of the period. Those in roman are modern descriptive titles. Brackets indicate a presumed rather than a documented date. All works were made from glass negatives unless otherwise noted.

Frontispiece

Self-Portrait, [ca. 1854] Albumen silver print 19.5 x 14.7 cm (7 ¹¹/₁₆ x 5 ¹³/₁₆ in.) Private collection, London

- Self-Portrait, February 1852
 Albumen silver print
 12.2 x 9 cm (4¹³/₁₆ x 3⁹/₁₆ in.)
 Gilman Paper Company Collection, New York PH83.901
- Moscow, Domes of Churches in the Kremlin, 1852
 Salted paper print from paper negative
 17.9 x 21.6 cm (7 ½ 6 x 8 ½ in.)
 Gilman Paper Company Collection, New York
 PH78.458
- South Front of the Kremlin from the Old Bridge, 1852
 Salted paper print from paper negative
 18.4 x 21.4 cm (7½ x 8½ in.)
 The J. Paul Getty Museum, Los Angeles
 84.X0.1343.16
- Walls of the Kremlin, Moscow, 1852
 Salted paper print from paper negative
 17.8 x 21.1 cm (7 x 8 ⁵/16 in.)
 Gilman Paper Company Collection, New York
 PH77.246

- 5. Walls of the Kremlin, Moscow, 1852 Salted paper print from paper negative 17.7 x 21.5 cm (6 15/16 x 8 7/16 in.) Collection Centre Canadien d'Architecture / Canadian Centre for Architecture, Montréal PH1982:0426
- 6. The Church of the Redeemer, Moscow, under Construction, 1852
 Salted paper print from paper negative
 17.1 x 21.5 cm (6³/₄ x 8⁷/₁₆ in.)
 The RPS Collection at the National Museum of Photography, Film & Television, Bradford
 2003-5000/3282
- Banks of the Dnieper; Distant View of the Forts and Low Town of Kief, 1852
 Salted paper print from paper negative 17.2 x 21.1 cm (6³/₄ x 8⁵/₁₆ in.)
 The RPS Collection at the National Museum of Photography, Film & Television, Bradford 2003-5000/8247/1
- Fountains Abbey, the Nave, 1854
 Salted paper print
 19.5 x 22.5 cm (7 ¹¹/₁₆ x 8 ⁷/₈ in.)
 The RPS Collection at the National Museum of Photography, Film & Television, Bradford 2003-5000/3049
- The Cloisters, Tintern Abbey, 1854
 Salted paper print
 18.3 x 22.1 cm (7³/₁₆ x 8¹¹/₁₆ in.)
 National Gallery of Art, Washington, D.C.,
 Anonymous Gift
 2004.22.1

- Rievaulx Abbey, Doorway, North Transept, 1854
 Salted paper print
 23.4 x 19.9 cm (9³/₁₆ x 7¹³/₁₆ in.)
 Collection Centre Canadien d'Architecture / Canadian Centre for Architecture, Montréal
 PH1982:0350
- 11. Rievaulx Abbey, the High Altar, 1854
 Albumen silver print
 29.5 x 36.5 cm (11⁵/₈ x 14³/₈ in.)
 Gilman Paper Company Collection, New York
 PH85.1162
- 12. Rievaulx Abbey, 1854
 Albumen silver print
 35.6 x 29.8 cm (14 x 11 3/4 in.)
 Gilman Paper Company Collection, New York
 PH89.1383
- Wharfe and Pool, Below the Strid, 1854
 Salted paper print
 34.5 x 28.2 cm (13% x 11% in.)
 Gilman Paper Company Collection, New York
 PH91.1460
- The Cattle Pier, Balaklava, 1855
 Salted paper print
 28.5 x 35.4 cm (11 ½ x 13 15/16 in.)
 Wilson Centre for Photography
 84:0256
- Landing Place, Railway Stores, Balaklava, 1855
 Salted paper print
 27.9 x 36.4 cm (11 x 14⁵/₁₆ in.)
 Gilman Paper Company Collection, New York
 PH78.447

- Cookhouse of the 8th Hussars, 1855
 Salted paper print
 15.9 x 20.3 cm (6 ½ x 8 in.)
 The J. Paul Getty Museum, Los Angeles
 84.XM.1028.31
- 17. Group of Croat Chiefs, 1855
 Albumen silver print
 19.2 x 16.5 cm (7⁹/₁₆ x 6 ¹/₂ in.)
 Wilson Centre for Photography
 97:5616
- 18. Captain Lord Balgonie, Grenadier Guards, 1855
 Salted paper print
 20 x 16.5 cm (7⁷/₈ x 6 ¹/₂ in.)
 Wilson Centre for Photography
 97:5622
- 19. General Bosquet, 1855
 Salted paper print
 20.8 x 15.9 cm ($8\frac{3}{16}$ x $6\frac{1}{4}$ in.)
 Gernsheim Collection, Harry Ransom Center,
 The University of Texas at Austin
 964:0351:0271
- Sebastopol from Cathcart's Hill, 1855
 Salted paper print
 21.8 x 34.7 cm (8⁹/₁₆ x 13¹¹/₁₆ in.)
 Gilman Paper Company Collection, New York
 PH90.1441
- Valley of the Shadow of Death, 1855
 Salted paper print
 27.6 x 34.9 cm (10⁷/s x 13³/4 in.)
 The J. Paul Getty Museum, Los Angeles
 84.XM.504.23
- 22. Landscape with Clouds, [1856]
 Salted paper print
 25 x 43.6 cm (9¹³/₁₆ x 17³/₁₆ in.)
 The Metropolitan Museum of Art, New York,
 The Rubel Collection, Promised Gift of
 William Rubel
 L1997.84.5
- 23. Landscape with Clouds, [1856] Salted paper print

31.4 x 44.3 cm $(12^{3/8}$ x $17^{7/6}$ in.) The Metropolitan Museum of Art, New York, The Rubel Collection, Purchase, Anonymous Gift, Curator's Discretionary Grant from The Judith Rothschild Foundation, and Thomas Walther Gift, 1997 1997.382.35

- 24. Lindisfarne Priory, 1856
 Salted paper print
 30.3 x 37.1 cm (11 15/16 x 14 5/8 in.)
 The J. Paul Getty Museum, Los Angeles
 84.XP.219.8
- Melrose Abbey, South Transept, 1856
 Salted paper print
 41.7 x 35.5 cm (16⁷/₁₆ x 14 in.)
 Collection Centre Canadien d'Architecture / Canadian Centre for Architecture, Montréal PH1982:0514
- 26. Roslin Chapel, South Porch, 1856
 Salted paper print
 35.8 x 43.3 cm (14 1/8 x 17 1/16 in.)
 Gilman Paper Company Collection, New York
 PH89.1385
- 27. The Princess Royal and Princess Alice, [1855] Salted paper print 33.7 x 30.5 cm (13 ¼ x 12 in.) The RPS Collection at the National Museum of Photography, Film & Television, Bradford 2003-5000/3324/1
- 28. Princesses Helena and Louise, 1856 Salted paper print 33 x 29.2 cm (13 x 11½ in.) The RPS Collection at the National Museum of Photography, Film & Television, Bradford 2003-5000/3320
- 29. A Ghillie at Balmoral, 1856
 Salted paper print
 38.2 x 31.4 cm (15 ½6 x 12 ¾ in.)
 The RPS Collection at the National Museum of Photography, Film & Television, Bradford
 2003-5000/3325

- Prince Alfred, Duke of Edinburgh, 1856
 Salted paper print
 33.2 x 26 cm (13 ½ x 10 ¼ in.)
 The RPS Collection at the National Museum of Photography, Film & Television, Bradford
 2003-5000/3323/2
- 181. View from Ogwen Falls into Nant Ffrancon,
 1857
 Albumen silver print
 42.4 x 36.5 cm (16 11/16 x 14 3/8 in.)
 The J. Paul Getty Museum, Los Angeles
 85.XM.169.22
- 32. Pont-y-Garth, near Capel Curig, 1857 Albumen silver print 34.3 x 43.5 cm (13 ½ x 17 1/8 in.) The J. Paul Getty Museum, Los Angeles 85.XM.169.9
- On the Llugwy, near Bettws-y-Coed, 1857
 Albumen silver print
 35.6 x 42.2 cm (14 x 16 % in.)
 The J. Paul Getty Museum, Los Angeles
 85.XM.169.15
- Falls of the Llugwy, at Pont-y-Pair, 1857
 Albumen silver print
 35.8 x 42.9 cm (14 ½ x 16 ½ in.)
 The Metropolitan Museum of Art, New York, Purchase, Louis V. Bell Fund and Mrs. Jackson Burke Gift, 1988
 1988,1027
- Glyn Lledr, from Pont-y-Pant, 1857
 Albumen silver print
 34.2 x 43.8 cm (13⁷/₁₆ x 17 ¹/₄ in.)
 H. H. Richardson Collection, Frances Loeb
 Library, Harvard Design School, Cambridge,
 Massachusetts
- 36. Pont-y-Pant, on the Lledr, from Below, 1857
 Albumen silver print
 35.5 x 44.1 cm (14 x 17 % in.)
 H. H. Richardson Collection, Frances Loeb
 Library, Harvard Design School, Cambridge,
 Massachusetts

- Moel Seabod, from the Lledr Valley, 1857
 Albumen silver print
 34.9 x 43.2 cm (13³/₄ x 17 in.)
 The J. Paul Getty Museum, Los Angeles
 85.XM.169.14
- Albumen silver print

 40.3 x 33.6 cm (15 1/8 x 13 1/4 in.)

 The RPS Collection at the National Museum of Photography, Film & Television, Bradford 2003-5000/3217
- 39. Slate Pier at Trefriw, 1857 Albumen silver print 32.2 x 43.2 cm (12 11/16 x 17 in.) The RPS Collection at the National Museum of Photography, Film & Television, Bradford 2003-5000/2998/2
- 40. The British Museum, 1857
 Albumen silver print
 33.2 x 42.2 cm (13 ½ 6 x 16 ½ in.)
 Trustees of The British Museum
 CE 114/2905
- 41. Gallery of Antiquities, The British Museum,

 [ca. 1857]

 Albumen silver print

 26.2 x 29.2 cm (10 \(^5\)/16 x 11 \(^1\)/2 in.)

 The RPS Collection at the National

 Museum of Photography, Film & Television,

 Bradford

 2003-5000/3024
- 42. Head of Minerva, from the Marble in the British Museum, [1858]
 Salted paper print 36.4 x 28.9 cm (14⁵/₁₆ x 11³/₈ in.)
 The J. Paul Getty Museum, Los Angeles 94.XM.56.2
- 43. Hermaphrodite Feeding a Bird, [1854–58]
 Salted paper print
 36.5 x 27.3 cm (14 3/8 x 10 3/4 in.)
 Wilson Centre for Photography
 96:5368

- 44. Skeleton of Man and of the Male Gorilla (Troglodytes Gorilla) I, [1854–58]
 Salted paper print
 36.5 x 28 cm (14 3/8 x 11 in.)
 Victoria and Albert Museum, London
 40.849
- 45. Elephantine Moa (Dinornis elephantopus), an Extinct Wingless Bird, in the Gallery of Fossils, British Museum, [1854–58]
 Salted paper print
 38.1 x 30.3 cm (15 x 11 15/16 in.)
 The J. Paul Getty Museum, Los Angeles 84.XP.452.3
- Gallery with Discobolus, British Museum,

 [ca. 1857]
 Albumen silver print

 24.9 x 29.5 cm (9 13/16 x 11 5/8 in.)

 The RPS Collection at the National Museum of Photography, Film & Television, Bradford 2003-5000/3020
- 47. York Minster, from the South East, [ca. 1856]
 Albumen silver print
 36 x 43.2 cm (14 3/16 x 17 in.)
 Collection Centre Canadien d'Architecture /
 Canadian Centre for Architecture, Montréal
 PH1979:0367
- 48. Glastonbury Abbey, Arches of the North Aisle, 1858
 Albumen silver print
 42.7 x 35.4 cm (16¹³/₁₆ x 13¹⁵/₁₆ in.)
 The J. Paul Getty Museum, Los Angeles
 84.XM.504.28
- 49. Ely Cathedral, East End, 1857
 Albumen silver print
 41.4 x 35.7 cm (16 ½ x 14 ½ in.)
 Collection Centre Canadien d'Architecture /
 Canadian Centre for Architecture, Montréal
 PH1976:0082
- 50. Ely Cathedral, from the Park, 1857
 Albumen silver print
 35.7 x 44 cm (14 ½ x 17 ½ in.)
 Collection Centre Canadien d'Architecture /

- Canadian Centre for Architecture, Montréal PH1976:0053
- Lincoln Cathedral, West Porch, 1857
 Albumen silver print
 36 x 44 cm (14³/₁₆ x 17⁵/₁₆ in.)
 H. H. Richardson Collection, Frances Loeb
 Library, Harvard Design School, Cambridge,
 Massachusetts
- Lincoln Cathedral, The Galilee Porch, 1857
 Albumen silver print
 44.2 x 36.4 cm (17⁷/₁₆ x 14⁵/₁₆ in.)
 H. H. Richardson Collection, Frances Loeb
 Library, Harvard Design School, Cambridge,
 Massachusetts
- Lichfield Cathedral, Central Doorway, West Porch, 1858
 Albumen silver print
 41.6 x 36.2 cm (16 3/8 x 14 1/4 in.)
 The J. Paul Getty Museum, Los Angeles
 84.XP.219.36
- 54. Lichfield Cathedral, South Transept Portal and Steps, 1858
 Albumen silver print
 35.7 x 42.6 cm (14½6 x 16¾ in.)
 Collection Centre Canadien d'Architecture / Canadian Centre for Architecture, Montréal PH1982:0787
- 55. Salisbury Cathedral, View in the Bishop's Garden, 1858
 Albumen silver print
 34.3 x 44 cm (13½ x 17½6 in.)
 Collection Centre Canadien d'Architecture /
 Canadian Centre for Architecture, Montréal
 PH1979:0445
- 6. Salisbury Cathedral The Nave, from the South Transept, 1858
 Albumen silver print
 30.2 x. 31.1 cm (11½ x 12½ in.)
 Gilman Paper Company Collection, New York
 PH81.753

- 57. Westminster Abbey, Cloisters, [ca. 1858]
 Albumen silver print
 21.4 x 18.6 cm (8⁷/₁₆ x 7⁵/₁₆ in.)
 Collection Centre Canadien d'Architecture / Canadian Centre for Architecture, Montréal PH1982:0135
- 58. Lambeth Palace, [ca. 1858]
 Albumen silver print
 33.9 x 42.2 cm (1338 x 1658 in.)
 Gilman Paper Company Collection, New York
 PH89.1386
- 59. Houses of Parliament, [ca. 1858] Albumen silver print 34 x 41.7 cm (13³/s x 16⁷/16 in.) The RPS Collection at the National Museum of Photography, Film & Television, Bradford 2003-5000/3266
- 60. Westminster from Waterloo Bridge, [ca. 1858]
 Salted paper print
 30.3 x 42.2 cm (11¹⁵/₁₆ x 16⁵/₈ in.)
 Collection Centre Canadien d'Architecture /
 Canadian Centre for Architecture, Montréal
 PH1978:0108
- 61. Reclining Odalisque, 1858
 Salted paper print
 28.5 x 39 cm (11 1/4 x 15 3/8 in.)
 The Metropolitan Museum of Art, New
 York, The Rubel Collection, Purchase,
 Lila Acheson Wallace, Anonymous, Joyce
 and Robert Menschel, Jennifer and Joseph
 Duke, and Ann Tenenbaum and Thomas H.
 Lee Gifts, 1997
 1997.382.34
- 62. Pasha and Bayadère, 1858
 Albumen silver print
 45 x 36.2 cm (17¹¹/₁₆ x 14¹/₄ in.)
 The J. Paul Getty Museum, Los Angeles
 84.XP.219.32
- 63. Orientalist Group, 1858
 Albumen silver print
 26.3 x 25.5 cm (10 3/8 x 10 1/16 in.)

Wilson Centre for Photography 91:4253

- 64. Orientalist Group, 1858
 Salted paper print
 35.6 x 27.1 cm (14 x 10 ½ in.)
 The J. Paul Getty Museum, Los Angeles
 90.XM.110
- 65. Nubian Water Carrier, 1858
 Albumen silver print
 26.1 x 20.5 cm (10 ½ x 8 ½ in.)
 The RPS Collection at the National Museum of Photography, Film & Television, Bradford
 2003-5000/3009
- Harewood House, Yorkshire, 1859
 Albumen silver print
 28.4 x 23.1 cm (11³/₁₆ x 9¹/₈ in.)
 The RPS Collection at the National Museum of Photography, Film & Television, Bradford
 2003-5000/3260
- 67. The Upper Terrace, Harewood House, 1859
 Albumen silver print
 35.4 x 43.6 cm (13¹⁵/₁₆ x 17³/₁₆ in.)
 The RPS Collection at the National Museum of Photography, Film & Television, Bradford 2003-5000/3262
- 68. The Terrace, Garden and Park, Harewood, 1859
 Albumen silver print
 34 x 42.5 cm (13 \s^3/8 x 16 \s^3/4 in.)
 By Kind Permission of the Earl and Countess
 of Harewood, and the Trustees of Harewood
 House Trust
 HHTPh:2001.1.4
- 69. Hardwick Hall, from the South East, 1858
 Albumen silver print
 34.5 x 44 cm (13 % x 17 % in.)
 H. H. Richardson Collection, Frances Loeb
 Library, Harvard Design School, Cambridge,
 Massachusetts
- **70.** The Lily House, Botanic Garden, Oxford, 1859 Albumen silver print

28.9 x 28.1 cm ($11\frac{3}{8}$ x $11\frac{1}{16}$ in.) The RPS Collection at the National Museum of Photography, Film & Television, Bradford 2003-5000/2992

- 71. Wollaton Hall, [ca. 1859]
 Albumen print
 30.3 x 43.9 cm (11 15/16 x 17 5/16 in.)
 Collection of Richard and Ronay Menschel
- 72. The Billiard Room, Mentmore, [ca. 1858]
 Albumen silver print
 30.3 x 30.6 cm (11 15/16 x 12 1/16 in.)
 The J. Paul Getty Museum, Los Angeles
 2001.27
- Albumen silver print

 27.8 x 28.2 cm (10 15/16 x 11 1/8 in.)

 By Permission of the Governors of Stonyhurst

 College

 B12.99
- 74. Paradise, View down the Hodder, Stonyhurst, 1859
 Albumen silver print 28 x 28 cm (11 x 11 in.)
 Wilson Centre for Photography 96:5463
- 75. Spoils of Wood and Stream, 1859 Albumen silver print 34.3 x 42.7 cm (13½ x 16¹³/16 in.) The RPS Collection at the National Museum of Photography, Film & Television, Bradford 2003-5000/2895/1
- 76. Still Life with Game, [1859] Albumen silver print 34.1 x 41.9 cm (13 11/16 x 17 5/16 in.) The RPS Collection at the National Museum of Photography, Film & Television, Bradford 2003-5000/2894/1
- 77. Up the Hodder, near Stonyhurst, 1859
 Albumen silver print
 31 x 43.2 cm (12 3/16 x 17 in.)

Victoria and Albert Museum, London Ph.323-1935

- 78. Valley of the Ribble and Pendle Hill, 1859
 Albumen silver print
 32.1 x 42.5 cm (12 \(^5\)/s x 16 \(^3\)/4 in.)
 The Metropolitan Museum of Art, New York,
 The Rubel Collection, Purchase, Lila Acheson
 Wallace and Ann Tenenbaum and Thomas H.
 Lee Gifts, 1997
 1997.382.33
- 79. View from the Newby Bridge, 1860 Albumen silver print 34.8 x 44 cm (13¹¹/₁₆ x 17⁵/₁₆ in.) The RPS Collection at the National Museum of Photography, Film & Television, Bradford 2003-5000/3225/1
- Borwentwater, Looking to Borrowdale, 1860
 Albumen silver print
 24.2 x 29.3 cm (9½ x 11½ in.)
 The RPS Collection at the National Museum of Photography, Film & Television, Bradford
 2003-5000/3218
- 81. General View from the Town Park [Windsor Castle], 1860
 Albumen silver print

22.6 x 43.3 cm (8 $^{7}\!\!/_{8}$ x 17 $^{1}\!\!/_{16}$ in.) The Royal Collection RCIN 2100061

- 82. The Long Walk, 1860
 Albumen silver print
 17.5 x 29.4 cm $(6\frac{7}{8}$ x $11\frac{9}{16}$ in.)
 The Royal Collection
 RCIN 2100070
- View from the Foot of the Round Tower, 1860
 Albumen silver print
 29.7 x 42.7 cm (11 11/16 x 16 13/16 in.)
 The Royal Collection
 RCIN 2100047
- Saint George's Chapel and the Round Tower, Windsor Castle, 1860
 Albumen silver print 30.7 x 43.3 cm (12 ½ x 17 ½ in.)
 The Royal Collection RCIN 2100045
- 85. The Queen's Target, 1860
 Albumen silver print
 21.6 x 21.3 cm (8½ x 8¾ in.)
 Museum Ludwig, Cologne / Collection
 Robert Lebeck
 SL 801

- 6. Flowers and Fruit, [1860]
 Albumen silver print
 35.3 x 42.9 cm (13 \(^{7}\)s x 16 \(^{7}\)s in.)
 The RPS Collection at the National Museum of Photography, Film & Television, Bradford
 2003-5000/3104/1
- 87. Decanter and Fruit, [1860]
 Albumen silver print
 41.7 x 35.2 cm (16⁷/₁₆ x 13⁷/₈ in.)
 The RPS Collection at the National Museum of Photography, Film & Television, Bradford
 2003-5000/3110/1
- 88. Decanter and Fruit, [1860]
 Albumen silver print
 36.5 x 42.9 cm (14% x 16% in.)
 The RPS Collection at the National Museum of
 Photography, Film & Television, Bradford
 2003-5000/3092
- 89. Tankard and Fruit, [1860]
 Albumen silver print
 35.9 x 43 cm (14½ x 16½6 in.)
 The RPS Collection at the National Museum of
 Photography, Film & Television, Bradford
 2003-5000/3097

Notes to the Essays and Chronology

The following abbreviations are used in the notes:

British Journal of Photography*

RIP

SFP

D_{01}	British Southat of I holography
CCA	Canadian Centre for Architecture, Montreal
GEH	George Eastman House, Rochester
HDS	Harvard Design School, Cambridge, Massachusetts
HRC	Harry Ransom Center, University of Texas at
	Austin
ILN	Illustrated London News
JPGM	J. Paul Getty Museum, Los Angeles
JPS	Journal of the Photographic Society**
JSA	Journal of the Society of Arts
NMPFT	National Museum of Photography, Film &
	Television, Bradford, England
NMR	National Monuments Record, Swindon, England
RPS	Royal Photographic Society (collection now in the

*The Liverpool Photographic Journal, begun in 1854, changed its name in 1857 to Liverpool and Manchester Photographic Journal; in 1859 to Photographic Journal; and in 1860 to British Journal of Photography. Citations in the notes and bibliography to Photographic Journal (BJP) refer to this publication.

Société Française de Photographie, Paris

**The Journal of the Photographic Society, published by the Photographic Society beginning in 1853, changed its name in 1859 to Photographic Journal. Citations in the notes and bibliography to Photographic Journal refer to this publication.

"A New Starting Point": Roger Fenton's Life

SARAH GREENOUGH

NMPFT)

The title quotation is from Queen Victoria's journal, quoted in Gibbs-Smith 1950, p. 7; see note 7 below.

 In the preparation of this essay I am indebted to Roger Taylor and Gordon Baldwin, whose comprehensive chronology is published in this volume. Building on the work of our colleague Valerie Lloyd and pursuing their own exacting research, they have greatly expanded our understanding of Fenton's life and art. I am grateful for

- their generosity and to them and Malcolm Daniel for valuable comments on the draft of this essay.
- 2. The room was described by one reviewer as "a place of execution" where, formerly, "so many unfortunate painters (often young, struggling, and promising) had to endure the misery, during a whole season, of knowing that a ban was effectually placed upon their exertions." "Royal Academy," Art-Journal, June 1, 1851, p. 153.
- 3. Ibid.
- Unfortunately, none of Fenton's paintings have ever been located or reproduced.
- 5. "Royal Academy," Art-Journal, June 1, 1851, p. 153.
- His uncertain assessment of both his career and his abilities is poignantly suggested by the fact that in the 1851 census Fenton listed himself as a "painter," a term usually reserved for house painters, not artists. Kamlish 2002, p. 302, n. 29.
- Victoria, Queen of England, Journal (archival source), May 1, 1851, quoted in Gibbs-Smith 1950, p. 17.
- 8. Gibbs-Smith 1950, p. 7.
- On the link between art and money in nineteenthcentury England, see Macleod 1996.
- 10. Treuherz 1999, p. 13.
- Warner 1997, pp. 19–22 (quotation on p. 20). See also Treuherz 1999, pp. 12–20.
- 12. Reports by the Juries 1852, p. 244.
- 13. On the restrictive nature of the English patent system at midcentury, see Dickens, May 7, 1853, pp. 229–34. Sir Charles Eastlake, president of the Royal Academy, and Lord Rosse, president of the Society of Arts, wrote to Talbot in July 1852, urging him to relax his patent. They expressed their desire that "as the art itself originated in England, it should also receive its further perfection and development in this country" and their judgment that "in some branches of the art . . . the French are unquestionably making more rapid progress than we are." Talbot acknowledged in his reply that with "the Great Exhibition . . . a new era has commenced for photography." Quoted in Arnold 1977, p. 191. See also "The Exertions of Mr. Fenton" by Pam Roberts in this volume.
- 14. Dickens 1854 (1961 ed.), p. 16.
- For an excellent discussion of this division in the 1840s, see Taylor, "All in the Golden Afternoon," 2002, pp. 6–9. See also Seiberling 1986, p. 127.

- John Ruskin to John James Ruskin, February 25, 1859,
 Ruskin 1905, p. 336; quoted in Lloyd 1988, p. 18.
- 17. Information about Joseph Fenton, his property, and his sons James and John comes from "Failure as Viewed in Heywood," Heywood Advertiser, ca. 1878. I am grateful to Roger Taylor for sharing this information with me.
- 18. Rose 1996, p. 17.
- Greenall Family of Dutton Papers (archival source), DDX 445/1/3, DDX 445/1/4. My thanks to Roger Taylor for this reference.
- 20. Ironically, John's brother contested this same seat in 1841 as a Conservative, losing to the Whig candidate; John's son William, Roger's younger brother, continued in his father's political career and actively campaigned to have Heywood enfranchised under the Reform Bill of 1867.
- 21. Baldwin 1996, p. 8, points out that at this time passports were usually issued to people who planned extended stays abroad. Ernest Lacan wrote in 1856 that Fenton had studied with Delaroche for "several years" (Lacan, *Esquisses photographiques*, 1856, p. 96). Later scholars have repeated the assertion: see Gernsheim 1954, p. 4; Hannavy 1976, p. 17.
- 22. The prefect of police, Gabriel Delessert, urged Delaroche to close his studio "in light of the scandal and the constant history of student disorder." The studio closed in either July or October 1843. Hauptman 1985, p. 80.
- 23. Roger Fenton to Grace Fenton, April 29, 1855; Fenton, Letter Book (archival source), NMPFT (RPS Collection), p. 17. Unfortunately, Helmut and Alison Gernsheim edited out most of Fenton's personal comments to his wife when they published the letters from the Crimea; see Gernsheim 1954.
- 24. Grace and Roger Fenton's eldest daughter, Josephine Frances, died on March 12, 1850, five years of age, and their only son, Anthony Maynard, died on April 24, 1860, at the age of fifteen months. Their daughter Aimée Frances, born June 6, 1850, does not appear in the 1861 census record for their residence at Albert Terrace.
- 25. "29 juin 1844, Roger Fanton [sic], [age] 25, [adresse] rue d'Alger 5, [nom du maître] Michel-Martin Drolling." Musée du Louvre, Registre des cartes d'élèves (archival source), 1840–45, p. 173, entry 2432. Although Drolling

- was a professor at the École des Beaux-Arts, Fenton, like most students who sought matriculation in the school, probably studied at the painter's private atelier. See Hauptman 1985, p. 79.
- See Boime 1971, pp. 52–58, for a discussion of Drolling's studio.
- Only French or naturalized French male artists who were bachelors were eligible to compete for the Prix de Rome. See Grunchec 1984, p. 25.
- 28. Boime 1971, p. 54. Baudry entered Drolling's studio in 1844 and enrolled at the École in 1845. Other students who also studied with Drolling between 1844 and 1847 include Jules Breton, who began in 1847; Jean-Jacques Henner, who enrolled at the École as a pupil of Drolling in 1846; and Charles Chaplin, who entered the École in 1840 and regularly visited Drolling's studio. Alfred de Curzon enrolled at the École as Drolling's student in 1840. See Boime 1971; *The Dictionary of Art*, ed. Jane Turner (New York: Grove's Dictionaries, 1996); Grove Art Online (www.groveart.com).
- 29. Boime 1971, p. 23.
- 30. "Late Charles Lucy," ILN, June 7, 1873, p. 544.
- 31. See the references to Fenton and Lucy in Brown 1981, entries for February 23 and 25, 1848; June 3, 1848; and March 13 and 14, 1850.
- 32. Fenton's name does not appear on the earliest proposals for the school's formation in February 1850 (Kamlish 2002, p. 298), but he is listed as a member of the Management Committee as of May 1, 1850. See *Almanack of the Fine Arts* 1852, p. 138.
- 33. "Suburban Artisan Schools," Art-Journal, April 1, 1852, p. 103. By 1852 there were 105 men and 30 women enrolled in the school. See also "Suburban Artisan Schools.—The North London School of Drawing and Modelling," ILN, January 17, 1852, p. 46.
- 34. Brown's diaries and correspondence between 1848 and 1851 contain numerous references to Fenton. Brown painted Fenton's oldest daughter, Josephine Frances, the day after she died in March 1850. See Brown 1981, entry for March 13, 1850; Brown to Lowes Dickenson, March 5, 1851, quoted in Kamlish 2002, p. 298. Kamlish suggests that Brown may have acted as Fenton's tutor at the time of this letter (p. 299).
- John Ruskin, "Pre-Raphaelitism" (1853 lecture), Ruskin 1904, p. 157; quoted in Warner 1997, p. 22.
- 36. In his letters from the Crimea Fenton mentions making sketches; see Gernsheim 1954, pp. 62, 75. In July 1852 Fenton exhibited with other members of the North London School of Drawing and Modelling, but the medium of his entry is not known. It is not named in the only known reference to this exhibition, a review in the *Builder*, "Suburban Artisan Schools," July 10, 1852, p. 444. Kamlish 2002, p. 300, assumes he showed photographs, but photography was rarely exhibited at the

- time, and the review refers to the media shown as "paintings and drawings, bronzes, gold and silver work, pottery, bookbinding, wood-carving, & etc. & etc.," making it more likely that he exhibited drawings or paintings.
- Fenton, "On the Present Position and Future Prospects of the Art of Photography," JSA, December 24, 1852, p. 52.
- 38. Ibid., pp. 50–53.
- 39. Ibid., pp. 51, 52.
- There has been considerable disagreement about when Fenton began to photograph. Gernsheim 1954, p. 5, states that Fenton was a member of the Calotype Club in 1847. Lloyd 1988, pp. 3-4, pointing out that Fenton is not named in published lists of the club's principal members, concludes that he began photographing "by February 1852, if not before." Noting that Fenton's article "Photography on Waxed Paper," in the fifth edition of W. H. Thornthwaite's Guide to Photography, published in August 1852, pp. 94-101, displays considerable expertise, John Hannavy (1993, pp. 233-43) believes that he must have been photographing well before 1851, possibly as early as 1849 or 1850. However, the purpose of Thornthwaite's Guide was to include the most up-to-date technical information, and editions were rapidly produced. The fourth edition, released in May 1852, does not include Fenton's article. which therefore must have been written in the summer of 1852. Moreover, since no surviving photographs by Fenton can be conclusively dated before February 1852 and there are no references to his photographs in the literature before this date, it seems likely he began to photograph only in the summer or fall of 1851. Paul Jeuffrain (see note 55 below) referred to him as a "distinguished painter . . . who has only worked on photography for a few months"; see Jeuffrain, March 20, 1852, p. 50. For evidence that Fenton saw and enthusiastically responded to the photographs on display in the Great Exhibition, see Fenton's "Photography in France," Chemist, February 1852, p. 221, where he noted that "everybody will recollect in the south aisle of the Crystal Palace, the unrivalled productions of [the photographer Frédéric] Martens."
- 41. See Mondenard 2002.
- 42. Fenton, "Photography in France," *Chemist*, February 1852, p. 222. It is noted in Voignier 2004, pp. 144–46, that the photographer often identified as O. Mestral actually had the first name Auguste.
- 43. In Thornthwaite, Fenton ("Photography on Waxed Paper," August 1852, p. 97) refers to modifications to Le Gray's waxed-paper-negative process given to him by "M. Pulch of Paris" (earlier, in Fenton, "Photography in France," *Chemist*, February 1852, p. 222, he correctly gave his name as "Puech") and by "Vicomte Vigies [actually Vigier], one of the most successful and indefatigable of the French photographers." While in France in 1851 and shortly thereafter Fenton also experimented with collodion, without immediate success. See

- Fenton, "Photography in France," *Chemist*, February 1852, p. 222.
- Le Gray 1850, quoted by Aubenas in Aubenas et al. 2002, p. 35.
- L. Maufras, "Étude biographique," Le Monte-Cristo, January 5, 1860, quoted by Aubenas in Aubenas et al. 2002, pp. 36 and 40.
- 46. Le Gray 1852, quoted by Aubenas in Aubenas et al. 2002, p. 44.
- Fenton, "Photography in France," Chemist, February 1852, p. 221.
- 48. Ibid.
- 49. Ibid., p. 222.
- Fenton, "Proposal for the Formation of a Photographical Society," *Chemist*, March 1852, pp. 265–66.
- 51. "Photographic Society," JSA, January 7, 1853, p. 76.
- 52. Talbot was clearly annoyed by the adversarial tone taken by some backers of the proposed photographic society, although his relationship with Hunt appears to have remained cordial. In a postscript marked "Private" in his letter to Hunt, he wrote, "I assure you that I have the best wishes for the formation of a prosperous society. but it appears to me that there is not much reciprocity of feeling on the part of those who would naturally take a leading part in it. However I have done all that lay in my power." Talbot to Hunt, March 24, 1852, NMPFT (RPS Collection T/2 1279; archival source); Talbot Correspondence Project (website), doc. 06585. An undated manuscript in the Science Museum, London, cited in Arnold 1977, p. 188, proposes that the Photographic Society "cannot admit among its members a person" who takes out a patent on any photographic invention.
- 53. Talbot to Eastlake, June 9 and 10, 1852, NMPFT (RPS Collection T/2 1274B; archival source); Talbot Correspondence Project (website), doc. 06639. William Parsons, 3rd Earl of Rosse (1800–1867), who invented the largest telescope of the nineteenth century, was also a Member of Parliament and president of the Royal Society.
- 54. Fenton, "Photography in France," *Chemist*, February 1852, p. 222. In "Photography on Waxed Paper," August 1852, pp. 94–95, Fenton wrote that the choice of paper "is not quite so important here as in the ordinary Talbotype," indicating that he was also familiar with Talbot's calotype process.
- 55. Paul Jeuffrain, an amateur photographer, later donated the February 1852 photographs Fenton sent him to the Société Française de Photographie. It is possible that Fenton knew Jeuffrain, a cloth manufacturer from Elbeuf, through his family's business connections, although he also could have met him in Paris in the fall of 1851. See "Réunion photographique," La Lumière, May 28, 1853, p. 87, for Lacan's showing of Fenton's photographs.
- "Photographic Album," ILN, October 30, 1852, p. 362;
 "Photograph Album," Athenaeum, November 13, 1852,

- p. 1247; "Photographic Publications," *Art-Journal*, December 1, 1852, p. 374.
- On Bourne's daguerreotypes and calotypes, see Vignoles 1982, pp. 118, 122, 128–31, 139, 142.
- 58. Fenton told the members of the Photographic Society that in October 1852 the temperature in Kiev had been "considerably below the freezing-point." See Percy, March 3, 1853, p. 11.
- 59. Hannavy 1993, p. 238, suggests that before he left England Fenton familiarized himself with the reflecting stereoscope invented by Charles Wheatstone and the stereo camera because Vignoles specifically wished to have stereo views made of his bridge.
- See Taylor, Photographs Exhibited in Britain, 2002, pp. 18, 38.
- 61. The Society of Arts quickly realized that photography would be an immensely valuable addition to its activities and in early 1853 tried, unsuccessfully, to keep the Photographic Society from establishing itself as a separate entity. See "Photographic Society," JSA, January 28, 1853, p. 114.
- 62. Seiberling 1986, p. 127. Cundall and Delamotte sold individual prints from the exhibition for prices varying from a few shillings (Fenton and others) to more than two pounds (Martens), as well as portfolios of collected works. Most of Fenton's views from Russia were seven shillings and sixpence.
- 63. Philip Henry Delamotte, advertisement in *Catalogue of Photographic Pictures Exhibited at the Photographic Institution* 1853, n.p.
- See "A Most Enthusiastic Cultivator of His Art" by Roger Taylor in this volume for a different interpretation of Fenton's prices.
- 65. It is possible that Fenton began working for the British Museum as early as the summer of 1852; on July 3, 1852, Wheatstone wrote to Edward Hawkins, Keeper of Antiquities, recommending Fenton "to take some photographs of the antiquities in the British Museum." See Date and Hamber 1990, p. 316. However, no further references to Fenton appear in museum records until the summer of 1853, and no surviving photographs by Fenton of British Museum objects can be conclusively dated to 1852 or 1853; thus it is likely that he was not hired by the museum until the fall of 1853
- Fenton to Hawkins, October 4, 1853, British Museum, Original Letters and Papers (archival source).
- 67. Fenton to Hawkins, July 14, 1853, British Museum, Original Letters and Papers (archival source).
- 68. Delamotte to Hawkins, July 25, 1853, British Museum, Original Letters and Papers (archival source).
- Wheatstone to Hawkins, October 6, 1853, British Museum, Original Letters and Papers (archival source);
 British Museum, Trustee Committee Minutes (archival

- source), pp. 8614–15, October 8, 1853. On November 12, 1853, the trustees authorized an additional seventy-seven pounds five shillings for photographic equipment. See British Museum, Trustee Committee Minutes (archival source), p. 8619, November 12, 1853. Fenton referred to himself as "Photographer to the Museum" in 1859 (see Date and Hamber 1990, p. 322).
- 70. Fenton to Hawkins, July 14, 1853, and Fenton to Anthony Panizzi, July 30, 1857, British Museum, Original Letters and Papers (archival source). Sometimes Fenton's methods were risky. When he photographed the *Epistles of Clement of Rome* in 1856, Fenton, unable to make the photographs inside the studio, fastened the book's leaves to a board on an outdoor wall. The Keeper in the Department of Manuscripts, Frederic Madden, complained that the "open air . . . was rather a ruder trial than I had anticipated for the MS for the effect of the air and the sun were very powerful on it." Date 1989, p. 11.
- British Museum, Trustee Committee Minutes (archival source), p. 8959, May 13, 1854.
- 72. Ibid., p. 8733, August 12, 1854; Hamber 1996, p. 381.
- British Museum, Trustee Committee Minutes (archival source), p. 8746, October 14, 1854.
- 74. Ibid., p. 8751, November 11, 1854.
- 75. "January 21st, 1854," JPS, January 21, 1854, p. 153. Because Prince Albert was the patron of the North London School of Drawing and Modelling, scholars have suggested that Fenton met him as early as 1850 (see Lloyd 1988, p. 3), but this January 1854 meeting was clearly their first meaningful encounter.
- 76. "Photographic Society," Athenaeum, January 7, 1854, p. 23.
- 77. "January 21st, 1854," JPS, January 21, 1854, p. 153; Morning Post, quoted in "Exposition de la Société Photographique de Londres," La Lumière, January 14, 1854, p. 5.
- Victoria, Queen of England, Journal (archival source), January 3, 1854.
- See Dimond and Taylor 1987. In 1852 Prince Albert began to collect photographs of all of Raphael's works.
 See Robertson 1978, p. 186; Dimond in Dimond and Taylor 1987, pp. 44–49.
- 80. From "The Charge of the Heavy Brigade at Balaclava." At the end of his life, no doubt disturbed by the jingoistic tone of his earlier "Charge of the Light Brigade" (1854), Tennyson wrote this much more somber and ambivalent description of the infamous battle.
- "Her Majesty 'Leading' the Fleet to Sea," *ILN*, March 18, 1854, p. 242.
- 82. Dimond and Taylor 1987, p. 81, no. xii.
- 83. "Arsenal of Portsmouth," ILN, March 18, 1854, p. 242.
- 84. Sir John Hall's diary from the Crimean War, quoted in Barnsley 1963, p. 6. My thanks to Roger Taylor for bringing this to my attention.

- 85. Russell 1995, p. 53.
- Victoria, Queen of England, Journal (archival source),
 February 22, 1855, quoted by Taylor in Dimond and
 Taylor 1987, p. 39.
- 87. Barnsley 1963, p. 7.
- 88. Taylor in Dimond and Taylor 1987, p. 39.
- 89. See "To the Editor," JPS, March 21, 1854, p. 177. According to an unnamed author in the Moniteur universel (cited in "La Photographie et la guerre," La Lumière, April 15, 1854, p. 54), Lord Raglan had proposed to have a photographer with him in the Crimea, and the idea had originated with Prince Albert.
- 90. See "April 21st, 1854," JPS, April 21, 1854, p. 189.
- 91. Ibid.; "Photography Applied to the Purposes of War," Art-Journal, May 1, 1854, p. 153. A photographer, Richard Nicklin, was assigned to Captain (later Major) John Hackett of the Seventy-seventh Regiment and sailed to the Crimea in late May 1854. He and his two assistants died in the sinking of the Rip Van Winkle in November 1854, and no work from this endeavor appears to have survived. Gernsheim 1954, p. 12, notes that Major Hackett applied for replacement photographers and "Ensigns Brandon and Dawson" were sent in the spring of 1855, after being trained by John Mayall.
- 92. See ILN, July 15, 1854, p. 45.
- 93. Wilson 2003, p. 186.
- 94. See Knightley 1975, p. 15; Lloyd 1988, p. 14.
- 95. See Lalumia 1984, pp. 117, 121. Hannavy 1974, p. 11, writes that "Government officials" approached Agnew asking him to hire a photographer whose pictures "had to conform to strict official requirements." For further discussion of this issue, see Keller 2001, p. 123.
- 96. Keller 2001, pp. 123-26.
- 97. Fenton, "Narrative of a Photographic Trip," *JPS*, January 21, 1856, p. 286.
- 98. Ibid.
- On the editing of this correspondence by the Gernsheims, see note 23.
- 100. Quoted in Gernsheim 1954, pp. 44, 45.
- 101. Ibid., pp. 51, 57.
- 102. Ibid., pp. 47, 89.
- 103. Ibid., p. 61.
- 104. Ibid., p. 58.
- 105. In his address to the Photographic Society on his return to England, Fenton acknowledged the omission of views of the aftermath of battle "so ably depicted by Robertson" after his departure. See Fenton, "Narrative of a Photographic Trip," JPS, January 21, 1856, p. 290.
- 106. Gernsheim 1954, p. 46.
- 107. These included the photograph of General Sir George de Lacy Evans, who, at nearly seventy, had been wounded in the Battle of Alma and had returned to England before Fenton arrived in the Crimea. Keller 2001, p. 138.

- 108. On how the officers themselves viewed the Crimean battles as spectacles, see ibid., pp. 4–8.
- 109. Gernsheim 1954, p. 75.
- 110. Wilson 2003, pp. 175-95.
- 111. "Report of the Council," JPS, February 21, 1855, p. 117; Gernsheim 1954, pp. 57, 90, 75. Fenton wrote of his diligent efforts to get the "people together whose portraits are wanted," a comment that suggests he had a list, perhaps supplied by Agnew. Gernsheim 1954, p. 57.
- 112. Fenton, Photographs of the Seat of War in the Crimea, portfolio of photographs issued 1855–1856, title page.
- 113. See, for example, Gernsheim 1954, p. 58.
- 114. Ibid., pp. 74–75. Because Napoleon was often depicted with his arm raised and hand pointed, there is no way of knowing what portrait Fenton had in mind.
- 115. Ibid., p. 57.
- 116. Ibid., p. 71.
- 117. Ibid., pp. 59, 68-69.
- 118. See, for example, "Photographs from the Crimea," Athenaeum, September 29, 1855, p. 1118; or Morning Chronicle, September 20, 1855, and Guardian, October 3, 1855, quoted in Keller 2001, p. 133.
- 119. As noted in Keller 2001, pp. 131–34, Fenton actually took two photographs of the shallow ravine from the same camera position. In the first the cannonballs lie mostly scattered by the side of the road; in the second the cannonballs have been placed more prominently on the road itself.
- 120. Gernsheim 1954, pp. 97, 99, 105.
- Victoria, Queen of England, Journal (archival source), August 8, 1855.
- 122. "Photographs of the Seat of War," *ILN*, September 15, 1855, p. 326.
- 123. "Photographs from Sebastopol," *Art-Journal*, October 1, 1855, p. 285; "Photographs from the Crimea," *Athenaeum*, September 29, 1855, p. 1117.
- 124. "Topics of the Week," *Literary Gazette, and Journal of Science and Art*, September 22, 1855, p. 605.
- 125. Scenery,—Views of the Camps, &c., consisted of ten parts, each containing five subjects; Incidents of Camp Life,—Groups of Figures, &c. had ten parts, each containing six subjects; and Historical Portraits had five parts, each of six subjects. A single part cost two pounds two shillings. See advertisement in Exhibition of the Photographic Pictures Taken in the Crimea by Roger Fenton, Esq. 1855, opening pages (unpaginated).
- 126. See advertisement in Exhibition of the Photographic Pictures Taken in the Crimea by Roger Fenton, Esq. 1855, p. 15; Gernsheim 1954, p. 27. Fenton's Crimean photographs were distributed in France by Jacques-Antoine Moulin, a French photographer, in London by Colnaghi, and in New York by "Williams," information that is printed on their mounts.
- 127. Elizabeth Eastlake, April 1857, p. 443.

- "C'est la photographie paysagiste poussée à son dernier degré de perfection." Molard, October 1856, p. 283.
- 129. "Exhibition," JPS, May 21, 1858, p. 208.
- 130. "Photographic Society. Annual General Meeting. Feb.7th, 1856," JPS, February 21, 1856, pp. 299–304.
- JPS, no. 42 (May 21, 1856), pp. 37–38; "Photographic Society. Ordinary Meeting. May 1, 1856," JPS, May 21, 1856, p. 38.
- 132. Public Records Office, Kew, B.T. 41, box 560/3062, quoted in Seiberling 1986, p. 76; "Photographic Association," JPS, May 21, 1856, n.p.; "Manchester Photographic Society," Photographic Notes, May 25, 1856, p. 51.
- 133. See JPS, no. 42 (May 21, 1856), p. 37.
- 134. "Photographic Society. Anniversary Meeting. Thursday, February 2nd, 1854," JPS, February 21, 1854, p. 166.
- 135. "Photography and the Photographic Society," *Builder*, February 11, 1854, p. 73.
- 136. "To the Editor," JPS, September 21, 1858, p. 31; "Forthcoming Exhibition," JPS, September 21, 1858, p. 31.
- 137. Earlier that spring Prince Albert had donated fifty pounds to the Photographic Society to encourage research into this question. See "Photographic Society. Annual General Meeting. Feb. 7th, 1856," JPS, February 21, 1856, p. 300.
- 138. See Fenton to William Henry Fox Talbot, February 4, 1854, Lacock Abbey Collection LA54-007 (archival source); Talbot Correspondence Project (website), doc. 06912.
- "Photogalvanography," Photographic Notes, May 25, 1856, pp. 60–62.
- 140. Photographic Art Treasures 1856, pt. 1, title page.
- 141. "Photo-Galvanography, or Nature Engravings," advertisement in the *Athenaeum*, May 16, 1857, p. 614.
- 142. John Henry Bolton to William Henry Fox Talbot, May 1, 1857, Lacock Abbey Collection LA57-015 (archival source); Talbot Correspondence Project (website), doc. 07399.
- 143. See Talbot to Bolton, April 24, 1857, Lacock Abbey Collection LA57-013 (archival source); Talbot Correspondence Project (website), doc. 07396. See also Bolton to Talbot, May 1, 1857, Lacock Abbey Collection LA57-015 (archival source); Talbot Correspondence Project (website), doc. 07399.
- 144. Bolton to Talbot, August 13, 1857, Lacock Abbey Collection LA57-022 (archival source); Talbot Correspondence Project (website), doc. 07437.
- 145. See "Exhibition of Art Treasures at Manchester," Liverpool and Manchester Photographic Journal, July 15, 1857, p. 145.
- 146. Dimond in Dimond and Taylor 1987, p. 43.
- 147. See Taylor in Dimond and Taylor 1987, pp. 15–17. Rejlander's *The Two Ways of Life* was an allegorical depiction of the choice faced by two young men between a life of virtue and one of vice. To make it, Rejlander photographed more than twenty models at different times.
- 148. See Dimond in Dimond and Taylor 1987, pp. 51-55.

- British Museum, Trustee Committee Minutes (archival source), pp. 9018–19, June 7, 1856.
- 150. See William Jacobson et al. to Henry Ellis, February 9, 1856, and Ellis to Reverend Selwyn, February 11, 1856, British Museum, Original Letters and Papers (archival source).
- 151. Fenton to Panizzi, July 30, 1857, British Museum, Original Letters and Papers (archival source).
- 152. Ibid.
- 153. See British Museum, Trustee Committee Minutes (archival source), p. 9447, July 24, 1858, and p. 9484, November 13, 1858. It has been suggested that in the summer of 1858 Fenton set up a kiosk in the museum's front hall. Hannavy 1976, p. 42. Although his photographs could be purchased at the museum, there is no evidence that he had a sales booth.
- 154. British Museum, Minutes of the Sub Committee (archival source), pp. 1114–16, July 7, 1859.
- 155. Fenton to Panizzi, July 7, 1859, British Museum, Original Letters and Papers (archival source).
- 156. Darrah 1977, pp. 3, 4.
- 157. "Stereoscopic Magazine," Literary Gazette, and Journal of Belles Lettres, Science, and Art, April 24, 1858, p. 408. See also Stark 1981, p. 11.
- 158. "Stereoscopic Magazine," Literary Gazette, and Journal of Belles Lettres, Science, and Art, April 24, 1858, p. 408.
- 159. Rejlander, April 21, 1858, p. 196.
- 160. Ibid.
- 161. "London Photographic Society," *Photographic News*, January 11, 1861, pp. 18–19.
- 162. Quoted in Date 1989, p. 12.
- Parliament, House of Commons, Report from the Select Committee, 1860, p. 89.
- 164. Ibid.
- 165. Darrah 1981, pp. 5-6.
- 166. Hervé, May 21, 1858, p. 223.
- 167. After numerous objections were raised to this proposal, the Organizing Committee established a separate hall for photography. See, for example, *Photographic Journal*, no. 109 (May 15, 1861), pp. 171–74; "Photographic Society of London . . . June 4, 1861," *Photographic Journal*, June 15, 1861, pp. 196–98; "Photographic Society," *Art-Journal*, July 1, 1861, p. 223.
- 168. Nadar 1899, pp. 194-96.
- 169. "Photographic Exhibition," Photographic News, January 27, 1860, p. 242.
- 170. "Exhibition of the Photographic Society," *Photographic News*, January 28, 1859, p. 242.
- 171. "Photographic Exhibition," *Photographic News*, February 3, 1860, p. 254.
- 172. "Exhibition of the Photographic Society of Scotland," *Photographic Journal*, January 16, 1860, p. 132;
 "Photographic Exhibition," *Photographic News*, January 18, 1861, p. 25.

- 173. "Photographic Exhibition," Athenaeum, January 21, 1860, p. 98; "Exhibition of the Photographic Society," Art-Journal, February 1, 1861, p. 48.
- 174. Photographic Journal, no. 93 (January 16, 1860), p. 115; "London Photographic Society's Exhibition," BJP, February 15, 1861, pp. 67–68; "Exhibition of the Photographic Society," Art-Journal, March 1, 1860, p. 72.
- 175. "Exhibition of the Photographic Society," Art-Journal, March 1, 1860, p. 71.
- 176. Photographic Notes, no. 98 (May 1, 1860), p. 116.
- Parliament, House of Commons, Report from the Select Committee, 1860, p. 91.
- 178. "London Photographic Society," *Photographic News*, January 11, 1861, pp. 18–19.
- 179. "Photographic Society. Ordinary Meeting. May 7, 1857," JPS, May 21, 1857, p. 271.
- 180. "Archer Fund," Photographic Journal, May 15, 1860, p. 243.
- 181. "Failure as Viewed in Heywood," *Heywood Advertiser*, ca. 1878.
- "Retirement of Mr. Fenton," *Photographic Journal*, October 15, 1862, p. 158.
- "Mr. Fenton's Photographic Effects," Photographic News, December 5, 1862, p. 588.
- 184. Law List 1863, p. 45. Fenton was a barrister for the Assize (or traveling) Courts of Manchester, Salford, and York; he continued to reside at Mount Grace in Potter's Bar. It is noted in "Late Mr. Roger Fenton," BJP, August 20, 1869, p. 401, that at the end of his life Fenton had a "connection with the Stock Exchange."
- 185. "Late Mr. Roger Fenton," BJP, August 20, 1869, p. 400.

"On Nature's Invitation Do I Come": Roger Fenton's Landscapes

MALCOLM DANIEL

In addition to the many people whose invaluable assistance is acknowledged at the beginning of this catalogue, I wish to signal my particular gratitude to Roger Taylor. He has shared his deep knowledge of Victorian history and culture, clarified details of early photographic technique, opened his library and files, passed on specific research relevant to my topic, and—most memorably and pleasurably—led me on walks to the Strid, through the ruins of Rievaulx, and along the banks of the Ribble and Hodder. I know of no scholar more generous than he.

The exhibition and catalogue have been a very happy collaboration, and I am indebted to my co-curators, Sarah Greenough and Gordon Baldwin. They have taught me much through their discussion of Fenton's pictures, research and writing for the catalogue, and careful reading and critique of this essay.

As always, I am deeply grateful also to my partner, Darryl Morrison, who bravely sat in the passenger's seat as we explored North Wales and who patiently and lovingly endured my weekend work and evening anxiety during the writing of this essay.

The title of the essay is taken from "The Recluse" by William Wordsworth, whose Romantic reverence for nature seems to me embedded in Fenton's landscapes and whose verses are therefore frequently invoked here.

- 1. Howitt 1840, p. 10.
- 2. Ibid., p. 6.
- Although its origins go back to antiquity, the notion of the sublime in literary and aesthetic theory was most forcefully articulated and debated in eighteenth-century Britain, notably in Edmund Burke's 1756 essay A Philosophical Enquiry into the Origin of our Ideas of the Sublime and the Beautiful. Vast scale, power, darkness, or ruggedness-to the point of inducing a sense of terror-characterized the sublime, and stood in contrast to the smoothness, delicacy, and lightness associated with its antipode, beauty. The idea of the picturesque-literally, the combination of qualities thought to make a scene worthy of artistic depiction—was developed in response to Burke and constituted a sort of middle ground between the sublime and the beautiful. As the idea was elaborated by its chief proponent, William Gilpin, in the 1760s through the 1780s, landscape painting (or landscape itself) was enlivened by irregular contours, decaying ruins, local color, and low vantage points that immerse the viewer in a scene. By the mid-nineteenth century the theories of the sublime and the picturesque were little debated, but they had been largely internalized into the aesthetics of landscape artists.
- 4. Noon 2003.
- 5. "Exhibition," JPS, May 21, 1858, p. 208.
- 6. For examples of such views, see Hannavy 1993, figs. 7, 8.
- See "A New Starting Point" by Sarah Greenough in this volume, p. 14, for the photographs from this campaign.
- For Fenton's use of paper negatives during the first year of his career, see Hannavy 1993, pp. 233-43. Regarding the many variations on the paper negative process, see also Taylor and Ware 2003, pp. 308-19.
- 9. The inscription in Jeuffrain's album specifies that Fenton used "papier ciré sec (Le Gray)" for these landscape views, although the album's portraits and self-portrait by Fenton, also made in February 1852, were made using collodion-on-glass negatives.
- O. See Taylor, Photographs Exhibited in Britain, 2002, pp. 304–9. The fact that some of the Burnham Beeches pictures are identified as being from waxed paper negatives suggests a date of 1852 or 1853, as Fenton appears to have switched to collodion on glass shortly after his return from Russia in the fall of 1852. Richard Pare has suggested in a verbal communication that a series of Burnham Beeches pictures found in the "gray albums" may be Fenton's, but those albums included work by

- other photographers, and there is no way to determine the author of these particular images (see note 30 below).
- 11. Hannavy 1993, pp. 238–39, figs. 5–7. In his journals, the engineer Charles Blacker Vignoles was quite specific in noting that Fenton was to make stereoscopic views of the bridge he was constructing over the Dnieper.
- 12. Scenery of the Wharf 1855, p. 3.
- Fenton, "On the Present Position and Future Prospects of the Art of Photography," in Catalogue of an Exhibition of Recent Specimens of Photography 1852, p. 5.
- Denis Diderot, *Diderot on Art*, ed. and trans. John Goodman, vol. 2, *The Salon of 1767* (New Haven and London: Yale University Press, 1995), p. 198.
- 15. Howitt 1854, vol. 1, p. 241.
- 16. Banks 1866, p. 26.
- 17. Ibid., p. 28.
- 18. Black's Picturesque Guide to Yorkshire 1862, pp. 50-51.
- 19. "Fine-Art Gossip," Athenaeum, June 27, 1857, p. 826.
- Photographic Notes, no. 15 (November 15, 1856), p. 235, discussing Fenton's photographs.
- 21. "Photographic Exhibition," JPS, February 21, 1857, p. 215. The phrase cited by the reviewer is a misquotation of Wordsworth's "Upon Westminster Bridge." The Reach of the Dee is at the NMPFT (RPS Collection 2003–5000/3012).
- 22. JPS, no. 15 (March 21, 1854), p. 178.
- 23. Phipson, October 21, 1856, p. 147. Neither the review nor the exhibition catalogue is specific as to the identity of the landscapes displayed; the catalogue reads simply, "Vues de Hampton-court; Cléopatre; ruines."
- 24. Notices of the First Exhibition of the Norwich Photographic Society 1857, p. 5. The exhibition opened November 17, 1856. The image of Hampton Court referred to in this review cannot now be identified. No known photograph of this subject by Fenton shows natural skies.
- 25. Taylor, *Photographs Exhibited in Britain*, 2002, p. 328. The exhibition opened December 20, 1856. *Photographic Notes*, in a wider review of Fenton's work, commented that "two Views entitled Evening (288 and 296) . . . are among the most conspicuous where all are artistic in a high degree." "First Exhibition of the Photographic Society of Scotland," January 1, 1857, p. 26.
- 26. Photographic Notes, no. 15 (November 15, 1856), p. 235.
- For a full discussion and numerous reproductions of Le Gray's seascapes, see Aubenas et al. 2002. The Great Wave is illustrated on p. 125.
- For the reception of Le Gray's seascapes in England, see Jacobson 2001, in which the *Times* advertisement by Murray & Heath is cited.
- 29. These cloud studies have traditionally been dated 1859, based on the fact that Fenton first exhibited a related work, *September Clouds* (fig. 24), at the Photographic Society in 1860 and on the assumption that he showed it at the earliest opportunity after making it. However,

- Fenton frequently exhibited photographs several years after making them, or exhibited previously shown photographs with variant titles, and this might well have been the case here, since Clouds after Rain and Evening had not yet been shown outside of Scotland. Fenton's association with Thomas Gladwell, beginning in late 1858, also brought many of his older images back into play (see "A Most Enthusiastic Cultivator of His Art" by Roger Taylor in this volume). Furthermore, although we do not know if Fenton was photographing in September 1859, he was definitely off in Scotland making photographs with natural skies in September 1856. Finally, it should be noted that September Clouds and the related works have more in common, stylistically, with other works from Fenton's 1856 campaign such as Loch Nagar from Craig Gowan (fig. 22) than with the views around Stonyhurst that he made in the summer and winter of 1859.
- 30. Commonly referred to as the "gray albums" for the color of their pages, these three portfolios contained many rare or unique works by Fenton. They were dismantled and sold piecemeal in the late 1970s and early 1980s by Christie's, London. Since the consignor insisted on anonymity, and since the volumes were not documented before being dismembered, it is now impossible to trace their provenance or to reconstruct their full contents or sequencing. Nonetheless, it is clear that they represented a personal compendium of Fenton's work, most often in unretouched proof prints. The portfolios contained photographs from 1852 to 1859 (weighted toward the later years) and included a large number of Orientalist pictures; numerous works by other photographers were also pasted to the pages.
- William Wordsworth, "Lines Written a Few Miles above Tintern Abbey, on Revisiting the Banks of the Wye during a Tour, July 13, 1798."
- 32. The two untitled prints in the Metropolitan Museum collection (pls. 22, 23) have been assumed to be coincident with September Clouds because of their similarity of composition, although the latter is smaller in format and known only in two albumen silver prints, one at the NMPFT (RPS Collection), the other in a private collection, New York. The difference in print size and medium is no argument against this having been made at the same time as the Metropolitan Museum prints, for Fenton used negatives of both sizes on his Scottish trip and printed some images as salted paper prints and others as albumen silver prints.
- "Photographic Exhibition," Photographic News, January 27, 1860, p. 242.
- 34. Constable to John Fisher, October 23, 1821, Constable 1968, p. 77.
- For a discussion of this topic, see Gage 2000, pp. 125–34;
 Lyles 2000, pp. 135–50.

- 36. Davidson 1860, p. vi.
- See "Mr. Fenton Explained Everything" by Roger Taylor in this volume, pp. 79–80.
- 38. Of Fenton's pictures, it was said that "foggy and misty though they be, [they] are a higher tribute to their author's consummate skill than any success, even the most perfect, could afford." *Liverpool and Manchester Photographic Journal*, no. 4 (February 15, 1857), p. 35. Bedford's scenes were discussed on the same page. On Bedford, see Spencer 1987, pp. 237–45.
- Liverpool and Manchester Photographic Journal, no. 4 (February 15, 1857), p. 35.
- "Photographic Exhibition of the Manchester Photographic Society," *Photographic Notes*, October 15, 1856, pp. 204–5.
- The Reverend J. B. Reade, quoted in the Liverpool and Manchester Photographic Journal, no. 4 (February 15, 1857), p. 37.
- 42. Roscoe 1853, p. 121.
- 43. Hansard 1834, p. 202.
- 44. Lord 1998, pp. 23-25.
- 45. Ibid., pp. 34-38.
- 46. Catalogue of the Collection . . . Formed by Roger Fenton, June 13, 1870, lots 86, 82, 81. "J. P. Jackson" listed in the auction catalogue may be a typographical error for S. P. Jackson (Samuel Phillips Jackson), listed as the artist of lot 90, for example.
- 47. See, for example, the list of works exhibited by David Cox in Bunt 1946, pp. 87–117.
- 48. Davidson 1860, p. 31.
- 49. Roscoe 1853, p. 216.
- 50. Stereoscopic Magazine: A Gallery of Landscape Scenery, Architecture, Antiquities, and Natural History, Accompanied with Descriptive Articles by Writers of Eminence, published by Lovell Reeve beginning in July 1858. Fenton contributed views of North Wales, Ely and Peterborough cathedrals, gallery interiors and objects in the British Museum, and scenes at and around Stonyhurst.
- 51. Davidson (1824–1885) was a Devon-born historian, a graduate of Trinity College, Cambridge, and a lawyer called to the bar in 1850. How he knew Fenton or became aware of Fenton's Welsh stereos is unknown. "James Bridge Davidson," *Devon Notes and Queries*, 1903, p. 129.
- 52. Davidson 1860, p. 1.
- 53. Roscoe 1853, p. 207.
- 54. Ibid., p. 208.
- 55. Davidson 1860, p. v.
- 56. Lord 1998, p. 59.
- "Pont-y-Pant," Stereoscopic Magazine, May 1859, p. 164.
 See also Davidson 1860, p. 77.
- 58. Davidson 1860, p. 133. The bridge depicted in Fenton's photograph is said to date to the fifteenth century. The stone piers of Pont-y-Pant still stand, little changed, but the wooden roadway and rails have been replaced by a concrete bed and metal fence.

- 59. Ibid., pp. 131-32.
- 60. Roscoe 1853, p. 208.
- 61. At the Glasgow Photographic Society exhibition of 1859, Fenton exhibited four views: "Bed of the Lledr, near Pont-y-Pont"; "Rock in the Lledr, near Pont-y-Pont"; "Pont-y-Pont, Wales, from Above"; and "Pont-y-Pont, Wales, from Below." Taylor, *Photographs Exhibited in Britain*, 2002, p. 337.
- This, at least, is the explicit reason provided by Davidson 1860, p. 132.
- 63. Ibid.
- 64. See Thackray 1996, pp. 65-74.
- 65. William Wordsworth, "Lines Written a Few Miles above Tintern Abbey, on Revisiting the Banks of the Wye during a Tour, July 13, 1798."
- 66. "What is here seen is a mere residuum of that irresistible flood which is sometimes hurled down this contracted gorge, powerful enough, it is presumed, to carry with it blocks of felstone of considerable size." Davidson 1860, pp. 168–69. This spot is the modern-day Ffos Noddum.
- 67. Davidson (ibid., p. 169) writes that "the ordinary loneliness of the scene is effectually dispelled in summer by a troop of artists, who take up various positions on the rocks, and enliven their labours with occasional chants, and other vocal efforts more or less amusing."
- 68. "Photographic Society," *Athenaeum*, no. 1582 (February 20, 1858), p. 246.
- 69. Davidson 1860, p. 168.
- "Photographic Society," Literary Gazette, and Journal of Belles Lettres, Science, and Art, February 20, 1858, p. 186.
- Ann Radcliffe's phrase from the best-selling novel The Mysteries of Udolpho (1794) was applied to this spot in Black's Picturesque Guide to North Wales 1857, p. 96.
- 72. Roscoe 1853, p. 118.
- 73. Among the photographs of Wales that Fenton may have known before setting out on his own excursion would have been Alfred Rosling's *Near the Pass of Nant Frangen, North Wales*, taken in July 1856 and published in the *Photographic Album for the Year 1857*.
- 74. The third view of the Nant Ffrancon pass is in the collection of the NMPFT (RPS Collection 2003-5000/3220). All three versions are illustrated in Lloyd 1988, pls. 71–73.
- 75. Roscoe 1853, p. 119.
- 76. Ibid., p. 120.
- The Conway was navigable to Trefriw by vessels of up to sixty tons. Black's Picturesque Guide to North Wales 1857, p. 147.
- 78. Davidson 1860, p. 26. Davidson also reported (pp. 19–20) that a small steamboat carried passengers daily from Conway to Trefriw. Pleasure boats brought day-trippers from Conway to the spa at Trefriw well into the twentieth century.
- See Taylor, Photographs Exhibited in Britain, 2002, p. 335–36.

- 80. "Exhibition," JPS, May 21, 1858, pp. 208-9.
- 81. "Photographic Society," Athenaeum, May 29, 1858, p. 693.
- 82. "Photographic Society," Literary Gazette, and Journal of Belles Lettres, Science, and Art, February 20, 1858, p. 185.
- "Photographic Exhibition at the Crystal Palace," Photographic News, October 8, 1858, p. 53.
- 84. Dobson 1877, p. 87. Dobson was writing of the Sale Wheel, a bend in the Ribble River that was a popular fishing spot.
- "Exhibition of the Photographic Society," *Photographic News*, January 21, 1859, p. 230.
- 86. Dobson 1877, p. 52.
- 87. Ibid., p. 59.
- 88. I am indebted to Roger Taylor for a copy of Stonyhurst College's inventory of photographs by Fenton, which includes all of the artist's known images of the college and its grounds, and for his extensive research on the Fenton family's ties to the surrounding area.
- 89. Fenton's contact at the college was probably Father William Kay, a former Stonyhurst student who was appointed professor of chemistry in September 1856 and who, in the year of Fenton's visit, lectured on photography. Stonyhurst College, First Prefect's Log (archival source), entry for November 17, 1859.
- 90. Dobson 1877, p. 79. James Fenton had inherited Dutton Hall in December 1857 following the death of his father, also named James, who was the brother of Roger's father.
- North Lancashire, Whalley Polling District, Register of Persons Entitled to Vote (archival source), July 26, 1851, entry no. 11358, Roger Fenton.
- 92. All six views are in the collection of Stonyhurst College: D40 46, D45 43, D46 44A, D47 44B, D48 111, D49 111. See also Lloyd 1988, no. 80. Concerning the name of this spot on the Ribble, Halieutes (John Gerard) writes: "The name [Raid Deep] is thus given on the maps, but is always pronounced *Ree* Deep. A learned friend tells me that *Ree* is undoubtedly the right name, meaning a flood or broad expanse of water, the name here therefore signifying 'broad and deep.'" Halieutes 1883, p. 5.
- 93. It is also possible that Fenton chose to round the bottom corners because the coverage of his lens fell off at the bottom and the dark corner hinted at in the lower left was distracting.
- Hansard 1834, pp. 213–14, quoting Sir Henry Ellis's edition of Walton's Compleat Angler.
- 95. Halieutes 1883, p. 3.
- 96. Most of the fish caught were pulled in by net—12,900 salmon in 1868, the earliest year for which figures are available, compared with just 20 that year taken by rod. Within twenty-five years of Fenton's visits, industrial pollution had so affected the Ribble's waters that what had once been "an excellent trout stream" was "now not worth fishing." Ibid., pp. 3, 4.

- 97. Ibid., p. 3.
- 98. "London Photographic Society's Exhibition," *BJP*, February 1, 1860, p. 42; "Photographic Exhibition," *Photographic News*, February 3, 1860, p. 255; "Photographic Exhibition," *Photographic Notes*, April 15, 1860, p. 113.
- "Photographic Exhibition," Athenaeum, January 21, 1860, p. 98.
- "Photographic Society's Exhibition," Builder, January 28, 1860, p. 59.
- 101. "London Photographic Society's Exhibition," BJP, February 1, 1860, p. 42. Cottages at Hurst Green is in the collection of the NMPFT (RPS Collection, 2003-5000/3140) and is illustrated in Lloyd 1988, pl. 85.
- "Photographic Exhibition," *Photographic News*, February 3, 1860, p. 255.
- "Photographic Exhibition," Athenaeum, January 21, 1860, p. 98.
- 104. "Photographic Exhibition," *Photographic News*, February 17, 1860, p. 282.
- 105. Black's Shilling Guide to the English Lakes 1853, p. 3.
- 106. Ibid.
- 107. Black's Picturesque Guide to the English Lakes 1851, p. 4.
- 108. William Wordsworth, The Excursion, "Book Ninth: Discourse of the Wanderer, and an Evening Visit to the Lake," lines 437–40. The passage is quoted as transcribed by Fenton. See Taylor, Photographs Exhibited in Britain, 2002, p. 341.
- 109. Black's Picturesque Guide to the English Lakes 1851, p. 132.
- 110. Black's Shilling Guide to the English Lakes 1853, p. 25.
- Hills at the Foot of Derwentwater is in the collection of the NMPFT (RPS Collection 2003-5000/3227).
- 112. "Exhibition of the Photographic Society," Art-Journal, February 1, 1861, pp. 47–48. See also "London Photographic Society's Exhibition," BJP, January 15, 1861, p. 37.
- 113. Before leaving for Egypt, Frith tested his mammothplate camera in England and Scotland in 1856; five views, all architectural, survive as negatives. Nickel 2003, pp. 45–46.
- 114. For a fuller discussion of this issue, see "A Most Enthusiastic Cultivator of His Art" by Roger Taylor in this volume.

In Pursuit of Architecture

GORDON BALDWIN

 The paintings Fenton had entered in Royal Academy exhibitions in the late 1840s, however, attracted few and far from enthusiastic reviews. His career as a barrister, which he may have pursued intermittently in the 1850s

- before embracing it definitively in 1862, attracted no notice whatever.
- 2. See, for example, two comments on Fenton's work in reviews of the 1859 annual exhibition of the Photographic Society: "We regret to state that the majority of [Fenton's] landscapes are far below the average merit of his pieces. Among his best are 'Tintern Abbey,' ("Exhibition of the Photographic Society," *Photographic News*, January 21, 1859, p. 230); and "Amongst this gentleman's landscapes there are so many that we covet, that we feel almost inclined to mention the whole of them; but Nos. 34, *Glastonbury Abbey*, and 54, *Raglan Castle*, are especially fine" ("Photographic Society's Sixth Annual Exhibition," *Photographic Journal* [BJP], February 1, 1859, p. 35).
- 3. The vocation of photography was so new that the choices Fenton made about subject matter (as well as about photographic processes, exhibition venues, and merchandizing strategies) contributed to the defining of what a career in the field could be.
- 4. Numbering sequences in the exhibition catalogues indicate that his work was sometimes interspersed with that of others; see Taylor, *Photographs Exhibited in Britain*, 2002, pp. 302–43. Because of Fenton's habit of showing his newest work, Taylor's book is essential for dating photographs by Fenton (and others).
- The number 450 is approximate, since in some cases there
 are ambiguous titles and no extant prints. Fenton produced
 about 360 images documenting the Crimean conflict.
- 6. These include a number in Lancashire, such as Crimble Hall, his father's house; Gawthorpe, his first cousin James Kay-Shuttleworth's house; and Hurst Green, where the Fenton family owned land and a factory. Harlsey Hall, his father-in-law's house near Northallerton in Yorkshire, was another family site.
- 7. Ackerman 2002, p. 98.
- Parts one and two of the portfolio, called *The Photo-graphic Album* and containing six photographs by Fenton, were published in 1852 by the Joseph Cundall Photographic Institution.
- For criticisms of these photographs, see Hannavy 1976, pp. 23–26. Hannavy's was the first substantial account of Fenton's life and overall career.
- 10. In January of 1853 he exhibited a photograph of a cottage porch at Southam, Warwickshire, presumably made on another expedition in 1852, but no print of the subject has been located.
- Without specifying where any are to be found, Hannavy states that "the bridge does not appear in many photographs." Hannavy 1976, p. 26 (note). A signed print of the bridge under construction is in the collection of the Emperor Dom Pedro II in the National Library of Brazil, Rio de Janeiro.
- It is unclear exactly how many photographs Fenton made in Russia. Some photographs in an album in the

- collection of the JPGM have numbers in their negatives ranging up to 360, but the numbers do not appear on all the images and were perhaps later additions.
- 13. The only photographic works that possibly antedate them, made by the artist John Cooke Bourne, also document the construction of the Vignoles bridge; some of these may date from 1851. Some of Bourne's pictures of this bridge were exhibited at the Photographic Society in London in 1854 and 1855; Taylor, *Photographs Exhibited in Britain*, 2002, p. 156. He is not known to have photographed in any area of Russia other than Kiev. In the 1840s daguerreotypes were taken in Moscow (from which acquatints were made for publication in Lerebours 1842), but none of them appears to have survived.
- 14. A fleeing perspective is one in which the principal vanishing point lies outside the frame of the image and is so named for the rapid dimunition of whatever is depicted toward one point in the distance.
- Hannavy, "Finding Roger Fenton's Russia" (website). In 2002 Hannavy made a photograph from the same point that was compositionally similar to Fenton's.
- 16. Catalogue of the Collection . . . Formed by Roger Fenton, June 13, 1870. It is possible (if not particularly likely) that his widow kept other pictures not in this catalogue that more embodied a taste for the picturesque. Among the better drawings Fenton owned were three views of Paris and one of Rouen from the 1830s by Thomas Shotter Boys (1803–1874).
- For their titles, see the Chronology. They received tepid reviews.
- The speech, given in December 1855, is printed in Fenton, "Narrative of a Photographic Trip," JPS, January 21, 1856, pp. 284–91. The Photographic Society later became the Royal Photographic Society.
- For a thorough treatment of the idea of the picturesque and its lineage from William Gilpin through Uvedale Price and beyond, see Andrews 1989.
- 20. See Charlesworth 1994 for an extended discussion of the various ways Rievaulx was seen between the mideighteenth and mid-nineteenth centuries and the political implications of these viewpoints.
- See, for example, Churton 1843–56, which contains four views by Richardson of Rievaulx as well as images of the abbeys of Kirkstall and Fountains, where Fenton also worked.
- 22. See Taylor, Photographs Exhibited in Britain, 2002, pp. 305–7, for the titles of all these works, and pp. 732–34 for B. B. Turner's exhibition history. Prints of most of Fenton's images of Tintern are at the CCA, with a few elsewhere, including at the SFP. Three of the five he made at Gloucester and two from Tewkesbury are in the NMPFT (RPS Collection). The other two from Gloucester are at the CCA and the HRC. The Raglan images are scattered in locations that include the CCA,

- the SFP, and the GEH. A print of one of the four photographs of Gawthorpe that Fenton exhibited in 1854 is at the JPGM.
- 23. Besides photographing at Rievaulx, Bedford worked in the middle 1850s at many other of the same sites as Fenton, including Fountains, Raglan Castle, Tintern, Whitby, and York, and also made landscapes in North Wales as Fenton had. However, Bedford's repertoire did not include country houses or London views.
- 24. There are two exceptions, one-point perspective photographs made down the length of an aisle at Salisbury Cathedral and up the nave of Wells Cathedral.
- 25. Although raised in the United Reformed Church, Fenton was married in an Anglican church, attended Anglican services (as we know from his brother-in-law Edmund Maynard's journal, now in the possession of one of his descendants; archival source), and was buried in an Anglican churchyard. Using a Roman Catholic setting to depict religious practice not tied to a specific doctrine, Fenton appears to have been relatively free of anti-Catholic prejudice.
- A print of this image, entitled The Valley of Rievaulx Looking East, is at the NMPFT (RPS Collection).
- 27. Andrews 1989, p. 64. Other photographers included figures in photographs of ruins, but the mundane poses of their models show they are meant only to be ordinary visitors and are hardly infused with spiritual intent.
- 28. The two images of Rievaulx not illustrated here are a variant of the view of Mrs. Fenton praying and a study of the doorway of the porch of the empty refectory, both in the NMPFT (RPS Collection).
- 29. Fenton, "Narrative of a Photographic Trip," *JPS*, January 21, 1856, p. 286.
- 30. Use of the railroads is strongly implied in Fenton's account, ibid., in which he describes hiring horses at York to draw the photographic van on its inaugural run. As Ed Bartholomew, curator of the photographic and film collection of the National Railway Museum in York, explained in correspondence, it was possible in the midnineteenth century to transport nearly anything by train. The fact that Fenton's brother William was a director of railway companies may have facilitated the transport of the van on trains.
- 31. Sparling's importance to Fenton has been consistently undervalued. He was a highly competent technician whose grasp of photographic chemistry and processes is manifest in the excellent manual he published; see Sparling 1856. On the title page the author is described as "Assistant to Mr. Fenton, Honorary Secretary to the Photographic Society."

Other views Fenton made at Lindisfarne include two top-hatted and frock-coated tourists and a few other people; they held still long enough to be photographed at a distance but were otherwise unengaged with the camera.

- 32. Fenton made five other views of Lindisfarne Priory.

 Three of them concentrate on the west front, the largest standing element of the ruin; prints of two of these are in the collection of the CCA and the third in that of the JPGM. A fourth is a study of a doorway, and a fifth, an overall view of the scant remains of the structure seen from the west across a nearly barren field, is known to this writer only through an auction catalogue illustration.
- 33. Another print of this view is at the NMPFT (RPS Collection). Of the four other shots of Melrose, one is at the CCA and another in Special Collections at the Frances Loeb Library of the HDS. A third is reproduced in auction catalogues (Christie's South Kensington, June 28, 1979, lot 188, and Sotheby's Belgravia, October 29, 1982, lot 132); the fourth, of the church's east end, was shown at the Edinburgh Photographic Society in December 1856 (Taylor, *Photographs Exhibited in Britain*, 2002, p. 329).
- 34. All three of the images Fenton made at Roslin are studies of this flank of the chapel. In a vertical variant of the plate reproduced here he emphasized the depths seen through the doorway by placing one person in the first doorframe and another at the distant fence; a print is in a private collection, New York. Other prints of the horizontal image are at the Victoria and Albert Museum, London, and the NMPFT (RPS Collection). A more general horizontal study of the south side is at the HDS.
- 35. Oddly, the orphan pinnacle on the left is a nineteenth-century addition. Maddison 2000, p. 60.
- 36. Winkles's engraving shows the full height of the central tower, which Fenton could not do without moving much farther from the cathedral, and conveniently moves aside some buildings that overlap the west front in Fenton's medium-range view.
- 37. The same prospect today shows the same trees and the same towers, all of great age. Catherine Evans Inbusch and Marjorie Munsterberg have pointed out that the cathedral as seen from the park was a favored nineteenth-century view and that the photograph was made in early morning. See Pare 1982, p. 223, pl. 9.
- 38. Prints of it are at the NMPFT, in the GPCC, and according to Lloyd (1988, no. 116), in a private collection. There is also a stereo view made of the lane; it was published in the *Stereoscopic Magazine* in May 1859, and prints are in the collections at the GEH and the JPGM. Fenton's stereographs have been relatively little studied, although he made a fair number of them, seemingly always in conjunction with larger-format work, and usually marked with his name.
- 39. Anthony Hamber discovered and kindly pointed out this 1861 advertisement of cathedral views by Fenton in the Sarum Almanack Advertiser. Providing numbers of images but not titles, it lists one at Malvern Priory, two each of Tewkesbury and Gloucester cathedrals, three each of

- Beverley and Southwell, five each of York, Peterborough, and Lichfield, ten of Lincoln, twelve each of Ely and Wells, and thirteen of Salisbury. (Sarum, a predecessor of Salisbury, was largely destroyed to build the later town.)
- 40. The larger-format view of the Peterborough transept is in the NMPFT (RPS Collection) and the HDS. The NMPFT has one view of the west front and the JPGM another. The CCA has two prints of the image of the east end. It is possible that some or all of his family accompanied Fenton on at least part of this itinerary, perhaps en route to visit their Maynard relations in Yorkshire. A stereograph of the south transept, published in the *Stereoscopic Magazine* in August 1859, shows two little girls, approximately the ages of two of Fenton's four daughters, sitting on a garden bench.
- 41. A print of this image can be found in the NMPFT (RPS Collection) and is reproduced in Hannavy 1976, pl. 47.
- 42. The name Galilee for this kind of covered space attached to a cathedral, church, or abbey refers to its function as the last station in a medieval Corpus Christi procession; the analogy suggested is to Christ leading his disciples into Galilee after the Resurrection. The porches were also places where bodies were placed previous to interment or, in abbeys, where women could meet monks to whom they were related. See http://www.suffolkchurches.co.uk/zgalilee.htm.

 The porch at Lincoln may have been built as a state entrance for the bishops; see Cook 1950, p. 31.
- 43. The critic for *La Lumière* ("Association Photographique d'Architecture," January 23, 1858, p. 14) particularly admired this study when it was shown at the Architectural Photographic Association in 1858: "Les vues anglaises de M. Fenton sont remarquablement belles, et il n'est pas hors de propos de citer, comme particulièrement réussis, les détails de l'entrée sud du presbytère à Lincoln, et deux vues de la cathédrale de Ely." (Mr. Fenton's English views are remarkably fine, and it is not irrelevant to single out as particularly successful the details of the southern entrance to the presbytery at Lincoln and two views of Ely Cathedral.) Francis Frith included this image and that of the west doors in the portfolio The Works of Roger Fenton—Cathedrals, issued at an unknown date in the 1860s. Presumably he printed from plates of Fenton's that he purchased in 1862 or, conceivably, used prints bought at the same sale.
- 44. The first is reproduced in Lloyd 1988, no. 112, and is listed as being in a private collection. The second is reproduced in an auction catalogue (Bloomsbury Book Auctions, June 1, 2000, lot 18). Prints of the third and fourth are in the NMPFT (RPS Collection).
- 45. A variant of this last image, made slightly earlier the same day, now in the NMPFT (RPS Collection), was unsuitable for reproduction because it showed a defecating dog. Fenton would have immediately become aware

- of that inadvertent inclusion because it was necessary to process the collodion negative right after its exposure in the camera, and this must have led him to make the second view. His perfected view is very similar to one made nearby by William Henry Fox Talbot.
- 46. The GEH and the JPGM have examples of a stereo view entitled West Porch, York Minster that is similar to the closer view. It was not published in the Stereoscopic Magazine until August 1860 and perhaps was made on a later trip. Prints of the view with approximately half the west front are at the HDS and the NMPFT (RPS Collection), and one of the closer view is in the gallery collection of Jane Corkin, Toronto.
- 47. Fenton's library contained a portfolio of eighty-five of Piranesi's engraved views of Rome, so it can be assumed that he was at least moderately familiar with the conventions of architectural drawing. Catalogue of the Library... of the Late Roger Fenton 1870, lot 1082.
- 48. In the 1850s Bedford was Fenton's primary competitor as a photographer of architecture. Before (and at least for a while after) he took up photography he was a draftsman and lithographer, and he portrayed York Minster in all three media. In exhibition reviews the works of the two men were specifically compared; see, for example, "Exhibition of the Photographic Society," *Photographic News*, January 21, 1859, p. 230, in which Bedford is said to be overtaking Fenton as the foremost photographer of landscape and architecture.
- It is of course possible that Winkles altered the proportions in Browne's drawing while engraving it.
- For a twentieth-century example, see the line drawing by Brian Cook in Batsford and Fry 1935, p. 107.
- Each is known from an auction catalogue illustration: Sotheby's Belgravia, March 12, 1982, lot 379, and Bloomsbury Book Auctions, May 30, 2002, lot 10.
- 52. Taylor, Photographs Exhibited in Britain, 2002, pp. 333-36.
- 53. Eighteen fifty-eight was also the year he made Orientalist studies; see "Trying His Hand upon Some Oriental Figure Subjects" in this volume.
- 54. Churton 1851, frontispiece and pp. 146, 148. In conjunction with its descriptions of rail lines this guide contains short accounts of the towns served and of houses of the gentry, like Fenton's in-laws, the Maynards, adjacent to the train routes. I am grateful to Roger Taylor for alerting me to its existence and utility.
- 55. See the discussion of this series on p. 68. Roger Taylor discovered the name of the series; see "A Most Enthusiastic Cultivator of His Art" in this volume, p. 208.
- 56. See Pare 1982, p. 19.
- 57. Prints of two of the chapel photographs are at the CCA; the third is known from an auction catalogue illustration. The Museum of Modern Art, New York, has an axial view of Fenton's showing the piers, and the JPGM and the Sturgis Collection in the

- Washington University Archives, Saint Louis, have images of the arches.
- 58. For a detailed account of the work of the two painters at Salisbury, see Whittingham 1980. Fenton may have known some of their paintings of the site.
- Fenton would necessarily have been familiar with Constable's paintings. The relation of Fenton's work to Constable's, particularly compositionally, deserves study.
- 60. The last-named view, illustrated in this catalogue (pl. 56), is in the GPCC. A view of the nave from the west gallery was commended by the critic for the *Athenaeum* ("Photographic Society," January 15, 1859, p. 86; see also "Exhibition in Suffolk Street," *Photographic Journal*, January 21, 1859, p. 147), but no print of it is now known. A print of an exterior variant made in the bishop's garden is at the CCA. Prints of all the other Salisbury images are at the NMPFT (RPS Collection).
- 61. The lay of the land around Wells was the reason for the view of the cathedral from a distance being taken, uncharacteristically, from behind the cathedral, looking downhill to it and the bishop's palace and gardens. Fenton made three images as he approached the thirteenth-century west front, a fourth of a bridge spanning a road that separated the church from its dependencies, a fifth of the north end of the cathedral, and a sixth of the north porch, with a schoolboy next to a bulletin board.
- 62. Examples of most of the photographs of Wells are at the NMPFT (RPS Collection). A variant view of the west front, the image of the schoolboy in the north porch, and the overall view from afar are in the collection of the HDS. A second variant of the west front is at the GEH. The detail of statues is at the CCA.
- 63. Cutt and Neale 1991, p. 2. Prints of all three images are at the RPS, and one of the lady chapel is also at the Wilson Centre for Photography.
- 64. The resourceful Ken Jacobson brought this view to light.
- 65. The dimensions of the untrimmed prints are approximate, since so few are known.
- 66. The style of the doorway seems just on the cusp between the Early English and Decorated styles. See Fletcher 1961, pp. 498, 508.
- 67. Britton 1836, p. 37 and pl. 3.
- 68. Fairbairns 1928, p. 8.
- During the civil wars of the seventeenth century, the cathedral was bombarded, which may account for some of its visible deterioration.
- 70. Britton 1836, p. 39. Prints of all of Fenton's images of Lichfield are at the NMPFT (RPS Collection). Four are also at the CCA. There is one print in the Sturgis Collection in the Washington University Archives, Saint Louis, and one in a private collection.
- Fenton made two other studies of the east facade, one straight-on like an architectural elevation drawing, the

- other taken at a slight angle from a raised terrace to the north. A print of the former is at the NMPFT (RPS Collection), one of the latter in a private collection in England.
- 72. Prints of all of these images are at the NMPFT (RPS Collection), except that of Fenton in the garden, which was in a private collection in 1988 (Lloyd 1988, no. 133), and some are to be found elsewhere as well.
- The NMPFT (RPS Collection) has the distant view, the GEH the other.
- 74. See *Personal View* 1985, p. 104, pl. 14, commenting on a Fenton photograph of Salisbury Cathedral.
- 75. The exterior photograph of Mentmore, securely attributed to Fenton on the basis of its physical characteristics and on stylistic grounds, is in an album in the Rothschild Archive, London. This picture of Windsor is in the Royal Archives, Windsor Castle, and is reproduced in Dimond and Taylor 1987, p. 56, pl. 43.
- 76. None of its prints are dated. A print of an image of the British Museum entered the museum's collection in 1857, and since Fenton was employed there it may have been the first of what later grew to be a series.
- 77. No print of Highgate Cemetery is known. A small-scale version of the print of Hammersmith Bridge (which has been described as a "grotesque Victorian folly") is at the NMPFT (RPS Collection), and the picture of Saint Mark's Church is in the Jeuffrain album at the SFP. A view of the entrance front of the then newly constructed Holford House, later known as Dorchester House, is reproduced in Stamp 1984, p. 117. Stamp's book is generally valuable for understanding Fenton's London photographs. A print of Holford's street side is at the Royal Institute of British Architects, London. No print of Saint James's Park in the fog has been located. Both Zoological Gardens pictures, which possibly date from as early as 1852, are in an album in a private collection in London, one is also at the JPGM, and one is in the Jeuffrain album at the SFP.
- 78. Thirteen of these photographs are found only in the collection of the National Monuments Record, Swindon (NMR). The Museum of the City of London has three from the series. Prints of the others, numbered or not, are at the NMPFT (RPS Collection), the HRC, the CCA, in private collections, and in the Tolstoy Museum, Moscow.
- 79. Although Fenton was orderly, it seems unlikely that the numbers on the mounts (there are none in the negatives) correspond exactly to the order in which the pictures were made. Had that been the case, Fenton would have set out to create a series and decided to begin across the river looking at Parliament and to end with Buckingham Palace. It seems more likely that he was systematic after the fact—that the numbers were assigned later, when a considerable group had accumulated, and perhaps in conjunction with merchandizing the prints.

- 80. Catherine Evans Inbusch and Marjorie Munsterberg in Pare 1982, p. 228, pl. 11.
- 81. The bridge was demolished in 1860 and its wroughtiron chains used to posthumously complete Brunel's masterpiece, the Clifton Suspension Bridge spanning the Avon Gorge at Bristol, which still stands.
- 82. There may well have been others of the Houses of Parliament, as is suggested by a gap in the numbering series between seven, the most distant view, and twelve, a frontal image of Westminster Abbey.
- 83. These portraits, from the early 1850s, showed little of the rooms in which they were taken. At least one in the group was made outdoors.
- 84. It is in the collection of the NMR.
- 85. Information about the position of Fenton's brother-in-law is provided by Robin Diaper, curator of the nineteenth-and twentieth-century collection at Harewood House, in his intriguing, informative, and as yet unpublished essay, "Tripods and Easels, Roger Fenton at Harewood: New Perspectives," which relies in part on the research of his colleague Karen Lynch; both scholars have very generously made the information available. Some of what follows is directly derived from that essay and research.
- 86. Fenton undoubtedly combined with his work at Harewood House a visit to his father-in-law at Harlsey Hall. Since the two places are a little more than forty miles apart, separate stays would have been necessary, and Grandfather Maynard's mount is likely borrowed. In the Harewood collection there is a closer-up portrait of Maynard on horseback near a standing man who is presumably his son Charles Septimus Maynard.
- 87. It is not clear whether the works by Sandby and Turner were in the house at the time of Fenton's visit or were in another residence belonging to the Lascelles family.
- 88. The specifics of Fenton's commission are unknown, but there is a record of payment to him for photographs.

 Diaper 2003, p. 10.
- 89. Diaper has identified them as most likely being Henry Lascelles, the 4th Earl of Harewood; his second wife; his eldest daughter; two of his sisters; and one of his brothers. Ibid., p. 11.
- The phrase was devised by Henry James to describe a not entirely dissimilar gathering in *The Portrait of a Lady*.
- 91. The remaining three photographs from Harewood were made on the lower terrace. In one, having left someone else (an assistant, his brother-in-law, or a member of the Lascelles family) to lift the lens cap, Fenton posed, leaning on the distant stone balustrade of the upper terrace. Except for a photograph in the collection of a Fenton collateral descendant, the Harewood images are known only in prints at Harewood itself or in the collection of the RPS (now at the NMPFT), to which a Fenton descendant sold or donated them in the 1930s. Since three from the

- series were exhibited in 1861, it is possible that there are unlocated prints.
- 92. Having processed the negative immediately, Fenton could correct in his second exposure anything he deemed inadequate in the first. The self-portrait was offered for sale by Sotheby's, London, May 22, 2003, lot 25.
- 93. The refectory image is illustrated in Lloyd 1988, no. 132, as is an overall view of the college, no. 131. Both prints are in the college's collection. Fenton's connection to Stonyhurst College is unclear, although nearby there were extensive family lands and a mill as well as relations with whom he could stay, and his father's house was less than thirty miles away. See also "On Nature's Invitation Do I Come" by Malcolm Daniel in this volume, p. 47.
- 94. Taylor, *Photographs Exhibited in Britain*, 2002, pp. 55, 393–40. Nearly a hundred of Fenton's photographs of Stonyhurst remain at the school, some in an album presented by Fenton in 1858. Another twelve are at the NMPFT (RPS Collection).
- 95. Pictures of the museum and most of the colleges are at the NMPFT (RPS Collection). The sole Brasenose image is at the Münchner Stadtmuseum. Some Magdalen prints are at the Royal Institute of British Architects, London, two are at the GEH, and many are in the Magdalen College Archive, Oxford. There are likely other Fenton photographs elsewhere in Oxford. Lloyd 1988 illustrates the Magdalen tower photograph, no. 141, and a view of the museum, no. 140.
- 96. Leroux-Dhuys 1998, p. 218. As a Lancashire native Fenton may not have thought of Furness as especially remote. The balance of this expedition was devoted to the production of landscapes in the Lake District, to be exhibited at the Photographic Society.
- 97. Prints of all of the images from the Furness series are in the NMPFT (RPS Collection) and nearly nowhere else except for three in a private collection, one of them a variant not in the NMPFT.
- 98. While in 1854 he was the photographer most favored by the royal family, by 1860, others, including Bedford and John Mayall (1810–1901), had replaced him. See "Mr. Fenton Explained Everything" by Roger Taylor in this volume. According to a Fenton family legend recounted to me by a collateral descendant in June 2003, Fenton's fall from favor was precipitated by his refusing a royal invitation because he stubbornly adhered to a prior engagement, behavior that would have constituted a severe breach of decorum.
- For example, in Molard, October 1856, p. 283; see also *JPS*, no. 47 (October 21, 1856), p. 149.
- 100. The variant of this image in the Hulton Archive shows a different large group of people. Many of them are soldiers with their backs to the camera but nevertheless posed.

- 101. With two exceptions, prints from the Windsor series are to be found only in the Royal Archives, Windsor Castle, and the NMPFT (RPS Collection; as gifts from the Fenton family), which suggests that Fenton may have withheld wide distribution of these pictures, perhaps after selling an album of them to the archive.
- 102. For his entries in these exhibitions, see Taylor, Photographs Exhibited in Britain, 2002, pp. 340–42.

"Mr. Fenton Explained Everything": Queen Victoria and Roger Fenton

ROGER TAYLOR

The title quotation is from Queen Victoria's journal: Victoria, Queen of England, Journal (archival source), January 3, 1854. This manuscript, the only surviving version of the journal, is not the original but a copy transcribed (and doubtless edited) by Princess Beatrice after the queen's death. I would like to thank Frances Dimond, Martin Clayton, and their colleagues at the Royal Archives and Royal Library, Windsor Castle, for their generous help and the access they provided to the collections.

- "On the Ice," ILN, January 7, 1854, pp. 9–10; "Snow Storm," ILN, January 7, 1854, p. 7.
- Sir Charles Wheatstone and Robert Hunt were also in attendance: "Photographic Society," *ILN*, January 7, 1854, p. 6. For the queen's remark, from her journal, see the unnumbered note above.
- 3. "January 21st, 1854," JPS, January 21, 1854, p. 153.
- 4. "Fine-Art Gossip," Athenaeum, June 11, 1853, p. 711.
- Queen Victoria noted, "The cold was dreadful in London, a great deal of snow . . . the streets very slippery." Journal (archival source), January 3, 1854.
- 6. Born in Darmstadt and educated in Edinburgh, Becker (1826–1888) took up his appointment as royal librarian and tutor in May 1851. He was an experienced photographer by that date, and his work survives in several albums in the Royal Photograph Collection, Windsor Castle. In 1862 he became the treasurer to Alice, Princess Louis of Hesse. Pangels 1996.
- The term "rational recreation" was widely used in the nineteenth century. See Bailey 1987.
- Privy Purse Accounts (archival source): PP2/5/4343,
 The Photographic Institution, April 1854, for prints and attendance of P. H. Delamotte at Buckingham Palace; PP2/6/4508, William Spooner, May 1854, for photograph albums; PP2/6/4607 and PP2/7/4863, Horne, Thornthwaite & Wood, May and September 1854, for photographic supplies; PP2/6/4633, William Duguid, May 1854, for a portable darkroom and portrait room for Buckingham Palace.

- 9. Although it was widely believed and reported that both the queen and Prince Albert dabbled in photography, there is not a shred of evidence to support the claim. Surely, any photographs taken by the prince would have been carefully preserved for posterity by Queen Victoria following his premature death in December 1861.
- 10. Les Deux Petits Savoyards, a one-act "opera comique," was composed by Nicolas-Marie Dalayrac (1753–1809). The version presented by the royal children must have been a special adaptation performed as a narrative. In her Journal (archival source), January 16, 1854, the queen calls it a "comedie en une act" and refers to "the little performance." The choice of this play is probably an expression of the close Anglo-French relations of the period—when, for the first time in the nineteenth century, France was regarded as an ally by the court, politicians, and the nation at large.
- 11. Ibid.
- 12. Ibid., January 23, 1854. The dating of Fenton's photographs in the Royal Photograph Collection is complex. When the prints were mounted into albums and inscribed, often years after they were made, the assignment of dates was arbitrary. Some dates are those of the event that the photographs commemorate, others refer to when the photographs were made, and still others seem to have no apparent significance. The last is the case with the *Savoyards* pictures, which are inscribed February 1, 1854, a date that relates neither to the performance nor to the making of the photographs.
- 13. Perhaps the youngest performers—Prince Arthur, just three months away from his fourth birthday, and Princess Louise, aged five—could not endure the long exposures, for photographs of them seem not to exist.
- 14. Privy Purse Accounts (archival source), PP2/8/5080, William Bambridge invoice covering the period June— December 1854 for photographing dogs, deer, elk, oxen, pigs, and pugs in the kennels and dairy farm at Windsor.
- Victoria, Queen of England, Journal (archival source), February 10, 1854.
- 16. Ibid.
- Millar 1995, p. 393. And see Baldwin 1996, pp. 40–41, fig. 19.
- 18. For a listing of the households of Queen Victoria and Prince Albert, see *British Almanac* 1854, p. 38. Absent from these lists are the countless numbers of domestic servants, grooms, stable boys, and others essential to the smooth running of the court.
- 19. Kelly's Handbook 1879, preface.
- For an account of the distinctions between a Levee, Drawing Room, Court, and Audience, see *Court Etiquette* 1849.
- 21. "Court," ILN, May 13, 1854, p. 434.
- See "Russo-Turkish War" 1904, pp. 1086–88. An excellent source on the Crimean War is Massie 2003.

- 23. Martin 1874-79, vol. 3, p. 188.
- Victoria, Queen of England, Journal (archival source), June 30, 1854.
- 25. In all likelihood Fenton used this letter to establish his credentials, photographic and otherwise, with the British ambassador upon his arrival in Constantinople. He probably relied on the same missive when meeting Lord Raglan and others in need of persuasion. For the text of the letter, see Gernsheim 1954, p. 41.
- 26. Most notable were the commissions undertaken by the Photographic Institution, where Delamotte and Robert Howlett both worked as photographers. See Privy Purse Accounts (archival source), PP2/4/4035, PP2/5/4343, PP2/20/7254.
- 27. A story told in the Fenton family suggests that Fenton fell out of favor after declining a summons from Prince Albert to be present on some occasion. The few examples of his work from this later period clearly indicate that the relationship had altered, but whether because of this perceived slight or because of a change in the royal family's attitude toward photographers in general is unresolved. Whatever the truth, for the Fentons it was obviously a matter of rejection and loss.
- 28. Two studies of Princess Victoria and Princess Alice are known to have been made, and the negative for one of these has survived in the Royal Archives. The negative has overall dimensions of 18 x 15 inches and carries cropping marks by Fenton that would produce prints of approximately 14 x 13 inches.
- 29. Unfortunately there is no surviving invoice for this sitting, which has been dated from a sequence of events recorded in the queen's diary. Princess Alice first showed signs of scarletina on July 23 and was "recovering" by August 1. By August 14 she was "going on well, but [had] not yet been out"; and on the evening of August 17 the Princess Royal left Osborne with her parents for the journey to Paris. This leaves August 14−17 as the likely period during which the portrait was made. Victoria, Queen of England, Journal (archival source), July 23 to August 18, 1855.
- 30. Records for the 1856 annual exhibition of the Photographic Society of Scotland list thirty-six views made by Fenton during his trip to Balmoral by way of Newcastle, Jedburgh, Holy Island, Edinburgh, Dunkeld, and Roslin. Taylor, *Photographs Exhibited in Britain*, 2002, pp. 328–29.
- 31. Privy Purse Accounts (archival source), PP2/22/7526, invoice from Roger Fenton to Queen Victoria. This invoice covers the period from August 1855 to January 1857 and gives details of Fenton's commission in Balmoral with the numbers of prints purchased.
- 32. Ibid. This invoice includes two items for wooden boxes made to house "Her Majesty's" negatives. By January 1857, Bambridge was effectively in charge of the queen's growing collection of privately commissioned negatives.

He was kept extremely busy during that year both with new photography and with reprinting from existing negatives; his invoice for the period from June 27 to September 23, 1857, amounted to 235 pounds 3 shillings, a considerable sum of money for the period and almost three times the size of Fenton's last invoice. Privy Purse Accounts (archival source), PP2/25/8110, invoice from William Bambridge to Queen Victoria.

"Trying His Hand upon Some Oriental Figure Subjects"

GORDON BALDWIN

The title quotation is from "Exhibition in Suffolk Street," *Photographic Journal*, January 21, 1859, p. 146.

- For an extended discussion of Fenton's exposure to French and English Orientalism, see Baldwin 1996, pp. 22–53. Said 1978 is a thorough, if opinionated, treatment of that cultural phenomenon.
- 2. The pictures can be so dated because Fenton habitually exhibited his newest work, and in December 1858 he showed four photographs on Orientalist themes at the Photographic Society of Scotland, Edinburgh. He showed seven of the same group at the London Photographic Society in January 1859 and later that year showed one in Aberdeen, two in Glasgow, and three in Paris. Société Française de Photographie 1859, p. 25; Taylor, Photographs Exhibited in Britain, 2002, pp. 333, 336–38.
- The sequence, drawn from a larger group of conventional family photographs, is illustrated in Dimond and Taylor 1987, p. 133, nos. 81a-d.
- 4. There are at least three variants. Two are in the Wilson Center for Photography, one of them reproduced here and the other in Baldwin 1996, p. 55, fig. 27. A third is in the collection of the Los Angeles County Museum of Art.
- 5. While the seemingly dark clothing might suggest that the picture is a depiction of mourning, after careful examination Sylvie Aubenas determined that the infant was intended to be seen as sleeping. A second print of this image is at the George Eastman House, Rochester.
- 6. Beards were fashionable in the 1850s, when men emulated returning veterans, who without supplies of hot water, mirrors, and the like had found shaving in the Crimea difficult. Therefore it is often a challenge to identify men in photographs of the period, and the number of times Dillon appears in this suite cannot be fixed with certainty. In plate 63 he is the central figure, in plate 64 the standing man. It was in the Crimea that Fenton first grew the beard that he wore for the rest of his life.

- 7. For valuable information on Dillon's role in the making of these photographs I am deeply indebted to Briony Llewelyn, author of the entry on Dillon in the Oxford Dictionary of National Biography (2004), and to a descendant of Dillon who led me to the portrait of Dillon that clinched the case for his participation in the making of the photographs, but who prefers to remain anonymous. It should be noted that the solo costume studies fall outside the Orientalist suite proper, since there are no props and no attempt was made to hide the machine-made European carpet in Fenton's studio.
- A group of six Egyptian watercolors by Dillon, dated from December 29, 1854, to February 14, 1855, was sold by Christie's, London, on November 9, 1971, lot 109.
- These are the titles of watercolors sold by Christie's, London, on June 9, 1970, lot 12.
- 10. En route to the Crimea Fenton had spent only two days in Constantinople, where he presented his letter of introduction to the ambassador and busied himself with purchasing horses to draw his van and souvenirs for his wife. Gernsheim 1954, pp. 39–42. On the return voyage he was far too ill with cholera to observe much of daily life.
- 11. Mark Haworth-Booth kindly alerted me to the existence of this album, which is in the Royal Engineers Library at the Brompton Barracks, Chatham, Kent, and Maggie Magnuson, the assistant librarian there, supplied very helpful information. The album originally belonged to the sister of Field Marshal Sir J. Lintorn A. Simmons (1821–1903), who was involved in the Russo-Turkish War and had close connections to the Turkish government (which explains the inclusion in the album of Fenton photographs from the Crimea). Subsequent assignments in the Near East may have sparked his interest in the Orientalist pictures. At the time of their making Simmons was consul general in Warsaw.
- 12. Prints from the negatives that he made during the cruise are in the collections of the Getty Research Institute, Los Angeles, and the SFP. De Rumine gave away albums of ten of these photographs to subscribers to *La Gazette du Nord*, a short-lived newspaper that he started in October 1859 to promote Franco-Russian relations and for which he wrote a series of articles describing the Mediterranean voyage. He died of cholera at thirty, leaving a large sum of money to the city of Lausanne for the construction of a palatial public building that was finally erected in 1906.
- 13. Sotheby's, London, April 29, 1982, lot 79 (the two figures) and lot 78 (the woman, standing alone in front of a striped drapery).
- Sotheby's Belgravia, June 25, 1982, lots 168, 169, 171.
 These prints also had a Haag provenance.
- Christie's South Kensington, June 18, 1981, lot 290; June 24, 1982, lot 329; October 28, 1982, lot 164; October 27, 1983, lot 198; October 25, 1984, lot 167.

- 16. It is of course possible that the man and woman wore clothes that they owned or had rented and that they came only once or twice to Fenton's studio. The woman, who appears completely veiled in all five pictures, probably had a social status higher than that of a professional model. The full beard and turban make it impossible positively to determine whether the man also posed in one of the photographs from the larger group.
- Catalogue of the Collection . . . Formed by Roger Fenton, June 13, 1870, lots 98, 99. For related connections between Fenton's and Haag's work, see "Mr. Fenton Explained Everything" by Roger Taylor in this volume, pp. 77–78.
- Haag departed London on August 4, 1858 (personal communication from a descendant).
- Distinguishing the only partly visible features is difficult, but there seem to be four others in addition to Dillon, de Rumine, Haag, and Fenton himself.
- 20. There are two additional images that fall outside the Orientalist suite proper, one in which she is draped only in loose folds of material with one breast bared and another showing her in conventional Victorian dress. This last was likely made for her to keep.
- 21. "We have more than all the detail of a water-colour drawing by John Lewis, and at the same time a low tone of singular breadth and sweetness" is how it was commended by a contemporary reviewer. "Exhibition in Suffolk Street," *Photographic Journal*, January 21, 1859, p. 146.
- 22. In other prints of this subject, such as the one that belongs to a descendant of Dillon, the image is trimmed at the top, cutting off the upper edge of the curtain and the skylight.
- 23. For a more thorough analysis of both props and costumes, see Baldwin 1996, pp. 2–4.
- 24. The painting, Interior of a Room in the House of Shaykh Sadat, is in the Searight Collection at the Victoria and Albert Museum; the photograph—in which a water pipe, requisite adjunct to this kind of decor, can also be seen—is in the hands of a Dillon descendant. The painting is reproduced in Atıl, Newton, and Searight 1995, p. 105.
- For a discussion of the cultural condescension that accompanied these fantasies, see Nochlin 1983, pp. 118ff.
- For an extended discussion of Fenton's exposure to French and English Orientalism, see Baldwin 1996, pp. 22–53.
- 27. The Dillon sketch is in a private collection in Great Britain. Other painters, such as Frederick Goodall, with whose work Fenton was acquainted, show a woman in the same pose; one example by Goodall, in the collection of the Royal Academy, London, is illustrated in ibid., p. 42, fig. 20. For another work by Goodall, see Sotheby's, London, sale catalogue, April 29, 1982, lot 119.
- 28. The variant with the model in the white garment is in a private collection in England. Of the two in which she wears a dark robe, one, in which the vessel is supported by her left hand and a visible wire, is illustrated in the

- Christie's South Kensington sale catalogue, March 15, 1979, lot 270. The other, in which only a (clearly evident) wire balances the jug, appears in the Christie's South Kensington sale catalogue, October 25, 1979, lot 358. In a fifth, different standing pose, she is wholly veiled and rests her hand on the pottery jug; Christie's South Kensington, sale catalogue, June 26, 1980, lot 425.
- 29. "Exhibition of the Photographic Society," *Photographic News*, January 28, 1859, p. 242. "Nubian," an elastic if not euphemistic term, was used to designate dark-complexioned persons as well as inhabitants of the upper Nile area.
- 30. "Photographic Society's Sixth Annual Exhibition," *Photographic Journal (BJP)*, February 1, 1859, p. 35.
- 31. This sensuously posed figure is only very distantly related to Ingres's reclining odalisques of the previous decade, which Fenton may have known. Typically in Ingres's paintings the model's nude or seminude body is opulently displayed, with her arms lifted over her head, leaving her body undefended. Fenton's odalisque is clothed and positioned so that her right arm and the table drum partially shield her from the viewer's gaze.
- 32. Unlike the print of Pasha and Bayadère, this untitled image has been cropped to remove the studio skylight and the European carpet under the Oriental rug, making it likely that Fenton contemplated exhibiting this print.
- 33. The props and background draperies have been thoughtfully rearranged for each image to subtly alter the scene.

Roger Fenton and the Still-Life Tradition

1. I would like to thank the very many people who, in various ways, have contributed to my research. I am grateful: to the Royal Photographic Society and especially its then-Honorary Curator, the late John Dudley Johnston, who in the 1930s had the perspicacity to acquire several hundred wonderful Roger Fenton photographs from Fenton descendants; to the entire staff of the Department of Photographs at the J. Paul Getty Museum, especially Weston J. Naef, Gordon Baldwin, Julian Cox, and Michael Hargraves; to the staff of the Getty Research Institute, especially Charles Salas, Sabine Schlosser, Frances Terpak, and Dominique Loder; to all my colleagues and friends who have inspired me with their knowledge and love of Roger Fenton's work—Anthony Hamber, John Hannavy, Steven Joseph, the late Valerie Lloyd, Hans P. Kraus Jr., Larry J. Schaaf, and Mike Weaver, as well as all those involved in the present publication and exhibition, most especially Roger Taylor; to everyone on the staffs of the Department of Photographs and the Royal Photographic Society at the National Museum of Photography, Film & Television in Bradford,

- UK, especially Brian Liddy, Jane Fletcher, and Siobhan Davis; and to Harry Ellis, Ken and Jenny Jacobson, and Martin Roberts.
- 1. "Photographic Society," Athenaeum, January 15, 1859, p. 86.
- 2. These forty-eight photographs were catalogued and copied in the early 1970s. Sometime in the mid-1970s nine of them disappeared and are presumed to have been stolen, leaving thirty-nine presently in the collection of the Royal Photographic Society (RPS), which now belongs to the National Museum of Photography, Film & Television, Bradford (NMPFT). The lost photographs have almost all resurfaced elsewhere in the intervening three decades.
- Photographic Society, Annual Report of the Council, February 1861, quoted in Johnston 1946, p. 20.
- On Victorian game and fishing seasons, see Beeton 1861; Hartley 1954.
- The exhibition was held at the Gallery of the Society of Painters in Water-Colours, 5A Pall Mall East, London.
- "Photographic Exhibition," Photographic Notes, April 15, 1860, p. 113.
- Robert Wilson Skeffington Lutwidge (1802–1873),
 Dr. Hugh Welch Diamond (1808–1886), and Thomas George Mackinlay (1809–1865) photographed compositions of game.
- "London Photographic Society's Exhibition," BJP, February 1, 1860, p. 42.
- NMPFT (RPS Collection 3081/1 and 3081/2). The title
 is written on the back of the print in the hand of John
 Dudley Johnston, honorary curator of the RPS from
 1926 to 1955.
- The image was exhibited at the British Institution again in 1861 in the form of a smaller version, a "little cabinet gem." "'Golden Age.' By G. Lance," ILN, February 23, 1861, p. 166.
- 11. Ibid.
- 12. See the Chronology in this volume.
- See "A Most Enthusiastic Cultivator of His Art" by Roger Taylor in this volume.
- 14. Macleod 1996, p. 443.
- Artist and Amateur's Magazine 1843, p. 80, cited in Tromans 2000, pp. 44, 54, n. 2.
- Muckley, Manual on Flower Painting, 1855; Muckley, Manual on Fruit and Still-Life Painting, 1886.
- "George Lance, Esq.," ILN, December 21, 1861, 2nd. suppl., pp. 647–48.
- The Vernon donation is now in the collection of Tate Britain, London.
- Despite almost single-handedly reviving interest in the still-life genre, Lance was never admitted to the membership of the Royal Academy.
- Catalogue of the Collection . . . Formed by Roger Fenton, June 13, 1870.
- 21. Witt 1982, pp. 242-43.

- 22. Lewis 1976.
- 23. Photographic Society, Annual Report of the Council, February 1861, quoted in Johnston 1946, p. 20.
- 24. Ibid.
- 25. "London Photographic Society's Exhibition," *BJP*, February 15, 1861, p. 68.
- 26. "Exhibition of Photographs at Manchester," *BJP*, October 1, 1861, p. 345.
- 27. "London Photographic Society's Exhibition," *BJP*, February 15, 1861, p. 68.
- 28. See Taylor, Photographs Exhibited in Britain, 2002.
- 29. The magazine was published by Lovell Reeve, London. For a complete listing of Fenton's photographs published in it, see *Stereoscopic Magazine* Publications Listing (website). For reproductions of each image in the *Stereoscopic Magazine* see *Stereoscopic Magazine* Views (website).
- Celebrated Ivory Carvings, from the Collection in the British Museum, in Stereoscopic Magazine, no. 15 (September 1859), text pp. 207–22; Group of Corals, British Museum, in Stereoscopic Magazine, no. 16 (October 1859), text pp. 239–40.
- 31. Fruit with Ivory and Silver Tankard, in Stereoscopic Magazine, no. 28 (October 1860), text pp. 117–18
- "Address," Stereoscopic Magazine, no. 33 (March 1861), opening page.
- "Photographic Society. Ordinary Meeting. March 2, 1858," JPS, March 22, 1858, p. 170.
- 34. "Address," Stereoscopic Magazine, no. 33 (March 1861).
- "Present High Temperature," Photographic News, July 15, 1859, p. 226.
- "Photographic Society. Ordinary General Meeting. Tuesday, November 1, 1859," *Photographic Journal*, November 15, 1859, p. 73.
- Presumably the chemist and photographer Thomas
 Frederick Hardwich. "Report of the Collodion Committee,"
 Photographic Journal, February 15, 1860, pp. 151–55.
- 38. The reference must be to no. 23 in the Photographic Society's 1861 exhibition, Tribute from China "Latet anguis in herba," the only photograph of a Chinese casket in that exhibition. The Latin phrase, taken from Virgil's Eclogues 3:93, translates "Beware the snake in the grass" and appears to have no relevance to this image, since there is no snake, or grass, in the ivory carving or anywhere else in the picture. However, the proverb was adopted as a family motto by the British Anguish family, using the pun of their name and the word "anguis." In 1843 the last male descendant of the Anguish family died, and the family estate, Somerleyton Hall near Lowestoft in Norfolk, was bought with its contents and much remodeled by Sir Samuel Morton Peto (1809–1889), the builder and railway baron. Peto was also the financier of the railway built in the Crimea running thirty-nine miles inland from Balaklava Harbor and completed on April 7, 1855, for which he received his knighthood. Fenton arrived at Balaklava on

- March 8, 1855, his passage provided by Peto. Peto was also involved in the redesign and rebuilding of the Houses of Parliament, which Fenton photographed. Did Peto, an enthusiastic collector of Indian and Chinese artifacts, invite Fenton to photograph still lifes at Somerleyton Hall, using fruit and flowers from the estate's greenhouses and kitchen gardens and decorative objects from his collection, and was Fenton making a wry reference to the motto of the Anguish family, which Peto had acquired along with their belongings?
- 39. "Chinese Curiosities," *Stereoscopic Magazine*, no. 34 (April 1861), p. 7.
- 40. "Chinese Ivory Casket," Stereoscopic Magazine, no. 34 (April 1861), p. 9. Professor John Obadiah Westwood (1805–1893) is therefore another possible source for the Chinese box and other artifacts.
- 41. See the Chronology in this volume.
- 42. Thompson, February 15, 1861, p. 111.
- 43. "London Photographic Society's Exhibition," *BJP*, January 15, 1861, p. 37.
- 44. Ibid.
- 45. "London Photographic Society's Exhibition," *BJP*, March 15, 1861, pp. 108–9.
- 46. The pineapples were to be sold at auction by Messrs. John and James Adam & Co. of Pudding Lane, Lower Thames Street, London. "Extensive Show of Pine-Apples," ILN, August 6, 1853, p. 80.
- 47. Roger Fenton to Grace Fenton, April 29, 1855, Letter Book (archival source), NMPFT (RPS Collection). On Fortnum & Mason's provision of food to the officers and to Florence Nightingale during the Crimean War, see http://www.fortnumandmason.com.
- 48. The tankard was recognized by a Fenton descendant. In the twentieth century it was used as a biscuit barrel (personal communication).
- "Photography at the International Exhibition," *Photographic Journal*, July 15, 1862, p. 80.
- Stereoscopic Magazine, no. 56 (February 1863), quoted in Hannavy 1976, pp. 89–90.
- 51. "Photographic Society," Athenaeum, January 15, 1859, p. 86.

"A Most Enthusiastic Cultivator of His Art": Fenton's Critics and the Trajectory of His Career

The title quotation is from "Photographic Exhibition at the Society of Arts," *Art-Journal*, February 1, 1853. p. 55.

 See Taylor, Photographs Exhibited in Britain, 2002, pp. 302-43, which lists 1,122 individual records of prints exhibited by Fenton between 1852 and 1862; some of these undoubtedly refer to the exhibition in different venues of the

- same studies. Fenton's work was seen in ninety-six venues in Britain, a total that includes fifty-four cities and towns visited by the touring exhibitions organized by the Society of Arts and the eight venues for his "Crimean Pictures." In addition he exhibited at five shows in Amsterdam, Brussels, and Paris. By way of comparison, his nearest competitor was Francis Bedford, who exhibited some six hundred prints in twenty-three exhibitions. Ibid., pp. 109–33.
- Strictly speaking, it was the photogenic drawing process that Talbot announced in 1839; from it developed the calotype process of 1841, which was quickly taken up by British photographers. See Schaaf 2000.
- 3. Catalogue of the Exhibition of Arts, Manufactures, and Practical Science 1848, p. 66. The handful of photographic entries (albeit interesting ones of Niagara and New York) took their place among hundreds of other items, ranging from a "comb, used by natives of the South Sea Islands" to "specimens of pliers."
- 4. Census of Great Britain, 1851 (London: Eyre and Spottiswoode, 1854), vol. 1, pp. cxxi-cxxv.
- Parliament, House of Commons, Report from the Select Committee of Art Unions 1845; this was the judgment of the artists, printsellers, and others called to give evidence before the Select Committee.
- 6. See Fenton, "Photography in France," Chemist, February 1852, p. 221, where Fenton recalls "the unrivalled productions of [the photographer] Martens" at the Great Exhibition. The earliest known examples of Fenton's photographs are dated February 18, 1852 (see Chronology). Their level of competence suggests that he was already an accomplished photographer by this date.
- For an account of the Great Exhibition and the subject of classification, see Auerbach 1999, chap. 4; Davis 1999, chap. 4. For a detailed contemporary account of photography at the exhibition and the medals awarded, see Reports by the Juries 1852, pp. 243–46.
- 8. Fenton, "Photography in France," *Chemist*, February 1852, p. 221.
- 9. Fenton, "Proposal for the Formation of a Photographical Society," *Chemist*, March 1852, p. 265.
- 10. Joseph Cundall (1818–1895) was a publisher of children's books and other illustrated books with premises in New Bond Street, where in 1853 he established the Photographic Institution with Philip Henry Delamotte (1821–1889). See McLean 1976. His proposal to the Society of Arts is noted in the manuscript minutes of the society's meetings; see Society of Arts, Minutes of Council (archival source), vol. 4, November 17, 1852. The three men's role as organizers of the exhibition is acknowledged in "Exhibition of Recent Specimens of Photography," JSA, December 31, 1852, p. 63.
- 11. "Photographic Exhibition," JSA, January 21, 1853, p. 100.
- Catalogue of an Exhibition of Recent Specimens of Photography 1852. See also Taylor, Photographs Exhibited in Britain,

- 2002, p. 38, for a comprehensive listing of exhibitors. In keeping with the artistic aspirations of the organizers, only prints—and no daguerreotypes—were shown.
- 13. "Photography," ILN, January 1, 1853, p. 11.
- 14. See "Inaugural Meeting of the Photographic Society," JPS, March 3, 1853, pp. 2–5, for a full account of the formation of the society and Fenton's report from the Provisional Committee.
- Fenton, "Upon the Mode in Which It Is Advisable the Society Should Conduct Its Labours," JPS, March 3, 1853, p. 9.
- "Photographic Exhibition at the Society of Arts," Art-Journal, February 1, 1853, p. 55.
- 17. "Interchange of Privileges," JSA, February 18, 1853, p. 147. By that date 113 institutions had joined, and by 1854 the number had increased to 201. JSA, September 29, 1854, suppl., n.p.
- For details of the tour venues and dates, see Taylor, *Photographs Exhibited in Britain*, 2002, pp. 38–40.
- Ibid., pp. 304–9. A third tour was planned and partially executed, but surviving records are patchy and offer no meaningful information on its content or tour venues.
- 20. "Photographic Publications," Art-Journal, December 1, 1852, p. 374, directly compared The Photographic Album with Egypt, Nubia, Palestine and Syria, concluding that Fenton had "made the best of the bad subjects" while Du Camp took the "much higher ground."
- 21. A full-page advertisement details the range and scope of these activities. It also indicates that Cundall took over the publication of *The Photographic Album*, reprinting parts 1 and 2 with "good impressions of the pictures . . . guaranteed" and continuing the series with the publication of parts 3 and 4. *Athenaeum*, no. 1329 (April 16, 1853), p. 485.
- 22. Ibid.
- 23. Prince Albert visited the exhibition at the Photographic Institution in July 1854, doubtless attracted by the opportunity to acquire works for his recently formed collection of photographs. "Court Circular," *Times* (London), July 17, 1854, p. 8.
- 24. A report on how the photographs were displayed is given in *Year-Book of Facts* 1854, p. 229. For a complete listing of photographers, see Taylor, *Photographs Exhibited in Britain*, 2002, p. 38, which contains entries for individual photographers and gives the prices of prints.
- 25. Even at three shillings Fenton's prints lay well beyond the reach of the vast majority of Londoners. At the time, three shillings would buy more than two hundred pounds of coal, and the average wage for a kitchen maid was three to six shillings per week. Book of the Household 1858, p. 489.
- For an explanation of the British class system and the changes it underwent, see Cannadine 1998, chap. 3.
- 27. To get some notion of the scale of this phenomenon for the entire Victorian period, see British Museum, Catalogue of Printed Books: Periodical Publications (London:

- William Clowes, 1899–1900), which contains a comprehensive listing of periodicals published during the nineteenth century. The entries for London alone occupy almost five hundred columns on very large pages.
- 28. Gernsheim 1984, pp. 131-33.
- Circulation figures for the *Illustrated London News* are given in Altick 1957, p. 394. While in 1850 the circulation was 67,000, by 1855 it had increased to 123,000.
- Taylor, Photographs Exhibited in Britain, 2002, pp. 302–43.
 See also Exhibition of the Photographic Pictures Taken in the Crimea by Roger Fenton, Esq. 1855.
- 31. Photographic societies used exhibitions as a means of encouraging the purchase of photographs, listing prices in the exhibition catalogues. See the rules for submission in "Photographic Society," JPS, December 21, 1853, p. 141.
- 32. Jaeger 1995, pp. 133–40. Jaeger lists thirty-five societies established between 1852 and 1861. All would have acknowledged the Photographic Society in London as the parent society to which they turned for guidance and support.
- 33. Taylor, Photographs Exhibited in Britain, 2002, pp. 302-43.
- 34. Sinclair submitted prints by other well-known photographers in addition to Fenton, including Édouard Baldus, Bisson Frères, Caldesi & Montecci, Le Gray, Henry Hering, and Maull & Polyblank (see individual entries in ibid.). Sinclair in later years became honorary secretary of the Edinburgh Photographic Society. I am grateful to my colleague Sara Stevenson of the Scottish National Portrait Gallery, Edinburgh, for this information.
- 35. Reviews for exhibitions of the Photographic Society of Scotland have been preserved as press clippings and are now kept in the National Archives of Scotland, Edinburgh, with those for 1858 in file B40 438. I am grateful to Peter Stubbs for these references; see his website at http://www.edinphoto.org.uk/index.htm.
- "Photographic Album," Athenaeum, November 13, 1852, p. 1247.
- "Photographic Publications," Art-Journal, December 1, 1852, p. 374.
- "Photographic Exhibition at the Society of Arts," Art-Journal, February 1, 1853, p. 55.
- Full details for the Committee of the North London School of Drawing and Modelling are given in the Almanack of the Fine Arts 1852, p. 138.
- 40. Under Hall the Art-Journal became one of the most influential periodicals of the period and, through his forthright editorial style, did much to stimulate public appreciation of art. His autobiography contains ample indication of his position within the nineteenth-century art establishment. Hall 1883.
- "Exhibition of the Photographic Society," Art-Journal, February 1, 1854, p. 49.
- 42. "Exhibition of Photographs," *ILN*, February 17, 1855, p. 166. This was the final review, the others having been

- published on January 27, 1855, p. 95, and February 10, 1855, p. 141.
- 43. This passage is from "English Photography," *Liverpool Photographic Journal*, December 8, 1855, p. 146, which printed a translation of a small portion of the original article in the *Bulletin de la Société Française de Photographie* (see Périer, November 1855, p. 317).
- 44. "Exhibition of Photographs," ILN, February 17, 1855, p. 166. The wood engraving was not the first reproduction of Fenton's photographs published by the Illustrated London News. The previous year, on February 4, 1854, a small wood engraving of his Russian Peasants was used to illustrate an article ("A Group of Russian Peasants," p. 88).
- 45. Fenton was awarded a "médaille de première classe" for photographs; see "Exposition Universelle," *Photographic Notes*, January 1 and 25, 1856, p. xix. The unprecedented entente cordiale that existed between Britain and France at this time was a direct consequence of their political alliance to go to war against Russia in the Crimea. Fenton's photographic achievements there must have been well known to the French authorities, as he was summoned to meet the emperor when he and William Agnew Jr. were visiting Paris. See entry for September 7, 1855, in the Chronology.
- "Photographs from the Crimea," Athenaeum, September 29, 1855, p. 1117.
- 47. "Photographs from Sebastopol," Art-Journal, October 1, 1855, p. 285.
- 48. "Crimean Exhibition," Athenaeum, March 22, 1856, p. 363. The "Crimean Exhibition" of William Simpson (1823–1899) was held at the French Gallery, 121 Pall Mall, London, in premises adjacent to Fenton's exhibition, where it undoubtedly offered a very different view of events.
- "Photographs from Sebastopol," Art-Journal, October 1, 1855, p. 285.
- 50. In April 1856 Fenton chaired a meeting at the Society of Arts at which Pretsch read a paper "On Photo-Galvanography, or, Engraving by Light and Electricity"; "Nineteenth Ordinary Meeting," JSA, April 25, 1856, pp. 385–89. See also "Photogalvanography," Photographic Notes, May 25, 1856, pp. 60–62.
- 51. "Fine Arts," Athenaeum, January 24, 1857, p. 120; "Photographic Art Treasures," Athenaeum, February 14, 1857, p. 198. For a contemporary account of the process and its history, see "Photogalvanography," Art-Journal, July 1, 1856, pp. 215–16. Within the history of photography, the development of photomechanical reproduction and the role of the Patent Photo-Galvanographic Company deserve wider attention.
- 52. Photographic Art Treasures 1856; Photographic Notes, November 15, 1856, p. 235.
- J. H. Bolton to William Henry Fox Talbot, May 1, 1857,
 Lacock Abbey Collection LA57-015 (archival source);
 Talbot Correspondence Project (website), doc. 07399.

- Bolton, Talbot's lawyer, reports that the Patent Photo-Galvanographic Company has losses amounting to four thousand pounds and is in chancery following a dispute with the manager of the company. The company was further undermined when it was recognized that Pretsch's patents conflicted with preexisting patents taken out by Talbot for his photoglyphic engraving process.
- 54. "Photographic Association," JPS, May 21, 1856, n.p.
- 55. The Photographic Association seems to have been established in direct response to the new opportunities offered by the Limited Liability Act, which had become law in August 1855. It allowed joint stock companies to issue shares with a nominal value of not less than ten pounds and gave new protection to shareholders. Companion to the Almanac 1856, p. 110.
- 56. "Photographic Society. Ordinary Meeting. May 1, 1856," JPS, May 21, 1856, p. 38. The published account of this meeting is brief. A transcription from shorthand notes taken at the meeting, which offers a fuller account, is in the NMPFT (RPS Collection); see Photographic Society, Manuscript Notes (archival source).
- Photograph Society, Manuscript Notes (archival source), p. 9.
- 58. Under this ruling, even eminent photographers such as Mayall could never be admitted to the Council.
- "Photographic Society. Ordinary Meeting. May 1, 1856,"
 JPS, May 21, 1856, p. 38.
- 60. "Photographic Society. Annual General Meeting. February 5, 1857," *JPS*, February 21, 1857, p. 222.
- 61. Fenton exhibited in Aberdeen, "Notes on the Photographic Exhibition at Aberdeen," Photographic Journal (BJP), October 1, 1859, pp. 243-44; Blackheath, Photographic Journal (BJP), no. 93 (May 1, 1859), p. 103; Edinburgh, Photographic Society of Scotland, Records (archival source), file B40438; Glasgow, "Glasgow Photographic Society," Photographic Journal (BJP), June 1, 1859, p. 139; Halifax, "Conversazione of the Halifax Literary and Philosophical Society," *Photographic News*, January 28, 1859, pp. 249-50 (in this instance work submitted by a local collector); London, "Photographic Society's Sixth Annual Exhibition," Photographic Journal, (BJP), February 1, 1859, pp. 34-36; Macclesfield, "Macclesfield Photographic Society's Exhibition," Photographic Journal (BJP), March 1, 1859, p. 60; Nottingham, "Nottingham Photographic Society's Exhibition," Photographic Journal (BJP), February 1, 1859, p. 36; and Paris, "Foreign Science," Photographic News, April 21, 1859, pp. 77–79.
- "Exhibition of Art Treasures at Manchester," Liverpool and Manchester Photographic Journal, July 15, 1857, p. 145.
- 63. "Exhibition," JPS, May 21, 1858, p. 208.
- "Photographic Society's Exhibition," Builder, February 20, 1858, p. 133.
- 65. "Photographic Exhibition," *Art-Journal*, February 1, 1859, p. 46.

- 66. Taylor, Photographs Exhibited in Britain, 2002, pp. 336–38. In addition to Thomas Agnew in Manchester, Fenton seems to have been well represented by printsellers in Scotland, including Colin Sinclair, White & Barr, and John Werge; see the exhibition records for the 1859 annual exhibition of the Glasgow Photographic Society.
- 67. "Photographs," Athenaeum, November 27, 1858, p. 694.
- 68. Along with Fenton's photographs Gladwell advertised his "celebrated collection . . . numbering upwards of 1,600 of the finest specimens produced," including works by Bisson Frères, Le Gray, and other, anonymous foreign photographers. Ibid. The main branch of Gladwell's business was at 21 Gracechurch Street, London, the other a few doors away at 87 Gracechurch Street, where it operated under the name City Stereo-scopic Depot.
- 69. No other advertisements promoting Fenton's photographs in the 1850s have been located.
- 70. "Photographs," Athenaeum, November 27, 1858, p. 694.
- "Exhibition of Photographs at the South Kensington Museum," Liverpool and Manchester Photographic Journal, March 1, 1858, p. 61.
- 72. "Photographic Exhibition," *Art-Journal*, April 1, 1858, p. 120.
- 73. "Photographic Exhibition," *Art-Journal*, February 1, 1859, p. 46.
- "Photography at the International Exhibition," Photographic Journal, July 15, 1862, p. 80.
- 75. "Retirement of Mr. Fenton," *Photographic Journal*, October 15, 1862, p. 158.

"The Exertions of Mr. Fenton": Roger Fenton and the Founding of the Photographic Society

PAM ROBERTS

The title quotation is from "Retirement of Mr. Fenton," *Photographic Journal*, October 15, 1862, p. 158.

- It was later known at different times as the Photographic Society of London, the Photographic Society of Great Britain, and finally the Royal Photographic Society (now often abbreviated RPS).
- 2. There have been unsupported claims that he was a member of the Photographic Club (also known as the Calotype Club) formed in 1847 by Peter Wickens Fry, Robert Hunt, and others: see Gernsheim 1969, p. 176. But these are disputed by various researchers writing subsequently: Lloyd 1988; Hannavy 1993, pp. 233–43; and the present catalogue.
- Fenton, "Proposal for the Formation of a Photographical Society," Chemist, March 1852, p. 265.
- 4. "Introductory Address," JPS, March 3, 1853, p. 1.
- 5. "Calotype Society," Athenaeum, December 18, 1847, p. 1304.

- 6. One of the few exceptions was Charles Wheatstone, professor of experimental physics at King's College, London, and inventor of the reflecting stereoscope and later a founder and vice president of the Photographic Society.
- 7. Taylor 1999, pp. 59-67.
- 8. Almanack of the Fine Arts 1852, p. 155.
- Also sometimes present was Dr. Hugh Welch Diamond;
 Archer had been his medical patient.
- "Report of the Jurors," JPS, December 15, 1862, p. 192.
 Dr. Hugh Diamond was among the jurors writing this report.
- 11. Details of the process, location, date, and photographer are written in ink on two paper labels on the back of the glass, in two different, contemporary hands. The upper label, most likely in Archer's own hand, reads, "Entrance to Beddington Park/whitened with Bichloride of Mercury/F. S. Archer." The lower label, in an unknown hand but possibly Fry's, reads, "Exhibited at Mr. Fry's house/in 1851 to the Members of the/Photographic Club." This item, badly damaged during World War II and remounted in 1957, is in the NMPFT (RPS Collection). The 1851 date could be a reference to the 1850 meeting that is wrong by a year, but it is more likely correct. The episode suggests that there was huge interest in Archer's experiments with collodion. He became a frequent visitor at the club's meetings, although not formally a member.
- 12. It should be noted, however, that Talbot had offered an arrangement in which society members would be able to sell photographs from their headquarters through the secretary, with 10 percent of the profit going to form a fund for the benefit of the society.
- "Inaugural Meeting of the Photographic Society," JPS, March 3, 1853, p. 3.
- 14. Hunt to Talbot, March 23, 1851, Lacock Abbey Collection LA51-009 (archival source); Talbot Correspondence Project (website), doc. 06399. The originally written date of 1850 was changed to 1851 in Hunt's hand.
- 15. NMPFT (Talbot Collection TALBT/7/5). In recent research, Marian Kamlish has suggested that Antoine Claudet, a French photographer living in England, was the author of this unsigned, undated document. While the thesis is persuasively argued, it seems unlikely: Talbot and Claudet were colleagues, even friends, and were in frequent correspondence for many years (although correspondence for the critical year of 1851 is missing), and there is no reference to this draft in their later correspondence. Moreover, Claudet was supportive of Talbot's patent rights rather than highly unsupportive, as this document is. For full details, see Kamlish 2002, pp. 296–306; Kamlish 2003, pp. 389–90; Taylor 2003, pp. 386–88.
- Talbot to Hunt, unsent draft of a letter, November 6 and 7, 1851, NMPFT (RPS Collection 141a; archival source); Talbot Correspondence Project (website), doc. 06507.

- 17. Fenton, "Photography in France," February 1852, pp. 221–22. Others probably favored such a step, but Fenton seems to have galvanized the group: "Eventually Mr. Roger Fenton, aided by Mr. Vignoles, conceived the idea of a Photographic Society. The suggestion was warmly entertained by Mr. Fry, Mr. Robert Hunt and a few others." "London Photographic Society. Report," BJP, February 15, 1861, p. 70.
- Fenton, "Proposal for the Formation of a Photographical Society," *Chemist*, March 1852, p. 266.
- Fenton, "Proposal for the Formation of a Photographical Society," undated (probably January–February 1852; archival source).
- 20. Hunt to Fry, March 5, 1852; NMPFT (RPS Collection; archival source); quoted in full in Johnston 1946, p. 2.
- 91 Ibid
- Hunt to Talbot, March 19, 1852, Lacock Abbey Collection LA52-015 (archival source); Talbot Correspondence Project (website), doc. 06580.
- Talbot to Hunt, March 24, 1852, NMPFT (RPS Collection T/2 1279; archival source); Talbot Correspondence Project (website), doc. 06585.
- Hunt to Talbot, April 28, 1852, Lacock Abbey Collection LA52-023 (archival source); Talbot Correspondence Project (website), doc. 06600.
- Wheatstone to Talbot, April 21, 1852, Lacock Abbey Collection LA52-019 (archival source); Talbot Correspondence Project (website), doc. 06596.
- 26. Fenton was making stereoscopic images for Wheatstone's reflecting stereoscope on June 15, 1852, and he continued to take stereoscopic images for Wheatstone later that year in Russia. For more detailed information, see Hannavy 1993, pp. 233–43. See also Joseph 1985, pp. 305–9.
- 27. Hannavy 1988, pp. 193-204.
- 28. Talbot to Eastlake, June 9 and 10, 1852, NMPFT (RPS Collection T/2 1274B; archival source); Talbot Correspondence Project (website), doc. 06639. See also Talbot to Rosse, June 10, 1852, NMPFT (RPS Collection T/2 1274E; archival source); Talbot Correspondence Project (website), doc. 06640.
- Eastlake and Rosse to Talbot, July 1852, NMPFT (RPS Collection T/2 1273; archival source); Talbot Correspondence Project (website), doc. 06653.
- "Photographic Patent Right," Times (London), August 13, 1852, p. 4.
- Le Neve Foster (great-grandson of the Photographic Society's Peter Le Neve Foster), June 23, 1939, pp. 818–23.
- 32. For a more detailed description of the exhibition, see "A Most Enthusiastic Cultivator of His Art" by Roger Taylor in this catalogue.
- Fenton, "On the Present Position and Future Prospects of the Art of Photography," in *Catalogue of an Exhibition* of Recent Specimens of Photography 1852, p. 8.

- Dante Gabriel Rossetti to Ford Madox Brown, January
 1853, quoted in *Praeraphaelite Diaries and Letters*, ed.
 William Michael Rossetti (London: Hurst and Blackett,
 1900), p. 31.
- Photographic Society, "Inaugural Meeting of the Photographic Society & Rules of the Photographic Society," NMPFT (RPS Collection; archival source).
- See "Inaugural Meeting of the Photographic Society," JPS, March 3, 1853, p. 4.
- 37. Ibid.
- 38. Ibid., pp. 4-5.
- 39. "Photographic Society. First Ordinary Meeting. Thursday, February 3, 1853." JPS, March 3, 1853, p. 5. See also Newton, March 3, 1853, pp. 6–8; Percy, March 3, 1853, pp. 9–11; Fenton, "Upon the Mode in Which It Is Advisable the Society Should Conduct Its Labours," JPS, March 3, 1853, pp. 8–9.
- Quotation from an unnamed source, 1850s; website of the Geological Society, www.geolsoc.org.uk/template.cfm?name=BH520.
- 41. Although William Ewart Gladstone spoke in the British Parliament in 1854 in support of spending 140,000 pounds to buy the Burlington House site and relocate the various learned societies there from their former home at Somerset House (which the government wanted to use for other purposes), the move began only in 1873, after two decades of discussion.
- 42. Moreover, membership began to drop, and on average the rooms were visited by only a single member a week. The society vacated the premises in 1860 and resumed the frequent changes of location that have dogged it for the last 150 years.
- The stepdaughter of Lord Palmerston (shortly to be prime minister), the viscountess was later a photographer herself.
- 44. "Exhibition of the Photographic Society," *Morning Chronicle*, January 4, 1854.
- 45. Ibid.
- 46. "Photographic Society," Athenaeum, January 7, 1854, p. 23.
- 47. "Photography and the Photographic Exhibition," *Builder*, January 21, 1854, p. 27.
- Talbot to Story-Maskelyne, December 4, 1854, Lacock Abbey Collection (archival source); Talbot Correspondence Project (website), doc. 07013.
- 49. See "A Most Enthusiastic Cultivator of His Art" by Roger Taylor, in this volume.
- Photographic Society Club, Rules of the Photographic Society Club Album, 1856, Rule 1, NMPFT (RPS Collection; archival source).
- 51. Other clubs having a crossover membership with the Photographic Society were formed around this time, including the Photographic Club (1855–57), the Photographic Exchange Club (1855–58), and, a few years later, the Amateur Photographic Association (1859–late 1860s).

- Photographic Society Club, Rules of the Photographic Society Club Album, 1856, Rule 8, NMPFT (RPS Collection; archival source).
- 53. Photographic Journal, no. 80 (March 5, 1859), p. 203.
- 54. It was not until more than sixty years later, in 1926, that the society began collecting in earnest, under the honorary curatorship of John Dudley Johnston.
- "Photography at the International Exhibition," *Photographic Journal*, July 15, 1862, p. 80.
- "Retirement of Mr. Fenton," *Photographic Journal*, October 15, 1862, p. 158.
- 57. Johnston 1946, p. 30.
- 58. "Late Mr. Roger Fenton," BJP, August 20, 1869, pp. 400–401. See also "Obituary," Photographic Journal, September 15, 1869, p. 126, and "Obituary," Photographic News, August 27, 1869, p. 419.

Roger Fenton: The Artist's Eye

RICHARD PARE

- 1. Years of engagement with the work of Roger Fenton have brought me into contact with many like-minded colleagues. I am grateful especially to Phyllis Lambert, who entrusted me with the task of exploring the broad subject of architectural representation in photography and assembling a collection that would become one of the core holdings of the Canadian Centre for Architecture. Through this undertaking I first saw the view of Ely Cathedral from the south in the gallery of the late Harry Lunn in 1976, occasioning the first of many discussions between us on the works of Fenton. Others to whom I am indebted for insights on Fenton's photography include Robert Hershkowitz, Mark Holborn, and Hans Kraus; David Travis at the Art Institute of Chicago; and Adrienne Lundgren, Preservation Specialist, Library of Congress, who brought to my attention the prints from Fenton's own collection in the library's archives. I would especially like to acknowledge Pavel Horoshilov, Deputy Minister of Culture of the Russian Federation, who told me of the remarkable album that includes works by Fenton in the collection of the Tolstoy Museum, Moscow, and kindly arranged for photography of the two works illustrated here. I am grateful to Vitaly Remisov, Director of the Tolstoy Museum, and Anna Kolupaeva, head of its Department of Culture; to Yuri Palmin for carrying out the photography on very short notice; and to Alexander Brodsky for invaluable coordination of the work in Moscow.
- Surprisingly few pictures were made of industrial activity in photography's early days. It was not until about 1870 that John Thomson, Thomas Annan, and James Mudd made the inner city and its inhabitants a subject of their photography.

- Both "green and pleasant land" and "dark Satanic mills" are from William Blake's poem "Jerusalem."
- 4. Although according to Thomas Huxley, Chambers displayed "prodigious ignorance and thoroughly unscientific habit of mind," Chambers's work was indicative of a growing intellectual restlessness with the biblical idea of creation. Huxley's remark is quoted in Dodds 1952, p. 190.
- 5. William Smith, A Delineation of the Strata of England and Wales, with Part of Scotland (London: J. Carey, 1815). Smith's map is displayed in the rooms of the Geological Society, Burlington House, London. For a full account of his life, see Simon Winchester, The Map That Changed the World: The Tale of William Smith and the Birth of a Science (London and New York: Viking, 2001).
- 6. In a letter written while on the way out to the Crimea, Fenton mentions seeing Gibraltar for the second time. "The old Rock has got his cap on and looks very sleepy, not half so brisk as the last time I saw him; no doubt if he could speak he would say, 'And you the same, old fellow.'" Gernsheim 1954, p. 35.
- 7. See Hershkowitz 1980, pl. 22.
- For a full discussion of the Crimean campaign, see Hibbert 1961.
- 9. See Russell 1855.
- For a somewhat different reading of Fenton's Crimean photographs, see "A New Starting Point" by Sarah Greenough in this volume, pages 19–22.
- 11. Fenton's Photographic Pictures of the Seat of War in the Crimea was published by Thomas Agnew in three portfolios in 1855 and 1856. Panorama views were available as individual prints (see the Chronology in this volume, September 22, 1855).
- Fenton made at least two other views of the cemetery on Cathcart's Hill; see Gernsheim 1954, pl. 48; Keller 2001, p. 157, fig. 128.
- 13. Plate 20 in this volume, though not presented as part of the panorama in the published portfolio, is another view from the sequence. It fits in as ninth in the series, connecting with adjacent images on both left and right. This raises questions about the selection Fenton made for the panorama and his objectives in preparing it. One possible explanation for the sequential discontinuities is that instead of working from a single vantage point and creating a 360-degree radial view of the valley (his first and last panels do not connect), Fenton made a sequence that on occasion moves laterally along the ridge. It is also worth noting that the last two images on the right of the panorama, showing the cemetery, were made later than the other photographs, at a time when the ground was more worn and more graves had been added. A set of prints from Fenton's own collection, including variants, is in the collection of the Library of Congress, Washington, D.C.

- 14. Gernsheim 1954, pl. 65.
- For the photographs of Pélissier and Russell, see Hannavy 1976, pls. 21, 23.
- 16. This was pointed out in Keller 2001, p. 138.
- 17. A Soviet-era housing settlement now stands at the head of the valley where the Russian batteries were positioned.
- For an engrossing account of the circumstances leading to the charge of the Light Brigade (immortalized by Alfred, Lord Tennyson), see Woodham Smith 1953.
- Victoria, Queen of England, Journal (archival source),
 August 8, 1855, quoted in Hannavy 1976, p. 61.
- Robert Whelan, Robert Capa: The Definitive Collection (London: Phaidon Press, 2001), p. 81, no. 110.
- 21. There are two versions of this image. In one version the cannonballs are seen as they fell (Gernsheim Collection, HRC; reproduced in Keller 2001, p. 134, fig. 100), while in the version published in this volume, shot appear to have been rearranged to produce a more dramatic rendering of the subject. It was common practice for parties to be sent out to collect the round shot so that they could be fired back again.
- 22. See Gernsheim 1954, p. 69.
- 23. "I had hoped to add to the collection of views which I had formed, photographs of the scenes since so ably depicted by Mr. Robertson, and with that view made everything ready for going into Sebastopol after the attack of the 18th of June, which we all knew to be impending, and which everybody had settled was to succeed so surely. . . . When that attempt failed, and to the list of friends already sacrificed were added new names, I felt quite unequal to farther exertion." Fenton, "Narrative of a Photographic Trip," JPS, January 21, 1856, p. 290.
- 24. Ibid
- 25. It is tantalizing to speculate on the relationship between Le Gray and Fenton, two photographers whose careers run parallel in many areas. The echoes of a shared photographic vocabulary, both technical and aesthetic, are ever present.
- 26. John Webster, *The Duchess of Malfi*, act 5, scene 3, lines 11–13.
- 27. There is no known print from Fenton's hand of this image. The surviving example, which is in a small format and is in the collection of the CCA, was printed by the Frith establishment after the firm acquired Fenton's negatives in the sale of his studio contents.
- 28. This photograph and fig. 78 are from a group of Fenton prints in a remarkable album in the collection of the Tolstoy Museum, Moscow. The album also includes works by Bisson Frères and Baldus, and previously unrecorded major works by Fenton and Le Gray.

 The phrase "chartered Thames" is from William Blake's poem "London."
- 29. Dimond and Taylor 1987, p. 148, no. 115.

A Chronology of the Life and Photographic Career of Roger Fenton

ROGER TAYLOR AND GORDON BALDWIN

- See "Failure as Viewed in Heywood," Heywood Advertiser, ca. 1878, n.p. This article gives a detailed historical account of the Fenton family up to the collapse of the Fenton bank in 1878 and provides many valuable insights.
- Greenall Family of Dutton Papers (archival source), DDX 445/1/3, DDX 445/1/4. The printed particulars of the sale and the signed agreement between Fenton and Weld reveal precisely what land and buildings were acquired, including bobbin mills in Hurst Green and elsewhere.
- 3. Stenton 1976, p. 136.
- Reported in "Mr. Roger Fenton's Photographs," Rochdale Weekly Banner, October 6, 1855.
- 5. Honourable Society of the Inner Temple, Admission Stamp Duty Register (archival source), 1837–42, ADM/4/12. We are grateful to Dr. Clare Rider, Archivist, Honourable Society of the Inner Temple, London, for this and other information. For a concise history of the Inns of Court and Chancery, the Inner and Outer Temples, and their place in the British legal system, see Encyclopaedia Britannica, 11th ed., s.v., Inns of Court.
- Burke 1906, p. 574. Joseph Fenton's true value was rumored to be double this figure, for some estates were bought jointly in the names of his two sons and himself. His will can be downloaded at www.documents online.pro.gov.uk.
- 7. Boase 1965, p. 1097.
- Post Office London Directory, 1846 (London: W. Kelly, 1846), p. 181; Public Record Office, Kew, Register of Passports, volume beginning September 4, 1841.
- 9. General Register Office, London, District of Northallerton, Register of Marriages (archival source), vol. 24, p. 337. Relatively little is known of the Maynard family and the extent of their holdings in Yorkshire and elsewhere, but as with other members of the elite group known as the "Upper Ten Thousand," their lineage and family connections ensured their status in society.
- 10. "29 juin 1844, Roger Fanton [sic], [age] 25, [adresse] rue d'Alger 5, [nom du maître] Michel-Martin Drolling." Musée du Louvre, Registre des cartes d'élèves (archival source), 1840–45, p. 173, entry 2432.
- 11. Lloyd 1988, frontis. This work is no longer believed to be a self-portrait.
- Family Record Centre, London, Census Returns for 1861, microfilm, RG/99/128. The entry for the Fenton

- household confirms that Annie Grace was born in Paris, noting that she was nevertheless a "British subject."
- 13. Kamlish 2002, p. 302, n. 17.
- "Calotype Society," Athenaeum, December 18, 1847,
 p. 1904. Two years later it was also known as "The Photographic Club"; "Photographic Club," Art-Journal, August 1, 1849, p. 262.
- 15. Although Gernsheim asserts that Fenton was a member of the Calotype Club, his name is not mentioned in the articles cited in note 14 above. See Gernsheim 1969, p. 176. See also Almanack of the Fine Arts 1852, p. 155, the longest account, which also fails to mention Fenton.
- 16. Brown 1981, entry for February 25, 1848.
- Ibid., entries for June 3, November 29, December 2, and December 12.
- 18. Graves 1904-5, vol. 3, p. 98.
- 19. Ibid.
- 20. Brown 1981, p. 70, n. 2. Almanack of the Fine Arts 1852, p. 138, gives the best account of the school and its management committees. For a wood engraving showing the activities of the school, see fig. 7 in this volume.
- 21. Her name is missing from the census returns for 1861 (Family Record Centre, London, microfilm, RG/99/128) and absent from all subsequent genealogies compiled by the family.
- Maynard, Diary (archival source), July-September 1850.
 We are grateful to Scott and Donise Ferrel for granting us generous access to Maynard's diaries.
- 23. Ibid., November 8, 1850.
- Honourable Society of the Inner Temple, Admission Register (archival source), 1842–68, ADM/2/8.
- "Royal Academy," Art-Journal, June 1, 1851, p. 153. See also Graves 1904–5, vol. 3, p. 98.
- Auerbach 1999, p. 124; Davis 1999, p. 153. Both books offer a wide perspective on the exhibition and the processes of selection, although touching only lightly on photography.
- Honourable Society of the Inner Temple, Call Papers (archival source), BAR/6/3. The address at King William Street is given in an advertisement for the Photographical Society; Art-Journal Advertiser, April 1852, n.p.
- 28. Fenton, "Photography in France," *Chemist*, February 1852, pp. 221–22.
- 29. Ibid.
- 30. Paul Jeuffrain album, collection of Société Française de Photographie, Paris. The page bears an inscription noting that the portraits were made by Fenton using collodion, in London in February 1852.
- Fenton, "Proposal for the Formation of a Photographic Society," *Chemist*, March 1852, pp. 265–66.
- Correspondence at the Birr Scientific and Heritage Foundation, Birr, Ireland, and in the Lacock Abbey

- Collection and Royal Photographic Collection (archival sources); Talbot Correspondence Project (website), docs. 06580, 06585, 06598, 06599, 06600, 06602, 06621, 06622, 06623, 06624, 06625, 06632, 06638, 06639, 06640, 06641, 06643, 06644, 06647, 06648, 06649, 06653, 06666, 06668. Although Talbot's zeal in protecting his patents has become almost a legend in the history of photography, correspondence between Talbot and those seeking change reveals the situation was actually far more complex.
- Lacock Abbey Collection LA52-015 (archival source);
 Talbot Correspondence Project (website), doc. 06580.
- 34. The dates come from the photographs, which are inscribed in the negatives.
- Photograph dated in the negative. See sale catalogue, Christie's South Kensington, March 15, 1979, lot 254.
- 66. "Weekly Proceedings," Society of Arts, Manufactures and Commerce, June 19, 1852, n.p. The committee consisted of Frederic Berger, Fenton (honorary secretary), Peter Le Neve Foster, Fry, Thomas Minchin Goodeve, Robert Hunt, Sir William Newton, Dr. John Percy, and Charles Wheatstone.
- 37. Vignoles, Journal (archival source), ADD 34532, p. 193r.
- 38. Fenton reports that on one occasion the thermometer "was standing considerably below the freezing-point." See Percy, March 3, 1853, p. 11.
- Vignoles, Journal (archival source), ADD 34532,
 pp. 197r, 200r.
- 40. Ibid., p. 213r.
- 41. "Photographic Album," ILN, October 30, 1852, pp. 362–63; see also "Photographic Album," Athenaeum, November 13, 1852, p. 1247; "Photographic Publications," Art-Journal, December 1852, p. 374. Cundall sent Talbot a copy of the Album in appreciation for his having relinquished his patent rights. Cundall to Talbot, September 2, 1852, Lacock Abbey Collection LA52-045 (archival source); Talbot Correspondence Project (website), doc. 06680. Part 3, issued in 1853, included two further studies by Fenton; advertised in Delamotte 1853.
- 42. Vignoles, Journal (archival source), ADD 34532, entry for November 10, 1852. Bourne subsequently showed his photographs of Russia at the annual exhibitions of the Photographic Society in 1854 and 1855. For details of the exhibitions, dates, and print titles, see Taylor, Photographs Exhibited in Britain, 2002, pp. 156–57.
- Held at the Adelphi theater in London, the exhibition closed on January 29, 1853. Taylor, *Photographs Exhibited in Britain*, 2002, pp. 302–5.
- Abstract printed in Catalogue of an Exhibition of Recent Specimens of Photography 1852, pp. 3–8, and JSA, December 24, 1852, pp. 50–53.
- 45. ILN, January 1, 1853, p. 12.
- 46. "The Stereoscope and Its Photographic Applications";

- abstract printed in "Seventh Ordinary Meeting," *JSA*, January 21, 1853, pp. 97–100.
- "Inaugural Meeting of the Photographic Society," JPS, March 3, 1853, pp. 2–5.
- 48. Photographic Society, Minutes of Council (archival source), pp. 2–4, January 7, 1853.
- Fenton, "Upon the Mode in Which It Is Advisable the Society Should Conduct Its Labours," JPS, March 3, 1853, pp. 8–9; Percy, March 3, 1853, p. 11.
- 50. Photographic Society, Minutes of Council (archival source), p. 11, February 10, 1853.
- Ibid., p. 14, February 17, 1853; "Photographic Exhibition," JPS, March 3, 1853, p. 12.
- Photographic Society, Minutes of Council (archival source), p. 19, February 24, 1853.
- 53. Ibid., p. 21, March 3, 1853.
- 54. Ibid., p. 26, March 10, 1853.
- 55. Ibid., p. 30, March 17, 1853.
- 56. Halkett, April 21, 1853, pp. 36-39.
- 57. Taylor, Photographs Exhibited in Britain, 2002, pp. 303-4.
- 58. "Photographic Gossip," JPS, May 2, 1853, p. 56.
- 59. These included views of Russia and of the woods near London. Photographic Society, Minutes of General Meetings (archival source), pp. 13–14; "Photographic Society. Fourth Ordinary General Meeting. Thursday, May 5, 1853," *JPS*, May 21, 1853, p. 57; Wheatstone, May 21, 1853, pp. 61–62.
- 60. Photographic Society, Minutes of Council (archival source), p. 53, May 12, 1853.
- "Réunion photographique," La Lumière, May 28, 1853, p. 87.
- Colonel Phipps to Sir Charles Eastlake, reported at Fifth Ordinary Meeting, June 2, 1853. Photographic Society, Minutes of General Meetings (archival source).
- 63. British Museum, Trustee Committee Minutes (archival source), p. 8571; British Museum, Original Letters and Papers (archival source), letter, July 9, 1853. See also Date 1989, pp. 10–12; Date and Hamber 1990, p. 316. We are grateful to Anthony Hamber for his generous help with information concerning Fenton's time at the British Museum.
- 64. British Museum, Original Letters and Papers (archival source), July 14, 1853. In response to a letter from Hawkins, Fenton offers recommendations for the size of both studio and darkroom, as well as for the kind of fittings to be employed (including a copious supply of distilled water), before setting out the costs involved. His most novel idea for the studio was "a little movable chamber in which the camera is to be placed," provided with curtains on all sides so that "all rays of light, except those reflected from the object to be copied are prevented from falling upon the surface of the lens."

- 65. The tour's twenty-four venues throughout Britain included mechanics' institutes, literary societies, and schools of art, each of which hosted the exhibition for about a week. The tour closed on April 1, 1854. Taylor, Photographs Exhibited in Britain, pp. 304–5.
- British Museum, Original Letters and Papers (archival source), October 4, 1853.
- 67. "I do not know any person better qualified to superintend the proposed photographic arrangements at the British Museum than Mr. Fenton." Ibid., October 6, 1853; British Museum, Trustee Committee Minutes (archival source), pp. 8614–15, October 8, 1853.
- Fenton, "On the Nitrate Bath," JPS, November 21, 1853,
 pp. 133–38; Fenton, "Épreuves sur verre collodioné,"
 La Lumière, November 26, 1853, pp. 191–92.
- 69. ILN, November 19, 1853, p. 425.
- Photographic Society, Minutes of Council (archival source), p. 84, December 1, 1853; "Photographic Society," JPS, December 21, 1853, p. 141.
- Fenton, "Exposition d'épreuves photographiques à Londres," La Lumière, December 10, 1853, p. 199.
- 72. Sir Charles Wheatstone and Robert Hunt were also in attendance. "Photographic Society," *ILN*, January 7, 1854, p. 6; see also "January 21st, 1854," *JPS*, January 21, 1854, p. 153; Victoria, Queen of England, Journal (archival source), January 3, 1854.
- Taylor, *Photographs Exhibited in Britain*, 2002, pp. 305–7.
 Many of Fenton's prints were lent to the exhibition by
 R. Beard or Vignoles, not by Fenton himself.
- 74. Reprinted in translation in "Exposition de la Société
 Photographique de Londres," January 14, 1854, p. 5.
- Victoria, Queen of England, Journal (archival source), January 16 and 23, 1854.
- 76. Ibid., January 25, 1854.
- Inscribed and dated print, Photograph Collection, Royal Archives, Windsor Castle.
- Fenton to Talbot, February 4, 1854, Lacock Abbey Collection LA54-007 (archival source); Talbot Correspondence Project (website), doc. 06912.
- 79. ILN, February 4, 1854, p. 88.
- Victoria, Queen of England, Journal (archival source), February 10, 1854.
- 81. British Museum, Trustee Committee Minutes (archival source), p. 8652.
- 82. Taylor, Photographs Exhibited in Britain, 2002, p. 305.
- 83. The sequence of eight prints is included in *Calotypes*, vol. 2, Photograph Collection, Royal Archives, Windsor Castle. For a detailed account of the departure of the fleet to the Baltic, see "Baltic Fleet," *ILN*, March 18, 1854, pp. 242–44. This maneuver was largely tactical and designed to force the Russians into war.

- Privy Purse Accounts (archival source), PP2/6/4638,
 Fenton to E. Becker, invoice, July 8, 1854.
- 85. Taylor, Photographs Exhibited in Britain, 2002, pp. 304-5.
- 86. Privy Purse Accounts (archival source), PP2/6/4638.
- Victoria, Queen of England, Journal (archival source), May 22, 1854.
- "The Queen's Visit to the French Embassy," ILN, May 20, 1854, pp. 473–74.
- Fenton to Talbot, June 20, 1854, and Talbot to Fenton, June 20, 1854, Lacock Abbey Collection (archival source); Talbot Correspondence Project (website), docs. 06999, 07001.
- Victoria, Queen of England, Journal (archival source), June 30, 1854.
- 91. "Photographic Society. Extraordinary Meeting, Thursday, July 6th, 1854," JPS, July 21, 1854, pp. 1–4.
- 92. British Museum, Minutes of the Sub Committee (archival source), p. 879.
- 93. Privy Purse Accounts (archival source), PP2/6/4638.
- 94. "Photographic Society," *JPS*, August 21, 1854, pp. 13–14.
- 95. No precise documentation exists for this trip or for others of a similar nature. However, Fenton first showed his Yorkshire views at the 1855 exhibition of the Photographic Society, which opened in early January. Fenton's presence at the Photographic Society Council meetings through July and beginning again in late October suggests that his trip took place sometime between these dates, as does the greater probability then of favorable weather.

For details of William Fenton's involvement with various railway companies, see *Bradshaw's Railway Manual* 1869. William Fenton's obituary appeared in the *Derbyshire Times*, April 2, 1904, and the *High Peak News* (Buxton, Derbyshire), April 2, 1904. We are grateful to Stuart Band, Archivist, Devonshire Collection, Chatsworth, for this information.

- Inscribed and dated print, Photograph Collection, Royal Archives, Windsor Castle.
- 97. Inscribed and dated print, Photograph Collection, Royal Archives, Windsor Castle.
- Fenton stated that the device "was not of such a character as the Photographic Society could approve." "Photographic Society. Ordinary Meeting. Nov. 2nd, 1854," JPS, November 21, 1854, p. 60.
- British Museum, Trustee Committee Minutes (archival source), p. 8751.
- 100. Athenaeum, no. 1419 (January 6, 1855), p. 3; Taylor, Photographs Exhibited in Britain, 2002, p. 309.
- Taylor, Photographs Exhibited in Britain, 2002, pp. 309–11.
- 102. Privy Purse Accounts (archival source), PP 2/12/5728.
- 103. "Exhibition of Photographs," *ILN*, February 17, 1855, pp. 165, 166.

- 104. Fenton, "Narrative of a Photographic Trip," JPS, January 21, 1856, pp. 284–91; Gernsheim 1954, pp. 35–106.
- 105. These were thought to be of such significance that they were subsequently transcribed for posterity by various members of the family. At least two of these "letter books" have survived: in the Gernsheim Collection, University of Texas at Austin, and NMPFT (RPS Collection) (archival sources).
- 106. Gernsheim 1954, p. 35.
- 107. Ibid., p. 41.
- 108. "Town and Table Talk," *ILN*, September 22, 1855, p. 347.
- 109. Gernsheim 1954, p. 52.
- 110. Ibid., p. 57.
- 111. Fenton, Letter Book, NMPFT (RPS Collection) (archival source), p. 5.
- 112. Gernsheim 1954, p. 65.
- Fenton, Letter Book, NMPFT (RPS Collection) (archival source), p. 15.
- 114. Ibid., p. 17.
- 115. Ibid., p. 19.
- 116. Ibid., p. 20.
- 117. Ibid., p. 23.
- 118. "Notice to Exhibitors to Whom Prizes Have Been Awarded," *JPS*, December 21, 1855, p. 277.
- Fenton, Letter Book, NMPFT (RPS Collection) (archival source), p. 43.
- 120. Ibid., p. 53.
- 121. Gernsheim 1954, p. 100.
- 122. Ibid., pp. 102-3.
- 123. Victoria, Queen of England, Journal (archival source), August 8, 1854. There are no references to support Gernsheim's assertion that Fenton was "immediately summoned to Osborne for an audience with the Queen and Prince Consort, and owing to his weak state enjoyed the unusual privilege of lying on a couch in the Royal presence while recounting his adventures." Gernsheim 1954, p. 22.
- 124. Although there is no documentary evidence on the two surviving portraits, circumstantial evidence suggests they were made about mid-August, when Princess Alice, recovering from scarletina, was well enough to venture outdoors and be photographed. Even so, she looks unwell.
- 125. Taylor, Photographs Exhibited in Britain, 2002, pp. 44, 311–28. For the Birmingham exhibition, see "Mr. Fenton's Crimean Photographs," Birmingham Journal, February 9, 1856, p. 7, and "The Crimean Photographs," Birmingham Journal, February 16, 1856, p. 3. We are grateful to Peter James for these references.
- 126. "Photographs of the Seat of War," ILN, September 15, 1855, p. 326, reprinted from Manchester Guardian. The medal and portrait are in the possession of a Fenton descendant.
- 127. Taylor, Photographs Exhibited in Britain, 2002, p. 309.

- 128. "Photographic Pictures of the Seat of War in the Crimea," Athenaeum, September 22, 1855, p. 1075. Each portfolio was issued as a part work at a cost of two pounds two shillings per part; the final part was issued in April 1856. An order form was included in all editions of the exhibition catalogue.
- Respectively, in *ILN*, October 6, 1855, p. 405; October
 13, 1855, p. 425; October 20, 1855, p. 472; November 3,
 1855, pp. 520, 524; November 10, 1855, p. 557; December
 29, 1855, p. 753.
- 130. Taylor, Photographs Exhibited in Britain, 2002, p. 44.
- 131. Ibid., pp. 46, 329-30.
- 132. Bourne, January 21, 1856, pp. 283–84; Fenton, "Narrative of a Photographic Trip," JPS, January 21, 1856, pp. 284–91.
- 133. "Lecture in Relation to the Theatre of War," handbill, 1856.
- 134. "Photographic Society. Annual General Meeting. Feb. 7, 1856," JPS, February 21, 1856, p. 301.
- British Museum, Standing Committee Minutes (archival source), pp. 907–8.
- 136. "Fenton's Crimean Photographs," announcement in ILN, April 12, 1856, p. 374. Examination of a copy of the third edition of the catalogue, now in the Dougan Collection, Art Museum, Princeton University, reveals that frequent duplication of numbers accounts for the listing of the 360 images as 297 entries.
- 137. "Nineteenth Ordinary Meeting," JSA, April 25, 1856, pp. 385–89; abstract published in "Photogalvanography," Photographic Notes, May 25, 1856, pp. 60–62. Pretsch took out a British patent for photogalvanography on November 9, 1854.
- 138. JPS, no. 42 (May 21, 1856), p. 37; "Photographic Society. Ordinary Meeting. May 1, 1856," JPS, May 21, 1856, p. 38. A prospectus for the association published in the advertising section of the Journal clearly sets out the aims and objectives of the company, which was seeking 10,000 pounds for capitalization. The council of the association comprised Vignoles (chairman), Delamotte, Fenton, Goodeve, Hardwich, Lake Price, and Lewis Pocock.
- 139. In his report to the Trustees Madden recommended that only fifty copies be printed and the price set at three pounds per copy. This was the first work published by Colnaghi on behalf of the museum. British Museum, Trustee Committee Minutes (archival source), pp. 9018–19, June 7, 1856.
- 140. Phipson, October 21, 1856, pp. 146–49; JPS, no. 49 (December 22, 1856), p. 172.
- 141. Taylor, Photographs Exhibited in Britain, 2002, p. 330.
- 142. Fenton's presence at Balmoral is confirmed by the portraits he made there (see following entry and note), and Scottish views were shown at the 1857 exhibition of the Photographic Society, which opened in the first week in January.

- 143. Privy Purse Accounts (archival source), PP2/22/7526, invoice submitted for seventy-three pounds ten shillings and sixpence, the total for negatives and prints made during August 1855, September 1856, and January 1857, paid April 2, 1857.
- 144. Sparling's treatise was published by Houlston & Stoneman, London.
- 145. A further four parts, each with four plates, were issued between January and July 1857. Of twenty plates issued, nine were from negatives by Fenton. For date of publication, see *Photographic Notes*, no. 15 (November 15, 1856), p. 235. For advertisements in which Fenton is named as "photographer to the company," see *Athenaeum*, no. 1524 (January 10, 1857), p. 54; no. 1526 (January 24, 1857), p. 120; no. 1542 (May 16, 1857), p. 614; and *Photographic Notes*, no. 25 (April 15, 1857), p. 146.
- 146. "Photographic Society. Ordinary Meeting. November 6, 1856," JPS, November 21, 1856, p. 155.
- 147. Taylor, Photographs Exhibited in Britain, 2002, p. 331.
- 148. Société Française de Photographie 1856, p. 22. For the date of the exhibition opening, see *JPS*, no. 47 (October 21, 1856), p. 135. The exhibition continued until February 15, 1857.
- 149. Gernsheim 1954, p. 26.
- 150. JPS, no. 49 (December 22, 1856), p. 171.
- 151. Taylor, Photographs Exhibited in Britain, 2002, pp. 328-29.
- 152. Ibid., pp. 331-33.
- Fenton to Talbot, April 21, 1857, Lacock Abbey Collection LA57-012 (archival source); Talbot Correspondence Project (website), doc. 07392.
- 154. Taylor, Photographs Exhibited in Britain, 2002, p. 333.
- 155. John Henry Bolton to Talbot, May 1, 1857, Lacock Abbey Collection LA57-015 (archival source); Talbot Correspondence Project (website), doc. 07399.
- 156. "Photographic Society. Ordinary Meeting. May 7, 1857," JPS, May 21, 1857, pp. 270–72.
- 157. See "Fine-Art Gossip," *Athenaeum*, June 27, 1857, p. 826, for a review of the exhibition.
- 158. "List of the Medallists for Photography," *Photographic Notes*, January 15, 1858, p. 26.
- 159. Although no precise documentation exists, the general dates of this campaign are presumed from Fenton's exhibition of these subjects beginning in early 1858.
- 160. James Bridge Davidson wrote in *The Conway in the Stereoscope* (Davidson 1860, p. 1), "In the autumn of last year the stereographs which form the illustrations of this volume were taken by Mr. R. Fenton at the same time, and frequently from the same point of view, as those larger pictures which attracted so much attention in the Photographic Society's Exhibition of 1858–9 [sic]." The exhibition history makes it clear, however, that Davidson was actually speaking of autumn 1857.
- 161. "Photographic Society. Ordinary Meeting. December 3, 1857," JPS, December 21, 1857, p. 102.

- Photographic Society of Scotland, Records (archival source), B40438, press cuttings and reviews for December 1857.
- 163. Fenton, "Law of Artistic Copyright," JPS, January 21, 1858, p. 151.
- 164. Taylor, Photographs Exhibited in Britain, 2002, p. 335.
 The exhibition closed in February.
- JPS, no. 65 (April 21, 1858), p. 189; Taylor, Photographs Exhibited in Britain, 2002, p. 50.
- 166. "Photographic Society. Ordinary Meeting. April 6, 1858," JPS, April 21, 1858, p. 190; Rejlander, April 21, 1858, pp. 191–96.
- "Art-Union of London," Art-Journal, June 1, 1858, p. 183;
 "Art-Union of London. Distribution of Prizes," Art-Journal,
 September 1, 1858, p. 283.
- "Photographic Society of Ireland," JPS, May 21, 1858, p. 215.
- 169. For exhibitions of these works, see 1858 entry for December 18, and 1859 entries for January 6, April, April 15, and September.
- Advertisement for the first issue of the Stereoscopic
 Magazine, in Athenaeum, no. 1597 (June 5, 1858), p. 709.
- 171. The geographical separation of the areas suggests that there were two separate trips. Fenton exhibited subjects from each of these locations in January 1859.
- "Photographs," advertisement in Athenaeum, November 27, 1858, p. 694.
- 173. Taylor, Photographs Exhibited in Britain, 2002, p. 333.
- 174. Photographic Journal (BJP), no. 86 (January 15, 1859), p. 13.
- 175. Taylor, Photographs Exhibited in Britain, 2002, pp. 338-39.
- 176. "Nottingham Photographic Society's Exhibition," Photographic Journal (BJP), February 1, 1859, p. 36.
- 177. We are grateful to Brian Coe and Brian Warren, honorable archivist of the Potters Bar and District Historical Society, for this information.
- "Macclesfield Photographic Society's Exhibition," Photographic Journal (BJP), March 1, 1859, p. 60.
- 179. "Photographic Society's Sixth Annual Exhibition," Photographic Journal (BJP), February 1, 1859, p. 35;
 "Photographic Exhibition," Art-Journal, February 1, 1859, p. 46; "Exhibition of the Photographic Society," Photographic News, January 28, 1859, p. 242.
- Photographic Journal (BJP), no. 90 (March 15, 1859),
 p. iv, advertisements.
- 181. Taylor, *Photographs Exhibited in Britain*, 2002, pp. 336–37.
- 182. Société Française de Photographie 1859, p. 25.
- 183. Art-Union of London 1859, p. 6.
- 184. Stereoscopic Magazine, no. 11 (May 1859).
- 185. "List of Offices, Sept. 1856–Sept. 1857," in Stonyhurst College, Prefect's Log (archival source), notes the appointment of Father William Kay to the post of "Professor of Chemistry." We are grateful for the generous help and access provided to the college archives by Janet Graffius and David Knight.

- Fenton to Anthony Panizzi, July 7, 1859, British
 Museum, Original Letters and Papers (archival source).
- 187. Taylor, Photographs Exhibited in Britain, 2002, p. 336.
- 188. "Photographic Society. Ordinary General Meeting. Tuesday, November 1, 1859," *Photographic Journal*, November 15, 1859, p. 73.
- 189. Photographic Society of Scotland, Records (archival source), press cuttings and reviews for December 1859, B40438. See also "Exhibition of the Photographic Society of Scotland," *Photographic Journal*, January 16, 1860, p. 132.
- 190. Stonyhurst College, Minister's Journal (archival source), 1849–77, entries for December 15–23, 1859, record heavy frosts and "skating for all."
- 191. "Stereoscopic Photography," Athenaeum, no. 1679 (December 31, 1859), p. 904. Full-page advertisement for Lovell Reeve's Publications in which The Conway in the Stereoscope is announced for publication the following Monday, i.e., January 2, 1860. See also Davidson 1860.
- 192. Taylor, Photographs Exhibited in Britain, 2002, pp. 339-40.
- 193. Seventeen studies of the Hythe School of Musketry, many dated February 1860, Photograph Collection, Royal Archives, Windsor Castle.
- 194. "Obituary," BJP, May 1, 1860, p. 137. The obituary noted that Sparling died of "inflammation of the liver and pelvic abscess."
- 195. "Photography and the Volunteers," *Photographic Journal*, July 16, 1860, pp. 269–71; "Review of the Volunteers by Her Majesty in Hyde Park," *ILN*, June 30, 1860, pp. 624–25, 628. The so-called Hythe portraits, some of which were actually made on the front step of Fenton's home on Albert Terrace, include studies of Charles Lucy, Horatio Ross with his son, and a self-portrait in uniform striking a pose described as "stand-at-ease-stand-easy-order-arms-do-as-you-like."
- 196. "Archer Fund," Photographic Journal, May 15, 1860, p. 243.
- 197. Although no precise documentation exists, the general date of this campaign is presumed from his exhibition of these subjects beginning in early 1861.
- 198. Photographic Society, Annual Report of the Council, February 1861; quoted in Johnston 1946, p. 20.
- 199. "Photography and the Volunteers," Photographic Journal, July 16, 1860, pp. 270–71; "National Rifle Association," ILN, July 7, 1860, suppl., pp. 17–18; "Meeting of the National Rifle Association," ILN, July 14, 1860, pp. 25, 42.
- 200. Parliament, House of Commons, Report from the Select Committee 1860, pp. 89–92. See also Photographic Journal, no. 100 (August 15, 1860), pp. 291–93, for further insights into this matter.
- 201. Privy Purse Accounts (archival source), PP2/45/1021. As prints of the Windsor views were delivered on July 14, 1860, it seems likely they were taken during May or June of that year, certainly during early summer.

- 202. "Photographic Society of London. Ordinary General Meeting. December 4, 1860," *Photographic Journal*, December 15, 1860, p. 50. Fenton's retirement took effect in February 1861.
- 203. Taylor, *Photographs Exhibited in Britain*, 2002, pp. 341–42.
- 204. Census Returns for 1861, Family Record Centre, London, microfilm, RG/99/128. By comparison, his father had eight servants ten years earlier to look after his family at Bamford Hall. Census Returns for 1851, Family Record Centre, London, microfilm, HO107/2213/87.
- 205. "British Association," Athenaeum, September 7, 1861, p. 313, and reviewed in "British Association for the Advancement of Science," BJP, September 16, 1861, pp. 330–31.
- 206. Ethel Fenton, Fentons of Crimble, ca. 1960, outlines the family history and gives an account of the dispute at Hooley Bridge Mill.
- 207. Taylor, Photographs Exhibited in Britain, 2002, pp. 342-43.
- 208. "Ruined Abbeys and Castles," Photographic Journal, May 15, 1862, p. 57.
- "Photography at the International Exhibition," *Photographic Journal*, July 15, 1862, pp. 79–80.
- "Retirement of Mr. Fenton," *Photographic Journal*, October 15, 1862, pp. 157–58.

- Athenaeum, no. 1828 (November 8, 1862), p. 580, advertisement for Stevens; *Photographic Journal*, no. 127 (November 15, 1862), p. 178.
- 212. "In some cases, three 10 x 8 negatives and a print of each sold for eight or ten shillings." "Mr. Fenton's Photographic Effects," *Photographic News*, December 5, 1862, p. 588.
- 213. The name of the house is cited on Fenton's death certificate; see note 220 below.
- 214. Law List 1863, p. 45.
- 215. Fenton and Durham, February 16, 1863, pp. 220-21.
- 216. General Register Office, London, District of Rochdale, Register of Deaths (archival source), vol. 8e, p. 9. Obituary in *Rochdale Observer*, August 1, 1863.
- 217. "Portraits of Roger Fenton," BJP, March 17, 1865, p. 143.
- 218. "London Photographic Society," Photographic News, December 14, 1866, p. 596; "Late Meeting of the Photographic Society," Photographic News, December 21, 1866, p. 609. Reports about the award ceremony are ambiguous; it seems to have been a retrospective affair dealing with the years 1862–65. Sixteen medals were awarded, in some cases two per individual.
- 219. "Architectural Exhibition," Builder, May 15, 1869, pp. 379–80. With thanks to Anthony Hamber.
- General Register Office, London, District of Barnet,
 Register of Deaths (archival source), vol. 3a, p. 95.

- 221. "Late Mr. Roger Fenton," BJP, August 20, 1869, pp. 400–401, outlines his contributions and achievements and reprints his formulas for the waxed paper process. "Obituary," Photographic News, August 27, 1869, p. 419.
- 222. Catalogue of the Collection . . . Formed by Roger Fenton, June 13, 1870. The collection contained some 144 works by contemporary British and French artists, including Richard Parks Bonington, Thomas Shotter Boys, Edward Henry Corbould, Auguste Delacroix, Walter Goodall, Carl Haag, George Lance, Pierre-Paul Prud'hon, and Ary Scheffer.
- 223. Catalogue of the Library . . . of the Late Roger Fenton 1870. Among the items sold were six albums containing a collection of more than eight hundred engravings gathered and mounted by Fenton.
- 224. We are indebted to Brian Warren, honorable archivist of the Potters Bar and District Historical Society, and to the late Colin Osman for this information.
- 225. British Museum, Original Letters and Papers (archival source), p. 4891, letter from Grace Fenton, April 28, 1872; British Museum, Letter Books (outgoing) (archival source), Thomas Butler to Grace Fenton, May 2, 1872.
- 226. "Fentons' Bank Failure," *Rochdale Observer*, December 7, 1878. The failure was attributed to unwise investments in risky ventures, and the subsequent bankruptcy of the partners humiliated the entire Fenton family.
- 227. Brian Warren to Valerie Lloyd, April 10, 1988.

Bibliography

Published sources are arranged according to year of publication.

The *Journal of the Photographic Society*, published by the Photographic Society beginning in 1853, changed its name in 1859 to *Photographic Journal*. Citations in the notes and bibliography to *Photographic Journal* refer to this publication.

The Liverpool Photographic Journal, begun in 1854, changed its name in 1857 to Liverpool and Manchester Photographic Journal; in 1859 to Photographic Journal; and in 1860 to British Journal of Photography. Citations in the notes and bibliography to Photographic Journal (BJP) refer to this publication.

Archival Sources

British Museum. Letter Books (outgoing). Archives, British Museum. London.

——. Minutes of the Sub Committee. Archives, British Museum, London.

———. Original Letters and Papers. Archives, British Museum, London.

———. Standing Committee Minutes. Archives, British Museum, London.

———. Trustee Committee Minutes. Archives, British Museum, London.

Fenton, Roger. Letter Book. Transcriptions of letters from Roger Fenton to Grace Fenton, Joseph Fenton, and William Agnew, February 27 to June 25, 1855. Gernsheim Collection, Harry Ransom Center, University of Texas at Austin.

Letter Book. Transcriptions of letters from Roger Fenton to Grace Fenton, April 4 to June 25, 1855. Royal Photographic Society Collection, National Museum of Photography, Film & Television, Bradford.

——. "Proposal for the Formation of a Photographical Society." Undated (probably January–February 1852). Onepage document. Private collection.

General Register Office, London. District of Barnet. Register of Deaths.

——. District of Northallerton. Register of Marriages. Vol. 24.

———. District of Rochdale. Register of Deaths.

Greenall Family of Dutton Papers. Lancashire County Record Office, Preston.

Honourable Society of the Inner Temple. Admission Register. 1842–68. Inner Temple Archives, London.

———. Admission Stamp Duty Register. 1837–42. Inner Temple Archives, London.

———. Call Papers. Inner Temple Archives, London.

Lacock Abbey Collection. William Henry Fox Talbot Correspondence. Fox Talbot Museum, Lacock, Wiltshire.

Maynard, Edmund. Diary. Private collection.

Musée du Louvre. Registre des cartes d'élèves. 1840–45. Inv. no. LL7. Archives, Musée du Louvre, Paris.

North Lancashire. Whalley Polling District. The Register of Persons Entitled to Vote . . . Aighton, Bailey, and Chaigley. Sheet dated July 26, 1851. Archives, Stonyhurst College, Stonyhurst, Clitheroe, Lancashire.

Photographic Society. "Inaugural Meeting of the Photographic Society & Rules of the Photographic Society." Two-page document. Royal Photographic Society Collection, National Museum of Photography, Film & Television, Bradford.

———. Manuscript Notes. Royal Photographic Society Collection, National Museum of Photography, Film & Television, Bradford.

———. Minutes of Council. Royal Photographic Society Collection, National Museum of Photography, Film & Television, Bradford.

———. Minutes of General Meetings. Royal Photographic Society Collection, National Museum of Photography, Film & Television, Bradford.

Photographic Society Club. Rules of the Photographic Society Club Album. 1856. Royal Photographic Society Collection, National Museum of Photography, Film & Television, Bradford.

Photographic Society of Scotland. Records of the Photographic Society of Scotland. 1856–73. National Archives of Scotland, Edinburgh.

Privy Purse Accounts. Royal Archives, Windsor Castle.

Royal Photographic Society Collection. Correspondence. National Museum of Photography, Film & Television, Bradford.

Society of Arts. Minutes of Council. Vol. 3, December 1850–June 1852. Vol. 4, June 1852–June 1853. Archives, Royal Society of Arts, London.

Stonyhurst College. First Prefect's Log. 1844—67. Manuscript volume. Archives, Stonyhurst College, Stonyhurst, Clitheroe, Lancashire.

———. Minister's Journal. 1849–77. Archives, Stonyhurst College, Stonyhurst, Clitheroe, Lancashire.

———. Prefect's Log. Manuscript volume. Archives, Stonyhurst College, Stonyhurst, Clitheroe, Lancashire.

Victoria, Queen of England. Journal. Royal Archives, Windsor Castle. This manuscript, the only surviving version of Queen Victoria's journal, was transcribed (and doubtless edited) after her death by Princess Beatrice.

Vignoles, Charles Blacker. Journal. 8 vols. Manuscript Collection, British Library, London.

Websites

Hannavy, "Finding Roger Fenton's Russia" (Article by John Hannavy. First published in *Freelance Photographer* magazine in 2002. Website hosted by the Winston Churchill Memorial Trust.) http://www.wcmt.org.uk/n3.asp

Stereoscopic Magazine Publications Listing

(Listing of the complete contents of *Stereoscopic Magazine*, published by Lovell Reeve from 1858 to 1865. Compiled by Julian Holland. Website hosted by the Macleay Museum, University of Sydney, Australia.)

http://www.usyd.edu.au/su/macleay/HPCphotog/hpcstereomag.htm

Stereoscopic Magazine Views

(Reproductions of stereo views published in *Stereoscopic Magazine*, published by Lovell Reeve from 1858 to 1865. Still Photograph Archive, George Eastman House, Rochester, New York.)

http://www.geh.org/stereo.html

Talbot Correspondence Project

(*The Correspondence of William Henry Fox Talbot* Project. Larry J. Schaaf, Project Director. Transcriptions of nearly ten thousand letters to and from William Henry Fox Talbot. Project housed at the University of Glasgow.)

http://www.foxtalbot.arts.gla.ac.uk/project

Photographic Exhibitions in Britain, 1839–1865: Records from Victorian Exhibition Catalogues

(Online version of Taylor, *Photographs Exhibited in Britain*, 2002 [see Published Sources]. Available July 2004. Individual records for more than twenty thousand photographic exhibits, listed by exhibition, photographer, title, process, exhibitor, and original prices, where known. Website hosted by De Montfort University, Leicester, and National Gallery of Canada, Ottawa.)

http://www.peib.org.uk

(Transcriptions of Roger Fenton's letters written from the Crimea. Ed. Roger Taylor. Website hosted by De Montfort University, Leicester. To be available late 2004.) http://www.rogerfenton.org.uk

Published Sources

1834

Hansard, George Agar. *Trout and Salmon Fishing in Wales*. London: Longman, Rees, Orme, Brown, Green & Longman, 1834.

1836

Britton, John. The History and Antiquities of the See and Cathedral Church of Lichfield. London: M. A. Nattali, 1836.

1840

Howitt, William. *The Rural Life of England*. 2nd ed. London: Longman, Orme, Brown, Green, & Longmans, 1840. 1st ed., 1836.

1842

Lerebours, Noël-Paymal. Excursions daguerriennes: Vues et monuments les plus remarquables du globe. 2 vols. Paris: Rittner and Goupil, 1842. [Originally issued in parts between 1840 and 1841.]

1843-56

Churton, Edward. *The Monastic Ruins of Yorkshire*. 9 pts. York: Robert Sunter, 1843–56.

1844-46

Talbot, William Henry Fox. *The Pencil of Nature*. London: Longmans, 1844—46. Reprint ed., New York: Hans P. Kraus Jr.; [Verona, Italy]: Stamperia Valdonega, 1989.

1845

Parliament. House of Commons. Report from the Select Committee of Art Unions; Together with the Minutes of Evidence, Appendix and Index. London, 1845.

1847

"The Calotype Society." *Athenaeum*, no. 1051 (December 18, 1847), p. 1304. [On the origins and meetings of this new society.]

1848

Catalogue of the Exhibition of Arts, Manufactures, and Practical Science, at Newcastle-upon-Tyne. Newcastle: J. Blackwell, 1848.

1849

Court Etiquette: A Guide to Intercourse with Royal or Titled Persons, to Drawing Rooms, Levees, Courts and Audiences, the Usages of Social Life... London: Charles Mitchell, 1849.

"The Photographic Club." Art-Journal 11 (August 1, 1849), p. 262.

1850

Le Gray, Gustave. Traité pratique de photographie sur papier et sur verre. Paris: Plon Frères, 1850.

1851

Black's Picturesque Guide to the English Lakes, Including an Essay on the Geology of the District. 5th ed. Edinburgh: Adam and Charles Black, 1851.

Churton, Edward. The Rail Road Book of England: Historical, Topographical and Picturesque; Descriptive of the Cities, Towns, Country Seats, and Other Subjects of Local Interest, with a Brief Sketch of the Lines in Scotland and Wales. London: E. Churton, 1851. Reprint ed., London: Sidgwick and Jackson, 1973.

"The Royal Academy. The Eighty-Third Exhibition—1851." Art-Journal 13 (June 1, 1851), pp. 153–62.

1852

Almanack of the Fine Arts for the Year 1852. Ed. Robert William Buss. London: George Rowney and Company, 1852.

A Catalogue of an Exhibition of Recent Specimens of Photography Exhibited at the House of the Society of Arts, 18 John Street Adelphi, in December, 1852. Rev. ed. London: Society of Arts, 1852.

"Exhibition of Recent Specimens of Photography." *Journal of the Society of Arts*, no. 6 (December 31, 1852), pp. 61–63.

Fenton, Roger. "On the Present Position and Future Prospects of the Art of Photography." In A Catalogue of an Exhibition of Recent Specimens of Photography Exhibited at the House of the Society of Arts, 18 John Street Adelphi in December, 1852, pp. 3–8. Rev. ed. London: Society of Arts, 1852.

"On the Present Position and Future Prospects of the Art of Photography." *Journal of the Society of Arts*, no. 4 (December 24, 1852), pp. 50–53.

------. "Photography in France." *Chemist* 3 (February 1852), pp. 221–22.

———. "Photography on Waxed Paper." In William Henry Thornthwaite, *A Guide to Photography*, pp. 94–101. 5th ed. London: Horne, Thornthwaite, and Wood, [August], 1852.

[Fenton, Roger]. "Proposal for the Formation of a Photographical Society." *Chemist* 3 (March 1852), pp. 265–66.

Jeuffrain, Paul. "Progrès du collodion." *La Lumière* 2 (March 20, 1852), p. 50. [Mention of collodion prints by Fenton.]

Le Gray, Gustave. *Photographie: Nouveau traité théorique et pratique*. Paris: Plon, 1852.

"The Photographic Album." *Illustrated London News*, October 30, 1852, pp. 362–63.

"The Photographic Album. Part II." *Illustrated London News*, December 11, 1852, p. 530.

"The Photographic Album. Parts I. and II." *Athenaeum*, no. 1307 (November 13, 1852), p. 1247.

"The Photographic Patent Right." *Times* (London), August 13, 1852, p. 4.

"Photographic Publications." *Art-Journal* 14 (December 1, 1852), p. 374.

"The Photographical Society." *Art-Journal* 14 (April 1, 1852), p. 103. [Notes prospectus of a Photographic Society.]

"Photographie, héliochromie, fluorescence." Cosmos 2 (December 18, 1852), pp. 87–88. [Translation of review from the London Art-Journal, 1852.]

Reports by the Juries on the Subjects in the Thirty Classes into Which the Exhibition Was Divided. Great Exhibition of the Works of Industry of All Nations, 1851. London: William Clowes and Sons. 1852.

"Suburban Artisan Schools." *Art-Journal* 14 (April 1, 1852), p. 103.

"Suburban Artisan Schools." *Builder*, no. 492 (July 10, 1852), p. 444.

"Suburban Artisan Schools.—The North London School of Drawing and Modelling." *Illustrated London News*, January 17, 1852, p. 46 [ill. p. 45].

Thornthwaite, William Henry. A Guide to Photography. 5th ed. London: Horne, Thornthwaite, and Wood, [August], 1852.

"Weekly Proceedings." Society of Arts, Manufactures and Commerce, no. 17 (June 19, 1852).

1853

Athenaeum, no. 1329 (April 16, 1853), p. 485. [Advertisement for The Photographic Album.]

Black's Shilling Guide to the English Lakes. Edinburgh: Adam and Charles Black, 1853.

Catalogue of Photographic Exhibition at the Aberdeen Mechanics' Institution. N.p., 1853.

A Catalogue of Photographic Pictures Exhibited at the Photographic Institution. London, 1853.

"Collodion." La Lumière 3 (December 5, 1853), p. 195. [Letter to Fenton from A. Maconochie.]

Delamotte, Philip Henry. *The Practice of Photography: A Manual for Students and Amateurs.* London: Joseph Cundall, 1853.

Dickens, Charles. "Patent Wrongs." *Household Words*, no. 163 (May 7, 1853), pp. 229–34.

"Exhibition of Recent Specimens of Photography at the Society of Arts." *Notes and Queries*, no. 166 (January 1, 1853), pp. 22–23.

"Exposition d'épreuves photographiques à la Société des Arts." La Lumière 3 (January 22, 1853), p. 15.

Fenton, Roger. "Épreuves sur verre collodioné. Bain de nitrate." La Lumière 3 (November 26, 1853), pp. 191–92.

——. "Exposition d'épreuves photographiques à Londres." Letter to the Sociéte Héliographique, Paris. *La Lumière* 3 (December 10, 1853), p. 199.

——. "On the Nitrate Bath. [Read November 3, 1853.]." Journal of the Photographic Society, no. 11 (November 21, 1853), pp. 133–38.

——. "Upon the Mode in Which It Is Advisable the Society Should Conduct Its Labours." *Journal of the Photographic Society*, no. 1 (March 3, 1853), pp. 8–9.

"Fine-Art Gossip." Athenaeum, no. 1337 (June 11, 1853), p. 711.

"The Greek Church." *Illustrated London News*, November 19, 1853, pp. 425–26. [Illustration of *Priest of the Greek Church* from Fenton calotype.]

Halkett, Major. "On a Peculiar Arrangement for a Camera." Journal of the Photographic Society, no. 3 (April 21, 1853), pp. 36–39. [With Fenton's comments on Major Halkett's paper.]

Henfrey, Arthur, ed. *Journal of the Photographic Society. Prospectus.* London: Photographic Society, 1853.

Hunt, Robert. "The Photographic Exhibition." Journal of the Society of Arts, no. 7 (January 7, 1853), pp. 78–79.

"Inaugural Meeting of the Photographic Society." *Journal of the Photographic Society*, no. 1 (March 3, 1853), pp. 2–5.

"Interchange of Privileges." *Journal of the Society of Arts*, February 18, 1853, p. 147.

"Introductory Address." Journal of the Photographic Society, no. 1 (March 3, 1853), pp. 1-2.

Journal of the Photographic Society, no. 2 (April 1, 1853), p. 26. [Fenton on the Count de Montizon's paper "On the Collodion Process."]

Journal of the Photographic Society, no. 3 (April 21, 1853), p. 42. [Fenton on Mr. Dancer's paper "On a Portable Camera, with Directions for Using the Frame, in Preparing the Glass Plates in the Open Air, for the Collodion Process."]

Journal of the Photographic Society, no. 4 (May 2, 1853), p. 54. □ Fenton's response to a letter to the editor. □

Journal of the Photographic Society, no. 9 (September 21, 1853), p. 115. Letter to the Editor. [Notice of Fenton's stereoscopic view of Burnham Beeches.]

Journal of the Photographic Society, no. 11 (November 21, 1853), p. 132. [Fenton on Dr. Hugh Welch Diamond's paper "On the Simplicity of the Calotype Process."]

Journal of the Photographic Society, no. 12 (December 21, 1853), pp. 147–48. [Fenton's response to William Crookes's paper "On the Restoration of Old Collodion."]

Lacan, Ernest. "Épreuves anglaises. MM. Fenton et Delamotte." *La Lumière* 3 (July 23, 1853), p. 119. [Discussion of prints of Raglan Castle.]

Marriott, T. L. "Stereoscope Angles." *Notes and Queries*, no. 203 (September 17, 1853), pp. 275–76. [Notice of a Fenton stereoscope.]

"Minuteness of Detail on Paper." Notes and Queries, no. 198 (August 13, 1853), p. 157. [Notice of Fenton's Well Walk, Cheltenham.]

"Miscellaneous. Notes on Books, etc." *Notes and Queries*, no. 170 (January 29, 1853), p. 120. [Fenton elected as honorary secretary of the Photographic Society.]

Newton, Sir William J. "Upon Photography in an Artistic View, and in Its Relations to the Arts." *Journal of the Photographic Society*, no. 1 (March 3, 1853), pp. 6–8.

Notes and Queries, no. 176 (March 12, 1853), p. 273. [Formation of an "Antiquarian Photographic Club."]

Notes and Queries, no. 176 (March 12, 1853), p. 274. [Discussion of Fenton's paper "Objects of the Photographic Society."]

Notes and Queries, no. 182 (April 23, 1853), p. 420. [Advertisement for *The Photographic Album*. Part III.]

"Notes on Mr. Berry's Process." *Journal of the Photographic Society*, no. 7 (July 21, 1853), p. 89. [Fenton's reply to letter on use of gallic acid.]

"Nouvelles de la semaine." Cosmos 2 (January 30, 1853), pp. 220-22. [Mention of Fenton's photographs, including one of Chartres Cathedral, in exhibition at Society of Arts.]

Percy, John. "On the Waxed-Paper Process as Applicable to Hot Climates." *Journal of the Photographic Society*, no. 1 (March 3, 1853), pp. 9–11. [With Fenton's comments on Dr. Percy's paper.]

"Photographic Exhibition." Journal of the Photographic Society, no. 1 (March 3, 1853), p. 12.

"Photographic Exhibition." *Journal of the Society of Arts*, no. 9 (January 21, 1853), p. 100.

"Photographic Exhibition." Journal of the Society of Arts, December 9, 1853, p. 62.

"Photographic Exhibition at the Society of Arts." *Art-Journal* 15 (February 1, 1853), pp. 54–56.

"Photographic Gossip." *Journal of the Photographic Society*, no. 4 (May 2, 1853), p. 56. [Account of Fenton's teaching photography to Dr. Vogel.]

"Photographic Society." *Journal of the Photographic Society*, no. 12 (December 21, 1853), p. 141. [Announcement of photographic exhibition.]

"Photographic Society." Journal of the Society of Arts, no. 7 (January 7, 1853), p. 76.

"Photographic Society." Journal of the Society of Arts, no. 8 (January 14, 1853).

"Photographic Society." Journal of the Society of Arts, no. 10 (January 28, 1853), p. 114.

"Photographic Society." *Notes and Queries*, no. 215 (December 10, 1853), p. 579. [Announcement of exhibition.]

"Photographic Society. First Ordinary Meeting. Thursday, February 3, 1853." *Journal of the Photographic Society*, no. 1 (March 3, 1853), p. 5.

"Photographic Society. Fourth Ordinary General Meeting. Thursday, May 5th, 1853." Journal of the Photographic Society, no. 5 (May 21, 1853), p. 57. [Discussion of Fenton's stereoscopes.]

"Photographie." *Cosmos 2* (April 10, 1853), pp. 463–66. [Account of Fenton's process of iodizing paper.]

"Photography." *Illustrated London News*, January 1, 1853, pp. 11–12. [Extracts from Fenton's paper "On the Present Position and Future Prospects of the Art of Photography."]

"Photography." *Illustrated London News*, April 2, 1853, p. 254. [Discussion of Fenton's use of the French measurement gramme.]

"Photography." Journal of the Society of Arts, March 4, 1853, p. 175.

"Réunion photographique." *La Lumière* 3 (May 28, 1853), pp. 87–88. [Discussion of Fenton photographs shown at the house of Ernest Lacan.]

Roscoe, Thomas. Wanderings and Excursions in North Wales. London: Henry G. Dohn, 1853. 1st ed., 1836.

"Rules for Taking Stereoscopic Views of Landscapes." *Journal of the Photographic Society*, no. 5 (May 21, 1853), p. 66.
[Discussion of Fenton's stereoscopes.]

Scot, Frank. "La Photographie en Angleterre." *La Lumière* 3 (May 14, 1853), pp. 77–78. [Discussion of Fenton's stereographs.]

——. "La Photographie en Angleterre." *La Lumière* 3 (May 28, 1853), pp. 85–86. [Mention of Fenton's Russian views.]

———. "La Photographie en Angleterre." *La Lumière* 3 (June 11, 1853), p. 93. [Report on Photographic Society meeting and discussion of Fenton's Russian stereoscopic views.]

———. "La Photographie en Angleterre." *La Lumière 3* (July 16, 1853), pp. 113–14. [Mention of Fenton's letter to the Société Héliographique, Paris.]

"Seventh Ordinary Meeting, Wednesday, January 19th, 1853." Journal of the Society of Arts, no. 9 (January 21, 1853), pp. 97–100. [Paper read by Antoine Claudet, "The Stereoscope and Its Photographic Applications."]

"Société Photographique de Londres." *La Lumière* 3 (February 19, 1853), pp. 30–31. [Report on society meeting.]

"Stereoscopic Angles." *Notes and Queries*, no. 192 (July 2, 1853), pp. 16–17. [Discussion of Fenton's stereoscopes and camera angles.]

Wheatstone, Sir Charles. "Note on a New Portable Reflecting Stereoscope." *Journal of the Photographic Society*, no. 5 (May 21, 1853), pp. 61–62.

1854

"April 21st, 1854." Journal of the Photographic Society, no. 16 (April 21, 1854), pp. 189–90.

"The Arsenal of Portsmouth." *Illustrated London News*, March 18, 1854, suppl., p. 242.

"The Baltic Fleet." *Illustrated London News*, March 18, 1854, suppl., pp. 241–64.

The British Almanac of the Society for the Diffusion of Useful Knowledge for the Year of Our Lord 1854. London: Charles Knight, 1854.

"The Court." Illustrated London News, May 13, 1854, p. 434.

"Court Circular." Times (London), July 17, 1854, p. 8.

Dickens, Charles. *Hard Times.* 1854. New ed., Signet Classic. New York: New American Library, 1961.

"English Photographs at the Paris Exhibition of 1855." Notes and Queries, no. 257 (September 30, 1854), pp. 271–72.

Exhibition of Photographic Pictures in Dundee. Dundee, 1854.

"The Exhibition of Photographs and Daguerreotypes, by the London Photographic Society." *Liverpool Photographic Journal*, no. 1 (January 14, 1854), pp. 17–19.

"The Exhibition of the Photographic Society." *Art-Journal* 16 (February 1, 1854), pp. 48–50.

"Exhibition of the Photographic Society." *Morning Chronicle*, January 4, 1854.

"Exposition de la Société Photographique de Londres." *La Lumière* 4 (January 14, 1854), p. 5. [Reprinted in translation from the *Morning Post.*]

"Exposition photographique." Letter to the Editor. [Signed Ch. G.]. La Lumière 4 (February 25, 1854), pp. 29–30.

Fenton, Roger. "Exposition de la Société Photographique de Londres." *La Lumière* 4 (December 30, 1854), p. 207.

——. "Photographic Society." *Notes and Queries*, no. 219 (January 7, 1854), p. 1. [Announcement of the exhibition of photographs.]

"A Group of Russian Peasants." *Illustrated London News*, February 4, 1854, p. 88. [Illustration of *Russian Peasants* from Fenton photograph.]

Hadow, Edward Ash. "The Quality and Proportions of the Materials Required in the Collodion Process. Part II.—Iodized Collodion and Nitrate Bath." *Journal of the Photographic Society*, no. 16 (April 21, 1854), pp. 190–94.

Hardwich, Thomas Frederick. "On the Collodion Process." Letter to the Editor. *Journal of the Photographic Society*, no. 14 (February 21, 1854), pp. 171–73. [Mention of Fenton's use of nitrate of silver.]

"Her Majesty 'Leading' the Fleet to Sea." *Illustrated London News*, March 18, 1854, suppl., pp. 242–43.

Howitt, William. Visits to Remarkable Places; Old Halls, Battle Fields, and Scenes Illustrative of Striking Passages in English History and Poetry. 2 vols. 3rd American ed. Philadelphia: Parry and McMillan, 1854.

"January 21st, 1854." Journal of the Photographic Society, no. 13 (January 21, 1854), p. 153. [Announcement of opening of Photographic Society exhibition.]

Journal of the Photographic Society, no. 15 (March 21, 1854), p. 178. ↑Mention of Fenton's photographs of clouds. ↑

Journal of the Photographic Society, no. 25 (December 21, 1854), pp. 81–82. [Fenton on Thomas Frederick Hardwich's paper "On Printing Positives."]

Lane, Harley. "Waxed-Paper Pictures." *Notes and Queries*, no. 226 (February 25, 1854), p. 182. [Mention of Fenton's waxed-paper photographs.]

"List of Members." Journal of the Society of Arts, and of the Institutions in Union 2 (November 11, 1853—November 10, 1854). [Fenton listed as a member.]

Liverpool Photographic Journal, no. 3 (March 11, 1854), pp. 37, 38. \[Several mentions of Fenton. \]

"London Photographic Society." Liverpool Photographic Journal, no. 9 (September 9, 1854), pp. 121–22.

"London Photographic Society. Ordinary Meeting, Saturday, November 2, 1854." *Liverpool Photographic Journal*, no. 12 (December 9, 1854), pp. 160–61. [Fenton on artificial scenery.]

"On the Ice." Illustrated London News, January 7, 1854, pp. 9-10.

"Photographic Institution." *Illustrated London News*, March 4, 1854, suppl., n.p. [Announcement of exhibition of photographs at the Photographic Institution.]

Photographic Society. Exhibition of Photographs and Daguerreotypes at the Gallery of the Society of British Artists. London: Taylor and Francis, 1854.

"Photographic Society." *Athenaeum*, no. 1367 (January 7, 1854), p. 23.

"Photographic Society." *Athenaeum*, no. 1369 (January 21, 1854), p. 90. [Announcement of Photographic Society's exhibition opening.]

"The Photographic Society." *Illustrated London News*, January 7, 1854, p. 6.

"Photographic Society." *Journal of the Photographic Society*, no. 21 (August 21, 1854), pp. 13–14. [Fenton to secure representation of English photographs at the 1855 Paris exhibition.]

"Photographic Society. Anniversary Meeting, Thursday, February 2nd, 1854." *Journal of the Photographic Society*, no. 14 (February 21, 1854), pp. 165–67. [Reprinted in "Proceedings of the London Photographic Society. Anniversary Meeting, Thursday, February 2, 1854," *Liverpool Photographic Journal*, no. 3 (March 11, 1854), pp. 39–41.

"Photographic Society. Extraordinary Meeting, Thursday, July 6th, 1854." *Journal of the Photographic Society*, no. 20 (July 21, 1854), pp. 1–4. [Mention of Fenton in connection with William Henry Fox Talbot's patent renewal.]

"Photographic Society. Ordinary Meeting. Nov. 2nd, 1854."

Journal of the Photographic Society, no. 24 (November 21, 1854),

pp. 59–60. [Fenton on artificial scenery.]

"Photographic Society's Exhibition." *Notes and Queries*, no. 219 (January 7, 1854), pp. 16–17.

"La Photographie et la guerre." *La Lumière* 4 (April 15, 1854), p. 51. [Reprinted in translation from the *Journal of the Society of Arts* and from the *Moniteur universel*.]

"La photographie et la guerre." *La Lumière* 4 (April 22, 1854), p. 64.

"La Photographie et la guerre." *La Lumière* 4 (April 29, 1854), p. 66. [Extract in translation from the *Journal of the Photographic Society.*]

"Photography and the Photographic Exhibition." Builder, no. 572 (January 21, 1854), pp. 27–28.

"Photography and the Photographic Society." *Builder*, no. 575 (February 11, 1854), p. 73. [Report of the society's meeting.]

"Photography Applied to the Purposes of War." *Art-Journal* 16 (May 1, 1854), pp. 152–53. [Mention of Fenton's Portsmouth photographs.]

"Proceedings of the London Photographic Society. Ninth Ordinary Meeting, April 6, 1854." *Liverpool Photographic Journal*, no. 5 (May 13, 1854), pp. 64–65.

"Proceedings of the London Photographic Society. Seventh Ordinary Meeting, Thursday, December 1st, 1853." *Liverpool Photographic Journal*, no. 1 (January 14, 1854), pp. 9–10.

"The Snow Storm.—The Weather." *Illustrated London News*, January 7, 1854, p. 7.

Teasdale, Washington. "On the Waxed-Paper Process."

Journal of the Photographic Society, no. 15 (March 21, 1854),

pp. 182–85. [Mention of Fenton's use of egg whites.]

Thomas, Richard W. "The Silver Bath." Letter to the Editor. *Journal of the Photographic Society*, no. 13 (January 21, 1854), pp. 159–60. [Written in response to Fenton's article "On the Nitrate Bath," *Journal of the Photographic Society*, no. 11 (November 21, 1853), pp. 133–38.]

"Waxed-Paper Process." Journal of the Photographic Society, no. 13 (January 21, 1854), p. 161. [Fenton on the waxed-paper process.]

The Year-Book of Facts in Science and Art. London: David Bogue, 1854.

1855

"Affairs in England." New York Daily Times, October 16, 1855, p. 2. [Brief mention of Fenton's Crimean photographs.]

Bede, Cuthbert [pseud.]. *Photographic Pleasures: Popularly Portrayed with Pen and Pencil.* London: T. McLean, 1855. [Discussion of Fenton's Russian photographs, pp. 76–78.]

British Association. Catalogue of Photographs and Photographic Apparatus, Exhibited at the Meeting in Glasgow, September, 1855. Glasgow: S. & T. Dunn, 1855.

"The Departing Year." *Illustrated London News*, December 29, 1855, pp. 753–54. [Illustration of Fenton photograph *Three Croat Chiefs.*]

"English Photography." *Liverpool Photographic Journal*, no. 24 (December 8, 1855), p. 146. [Excerpt in translation from Périer, November 1855.]

"Exhibition of Mr. Fenton's Photographic Pictures of the Seat of War in the Crimea." *Illustrated London News*, September 29, 1855, p. 382.

"Exhibition of Mr. Fenton's Photographic Pictures of the Seat of War in the Crimea." *Illustrated London News*, October 6, 1855, p. 407.

"Exhibition of Photographic Pictures of the Seat of War in the Crimea." *Illustrated London News*, October 27, 1855, p. 499.

"Exhibition of Photographs." *Illustrated London News*, February 17, 1855, pp. 164–66. [Illustration of the *Valley of the Wharfe* after Fenton photograph.]

"The Exhibition of Photographs Taken in the Crimea." *Notes and Queries*, no. 312 (October 20, 1855), n.p. [Announcement of exhibition.]

"The Exhibition of the Photographic Pictures Taken by Roger Fenton, Esq., in the Crimea." *Illustrated London News*, September 22, 1855, p. 359. [Announcement of exhibition.]

Exhibition of the Photographic Pictures Taken in The Crimea by Roger Fenton, Esq. Manchester: Thomas Agnew and Sons, 1855.

"Exhibition of the Photographic Society." *Illustrated London News*, January 27, 1855, p. 95.

"Exposition de la Société Photographique de Londres." La Lumière 5 (January 27, 1855), p. 15. [Extract in translation from Notes and Queries.]

"Exposition photographique de Londres." *La Lumière 5* (February 3, 1855), p. 17. [Reprinted in translation from the *Manchester Guardian*, January 17, 1855.]

Fenton, Roger. "Exposition annuelle de la Société Photographique de Londres." *La Lumière 5* (December 29, 1855), p. 205.

——. "Photographic Society." *Notes and Queries*, no. 321 (December 22, 1855). [Announcement of society's annual exhibition.]

"Fenton's Crimea." *Manchester Guardian*, September 22, 1855, p. 1. 「Announcement of exhibition. □

"Fenton's 350 Photographs Taken in the Crimea." *Athenaeum*, no. 1469 (December 22, 1855), p. 1501. [Announcement of removal of Fenton's Crimean photographs to the New Water-Colour Gallery, Pall Mall.]

"General Bosquet." *Illustrated London News*, October 6, 1855, p. 405. [Reproduction of Fenton portrait of General Bosquet.]

"History's Telescope." *Leader*, September 22, 1855, pp. 914–15. [Discussion of the role of portrait photography, especially studies of Lord Raglan, in the writing of history.]

Lacan, Ernest. "De la photographie et de ses diverses applications aux beaux-arts et aux sciences." *La Lumière 5* (January 20, 1855), pp. 11–12. [Extract from the *Moniteur*, January 12, 1855.] [Fenton's Russian photographs.]

"Mr. Fenton's Crimean Photographs." *Illustrated London News*, November 10, 1855, p. 557. [Illustration of Fenton's photographic van.]

"Mr. Roger Fenton's Photographs." *Rochdale Weekly Banner*, October 6, 1855. Copy in Local Studies, Rochdale Public Library, Lancashire.

"The New Commander in the Crimea." *Illustrated London News*, November 3, 1855, p. 520. [Illustration of *General Sir William John Codrington* from Fenton photograph.]

"Notice to Exhibitors to Whom Prizes Have Been Awarded." Journal of the Photographic Society, no. 37 (December 21, 1855), p. 277. [Fenton awarded a silver medal at the Exposition Universelle, Paris, 1855.].

"Nouvelles photographiques." *La Lunière 5* (May 5, 1855), p. 69. [Announcement of Fenton's arrival in the Crimea.]

"Omer Pacha." *Illustrated London News*, October 20, 1855, p. 472. [Reproduction of Fenton's portrait of Omar Pasha.]

"The Peace Coalition." *Illustrated London News*, October 13, 1855), pp. 425–26. [Reproduction of Fenton's portrait of General Simpson.]

Périer, Paul. "Exposition Universelle. 6° Article.— Photographes étrangers." *Bulletin de la Société Française de Photographie* 1 (November 1855), pp. 314–32.

"The Photographic Exhibition." *Notes and Queries*, no. 273 (January 20, 1855), pp. 51–52.

"Photographic Pictures of the Seat of War in the Crimea." *Athenaeum*, no. 1456 (September 22, 1855), p. 1075. [Thomas Agnew advertisement.]

Photographic Society. Exhibition of Photographs and Daguerreotypes at the Gallery of the Society of Water Colour Painters. London: Richard Barrett, 1855.

"Photographic Society. Annual General Meeting. Feb. 1st, 1855." *Journal of the Photographic Society*, no. 27 (February 21, 1855), p. 117. [Mention of Fenton's absence due to assignment in Crimea.]

"Photographic Society. Special General Meeting. Feb. 20th, 1855." *Journal of the Photographic Society*, no. 29 (April 21, 1855), p. 144.

"Photographie." *Cosmos* 6 (March 9, 1855), pp. 264–67. □Discussion of Fenton's work. □

"La Photographie en Crimée." *La Lumière 5* (September 1, 1855), p. 139. 「Announces Fenton's return to England.]

"Photographs from Sebastopol." *Art-Journal* 17 (October 1, 1855), p. 285.

"Photographs from Sebastopol." *Humphrey's Journal* [New York] 7 (November 15, 1855), pp. 223–25. [Reprinted from the London *Art-Journal*, October 1855.]

"Photographs from the Crimea." *Athenaeum*, no. 1457 (September 29, 1855), pp. 1117–18.

"Photographs of the Seat of War." *Illustrated London News*, September 15, 1855, p. 326. [Reprinted from the *Manchester Guardian*.]

"Portrait of W. H. Russell, "Our Special Correspondent." Athenaeum, no. 1461 (October 27, 1855), p. 1245. [Mention of lithograph by J. H. Lynch, after Fenton photograph.]

"Report of the Council." *Journal of the Photographic Society*, no. 27 (February 21, 1855), pp. 117–18. [Mention of Fenton's departure for the Crimea.]

Russell, William Howard. The War: From the Landing at Gallipoli to the Death of Lord Raglan. London: G. Routledge, 1855. New ed.: Russell's Despatches from the Crimea, 1854–1856. Ed. Nicolas Bentley. New York: Hill and Wang, 1967.

The Scenery of the Wharf: Comprising an Interesting Account of Ilkley, Ben Rhydding, Bolton Abbey and Other Places... Leeds: Alice Mann, 1855.

Shadbolt, George. "Fenton's Photographs from Crimea." *Notes and Queries*, no. 310 (October 6, 1855), pp. 272–73.

"Spahi and Zouave." *Illustrated London News*, November 3, 1855, p. 524. [Illustration of *Spahi and Zoave* from Fenton photograph.]

"Testimonial to Dr. Diamond. F.S.A." Notes and Queries, no. 277 (February 10, 1855), n.p.

"Topics of the Week." *Literary Gazette, and Journal of Science and Art,* no. 2018 (September 22, 1855), p. 605. [Discussion of Fenton's war photographs.]

"Town and Table Talk on Literature, Art, &c." *Illustrated London News*, September 22, 1855, p. 347. [Discussion of Fenton's exhibition of Crimean photographs.]

Ziegler, J. Compte rendu de la photographie à l'Exposition Universelle de 1855. N.p., 1855. [Discussion of Fenton, p. 42.]

1856

"Art Treasures Exhibition." Journal of the Society of Arts, no. 195 (August 15, 1856), p. 653.

"Art Treasures Exhibition." Journal of the Society of Arts, no. 207 (November 7, 1856), p. 798.

Bourne, John Cooke. "Description of a New Patent Portable Camera, with Separate Dark-Chamber, Wherein the Whole Negative Process May Be Performed; and Arrangements for Obtaining Increased Definition of the Picture." *Journal of the Photographic Society*, no. 38 (January 21, 1856), pp. 283–84.

Catalogue de l'exposition instituée par l'Association pour l'Encouragement et le Développement des Arts Industriels en Belgique. Brussels: E. Guyot and Stapleaux Fils, 1856.

Companion to the Alamanac; or, Year-Book of General Information for 1856. London: Knight and Company, 1856. Published with The British Almanac of the Society for the Diffusion of Useful Knowledge for the Year of Our Lord 1856. London: Charles Knight, 1856.

"The Crimean Exhibition." *Athenaeum*, no. 1482 (March 22, 1856), p. 363. [Announcement of exhibition.]

"The Crimean Photographs." Birmingham Journal, February 16, 1856, p. 3.

"Exhibition of Photographs at Bombay." *Humphrey's Journal* ∇New York 7 8 (December 1, 1856), pp. 233–35.

"Exposition Universelle. Liste officielle des récompenses accordées à la photographie." *Photographic Notes*, nos. 1 and 2 (2nd ed.) (January 1 and 25, 1856), pp. xix–xx.

Fenton, Roger. "Excursion photographique sur le théatre de la guerre en Crimée." *Bulletin de la Société Française de Photographie* 2 (March 1856), pp. 88–90. [Reprinted in translation from the *Journal of the Photographic Society*, no. 38 (January 21, 1856).]

Photographic Society," *Liverpool Photographic Journal*, no. 26 (February 9, 1856), pp. 23–24.

"Fenton's Crimean Photographs." *Athenaeum*, no. 1476 (February 9, 1856), p. 174. [Announcement of exhibition.]

"Fenton's Crimean Photographs." *Illustrated London News*, April 12, 1856, p. 374. [Announcement of exhibition.]

"Fenton's Crimean Photographs." *Illustrated London News*, May 3, 1856, p. 479. [Announcement of exhibition.]

"Fine-Art Gossip." Athenaeum, no. 1495 (June 21, 1856), p. 784. [Discussion of Augustus Egg's painting Council of War Deciding on the Attack of the Mamelon.]

"The Generals in Tent at Balaklava." *Art-Journal* 18 (July 1, 1856), p. 226. [Exhibition of Augustus Egg's painting based on Fenton photograph.]

Hardwich, Thomas Frederick. "Sur les divers agents destructeurs en photographie." *Cosmos* 8 (April 25, 1856), pp. 428−31.
□Discussion of Fenton's British Museum negatives. □

Journal of the Photographic Society, no. 42 (May 21, 1856), p. 37. [Discussion of conflict of interest among members of the Photographic Society and Photographic Association.]

Journal of the Photographic Society, no. 43 (June 21, 1856), p. 63. [Fenton on Paul Pretsch's paper "Photo-Galvanography, or Engraving by Light and Electricity."]

Journal of the Photographic Society, no. 47 (October 21, 1856), pp. 149–50. [Extract in translation from Humbert de Molard, "Exposition Universelle de photographie à Bruxelles," Bulletin de la Société Française de Photographie 2 (October 1856), pp. 282–84.] [Brief mention of perfection of Fenton's landscapes.]

Journal of the Photographic Society, no. 48 (November 21, 1856), p. 153. [Mention of Fenton's work at the exhibition in Pall Mall.]

Lacan, Ernest. Esquisses photographiques à propos de l'Exposition Universelle et de la guerre d'Orient: Historique de la photographie, développements, applications, biographies et portraits. Paris: Grassart and A. Gaudin, 1856. [Fenton mentioned, pp. 25, 96–99 (landscapes), 167–83 (Crimean War photographs).]

——. "Exposition photographique de Bruxelles." *La Lumière* 6 (December 6, 1856), p. 189.

——. "Exposition photographique de Bruxelles: Distribution des récompenses." *La Lumière* 6 (December 13, 1856), p. 193.

"The Last Ten Days." *Manchester Guardian*, January 17, 1856, p. 1. [Announcement of exhibition of Fenton's photographs of the Crimea. Lists photographs recently added.]

"Laws of the Photographic Society of London." *Journal of the Photographic Society*, no. 39 (February 21, 1856). [Insert following vol. 2.]

"Lecture in Relation to the Theatre of War." Handbill for Roger Fenton's lecture, "The Crimea," given January 21, 1856, at the Public Hall, Rochdale, Lancashire. Copy in Local Studies, Rochdale Public Library, Lancashire.

"London Photographic Society." *Liverpool Photographic Journal*, no. 30 (June 14, 1856), p. 84. [Fenton's resignation as member of the Council of the Photographic Society.]

Manchester Photographic Society. Exhibition of Photographs, at the Mechanics' Institution. Manchester: Cave & Sever, 1856.

"Manchester Photographic Society. General Meeting Held April 3rd, 1856." *Photographic Notes*, no. 6 (May 25, 1856), p. 51.

Molard, Humbert de. "Exposition Universelle de photographie à Bruxelles." *Bulletin de la Société Française de Photographie* 2 (October 1856), pp. 278–93.

"Mr. Fenton's Crimean Photographs." Birmingham Journal, February 9, 1856, p. 7.

"Nineteenth Ordinary Meeting, Wednesday, April 23, 1856." Journal of the Society of Arts, no. 179 (April 2, 1856), pp. 385–89.

Norwich Photographic Society. Norwich: Fletcher and Alexander, [1856.]

Phipson, T. "Universal Exhibition of Photography, Brussels." *Journal of the Photographic Society*, no. 47 (October 21, 1856), pp. 146–49. [Reprinted in translation from *Cosmos* 9 (October 3, 1856), pp. 345–50; (October 10, 1856), pp. 370–72.]

"The Photo-Galvanographic Company." *Chemist* 3 (May 1856), pp. 499–500.

"Photogalvanography." *Photographic Notes*, no. 6 (May 25, 1856), pp. 60–62.

"Photogalvanography; or, Engraving by Light and Electricity." *Art-Journal* 18 (July 1, 1856), pp. 215–16.

Photographic Art Treasures; or Nature and Art Illustrated by Art and Nature. London: Patent Photo-Galvanographic Company, 1856.

"The Photographic Association." Journal of the Photographic Society, no. 42 (May 21, 1856), n.p.

"Photographic Exhibition of the Manchester Photographic Society." *Photographic Notes*, no. 13 (October 15, 1856), pp. 204–6.

Photographic Notes, no. 15 (November 15, 1856), pp. 235–37. [Review of Photographic Art Treasures, presumably written by Thomas Sutton.]

Photographic Notes, no. 16 (December 1, 1856), p. 259. [Advertisement for Photographic Art Treasures.] Photographic Society. Exhibition of Photographs and Daguerreotypes at the Gallery of the Society of Water Colour Painters. London, 1856.

"The Photographic Society." *Athenaeum*, no. 1472 (January 12, 1856), pp. 46–47. [Discussion of Fenton's portraits.]

"Photographic Society. Annual General Meeting. Feb. 7th, 1856." Journal of the Photographic Society, no. 39 (February 21, 1856), pp. 299—304. [Fenton retires as secretary.] [Also mentioned in "Photographic.—Feb. 7.—Annual Meeting," Athenaeum, no. 1478 (February 23, 1856), p. 236, and "London Photographic Society," Liverpool Photographic Journal, no. 27 (March 8, 1856), p. 42.]

"Photographic Society. Ordinary Meeting. April 3, 1856." Journal of the Photographic Society, no. 41 (April 21, 1856), pp. 18–19. [Fenton on fading of watercolors.]

"Photographic Society. Ordinary Meeting. December 4, 1856." Journal of the Photographic Society, no. 49 (December 22, 1856), pp. 173–74. [Fenton retires from the Council; Fenton on modifications of paper processes.]

"Photographic Society. Ordinary Meeting. March 6, 1856." *Journal of the Photographic Society*, no. 40 (March 21, 1856), pp. 2–6. [Fenton on British Museum negatives.] [See also "London Photographic Society," *Liverpool Photographic Journal*, no. 28 (April 12, 1856), p. 52.]

"Photographic Society. Ordinary Meeting. May 1, 1856."

Journal of the Photographic Society, no. 42 (May 21, 1856), p. 38.

[Fenton on conflict of interest among members of the Photographic Society and Photographic Association.]

"Photographic Society. Ordinary Meeting. November 6, 1856." *Journal of the Photographic Society*, no. 48 (November 21, 1856), pp. 155–57.

"Photographic Society of London. Ordinary Meeting and Special General Meeting. January 3, 1856." *Journal of the Photographic Society*, no. 38 (January 21, 1856), pp. 281–82. [Fenton on the Crimea and proposed appointment of a paid secretary.]

"Photographic Society of Scotland." *Photographic Notes*, no. 7 (June 25, 1856), pp. 76–77. [Discussion of photogalvanographic patent process of Paul Pretsch and others.]

"The Photographic Society's Exhibition." *Illustrated London News*, January 19, 1856, p. 74.

"Photographic Views of Sebastopol, Taken Immediately after the Retreat of the Russians." *Notes and Queries*, 2nd ser., no. 11 (March 15, 1856), p. 220. [Mention of Fenton's photographs of the Crimea.]

"Rapport du jury: Chargé de juger la section de photographie à l'Exposition Universelle des Arts Industriels de Bruxelles." Bulletin de la Société Française de Photographie 2 (November 1856), pp. 344–52.

Sparling, Marcus. Theory and Practice of the Photographic Art; Including Its Chemistry and Optics with Minute Instruction in the Practical Manipulation of the Various Processes, Drawn from the Author's Daily Practice. London: Houlston & Stoneman, 1856.

Société Française de Photographie. Catalogue de la deuxième exposition annuelle des oeuvres des artistes et amateurs français et étrangers. Paris: Société Française de Photographie, 1856.

1857

"The Archer Testimonial." *Notes and Queries*, 2nd ser., no. 77 (June 20, 1857), p. 493. [Mention of Fenton as treasurer of Archer committee.]

Black's Picturesque Guide to North Wales. Edinburgh: Adam and Charles Black, 1857.

Catalogue de la quatrième exposition instituée par l'Association pour l'Encouragement et le Développement des Arts Industriels en Belgique. Brussels: Guyot, 1857.

"Documents officiels pour servir à l'histoire de la photographie: Extrait des rapports de jury mixte international de l'Exposition Universelle." *La Lumière* 7 (May 9, 1857), p. 75.

[Eastlake, Lady Elizabeth.] "Art. V. Photography." *Quarterly Review* 101 (April 1857), pp. 442–68.

"Exhibition of Art Treasures at Manchester." *Liverpool and Manchester Photographic Journal*, no. 14 (July 15, 1857), pp. 144–45.

Exhibition of the Art Treasures of the United Kingdom. Supplemental Catalogue. Drawings and Sketches of Old Masters, Engravings, Photographs. Manchester, 1857.

"Exhibition of the Photographic Society." *Photographic Notes*, no. 25 (April 15, 1857), pp. 140–42.

"Exposition de Bruxelles.—1857." Bulletin de la Société Française de Photographie 3 (December 1857), pp. 364–66.

"Exposition de Bruxelles. Récompenses distribuées aux photographes exposants." Cosmos 11 (December 18, 1857), p. 689.

"Exposition de la Société Photographique d'Écosse." *La Lumière* 7 (December 12, 1857), p. 198.

"Fine-Art Gossip." *Athenaeum*, no. 1548 (June 27, 1857), pp. 826–27. [Mention of Fenton's photographs of Bolton Abbey exhibited at Colnaghi's.]

"Fine Arts." Athenaeum, no. 1526 (January 24, 1857), p. 120. [Discussion of Fenton's association with the Patent Photo-Galvanographic Company and review of his work in Photographic Art Treasures.]

"First Exhibition of the Photographic Society of Scotland." *Photographic Notes*, no. 19 (January 1, 1857), pp. 24–26.

"First Exhibition of the Photographic Society of Scotland." *Photographic Notes*, no. 20 (February 1, 1857), pp. 45–46.

Journal of the Photographic Society, no. 52 (March 21, 1857), p. 234. [Fenton on Thomas Frederick Hardwich's paper "On the Manufacture of Collodion."]

L[acan], E[rnest]. "La photographie en Angleterre." La Lumière 7 (February 28, 1857), p. 33.

Liverpool and Manchester Photographic Journal, no. 4 (February 15, 1857), p. 35. [Mention of Fenton's contributions to Photographic Society exhibition.]

Liverpool and Manchester Photographic Journal, no. 4 (February 15, 1857), pp. 37–38. [The Reverend J. B. Reade on Manchester Photographic Society exhibition.]

"Manchester Photographic Society." Liverpool and Manchester Photographic Journal, no. 3 (February 1, 1857), pp. 28–29. □ Exhibition review. □

Moigno, F. "Exposition de la Société Française." *Cosmos* 10 (February 6, 1857), pp. 116–22.

Notices of the First Exhibition of the Norwich Photographic Society. N.p., 1857. [Reprinted from the Norfolk News.]

"Photographic Art-Treasures." *Athenaeum*, no. 1529 (February 14, 1857), p. 198. [Advertisement.]

"Photographic Art-Treasures." *Athenaeum*, no. 1542 (May 16, 1857), p. 614. [Advertisement.]

"Photographic Art-Treasures. Part I." Athenaeum, no. 1524 (January 10, 1857), p. 54.

"Photographic Art Treasures. Part 2." Photographic Notes, no. 23 (March 15, 1857), pp. 104-5.

"The Photographic Exhibition." Illustrated London News, January 17, 1857, p. 41.

"The Photographic Exhibition." *Journal of the Photographic Society*, no. 51 (February 21, 1857), pp. 213–17.

Photographic Society. Exhibition of Photographs, at the Gallery of the Society of Water Colour Painters. London: Richard Barrett, 1857.

"The Photographic Society." *Athenaeum*, no. 1524 (January 10, 1857), pp. 54–55. [Exhibition review.]

"Photographic Society. Annual General Meeting. February 5, 1857." *Journal of the Photographic Society*, no. 51 (February 21, 1857), pp. 217–22. [Fenton on Archer Fund.]

"Photographic Society. Ordinary Meeting. December 3, 1857." *Journal of the Photographic Society*, no. 61 (December 21, 1857),

pp. 101–2. [Fenton listed as vice-president.]

"Photographic Society. Ordinary Meeting. May 7, 1857."

Journal of the Photographic Society, no. 54 (May 21, 1857),
pp. 270–72. [Fenton on fund for F. Scott Archer.]

"Photographic Soirée at King's College." *Chemist* 4 (January 1857), pp. 255–56. [Fenton listed as an attendee.]

"Rapport sur l'exposition ouverte par la société en 1857." Bulletin de la Société Française de Photographie 3 (September 1857), pp. 250–72.

"Trésors de l'art photographique." *La Lumière* 7 (June 20, 1857), p. 98. 「Brief mention of Fenton's photographs.]

1858

Architectural Photographic Association. Exhibition of the Collection of Photographs for 1857, at the Galleries, in Suffolk Street, Pall Mall East. Catalogue. London: Architectural Photographic Association, [1858].

"Architectural Photographic Association." *Builder*, no. 780 (January 16, 1858), p. 42. [Fenton's involvement with the Architectural Photographic Association.]

Art-Union of London. Twenty-Second Annual Report of the Council of the Art-Union of London. London, 1858.

"The Art-Union of London." Art-Journal 20 (September 1, 1858), p. 283.

"The Art-Union of London. Distribution of Prizes." *Art-Journal* 20 (June 1, 1858), p. 183.

"Association Photographique d'Architecture." [Signed H. H.] *La Lumière* 8 (January 23, 1858), p. 14. [Mention of Fenton's involvement with the Architectural Photographic Association.]

Athenaeum, no. 1597 (June 5, 1858), p. 709. [Advertisement for the Stereoscopic Magazine, with description of contents.]

Blanchère, H. de la. "Sur les images amphipositives." La $Lumi\`ere$ 8 (January 30, 1858), pp. 18–19. [Fenton on amphipositives.]

Book of the Household. London: London Printing Company, 1858.

"The Exhibition." *Journal of the Photographic Society*, no. 66 (May 21, 1858), pp. 207–11.

"Exhibition of Photographs at the South Kensington Museum." *Liverpool and Manchester Photographic Journal*, no. 5 (March 1, 1858), pp. 61–63.

"Exhibition of Photographs at the South Kensington Museum." *Liverpool and Manchester Photographic Journal*, no. 7 (April 1, 1858), pp. 82–83.

"Exhibition of the Architectural Photographic Association." Photographic News, no. 16 (December 24, 1858), pp. 185–86. "Exposition photographique de Londres." La Lumière 8 (May 29, 1858), p. 84.

"Exposition photographique de Londres." *La Lumière* 8 (July 3, 1858), p. 105.

Fenton, Roger. "The Law of Artistic Copyright." Letter to the Editor. *Journal of the Photographic Society*, no. 62 (January 21, 1858), p. 151.

"The Forthcoming Exhibition." Letter to the Editor. *Journal of the Photographic Society*, no. 70 (September 21, 1858), p. 31.

Hervé, C. S. "Copyright and Photography." Letter to the Editor. *Journal of the Photographic Society*, no. 66 (May 21, 1858), pp. 223–24.

Journal of the Photographic Society, no. 74 (December 11, 1858), p. 89. [Fenton listed as a society member who will exchange fifty prints.]

"List of the Medallists for Photography, at the Brussels Exhibition of 1857." *Photographic Notes*, no. 43 (January 15, 1858), p. 26.

Macduff, Sholto. "Important Discovery in Photography." *Notes and Queries*, 2nd ser., no. 125 (May 22, 1858), pp. 423–24. [Brief mention of Fenton's presiding over discussion of carbon printing.]

Newton, Sir William J., and Roger Fenton. "List of Subscribers to the Archer Testimonial Fund." *Chemist 5* (January 1858), pp. 254–56. [See also Sir William J. Newton and Roger Fenton, "The Archer Fund," *Photographic Journal*, no. 85 (May 23, 1859), pp. 298–300.]

"The Photographic Exhibition." *Art-Journal* 20 (April 1, 1858), pp. 120–21.

"The Photographic Exhibition at the Crystal Palace." *Photographic News*, no. 3 (September 24, 1858), pp. 29–30.

"The Photographic Exhibition at the Crystal Palace." *Photographic News*, no. 4 (October 1, 1858), pp. 40–41.

"The Photographic Exhibition at the Crystal Palace." *Photographic News*, no. 5 (October 8, 1858), pp. 52–53.

Photographic Notes, no. 44 (February 1, 1858), pp. 34–35. [Brief mention of Fenton in Architectural Photographic Association.]

Photographic Notes, no. 46 (March 1, 1858), pp. 59–60. [Review of exhibition at Photographic Society, including Fenton's work.]

"Photographic Society." *Athenaeum*, no. 1582 (February 20, 1858), p. 246. [Discussion of Fenton's photographs.]

"Photographic Society." *Athenaeum*, no. 1596 (May 29, 1858), pp. 692–93. [Mention of Fenton's photographs.]

"The Photographic Society." Literary Gazette, and Journal of Belles Lettres, Science, and Art, February 20, 1858, pp. 185–86.

"Photographic Society. Ordinary General Meeting. December 7, 1858." *Journal of the Photographic Society*, no. 74 (December 11, 1858), pp. 90–94. [Mention of Fenton as chairman and a number of references to the actions of the chairman.]

"Photographic Society. Ordinary General Meeting. November 2, 1858." *Journal of the Photographic Society*, no. 72 (November 6, 1858), pp. 52–54. [Mention of Fenton as chairman.]

"Photographic Society. Ordinary Meeting. April 6, 1858." *Journal of the Photographic Society*, no. 65 (April 21, 1858), pp. 190–91.

"Photographic Society. Ordinary Meeting. March 2, 1858."

Journal of the Photographic Society, no. 64 (March 22, 1858),

pp. 170–72. [Fenton on Petzval's lens.]

"Photographic Society. Ordinary Meeting. May 4, 1858."

Journal of the Photographic Society, no. 66 (May 21, 1858),
p. 211. [Fenton announces death of Mrs. F. Scott Archer.]

"Photographic Society of Ireland." *Journal of the Photographic Society*, no. 66 (May 21, 1858), p. 215. [Members to receive a Fenton photograph.]

"Photographic Society's Exhibition." *Builder*, no. 785 (February 20, 1858), pp. 132–33.

"Photographs." *Athenaeum*, no. 1622 (November 27, 1858), p. 694. 「Thomas H. Gladwell advertisement."

"Rapport sur la section de photographie à l'Exposition des Arts Industriels de Bruxelles." *Bulletin de la Société Française de Photographie* 4 (March 1858), pp. 82–84. [Discussion of Fenton's position in English photography.]

Rejlander, Oscar G. "On Photographic Composition; with a Description of 'Two Ways of Life." *Journal of the Photographic Society*, no. 65 (April 21, 1858), pp. 191–97. [With Fenton's comments on Dr. Rejlander's paper.]

"Séances des sociétés de photographie. Société Française.— Séance du 15 avril 1858." Cosmos 12 (April 30, 1858), pp. 459–61. [Fenton donated prints to benefit Société Française de Photographie, Paris.]

"Société de Londres. Séance du 1^{er} juin 1858.—Présidence de M. Roger Fenton." *Bulletin de la Société Française de Photographie* 4 (September 1858), p. 233. [Lists Fenton as chairman.]

"Société de Londres. Séance du 4 mai [1858].—Présidence de M. Roger Fenton." Bulletin de la Société Française de Photographie 4 (September 1858), p. 232. [Lists Fenton as chairman.]

"Société de Londres. Séance générale annuelle du 2 février 1858.— Présidence de lord Pollack." Bulletin de la Société Française de Photographie 4 (September 1858), p. 230. [Mention of Fenton as new vice-president.]

"La Société Photographique de Londres." [Signed H. H.] La Lumière 8 (March 27, 1858), p. 50. [Discussion of Fenton's landscapes.] "Stereoscopic Magazine." Literary Gazette, and Journal of Belles Lettres, Science, and Art, no. 2153 (April 24, 1858), p. 408.

"To the Editor of the Photographic Journal." [Signed W.M'L.] *Journal of the Photographic Society*, no. 70 (September 21, 1858), pp. 30–31.

1859

Art-Union of London. Twenty-Third Annual Report of the Council of the Art-Union of London. London. 1859.

Athenaeum, no. 1628 (January 8, 1859), p. 55. [Mention of Fenton's landscapes at Suffolk Street exhibition.]

British Association. Exhibition of Photographs, in the Music Hall Building. Aberdeen, 1859.

Burty, Philippe. "Exposition de la Société Française de Photographie." *Gazette des beaux-arts* 1 (May 15, 1859), pp. 209–21.

"Conversazione of the Halifax Literary and Philosophical Society." *Photographic News*, no. 21 (January 28, 1859), pp. 249–50.

"The Exhibition in Suffolk Street." *Photographic Journal*, no. 77 (January 21, 1859), pp. 143–50.

"The Exhibition of the Photographic Society." *Photographic News*, no. 19 (January 14, 1859), pp. 217–18.

"The Exhibition of the Photographic Society." *Photographic News*, no. 20 (January 21, 1859), pp. 230–31.

"The Exhibition of the Photographic Society." *Photographic News*, no. 21 (January 28, 1859), pp. 241–42.

"Foreign Science. (From Our Special Correspondent.)."

Photographic News, no. 33 (April 21, 1859), pp. 77–79. [Review of Palais de l'Industrie exhibition.]

"Foreign Science (From Our Special Correspondent)." *Photographic News*, no. 38 (May 27, 1859), pp. 137–38. Review of Paris exhibition.

Glasgow Photographic Society. Catalogue of Their Exhibition of Photographic Works, Held in the Gallery of the Crystal Palace. Glasgow: S. & T. Dunn, 1859.

"Glasgow Photographic Society." *Photographic Journal (BJP)*, no. 95 (June 1, 1859), p. 139.

L[acan], E[rnest]. "Exposition photographique." *La Lumière* 9 (July 9, 1859), p. 109.

"London Photographic Society." *Photographic News*, no. 18 (January 7, 1859), p. 213. [Mention of Fenton as chairman.]

"London Photographic Society." *Photographic News*, no. 22 (February 4, 1859), pp. 261−62. [Discussion of Fenton's activities as chairman.]

"London Photographic Society." *Photographic News*, no. 31 (April 8, 1859), pp. 57–58. [Fenton on Mayall's discussion of lenses.]

"London Photographic Society." *Photographic News*, no. 35 (May 6, 1859), pp. 103–5. [Discussion of Fenton's actions as chairman.]

"London Photographic Society." *Photographic News*, no. 61 (November 4, 1859), p. 106. [Fenton on lenses.]

"Macclesfield Photographic Society's Exhibition." *Photographic Journal (BJP)*, no. 89 (March 1, 1859), p. 60.

Newton, Sir William J., and Roger Fenton. "The Archer Fund." *Photographic Journal*, no. 85 (May 23, 1859), pp. 298–300.

"Notes on the Photographic Exhibition at Aberdeen. [By a Travelling Photographer.]." [Signed "Sel d'Or."] *Photographic Journal (BJP)*, no. 108 (October 1, 1859), pp. 243–44.

"Nottingham Photographic Exhibition." *Photographic Journal*, no. 78 (February 5, 1859), p. 182.

"Nottingham Photographic Society: Exhibition at the Exchange Hall." [Signed F. R. F.] *Photographic News*, no. 20 (January 21, 1859), pp. 237–38.

"Nottingham Photographic Society's Exhibition." *Photographic Journal (BJP)*, no. 87 (February 1, 1859), p. 36.

"Photographic Exhibition." *Art-Journal* 21 (February 1, 1859), pp. 45–46.

Photographic Journal, no. 80 (March 5, 1859), p. 203. [Appointment of committee to form a collection of photography.]

Photographic Journal, no. 84 (May 7, 1859), pp. 281–82. Fenton's comments as chairman on technical process.

Photographic Journal, no. 88 (August 16, 1859), p. 11. [Fenton reports additions to Archer fund.]

Photographic Journal (BJP), no. 85 (January 1, 1859), frontis. [Illustration of The Undercliff near Niton, Isle of Wight after Fenton photograph.]

Photographic Journal (BJP), no. 86 (January 15, 1859), p. 13. [Mention of Prince Albert's visit to Photographic Society exhibition at Suffolk Street gallery.]

Photographic Journal (BJP), no. 93 (May 1, 1859), p. 103. [Review of exhibition in Blackheath.]

Photographic Society. Exhibition of Photographs and Daguerreotypes at the Gallery of the Society of British Artists. London: Richard Barrett, 1859.

"Photographic Society." *Athenaeum*, no. 1629 (January 15, 1859), pp. 86–87. [Mention of Fenton's Orientalist studies.]

"Photographic Society. Ordinary General Meeting. January 4, 1859." *Photographic Journal*, no. 76 (January 8, 1859), p. 122. [Discussion of Fenton's actions as chairman.]

"Photographic Society. Ordinary General Meeting. Tuesday, November 1, 1859." *Photographic Journal*, no. 91 (November 15, 1859), pp. 72–74. [Fenton on lenses.]

"Photographic Society, London. Ordinary General Meeting. April 5, 1859." *Photographic Journal*, no. 82 (April 9, 1859), pp. 241–44. [Fenton mentioned as member of collodion committee.]

"The Photographic Society's Exhibition." *Builder*, no. 832 (January 15, 1859), p. 36.

"Photographic Society's Sixth Annual Exhibition." *Photographic Journal (BJP)*, no. 87 (February 1, 1859), pp. 34–36.

"Pont-y-Pant." Stereoscopic Magazine, no. 11 (May 1859), pp. 161–64.

"The Present High Temperature." *Photographic News*, no. 45 (July 15, 1859), pp. 226–27.

Société Française de Photographie. Catalogue de la troisième exposition de la Société Française de Photographie comprenant les oeuvres des photographes français & étrangers. Paris: Société Française de Photographie, 1859.

"Stereoscopic Photography." *Athenaeum*, no. 1679 (December 31, 1859), p. 904. [Advertisement for *The Conway in the Stereoscope* by James Bridge Davidson, illustrated with Fenton's stereoscopic photographs.]

1860

"The Archer Fund. Additional Contributions." *Photographic Journal*, no. 97 (May 15, 1860), p. 243. [Announcement of receipt of prints from members, including Fenton, for distribution.]

"Architectural Photographic Association." *Builder*, no. 888 (February 11, 1860), pp. 87–88. [Fenton mentioned in a list of photographic classifications.]

"Architectural Photographic Association." *Builder*, no. 889 (February 18, 1860), p. 104. [Fenton's photographs mentioned.]

"The Architectural Photographic Association." *Photographic News*, no. 75 (February 10, 1860), pp. 265–67. [Exhibition of Fenton's photographs mentioned.]

"Architectural Photographic Association." *Photographic News*, no. 78 (March 2, 1860), pp. 307–8.

"Architectural Photographic Exhibition." *Photographic News*, no. 79 (March 9, 1860), pp. 319–20.

"Architectural Photographs." *Notes and Queries,* 2nd ser., no. 216 (February 18, 1860), n.p. [Advertisement lists Fenton's *Cathedrals of England.*]

"The Conway in Stereoscope." *Notes and Queries*, 2nd ser., no. 212 (January 21, 1860), n.p. [Advertisement for book by James Bridge Davidson, illustrated with Fenton's stereoscopic photographs.]

Davidson, James Bridge. *The Conway in the Stereoscope.*Illustrated with stereoscopic photographs by Roger Fenton.
London: Lovell Reeve. 1860.

Donelly, Captain. "On Photography, and Its Application to Military Purposes." *Photographic Journal*, no. 101 (September 15, 1860), pp. 328–30. [Mention of Fenton's exhibition standards.]

"Exhibition of the Photographic Society." *Art-Journal* 22 (March 1, 1860), pp. 71–72.

"Exhibition of the Photographic Society of Scotland." *Photographic Journal*, no. 93 (January 16, 1860), pp. 130–32.

Figuier, Louis. *La Photographie au Salon de 1859*. Paris: L. Hachette et Cie, 1860.

"Government Competition with Photographers." *Photographic News*, no. 103 (August 24, 1860), p. 194. [Fenton quoted on confiscation of British Museum negatives.]

"London Photographic Society." *Photographic News*, no. 118 (December 7, 1860), pp. 379–80. [Fenton's retirement as vice-president.]

"London Photographic Society's Exhibition." *British Journal of Photography*, no. 111 (February 1, 1860), pp. 41–42.

"The Meeting of the National Rifle Association." *Illustrated London News*, July 14, 1860, p. 42 (ill. p. 25).

"The National Rifle Association. Inauguration by Her Majesty of the First Prize Meeting." *Illustrated London News*, July 17, 1860, suppl., pp. 17–18.

"Obituary." [Obituary for Marcus Sperling.] British Journal of Photography, no. 117 (May 1, 1860), p. 137.

Obituary for Peter Wickens Fry. *Photographic Journal*, no. 101 (September 15, 1860), p. 314. [Fenton mentioned.]

Parliament. House of Commons. Report from the Select Committee of the House of Commons on the South Kensington Museum: With Notes. London, 1860.

"The Photographic Exhibition." $\it Athenaeum, no.~1682$ (January 21, 1860), pp. 98–99.

"The Photographic Exhibition." *Photographic News*, no. 73 (January 27, 1860), pp. 241–43.

"The Photographic Exhibition." *Photographic News*, no. 74 (February 3, 1860), pp. 253–55.

"The Photographic Exhibition." *Photographic News*, no. 76 (February 17, 1860), pp. 282–83.

"The Photographic Exhibition." *Photographic News*, no. 77 (February 24, 1860), pp. 294–96.

"Photographic Exhibition. (From a Correspondent.)." *Photographic Notes*, no. 94 (March 1, 1860), pp. 68–69.

"Photographic Exhibition. (From a Correspondent.)." *Photographic Notes*, no. 95 (March 15, 1860), p. 86.

"Photographic Exhibition. (From a Correspondent.)." *Photographic Notes*, no. 96 (April 1, 1860), p. 98.

"Photographic Exhibition. (From a Correspondent.)." [Signed A. H. W.] *Photographic Notes*, no. 97 (April 15, 1860), pp. 112–14.

Photographic Journal, no. 100 (August 15, 1860), pp. 291–93. [Article on copyright, including mention of Fenton.]

Photographic Society. Exhibition of Photographs and Daguerreotypes at the Gallery of the Society of Painters in Water-Colours. London: Taylor and Francis. 1860.

"The Photographic Society." *Photographic News*, no. 70 (January 6, 1860), pp. 211–12. [Mention of Fenton's actions as chairman.]

"Photographic Society. Ordinary General Meeting. January 3, 1860." *Photographic Journal*, no. 93 (January 16, 1860), pp. 116–17. [Mention of Fenton's actions as chairman.]

"Photographic Society of London." *Photographic News*, no. 83 (April 5, 1860), pp. 374–77. [Fenton's actions as chairman.]

"Photographic Society of London. Ordinary General Meeting. December 4, 1860." *Photographic Journal*, no. 104 (December 15, 1860), p. 50. [Fenton's retirement as senior vice-president.]

"Photographic Society of London. Ordinary General Meeting. Tuesday, April 3, 1860." *Photographic Journal*, no. 96 (April 16, 1860), pp. 192–94. [Fenton's actions as chairman.]

"Photographic Society's Exhibition." *Builder*, no. 886 (January 28, 1860), p. 59.

"Photographs of Public Collections." Letter to the Editor. *Photographic Journal*, no. 102 (October 15, 1860), pp. 3–5. [Mention of Fenton's association with British Museum.]

"Photography and the Volunteers." *Photographic Journal*, no. 99 (July 16, 1860), pp. 269–71. [Fenton's activities at the Hythe School of Musketry.]

"Report of the Collodion Committee." Photographic Journal, no. 94 (February 15, 1860), pp. 151–55. [Reprinted in translation in "Rapport du comité chargé par la société de Londres de l'étude du collodion," Bulletin de la Société Française de Photographie 6 (March 1860), pp. 77–83.]

"Report of the Collodion Committee." *Photographic News*, no. 75 (February 10, 1860), suppl., pp. 278–80. [Discussion of Fenton's paper on collodion.]

"Review of the Volunteers by Her Majesty in Hyde Park." Illustrated London News, June 30, 1860, p. 628 [ill. pp. 624–25].

1861

"Address." Stereoscopic Magazine, no. 34 (April 1861), n.p.

Architectural Photographic Association. Catalogue of the Fourth Annual Exhibition of English and Foreign Photographs. London: Architectural Photographic Association, 1861.

"Architectural Photographic Association." [Signed S. H.] British Journal of Photography, no. 135 (February 1, 1861), pp. 50–51. [Exhibition review.]

"Architectural Photographic Society." *Builder*, no. 936 (January 12, 1861), p. 21. [Mention of Fenton's submissions.]

"The Athenaeum,' January 19, 1861." *Photographic Journal*, no. 106 (February 15, 1861), pp. 117–18. [Reprint of review of Photographic Society exhibition in Pall Mall East.]

Beeton, Isabella. The Book of Household Management . . . Also, Sanitary, Medical, and Legal Memoranda; with a History of the Origin, Properties, and Uses of All Things Connected with Home Life and Comfort. London: Ward, Lock & Tyler, 1861.

"British Association." *Athenaeum*, no. 1767 (September 7, 1861), pp. 313–18.

"The British Association at Manchester." *Photographic Journal*, no. 113 (September 16, 1861), pp. 271–72. [Exhibition review.]

"British Association for the Advancement of Science. By Our Eye-Witness at Manchester." *British Journal of Photography*, no. 150 (September 16, 1861), pp. 330–31. [Exhibition review.]

"Chinese Curiosities." *Stereoscopic Magazine*, no. 34 (April 1861), p. 7.

"Chinese Ivory Casket." *Stereoscopic Magazine*, no. 34 (April 1861), p. 9.

"A Copy of the Photographic Album' (Fading Photographs)." Letter to the Editor. *Photographic Journal*, no. 114 (October 15, 1861), pp. 285–86. [Mention of Fenton's *Birth of Saint John.*]

"The 'Court Circular,' February 9, 1861." *Photographic Journal*, no. 106 (February 15, 1861), pp. 118–19. [Reprint of review of Photographic Society exhibition in Pall Mall East.]

"Criticisms on the Exhibition." *Photographic Journal*, no. 106 (February 15, 1861), p. 116.

"The Exhibition of Architectural Photographic Association." Photographic News, no. 125 (January 25, 1861), p. 37.

"Exhibition of Photographs at Manchester in Connexion with the Meeting of the British Association for the Advancement of Science. By Our Eye-Witness at Manchester." *British Journal* of Photography, no. 151 (October 1, 1861), pp. 344–47. [Exhibition review.] "Exhibition of the Architectural Photographic Association." Photographic News, no. 124 (January 18, 1861), p. 26.

"Exhibition of the Photographic Society." *Art-Journal* 23 (February 1, 1861), pp. 47–48.

"George Lance, Esq." *Illustrated London News*, December 21, 1861, 2nd suppl., pp. 647–68.

"The Golden Age.' By G. Lance." Illustrated London News, February 23, 1861, p. 166.

"'Illustrated News of the World,' Jan. 19, 1861." *Photographic Journal*, no. 106 (February 15, 1861), p. 119.

[Reprint of review of Photographic Society exhibition in Pall Mall East.]

"Lectures: Architectural Photographic Society." Builder, no. 943 (March 2, 1861), p. 145.

"London Photographic Society." *Photographic News*, no. 123 (January 11, 1861), pp. 18–19. [Mention of Fenton's position on the Council.]

"London Photographic Society." *Photographic News*, no. 127 (February 8, 1861), pp. 68–70. [Mention of Fenton's retirement.]

"London Photographic Society. Report." British Journal of Photography, no. 136 (February 15, 1861), pp. 69–72.

"London Photographic Society's Exhibition." British Journal of Photography, no. 134 (January 15, 1861), pp. 37–38.

"London Photographic Society's Exhibition." *British Journal of Photography*, no. 136 (February 15, 1861), pp. 67–68.

"London Photographic Society's Exhibition." British Journal of Photography, no. 138 (March 15, 1861), pp. 108–9.

"The Photographic Exhibition." *Photographic News*, no. 124 (January 18, 1861), pp. 25–26.

"The Photographic Exhibition." *Photographic News*, no. 125 (January 25, 1861), pp. 38–39.

Photographic Journal, no. 109 (May 15, 1861), p. 171. [Mention of Fenton as one of the "leading photographers."]

Photographic Society. Exhibition of Photographs and Daguerreotypes at the Gallery of the Society of Painters in Water-Colours. London: Taylor and Francis, 1861.

"The Photographic Society." *Art-Journal* 23 (July 1, 1861), p. 223. [Discussion of proposed placement of photographs in 1862 International Exhibition.]

"Photographic Society of London. King's College. Ordinary General Meeting. Tuesday, June 4, 1861." *Photographic Journal*, no. 110 (June 15, 1861), pp. 196–202.

"Photographic Society's Exhibition, Pall-Mall." *Builder*, no. 937 (January 19, 1861), p. 39.

"Photography as a Fine Art." *Photographic News*, no. 125 (January 25, 1861), pp. 41–42. [Mention of Fenton's landscape photographs.]

"Report of the Council of the Photographic Society." *Photographic News*, no. 128 (February 15, 1861), pp. 79–80. [Mention of Fenton's actions in founding the society.]

"Report of the Council of the Photographic Society." *Photographic Notes*, no. 118 (March 1, 1861), pp. 76–78. Fenton's role in founding the society.

"'The Sun,' January 24, 1861." *Photographic Journal*, no. 106 (February 15, 1861), pp. 119–21. [Reprint of review of Photographic Society exhibition in Pall Mall East.]

Thompson, S. "Notes on the Present Exhibitions." *Photographic Journal*, no. 106 (February 15, 1861), pp. 110–13.

"The Times,' January 18th, 1861." *Photographic Journal*, no. 106 (February 15, 1861), pp. 116–17. [Reprint of review of Photographic Society exhibition in Pall Mall East.]

1862

Black's Picturesque Guide to Yorkshire. 2nd ed. Edinburgh: Adam and Charles Black. 1862.

Catalogue of the Photographs Exhibited in Class XIV. International Exhibition of 1862. London, 1862.

The Illustrated Catalogue of the Industrial Department, British Division. Vol. 2. International Exhibition of 1862. London, 1862.

"Mr. Fenton's Photographic Effects." *Photographic News*, no. 222 (December 5, 1862), p. 588. [Auction of Fenton's equipment.]

"Photography at the International Exhibition." *Photographic Journal*, no. 123 (July 15, 1862), pp. 79–82. [Award given to Fenton.]

"Report of Jurors. Class XIV. Photography and Photographic Apparatus." *Photographic Journal*, no. 128 (December 15, 1862), pp. 190–93.

"Retirement of Mr. Fenton from Photographic Pursuits." *Photographic Journal*, no. 126 (October 15, 1862), pp. 157–58.

"Ruined Abbeys and Castles." *Photographic Journal*, no. 121 (May 15, 1862), p. 57. [Review of publication, *Ruined Abbeys and Castles of Great Britain* by William and Mary Howitt (1862). Fenton's photographs, included as photographic illustrations, are mentioned by the reviewer.]

1863

Fenton, Roger, and J. Durham. "Report." *Photographic Journal*, no. 130 (February 16, 1863), pp. 220–21. [Report on medals awarded in exhibition.]

Law List for 1863. London: V. & R. Stevens, 1863.

Obituary for John Fenton. *Rochdale Observer*, August 1, 1863. Copy in Local Studies, Rochdale Public Library, Lancashire.

1865

"Portraits of Roger Fenton, by J. Eastham, Manchester." *British Journal of Photography*, no. 254 (March 17, 1865), p. 143.

1866

Banks, William Stott. Walks in Yorkshire. Vol. 1, In the North West. London: J. Russell Smith, 1866.

"The Late Meeting of the Photographic Society." *Photographic News*, no. 433 (December 21, 1866), pp. 608–9. [Fenton to receive medal as one of the society's founders.]

"London Photographic Society." *Photographic News*, no. 432 (December 14, 1866), pp. 595–97. [Medal given to Fenton as founder of the society.]

1869

"The Architectural Exhibition, Conduit Street." *Builder*, no. 1371 (May 15, 1869), pp. 379–80.

Bradshaw's Railway Manual, Shareholders' Guide and Directory. London: W. J. Adams, 1869. New ed., with an introduction by C. R. Clinker. Newton Abbott: David & Charles, 1969.

"The Late Mr. Roger Fenton." British Journal of Photography, no. 485 (August 20, 1869), pp. 400–401.

"Obituary." [Obituary for Roger Fenton.] *Photographic News*, no. 573 (August 27, 1869), p. 419.

"Obituary. Roger Fenton, M.A." *Photographic Journal*, no. 209 (September 15, 1869), p. 126.

1870

Catalogue of the Collection of Ancient and Modern Pictures, Water-Colour Drawings, and Engravings, Formed by Roger Fenton, Esq., Deceased. Sale cat. Christie, Manson & Woods, London, June 13, 1870.

Catalogue of the Library of a Well-Known Collector . . . The Property of the Late Roger Fenton. Sale cat. London: Sotheby, Wilkinson, and Hodge, 1870.

1873

"The Late Charles Lucy." *Illustrated London News*, June 7, 1873, p. 544.

1874-79

Martin, Sir Theodore. *The Life of His Royal Highness the Prince Consort.* 5 vols. London: Smith, Elder & Company, 1874–79.

1877

Dobson, William. *Rambles by the Ribble*. 2nd ser. Preston: W. Dobson, 1877.

1878

"The Failure as Viewed in Heywood." Unidentified clipping, ca. 1878. Copy in Local Studies, Rochdale Public Library, Lancashire.

"Fentons' Bank Failure." *Rochdale Observer*, December 7, 1878. Copy in Local Studies, Rochdale Public Library, Lancashire.

1879

Kelly's Handbook to the Upper Ten Thousand, for 1879, Containing about Twenty Thousand Names of the Titled, Landed and Official Classes. 5th ed. London: Kelly, 1879.

"Report of Sale of Mr. Jonathan Nield's, Mr. William Fenton's and Mr. Joseph Fenton's Picture Collections at Christie, Manson & Woods, London, 3 May, 1879." *Rochdale Observer*, May 10, 1879. Copy in Local Studies, Rochdale Public Library, Lancashire.

1883

Halieutes [John Gerard]. "The Stonyhurst Fisheries." Stonyhurst Magazine, 1883, pp. 1–7.

Hall, Samuel Carter. *Retrospect of a Long Life: From 1815 to 1883*. New York: D. Appleton and Company, 1883.

1885

Muckley, William J. A Manual on Flower Painting in Oil Colours from Nature, with Instructions for Preliminary Practice; Also a Section on Flower Painting in Water Colours, etc. London: Winsor & Newton, 1885.

1886

Muckley, William J. A Manual on Fruit and Still-Life Painting in Oil and Water Colours from Nature; Also Instructions for Elementary Practice Preparatory to Beginning to Paint. London: Winsor & Newton, 1886.

1894

Campbell, Colin Frederick. Letters from Camp to His Relatives during the Siege of Sebastopol. Ed. Robert Blachford Mansfield. London: R. Bentley, 1894.

1899

Nadar [Félix Tournachon]. *Quand j'étais photographe.* Paris: Flammarion, 1899. Reprint ed., New York: Ayer, 1979.

1903

"James Bridge Davidson." *Devon Notes and Queries 2* (January 1902—October 1903), p. 129.

1904

Obituary for William Fenton. Derbyshire Times, April 2, 1904.

Obituary for William Fenton. *High Peak News* [Buxton, Derbyshire], April 2, 1904.

Ruskin, John. *The Works of John Ruskin*. Ed. E. T. Cook and Alexander Wedderburn. Library Edition. Vol. 12, *Lectures on Architecture and Painting (Edinburgh, 1853) with Other Papers, 1844–1854*. London: George Allen; New York: Longmans, Green, and Company, 1904.

"Russo-Turkish War." In *Haydn's Dictionary of Dates and Useful Information Relating to All Ages and Nations*, pp. 1086–88. 23rd ed. Ed. Benjamin Vincent. London: Ward, Lock & Company, 1904.

1904-5

Graves, Algernon. The Royal Academy of Arts: A Complete Dictionary of Contributors and Their Work from Its Foundation in 1769 to 1904. 8 vols. London: H. Graves and Company, 1904–5.

1905

Ruskin, John. The Works of John Ruskin. Ed. E. T. Cook and Alexander Wedderburn. Library Edition. Vol. 16, "A Joy for Ever" and The Two Paths, with Letters on the Oxford Museum and Various Addresses, 1856–1860. London: George Allen; New York: Longmans, Green, and Company, 1905.

1906

Burke, Ashworth P. A Genealogical and Heraldic History of the Landed Gentry of Great Britain. London: Harrison, 1906.

1928

Fairbairns, William H. *Lichfield Cathedral*. S.P. C. K. Cathedral Series. London: S. P. C. K.; New York: Macmillan, 1928.

1935

Batsford, Harry, and Charles Fry. *The Cathedrals of England*. New York: Charles Scribner's Sons; London: B. T. Batsford, 1935.

1939

Le Neve Foster, Peter. "The Centenary of Photography. Early Associations of the Society of Arts with Photography." *Journal of the Society of Arts*, June 23, 1939, pp. 818–23.

1941

Fenton, Lena R. "The First War Photographer. At the Crimea in 1855." *Illustrated London News*, November 8, 1941, pp. 590–91.

Strasser, Alexander. Immortal Portraits: Being a Gallery of Famous Photographs by David Octavius Hill, Julia Margaret Cameron, Gaspard Felix Tournachon Nadar, Roger Fenton, Adolphe Disderi, and Others. Classics of Photography. London and New York: Focal Press, 1941.

1942

Strasser, Alexander. Victorian Photography: Being an Album of Yesterday's Camera-Work by William Henry Fox Talbot, David Octavius Hill and Others. Classics of Photography. London and New York: Focal Press, 1942.

1946

Bunt, Cyril G. E., comp. "Works by David Cox Exhibited in London during His Lifetime." In F. Gordon Roe, Cox, the Master: The Life and Art of David Cox (1783–1859), pp. 87–117. Leighon-Sea: F. Lewis, 1946.

Johnston, J. Dudley. "The Story of the RPS." Unpublished manuscript. 1946. Copy in Royal Photographic Society Collection, National Museum of Photography, Film & Television, Bradford.

1950

Cook, George Henry. *Portrait of Lincoln Cathedral*. London: Phoenix House, 1950.

Gibbs-Smith, Charles Harvard, comp. *The Great Exhibition of 1851: A Commemorative Album.* London: His Majesty's Stationery Office, 1950.

"Photographs of Crimean War Are Exhibited—Additional Items." New York Times, September 10, 1950, sect. 2, p. 15.

1951

Gernsheim, Helmut. *Masterpieces of Victorian Photography*. Foreword by Charles Harvard Gibbs-Smith. London: Phaidon Press, 1951.

1952

Dodds, John W. The Age of Paradox: A Biography of England, 1841–1851. New York: Rinehart & Company, 1952.

1953

Woodham Smith, Cecil Blanche Fitz Gerald. *The Reason Why.* London: Constable, 1953.

1954

Gernsheim, Helmut, and Alison Gernsheim. Roger Fenton, Photographer of the Crimean War: His Photographs and His Letters from the Crimea. With an Essay on His Life and Work. London: Secker & Warburg, 1954. Reprint ed., The Literature of Photography, vol. 17. New York: Arno Press, 1973.

Hartley, Dorothy. Food in England. London: Macdonald & Company, 1954.

1957

Altick, Richard D. The English Common Reader: Social History of the Mass Reading Public, 1800–1900. Chicago: University of Chicago Press, 1957.

1960

Fenton, Ethel. *The Fentons of Crimble*. N.p., [ca. 1960]. Privately published. Copy in Local Studies, Rochdale Public Library, Lancashire.

1961

Fletcher, Sir Banister Flight. A History of Architecture on the Comparative Method. 17th ed. Rev. by R. A. Cordingley. London: Athlone Press, 1961.

Hibbert, Christopher. The Destruction of Lord Raglan: A Tragedy of the Crimean War, 1854–55. London: Longmans, 1961.

1963

Barnsley, R. E. "Mars and Aesculapius": An Address Given in the Royal Army Medical College. London: Sapphire Press, 1963.

1964

Jammes, Marie-Thérèse, and André Jammes. "Le Premier Reportage de guerre." *Camera*, vol. 43, no. 1. (January 1964), pp. 2–38.

1965

Boase, Frederic. Modern English Biography: Containing Many Thousand Concise Memoirs of Persons Who Have Died between the Years 1851–1900, with an Index of the Most Interesting Matter. Vol. 3. London: Frank Cass, 1965.

1967

Hood, Robert E. Twelve at War: Great Photographers under Fire. New York: Putnam. 1967.

1968

Constable, John. *John Constable's Correspondence*. Vol. 6, *The Fishers*. Ed. Ronald Brymer Beckett. Suffolk Records Society, vol. 12. London, H. M. Stationery Office, 1968.

1969

Gernsheim, Helmut, with Alison Gernsheim. *The History of Photography from the Camera Obscura to the Beginning of the Modern Era*. Rev. ed. London: Thames & Hudson, 1969.

1971

Boime, Albert. The Academy and French Painting in the Nineteenth Century. London: Phaidon, 1971.

1974

Hannavy, John. *The Camera Goes to War: Photographs from the Crimean War, 1854–56.* Exh. cat. Edinburgh: Scottish Arts Council, 1974.

Hodgson, Pat. Early War Photographs. Boston: New York Graphic Society, 1974.

1975

Harker, Margaret F. Victorian and Edwardian Photographs. Letts Collectors Guides. London: Charles Letts & Company, 1975.

Knightley, Phillip. The First Casualty, from the Crimea to Vietnam: The War Correspondent as Hero, Propagandist, and Myth Maker. New York: Harcourt Brace Jovanovich, 1975.

1976

Hannavy, John. *Roger Fenton of Crimble Hall.* Boston: David R. Godine, 1976.

Lewis, Frank. Edward Ladell, 1821–1886. Leigh-on-Sea: F. Lewis Publishers. 1976.

McLean, Ruari. *Joseph Cundall, a Victorian Publisher: Notes on His Life and a Check-List of His Books.* Pinner, Middlesex: Private Libraries Association, 1976.

Stenton, Michael, comp. Who's Who of British Members of Parliament: A Biographical Dictionary of the House of Commons Based on Annual Volumes of "Dod's Parliamentary Companion" and Other Sources. Vol. 1, 1832–1885. Hassocks, Sussex: Harvester Press, 1976.

1977

Arnold, Harry John Philip. William Henry Fox Talbot: Pioneer of Photography and Man of Science. London: Hutchinson Benham. 1977.

Jammes, Marie-Thérèse, and André Jammes. Niepce to Atget: The First Century of Photography, from the Collection of André Jammes. Exh. cat. Chicago: Art Institute of Chicago, 1977.

Millard, Charles. "Images of Nature: A Photo-Essay." In *Nature* and the Victorian Imagination, ed. U. C. Knoepflmacher and G. B. Tennyson, pp. 3–26. Berkeley and Los Angeles: University of California Press, 1977.

1978

Lewinski, Jorge. *The Camera at War: A History of War Photography from 1848 to the Present Day.* New York: Simon and Schuster, 1978.

Robertson, David Allan. Sir Charles Eastlake and the Victorian Art World. Princeton: Princeton University Press, 1978.

Said, Edward. Orientalism. New York: Pantheon Books, 1978.

1980

Hershkowitz, Robert. The British Photographer Abroad: The First Thirty Years. London: Robert Hershkowitz, 1980.

Hopkinson, Tom. Treasures of the Royal Photographic Society, 1839–1919. London: Heinemann, 1980.

Whittingham, Selby. *Constable and Turner at Salisbury*. 2nd ed. Friends of Salisbury Cathedral Publications. Salisbury: Friends of Salisbury Cathedral, 1980.

1981

Brown, Ford Madox. The Diary of Ford Madox Brown.

Ed. Virginia Surtees. Studies in British Art. New Haven and London: Yale University Press, 1981.

Darrah, William C. Cartes de Visite in Nineteenth Century Photography. Gettysburg: William C. Darrah, 1981.

Stark, Amy E. "Lowell Augustus Reeve (1814–1865): Publisher and Patron of the Stereograph." *History of Photography* 5 (January 1981), pp. 3–15.

1982

Evans, Tom. "Photographer and Monarch." Art and Artists, no. 185 (February 1982), pp. 18–19.

Pare, Richard, ed. *Photography and Architecture*, 1839–1939. Exh. cat. by Catherine Evans Inbusch and Marjorie Munsterberg. Montreal: Canadian Centre for Architecture; New York: Callaway Editions, 1982.

Vignoles, Keith H. Charles Blacker Vignoles: Romantic Engineer. Cambridge and New York: Cambridge University Press, 1982.

Witt, John Clermont. William Henry Hunt (1790–1864): Life and Work, with a Catalogue. London: Barrie & Jenkins, 1982.

1983

Faberman, Hilarie. Augustus Leopold Egg, R.A. (1816–1863). Ph.D. diss., Yale University, 1983.

Nochlin, Linda. "The Imaginary Orient." *Art in America*, vol. 71, no. 5 (May 1983), pp. 118–31, 187–91.

Vignoles, Keith H. "C. B. Vignoles and the RPS." *Photographic Journal* 123 (January 1983), pp. 28–30.

1984

Brettell, Richard R., with Roy Flukinger, Nancy Keeler, and Sydney Mallett Kilgore. *Paper and Light: The Calotype in France and Great Britain, 1839–1870.* Exh. cat. Boston: David R. Godine; Houston: Museum of Fine Arts; Chicago: Art Institute of Chicago, 1984.

Elwall, Robert. "The Foe-to-graphic Art': The Rise and Fall of the Architectural Photographic Association." *Photographic Collector* 5 [1984], pp. 142–63.

Gernsheim, Helmut. Incunabula of British Photographic Literature: A Bibliography of British Books Illustrated with Original Photographs. London: Scolar Press and Derbyshire College of Higher Education, 1984.

Grunchec, Philippe. *The Grand Prix de Rome: Paintings from the École des Beaux-Arts, 1797–1863.* Exh. cat., National Academy of Design, New York, and seven other institutions. Washington, D.C.: International Exhibitions Foundation, 1984.

Haworth-Booth, Mark, ed. *The Golden Age of British Photography,* 1839–1900. Exh. cat. Millerton, N.Y.: Aperture; Philadelphia: Philadelphia Museum of Art, 1984.

Lalumia, Matthew Paul. *Realism and Politics in Victorian Art of the Crimean War.* Studies in the Fine Arts, Iconography, no. 9. Ann Arbor, Mich.: UMI Research Press, 1984.

Stamp, Gavin. The Changing Metropolis: Earliest Photographs of London, 1839–1879. Harmondsworth, Middlesex: Viking, 1984.

1985

Bartram, Michael. The Pre-Raphaelite Camera: Aspects of Victorian Photography. Boston: Little, Brown, and Company, 1985

Bloore, Carolyn, and Grace Seiberling. A Vision Exchanged. Exh. cat. London: Victoria and Albert Museum, 1985.

Catalogues des expositions organisées par la Société Francaise de Photographie, 1857–1876. 2 vols. Paris: Guy Durier and Jean-Michel Place, 1985.

Hauptman, William. "Delaroche's and Gleyre's Teaching Ateliers and Their Group Portraits." *Studies in the History of Art* (National Gallery of Art, Washington, D.C.) 18 (1985), pp. 79–119.

Joseph, Steven F. "Wheatstone and Fenton: A Vision Shared." History of Photography 9 (October–December 1985), pp. 305–9.

A Personal View: Photography in the Collection of Paul F. Walter. Exh. cat. by John Szarkowski et al. New York: Museum of Modern Art. 1985.

1986

Seiberling, Grace, with Carolyn Bloore. *Amateurs, Photography, and the Mid-Victorian Imagination*. Chicago: University of Chicago Press, 1986.

1987

Bailey, Peter. Leisure and Class in Victorian England: Rational Recreation and the Contest for Control, 1830–1885. London: Methuen, 1987. First ed., 1978.

Dimond, Frances, and Taylor, Roger. *Crown and Camera: The Royal Family and Photography, 1842–1910.* Harmondsworth, Middlesex: Penguin Books, 1987.

Pare, Richard. *Roger Fenton*. First Masters of Photography, no. 4. New York: Aperture Foundation, 1987.

Spencer, Stephanie. "Francis Bedford's Photographs of North Wales: Selection and Interpretation." *History of Photography* 11 (July–September 1987), pp. 237–45.

1988

Frizot, Michel. "Roger Fenton: Le 'Pittoresque' Photographique." Beaux Arts Magazine, no. 60 (1988), pp. 64–69.

Hannavy, John. "Roger Fenton and the British Museum." History of Photography 12 (July–September 1988), pp. 193–204. Lloyd, Valerie. Roger Fenton: Photographer of the 1850s. Exh. cat. Hayward Gallery. London: South Bank Board, 1988.

Smith, Roger. "Selling Photography: Aspects of Photographic Patronage in Nineteenth-Century Britain." *History of Photography* 12 (October–December 1988), pp. 317–26.

1989

Andrews, Malcolm. The Search for the Picturesque: Landscape Aesthetics and Tourism in Britain, 1760–1800. Aldershot: Scolar, 1989

Date, Christopher. "Photographer on the Roof." *British Museum Society Bulletin*, no. 61 (Summer 1989), pp. 10–12.

1990

Date, Christopher, and Anthony Hamber. "The Origins of Photography at the British Museum, 1839–1860." *History of Photography* 14 (October–December 1990), pp. 309–25.

1991

Cutt, Samuel, and Frances Neale. Wells Cathedral. Andover: Pitkin, 1991.

1993

Hannavy, John. "Roger Fenton and the Waxed Paper Process." History of Photography 17 (Autumn 1993), pp. 233—43.

1994

Charlesworth, Michael. "The Ruined Abbey: Picturesque and Gothic Values." In *The Politics of the Picturesque: Literature,* Landscape and Aesthetics since 1770, ed. Stephen Copley and Peter Garside, pp. 62–80. Cambridge and New York: Cambridge University Press, 1994.

Roberts, Pam. *The Royal Photographic Society Collection*. London: Royal Photographic Society, 1994.

1995

Atıl, Esin, Charles Newton, and Sarah Searight. Voyages and Visions: Nineteenth-Century European Images of the Middle East from the Victoria and Albert Museum. Exh. cat. Washington, D.C.: Smithsonian Institution Traveling Exhibition Service; London: Victoria and Albert Museum, 1995.

Jaeger, Jens. "Photographic Societies in Britain in the Nineteenth Century: Structure and Influence of the First Amateur Movement in the 1850s." In "Darkness and Light": The Proceedings of the Oslo Symposium, 25.–28. August 1994, ed. Roger Erlandsen and Vegard S. Halvorsen, pp. 133–40. Oslo: National Institute for Historical Photography and Norwegian Society for the History of Photography, 1995.

Millar, Delia. The Victorian Watercolours and Drawings in the Collection of Her Majesty the Queen. 2 vols. London: Philip Wilson, 1995. Russell, William Howard. William Russell: Special Correspondent of The Times. Ed. Roger Hudson. London: Folio Society, 1995.

Taylor, Roger. "Darkness and Light: Approaching Victorian Landscape." In "Darkness and Light": The Proceedings of the Oslo Symposium, 25.–28. August 1994, ed. Roger Erlandsen and Vegard S. Halvorsen, pp. 19–28. Oslo: National Institute for Historical Photography and Norwegian Society for the History of Photography, 1995.

1996

Baldwin, Gordon. Roger Fenton: Pasha and Bayadère. Getty Museum Studies on Art. Los Angeles: The J. Paul Getty Museum, 1996.

Hamber, Anthony J. "A Higher Branch of the Art": Photographing the Fine Arts in England, 1839–1880. Documenting the Image, vol. 4. Amsterdam: Gordon and Breach Publishers, 1996.

Macleod, Diane Sachko. Art and the Victorian Middle Class: Money and the Making of Cultural Identity. New York: Cambridge University Press, 1996.

Pangels, Charlotte. Dr. Becker in geheimer Mission an Queen Victorias Hof: Die Briefe des Prinzenerziehers und Bibliothekars Dr. Ernst Becker aus seiner Zeit in England von 1850–1861. Hamburg: Jahn & Ernst, 1996.

Rose, Mary B. The Lancashire Cotton Industry: A History since 1700. Preston: Lancashire County Books, 1996.

Thackray, John. "The Modern Pliny': Hamilton and Vesuvius." In Ian Jenkins and Kim Sloan, *Vases and Volcanoes: Sir William Hamilton and His Collection*, pp. 65–74. Exh. cat. London: British Museum, 1996.

1997

Warner, Malcolm. "Signs of the Times." In *The Victorians: British Painting*, 1837–1901, pp. 17–41. Exh. cat. by Malcolm Warner, with Anne Helmreich and Charles Brock. Washington, D.C.: National Gallery of Art, 1997.

1998

Cannadine, David. *Class in Britain*. New Haven and London: Yale University Press, 1998.

Leroux-Dhuys, Jean-François. Cistercian Abbeys: History and Architecture. Cologne: Könneman, 1998.

Lord, Peter. Clarence Whaite and the Welsh Art World: The Betws-y-Coed Artists' Colony, 1844–1914. Aberystwyth: National Library of Wales, 1998.

1999

Auerbach, Jeffrey A. *The Great Exhibition of 1851: A Nation on Display.* New Haven and London: Yale University Press, 1999.

Daniel, Malcolm. "More Than Mere Photographs': The Art of Roger Fenton." *The Metropolitan Museum of Art Bulletin*, vol. 61, no. 4 (Spring 1999), pp. 24–31.

Davis, John R. The Great Exhibition. Stroud: Sutton, 1999.

Taylor, Roger. "The Graphic Society and Photography, 1839: Priority and Precedence." *History of Photography* 23 (Spring 1999), pp. 59–67.

Treuherz, Julian. "A Brief Survey of Victorian Painting." In Art in the Age of Queen Victoria: Treasures from the Royal Academy of Arts Permanent Collection, pp. 12–25. Exh. cat. ed. Helen Valentine. London: Royal Academy of Arts; New Haven and London: Yale University Press, 1999.

2000

Gage, John. "Clouds Over Europe." In *Constable's Clouds:*Paintings and Cloud Studies by John Constable, ed. Edward
Morris, pp. 125–34. Exh. cat. Edinburgh: National Galleries
of Scotland; Liverpool: National Museums and Galleries on
Merseyside, 2000.

Lyles, Anne. "'That Immense Canopy': Studies of Sky and Cloud by British Artists, c. 1770–1860." In *Constable's Clouds: Paintings and Cloud Studies by John Constable*, ed. Edward Morris, pp. 135–50. Exh. cat. Edinburgh: National Galleries of Scotland; Liverpool: National Museums and Galleries on Merseyside, 2000.

Maddison, John. *Ely Cathedral: Design and Meaning.* Ely: Ely Cathedral Publications, 2000.

Schaaf, Larry John. *The Photographic Art of William Henry Fox Talbot*. Princeton: Princeton University Press, 2000.

Tromans, Nicholas. "Museum or Market?: The British Institution." In *Governing Cultures: Art Institutions in Victorian England*, ed. Paul Barlow and Colin Trodd, pp. 44–55. Aldershot: Ashgate Publishing, 2000.

2001

Jacobson, Ken. "The Lovely Sea-View... Which All London Is Now Wondering At": A Study of the Marine Photographs Published by Gustave Le Gray, 1856—1858. Petches Bridge, England: Ken & Jenny Jacobson, 2001.

Keller, Ulrich. *The Ultimate Spectacle: A Visual History of the Crimean War.* Documenting the Image, vol. 7. Australia: Gordon and Breach Publishers, 2001.

2002

Ackerman, James S. Origins, Imitation, Conventions: Representation in the Visual Arts. Cambridge, Mass.: MIT Press, 2002.

Aubenas, Sylvie, et al. *Gustave Le Gray, 1820–1884*. Ed. Gordon Baldwin. Exh. cat. Los Angeles: The J. Paul Getty Museum, 2002. Kamlish, Marian. "Claudet, Fenton and the Photographic Society." *History of Photography* 26 (Winter 2002), pp. 296–306.

Mondenard, Anne de. La Mission héliographique: Cinq Photographes parcourent la France en 1851. Paris: Centre des Monuments Nationaux; Monum: Éditions du Patrimoine, 2002.

Taylor, Roger. "All in the Golden Afternoon': The Photographs of Charles Lutwidge Dodgson." In Roger Taylor and Edward Wakeling, *Lewis Carroll, Photographer: The Princeton University Library Albums*, pp. 1–120. Princeton and Oxford: Princeton University Press; Princeton: Princeton University Library, 2002.

Taylor, Roger. Photographs Exhibited in Britain, 1839–1865: A Compendium of Photographers and Their Works/
Photographies exposées en Grande-Bretagne de 1839–1865:
Répertoire des photographes et des leurs oeuvres. Library and
Archives, Occasional Paper/Bibliothèque et archives,
document hors-série 5. Ottowa: National Gallery of
Canada, 2002. [Online version available July 2004 at
http://www.peib.org.uk] [see Websites.]

2003

Diaper, Robin. "Tripods and Easels, Roger Fenton at Harewood: New Perspectives." Unpublished essay, 2003.

Kamlish, Marian. "A Response to Roger Taylor." *History of Photography* 27 (Winter 2003), pp. 389–90.

Massie, Alastair, ed. A Most Desperate Undertaking: The British Army in the Crimea, 1854–56. Exh. cat. London: National Army Museum, 2003.

Nickel, Douglas R. Francis Frith in Egypt and Palestine: A Victorian Photographer Abroad. Princeton: Princeton University Press, 2003.

Noon, Patrick J., with contributions by Stephen Bann et al. Crossing the Channel: British and French Painting in the Age of Romanticism. Exh. cat. London: Tate Publishing, 2003.

Schwartz, Joan M., and James R. Ryan, eds. *Picturing Place: Photography and the Geographical Imagination*. London: I. B. Tauris, 2003.

Taylor, Roger. "Claudet, Fenton and the Photographic Society: A Response." *History of Photography* 27 (Winter 2003), pp. 386–88.

Taylor, Roger, and Mike Ware. "Pilgrims of the Sun': The Chemical Evolution of the Calotype, 1840–1852." *History of Photography* 27 (Winter 2003), pp. 308–19.

Wilson, A. N. *The Victorians*. New York: W. W. Norton and Company, 2003.

2004

Voignier, Jean-Marie. "Mestral?" Études photographiques 14 (January 2004), pp. 144–46.

Index

Page numbers in *italics* refer to illustrations.

A Aberdeen, George Hamilton Gordon, Lord (1784–1860), 19–20	B Balaklava, Sebastopol, Ukraine, 20–21, 22, 24, 235, 257n.38	Fenton's employment with, 16, 27, 58, 233, 234–35, 238, 247n.65
Académie Royale de Peinture et de Sculpture, 7–8	Fenton's photographs of, 22, 117 (pl. 14), 118 (pl. 15)	Fenton's exterior views of, 68, 69, 144 (pl. 40)
Ackerman, James, 55	Baldus, Édouard (1813–1889), 11, 213, 226–27, 259n.34	Fenton's negatives appropriated by, 27, 29, 30, 238
Agnew, Thomas, 16, 20, 21, 22, 24, 205, 236, 247n.95, 260n.66	Balmoral Castle, Scotland, 38, 132, 207	Fenton's photographic record of collections of, 16, 27, 27,
Agnew, William, Jr., 236	royal family photographed at, 38, 60–61, 80, <i>131–33</i>	35, 55, 66, 73, 94, 145–50 (pls. 41–46), 210, 236
Albert, Prince (1819–1861), 5, 8, 16–17, 27, 75–81, 96, 211,	(pls. 28–30), 236	Photographic Room at, 16, 233, 234, 263n.64
247n.75, 255n.9, 258n.23	Bambridge, William, 80, 255nn. 14 and 32	Britton, John, 67
anniversary commemorations of, 76–77	Barre, Désiré Albert (1818–1878), 12	Brown, Adolphus, 21
Crimean War and, 17–18, 19, 20, 79, 205, 235	Barry, Sir Charles (1795–1860), 68, 70	Brown, Ford Madox (1821–1893), 8–9, 23, 232, 246n.34
death of, 31, 220, 239	Baudry, Paul (1828–1886), 8, 246n.28	Browne, Hablot (1815–1882): drawing by, reproduced in
Fenton's fall from favor with, 79-80, 254n.98, 255n.27	Bayard, Hippolyte (1801–1887), 11, 200, 211, 213	engraving (fig. 40), 63, 63
Fenton's photographs of, 17, 17, 74, 76-77, 78, 79, 79, 234	Beato, Felice (1830–1906), 21, 226	Brunel, Isambard Kingdom (1769–1849), 69
Great Exhibition and, 3, 201, 232	Becker, Ernst (1826–1888), 17, 75, 81, 216, 234, 255n.6	Brunton, Archibald, Esq., 92
Photographic Society and, 16, 75, 203, 217-18, 220, 233,	Becquerel, Edmond (1820–1891), 213	Buckingham Palace, London, 68, 69, 78
234, 237, 248n.137	Bedford, Francis (1816–1894), 25, 41, 46, 50, 52, 58, 64, 239,	photographic facilities in, 75
albumen silver prints, xiii, 28	252n.23, 253n.48, 254n.98	royal family photographed at, 17, 17, 69, 74, 75, 234
Alfred, Prince (1844–1900), Duke of Edinburgh, 75	Pont-y-Pair at Bettws-y-Coed (fig. 26), 41, 41, 42	Builder, 49, 218
Fenton's photographs of, 17, 74, 76, 76–77, 133 (pl. 30),	York Minster, South East View (fig. 39), 62, 63, 64	Bulletin de la Société Française de Photographie, 25, 204
234	Beldon, J. (active early 1860s), 59	Burke, Edmund (1729–1797), 249n.3
Alice, Princess (1843–1878), Fenton's photographs of, 17,	Bell, Thomas, 238	Burlington House, London, 217, 261n.41
74, 76, 76–78, 77, 80, 130 (pl. 27), 236, 255nn. 28	Berger, Frederic W., 215, 216	Burnham Beeches, Buckinghamshire, 35, 249n.10
and 29	Bisson Frères, 259n.34, 260n.68	Burton, Decimus, 68
Amateur Photographic Association, 261n.51	Black's Picturesque Guide to Yorkshire, 36	
Anguish family, 257n.38	Black's Shilling Guide to the English Lakes, 50	
Ansdell, Richard, 212	Blanquart-Evrard, Louis-Désiré (1802–1872), 200, 211	C
Archer, Frederick Scott (1813–1857), xii, 4, 30, 212, 237	Bogue, David, 14, 201, 233	Caldesi & Montecci, 259n.34
Archer, James, 212	Bolton Abbey, Yorkshire, 35-36, 36, 234, 237	Calotype Club. See Photographic Club
Archer Memorial Fund, 30, 237, 238	Bosquet, General (1810–1861), 226	calotype process (paper negative process or Talbotype), xii,
Architectural Exhibition (London, 1869), 239	Fenton's photographs of, 22, 23, 121, 236	xiii, 4, 5, 11, 199
Architectural Photographic Association, 62, 64, 72, 73, 237	Bourne, John Cooke (1814–1896), 14, 233, 236, 252n.13	Talbot's patent rights on, 4, 13, 212-15, 218, 232, 234, 245n.13
architectural subjects, 7, 14, 26, 36, 54, 55–73, 56, 58, 61–63,	Bouverie, Colonel, 217	Calotype Society, 232
65, 70, 91, 103-7, 110-14, 144, 152-65, 173-80, 188-92	Boys, Thomas Shotter (1803–1874), 252n.16	Cambridge, 27
(pls. 2-6, 8-12, 40, 47-60, 66-73, 81-85), 210, 228,	Brady, Mathew (1823–1896), 5	Cameron, Julia Margaret (1815–1879), 216
229-30, 237	Breton, Jules (1827–1906), 7, 246n.28	Capa, Robert (1913–1954), 225
see also specific buildings and sites	Brewster, Sir David (1781–1868), 35, 213	carte-de-visite portraits, 25, 29, 53
Arthur, Prince (1850–1942), 255n.13	Bridges, Rev. George (1788–1863), 216	Chambers, Robert (1802–1871), 222
Art-Journal, 14, 15, 24, 93, 202-3, 204, 205, 238, 259n.40	British Association for the Advancement of Science, 236,	Champfleury, Jules (1821–1889), 12
Art-Union of London, 206, 237, 238	238	Chaplin, Charles, 246n.28
Art Unions, 199–200	British Institution, 93	Chaplin, H., 93
Athenaeum, 14, 24, 45, 46, 49, 91, 98, 202–3, 204, 205, 206, 209,	British Journal of Photography, 49, 220, 239	Chassériau, Théodore (1819–1856), 88
211, 218	British Museum, London, 211, 215, 233, 239	Chatsworth House, Derbyshire, 67

Cheltenham, 55-56 Diamond, Hugh Welch (1809-1886), 216-17, 220 childbearing of, 232, 235, 237 Portrait of Roger Fenton (attributed to Diamond or Roger Chemist, 12, 212, 232 in husband's landscape and architectural views, 59, 83 Church of the Redeemer, Moscow, 57, 107 (pl. 6), 223 Fenton) (fig. 70), 218 at Photographic Society Club outing, 219, 219 Claudet, Antoine (1797-1867), 233, 260n.15 Dickens, Charles (1812-1870), 5, 31, 221 photographs of, 8, 9 Clifford, Charles (1821-1863), 52 Diderot, Denis (1713-1784), 35 Fenton, Hannah (stepmother), 56, 231 cloudscapes, 39-41, 40, 125 (pl. 22), 126 (pl. 23), 249n.29, Dillon, Frank (1823-1909), 84, 86, 87-88 Fenton, John (father, 1791-1863), 6-7, 56, 231, 239 250n.32 Dobson, William (1820-1884), 46 Fenton, Joseph (grandfather, 1756-1840), 5-7, 12, 16, 231 Drolling, Michel-Martin (1786-1851), 7-8, 22, 23, 232, Fenton, Josephine Frances (daughter, 1845-1850), 232, collodion. See glass negative process Colls, Lebbeus, 26 245n.24, 246n.34 Paul & Dominic Colnaghi & Co., 16, 22, 27, 29, 236, 237 Du Camp, Maxime (1822–1894): Egypt, Nubia, Palestine and Fenton, Roger (1819-1869): Commission des Monuments Historiques, 11 Syria, 201-2 Albert Terrace home of, 8, 87, 232, 239 Constable, John (1776-1837), 40-41, 64-65 Duffield, William (1816-1863), 92 art training of, 7-8, 22, 23, 221, 232 Duncombe, Thomas (1796-1861), 57 Cloud Study (fig. 25), 40, 41 birth and childhood of, 5, 6, 221, 231 Durieu, Eugène (1800-1874), 213 contact prints, xiii chronology of life and photographic career of, 231-39 commercialization of photography and, 25-26, 29, 52-53, Conway Castle, 43 Conway in the Stereoscope, The, 28, 42-43, 238, 265n.160 206-7, 208-10 E copyright, 220, 237 critical responses to work of, 14, 24, 25, 29-30, 46, 49-50, Eastham, John, "of Manchester" (fl. 1850-60s), 239 Corbould, Edward Henry (1815-1905), 77 52, 94, 96-97, 98, 204-5, 207-8, 251n.2 Cotman, John Sell (1782-1842), 57 Roger Fenton (fig. 18), 30 death of, 31, 239 Cox, David (1783-1859), 41, 42 Eastlake, Lady Elizabeth (1809-1893), 24 earliest known photographs by, 13, 34, 232 Cox, David, Jr. (1809-1885), 42 Eastlake, Sir Charles Lock (1793-1865), 13, 75, 203, 215, 216, education of, 6, 231 Cozens, Alexander (d. 1786), 40 217, 221, 232, 233, 234, 245n.13 family background of, 5-7 Crimble Hall, Lancashire, 5, 6, 7, 56, 231 École des Beaux-Arts, 8 illustrations based on photographs by. See Illustrated London Edward, Prince of Wales (1841-1910), 75 News; Valley of the Wharfe Crimean War, 17-24, 57, 79-80, 227, 234 Fenton's photographs of, 17, 74, 76, 76-77, 234 legal career of, 3, 6, 11, 31, 231, 232, 238, 239, 249n.184, departure of military forces for, 17-18, 18, 39, 234 Fenton's letters from, 7, 20, 235 Elizabeth, Countess of Shrewsbury, 67 251n.1 Elliott, Gilbert, 19 Fenton's photographs of, 19–24, 21–23, 25, 26, 27, 34, 37, marriage of, 231 43, 60, 70, 80, 91, 93, 117-23 (pls. 14-21), 203, 205, Ellis, Sir Henry, 233 medals and awards received by, 210, 220, 239, 245 Ely Cathedral, Cambridgeshire: 223-26, 224, 225, 235, 236, 262nn. 21 and 23 obituaries for, 220 Fenton's self-portraits in costumes of, 22, 83, 84 Fenton's photographs of, 61-62, 64, 154 (pl. 49), 155 as painter, 3, 7-9, 11, 57, 227, 232, 245n.6 Crystal Palace, London, 3, 4 (pl. 50), 230, 238 photographic training of, 11-12, 34 see also Great Exhibition of the Works of Industry of All Winkles's engraving of, 61, 61 photographic van of, 20, 23, 24, 37, 43, 57, 60, 252n.30 Nations Epistles of Clement of Rome, 27, 236, 247n.70 photographs of, 8, 30. See also self-portraits Cundall, Joseph (1818-1895), 15, 58, 200, 201, 202, 203, 212, Evans, Sir George de Lacy (1787–1870), 247n.107 photography begun by, 11, 211, 246n.40 215, 232, 233, 251n.8, 258nn, 10 and 21 "Exhibition of Photographic Pictures Taken in the Crimea" Potter's Bar home of (Mount Grace), 7, 31, 237, 239 and Robert Howlett, Crimean Braves (fig. 75), 226, 226 (London and other venues, 1855-56), 24, 203, 236 prices charged by, 15, 21, 29, 91, 97, 202, 208, 234, 236, Exposition Universelle (Paris, 1855), 204, 205, 234, 235 Curzon, Alfred de (1820-1895), 7, 246n.28 247n.62, 258n.25 Exposition Universelle de Photographie (Brussels, 1856), 39, religious practice of, 252n.25 retirement of, from photography, 31, 53, 210, 220, 239 Exposition Universelle de Photographie (Brussels, 1857), 237 see also architectural subjects; landscapes; Orientalist stud-Daguerre, Louis-Jacques-Mandé (1787–1851), xii, 4 ies; still lifes; specific subjects daguerreotype process, xii, xiii, 4, 5, 199 Fenton, Roger, paintings by: Daily Express (Scotland), 204 The letter to Mamma: What shall we write?, 9, 232 Dalayrac, Nicolas-Marie (1753-1809): Les deux petits Savoyards, Fairy, The (royal yacht), 17-18, 18 There's music in his very steps as he comes up the stairs, 3, 9, 232 76, 234, 255n.10 Fenton, Aimée Frances (daughter, b. 1850), 232, 245n.24 You must wake and call me early . . . , 9, 232 Darwin, Charles (1809-1882), 222 Fenton, Annie Grace (daughter, b. 1846), 9, 59, 60, 232 Fenton, Roger, papers by: Fenton, Anthony Maynard (son, 1859-1860), 30, 94, 237, 238, "Narrative of a Photographic Trip to the Seat of War in the David, Jacques-Louis (1748-1825), 7 Davidson, James Bridge, 41, 42-44, 250nn. 66, 67, and 78, 245n.24 Crimea," 236 265n.160 Fenton, Eccles, Cunliffe & Roby (later J. & J. Fenton & Sons), "On the Present Position and Future Prospects of the Art of Delacroix, Eugène (1798-1863), 12, 83, 88, 213 5, 231, 239 Photography," 10-11, 215, 233 Delamotte, Philip Henry (1820–1889), 15, 16, 29, 58, 200, 201, Fenton, Elizabeth Aipedaile (mother, 1792-1829), 6, 213 "Proposal for the Formation of a Photographical Society" Fenton, Eva Catherine (daughter, b. 1853), 233 (fig. 68), 12, 213, 214, 232 202, 203, 206, 207, 215, 233, 236, 237, 255n.26, 258n.10, 264n.138 Fenton, Grace Elizabeth (née Maynard) (wife), 7, 60, 67, 231, "Upon the Mode in Which It Is Advisable the Society Should Conduct Its Labors," 217, 233 Delaroche, Paul (1797-1856), 7, 8 232, 239

Fenton, Roger, photographs and portfolios by: Banks of the Dnieper; Distant View of the Forts and Low Town of Kief (pl. 7), 33, 108, 240 Billboards and Scaffolding, Saint Mark's Church, Albert Road (fig. 8), 13, 13, 68 The Billiard Room, Mentmore (pl. 72), 71, 179, 243 Bolton Abbey, West Window (fig. 21), 35, 36 Boys in the Refectory, Stonyhurst (pl. 73), 47, 71, 180, 243 Bridge in Patterdale, 50 The British Museum (pl. 40), 69, 144, 241 Burnham Beeches, 35 Captain Dames (fig. 14), 23, 23, 225 Captain Lord Balgonie, Grenadier Guards (pl. 18), 23, 121. 205, 224, 241 The Cattle Pier, Balaklava (pl. 14), 22, 117, 205, 240 Celebrated Ivory Carvings, from the Collection in the British Museum, 94 Charles Lucy, Grace and Annie Fenton, London (fig. 6), 8, 9 Chinese Curiosities (fig. 61), 95, 96 The Church of the Redeemer, Moscow, under Construction (pl. 6), 33, 57, 107, 223, 240 The Cloisters, Tintern Abbey (pl. 9), 111, 227, 240 Clouds after Rain, 39, 250n.29 Comus (fig. 58), 92, 92 Cookhouse of the 8th Hussars (pl. 16), 21, 119, 205, 241 Copy of a Picture by Lance, 92 Cornet Wilkin, Eleventh Hussars, Survivor of the Charge of the Light Brigade (fig. 74), 21, 225, 225 Cottages at Hurst Green, 49 Couple in Fancy Dress (fig. 56), 85, 87 Crimble Hall (fig. 3), 6, 7 Decanter and Fruit (pls. 87, 88), 195, 196, 244 Derwentwater (fig. 34), 51, 51 Derwentwater, Looking to Borrowdale (pl. 80), 51, 187, 244 Detail of Sculpture, Wells Cathedral (fig. 41), 65, 65, 65-66 The Double Bridge on the Machno (pl. 38), 43, 141, 222, 242 Down the Ribble (fig. 32), 47, 47-48 Elephantine Moa (Dinornis elephantopus), an Extinct Wingless Bird, in the Gallery of Fossils, British Museum (pl. 45), 94, 149, 242 The Elgin Marbles, British Museum, III (fig. 17), 27, 27 Ely Cathedral, East End (pl. 49), 61, 154, 242 Ely Cathedral, from the Park (pl. 50), 61-62, 65, 72, 155, 230, 242 Evening, 39, 249n.25, 250n.29 "The Fairy" Steaming through the Fleet, March 11, 1854 (fig. 11), 18, 18, 39 Falls of the Llugwy, at Pont-y-Pair (pl. 34), 42, 137, 222, 241 La Faute (fig. 53), 83-84, 85

Flowers and Fruit (pl. 86), 97, 194, 244 Flowers and Fruit (fig. 63), 97, 97

Fruit and Tankard, 93

Fountains Abbey, the Nave (pl. 8), 110, 227, 240

Fruit with Ivory and Silver Tankard, 94-95

Frank Dillon in Near Eastern Dress (fig. 54), 84, 86

Gallery of Antiquities, The British Museum (pl. 41), 94, Gallery with Discobolus, British Museum (pl. 46), 66, 94, 150, 242 General Bosquet (pl. 19), 121, 205, 236, 241 General Bosquet Giving Orders to His Staff (fig. 13), 22, 23 General View from the Town Park [Windsor Castle] (pl. 81), 72, 188, 244 A Ghillie at Balmoral (pl. 29), 80, 132, 205, 241 Glastonbury Abbey, Arches of the North Aisle (pl. 48), 64, 153, 242 Glyn Lledr, from Pont-y-Pant (pl. 35), 43, 138, 222, 241 Gorge of the Foss Nevin, on the Conway (fig. 27), 44, 44-45 Group of Corals, British Museum, 94 Group of Croat Chiefs (pl. 17), 21, 120, 205, 241 Group of Fruit and Flowers (fig. 62), 96, 97 Hardwick Hall, from the South East (pl. 69), 67, 176, 243 Harewood House (fig. 44), 69-70, 70 Harewood House, Yorkshire (pl. 66), 69, 173, 243 Head of Minerva, from the Marble in the British Museum (pl. 42), 94, 146, 242 Hermaphrodite Feeding a Bird (pl. 43), 94, 147, 242 Hills at the Foot of Derwentwater, 51 Houses of Parliament (pl. 59), 68-69, 164, 243 The Keeper's Rest, Ribbleside (fig. 33), 48, 49 Lambeth Palace (pl. 58), 68, 163, 230, 243 Landing Place, Railway Stores, Balaklava (pl. 15), 22, 118, 205, 240 Landscape with Clouds (pls. 22, 23), 39-40, 125, 126, 241, 249n.29, 250n.32 Lichfield Cathedral, Central Doorway, West Porch (pl. 53), 66-67, 158, 242 Lichfield Cathedral, South Transept Portal and Steps (pl. 54), 28, 67, 159, 242 The Lily House, Botanic Garden, Oxford (pl. 70), 177, 243 Lincoln Cathedral, The Galilee Porch (pl. 52), 62-63, 157, 242 Lincoln Cathedral, West Porch (pl. 51), 62, 156, 242 Lindisfarne Priory (pl. 24), 60, 127, 241 Loch Nagar from Craig Gowan (fig. 22), 38, 38, 39, 250n.29 The Long Walk (pl. 82, fig. 1), 2, 29, 189, 226, 229, 244 Melrose Abbey, South Transept (pl. 25), 60, 128, 241 Members of the Photographic Society Club at Hampton Court, July 18, 1856 (fig. 71), 219, 219 Mill at Hurst Green (fig. 2), 6, 6, 47, 49 Moel Seabod, from the Lledr Valley (pl. 37), 45, 140, 222, 242 Monastery at Kiev, 202 Moscow, Domes of Churches in the Kremlin (pl. 2), 14, 14, 33, 57, 103, 223, 240 Nubian Water Carrier (pl. 65), 86, 88, 171, 243 Omar Pasha (fig. 12), 21, 21, 224, 236 On the Llugwy, near Bettws-y-Coed (pl. 33), 136, 222, 241 Orientalist Group (pl. 63, fig. 51), 82, 84, 86, 89, 169, 170, Orientalist Group (pl. 64), 84, 86, 89, 169, 170, 243

Parian Vase, Grapes, and Silver Cup (fig. 57), 90, 97 Pasha and Bayadère (pl. 62), 84, 86, 87, 88, 89, 168, 204, 243 Pasha and Dancing Girl, 237, 238 Photographic Art Treasures; or Nature and Art Illustrated by Art and Nature, 26, 26, 206, 236 The Photographic Panorama of the Plateau of Sebastopol, 22, 223, 224, 261n.13 Photographic Pictures of the Seat of War in the Crimea, 21, 24, 236, 261n.10 The Plough Inn at Prestbury, 14 Pont-y-Garth, near Capel Curig (pl. 32), 43, 135, 222, 241 Pont-y-Pant, on the Lledr, from Below (pl. 36), 43, 139, 222, Portrait of Roger Fenton (attributed to Fenton or Hugh Welch Diamond) (fig. 70), 218 A Posthouse, Kiev (fig. 9), 14, 14, 223 Prince Alfred, Duke of Edinburgh (pl. 30), 61, 80, 133, 205, The Prince of Wales, Princess Royal, Princess Alice, the Queen, and Prince Alfred, February 8, 1854 (fig. 46), 76, 77 The Princess Alice as "Spring" in the Tableaux Represented February 10, 1854 (fig. 47), 77, 77-78, 85 Princesses Helena and Louise (pl. 28), 80, 131, 207, 227, 241 The Princess Royal and Princess Alice (pl. 27), 80, 130, 227, 241, 255n.29 "Public Buildings and Parks of London," 64, 68-69 The Queen, the Prince, and Eight Royal Children in Buckingham Palace Garden, May 22, 1854 (figs. 10, 45), 17, 17, 74 The Queen in Her Drawing Room Dress, May 11, 1854 (fig. 49), 78, 78-79 The Queen's Target (pl. 85), 29, 192, 230, 244 Queen Victoria and Prince Albert, June 30, 1854 (fig. 50), 79, 79 Raglan Castle Porch (fig. 16), 26, 26 The Raid Deep, River Ribble (fig. 30), 46, 47-48 Reach of the Dee, 38 Reclining Odalisque (The Reverie) (pl. 61), 86, 88-89, 167, 237, 243, 257n.31 Regent's Park (fig. 20), 13, 34, 34 Rievaulx Abbey (pl. 12), 59, 114, 227, 240 Rievaulx Abbey, Doorway, North Transept (pl. 10), 59, 112, 227, 228, 240 Rievaulx Abbey, the High Altar (pl. 11), 59, 113, 227, 240 Rievaulx Abbey, the Transepts (fig. 37), 58, 59 Rocks at the Head of Glyn Ffrancon (fig. 29), 45, 45 Roslin Chapel, South Porch (pl. 26, fig. 35), 54, 60, 129, 241 Saint George's Chapel and the Round Tower (pl. 84), 72-73, Salisbury Cathedral, View in the Bishop's Garden (pl. 55), 65, Salisbury Cathedral-The Nave, from the South Transept (pl. 56), 65, 161, 242 Scene in Tintern Abbey (fig. 76), 227, 227

Paradise, View down the Hodder, Stonyhurst (pl. 74), 49, 181,

Flacheron, Comte Frédéric (1813-1883), 200, 211 Fenton, Roger, photographs and portfolios by (continued): Hamilton, Lady Harriet, 234 Foster, Peter Le Neve (1809-1879), 215, 216, 217, 233, 234 Hampton Court Palace, Herefordshire, 221 Sebastopol from Cathcart's Hill (pl. 20), 22, 37, 122, 205, 241 Self-Portrait (1852) (pl. 1), 101, 240 Fountains Abbey, Yorkshire, 35, 59, 110 (pl. 8), 227, 234 Fenton's photographs of, 39 Self-Portrait [ca. 1854] (frontispiece), ii, 10, 240 Frank Dillon at His Easel (unknown photographer) (fig. 55), Photographic Society Club outing to, 219, 219, 236 Self-Portrait as Zouave, 2nd Division (fig. 52), 22, 83, 84 Hannavy, John, 57 Hardwich, Thomas Frederick, 96, 206, 236 September Clouds (fig. 24), 40, 40-41, 249n.29, 250n.32 Frith, Francis (1822-1898), 31, 50, 52, 58-59, 88, 216 Skeleton of Man and of the Male Gorilla (Troglodytes Gorilla) I Fry, Peter Wickens (d. 1860), 212, 213, 215, 217, 218, 220, Hardwick Hall, Derbyshire, 67, 176 (pl. 69), 253n.71 (pl. 44), 94, 148, 242 232, 260n.2 Harewood House, Yorkshire: Slate Pier at Trefriw (pl. 39), 45-46, 142, 222, 227, 242 Furness Abbey, Cumbria, 50, 59, 238 Fenton's photographs of, 67, 69-71, 70, 173-75 (pls. 66-68), South Front of the Kremlin from the Old Bridge (pl. 3), 33, 56, 229, 238, 254n.91 Sandby's watercolor of, 70, 70 104, 240 G Hawkins, Edward, 233 Spoils of Wood and Stream (pl. 75), 49, 91, 182, 243 Still Life with Game (pl. 76), 183, 243 The Gallery, London, 236 Hawksmoor, Nicholas (ca. 1661-1736), 230 Study of a Partially Draped Young Woman (fig. 72), 222, 222 Gallery of the New Society of Painters in Water-Colours, Haydon, Benjamin Robert (1786-1846), 93 Tankard and Fruit (pl. 89), 197, 244 London, 93, 236 Hecla, 19, 20, 235 The Terrace, Garden and Park, Harewood (pl. 68), 70-71, 175, Gallery of the [old] Society of Painters in Water-Colours, Helena, Princess (1846-1923), Fenton's photographs of, 17, 74, London, 93, 96, 238 76-77, 80, 131 (pl. 28) 229, 243 Gallery of the Water Color Society, London, 24 Tewkesbury Abbey (fig. 36), 14, 56, 56 Henfrey, Arthur, 217 Gambart, Ernest, 201 The Thames and Saint Paul's, Looking Downstream from Messeurs Henneman & Company, 212 Waterloo Bridge (fig. 77), 228, 229 Garland, Robert, 61 Henner, Jean-Jacques (1829-1905), 246n.28 Turk and Arab, 237 Gazette du Nord, La, 256n.12 Herbert, John Rogers, 212 Turkish Musicians and Dancing Girl, 88 genre scenes, 83-84, 84, 85 Hering, Henry, 259n.34 The Upper Terrace, Harewood House (pl. 67), 71, 174, 243 see also Orientalist studies Herring, J. F. (1795-1865), 93 Up the Hodder, near Stonyhurst (pl. 77), 184, 243 geology, 43-44, 222 Hildyard, Miss (governess to royal children), 77 Gibbs, Mr. (tutor to royal children), 77 Holden, Rev. Dr. Henry, 59 Valley of the Ribble and Pendle Hill (fig. 31), 47, 47-48 Valley of the Ribble and Pendle Hill (pl. 78), 47-48, 185, 243 Gilpin, William (1724-1804), 36, 249n.3 Honourable Society of the Inner Temple at the Inns of Court, Valley of the Shadow of Death (pl. 21), 23-24, 37, 123, 205, Gladstone, William Ewart (1804-1898), 261n.41 6, 231, 232 225, 241, 262n.21 Gladwell, Thomas, 52, 208, 237, 250n.29, 260n.68 Hooley Bridge, Lancashire, mill at, 5-6, 31, 231, 238 View from Ogwen Falls into Nant Ffrancon (pl. 31), 45, 134, "Photographs," advertisement by (fig. 67), 68, 208, 209 House of Commons Select Committee on South Kensington 222, 241 Glasgow Photographic Society, 238 Museum, 29, 30, 238 Houses of Parliament (Westminster), London, 68-69, 164, 165 View from the Foot of the Round Tower (pl. 83), 72, 190, 244 glass negative process (wet plate, wet collodion, or wet collodion on glass), xii-xiii, 4, 5, 34, 35, 58, 60, 212, 218, 220, View from the Newby Bridge (pl. 79), 50, 186, 244 (pl. 60), 229, 229-30 View of Cemetery on Cathcart's Hill (fig. 73), 22, 223, 224 Howitt, Mary: Ruined Abbeys and Castles of Great Britain, 239 The Village Stocks, 14 Glastonbury Abbey, Somerset, 64, 153 (pl. 48) Howitt, William, 33 Gloucester Cathedral, Gloucestershire, 55-56, 58 Volunteer Class, 238 Ruined Abbeys and Castles of Great Britain, 239 Howlett, Robert (1830-1858), 26, 255n.26 Walls of the Kremlin, Moscow (pl. 4), 14, 33, 56, 105, 240 Godwin, George, 232 Walls of the Kremlin, Moscow (pl. 5), 33, 56, 106, 240 The Golden Age. See under Lance and Joseph Cundall, Crimean Braves (fig. 75), 226, 226 Goodeve, Thomas Minchin, 206, 215, 217, 264n.138 Hunt, Robert (1807-1887), 12, 13, 212, 213-15, 217, 218, 232, The Water Carrier, 237 Westminster Abbey, Cloisters (pl. 57), 162, 243 Graphic Society, 211-12 233, 246n.52, 260n.2 Westminster Abbey and the Houses of Parliament, Saint Stephen's "gray albums," 39-40, 249n.10, 250n.30 Hunt, William Henry (1790-1864), 93-94, 98 Tower, and the Victoria Tower, from Great Smith Street Great Exhibition of the Works of Industry of All Nations The Photographer, 93-94 Hunt, William Holman (1827-1910), 9, 88 (fig. 78), 69, 229, 230 (London, 1851), 3, 4, 11, 12, 34, 200, 201, 202, 211, 232 Great Western Railway, 201 Hythe School of Musketry, 94, 238 Westminster from Waterloo Bridge (pl. 60), 69, 165, 229-30, 243 Gros, Jean-Baptiste-Louis (1771-1835), 213 Grundy, William Morris (1806-1859), 28, 88 West Porch, York Minster, 253n.46 Wharfe and Pool, Below the Strid (pl. 13), 32, 36-37, 115, Illustrated London News, 19, 24, 79, 92, 93, 98, 202-3, 204-5, 240 Η 236, 259n.44 Windings of the Dee, 38 Wollaton Hall (pl. 71), 67-68, 178, 243 Haag, Carl (1820-1915), 77-78, 79, 85 Fenton reviewed in, 14, 56, 204-5 The Golden Age (fig. 59), 92, 93 The Princess Alice as "Spring" (fig. 48), 77, 77-78, 85 York Minster, from the South East (pl. 47), 63-64, 152, 242 Fenton, Rose Maynard (daughter, b. 1855), 235 Hackett, John, 247n.91 Mr. Fenton's Photographic Van-From the Crimean Exhibition Haddon Hall, Derbyshire, 67 Fenton, William (brother, b. 1820), 6, 231, 234, 245n.20, (fig. 15), 24, 24 Hall, John, 19 The North London School of Drawing and Modelling, Camden 252n.30 Ferrier, Claude-Marie (1811-1889), 201 Hall, Samuel Carter (1800-1889), 204, 232, 259n.40 Town (fig. 7), 8, 10

Priest of the Greek Church, 234	picturesque and, 33, 35, 36, 45, 249n.3	Manchester Photographic Society, 41, 236
Russian Peasants, 234, 259n.44	rendering of skies in, 38-41	Mann, J. H. (fl. 1827–70), 92
Soirée of Photographers, in the Great Room of the Society of Arts	ruined abbeys and churches in, 35-36, 55, 227	Mantegna, Andrea (1431–1506): The Triumph of Caesar, 221
(fig. 64), 200, 200, 233	sublime and, 33, 41, 43-44, 45, 50, 249n.3	Margetts, Mrs. (still-life painter), 93
Valley of the Wharfe (fig. 65), 204, 205, 235	water and fishing in, 49	Marilhat, Prosper (1811–1847), 88
Industrial Revolution, 3-4, 5, 221, 261n.2	see also specific places	Martens, Frédéric (ca. 1809–1875), 200, 211
Ingres, Jean-Auguste-Dominique (1780–1867), 257n.31	Lansdowne, Lord Henry, 215	Maufras, L., 11
International Exhibition (London, 1862), 29, 73, 210, 220, 239	Laroche, Martin, 218	Maull & Polyblank, 259n.34
	Lascelles family, 69, 70	Mayall, John (1810–1901), 29, 247n.91, 254n.98
	Le Gray, Gustave (1820–1884), xii, 5, 7, 11–12, 13, 29, 34–35,	Roger Fenton and His Wife (fig. 4), 7, 8
J	56, 200, 201, 211, 213, 226, 232, 233, 236, 259n.34,	Maynard, Charles Septimus (brother-in-law), 69, 70
Jackson, J. P., 42	260n.68	Maynard, Edmund (brother-in-law), 232
Jeuffrain, Paul (1808–1896), 14, 34, 246n.55	Brig on the Water (fig. 23), 39, 39	Maynard, Grace Elizabeth. See Fenton, Grace Elizabeth
Jocelyn, Viscountess, 217	The Great Wave, 39–40	Maynard, John Charles (father-in-law), 70, 231
Jones, Rev. Calvert (1802–1877), 217	Lemaître, Augustin-François (1790–1870), 213	Maynard, Sarah Jefferson (sister-in-law), 83
Journal of the Photographic Society, 217, 218, 219-20, 233, 237	Leopold, Prince (1853–1884), 77	Melrose Abbey, Scotland, 60, 128 (pl. 25), 241
reviews of Fenton's work in, 25, 33, 38, 46	Le Secq, Henri (1818–1882), 7, 11, 200, 211, 213	Mentmore, Buckinghamshire, 67, 68, 71, 179 (pl. 72)
	Lewis, John Frederick (1805–1876), 83, 88	Mestral, Auguste (1812–1884), 11, 34
	Lichfield Cathedral, Staffordshire, 64, 66–67, 158 (pl. 53),	Millais, John Everett (1829–1896), 9
K	159 (pl. 54)	Mission Héliographique, 11
Kater, Edward, 212, 220	Limited Liability Act (1855), 259n.55	Montfort, Baron Benito de, 12, 34, 213
Kay, Father William, 238, 251n.89	Lincoln Cathedral, Lincolnshire, 62-63, 64, 156 (pl. 51), 157	Montizon, Juan Carlos María Isidro de Borbón, Count de
Keith, Thomas (1827–1895), 52	(pl. 52)	(1822–1887), 217
Kiev, Fenton's photographs of, 14, 14-15, 33, 56, 108 (pl. 7),	Lindisfarne Priory, Northumberland, 60, 127 (pl. 24), 252nn.	Morning Chronicle, 218
222–23, 233, 234	31 and 32	Morning Post, 234
King's College, London, 220, 236	Literary Gazette, 24, 46, 202-3	Moscow, Fenton's photographs of, 14-15, 33, 56-57, 103-7
Knight, James Payne, 212	Llewelyn, John Dillwyn (1810–1882), 52, 217	(pls. 2–6), 222–23, 233
Kremlin, Moscow, 33, 56–57, 103–6 (pls. 2–5), 223	London, Fenton's photographs of, 13, 34, 64, 68–69, 162–65	Mount Grace, Potter's Bar, 7, 31, 237, 239
	(pls. 57–60), 228, 229, 229–30, 232, 237, 254n.77	Mr. Fenton's Photographic Van—From the Crimean Exhibition
_	London Stereoscopic Company, 28	(fig. 15), 24, 24
L	London University Corps, 238	Muckley, William J., 93
Lacan, Ernest (1829–1879), 7, 14, 233	Louisa, Lady Harewood, 70	Mudd, James, 30
Ladell, Edward (1821–1886), 93, 94, 97, 98	Louise, Princess (1848–1939), Fenton's photographs of, 17, 74,	Murray, John (1809–1898), 52
Still Life (fig. 60), 94, 94	76–77, 80, <i>131</i> (pl. 28)	Murray & Heath, 238
Lake District, Fenton's photographs of, 50–52, 51, 187 (pl. 80),	Louis-Napoléon (Emperor Napoléon III, 1808–1873), 12, 24, 236	
207, 238	Louvre, Paris, 7, 8, 232	
Lambeth Palace, London, 68, 163 (pl. 58), 230	Lucas, Charles, 19	N
Lambing Clough Farm, Lancashire, 47	Lucy, Charles (1814–1873), 8, 22, 23, 232	Nadar (1820–1910), 5, 29
Lancashire:	The Embarkation of the Pilgrim Fathers in the Mayflower	Napier, Sir Charles (1786–1860), 18
Fenton family's properties in, 5–6, 47, 231	(fig. 5), 8, 9	Napoléon III, Emperor (Louis-Napoléon, 1808–1873), 12, 24
Fenton's birth and childhood in, 5–6, 231	photograph of, 9	236
Fenton's photographs of, 46–48, 46–50, 71, 181 (pl. 74),	Lumière, La, 12, 213, 233, 234, 253n.43	National Gallery, London, 93
184–86 (pls. 77–79), 207, 238	Lyte, Maxwell (1828–1906), 30, 234	National Rifle Match, Wimbledon Common, 29, 238
Lance, George (1802–1864), 28, 93, 97, 98		Nègre, Charles (1820–1880), 7, 88
Fenton's photographs of paintings by, 92, 92	V.	Neoclassicism, 7
The Golden Age, wood engraving after a painting by	M	Newcastle, Duke of, 20, 235
(fig. 59), 92, 93	Macclesfield Photographic Society, 237	New Society of Painters in Water-Colours, 41, 42, 93
Peaches and Grapes, 93	MacKewan, Dr., 42	Newton, Sir William John (1785–1869), 12, 29, 212, 215, 216
The Summer Gift, 93	Maconochie, A., 217	217, 233, 234, 237
landscapes, 6, 25, 32, 33–53, 34, 36, 38–41, 44–48, 51, 70, 91,	Machherson, Robert (1811–1872), 52	Nicholas I, Czar (1796–1855), 14, 19, 56, 233
94, 108, 115, 134–42, 181, 184–87 (pls. 7, 13, 31–39, 74,	Madden, Sir Frederic (1801–1873), 236	Nicholas of Nassau, Prince (1832–1905), 234
77–80), 210, 222, 226–27, 227, 235, 239	Major, Rev. John Richardson, 219, 236	Nicklin, Richard, 247n.91
geological formations and, 43–44, 222 inclusion of figures in, 25, 227, 228–29	Manchester Art Treasures Exhibition (1857), 27, 29, 88, 93,	Niépce de Saint-Victor, Abel (1805–1870), 25
merusion of figures in, 20, 227, 228–29	237	Nightingale, Florence (1820–1910), 19

		D: ID
Ninth (West Middlesex) Rifle Volunteers, 94	Photographic Facsimiles of the Remains of the Epistles of Clement	Prix de Rome, 7, 8
Nolan, Captain, 224–25	of Rome, 27, 236, 247n.70	Puech, Monsieur (photographer), 213
Norfolk News, 39	Photographic Institution, 15, 202, 233, 235, 258nn. 10 and 23	Pugin, A. W. N. (1812–1852), 68
North London Photographic Association, 97	Photographic Journal, 30, 220, 237–38, 239, 251n.2	
North London School of Drawing and Modelling, 8, 92, 204,	Photographic News, 40, 46, 49–50, 88, 220, 238, 239, 251n.2	n.
211, 232, 246n.36, 247n.75	Photographic Notes, 37, 39, 49, 249n.25	R
The North London School of Drawing and Modelling, Camden	Photographic Society, 17, 19, 30–31, 39, 57, 81, 95–96, 202,	Raglan, Lord (1788–1855), 19, 20, 21, 223–24
Town (fig. 7), 8, 10	211–20, 221, 235, 239	Raglan Castle, Wales, 26, 58
Norwich Photographic Society, 39, 236	Archer Memorial Fund and, 30, 237, 238	"Recent Specimens of Photography" (London, 1852), 215–16,
Nottingham Photographic Society, 237	commercialization of photography and, 25–26, 30, 206–7,	233
	208–10	Reeve, Lovell (1814–1865), 28, 42, 237, 238
	diminished authority of (early 1860s), 30	Regent's Park, London, 34, 34, 35, 68, 232
	Fenton's attendance at Council meetings of, 233, 234, 235,	Rejlander, Oscar G. (1813–1875), 25, 27, 237
Omar Pasha (1806–1871), Fenton's photograph of, 21, <i>21</i> , 224,	236, 237, 238, 239	The Two Ways of Life, 27, 28, 237, 248n.147
236	Fenton's proposal for formation of, 12, 213, 214, 232	Richardson, William (1822–1877), 57–58
Orientalist studies, 25, 28, 29–30, 73, 82, 83–89, 84, 86, 87,	founding of, 5, 12–13, 58, 200, 201, 203, 211–17	Rievaulx Abbey, Yorkshire, 20, 35, 57–60
167–71 (pls. 61–65), 210, 237–38	inaugural meeting of, 13, 216–17, 233	Fenton's photographs of, 39, 57, 58, 59–60, 112–14
Osborne House, Isle of Wight, royal family photographed at,	"Inaugural Meeting of the Photographic Society & Rules of	(pls. 10–12), 227, 228, 234
80, <i>130</i> (pl. 27), 236	the Photographic Society" (fig. 69), 216, 216	Roberts, David, 83, 88
O'Sullivan, Timothy (1840–1882), 227	journal of. See Journal of the Photographic Society	Robertson, James (1831–1881), 19, 21, 226
Owen, Hugh (1804–1881), 201, 212, 217, 232	members of inaugural Council of, 216–17	Robinson, Henry Peach (1830–1901), 25
Oxford, 27	name of, changed to Royal Photographic Society, 216–17	Romanticism, 35, 49, 59, 227 Roscoe, Thomas: Wanderings and Excursions in North Wales, 41,
Fenton's photographs of, 71–72, 177 (pl. 70)	objectives of, 201, 211, 217 offices held by Fenton in, 13, 25, 30, 201, 203, 217, 219, 220,	
	•	42, 43, 45, 50 Poolin Changle Scotland, 54, 60, 160 (pl. 96), 950n 84
D.	237, 238	Roslin Chapel, Scotland, 54, 60, 129 (pl. 26), 252n.34 Rosling, Alfred (1802–1882), 216, 234, 250n.73
P	premises for, 217, 220	Ross, Andrew, 95
Paget, Lady George, 20	rules of, 216, 217	Ross & Thomson (James Ross and John Thomson), 201
Paget, Lord George (1818–1880), 21	Talbot's patent rights and, 13, 212–15, 218, 234 Photographic Society, annual exhibitions of, 5, 55, 93, 203,	Rosse, William Parsons, Lord (1800–1867), 13, 215, 232,
Palmer, Samuel (1805–1881): A Cascade in Shadow, Drawn on	209	245n.13
the Spot, near the Junction of the Machno and Conway, North	inaugural (1854), 16, 58, 75, 203, 217–18, 234	Rossetti, Dante Gabriel (1828–1882), 9, 216
Wales (fig. 28), 44, 44 panoramas, of Sebastopol, 22, 223, 224, 261n.13	second (1855), 204, 234, 235	Rothschild family, 71
paper negative process. See calotype process	third (1856), 236, 255n.30	Rousseau, Philippe H. (1816–1887), 93
Papworth, Wyatt, 239	fourth (1857), 237	Royal Academy of Arts, 3, 9, 42, 84, 93, 94, 209, 232
Paris, Fenton's sojourns in, 7, 11–12, 13, 34, 211, 213, 232	fifth (1858), 46, 88, 237	royal family, Fenton's photographs of, 17, 17, 27, 38, 60–61,
Patent Photo-Galvanographic Company, 26, 206, 236, 237	sixth (1859), 237, 256n.2	69, 74, 75–81, 76–79, 85, 130 (pl. 27), 131 (pl. 28), 133
Paxton, Joseph (1801–1865), 3, 4, 71	seventh (1860), 40, 49–50, 71, 91–92, 238	(pl. 30), 227, 234, 235, 238, 255nn. 12, 13, 28, and 29
Pélissier, Jean-Jacques (1794–1864), 21, 224	eighth (1861), 50, 52, 72, 73, 96–97, 238	see also specific royals
Pennefather, Sir John Lysaght (1800–1872), 21	ninth (1863), 239	Royal Photographic Society, 91, 216–17
Percy, John (1817–1889), 215, 217, 233	Photographic Society Club, 219, 219, 236	see also Photographic Society
Peto, Sir Samuel Morton (1809–1889), 235, 257n.38	Photographic Society of Ireland, 237	Rumine, Gabriel de (1841–1871), 84–85, 256n.12
Petzval lenses, 95	Photographic Society of Scotland, 39, 40, 204, 237, 238, 256n.2	Ruskin, John (1819–1900), 5, 9
photogalvanograph, xiii, 26, 206, 236, 237	photogravure. See photogalvanograph	Russell, J. Scott, 232
photogenic drawing, xii	picturesque, 33, 35, 36, 45, 57, 67, 249n.3	Russell, William Howard (1820–1907), 19, 20, 22, 223, 224, 226
Photographic Album, The, 14, 201–2, 204, 233, 258n.21, 260n.2	Piranesi, Giovanni Battista (1720–1778), 253n.47	Russia:
Photographic Album for the Year 1857, The, 41, 41	Pocock, Lewis, 206, 264n.138	British war with, 18-19. See also Crimean War
Photographic Art Treasures; or Nature and Art Illustrated by Art	Pre-Raphaelites, 8–9, 10	Fenton's photographs of, 7, 14, 14-15, 16, 33, 34, 35,
and Nature, 26, 206, 236	Pretsch, Paul (1808–1873), xiii, 26, 201, 206, 236	56-57, 58, 103-8 (pls. 2-7), 202, 222-23, 233, 234, 239,
advertisement for (fig. 66), 206, 206	Price, William Lake (1810–1896), 25, 26, 29, 206, 207, 236,	251n.12
Photographic Association, 25–26, 206–7, 209, 219, 236,	264n.138	
259n.55	printing:	
Photographic Club (Calotype Club), 211-12, 213, 219,	division of labor and, 12	S
246n.40, 261n.51	Fenton criticized for deficiencies in, 49-50	Saint Mark's Church, Albert Road, London, 13, 68, 232

processes for, xiii

Salisbury Cathedral, Wiltshire, 64–65, 160 (pl. 55), 161 (pl. 56)

Photographic Exchange Club, 261n.51

salted paper prints (salt prints), xiii, 27-28 stereoscopic views, 13-14, 15, 25, 28, 29, 35, 52, 215, 223, 233, domestic life of, 78 Sandby, Paul (1731-1809): Harewood House (fig. 43), 70, 70 237, 238, 247n.59 Fenton's fall from favor with, 79-80, 254n.98, 255n.27 Sarum Almanack Advertiser, 62 landscapes, 35, 42-43, 238, 252n.38, 253nn. 40 and 46, Fenton's photographic documentation of royal family and. Scarlett, Sir James (1799-1871), 21 265n.160 17, 27, 60-61, 75-81, 85, 235, 236 Scotland: still lifes, 94-95, 95, 96, 97 Fenton's photographs of, 17, 17, 74, 76, 76–77, 78, 78–79, Fenton's photographs of, 37-41, 38, 54, 60-61, 128 (pl. 25), still lifes, 25, 28, 29, 30, 50, 90, 91-98, 92-97, 182 (pl. 75), 183 79, 234 129 (pl. 26), 203, 207, 236, 237 (pl. 76), 194-97 (pls. 86-89), 210, 228, 238, 239 on Fenton's work, 16, 225, 236 see also Balmoral Castle, Scotland Stonyhurst College, Lancashire, 46-47, 49, 71, 91, 180 (pl. 73), Great Exhibition and, 3, 232 Scott, Captain, 19, 217 238, 254n.93 Photographic Society and, 16, 75, 203, 217-18, 233, 234 Scott, John, 29 Stonyhurst College & Its Environs, 28 The Queen's Target and, 29, 192 (pl. 85), 230, 244 seascapes, 18, 18, 39, 39-40 Story-Maskelyne, Nevil (1823-1911), 217, 218 Victoria & Albert (royal yacht), 75 Sebastopol, Ukraine, 19, 22, 23, 37, 122, 205, 224, 225-26, sublime, 33, 41, 43-44, 45, 50, 249n.3 Victoria Cross, 19 235, 262n,23 Sutton, Jack Stayplton, 83 Victoria Gouramma, Princess, 234 Fenton's panorama of, 22, 223, 224, 261n.13 Sutton, Thomas (1819-1875), 39 Vigier, Vicomte (d. 1862), 213 see also Balaklava, Sebastopol, Ukraine Szarkowski, John (b. 1925), 68 Vignoles, Charles Blacker (1793-1875), 14, 56, 57, 206, 217, Seddon, Thomas (1821-1856), 232 231, 233, 236, 247n.59, 264n.138 Sedgfield, William Russell (d. 1902), 59, 64, 239 Vogel, Eduard, 233 self-portraits, frontispiece, 10, 101 (pl. 1), 240 Т in costume, 22, 83, 84 Talbot, William Henry Fox (1800-1877), xii-xiii, 4, 11, 34, Seymour, F., 217 52, 201, 216, 217, 234, 246n.52, 253n.45 W Shaw, George (1818-1904), 217 patent rights of, 4, 13, 26, 212-15, 218, 232, 234, 237, 245n.13 Wales: Sign near Wells Cathedral Advertising Fenton Photographs Pencil of Nature, 221 Fenton's photographs of, 26, 41, 41-46, 44, 45, 134-42 Talbotype. See calotype process (unknown photographer) (fig. 42), 66, 66 (pls. 31-39), 203, 207, 227, 237, 238 Simpson, William, 205 Telford, Thomas (1757-1834), 43 see also Tintern Abbey, Wales Sinclair, Colin, 203-4, 259n.34, 260n.66 Tennyson, Alfred, Lord (1809-1892), 17 Walton, Izaak (1593-1683), 49 skies, rendering of, 38-41 "The Charge of the Light Brigade," 23, 247n.80 Waterloo Bridge, London, 43, 68 see also cloudscapes "The May Queen," 9, 232 Fenton's photographs from, 69, 165 (pl. 60), 228, 229-30 "Smartt's Photographic Tent," 238 Tewkesbury Abbey, Gloucestershire, 14, 55-56, 56 Watkins, Carleton (1829-1916), 227 Smirke, Sir Robert (1780-1867), 69 Thomson, James (1700-1748): The Seasons, 77 waxed-paper-negative process, xii, 11, 34, 56, 233 Smirke, Sydney (1798-1877), 233 illustrations for, 77, 77-78 Webster, John (ca. 1580-ca. 1625), 227 Smith, Lyndon, 30 Thomson, John (1837–1921), 201 Weld, Thomas, 47, 231, 238 Smith, William, 222 Thornthwaite, W. H.: Guide to Photography, 233, 246n.40 Wells Cathedral, Somerset, 64, 65, 65-66, 253n.61 Snowdonia, Wales, Fenton's photographs of, 41-46, 134-42 Times (London), 19, 39, 223 Werge, John, 260n.66 (pls. 31-39), 222 Tintern Abbey, Wales, 55-56, 58, 111 (pl. 9), 208, 227, 227, 234 Westall, William (1781-1850), 57 Société Française de Photographie, 34, 84, 200, 207, 236, 238 Tripe, Linnaeus (1822-1902), 52 Westmacott, Richard (1799-1872), 68 Société Héliographique, 12, 34, 211, 212, 213, 217, 232 Tupper, Martin (1810-1889), 77 Westminster (Houses of Parliament), London, 68-69, 164 Society of Arts, 10-11, 203, 204, 217, 220, 233, 236, 237 Turner, Benjamin Brecknell (1815-1894), 52, 58, 238 (pl. 59), 165 (pl. 60), 229, 229-30 founding of Photographic Society and, 12-13, 215, 216, Turner, Joseph Mallord William (1775-1851), 25, 33, 37, 40, Westminster Abbey, London, 68-69, 162 (pl. 57), 229, 230 232, 247n.61 57, 64-65, 70 wet plate, wet collodion, or wet collodion on glass. See glass photographic exhibitions of, 15, 200, 200-201, 204, 215-16, negative process 233, 234 Wey, Francis (1812–1882), 213 Society of British Artists, 93, 217, 234 U Wharfedale, Yorkshire, Fenton's photographs of, 32, 36-37, Society of Painters in Water-Colours, 93 University College, London, 6, 231 115 (pl. 13), 205, 234 Soirée of Photographers, in the Great Room of the Society of Arts Wheatstone, Charles (1802-1875), 12, 13, 16, 35, 215, 216, (fig. 64), 200, 200, 233 217, 233, 247n.59, 260n.6 V Somerleyton Hall, Norfolk, 257n.38 White, Henry (1819-1903), 52, 238 Somers, Earl, 216 Valley of the Wharfe, wood engraving after photograph by White & Barr, 260n.66 Fenton (fig. 65), 204, 205, 235 Southgate and Barrett, London, 236 Wilkin, Cornet John, 21, 225 South Kensington Museum (now the Victoria and Albert Vernon, Robert, 93 William (handyman), 20, 235 Museum), London, 27, 29, 30, 238 Victoria, Princess Royal (1840-1901), Fenton's photographs Wilson, George Washington (1823-1893), 25, 52, 239 Sparling, Marcus (d. 1860), 20, 60, 233, 235, 236, 238, 252n.31 of, 17, 76, 76-77, 80, 130 (pl. 27), 255nn. 28 and 29 Wilson, Sir Thomas Maryon (1800-1869), 212, 217 Theory and Practice of the Photographic Art, 236 Victoria, Queen (1819-1901), 5, 16-17, 75-81, 96, 238, 255n.9 Windsor Castle, 78 Stereoscopic Magazine, 28, 35, 42, 43, 94-95, 95, 96, 98, 238, anniversary commemorations of, 76-77 Fenton's photographs of, 2, 29, 47, 68, 72-73, 188-92 253nn. 40 and 46 Crimean War and, 17-18, 19, 24, 79, 225, 236 (pls. 81-85), 229

Windsor Castle (continued):
photographic facilities in, 75
royal family photographed at, 17, 75, 77, 234
Windsor Park, 238
Winkles, Benjamin (1800–ca. 1860):
Ely Cathedral, East End (fig. 38), 61, 61
York Cathedral, South Transept (fig. 40), 63, 63–64
Wollaton Hall, Nottinghamshire, 67–68, 178 (pl. 71)
Wordsworth, William (1770–1850), 40, 44, 50
The Excursion, 50
"The Force of Prayer; or, The Founding of Bolton Priory.
A Tradition," 37
"The White Doe of Rylstone," 36, 50
Wyatt, Digby (1820–1877), 232
Wyatville, Sir Jeffry (1766–1840), 72

Y

York Minster Cathedral, Yorkshire:
Bedford's depictions of, 62, 63, 64, 253n.48
Fenton's photographs of, 63–64, 152 (pl. 47), 253n.46
Winkles's engraving of, 63, 63–64
Yorkshire, Fenton's photographs of, 32, 35–37, 36, 39, 57–60, 58, 63–64, 69–71, 70, 110, 112–15, 152, 173–75 (pls. 8, 10–13, 47, 66–68), 203, 205, 207, 234, 236, 264n.95

Z Zoological Gardens, London, 13, 68, 232

Photograph Credits

All rights reserved. Photographs were in most cases provided by the institutions or individuals owning the works and are published with their permission; their courtesy is gratefully acknowledged. Additional information on photograph sources follows.

© Copyright The British Museum: fig. 17

The descendants of Frank Dillon: fig. 55

Christopher Foster: fig. 42

The Illustrated London News Picture Library, London: figs. 7, 15, 64, 65

Lavis Fine Arts, Toronto: fig. 25

© 2004 Board of Trustees, National Gallery of Art, Washington: fig. 34

Royal Collection © 2004 Her Majesty Queen Elizabeth II: pls. 81, 82, 83, 84

V & A Images/Victoria and Albert Museum, London: figs. 33, 72